Books by Nathaniel Burt

Palaces for the People

A *
Museum
and Gallery of the Fine Arts in Holliday Street

Established by Rembrandt Peale AD 1813 Cost 18.000 D s

R.C.Long Arch t

Palaces for the People

A SOCIAL HISTORY OF THE AMERICAN ART MUSEUM

by

Nathaniel Burt

BOSTON Little, Brown and Company TORONTO

To
Rensselaer W. Lee
Edgar P. Richardson
and
Walter M. Whitehill
with
deepest respect.

FIRST EDITION

T 11/77

LIBRARY OF CONGRESS CATALOGUE CARD NO. 77–87153

Designed by Christine Benders

*Published simultaneously in Canada
by Little, Brown & Company (Canada) Limited*

PRINTED IN THE UNITED STATES OF AMERICA

"*Through pleasures and palaces though you may roam,
Be it ever so humble, there's no place like home.*"
—"Home, Sweet Home," John
Howard Payne

Contents

List of Illustrations

BOOK I

In the Beginning

Chapter I

i

IT WAS THE BEST of times, the worst of times. The year was 1970, a year of triumph and scandal in the vast province of the American art museum. Though many millions of Americans have never set foot in a museum, it is estimated that at least seventy million have visited some museum at least once. And the estimated annual attendance at all museums is now nearly seven hundred million admissions. Much of the triumph and the difficulties of the modern American museum hang on just this fact of mounting popularity.

No museums have felt the double edge of popularity more keenly than those two great American dowagers, the Metropolitan Museum of Art in New York and the Museum of Fine Arts in Boston. In 1970 both celebrated their slightly fictitious centennials. (Although the Met and the BMFA were chartered in 1870, the Met did not begin to exhibit until 1871, the BMFA until 1876.) Both drew record crowds and press coverage. Both were triumphant. And both were scandalous.

Hoopla, so familiar to Manhattan, so foreign to Boston, characterized the year from beginning to end. Some deplored and were shocked;

others were stimulated and amused. Everyone, sooner or later, must have seen in some newspaper or on some TV channel the more sparkling or disastrous aspects of this hoopla: for the dowagers came of age with éclat.

In a hundred years these two museums have risen from a gleam in the eyes of various worthy ladies and gentlemen to world position, a kind of cultural glory that Europeans recognize as a most powerful weapon of national propaganda and power but that Americans rather tend to ignore. Florence knows what its museums mean to it. New York and Boston only fitfully sense it. Yet both American museums, in a somewhat different way, have a global stature. The Metropolitan ranks as one of the world's greatest, in a category only slightly less exalted than that of the Louvre. The BMFA is among the very first, too, but in a different category, that of the city museum rather than the national museum.

True, New York is just a city, too, not a capital; but its peers elsewhere in Madrid or Leningrad represent more than just municipal glory. Boston, however, compares rather to the museums of Germany and Italy that for all their stature are still, like Munich or Dresden, what Europeans call "provincial" rather than "national." The competition at this level, however, is formidable. The fact that these two museums, after just a hundred years of existence, can now be mentioned in the same breath with their European counterparts is nothing short of a cultural miracle, a miracle of which Americans ought to be more conscious.

The two centennials must have done much to make Americans aware of their museums. At least the celebrations have brought the existence of these — the two oldest functioning great American art museums — to public notice. The attendant scandals may have injured dignity, but they certainly did no harm to publicity.

ii

In both cases the party began before the birthday. Since the Metropolitan, if not the older, is by now the bigger and more famous of the two (a somewhat sore subject in Boston), the celebration was noisier there. It really began in New York as far back as 1966, when Thomas Hoving was appointed as the new Director. Hoving was originally a bona fide scholar of medieval art and Curator of the Cloisters. The Cloisters, that rarefied and beautiful offshoot of the Metropolitan set upon a remote hilltop at the far northern tip of Manhattan by John D. Rockefeller, Jr., represents everything pristine, studious, and refined in museums. Hard to get to, esoteric in its collections, it stands as a mod-

ern reconstruction of monastic seclusion. From this seclusion, Hoving was pulled into midtown life by his friendship with Mayor Lindsay. Made Park Commissioner in 1965, he set the town in an uproar with his ebullient and imaginative transformations of the city's parks into locales for "happenings." New York's Lindsay-inspired ambition to show itself off as Fun City had no better propagandist. Hoving had just gotten into his stride when, to the consternation of many, he found himself back in the museum world as Director of the Metropolitan. The previous Director, James Rorimer, who had been Rockefeller's instrument, advisor, and alter ego in the creation of the Cloisters, was inclined to be reticent, technical, orderly. Hoving immediately began to feed the Metropolitan into the maw of Fun City.

Although Hoving's first exhibition at the Met, called "In the Presence of Kings" (objects made for royalty through the ages), was irreproachable esthetically and scholastically, some later openings were not. At least the Metropolitan always seemed to be in the newspapers and hot water. In 1967, for instance, the Museum bought a big beautiful Monet for $1,411,200 from the Pitcairns in Philadelphia. A Pitcairn, who had bought the picture in 1926 for just about one percent of its final price, now needed some two million dollars to subsidize a chamber orchestra and began to draw on the cache of masterpieces tucked away in castles built about a Swedish Romanesque Swedenborgian cathedral in Bryn Athyn, north of Philadelphia. No one objected to the Monet as a picture, though as an earlier work it was not considered "characteristic"; but there was great consternation over the price. As in the case of the Met's previous purchase of Rembrandt's *Aristotle Contemplating the Bust of Homer,* bought for some two and a half million dollars in 1961, a general cry went up: was any picture worth it? For Rembrandt, perhaps yes — although the Met owned over thirty Rembrandts at the time, none of them purchased. But an "uncharacteristic" early Monet?

Almost simultaneously with the fuss about the Monet came a real scandal, which Calvin Tompkins has brilliantly written about in *Merchants and Masterpieces.* It was announced that a small Greek horse, long considered one of the Met's greatest treasures, was definitely a forgery. The Met had been through a famous forgery scandal involving a magnificent and bogus statue of an Etruscan warrior. The horse, a spirited and riderless bronze, was equally famous and equally beautiful. The twelfth edition of the *Encyclopaedia Britannica* in 1928 had reproduced it in full-page color as a supreme example of Greek craftsmanship. But one fatal day back in 1961, an expert (although not a curator) happened to notice, as he walked by, a suspicious seam running from nose to tail, which seemed to indicate that the bronze was cast in a manner unknown to the fifth-century Greeks who were supposed to have created it. X-ray tests gave the impression that it was a

modern fake. Experts who up to that time had considered it an authentic masterpiece suddenly began to discover esthetic flaws. The eyes were "sentimental," all of a sudden. The horse was reintroduced to the public in 1967 as "one of the most important classical art forgeries ever discovered" and drew more attention than it ever had as genuine. This raised eyebrows not already raised by the discovery of the forgery itself. Then, to the consternation of all, another group of museum experts decided that the horse wasn't a forgery after all. In 1973 the horse was recanonized, with qualifications. It was no longer labeled as "Greek" but as "Hellenistic? Roman?". Are the eyes still "sentimental"? With its reputation slightly tarnished, the horse is once more a legitimate part of the museum's Classical collection.

Even one of the Metropolitan's greatest coups, the acquisition from the Egyptian government via the American government of a great hunk of architecture, the Temple of Dendur, began to cause trouble. The Temple, about to be submerged by the waters of the Aswan Dam, was given to the Met because of its activities in helping salvage such threatened works of Egyptian art — and also because the Met said it could find room for this oversized present. Immediately, outcries: where could the Museum put the Temple except in back, encroaching out into Central Park? Never, screamed Park lovers, a scream that has persisted to this day. Why not set it up somewhere on its own, a second Cloisters? And so began a running confusion of charges and countercharges that eventually engulfed the Museum in a full-fledged lawsuit.

Then there was the minor scandal of the James Rosinquist *F-111*. This was a large and lurid Pop environmental construction whose very presence in the Met offended many — and intrigued more. But still, it all seemed to build up the image of Hoving Happenings.

The glories of the "Presence of Kings" and the record-breaking attendance at the beautifully arranged show of Italian frescoes, though they brought out the crowds and burnished the reputation of the Museum, did not stir up the newsmen.

In fact, nothing in the Metropolitan's entire history stirred up the newsmen like the next scandal caused by the well-intentioned but not universally acclaimed exhibition called "Harlem on My Mind." Perhaps the very title itself might have given pause to those sensitive to the currents of the Black Revolution. It comes from a song written by Irving Berlin (not a native of Harlem) for a 1933 show in which Ethel Waters, playing the role of the expatriate black chanteuse Josephine Baker, sings nostalgically, "I've a longing to be low down / and my 'parlez vous' / will not ring true / with Harlem on my mind."

The exhibition itself was fairly nostalgic, too — the brownstone respectability of the early 1900s, the cultural renaissance of the Carl Van Vechten twenties, and the rise of Cotton Club glamour in the enter-

tainment world. As a sprightly and interesting mixed-media exercise in old photographs and new methods, it had its charms and stimulations; but its charm left radicals cold and it stimulated mostly controversy. On one side, art lovers proclaimed that it had no business in a museum in the first place. On the other side, various angrily conflicting Harlem groups united in saying that it was a travesty. Picketings and protests and unburdenings to the press took place; but most unfortunate of all was the personal protest of an unknown vandal who went about the galleries of European paintings defacing masterpieces, including one of the Rembrandts, with the letter H incised with a ball-point pen (Hoving? Harlem?). Curators all over the world blanched. A liberal journalist, attacking the Met in general, said, "Why are we so shocked when vandals deface paintings and yet remain not at all shocked about the fact of Harlem?"

Much worse was the preface to the Harlem show's catalog. It contained an essay written as a school paper by a young black girl named Candice Van Ellison. It was full of ethnic prejudices, bluntly expressed. For instance: "Behind every hurdle that the Afro-American has yet to jump stands the Jew who has already cleared it." The facts that this particular sentence was not by Candice Van Ellison but was a quotation from a reputable sociological textbook (one of whose authors was Jewish) and that the show itself was mounted by a Jew were overlooked in the furor. Rabbis thundered, Mayor Lindsay, never one to neglect an ethnic vote, castigated his friend Hoving. Miss Ellison remarked, "I don't see what the Mayor is mad about. What I wrote was true." The Museum, in the interests of free speech, refused to repress the preface. Instead Hoving abjectly apologized to the Mayor and the city and then just quietly withdrew the catalog, now a collector's item, though long thereafter readily available at bookstores in hard cover.

By the end of 1969 Hoving's reputation was at a new low and the Centennial hadn't even started. The omnipotent (if mutually antagonistic) senior art critics of the *New York Times* declared themselves anti-Hoving. Hilton Kramer referred to the Harlem show as "lamentable in many ways . . . belongs more to the history of publicity" than to that of art. It had "for the first time politicized" the Met. John Canaday was equally scathing. In his 1969 summary of the decade of the sixties in the art world, he nominated for the greatest disasters during that time the floods in Florence and Hoving's directorship of the Metropolitan Museum. The ravages of the floods could be, and were being, repaired; in fact, the floods had turned out a blessing in disguise as an inspiration to renovation and rescue. But what of Hoving? He had, said Kramer, "cast doubt on the integrity" of the Met; and he had, said Canaday, "gone from good to bad to unpardonable" and "cheapened the image of the institution."

Actually, for a while (only a while) it was all upwards and onwards from the nadir of 1969. Even Canaday hinted as much. "If Hoving has no tricky surprises up his sleeve and can restrain the impetuousness with which he commits the Met to tawdry projects, the Met may be on the way to redemption by 1971." In fact, though the Met is still and always awash in controversy, the Centennial year did indeed turn out to be a socioeconomic-esthetic redemption, if only a temporary one, and a full-blown exercise in hoopla, too.

<center>

...

iii

</center>

Redemption perhaps, but not one unattended by squawks. Though the true opening date of the Centennial was not until April 13, the first exhibition of the season was a mammoth disclosure of modern American painting called "New York 1940–1970." The vast collections of European painting on the second floor were moved out to provide space for this and subsequent Centennial exhibitions, and new galleries were opened where a limited selection could be hung in a deliberately quaint fashion, "skied" one above the other in quasi-Victorian style. The modern exhibit, uncompromisingly Abstract Expressionist or later except for a token inclusion of realists Edward Hopper and Milton Avery, caused squawks from anti-Modernists. For the average museum-goer it provided gawks rather than squawks, an eye-shattering and entirely stunning demonstration of what American postwar Modernists had been up to all these years.

There was nothing wrong with this; though some traditionalists had doubts about the presence of so much very advanced art in a sacred temple of the Muses. But nonetheless, controversy raged. The curator and creator of the exhibit, Henry Geldzahler, made it quite clear in the preface to the catalog of his show that he considered this not just a fine display of what some artists had been doing but a total summation of what *the* artists of the modern world, centered in *the* art capital of the world, New York, had been doing to and for *the* art of the world. They had transformed it forever, and a good thing, too. They were to be compared to the artists of the Renaissance and of Impressionism, only more of them were significant and historically crucial. This accolade by *the* Museum was in recognition of one of *the* great esthetic developments and achievements of all time. In fact, as one captious critic put it, it was "The definite final verdict from on high of what alone merits our applause."

Mr. Geldzahler didn't put it so breathlessly or forthrightly, but this is what he surely meant. These forty-three artists were the Elect, the Immortals, artists on a par with Giotto and Manet. Imagine the affront

to a score of other artists, bona fide members in good standing of the avant-garde and the New York School, who were not included in the exhibit (for no reason explained in the catalog except by a summary list of the artists so rejected, without comment). Imagine the effect on other cities, other museums, other art centers, artists of other persuasions whom this exhibition was, at least according to the catalog, designed to put in their places. Innocent bystanders, those who hadn't read the catalog and didn't know Geldzahler or the artists, might be mystified at the foam that flecked the lips of art critics. On the inside, however, it was open season on Geldzahler.

But this false dawn was soon obliterated by the true sunrise of the Centennial, the actual opening in April. First Mrs. Nixon on the night of April 12 received at an intimate dinner for seventeen hundred a sneak preview of the new exhibit. Then next day Mayor Lindsay came and started the new fountains added to the facade in preparation for just this occasion. The whole front part of the Museum, in fact, had been refurbished, to the great annoyance of visitors. New, larger, and more dignified front steps had been added and a cleaning up and clearing out of the grandiose front hall had been effected with fresh lighting, fresh flowers donated by Mrs. Dewitt Wallace of the *Reader's Digest* in niches, new and workable coat rooms, new and alluring book salesrooms. (Squawks.) A jolly party for the staff and the public on the afternoon of the thirteenth attracted over fifty thousand people, who were served soft drinks and snacks, a sort of enormous birthday party where the atmosphere was that of a megalopolitan "church supper." The only flaw was that a gigantic birthday cake proved too gigantic and refused to hold up under the stress of candle lighting. Some saw this as symbolic of the Met itself and its top-heavy gigantism.

Then, the evening following the "at home," came the ball. There was no question about it, the ball was the social event of the New York season, perhaps of the century. Said the *New York Post*'s fashion editor, "The opera opening has become tacky, the charity ball is on the way out, but the Met's 100th birthday party last night was the perfect picture of what New York night life is supposed to be." Some two thousand people at $40 to $125 a head came dressed to the gills; galleries were transformed into an 1870 ballroom, a Belle Epoque 1910 salon, a 1930s supper club, a Futurist discotheque. Barbra Streisand, done up like the Egyptian queen Nefertiti (who is in Berlin, incidentally, not New York), took over the supper club. Celebrities of every kind and age waltzed, fox-trotted, or gyrated, depending on decor. *Women's Wear* devoted pages of photographs to the clothes, social columnists to the names. *The New Yorker* sent a Roving Reporter. There were stories on it in half the newspapers of the country. It was a *success.*

The ball was, incidentally, part of the preview of the first true Centennial exhibit, "19th Century America," an array of sculpture, furniture, objects, painting that could be considered as epoch making in its way as the previous New York School show. Whereas that proclaimed the new art in fact old and established, the nineteenth-century exhibit proclaimed the old and disestablished, the somewhat downgraded art of America from 1815 to 1915, now was to be reassessed and readmired.

New Yorkers and their art critics reacted as though nobody had ever paid any attention to nineteenth-century America before April 14, 1970. "One can assess the folly of the genteel neglect and snobbish disdain that has recently been the lot of much of this work. Now for the first time we can fully recognize and delight . . . in the arts of 19th century America." The fact that the Boston's Museum of Fine Art's Karolik Collection had brought half the pre–Civil War artists displayed here to public attention twenty-five years ago, that James Thomas Flexner and others had been writing about them to vast effect for the previous decade, that dealers had been making a killing — all this meant little to New Yorkers. What counted was that *they,* in the person of the Metropolitan Museum, had now decided to pay attention to the nineteenth century.

Camp and real creativity were indiscriminately mixed; silly statuettes and overstuffed furniture were lumped in with masterpieces. But that just made it all the more chic. It was as good as the ball itself. Indefatigable Hilton Kramer of the *Times* got out his hatchet, burnished with use. He scalped the Met for showing some of "our most sublime achievements with some of the worst pictures ever elevated to museological status." Leutze's *Washington Crossing the Delaware* hung along with Eakins, Bingham, and Homer.

Even the ball, enormously popular as it was, won its quota of outrage, very decorous outrage to be sure. In face-lifting the facade, a row of fine old trees, by Manhattan street standards, had been cut down. Coupled with the already simmering fuss about the Museum's encroachment on the Park with its Temple of Dendur and all, some sixty stirred-up Park and tree lovers picketed the ball. To be in keeping, they all wore evening clothes, black tie and long dresses. But the spirit was definitely anti-Met. As one of their spokesmen barked, "I consider trees more essential than the damned new facade of that damned Museum which has no business being in the Park anyway."

After this, however, joy at the Met was fairly unconfined. A choice exhibit entitled "The Year 1200" drew the acclaim of scholars, critics, and a comparatively slim crowd. Canaday (if not Kramer) came down from his dungeon and admitted that at last Hoving had done something right. After all, his field was medieval art and he had been up at the Cloisters. A somberly magnificent panorama of pre-Columbian art,

"Before Cortés," transported massive monuments from Mexico to the astonishment of all.

Then, in a last blaze of glory came the finale, "Masterpieces of Fifty Centuries," which was exactly that. There had been some idea of culling all the world's most famous works of art from all over — Paris, Amsterdam, Madrid — but insurance rates and the dangers of shipping reduced the show to a sampling of the Met's own masterpieces. Here in a museum inside of a museum ("The Reader's Digest of All Art Shows of All Time") was a run-through of the kinds of things the Met owns and displays: prehistoric pottery, Middle Eastern and Egyptian sculpture and jewelry, Attic vases and statues, the whole range of European art, and what have you. There was the famous Rembrandt, *Aristotle Contemplating the Bust of Homer,* the famous Pitcairn Monet. A Pollock and a Hans Hoffmann came from the New York School to top the show off in the last of its thirty-three galleries. As a gesture of sober and refined arrogance to celebrate a hundred years of existence, it would be hard to beat.

Not many museums in the world could do it; none could have done it with more flair and elegance. However, there were again protests. Some objected to the arrogance. Masterpieces indeed! What about the Regnault — French salon art of the worst period? Some (Hilton Kramer, for one) objected to the flair, the showmanship of it all. "But the irritations . . . oh the irritations!" The hi-fi setting of the lighting with its dramatic room-to-room progression of darkness to brightness, the equally dramatic posing of the objects themselves: Broadway, not art. One sourpuss, in a letter to the *Times,* complained that it gave the vulgar impression of "a shopkeeper's boasting of his merchandise." Most critics and visitors were properly awed and pleased.

Many other side shows — a stunning exhibit of eighteenth-century Italian drawings, a trading of goodies with the Boston Museum of Fine Arts in which they sent the Met a hundred pictures and the Met sent them a hundred pictures — enriched that already almost too rich year. There were concerts (at one of which a stink bomb was thrown to protest a Russian performer), lectures, symposia, seminars.

And meanwhile Mr. Hoving, to make the point of all this celebration, unveiled a grandiose plan for a final completion and aggrandizement of the Museum. The motley and nondescript backside looking on Central Park is to be unified and concealed behind a sort of enormous glass greenhouse. This is to contain room for the three splendid new acquisitions of the Hoving regime: first, that Temple of Dendur; next, the magnificent Lehman Collection, considered to be the last such trove of Old Masters left in private hands in America, which came to the Museum on the death of Robert Lehman in the summer of 1969; and, finally, Nelson Rockefeller's collection of primitive art, named in honor

of his son Michael, a student of primitive art who lost his life in New Guinea.

Both the Temple of Dendur and the Lehman Collection require special pavilions, the latter because it was left as an inviolate whole. Museums nowadays never take benefactions that stipulate a collection must be kept together intact. But what could you do about something like the Lehman Collection? Even the Met wasn't big enough to turn that one down.

Although in fact the new glass house won't take up more room than that allotted to the city when the original museum was started in the Park in the 1870s and though most of the ground is now occupied by parking lots (which will be buried in the basement of the new construction), there has been a most violent squabble — the usual outrage, controversy, pickets. People objected to moving the Lehman Collection from its original lovely town house on West Fifty-fourth Street, where it was so serenely at home. Dispersalists continue to take potshots at Behemoth. Many nowadays feel sheer bigness in a museum is wicked. Most violent of all have been the protests of Park lovers, who went so far as to sue. Suit was dismissed, however. And then somehow about fifty million dollars was to be raised for all this novelty.

Between the Centennial and these current dilemmas the Met went through its most dreadful crises, the scandals of the de Groot deaccessioning and the Greek krater. These almost deaccessioned Director Hoving. However, since they bear a close family relationship to things that happened during the Boston Centennial and since the Boston Centennial really requires a background to be properly appreciated, these latest Hoving Happenings and the vindictive pursuit of them by the *New York Times* should be saved for the end.

Chapter II

i

BOSTON'S EQUALLY RICH and, in different ways, almost as controversial Centennial can only be appreciated in the light of history; for both the BMFA collection (unlike that of the Met) and the history of the museum in America generally go back long before 1870. The American museum as a phenomenon is, indeed, as old as the European. This sounds and is paradoxical; but the modern museum is an idea as much as it is a fact, and the *idea* of the public museum was tangibly sprouting in America at the same time as it was in Europe.

For all its august trappings and air of superior and detached taste and erudition, the museum as we know it today (opposed to the "collection" as Europe knew it after the Renaissance) is a thoroughly popular, democratic phenomenon. The European upper classes didn't need museums. They lived in them. To this day the Roman palazzo, German schloss, French chateau, or English great house is a depository of art, the walls stacked with paintings by Old Masters, some of them good, the halls crammed with statues. The last place a king or prince or cardinal of the old dispensation would think of going would be to a public museum. Why leave home?

But for the average citizen, especially in America, things are different. Up to the Civil War nobody in America lived in a real palace crammed with real art. Few did so afterward, and not for very long. The point of the museum in America is that it is no place like home, that it *is* a palace in a land where palaces are, strictly speaking, non-existent. In America the museum represents something that doesn't exist elsewhere in the country. In Europe it is usually merely the making public of something that has existed forever. The key to some ancient hoard located in some grand edifice has simply been turned over to the government, either as the spoils of revolutionary victory or the triumph of liberal thought.

In other words, people who live in palace-museums don't need them. People who don't, do. This is the essentially popular basis of the art museum. It is the substitution of the words "our palace" for the words "my palace." The craving for palaces being, it would seem, one of the staples of human desire, this is one way in a generally nonpalatial world to satisfy the urge.

"Our Palace," with its grand halls and columns and fountains and its acres and acres of valuable and tasteful decor, is what in fact most major American museums, particularly the "big-city prides," have become. To bathe in the illusion of living in marble halls on a Sunday afternoon and to feel a sort of proprietorship in all this luxury is certainly one of the basic appetites the art museums satisfy. The beauty of it all is basic, as is indeed the value and luxuriousness; but the actual esthetic impact of individual works of art probably is, for the average millions of museum-goers, somewhat secondary. The true art lover, the real connoisseur, the seeker after knowledge is the exception, not the rule, in Our Palace in the Park.

ii

The American museum was made. The European museum just grew. The American museum was and is an idea. The European museum was a fact. Almost without exception the European museum was first a collection. With few exceptions most American museums were first an ideal. Many of them were created, and sometimes even their buildings built, before they owned anything at all. Furthermore, almost without exception the larger American museums began with a deliberate appeal to the public. Most of the earlier European museums remained semi-exclusive cabinets of curiosities visible only to a few. The American museum began, and has remained, wide open.

Of the three museums in Europe generally acknowledged to be the oldest, only one was originally devoted entirely to art; the other two

were essentially scientific. Art gradually crept into them, one might say crept over them, a curious process that is still going on as what was once pure knowledge — ethnography, anthropology, archaeology — turns into esthetics. An old basket ceases to be just a specimen and becomes an object, something to be enjoyed rather than merely studied. This close link between science and art in the history of museums is just as characteristic of America as it is of Europe.

The business of what is "oldest" and "first" is always a tricky one. However it seems fairly well established that the oldest extant public art collection in Europe, and therefore probably the world, is in Basel, Switzerland. This Catholic city-principality on the Rhine, now flanked by both France and Germany, was during the Renaissance a center of humanistic culture and the seat of a thriving university. Scholars like Erasmus and painters like the Holbeins found a welcome there and made friends. Among these friends was Bonifacius Amerbach (1495–1562). His father Hans had been a pioneer and most prosperous printer. In the course of business he had collected prints, some by his friend Dürer, often for use as book illustrations. His son Bonifacius used his father's small collection as a basis for his own, adding in particular various paintings by his friend Hans Holbein, Jr., including a fine portrait of himself and a portrait of their mutual friend Erasmus. Bonifacius was a professor of jurisprudence at the University. His son Basilius (1533–1591) was the same, and it was he who increased the holdings of the Amerbach Kabinett from about a hundred items to over four thousand.

Basilius was a true collector; in 1578 he built a room onto his house to hold his treasures and there the treasures stayed for nearly a century, adding luster to the city and the family name. Besides the Hans Holbeins, Basilius also had the good sense to collect beautiful paintings by lesser-known Swiss Renaissance artists such as Nicklaus Manuel Deutsch, Urs Graf, and the other Holbein (brother Ambrosius). He also went in for prints, goldsmithery, fine editions, and pieces of antiquity. There were, of course, such middle-class collections all over Germany before the devastation of the religious wars; but only a few like the Amerbach Kabinett survived.

By 1662 the family finances had declined, perhaps as a result of those wars. The rumor got around town that an Amsterdam dealer was looking over the Amerbach collection, that jewel of local pride, and to prevent its loss and dispersal the town council in a burst of almost unprecedented forethought voted funds to buy it. It was bought and presented to the University. The University hung, or perhaps better, hid it in its library in the house "zur Mücke" (many of the old houses in Basel are given names in this fashion). There the collection moldered, examined by an occasional professor or artist. In 1823 an-

other windfall enriched the collection. A later Basel bourgeois, also a doctor of law, Remigius Faesch (1595–1670), built up his cabinet along somewhat the same principles as the Amerbachs. He too collected Holbein and the Swiss Renaissance artists and, incidentally, actually called his collection a "Museum." Remigius left it all to his descendants with the proviso that it stay in Faesch hands as long as there was a doctor juris in the family. The family was without lawyers for the first time in 1823 and so, according to the will, the collection went to the University. By this time the currents of modernism were stirring even in Basel, which had become something of a backwater after its sixteenth-century glory. Artists began to complain of the inaccessibility of the University's pictures; the University needed a new library. The Haus zur Mücke was abandoned and by 1849 a new, spacious, Neoclassical city museum was built, science downstairs, art on top. At last the public could really see the Amerbach and Faesch collections. Accessions and donations increased and in 1936 a handsome white Neoclassic-modern edifice was built. The collection began to acquire Picassos by the dozen. Today the Basel Museum is one of the best in all Europe, one of the few that has achieved international status along the lines of the typical American big-city museum — private collections of local burghers, public subsidy by the town council, a true monument to civic pride.

The Basel Museum in the twentieth century has specialized in modern painters, notably Picasso. Civic pride reached its crest in 1967 when some of the Museum's most famous Picassos were about to be taken away. The owner, a local merchant who had them there on loan, suddenly needed cash and decided to sell them. It was all much like 1662; rather than let the pictures leave the city the citizens raised the purchase money by popular subscription. The Picassos are still in Basel, and Picasso was so delighted by these manifestations of municipal enthusiasm that he donated several of his works to the collection.

. . .

iii

The Basel Museum is not only the oldest of its kind now in existence,* but very much the prototype of today's average American big-city institution. The two English museums that can claim to be next

* The ancient Library of Alexandria, actually called "The Museum," is usually considered the world's first "art museum." Besides books, it also contained works of art. It was destroyed by Caesar who, according to Shaw, thought it good riddance. Collections, sometimes visible to the public, have existed in most mellow civilizations, especially in the Orient. Rome was full of palaces left to the public that were in fact "museums." But Basel is the oldest of now existent public museum collections.

oldest, not only in England but in Europe and the world, are quite different in spirit and in the history of their foundation. The senior of them is the Ashmolean of Oxford, whose peculiar name commemorates a most peculiar individual. The peculiarity does, in fact, begin with the name; it is a misnomer. The proper name should have been the Tradescantianum because Tradescant was the name of the man, or men, who actually formed the collection. The Tradescants were a family of professional gardeners and botanists. Throughout the seventeenth century they served the Stuarts in the capacity of royal gardeners, and through two generations John Tradescant, Sr. (died about 1637) and Jr. (1608–1662) collected plants from as far off as Virginia and Russia and curiosities of all sorts. They were adventurous souls. John Sr. made a pioneer botanizing expedition to Archangel in 1618. John Jr. went to Virginia as early as 1637. Between them they are credited with introducing into England (and hence into America) the lilac, the acacia, the plane tree, and other plants. The spiderwort, a native of Virginia brought back by John Jr., which is still an ornament of the garden, bears the Latin name *Tradescantia.*

The younger John Tradescant lost an only son and heir in 1652 and in his grief decided to turn over the rights to his collection to a friend named Ashmole. The Tradescants were quaint enough, with their passion for shells and plants and their daring botanical voyages; Ashmole was downright eccentric. Elias Ashmole (1617–1692) was described by a contemporary as "the greatest virtuoso and curioso that ever was known" in England. Born the son of a "saddler of good family," in early middle age he became infatuated with astrology and alchemy. He came to London, where he "mixed much in astrological circles" and was one of the earliest English Freemasons (1646). He became a disciple of Master Backhouse, a venerable Rosicrucian who "opened himself very freely touching the Great Secret" and who bequeathed to Ashmole the "true matter of the Philosophical Stone," a true matter that Ashmole unfortunately failed to pass on to posterity. Although Ashmole actually made his living as a solicitor, he seemed on the way to becoming an accomplished warlock. He was soon able to give up sordidly mundane pursuits. He married, as his second wife, a Lady Mainwaring, who was rich, twenty years older than himself, and evidently very disagreeable. "He enjoyed his wife's estate, though not her company." He studied Hebrew and heraldry, the latter to such effect that Charles II appointed him Windsor Herald. His wife petitioned for a separation but, despite eight hundred sheets of depositions, the case was dismissed. Ashmole went on to more and more exalted and prosperous offices, dropping alchemy in favor of such posts as that of Accountant General of Excise and Comptroller of the White Office. His great work, *The Institution, Laws and Ceremonies of the Order of the*

Garter, appeared in 1672, thus assuring him immortality. He was in his latter years a wealthy and respected gentleman. Happily married, too. Obnoxious Lady Mainwaring died, and in 1668 the widower married a much younger woman. He devoted his declining years to his antiquarian research.

His old friend Tradescant had died in 1662. Though both Mr. and Mrs. Tradescant had formally conveyed their "Museum Tradescantianum," more familiarly known as "Tradescant's Ark," to Ashmole by deed in 1659, when John's will was read it left everything to his widow, including the collection. Ashmole sued, but a mutually satisfactory arrangement was evolved. Ashmole built a house in Lambeth right next to the Tradescant house and garden and moved the stuffed birds, quadrupeds, fish, shells, insects, minerals, fruits, war instruments, "habits," utensils, coins, and medals into it. There Ashmole and Mrs. Tradescant lived amicably side by side until one fatal day in 1678 when Mrs. Tradescant (née Hester Pooks) was drowned at high noon in the pond of her husband's famous garden. Mr. Ashmole immediately removed the family portraits from the Tradescant house into his own, these being evidently the first and only paintings of the Ashmolean collection. There were (and still are) several of these curious Tradescant portraits, notably a double portrait of John Jr. and his "friend Zythepsa." Zythepsa is not, as one might hope, an Eastern houri, but a Quaker brewer of Lambeth who adopted that outlandish name in typical seventeenth-century pedantic fashion. Most conspicuous in the portrait is a glittering heap of shells, representing the Museum Tradescantianum, which quite overpowers the two somewhat huddled humans on the other side of the canvas.

Ashmole, aging, honored, rich and remarried, determined in 1677 to bestow the Museum on Oxford "on condition of a suitable building being provided" to house it. In 1682 such a building, planned by Wren, was provided, and into it went twelve wagonloads of curiosities, including one of the only known stuffed dodos, already extinct. Dr. Plot was appointed curator, the Museum was named the Ashmolean after the donor, not the collectors, and the sequestered Tradescant portraits provided the nucleus for what is now one of the choicest collegiate art collections in the world, graced by Michelangelo, da Vinci, Rembrandt, and many a Rubens. The dodo decayed and was thrown away in 1755, but pieces of it, head and foot, are still on display in Oxford's scientific museum, where most of the Tradescants' other curiosities eventually went.

iv

The British Museum began under more stately auspices; but it, too, originally had nothing to do with art. The Museum was founded upon three collections rather than one. Two of them were libraries: the Cotton collection of manuscripts and the Harley library. The third was the immense natural history collection of Sir Hans Sloane. Great art entered the British Museum, and late at that, as archaeology. Antiquities were gradually added. Some of them, like the Elgin Marbles, happened to be esthetically transcendant. But they were included for scientific, not esthetic, reasons; and the British Museum still thinks of itself as a depository of knowledge rather than of beauty.

The amiable Sir Robert Cotton, born in 1571, was the earliest of the Museum's benefactors. He was the first great antiquarian of his time both chronologically and socially, and he would have been happy and renowned simply as a gatherer of ancient documents and friend of the famous — Raleigh, Bacon, Ben Jonson. But alas, the price of fame was high. Queen Elizabeth called on him, as an expert in ancient rituals, to settle a delicate matter: at a treaty conference between Spain and England, which ambassador should have precedence? Cotton discovered seven antique reasons why precedence should belong to the Englishman. His political future was determined and his life ruined. He went on to become Member of Parliament and a favorite of that other antiquarian, James I. But he chose the wrong side and wrong associates in the interminable plots and stratagems of the time and, under Charles I, found himself, like so many others, in jail in the Tower of London. A supposedly "seditious pamphlet" was found among his books. His library was put under lock and seal and even when he was released from jail he was forbidden access to it. This was more than the poor man could take. He lived less than a year. All his attempts to be allowed to get back to his precious books failed and he died brokenhearted in 1631.

The library was eventually restored to his son, Sir Thomas Cotton, and thence descended to a Sir John. In 1700 it came from him to the nation. It contained irreplaceable treasures, but the nation didn't seem to care very much. It was housed in a peculiar narrow room (six feet wide, twenty-six long, but very high) in "Cotton House" near Westminster, and there both house and library rotted away. Eventually the library was moved, twice, in fact; but the new housing proved little more secure. "Ashburnham House," where it had been deposited, was destroyed in a disastrous fire in 1731. The library was not actually destroyed, but about a fifth of it was lost, thanks especially to the

cowardice of the librarian, Dr. Bentley, who fled the building as soon as fire was discovered. Bentley blamed the fire on the "Nemesis of Cotton's ghost," angry that his gift hadn't been better cared for. Other more courageous book lovers and fire fighters saved most of the collection and the "nation was aroused." High time. Plans for a British Museum were already being formed and the Cotton library was included in them.

The next collection that went into the making of the British Museum was the library of the not-so-amiable Robert Harley, created Earl of Oxford. Harley was descended from a Puritan family who loathed art in any form as an agent of the Devil. His grandfather had been active in desecrating Westminster Abbey. He had, indeed, reveled in the task, paying six shillings for "three days work in planing out some pictures" and ten shillings for "taking down the high altar in Henry the Seventh's Chapel." Odd that from such a specifically antiesthetic family, and without any esthetic intention, should have been born what is now one of the great depositories of art masterpieces in the world.

Harley's contribution was his manuscript collection. A pure politician, he seems to have brought them together merely for conspicuous consumption and with the desire to be considered a gentleman of intellectual parts. He, too, like Cotton, landed in the Tower, in his case for his Jacobite intrigues under the Hanoverians.

It was his somewhat more amiable son Edward, friend and patron of Pope, Swift and Prior, who really founded the magnificence of the library and in fact bankrupted himself in the process. He had married a "dull, worthy woman" (who hated Pope) for her five-hundred-thousand-pound dowry. He managed to get rid of this and more through "indolence, good nature and want of worldly wisdom," and in 1740 had to sell his great house Wimpole for one hundred thousand pounds, which did not begin to cover his debts. He "sought to drown his sorrows in wine"; but when he died in 1741 he still had his library — innumerable books in manuscript and print and over forty thousand prints, as well as coins, medals, and portraits.

His hard-up widow sold nearly everything but the manuscripts. She was pressed by various important people to add these to the Cotton gift, both to be permanently and properly housed. Her son-in-law, the Duke of Portland, persuaded the House of Commons to buy the Harley manuscripts from the widow, cheap, and buy them they did. So the Harleian manuscripts, the rarest part of the Harley library, joined the Cottonian manuscripts as a basis for the British Museum.

v

The true originator of the British Museum and its basic collection was neither a Cotton nor a Harley, but Sir Hans Sloane. Sloane was the most famous English medical man of the early eighteenth century, President of the College of Physicians, President of the Royal Society succeeding Isaac Newton, and an avid collector of natural history specimens. He began his collection in Jamaica, where he went in 1687 as the personal physician of the Governor. He retired from active life in 1741, at the age of eighty-one, and moved himself and his treasures to the rural shades of Chelsea. There he was visited by royalty; and there he showed them his Swedish owl, his gems and butterflies, his library and his prints (including those of Dürer and Holbein), his twenty-three thousand medals, and a "foetus cut out of a woman's belly." The only works of art were those graphics and medals, the jewelry and the precious ornaments. It was a "museum," not a "gallery." According to the sensible English usage, a museum contains objects for study; a gallery contains pictures for enjoyment. Hence the British Museum and the National Gallery.

In 1749, still alive and hearty, Sloane made a will bequeathing his whole collection to the British nation on condition that the government pay his executors twenty thousand pounds. In 1753 he died.

The Harleys are commemorated by Harley Street, famous for its medical residents. Hans Sloane is commemorated in a whole series of Sloanes (Sloane Street, Sloane Square) and Hanses (Hans Place, Hans Road) derived from the marriage of one of his daughters to a Cadogan (Cadogan Square). The Cadogans, much like some modern real estate promoters, named various byways after their famous father-in-law when they cut up their lands. But the true monument to the names Cotton, Harley, and Sloane is the British Museum. In 1753 Parliament accepted the offer made by Sloane's will and authorized the holding of a lottery to raise the necessary funds. In 1759 a building, picturesque "Montagu House," containing all three collections, was "thrown open to the public."

This sounds a good deal more expansive than it really was. In fact it was almost impossible for the public to get into the place. There were so many restrictions and days of closing and admission tickets were so difficult to obtain that in fact the British Museum was anything but "thrown open." Even when a visitor did manage to squeeze in, he was taken around on a cursory (considering the size of the collection) three-hour tour, during which he could not really examine the treasures closely and at leisure. The admission tickets were so much in demand

that scalpers got hold of them and resold them at a pretty profit. The reading room, which had twenty chairs and one table in it, usually contained only a half-dozen scholars throughout the eighteenth century. Not until the reforms and popular movements of the 1830s and 1840s began to take effect did the present august building and the present liberal admission policies come into being.

Art crept into the Museum stealthily and by degrees. The classical collection, for instance, now one of the esthetic glories of the world, began with a comparatively modest, but choice, collection of Greek vases made by the well-known cuckold and antiquarian, Sir William Hamilton, who late in life married his beautiful Emma, Lord Nelson's mistress, and lived to regret it. His vases, bought by the Museum for much less than they were worth, were eagerly studied and copied by the potter Josiah Wedgwood, and so was established the fame and immense popularity of Wedgwood pottery. The most beautiful of the Museum's specimens of this sort is the Portland Vase. It was owned by Hamilton, too, but sold to a later Duke of Portland (descended perhaps from poor bankrupt Harley). It is supposedly the subject of one of the English language's most famous poems, Keats's "Ode on a Grecian Urn." Keats's "still unravish'd bride of quietness" was obviously not intended as a description of Emma, Lady Hamilton.*

When to the Hamilton Collection were added in 1816 the marbles taken — some like to say stolen — from the Parthenon by the Earl of Elgin, the Museum's classical collection achieved a preeminence rivaled only by the Louvre (for which things were stolen by Napoleon), Rome (things originally stolen from Greece), Naples, and Athens. But the British Museum is not interested in art, merely in archaeology.

* It was probably the Elgin Marbles Keats really had in mind.

Chapter III

i

THE FIRST TRUE Palace of Public Art, the original Great Museum, was the Louvre in Paris. It was and still is acknowledged as the greatest universal art museum of the world, with more and better masterpieces of all kinds in it than exist anywhere else.* The Louvre was an ancient royal palace that contained an already splendid art collection begun by Francis I and increased under Louis XIV. It was housed in splendid rooms. However, when Louis built Versailles most of the art was moved there from the Louvre, and during the eighteenth century the Louvre went to wrack and ruin. It was used for government offices, private apartments and shops, and above all for artists' studios. The big rooms were cut up to suit the convenience of tenants, chimneys were stuck about, windows divided or closed up, the outside walls and inside courtyards were cluttered with boutiques and sheds of every kind. Among the chief destructive elements were chamber pots and pigeons. The former were emptied ad lib from the windows, without even warn-

* The Vatican is its rival for first place.

ing cries, disfiguring the facades and drenching unwary pedestrians. Several important people were caught in the downpour and complained, but even putting bars in windows did no good. Shooting pigeons was ineffective, but it helped destroy the building. Inside the unoccupied galleries swarmed bats and rats, and the more moldering purlieus were hideaways for criminals. It was unsafe to wander about at night.

Just the same, the *ancien régime* was continually planning to refurbish the place, put the works of art back into it, and create a great public museum. The word "muséum" first appeared in the French language, sanctioned by scholars, in the 1770s. The first true public art gallery in France appeared even earlier. In 1750 a selection of pictures from the royal collection was exhibited to the public in the Luxembourg Palace, though only for three hours on two days of the week. Still, it was a public art museum of a sort, one of the first of its kind. Of course anybody who wanted to could always go look at the pictures in Versailles, which was also more or less "open to the public." Meanwhile the plans for rehabilitating the Louvre dragged on and on, getting nowhere. By 1781 a staircase leading to the proposed picture galleries had been built, but there were still no picture galleries. Up to the Revolution nothing more had actually been accomplished.

One of the reasons the Revolution was popular in France was because it did get things done. One of the things done was the opening of the Louvre, at last, as an art museum. In a few months, under the personal direction of Jean Roland,* the principal galleries were cleaned, reopened, and filled with collections of everything, confiscated mostly from churches and the houses of émigrés. There were some splendid pictures but also an uneven clutter of furniture, clocks, porcelain, and whatnot. There was a spectacular grand opening in August 1793, then an almost immediate closing for repairs, then another, somewhat more permanent, grand opening in November. All this took place right at the beginning of the Terror of which Roland was a victim. Actually, however, the Louvre remained in turmoil and disorder for the rest of the eighteenth century, sometimes open, sometimes closed, sometimes with pictures on the walls, sometimes not. People continued to have apartments there after 1793 as they had before, just different people, friends of the new management.

What put the Louvre on a firm basis as a museum and established its glory was Napoleon's success. The French had already worked out a system of expert looting in the countries they conquered before Na-

* Roland was soon out of office. He committed suicide when his famous wife was guillotined, crying, "O Liberty, what crimes are committed in thy name."

poleon's victories in Italy. Belgium was the first victim. There various French art officials examined, listed, and stole everything of Rubens and Vandyke they could get their hands on and carted it back to Paris. The Louvre was the depository. Then Napoleon in Italy personally saw to it that every three-star treasure he dared confiscate went back to the Louvre, too. Titians, Correggios, Guido Renis, all the darlings of that age, trundled northward, sometimes sawed in two for easier transportation. The Apollo Belvedere, the Laocoön, the Venus de Medici, and all sorts of other world-famous items, including the Lion of St. Mark and the bronze antique horses from the facade of the cathedral in Venice, joined the route. Napoleon's efficient agent was Virant Denon, minor artist and pornographer, who had accompanied Napoleon to Egypt as a pioneer Egyptologist and had become the Director of the Louvre.

Germany came next. Treasures piled up and, with certain notable exceptions, the great art of the world was concentrated in Paris. Somewhat less than half the world masterpieces recognized as such at the time, but more than would ever be gathered together at once again, were there. In 1803 the Louvre was renamed the Musée Napoleon, and during the last years of Napoleon's imperial career it became undoubtedly the most splendid collection of art in the history of the world.

Napoleon's example was followed by his brothers, whom he appointed kings of conquered nations. Brother Louis founded the Rijksmuseum in Amsterdam; brother Joseph had a hand in the organization of the Museo Nazionale in Naples and then, when transferred to the Spanish branch of the business, tried to start a predecessor of the Prado in Madrid. Surplus paintings from the loot in the Louvre were parceled out not only to Napoleon's friends and family (Josephine did very well) but also to provincial French cities, where many of them remain to this day as jewels of local collections.

When Napoleon fell, the occupying allies tried to get all this stolen art returned. The French resisted stoutly and Denon used every trick in the bureaucratic bag to delay and obstruct. However, about half the objects, including most of the famous antique statuary (the Venetian horses, the Lion of St. Mark, the Vatican antiquities) and the Italian Old Masters, were in fact returned. The treasures unearthed in Egypt by Napoleon's expedition, such as the famous Rosetta Stone, were confiscated there by the victorious English and taken back to the British Museum, so that it too has its share of "liberated material." Spanish guile, however, proved too much even for Denon, and he was unable to steal anything much there for the Louvre; fortunately for the future Prado. Dresden, Florence and Naples were all spared for political reasons. But the reputation of the Louvre, established under Napoleon, survived these postwar reparations. The name was changed back to the

Louvre from the Musée Napoleon, but it remains one of the monuments to his ruthless and glorious regime.

As part of the Enlightenment various other princely collections had already been opened to the public by the later eighteenth century in Vienna, Stockholm, Florence and Rome. After the Napoleonic wars everybody became museum-conscious; and throughout the nineteenth century, from the Prado in 1819 through the National Gallery in London in 1828 and the Munich Pinakothek in 1836, the sovereigns, nations, and cities of Europe continued to pour their treasures into great public exhibition places.

ii

America was way behind. There were no treasures to pour and it was not until the twentieth century was well under way that the collections of the Metropolitan began to come into the area of comparison with the Louvre, or the National Gallery in Washington with that in London. But the idea of the museum was very much present in America; and various odd sprouts and offshoots began to appear in what, for the history of the art museum, could be called "pioneer days."

America's first and oldest museum is the Charleston Museum, begun in 1773 as an offshoot of the venerable Library Society (1743). This has always been entirely scientific, devoted to natural history. It is not an art museum; its model was obviously the British Museum. The Charleston Museum is now housed in a great auditorium built for a turn-of-the-century reunion of Confederate veterans and is full of stuffed animals and other such specimens.

The true progenitor of the art museum as such in America was that homespun Leonardo, Charles Willson Peale (1741–1827). He opened his own "museum," which housed his portrait gallery of Revolutionary heroes, to the public as early as 1786. He was the principal inspirer and progenitor of the Pennsylvania Academy of Fine Arts, begun in 1805, which survives to this day as America's oldest art institution. It has always been an art museum as well as an art school. Not only did Peale have his own museum in Philadelphia, which lasted beyond his death to the mid-nineteenth century, but his sons founded and ran museums, most notably the Peale Museum in Baltimore. The graceful Baltimore building constructed in 1814 is the oldest museum building in the country. It is once more a museum and has pictures in it.

This American activity was contemporary with the opening of the Louvre as a public museum, but whereas that flamboyant display of stolen goods represented the end of a long process of hoarding and

ransacking, Peale's efforts were at the very beginnings of serious American art and science. Whereas in Europe painting had been for centuries a "fine art" patronized by kings, its practitioners glorified as geniuses, in America painting was a craft and a rather lowly one at that. Both the strengths and the weaknesses of American painting lay in this craftsmanship. Anyone who had the knack could take up painting and make a living limning his neighbors or traveling about from settlement to settlement turning out likenesses. There were no art schools, no academies, no collections and few models except similar paintings and a few prints. Until well into the nineteenth century this simple craft tradition produced painters by the score, most of whom never got beyond the anonymous primitive stage. Others, like Peale and Copley, moved up into the realm of formal painting. This gave to American painting a sort of grass-roots strength and abundance. Sign painter, coach painter, face painter — a man could make a living somehow with brush and color without worrying about the Masters or the Ideal or Inspiration. Or even too much about fashion, though all through history American sitters have insisted on the traditional trappings of gentility as expressed in fancy clothes and fanciful backgrounds. The weaknesses of American painting remained equally characteristic. There were always awkwardnesses, plainnesses, crudities; and the re-entry into a Europeanized world of sophisticated fine arts was always very painful for anyone who had achieved competence in the native tradition. If a painter got to be good enough, went to a comparatively worldly city like Boston or Philadelphia full of people who had been abroad, and then went on to Rome, Paris or London, the simple craft approach was no longer good enough. This dilemma — the psychological split produced by the conflict of native craft in its power and crudeness as opposed to cosmopolitan skill in its brilliance and facility — first became acute in Peale's generation and has remained acute to the present in the art history of America.

This dilemma of native versus cosmopolitan, of Leather-stocking versus Silk-stocking, affects not only painting but museums, too. Support of or opposition to museums again and again plays variations on this theme of conflict. As far as art museums or organizations (schools, academies) have been concerned, the conflict is expressed by two not always reconcilable ideals. One is to "encourage native art"; the other is to "make available the best of Western art." One tends to encourage nativist ideals, the other cosmopolitan ones. The attempt to combine the two noble aims has nearly always resulted in some degree of confusion.

iii

Peale definitely belongs to the nativist, craftsmanly American tradition, but not in its purity. He, like almost everyone else who painted in America after 1770, was exposed to Europe and particularly to England and Benjamin West.

If Peale is the legitimate father of the American museum, Benjamin West (1728–1820) is the grandfather and the progenitor of formal painting in America as a whole. Peale can pretty well stand for the Leather-stocking American tradition. West certainly represents the Silk-stocking. Peale was born, raised, worked, except for two years abroad with West, and died in America. This was not true of most of his famous contemporaries. West lived, worked, and died in England. Copley moved to England, worked, and died there. Stuart and Trumbull learned their trade in England under West before they came to America to mature practice. Of well-known Revolutionary painters only Ralph Earl of Connecticut, who also studied under West, resembles Peale in his nativism.

American art divides itself, as of 1760, into the pre-West and post-West periods. Before 1760 many face painters, most of them foreign-born, developed on the basis of provincial English style a sturdy if crude tradition of decorative portraiture, with a few essays in landscape and even religious painting. The two most famous end products of this Colonial tradition were Copley in Boston, from a line going back through Feke and Smibert, and Peale in Maryland and Pennsylvania, in a line going back through John Hesselius and his Swedish-born father, Gustavus. Copley began to master his native American manner as early as 1760. Peale did not come to maturity as a painter until about ten years later, after his English visit. Until the arrival of that prodigy Gilbert Stuart in the 1790s, first Copley, till he left during Revolutionary times, then Peale was acknowledged as premier painter (that is, portraitist) of America.

In 1760 Benjamin West went to Europe and never came back. He was the very first American painter to make a real European reputation. His impact on European art was considerable, much greater, in fact, than he has, up to modern times, been given credit for. His impact on American art was incalculable. Almost every important American artist for two generations studied with him at some time. West set the pattern of the American expatriate, from Whistler to Eliot, who conquers the Old World, but always at a price — the loss of any possible indigenous flavor of the New World. West stormed what was then considered the summit of European art, the painting of large historical-

allegorical-religious-mythological set pieces, the Grand Style, the "great machines" required of every aspirant for the Prix de Rome.* West thereby established himself as unique in barbarous England. No other painter succeeded in this particular area, not even ambitious Reynolds.

West was famous in England, well known on the continent, and a prodigy at home. As an acknowledged master of the skills and traditions of the Art of Painting as practiced by Raphael, Correggio, the Carraccis and Mengs — academic painting, that is — West trained his crude compatriots and sent them back refined and elevated. What the Grand Tour was to a young Englishman of fortune, study with West was for the young American of talent. No one escaped him. His pupils Stuart and Sully planted fluent and fashionable portraiture on American soil. His pupils Allston and Morse failed to establish the Grand Manner and its "machines."

What a pity that West isn't generally accounted a great painter! His story is so marvelous, such an incredible tale of virtue rewarded and success accepted with calm complacent composure. Its legendary outlines are told in every book on American art: the idyllic upbringing in a sort of Edward Hicks "peaceable kingdom" in rural Pennsylvania among godly Quakers where pictures were unknown. The almost private and personal discovery of the art of painting, all on his own, with brushes made from a cat's tail and the mixing of colors taught him by Indians. Established as a successful, if crude, teenage limner in Pennsylvania, he managed an awkward version of the *Death of Socrates*, although up to that point he had no idea who Socrates might be. He was adopted by Provost Smith of the College of Philadelphia, who taught him the rudiments of classical mythology and history. Friends and patrons raised a purse to send him abroad and he went first to Italy, where introductions opened the great world to him. The tale of marvels continues: how the blind connoisseur Cardinal Albani in Rome felt his handsome face, asking, "Is he white or black?" How a cortege of gilded carriages followed through the streets of Rome to the Vatican to watch the impact on this charming savage of the Apollo Belvedere. "How like a Mohawk warrior!" he exclaimed. Sensation! First dismay, then the realization that this was exactly the right thing for a charming savage to say. It was the first example of the good fortune that continued to attend him throughout his prodigiously long life.

West went from Italy to England, already a lion and carrying with him two already expert concoctions in a Neoclassic mode. The pictures were exhibited in London in 1764. No one bought the pictures, of

* This corresponds nowadays to the symphony for musical composers. Nobody needs them, but everybody feels compelled to write them.

course, since it was absurd to think of buying a modern English picture when you could buy an old Italian one. The only salable English pictures were portraits. But West's fame brought him to the attention of the Archbishop of York, who had his son read aloud to West the story, from Tacitus, of Agrippina bearing the ashes of Germanicus back to Italy. He painted the subject in the most solemn of Neoclassic styles and a fever of inspiration. It was shown to King George. George was so enthusiastic that he himself read to West the story of Regulus leaving Rome. West painted this subject for the King in Neoclassic style and fever of inspiration.

From then on the palace was open to West. He became not only the King's favorite painter (in contrast to Reynolds, whom the King didn't like), but one of his best personal friends. Neither his religious background nor his politics, firmly if modestly maintained throughout the Revolution, alienated him from the Royal Person. Only the King's madness put an end to this extraordinary meeting of minds between the Head of the Established Church and a Quakerish colonial, between the Head of the British Empire during the American Revolution and a Republican.

West was one of the original members of the Royal Academy in 1768, and in fact its real founder. He succeeded Reynolds as President. With the death of Gainsborough in 1788 and Reynolds in 1792, West had no real challengers as First Painter of the Empire. When Napoleon inaugurated the eye-shattering Salon of 1802 in the Louvre, it was West among British artists who was honored; and it was his turbulent *Death on a Pale Horse,* romantic among the frigidities of David, that was the startling and prophetic sensation. When he got back to England, he annoyed everyone by saying how much better they arranged things in France and how England too should have a Louvre. He never stopped harping on the subject, though accused of being a Red and at one point unseated from his presidency of the Academy on account of his politics. King George, now insane, was no longer his patron. His rival in these squabbles was Wyatt, the architect, but Wyatt was so inefficient as President that the Academy gratefully reelected West. Shortly thereafter Wyatt was killed in a carriage accident, leaving behind him, said gossip, a serving maid big with child. Such the deserts of vice!

The history and background of the Royal Academy was almost exactly duplicated by the history of Peale's Pennsylvania Academy half a century later. When West first came to London, an association of English painters calling themselves the Society of Artists had organized and put on the very first public exhibition of English art in 1760. It was with this Society that West exhibited in 1764. Almost immediately the artists began to fight, and in no time a rival organization split off and held separate annual exhibitions. To strengthen its position, the Soci-

ety of Artists got a charter and was thereafter known as the Incorporated Society of Artists. The rival group called itself the Free Society.

One of the purposes of the Royal Academy was to take the annual exhibitions out of the hands of the jealously bickering artists and give it royal patronage and respectability. West was one of four men, and by far the most distinguished of the four, who drew up the charter of the Academy; and it was West, on the basis of his friendship with George, who persuaded the King to support the idea. Reynolds carefully avoided being involved and waited in ostentatious seclusion to be called to the first presidency, which of course he was. Rivals of Reynolds, like Romney, refused to exhibit at his new Academy. Though the Academy later became ossified, in the beginning it was considered a brave pioneering venture designed to establish English painting on a par with French and Italian. It never succeeded in this, but it did give English painting and English artists a security and prestige they had never known before.

West did not live to see his National Gallery (1828) realized. But after his break with feebleminded King George in 1801, when it seemed that his artistic career was over, the Pennsylvania Hospital in his native Philadelphia commissioned him to paint for them a huge *Christ Healing the Sick*. He did and put it on public exposition before it was to be sent across the ocean. It was such a sensational success that everyone pleaded with him not to let it out of the country. An organization called the British Institution, of which West was one of the chief instigators, had been formed with the purpose, among others, of acquiring pictures for a future National Gallery. The British Institution bought *Christ Healing the Sick* for three thousand guineas, a stupendous price in those days. It was one of the first and most expensive of their acquisitions. The propaganda for the establishment of a National Gallery caused by this purchase did much to raise interest in the project, and West's picture has been thought of as a sort of cornerstone of its collection, though it is no longer on exhibit there. He had to paint a copy for the hospital, which *is* on exhibit. As for West, he was once again "made." His enemies and critics (like Byron, whose lines, "the dotard West, Europe's worst daub, poor England's best," damned poor Benjamin throughout the nineteenth century) were, for the time at least, confounded. He died still revered as England's great master of historical painting, doing enormous acreages of canvas to the very end. To the very end he was also President of the Royal Academy he had persuaded the King to patronize over half a century before. In his day he was the most famous artist of England and America.

The long eclipse of his reputation, which began about 1830 and continued unbroken till about 1930, has at length brightened a bit. He is represented in every good American museum and is now acknowl-

edged, in France and America at least, if not in England, as a forerun-
ner of both the classicisms of David and the romanticisms of Delacroix.
He was certainly the pioneer in his period of realism in the depiction of
past historic events, with his *Death of Wolfe* and *Penn's Treaty*. As
organizer of the Academy and proposer of the National Gallery, he
bears somewhat the same relation to institutionalized art in England as
Peale does in America.

Though West's reputation as a painter has improved in recent years,
it has a long way to go. But nobody can deny his preeminence as a
teacher of American artists. Copley, Stuart, the Peales, Trumbull,
Allston, Morse, Fulton, Earl, Sully — all these and many others went
through the experience of West's unfailing kindness and care, were
awed by his vast, silent studio where the Master worked in a hush of
reverence surrounded by his enormous creations. Friend of the King,
President of the Academy, greatest historical painter in Europe! How
privileged the youth who could claim his attention. But with demo-
cratic and Quaker simplicity, West welcomed them all and taught them
the rules and practical matters of anatomy and composition. Even to
the mockery and insolence of moody Gilbert Stuart he responded only
with mild reproof.

iv

Not the least of West's pupils were the Peales, father Charles and son
Rembrandt, a generation apart. The father seemed to learn little. At
least his style remained hard, bright, linear, with none of the subtleties
and fancy brushwork he might have picked up abroad. In fact Peale
didn't seem to like England much and he returned even more nativist,
more a Son of Liberty than when he went. It was as a nativist and a
fervent democrat that he started his Museum and encouraged the
Academy of Fine Arts. The motivations were national pride and hope
for the future glory of American art rather than the importation of
higher standards from abroad. Painting remained to him a craft, like
the saddle making he first learned as an apprentice in Annapolis.
Painting was glorious because it could record the faces of the glorious
men of the Revolution. By admiring the faces of these men, as painted
from life during the Revolution by Peale himself, future generations
could be inspired to equal their heroism and virtue. Purely esthetic
values were secondary.

The careers of Peale, his brother James, his sons Raphaelle and Rem-
brandt, his other sons, daughters, nephews, and nieces, many of them
painters, are all part of the web of American painting from the Revolu-

tion to the Civil War. But they are particularly important in their activities as creators and maintainers of America's first museums.

As early as 1781–1782, Charles Peale opened a new gallery of paintings at Third and Lombard streets in Philadelphia to visitors. In 1783 he was given some mastodon bones to sketch for an interested scientist abroad. These attracted so much attention that he began to turn towards natural history. More and more specimens and curiosities crowded his gallery of heroes and in 1786 he officially opened a museum which was supposed eventually to combine a *complete* exhibit of the wonders of the natural world arranged according to the system of Linnaeus, with a *complete* portrait gallery of all the notables of the American Revolution. Peale had been the first (1772) to paint Washington. By the end of his career he or his kin had painted all the presidents up through Jackson. He certainly left an extraordinary record of the faces of the famous men of his time — likenesses that are honest, true and hard, if not always very exciting as works of art. These portraits were an integral part of his gallery, though natural history came to assume more and more importance there. His relations helped him out painting them, and by the time the museum was finally dispersed in 1854, there were as many as two hundred sixty-nine paintings in it. Many of them stayed in Independence Hall. Now housed in a new museum nearby, they still form, in a curious sort of way, America's first art museum, dating back to the Revolution.

The real success of the museum, which dated from Peale's unearthing and assembling the skeleton of a mastodon in 1801, belongs to the history of science rather than of art. The gallery of heroes by itself would never have maintained the Peale Museum. In any case the portraits were looked at as historic records, not as works of art. The descendants of Peale's efforts were not art museums as we know them but either museums of natural history containing a form of painting that Peale invented, the habitat group, or historical societies or carnival freak shows. As the nineteenth century advanced, the principles of paid admisssion and profuse advertising, on which Peale's venture depended, degenerated into more and more rampant, spectacular, and vulgar exhibitionism. Rival museums, even those run by his own sons in Baltimore (Rembrandt), New York (Rubens), and far-off Utica (Linnaeus), tended to emphasize the marvelous as opposed to the factual. Musical performances (Signor Hellene and his one-man orchestra, the Pandean Band, packed them in), theatrical displays, dramatizations of Dickens, exhibitions of huge single spectacular canvases like Rembrandt Peale's *Court of Death,* freaks, oddities, and jokes more and more ousted serious art and science. The end result of this was P. T. Barnum, who in fact bought up the remains of the various Peale

museums in New York, Philadelphia, and Baltimore and went on to triumph as King of the Circus. Natural history museums like those in Charleston and Philadelphia, supported by eminent citizens and not operated for profit, took over the more serious side of Peale's exhibits without Peale's imagination and artistic flair. It was a century before the Peale habitat group was used again.

Peale's exertions in favor of art, however, did not stop with his museum. Somehow, in between running the museum, tinkering with new patented stoves and steambaths, making false teeth, riding a velocipede, siring seventeen children, and marrying three wives, he managed to follow his teacher West in organizing America's oldest, if not first, academy of arts. The idea back of his museum was national glory, not just the cultivation of taste and sensibility. The idea back of his more purely artistic activities was also national glory. As the artists of England got together to solidify their position and hold exhibitions, thus enhancing the national school of painting, so Peale got together an association of Philadelphia artists. For the first time in American history a city contained enough artists to make such a plan seem feasible. In 1974 a Columbianum, or American Academy of Fine Arts, was actually founded and held a memorable exhibition, the first of its kind in America as that of 1760 had been the first in England. This took place in Independence Hall in the spring of 1795. Charles Peale contributed his famous trompe l'oeil *Staircase Group*, painted for the occasion, a double portrait of two of his sons that fooled Washington into bowing to the boys. There were also paintings by Raphaelle, Rembrandt, and James Peale.

The exhibition was a great success; the organization failed. It was the Society of Artists all over again. A group of British-born and English-oriented artists split off from the Columbianum and founded their own Columbianum. The cause was affront at Peale's radical politics and their resentment at various "Republican sentiments" expressed at meetings. Various worthies who had been asked to patronize the organization grew disgusted. The Columbianum broke up and both organizations immediately died.

Ten years later the idea revived again. This time, exactly as in England in the case of the Royal Academy, the patronage of the respectable was acquired first and then the artists became involved. In 1805 a board of twelve eminent citizens, of whom Peale and the sculptor William Rush were the only professional artists, formed themselves, were incorporated, got funds, built a building, started a school, put on annual exhibits, and collected casts from the antique and even a few Old Masters. Whereas the Columbianum had split on the rocks of artistic temperament, the Pennsylvania Academy of Fine Arts, despite the excoriations of artists down through the years, has survived to this

day on the foundation of patronage and direction by the "best people."
All through its history artists have been rebelling and seceding; but the
Academy remains as a school, as a place for exhibits of contemporary
art, and, above all, as a gallery of older paintings. It is now one of the
more distinguished museums of American art, from Peale on up. There
may be seen West's *Death on a Pale Horse* and the works of all his
pupils, founders of the American School. As such, the Pennsylvania
Academy of Fine Arts can claim to be America's oldest art museum.

Chapter IV

i

PEALE'S PLACE at the very beginnings of the museum in America is important. His nativist bias influenced the direction of American art and museums decisively; but his own Museum decayed and fell ripely into the hands of P. T. Barnum, whose interest in art was minimal. The Columbianum failed, and the Academy, which was successful, is not exactly a full-fledged, general, typical American museum of fine arts of the order of those in New York and Boston.

Two Connecticut organizations, the Yale University Museum of Art and the Wadsworth Athenaeum in Hartford, are such "real art museums." Both owe their existence to the other early American artist who rivals Peale as a pioneer in the field of institutionalized art. This is testy Colonel John Trumbull (1756–1843), whose American Academy in New York preceded the Pennsylvania Academy and whose collection, unlike Peale's, served as the core about which a true art museum grew.

In some ways Peale and Trumbull were very much alike. Both were ardently patriotic and their interest in art could be described as more heroic than esthetic. Both were Sons of Liberty and fought actively and

valiantly in the Revolution. (Peale emerged as captain, Trumbull as colonel.) Both thereafter consciously devoted themselves to glorifying that Revolution in paint and to preserving the likenesses of those who led it. Both studied with Benjamin West, who was their only true professional teacher. Both lived to a ripe old age. Both were instrumental in founding museums and were active in the life of the earliest American academies of art.

Here the likenesses end and the contrasts begin. There are many of these, but the single most important one is: class. Peale was essentially lower-middle class, a skilled workman, despite chimeric pretensions to English gentility derived from his no-good father. He was reared in poverty and began as a simple apprentice to a craftsman. A craftsman he remained all his life.

John Trumbull was born an aristocrat in the sense this could be understood in Colonial America. He was never a craftsman and was never an apprentice. Such an apprenticeship for one of his family background would have been considered disgraceful. His approach to art was always idealistic, painting as a Fine Art. This was — and is — the usual attitude of the well-born, who can never think of the arts in terms of plumbing and carpentry but must justify their defection from the professions and the Establishment with references to inspirations and ideals and the advancement of civilization. Trumbull was educated, the first American artist of note who was a college graduate (Harvard, 1773). He was a gentleman in a day when that designation meant something more specific than a mere attachment to old-fashioned good manners and style. It meant that he belonged to a family of property and official position. Members of the college classes at Harvard and Yale until well into the eighteenth century were always listed not alphabetically but by social status, usually determined by the official position of parents and kinsmen in the hierarchy of Colonial government. By the time John went to Harvard the custom was outmoded; but his brother Jonathan (Harvard, 1759) had been number one in his class and his cousin and namesake, the poet John Trumbull (Yale, 1767), had been listed number two. The custom, incidentally, was discontinued at Yale the very next year, with the class of 1768, and from then on the students were listed "democratically" and alphabetically.

John Trumbull's father, Jonathan Trumbull (1710–1785), was a self-made man and had been number thirty-one of the thirty-seven members of the Harvard class of 1727. But he had married above himself, made and then lost a fortune, and become Governor of Connecticut (1769–1784). He was, in fact, the only Colonial Governor who served under the Crown, through the Revolution and into Independence. Not only was John Trumbull's father a very important man, but he was surrounded on all sides by kinship to other such worthies. One of

Governor Trumbull's sons, for instance, John's brother Jonathan, also became Governor of Connecticut (1797–1809). Still another brother, Joseph, became the first Commissary General of the Continental Army, a position of vital importance. When Joseph died he was succeeded by his friend Jeremiah Wadsworth, first citizen of Hartford, "father of insurance" there, whose son Daniel married Jonathan Trumbull, Jr.'s daughter Faith, painter John's niece. This had fatefully beneficial effects on the history of the American museum. A brother-in-law of painter John was Jedediah Huntington, himself son of a general and hero of the Battle of Long Island. Still another was William Williams, a Signer of the Declaration of Independence. Through the Wadsworths he was connected with the Talcotts and the Wolcotts, also Governors and Signers. In fact, from the early eighteenth to the early nineteenth centuries there wasn't a decade when some Talcott, Wolcott, Trumbull, or Huntington was not securely seated in the Governor's chair, not to mention the Senate, Congress, or other high office.*

For a man with such illustrious relatives to decide to become a painter, a mere limner, a dauber of coaches and faces, an itinerant peddler of paints, was almost unthinkable. To be sure, a few American painters like John Copley and John Hesselius had emerged into respectability, had married well, and were considered gentlemen. Benjamin West, of course, was a friend of the King. But most American painters were on a social level with carpenters. It was all very well to think of Sir Peter Paul Rubens and Sir Anthony Vandyke, to remember the names of Phidias and Apelles, artists revered in antiquity. But when John Trumbull argued with his hardheaded father about taking up the profession and cited these glorious examples, Governor Trumbull dryly remarked, "You forget, sir, that Connecticut is not Athens." The justness of this remark was only too definitely proved by later events in Trumbull's own career, and indeed in the history of the American museum.

This class bias thwarted Trumbull's ambitions, ruined him as an artist, and dissipated his talents. Peale would have been a better and more successful painter if he'd been more the educated sophisticate and less the craftsman, if he'd had more esthetic sensibility and a less eager interest in tinkering with stoves and false teeth, and if he'd been more of a snob and cultivated upper-class patrons. Trumbull would have been a far better and more successful painter if he'd been less the highfalutin artist and more the down-to-earth craftsman. He spoiled his life not by tinkering but by a yearning for nonesthetic success and

* Governors of Connecticut: Talcott, Joseph, Governor 1724–41; Wolcott, Roger, Governor 1750–54; Trumbull, Jonathan Sr., Governor 1769–84; Huntington, Samuel, Governor 1786–96 (Signer); Wolcott, Oliver, Governor 1796–97 (Signer); Trumbull, Jonathan Jr., Governor 1797–1809; Wolcott, Oliver Jr., Governor 1817–27.

riches, all of which led him into distracting adventures in diplomacy and speculation.

Trumbull's career was peculiar and variegated and much of it does not concern the history of painting or of the museum except in a negative way. He began life with two disadvantages: one eye and a dominant father. He lost his left eye in a childhood accident. His father was bent on making him a respectable member of society, a clergyman or a lawyer. Though he displayed a precocious interest in drawing, this interest was discouraged. He was sent to college not to absorb art but to prepare himself for life in the Establishment.

Instead of nipping his unfortunate tendencies in the bud, his experiences at Harvard and in Boston served to encourage them. He was promptly introduced by his brother to Copley and was permanently impressed by Copley's stylish clothes and solid social position. If a painter could live like that, surely it was no disgrace for a Trumbull to attempt to follow in his footsteps. He saw portraits by Copley in Boston and Cambridge. He copied prints and made his first essays, very much like the young Benjamin West, in history painting, a crude rendering of the *Death of Paulus Emilius*. Unlike West and his ignorance of Socrates, Trumbull presumably knew who Paulus was.

Almost as soon as he graduated in 1773, the Revolution began. On the basis of his skill as a draftsman and mapmaker, he was appointed aide-de-camp to Washington, who had just recently been appointed Commander-in-Chief and was campaigning in Boston. Trumbull then became aide-de-camp to General Gates, saw much action, and might have become a really distinguished soldier. But the kind of absurd self-estimation and touchiness, the "honor of a gentleman," that made him in later years so disagreeable cut short his military career. His commission as colonel, when he received it, was dated three months after it should have been. Enraged by this unfair demotion in seniority, he resigned in a huff. He later volunteered as aide-de-camp to another general in another campaign, but his true military activity was finished. He never thereafter failed to call himself *Colonel* Trumbull.

Colonel Trumbull, now aged twenty-one, then decided, despite his father's disapproval, to become a painter. To that end he went to England in 1780, in the middle of the war, to study with the always hospitable West. American Loyalists who had emigrated to London took a dim view of a Colonel of the rebel army settling freely in their adopted city. He must obviously be a spy, concealing his activities under the specious guise of an art student. When Major André was hung as a spy in America, Trumbull was arrested in retaliation and spent many months in jail; rather comfortably, after the eighteenth-century fashion for well-born miscreants. When released, he was ordered to leave the country and he did.

After a desultory interim in America, he returned to England as soon as peace was signed. There in the years from 1784 to 1789 he developed into West's favorite pupil and did most of his good work. Unlike Peale, who learned little from West, or Stuart, who learned much but applied his knowledge almost solely to portraiture, Trumbull learned to paint history just like his master.

West had begun a project of depicting the great scenes of American history in his two most famous paintings, the *Death of Wolfe* of 1771 and the slightly later *Penn's Treaty*. When the Revolution came along it seemed inadvisable for the King's official painter of history to indulge himself in chronicling the glories of the enemy. Here, however, was a disciple who was willing and able to devote himself to doing just that. Mastering West's basic technique and manner, particularly as displayed in *Wolfe,* Trumbull began a series of pictures of Revolutionary battles. Under the spell of West and *Wolfe* he concentrated at first on death scenes — Warren at Bunker Hill, Montgomery at Quebec, Mercer at Princeton. These were small sketches, brilliantly executed with Rubenesque energy. The faces, however, sometimes left blank at first and filled in later, were minutely accurate portraits of the participants. The first were the best. Altogether he made eight of these American historical pictures.* Perhaps the most famous of them is the *Declaration of Independence*. Jefferson drew a plan of the State House room to help him and gave him firsthand accounts of the events surrounding the Declaration. Everybody of importance in America encouraged Trumbull in this project.

In 1789 he returned home with the object of completing his portrait studies for the faces of these various panoramas and of making his fortune from them. Everyone from Washington (whose portrait he of course painted) on down was cooperative, but somehow subscriptions for engravings of his masterpieces lagged. There seemed to be no interest in establishing a National Trumbull Collection. Testy John, never one to put up with humiliation, gave up America and painting in another of his huffs, just as he had earlier given up soldiering.

At this point, in 1794, he made the mistake of trying to become a businessman and diplomat. He was a failure in business and successful but undistinguished as a diplomatic assistant to John Jay in England. For ten years he occupied himself there with nonartistic affairs and so lost his opportunity of establishing himself as a painter in America. He married a beautiful but unlettered Englishwoman named Sarah Harvey. They had no children; she took to drink.

* *The Battle of Bunker's Hill, The Death of Gen. Montgomery at Quebec, The Declaration of Independence, The Battle of Trenton, The Battle of Princeton, The Surrender of Gen. Burgoyne, The Surrender of Lord Cornwallis,* and *Washington Resigning his Commission.*

When he decided once more to "take up the pencil" and return to America, he could make a living only as a portraitist. Since Gilbert Stuart occupied Boston and the various Peales Philadelphia, he chose to settle in New York; but he was not a success. Instead of sticking it out, he once more returned to England. He again found himself an enemy alien in a war, that of 1812. No one in England would patronize him, so he devoted himself to painting large literary or Biblical canvases, occasionally using his wife as a model. They were not good.

As soon as the war was over he returned to America, this time forever. He again tried to set up as a portrait painter, but by now his skill had greatly deteriorated. However he was exceptionally lucky. The Capitol in Washington had been burned by the British and was now being rebuilt. As a gesture towards supporting native American art, it was decided to commission patriotic pictures for the new rotunda. On the basis of the brilliant sketches made so long ago, Trumbull in 1817 got the commission. Four (Saratoga, Yorktown, Independence, Washington's Resignation) of the subjects were chosen, at eight thousand dollars each, a very substantial sum in those days; and the aging artist set to work to make enlargements of his sketches. It took him seven years, until 1824, to do it. They were comparative failures. Other more competent artists, like Morse and Vanderlyn, who had wanted the job, were furious. Nobody really liked the enlargements very much; but unfortunately it is these awkward enlargements, not the original brilliant sketches, that have been the basis of Trumbull's reputation. After all, they are still there for everybody to see in the Capitol. They have become icons, the basis for school textbook illustrations, especially what John Randolph called the "shin piece," Trumbull's *Declaration of Independence* with its expanses of silk-stockinged eighteenth-century legs.

ii

Another bit of luck came to him at the same time as his commission. In 1817 he was elected President of an American Academy of Fine Arts. This was the very first of such American academies, unless one includes Peale's abortive Columbianum, which was an association of artists for the purpose of exhibiting their own works. The American Academy of Fine Arts in New York was to be a school and gallery based on casts from the antique, the same sort of things that the Pennsylvania Academy became in 1805. Like the Pennsylvania Academy, it was run not by quarrelsome artists but by a board of men of substance. The inspirer of the Academy in New York was not an artist but Robert R. Livingston of steamboat fame.

Livingston had been American minister to France during the time of Napoleon's spectacular 1802 exhibition at the Louvre at which Benjamin West's *Death on a Pale Horse* had made such a sensation. Incited by Napoleon's example, Livingston got other gentlemen of fortune back home to subscribe to a fund to buy and bring back casts. In 1803 the Apollo Belvedere, the Laocoön, the Dying Gladiator, and others arrived — in facsimile — in the New World. Twelve and one-half dollars was set aside to attach fig leaves where advisable. This was all to be "a germ of those arts so highly cultivated in Europe, but not yet planted here." The fact that West, Peale, Copley, Stuart — and Trumbull — between them had already created an admirable native American school of painting was not to be thought of. Had they not, after all, refined their craft abroad? This new Academy, and the attitude back of it, was the seed or "germ" of a whole approach to art in America and to museums in America: the Silk-stocking attitude that through the years continued to battle with Peale's notion of a native-born art devoted to native glories.

Evidently boards in New York, unlike boards in Philadelphia, did not have much staying power. The casts were exhibited to diminishing popular interest; the board, though still in being, remained inactive. Another brief flutter of life occurred in 1808 when the Academy received a charter and its name was aggrandized from the New York to the American Academy of Fine Arts. Robert Livingston was President of the board, John Trumbull, just before returning to England again, was Vice-President. The casts were exhibited once more, attracted little attention, and were then stored.

Finally in 1816 the Academy was resurrected. DeWitt Clinton was now President, the casts found a new exhibition hall in a former alms house, pictures were borrowed, and in October of 1816 a show was opened. For the first time the Academy exhibition was a popular success. Such a success, in fact, that a mood of reckless extravagance infected the board. The extravagance took the form of a guarantee to buy various Trumbull pictures for an absurdly high price, Trumbull having been placed in the presidency by Clinton, who had resigned. After this, the euphoria of the Academy declined.

The principal cause of the decline was Trumbull. The treasury had been exhausted through lack of foresight. The debt incurred to Trumbull, which in fact was never paid, prevented any expansion. There was no more money to buy new pictures, so the same old ones, plus the casts, were shown again and again each year to decreasing public response.

The Academy's school, which was supposed to be that "germ" from which an American art would sprout, was killed off by Trumbull's dictatorial refusal to let students in to see the casts and to concern

himself with teaching them. "Beggars are not to be choosers" was Trumbull's advice to young artists seeking admission. The Academy became, in fact, a sinecure for the Colonel and its rooms a mere storehouse for his pictures and the casts.

In Philadelphia the art academy began as an unsuccessful organization run by artists under Peale's direction and was followed by a successful organization run by prominent citizens that exists to this day. The history of art academies in New York was just the opposite: an academy run by worthies fell into the hands of the city's chief artist and died. Another organization, founded and run by artists, took its place and exists to this day.

This counteracademy was the National Academy of Design, and the activist behind it was Samuel F. B. Morse (1791–1872), the inventor of the telegraph. Like Trumbull, Morse was to some extent hatched from a nutmeg. Though he was born in Massachusetts, his father Jedidiah, a clergyman and famous geographer, was a native of Connecticut and went back to live there at the end of his life. Samuel, too, returned as a student at Yale, graduating in 1810, and considered New Haven his home.

Like every other young American artist, Morse went to London and studied in the school of West. He was part of a second generation of West students who became fast friends, a group that included the Romanticist Washington Allston, who was Morse's actual teacher. The kind of Revolutionary ardor that had inspired Peale and the young Trumbull had died down and was now replaced by a blend of nascent Romanticism and the last echoes of West's Neoclassic grand style.

Gentlemen by birth, inspired like Trumbull with the same secondhand ideals of fine art, full of a somewhat similar missionary zeal, West's favorite American disciples of this second generation, Morse and Allston, came back to America determined to bring to their benighted country some of those germs of the exalted European tradition.

Blocking their careers in every direction was that relic of former grandeur, Colonel Trumbull. It was the Colonel who was chosen to decorate the Capitol. It was the Colonel who was elected President of the Academy. It was the Colonel who did everything in his power to prevent the Academy from encouraging younger artists.

In lieu of the nonexistent school of Trumbull's Academy, a group of these younger artists led by Morse formed in New York a Drawing Association. They rented or borrowed the Academy's unused casts and set to work to teach themselves the elements. They had no real thought of competing with the Academy, but Trumbull's high-handed attempts to coerce them into membership and then to control and intimidate them forced them into independence. It was the American Revolution all over again. The end result was the formation of the National Acad-

emy of Design in 1826. This, like the Pennsylvania Academy, combined a school with an agency for annual exhibitions of new works by the living and practicing members. There were no casts and no Old Masters and hence no museum of the sort maintained in Philadelphia. Pictures exhibited in one year could not be exhibited in the next, thus avoiding the monotony that killed off the popularity of the older Academy shows.

The National Academy flourished; the American Academy perished. Neither of them ever really intended or pretended to sponsor true museums. And in its turn the once youthful National Academy became almost as fossilized as the American. Morse, discouraged as an artist, turned to electricity. In 1841 the American Academy folded for good and its assets were sold.

Along the way to failure, however, Trumbull made one generous gesture: he discovered and promoted the career of landscapist Thomas Cole, founder of the Hudson River School. He saw some Cole pictures in a store window, bought one, and got friends to buy others. It was Cole's first step towards his later fame. Trumbull was, however, left more or less destitute in his old age. He could no longer compete with a rising generation of portraitists; his great canvases in the style of West, his idea of high art, were unsalable. He was, in his seventies, a broken and defeated man, but still physically vigorous and ambitious. He was rescued by his family connections and his real influence on real American museums began. A niece, daughter of Governor Jonathan Trumbull, Jr., had married Benjamin Silliman. Silliman was one of the most famous scientists of his day, a chemist and geologist and a professor at Yale. He was also a man of taste. He visited his widowed uncle-in-law in his moldering but still spacious studio in New York. Trumbull was at the end of his resources. He would have to sell all his pictures for whatever they would fetch; little enough by then. Moved as much by family feelings as by esthetic considerations, Silliman worked out with Trumbull a scheme whereby Yale College would accept the contents of Trumbull's studio, build a small gallery to house and show them, and in return give Trumbull a thousand-dollar annuity for the rest of his life. The College could hope it wouldn't cost them much since Trumbull was already in his seventies.

The College Corporation accepted the proposition as transmitted to them by Professor Silliman. Trumbull, who was a good architect and might have made a successful career in the profession, designed a Neoclassic tomblike box for his gallery. This was erected on the College grounds in New Haven, and in 1832 the gallery was opened. Trumbull went to live with the kindly Sillimans. There he wrote his self-justificatory but sometimes acute *Autobiography,* published in 1841. He lived

on and on, dying finally at the age of eighty-seven in 1843, just after the final demise of his Academy.

Yale was furious; it had been a poor bargain. But in return for the annuity they got the kernel of what is by now the first and one of the best of collegiate art galleries. Most of Trumbull's better, as well as some of his worst, paintings, originally part of the too-often-exhibited collection of the American Academy, were included. The brilliant small early sketches of his Revolutionary pictures, along with numberless miniature portraits made from life of generals and statesmen, were now at Yale along with lugubrious later essays on Biblical and historical subjects.

iii

If Trumbull had done no more than provide the germ for a museum at Yale, his seminal position, along with that of Peale, would have been secure. However, again through family connections, he is indirectly involved in the creation of the Hartford Athenaeum. Silliman was Trumbull's nephew-in-law, hence the museum at Yale. Daniel Wadsworth was Trumbull's nephew-in-law, hence, more or less, the Hartford Athenaeum. The two families of Wadsworth and Trumbull had always been close, as testified by the natural succession of Jeremiah Wadsworth to the position of Commissary General vacated by his friend Joseph Trumbull. John Trumbull fell in love with Harriet, a much younger daughter of Jeremiah, who died of consumption in 1793.*

These bonds with the Wadsworths bore artistic fruit. Jeremiah Wadsworth's one son, Daniel, a gentleman of means and taste, collected Trumbulls. Just at the time of Trumbull's death, Wadsworth decided to endow his native city, then a thriving metropolis of at least ten thousand people, with a cultural monument he called an Athenaeum.

By the 1840s Athenaeums were a staple of American life. They were usually, like those of Boston and Philadelphia, private libraries used by gentlemen as clubs where they could read and play chess. Sometimes, as in the case of the Boston Athenaeum, these library-clubs had art in them. The Hartford Athenaeum was not quite like these. Housed in a

* At almost the same time as his proposal to Harriet, he got himself involved with a servant girl misnamed Temperance Ray. She produced a bastard son and claimed Trumbull as the father. Though there was much doubt about it, and much competition for the honor, Trumbull gallantly accepted the child as his and later took him to England as his nephew. His new wife Sarah made no objections. The boy grew up, became a British soldier during the War of 1812, breaking his patriotic father's heart, and died obscurely. He was Trumbull's only known descendant.

rather formidable building originally planned to look like Trumbull's gallery in New Haven but which ended up a turreted Gothic fortress, it had space for three quite separate activities: a Young Men's Institute, which was really a library and reading room; a Connecticut Historical Society; and in the middle, an art gallery. The idea was born in the head of Daniel Wadsworth in 1841, the building was begun in 1842, and the gallery opened in 1844.

What was in it? Fortunately an 1844 catalog exists so that we have a rough idea of the art in America's first true public, civic art museum. Eighty-two pictures are listed as hanging there, of which the most important by the standards of the time were five great historical Trumbulls. These were clumsy copies Trumbull made late in life of some of his battle pieces — Bunker Hill, Trenton, Princeton, Quebec — and that "shin piece," *The Declaration of Independence.* The bulk of the catalog was devoted to a detailed description not of the pictures but of the battles. There was (and is) a *Mount Aetna* by Thomas Cole, which looks very much like one of his pupil Frederick Church's South American volcanoes. There was (and is) a splendid huge portrait of Benjamin West as Dean of English painting by *his* pupil Sir Thomas Lawrence, acquired from Trumbull's American Academy after its collapse. The American "Modernists" were represented by Vanderlyn's depiction of the murder of Mrs. McCrea by savage Indians, the Peale family by an *R. Peale by Candlelight. The Destruction of Jerusalem* by Whichelo was annotated in the catalog by a long description not of the picture or of Whichelo, but of Jerusalem. There were Wadsworth family portraits, various spurious Old Masters, and items bought by Hartford from the final dissolution of the Academy.*

Thus the basic collection of the Athenaeum consisted of pictures by Trumbull himself, pictures by his protégé Cole, pictures once belonging to his Academy, or pictures belonging to his nephew Daniel Wadsworth. When Daniel died in 1848, the rest of his collection went to the Athenaeum, the most worthwhile pictures being his Coles, including the view of Monte Video. The least worthwhile were a selection of those spurious Old Masters — attributed to Tintoretto, Titian and Raphael — and items such as a painting by an unnamed artist described in the catalog as "*Charity,* from an Italian picture, of high reputation."

Aside from weeding out the Titians, Poussins, Raphaels and pictures of "high reputation," the collection remained as it was and settled down for the rest of the century to decades of salutory neglect, salutory at least in that the Coles were not thrown out when fashion changed

* The Academy's casts stayed in New York as property of the National Academy until they were destroyed by fire in 1905.

after the Civil War. Indeed, a small accretion of Cole's contemporaries and followers was bought and displayed right through to the present revival. An 1863 catalog is a reprint of those of 1844 and 1856, listing one hundred thirty-nine numbers (with some mysterious gaps). The catalog of 1901 has been reduced to only one hundred ten, the holdings improved by the addition of Cropsey, Ingham, Church, Inness, Moran, Casilaer, Wyant and some minor, but this time authentic, Dutch masters. But still, at the beginning of the twentieth century the largest single block of paintings remained those two favorites of Mr. Wadsworth, Trumbull (thirteen pictures) and Cole (five).

In other words, once the Trumbull-inspired galleries at Yale and Hartford had been created, nothing much happened. The Yale gallery moved and acquired the Jarves collection. The Hartford gallery just sat. Connecticut was *not* Athens. But for a small college and a tiny city in the New World to have had the vision and temerity to create and maintain public art galleries at all was something of a miracle. New York had to wait until 1870.

As for Colonel Trumbull, when he finally died, to the great relief of the Treasurer of Yale, he specified that he was to be buried next to his wife right under his picture of George Washington in his picture gallery. There, in a grave he wished to have inscribed "To his Country he gave his SWORD and his PENCIL," he rested until the move in 1866. He was moved, too, still lying at George's feet like a faithful hound.

In 1928 he had to move again into a still newer building. This time Washington's picture was on the third floor. There was no room for the Colonel up there, so he and his Sarah, still directly under Washington's portrait, now lie down in the cellar. The best of Trumbull's work flanks the portrait in the collection upstairs. If it had not been for the fortunate accident of his kinship with Silliman, these early sketches might have been dispersed and lost, as so many of his drawings were when Silliman's grandson sold them at auction in 1897–98. These works now establish him as one of the better eighteenth-century artists and, along with C. W. Peale, as an invaluable chronicler of the Revolution and the faces of its participants. Rooted in Trumbull's basement tomb, the Yale museum flowers up above as one of the oldest and best of university teaching museums. Out west in Hartford, the Athenaeum remains the oldest and one of the best of American big-city museums. In addition to giving his SWORD and his PENCIL to his country, he inadvertently gave his country two of its first art museums.

Chapter V

i

AFTER THE OPENING of Yale's Trumbull Gallery in 1832 and the Hartford Athenaeum in 1844, no more real art museums were founded in America until after the beginning of the Civil War. Since during this period, from 1800 to 1860, institutions of other kinds — educational, scientific, historical, literary — proliferated, the absence of art museums is rather surprising. It would be easy but erroneous to blame this absence on a simple lack of taste for the arts in America. In fact, taste for the arts, of a sort — contemporary American painting and sculpture in particular — flourished. There was probably never a country or a time when so many people so loved art — some art — as in America from 1830 to 1860. Why didn't this affection spill over into the founding of art museums?

The reason was simple. Museums, then and now, were generally conceived of as depositories of the art of the past: Old Masters. The art that enthralled the American public before the Civil War was art of the present. This period saw the rise and triumph of nativist American

landscape and genre, the heyday of the Leather-stocking, the eclipse of the Silk-stocking. Thomas Cole and the Hudson River School (landscape) and George Gingham and William Sidney Mount (genre) were the kind of art the public wanted to look at and buy, not moldy pseudo-Raphaels or high-toned imitations of Benjamin West. It was an exciting time for American artists, but a dull time for museums.

The museums at Yale and Hartford, created under the shade of Colonel Trumbull, were the final products of the Revolutionary era. When Trumbull bought Cole's picture from Paff's shop window and got Dunlap and Durand to buy the others, he unconsciously inaugurated a new, very much post-Revolutionary era. His own patriotic-heroic conception of American art was succeeded by a romantic-homely one. Nature and just folks took the place of history and dying generals. Morse's National Academy and the Art Union took the place of Trumbull's decadent American Academy.

Since the newer National Academy was an association of artists, its exhibitions were entirely devoted to the latest productions of Academicians. The Art Union, on the other hand, was a lottery. Run by a board of disinterested gentlemen with the deliberate object of encouraging native art, the Art Union invited subscribers to buy what in fact was a lottery ticket. For this every subscriber got a splendid engraving of a new American picture (Bingham's *Jolly Flatboatmen,* for instance). Then there was a big drawing and the lucky winner got original paintings. Meanwhile the Union maintained a great gallery where their purchases were exhibited to the delight of immense crowds, estimated as equal to over fifty percent of the entire population of the city of New York. From 1839 till it was struck down as illegal gambling in 1852, the Union distributed thousands of engravings and pictures and did more to stimulate native art than any number of academies. But even without the Union, the appreciation of contemporary American art was a rising wave that crested just before the Civil War and drowned out any real hope of founding museums devoted to the European art of the past.

During this period the various Peale museums were absorbed into Barnum circuses. Of the Academies, the one in New York died, the one in Philadelphia survived; but neither was a very vital organization. The real progress towards the creation of museums during this period lay not in the public, but in the private sector. For the first time Americans began to build real collections. Though few of these collections actually survived as bases for museums, they served to set a pattern and to raise a problem. The pattern was that of collections as such, rather than of pictures bought just to decorate a house. The problem was: once the collection had been formed, what was to become of it? Suppose the heirs didn't want to maintain the collection as a whole? It was obviously a loss to the community to have such collections dis-

persed by sale. The only proper solution was to give the collection to a
museum. But if there were no museums? Thus the very fact of the
existence of collections inevitably created museums to receive them.

ii

The various collections in America of the period divided themselves,
as they still do, into two categories. There were collectors who concen-
trated primarily on contemporary art. There were those who concen-
trated on what they assumed or hoped to be Old Masters. Those who
collected contemporary art confined themselves pretty much to Ameri-
can painting and sculpture. The collection of contemporary European
art did not really develop until after the Civil War.

A few of these collectors emerge as representative: Luman Reed,
Robert Gilmor, Jr., Thomas Jefferson Bryan, James Jackson Jarves.
Finally in William Wilson Corcoran we have a collector of this period
who actually took the final step of building his own museum to house
his own collection. Though private persons had filled their houses with
art during the eighteenth and even seventeenth centuries, no one had
gone beyond the principle of home decoration.

The generally held idea that these earlier collections consisted of
nothing but family portraits is challenged by the record of the paint-
ings owned by a Doctor de Lange. His house in New Amsterdam was
thoroughly Dutch, containing over sixty works of art, fruit, flowers,
faces, places — a remote provincial reflection of Holland's middle-class
patronage of painting. The grandees of Philadelphia, Maryland and
Virginia not only had portraits painted but even occasionally indulged
in souvenirs of the Grand Tour, a perhaps Correggio, a maybe Murillo.
The Hamiltons in Philadelphia, for instance, were famous for their
Murillo in mid-eighteenth century. Copley records seeing several "Van
Dycks" on a visit to New Brunswick, New Jersey.

Luman Reed (1787–1836) emphasized the difference between these
house decorators and the art amassers of the nineteenth century. Reed
was rich enough and his collection large enough to justify his creating a
special gallery on the top floor of his "magnificent mansion" that was
open to the public one day a week. Reed was a self-made grocer from
upstate New York of limited education and seemingly unlimited en-
thusiasm who was suddenly smitten by a passion for modern American
painting. An almost pure specimen of the Leather-stocking collector, he
bought what he liked, and what he liked was American landscape and
genre. Whereas Trumbull had paid twenty-five dollars for his Cole and
Dunlap resold his to diarist Hone for fifty dollars, Reed thought noth-
ing of buying a Cole for five hundred dollars. He even commissioned

works from him, notably the *Course of Empire* series, so famous in its day and so well known again now. He not only bought generously, he became a personal friend and advisor to the whole group. Mount, Durand, and Cole were his special favorites, personally and artistically.

Reed's sudden death in 1836 was a severe shock to the art world of New York and immediately posed the problem of disposal. The attempted solution was a classic example of the need for a museum. Reed's heirs, especially his son-in-law Jonathan Sturges, helped by a group of art-minded grocers, friends, and business associates of Reed, raised funds to buy the collection from the estate and house it in the old city-owned Rotunda where Vanderlyn's panorama of Versailles had once been exhibited. They established what they called the New York Gallery of Fine Arts. Paid admissions were supposed to support it; but the public, as in the case of the old American Academy, once again demonstrated its unwillingness to see the same old pictures over and over again each year. The board didn't have money to buy new works. In 1848 the city took back the Rotunda and by default in 1858 the collection was handed over to the New-York* Historical Society, the depository of homeless treasures, where it still remains. There could have been few more telling demonstrations of the need for an art museum in the city.

The collection of Robert Gilmor (1774–1848) was by no means as pure an example of Silk-stocking taste as Reed's was of Leather-stocking, since along with Old Masters and English moderns Gilmor also bought from Cole and other native Americans. Like Reed, he was a friend and correspondent of Cole; but his real pride and interest lay in his collection of older pictures. He had what was considered at the time to be the foremost group of them in American hands.

Unlike Reed, Gilmor was not a self-made man but the inheritor of a large Revolutionary fortune in Baltimore. He retired from business to devote himself to collecting and managed to amass pictures that he devoutly believed authentically represented the whole field of great European painting as it was then understood. He was wrong, but not as wrong as all that. Some of his canvases were genuine and his careful attributions have held up. A few are even now housed snugly in museums.

Washington Allston, that disciple of West, in a criticism of the genre pictures of William Sidney Mount perfectly expressed the Silk-stocking attitude to American artists and also the raison d'être for such collections as Gilmor's: "If he [Mount] would study Ostade and Jan Steen . . . and master their color and chiaro oscuro, there is nothing . . . to

* The original papers of incorporation of 1809 had this mysterious hyphen and the Society has been inordinately proud and touchy about it ever since.

prevent his becoming a great artist." Gilmor's Ostades and some other Dutch paintings happened to be genuine. His Vandykes and Rubenses and Velásquezes have disappeared into whatever abyss awaits the un-authentic pseudo–Old Master. There was no doubt about the authen-ticity of his Doughty and Allston, his Peales and Coles, or about his good contemporary English pictures. But alas, just like the Reed collec-tion, the Gilmor collection had nowhere to go. After his death in 1848 his heirs had to sell. Eventually some of his pictures came back to Baltimore, even to the Art Museum there; but what a coup for the city it would have been if the whole works, copies and originals, could have been deposited under one secure roof. Hartford would have had a rival.

There was one other collection during this earlier period, contem-porary with Reed and Gilmor, that really did have pricelessly genuine Old Masters in it; but unfortunately, although it was in America for some time, it did not belong to an American and did not stay here. This was the collection of Joseph Bonaparte (1768–1844) in Borden-town, New Jersey. Joseph was Napoleon's older brother and during his career as appointed King of Naples, then King of Spain, he managed to get his hands on a whole mass of good things. He was then somehow able to transport much of it to exile in America, where he built a mansion on a bluff overlooking the Delaware. There, from 1817 to 1832, under the fictitious title of Comte de Survilliers, he lived the life of an affluent and public-spirited country gentleman, surrounded by massive Empire furniture in marble and ebony, blue cashmere curtains and upholstery, and a stunning group of paintings. There were the portraits of the Imperial family, David's picture of Napoleon crossing the Alps, Canova's nude statue of Pauline Bonaparte. Besides this there were the Old Masters. Many were minor Dutchmen, stolen by the Span-ish from the Lowlands, stolen by Joseph from the Spaniards. But there were also (supposedly) seven Murillos, five Rubenses, three Titians, and a galaxy of others — Poussin, da Vinci, Vandyke, Velásquez, Raphael, Correggio, Veronese. This is the same list of names that ap-pears in collections like those of Daniel Wadsworth and Robert Gil-mor; but in this case there is no reason to suppose they were not mostly genuine. When the Bonapartes stole, they usually knew what they were stealing.

Joseph was a most generous host at "Point Breeze." He entertained lavishly and had many friends, particularly among the Philadelphia aristocracy. He encouraged artists to study his masterpieces; Dunlap gives a long account of Thomas Sully's examination of Titian, Velásquez, and Rubens. Occasionally pictures were lent to exhibitions such as those of the American Academy. Visitors were either impressed or, in the case of Victorian females, shocked. Nude Pauline and Jo-

seph's glowing admiration of her much-exposed parts shocked them most. The Bonapartes themselves had no false modesty. When someone asked Pauline if she wasn't "uncomfortable" posing in the nude that way for Canova, she said, "Uncomfortable? Why should I be uncomfortable? There was a nice warm stove in the studio."

Joseph loved America. If things had been different, he would undoubtedly have settled, become a citizen, and perhaps left his pictures to the Pennsylvania Academy or some such. But alas for America and art, he had to go back to Europe. The Restoration in France was an obvious failure; his nephew Louis Napoleon was eager to step in as Napoleon III. Joseph, as oldest Bonaparte and hence head of the family, had to be closer to the scene of action. He had left his invalid wife Julie, sister of Napoleon's first love Desirée, who became Queen of Sweden, in Europe. Despite the local consolation of an ex-Quakeress, Annette Savage, he missed Julie. His children, who spent considerable time with him at "Point Breeze," went back to settle in Europe and he missed them, too. So eventually he moved to England, was miserable, came back to New Jersey, returned to Europe for good, and in 1844 died in a palazzo in Florence.

The art had to be sold off to keep the family afloat during those last years of exile. Bits and pieces did stay in this country — furniture, notably pieces made by Michel Bouvier, the original American ancestor of Jacqueline Onassis, even a few paintings given to various Philadelphia friends. But the Raphael, the Velásquez, the da Vinci went back across the ocean and it was a long, long time before any genuine things of this sort appeared in America again. America's first real collection of great art came and went without leaving much trace. "Point Breeze" was torn down. Even the bed in which Joseph died in Florence was destroyed by the 1969 flood.

iii

One of Edith Wharton's most graceful novellas, first chronologically in her series of four called collectively "Old New York," is the tale *False Dawn*. It concerns a rather feeble young man of good if stodgy New York family. The young man is extravagantly interested in art, much to his family's disapproval. Nonetheless his pompous and hidebound father sends him to Italy to bring back a few Correggios and Guercinos for his father's collection. The father has no interest in art but merely wants to have an Old Master or two to darken up the house.

The young man goes to Italy and there becomes infatuated with Italian Primitive art, under the influence of Ruskin and early English Pre-Raphaelitism. He buys a group of these then-scorned "gold-

background" pictures and brings them back to New York instead of his Correggios. His father, furious at this disobedience to his orders, disowns the boy, who thereupon sets up a gallery on his own, intending to live off the proceeds of paid admittance. This outrage to respectability alienates Old New York. Nobody visits the exhibition. The boy, now growing older, sits in his gallery waiting for a recognition that never comes. He dies in obscurity and the pictures are stowed in the attic by his heirs and left to rot. By the time enlightened Edith Wharton comes along they have become priceless, the collection is posthumously vindicated, and Old New York is revealed in all its ignorant, provincial, conventional stupidity.

This story was based on reality, on two different examples, in fact; but there are differences between fiction and reality. The two collections Edith Wharton had in mind were those of Thomas Jefferson Bryan and James Jackson Jarves. Both did in fact have "gold-background" Primitives in them and both collections were exhibited in New York to massive lack of appreciation. Both collectors died without ever really knowing what treasures they had acquired. Otherwise fact diverges in some degree from fiction. In the first place, neither collection consisted entirely or even primarily of Primitives. In the second place, though it is true New York did not appreciate them and they were generally ignored until the twentieth century, the collections did not rot in attics but found secure homes, where they exist to this very day.

Besides the picturesqueness of incident, however, both collections are important in another way. They are important as the first actually formed by Americans with museum exhibition in view. They were not random pictures bought because the collector liked them, like the Reed and Gilmor collections, nor did they represent a mere infatuation with the ideals of Ruskin. Both collections were deliberately designed to illustrate the panorama of European painting from its beginnings down through what was then considered to be its post-Raphael decadence. The Bryan collection covered all schools and countries; the Jarves collection limited itself to Italy. In other words, the collections had an historical and educational purpose and were obviously made to be seen by a public, not just enjoyed in private.

Thomas Jefferson Bryan (1803–1870) was a dreamy gentleman of Byronic good looks and affluent Philadelphia parentage. Like many another esthetic American rentier, he preferred to live in Paris. There, during some twenty years of residence from the 1830s to the 1850s, he evolved the idea of bringing back to his native country an instructive and illustrative group of paintings by the best hands and to that end amassed over two hundred works ranging from early Italians to seventeenth-century Dutchmen and Frenchmen. Later on he added early

Americans, some of them acquired at the sale of the defunct Peale Museum in Philadelphia. C. W. Peale's famous group portrait of his family is one of these.

In 1852 Bryan brought his Parisian collection back to America and tried to give it to his native city. Philadelphia wasn't interested. He thereupon took his pictures to New York and, just like the hero of *False Dawn,* opened his own gallery on Broadway. There he sat, robed and patriarchal like some Renaissance grandee, with snowy beard and rubicund face, waiting for the public to flock. The public flocked to the exhibitions of the Art Union, not to Bryan's Gallery of Christian Art. In 1857 he lent his pictures to the newly opened Cooper Union; but when he caught Peter Cooper pointing at a "Rembrandt" with an umbrella, he angrily removed them. Finally in 1864 he gave up and his collection joined Luman Reed's in that capacious catchall, the New-York Historical Society.

Bryan made conditions: the collection must be kept together and must not be loaned out of New York. The pictures had even less to do with the history of New York than the Reed pictures did, but the Society did its best over the years to keep and show them. Eventually in 1967 it got legal permission to break the collection up; sell the dead wood,* of which there was a good deal; and keep the best items for the splendid new gallery opened in 1968. There, along with paintings from the Reed and other such orphaned collections, Bryan's Primitives and some of his other authentic Old Masters make a brave show.

Actually, quite unlike Mrs. Wharton's precocious hero, Bryan seemed to have no special appreciation of his gold-background Primitives. He just included them because of historical necessity. He was much prouder of those Old Masters from a later period, which inevitably turned out to be mostly copies or frauds.

iv

Bryan was an amiable, evidently rather retiring gentleman. He was so unworldly that he remained unaware of the fact that his faithful valet of many years was really a woman in disguise. That's the story, at any rate. He made no great stir in his lifetime and his pioneering efforts have never been adequately appreciated as *the* first attempt in America to build a true museum study collection along the kind of historical-chronological lines on which all good museums are now ar-

* Not so dead, some of it. One item, a Dutch picture reputed to be by Hercules Seghers, sold for one hundred and ten thousand dollars. Bryan's ghost must have been pleased. The Historical Society certainly was.

ranged as a matter of course. We take for granted nowadays that pictures will be grouped by schools and periods; in those days they were much more likely to be put together by size or because the colors matched.

James Jackson Jarves was anything but unworldly and retiring; and though he was not much more successful than Bryan in his attempt to endow some American city with a study collection illustrating the history of European art, he did make a stir and actually ended up as America's best-known art expert and the chief propagandist of the Silk-stocking versus the Leather-stocking attitudes toward art in general and museums in particular.

Jarves (1818–1888) was the son of Deming Jarves, the man who created and perfected the manufacture of Sandwich glass. Though Jarves was supported by this very successful and profitable endeavor and though his father's wares have now become treasured heirlooms and expensive collector's items, James thought they were embarrassingly crude. Like many another Silk-stocking esthete, he was sometimes myopic when it came to American beauties, even his own family's output. He wanted his father to make imitation Venetian glass.

It must not be imagined, however, that there was anything precious or fin de siècle about Jarves. He was, in fact, a rugged explorer by nature. He escaped from his father's factory in Sandwich, Massachusetts, to the Sandwich Islands, that is, Hawaii. There he was one of the island's first newspaper men and historians. Then by various odd shifts of fortune, he landed in Florence, where he became a friend of Ruskin and the Brownings — he shared Elizabeth's interest in spiritualism — and others of the expatriate Anglo-American colony. He threw himself into art collecting. Like Bryan, Jarves, beginning somewhat later in the early fifties, conceived the idea of a series of paintings to illustrate the development of the art of painting from its first crude infancy to its culmination in Raphael and its decline afterward. Like Bryan, he had no real conception of the worth of earlier painting; but unlike Bryan, he became something of an expert in this field. He had an eye, knowledge, enthusiasm and just enough money to buy pictures, if not to support his unhappy wife and children.

In 1860, he brought his collection back to America and, like Bryan, expected some American city to snap it up as the nucleus of a museum. The honor of rejecting the Bryan collection went to his native city, Philadelphia. The honor of rejecting the Jarves collection had by 1860 already gone to his native city, Boston, and specifically to the Boston Athenaeum.

Jarves had previously been involved in the sale of a shady Titian. This was held against him. His collection was judged dubious or worthless by various incompetent authorities, and at the particular instance

of Charles C. Perkins, later so influential in the creation of the Boston Museum of Fine Arts, and his brother Edward, the Athenaeum turned down Jarves's offer of sale. Like Bryan, he went to New York. He exhibited his collection in the newly opened building of Derby's Institute of Fine Arts, a dazzlingly ornate commercial emporium on Broadway. The decor of this palace of culture caused much more favorable comment than Jarves's queer old pictures. The New-York Historical Society exhibited them again in 1863. Nobody cared. Nobody would buy the collection as a unit and Jarves resolutely refused to break it up. He finally arranged a deal with Yale. It was all rather reminiscent of the Trumbull business. Yale was to lend Jarves twenty thousand dollars for three years. He in turn was to leave his collection with them as security.

Jarves kept right on collecting pictures and neglecting his family. When the three years were up, he couldn't repay the loan. There was an auction of the Jarves collection in New Haven at which the only bidder was — as it happens — Yale. They got it for twenty-two thousand dollars, which even at nineteenth-century prices was absurdly cheap. Jarves was furious and accused Yale of shady dealing. Yale put the pictures in its new (1866) art building along with the Trumbull pictures and Trumbull's tomb. There they moldered, more or less unappreciated and unrecognized, till the tide of fashion turned towards Italian Primitives at the end of the century, Edith Wharton's period.

At that time experts began to reexamine the collection and found it to be, like the Bryan collection, a mixture of genuine Primitives and fake later Old Masters. The Raphael, like all the other Raphaels in America except perhaps that of Joseph Bonaparte, was no Raphael; but the Sassettas were definitely Sassettas. Since the Jarves collection was purely Italian, his holdings in early Italian pictures were richer than Bryan's. It turned out to be a really thorough, if selective, coverage of Italian painting from the thirteenth through the fifteenth centuries and, as such, unique on the continent.

Jarves himself went back to Florence to become a sort of art agent for American buyers and a propagandist for spreading germs of European culture about in his barbarous homeland. His New Bedford wife, who had learned to dislike him in Hawaii, finally died in Florence after producing an allegedly illegitimate daughter and Jarves came back to Boston and remarriage. He not only had a second wife, but a second collection. Some of this was eventually acquired by a rich Clevelander with the fictional-sounding name of Liberty E. Holden and is now the foundation of the Cleveland Museum's priceless hoard.

The Jarves collection at Yale, stripped of its Raphael but including its by-now definitely authenticated Sassettas, Gaddis, Daddis, and so forth, remains there as still one of the best collections of the sort in the

world, small but very choice. As intended by Jarves, it is very represen-
tative, a true "teaching collection" for the history of Italian painting
and as such the first in the country with the exception of Bryan's much
less concentrated group.

v

Purged remnants of the Bryan collection are now handsomely dis-
played in a special gallery in the New-York Historical Society's mu-
seum, where Luman Reed's collection has also been handsomely
rehung. So there and at New Haven it is now possible to get some idea
of Trumbull, Jarves, Reed, and Bryan at their best. Nonetheless, not
one of these earlier collections actually went towards the founding of a
big-city art museum of the sort envisaged by Bryan and Jarves. Neither
Baltimore, despite remnants of Gilmor, nor Philadelphia, despite
remnants of Peale, nor Boston really benefited from the efforts of these
early pioneers. Only Washington, in the museum given to the city by
Corcoran, has an example of a museum based on the fruits of a pre–Civil
War collection.

There is nothing particularly picturesque about the personality of
William Wilson Corcoran (1798–1888). He was a banker of Irish an-
cestry, a native of Georgetown, who after business failure in 1840 went
into a banking partnership with George Washington Riggs. The bank
they started still exists today as the Riggs National Bank. Corcoran
made such a success of this that he was able to pay off the debts of his
former bankruptcy, help finance the Mexican War in 1848, and retire
with a fortune in 1854. Since he lived into his ninetieth year, he had a
nice long time to enjoy himself.

Corcoran's principal avocation was the collecting of art, mostly the
then-fashionable contemporary American nativist art of the sort pre-
ferred by Luman Reed. He decided to give his paintings to the nation,
and since there was no museum in existence to take care of them, he
decided to build one. The Corcoran Gallery of Art, designed by the
architect James Renwick (who designed St. Patrick's Cathedral in New
York), was begun in 1859, and if it hadn't been for the Civil War it
would have been the first of the big-city museums. Unfortunately Cor-
coran was a Southern sympathizer. He escaped to Europe for the dura-
tion and his unfinished Gallery was commandeered by the Government
to house the office of the Quartermaster General.* When the war was
over, Corcoran returned, all was forgiven and forgotten, the quarter-

* Joseph Trumbull was the first Quartermaster General and Jeremiah Wadsworth
was the second.

masters moved out, and in 1874 the Gallery finally opened, housing Corcoran's collection as was intended. But by that time the whole atmosphere of American art and collecting had changed. Although Corcoran's original collection belongs to the history of the pre–Civil War period, the history of his museum belongs to that of the post–Civil War period.

Corcoran was not so interesting as a person — he was very much the respectable Victorian banker, leonine, courteous in deportment, with gold-headed cane and rosebud in the buttonhole. He was interesting rather as an example of the kind of man who was to support museums in America for the next half century. He was rich, he was retired, he was an all-round philanthropist giving money to all sorts of charities, and above all he had ties with other such philanthropists. He is, in fact, part of a sort of web of beneficence. His partner, George Washington Riggs, had a half brother, William Henry Riggs (1837–1924), who was educated abroad, where he became a close friend of J. P. Morgan, and finally settled in Paris. In Paris William Riggs developed into one of the world's greatest collectors of, and experts on, arms and armor, his collection eventually going to the Metropolitan in New York, largely due to Morgan's influence.

George W. Riggs's father, Elisha, had been a partner of George Peabody (1795–1869). Peabody, after his business experience in Georgetown with Riggs, moved to Baltimore and finally to London in 1837. There he became the most prominent American financier in England. Junius Morgan of Hartford, father of J. P., became his partner in 1854. Peabody outdid even Corcoran in his benefactions, and the whole Eastern seaboard of the United States is still dotted with Peabody institutes of one kind or another — the Peabody Museums at both Yale and Harvard, the Peabody institutions in both Salem and Baltimore. None of these was meant to be an art museum, but some, like the museum in Salem, have become so de facto.

As for the Morgans, they were, father, son and grandson, not only among the principal benefactors of the Wadsworth Athenaeum in their hometown, Hartford, but the most magnificent of the patrons of New York's Metropolitan. Corcoran is thus a link in a golden chain of early American millionaires; a tradition of great public benefactions to which the American museum is almost totally indebted.

During this long period between the Revolution and the Civil War, then, although very little was actually accomplished toward the creation of art museums in the country, all sorts of beginnings were made. The idea of the museum emerged and above all the idea and fact of art collections and of art benefactors were firmly established.

Chapter VI

i

BESIDES THE HANDFUL of art museums and art agencies that endured and flourished and the collections that were formed and survived to some extent or in some form, there were all sorts of institutions, not art museums, that had what could be called "artistic leanings." The first half of the nineteenth century was a golden age of institutions in America and cultural institutes and associations and academies proliferated. Some of these, just because they existed, attracted art as magnets attract filings. The example of the New-York Historical Society is a perfect one.

By now almost every state of the Union and most cities, towns and even villages have historical societies, with headquarters of some kind or other. They almost inevitably tend to amass ancestral portraits and objects of both historic and esthetic interest.* Most of the bigger and

* The state of New Jersey, for instance, has over fifty such historical society museums containing portraits, furniture, and crafts.

older societies were founded in this Age of the Institution. Boston was the first in 1791 with its Massachusetts Historical Society. New York came next in 1804. The initiator of both was a New York merchant of Huguenot and New Jersey connections named John Pintard (1759–1844). He inspired his friend and correspondent in Boston, the Reverend Jeremy Belknap, to begin an historical society there, and then got one going in New York. Pintard had already had dealings of a sort with such an institution. As first Sagamore of the Society of Saint Tammany in New York, he was instrumental in founding what was intended to be a collection of appropriate Indian and patriotic souvenirs. The Society of Saint Tammany was a semihumorous, semiserious nativist organization designed to rival and confound the various British organizations — societies of Saints George, David, Patrick, and Andrew representing England, Wales, Ireland and Scotland — that loomed so large on the social and political horizon of eighteenth-century Americans. Pintard's Tammany museum set itself, rather overgenerously, to receive "everything, and from whatever clime." A few Indian artifacts were in fact acquired, but the museum faded away shortly after its founding in 1791 and the artifacts disappeared. It was, however, New York's first "museum."

Pintard's next venture, the New-York Historical Society, was more durable. The Boston Historical Society, though it did accumulate portraits and prints, never got caught in true art collecting for the sake of art. The New-York Historical Society was something else again. Perhaps the ghost of the Tammany museum haunted it, for the Society seemed to take anything given it, whether applicable to New York history or not. For almost two decades, from roughly 1860 to 1880, the Society was in fact the most important and complete art museum not only in New York but in the country. The usual nest egg of portraits, prints, and random paintings and busts was gathered during the Society's first half century of existence as it wandered from place to place and its fortunes fluctuated between energy and inertia.

Finally in 1857 the Society built and opened a new headquarters on Eleventh Street. In it was a fireproof picture gallery, of which the decorations in white and gold were described as "chaste and pretty." Since this was the only such fireproof gallery in the city, if not the nation, collections looking for homes found it irresistibly attractive. First, in 1858, was given the Reed collection as embodied in the New York Gallery of Fine Arts. In the same year there was also the massive gift of the Lenox sculptures from Nineveh, which were so heavy they had to be kept in the cellar. Next, in 1860, came the immense Abbott collection of Egyptian antiquities, of which the most popular items were some mummified bulls. In 1863 the Society bought many of the

original watercolors of Audubon's "Birds of America" from Audubon's widow. In 1864 the Bryan paintings fell to the Society, and in 1882 Louis Durr, a German immigrant of 1848, left them another hoard of over one hundred fifty paintings, many of them dubious Old Masters.

By the time the Society printed its first complete catalog in 1885, its collection was, at least on paper, the most comprehensive and valuable in America, even compared to that of the new Metropolitan Museum. "On paper," alas, is the crucial phrase; for if the works in the Bryan and Durr collections had been what the catalog said they were, the Society's holdings would now be of astronomical value. Almost every great name in painting is represented, sometimes in quantity — Italians like Bryan's Raphael, Titian, Tintoretto and Botticelli; his more than one da Vinci, Mantegna, Correggio, and Giorgione; his five Rubenses and Poussins; his four Velásquezes (one of which may in fact be real); and his Watteaus and Holbeins and Dürers and Ruysdaels. *If* they had been genuine! But almost none of them was, despite Bryan's most devoted and careful efforts to buy only the best. However at the time, since nobody knew they *weren't* real, it could be supposed they were; and so the neglect of the collection by New York connoisseurs and amateurs seems incomprehensible.

The public did have some excuse, no doubt of that. The building on Eleventh Street became totally inadequate to house, much less display, so much art. Paintings covered the walls from floor to ceiling, many up staircases and in the darkest corners. The Society was, after all, not devoted to art but to history, and to local history at that. At one time, after it got the Bryan collection, it made a gesture toward a true art museum of its own. The city set aside for it the tract of land on Fifth Avenue in the Eighties where the Met now stands. It considered building there and had Richard Morris Hunt make a design, but the project was too expensive for the Society. Then just at that point came the Metropolitan and the Society retired into seclusion.

In many ways this was both mysterious and unfortunate. The Society had its collection, had the institution, even had the land. It already needed to move from its cramped quarters downtown. The Metropolitan had nothing but a group of dynamic backers. Perhaps the Society, always dominated by the Oldest of New Yorkers, was afraid of becoming too intimate with parvenu millionaires. In any case, it failed to become America's first important art museum by a very narrow margin. The Society had to stay in its old building, growing more and more dilapidated and far from the center of fashion, until 1908. Then it finally moved into a marble palace on Central Park West, equally far from the center of fashion. Gradually over the years it divested itself of its mummified bulls and sculptures from Nineveh, mostly to the Brooklyn Museum (*not* to the Metropolitan). Finally, when the Society even

managed to divest itself of much of the Bryan collection, especially the less important European paintings, it was able to concentrate on American paintings, many of them with some New York reference.

The end result is certainly successful — a fine small museum of American paintings with a kernel of very fine European Old Masters. But somehow it was, seen from a long vista, a failure of intention. The public could never really see the pictures; they were so badly hung and lit they were almost invisible. Only members and guests could get into the building anyway. Most of Bryan's and Durr's attributions were faulty and overinflated. The Reed collection really comes out better in the end because it was more genuine. What could have and should have been a treasure turned out to be false gold, and America's first inclusive public art collection never in fact was.

ii

The New-York Historical Society is just one, though the most conspicuous, example of the institution that blunders into art unintentionally. Another example is the Smithsonian Institution. The Smithsonian is by now one of the most grandiose overall proprietors of art in the world, since it has been designated as keeper of all objects of art belonging to the U.S. Government. It includes the National Gallery, the Freer Collection, the National Portrait Gallery, and presumably every monument and mural in the overdecorated capital city of the United States.

The Smithsonian began much like the British Museum, with predominantly scientific interests, and had an original background of equally picturesque English oddity. The man who started it all was a bastard of wealth and good family who called himself James Smithson. Why he chose that name and why he chose to leave his money to a country he never even saw and with which he had no connection is a story remote perhaps from the history of American museums, but too peculiar to resist.

The story begins perhaps with William the Conqueror and the foundation of two of England's most ancient and bloody noble houses, the Percys and the Seymours. The Percys became Earls of Northumberland at an early date and with monotonous regularity died in battle or on the block, as was only proper to people of their position. The Seymours were comparative newcomers. They reached the summit of their prominence under Henry VIII when Jane Seymour became Henry's third and most successful wife. She was the mother of his only son and died in bed and still married to Henry, the only one of the six to do so. Her brothers went on to active careers and ended up appropriately

headless. One of them tried, unsuccessfully, to marry Elizabeth. He did marry Catherine Parr, Henry's widow. The Seymours acquired the title of Dukes of Somerset.

In 1670 the eleventh Earl of Northumberland, representing one of the oldest peerages in the kingdom and bearing the Norman name of Josceline Percy, died without a surviving son. He left a little daughter, however, named Elizabeth, who at the age of four inherited vast quantities of land and money and six earldoms in her own right: Percy, Lucy, Fitz-Payne, among others. She was a catch. She was brought up by a hard-bitten grandmother whose one object was to get the girl married. First, when Elizabeth was about twelve, her grandmother got her married to Henry Cavendish, Earl of Ogle, heir of the Duke of Newcastle. He was fifteen and described, even within the family, as the "ugliest and saddest creature." He obediently changed his last name to Percy, one of the requirements of the marriage settlement, and then died. Grandmother lost no time and immediately settled the girl, aged fourteen, on a famous middle-aged rake named Thomas Thynne. He was nicknamed "Tom of Ten Thousand" in admiration of his wealth and number of female conquests. He did not change his name to Percy. His little bride was so terrified of him that she fled to friends in Holland. Then, very conveniently for her, Tom of Ten Thousand was murdered in the streets of London at the instigation of a jealous rival and her grandmother had to start all over again.

Her next candidate was Charles Seymour. He was the younger brother of Francis Seymour, fifth Duke of Somerset. Francis, like Tom, was murdered. A jealous Italian husband killed him for making advances to his wife in church. So in 1678 Charles became sixth Duke of Somerset. In 1682 he married Elizabeth and changed his name to Percy. His wife inherited her properties and there was no holding him. He switched his name back to Seymour and carried on in such a ludicrously high-handed fashion that he was nicknamed "Charles the Proud." He docked twenty thousand pounds from the inheritance of one of his daughters because she sat down in his presence. He never spoke to his servants; they had to obey him by interpreting his signs. When he emerged from his country estates, he had outriders clear the roads so no one could stare at him. He remarried after Elizabeth's death, and when his new wife one dreadful day tapped him with her fan, he remarked, "Madam, my first duchess was a Percy, and *she* never took such a liberty."

Despite all this, he and his Percy wife were great favorites of Queen Anne. Charles' favorite hobby was acting as chief mourner at royal funerals. Charles and Elizabeth had one son, Algernon. Algernon having married a Thynne (one might have thought that one Thynne was enough in that family), the family was once more represented by an

only surviving daughter, another Elizabeth, another Last of the Percys. As a catch she equaled her grandmother, from whom she inherited the reliques and baubles of the Percys.

Meanwhile in at least comparative obscurity was born a boy with the rather plain name of Hugh Smithson. His mother's first name was Philadelphia. His parents were respectable Yorkshire gentry of good connections. Hugh inherited a baronetcy from a grandfather. The family had originally been successful haberdashers who bought the baronetcy in the 1660s. Hugh Smithson grew up to be the handsomest man of his day and one of the most adroit and self-confident; but he was a long way from being Earl of Northumberland or Duke of Somerset. He determined to remedy these deficiencies by marrying Lady Betty, as the Elizabeth Percy of his generation was always called. He succeeded, over the violent objections of Charles the Proud, still alive, who knew one when he saw one. Since Lady Betty inherited everything from her grandmother, not Charles, Charles could do very little but object. He died, Algernon died, and down came the shower of gold, lands, titles. Hugh had changed his name from Smithson to Percy; now he became in his own right Earl of Northumberland. By exerting pressure in the right places at the right time, he parlayed his earldom into a dukedom and became Duke of Northumberland.

From then on Hugh and his Lady Betty lived high, wide and handsome with city palaces and country castles, playing at politics and showing off. Despite the scorn of viper-tongued Horace Walpole and the disdain of the old nobility, Hugh born Smithson, Duke of Northumberland, Earl Percy, Viscount Louvaine (a title made up out of an old Percy heirloom) was too much for them. He had sons and descendants (legitimate) who have carried on in proper Percy fashion as Dukes of Northumberland to this day. One of them was that Percy who fought in America with distinction in the British retreat from Concord, although he was violently opposed to the American war.

Besides all this, Hugh Smithson-Percy, like Charles II, had time to father various bastards. One of these was the son of a very respectable widowed woman née Elizabeth Keate. She was a descendant of the Seymours, indeed a great-grandniece of Charles the Proud and hence cousin to Lady Betty, which is more than Hugh could say. She'd been left very well off by her deceased husband John Macie and by inheritance from her own well-placed family.

The son was brought up as James Macie. Young Macie was a scientific genius of sorts, was renowned at Oxford for his studies of mineralogy, wrote many scientific papers, and was the youngest man ever to be nominated a Fellow of the Royal Society. A kind of zinc was named Smithsonite in his honor. His father refused to recognize him or have anything to do with him, though the old man adopted two of his

illegitimate daughters, let them call themselves Percy and even, permitted them to be buried in Westminster Abbey alongside his legitimate daughter.

Young James was inordinately proud of his noble ancestors and yet was a decided radical. Quite late in life he changed his name officially to Smithson, just as his father had changed his name to Percy. He applauded the French for ridding themselves of the "contemptible incumbrance" of monarchy. Yet he boasted that "the best blood of England flows in my veins"; but added significantly, "My names shall live . . . when the titles of the Northumberlands and the Percys are extinct and forgotten."

He never married; devoted himself to science and his one weakness, gambling; lived much on the Continent; and died in 1829 in Genoa, where he was buried. He left all his money to the United States "to found at Washington, under the name of the Smithsonian Institution, an establishment for the increase and diffusion of knowledge among men." It amounted to over one hundred thousand pounds.*

Congress, with considerable obtuseness, didn't want to take the gift. Perhaps congressmen were shocked by Smithson's nativity. John Quincy Adams, however, more or less forced the legislators to accept the present. The United States took possession in 1836 and after years of wrangling finally established the Institution in 1846 with Joseph Henry, the rival of Samuel Morse as inventor of telegraphy, as the first Secretary.

The bias of the Institution from the beginning was always scientific; but, just as in the case of the British Museum, art crept in. Under the guise of archaeology and ethnography and geography and history, the Institution acquired things like George Catlin's magnificent records of the Mississippi Valley Indians. An exhibition gallery was included in the plans of the 1855 building on the Mall, and eventually, when the Smithsonian was designated as official curator of all government art, the National Gallery and other art collections came under its enormous wingspread. But this was all much later. The National Gallery has its own very special story.

And so the bastard James was right: the not very elegant name of

* The income was left for life to a nephew; if he had had children the estate would have gone to them. James had a brother, another "natural son" of Elizabeth and her duke, who was called Henry Dickinson. He in turn had a natural son of a Mrs. Coates. He was called Henry Hungerford. His mother, Mrs. Coates, married a Frenchman named de la Batut, and Henry called Hungerford changed *his* name to Baron Eunice de la Batut. Of all this welter of illegitimate names — Smithson, Macie, Dickinson, Hungerford, de la Batut — it is plain Smithson that survives, thanks to the Institution. Henry-Eunice died in 1835 without children and the money then went to the United States.

Smithson is known all over the world and by millions of people to whom the more euphonious Percy and Seymour and Northumberland mean nothing.

iii

It would be fruitless to go into the backgrounds of the many other similar institutions, picturesque as some of them might also be. The Cooper Union, for instance, briefly had the Bryan collection and lost it because of an umbrella. The Union was founded by millionaire iron-master Peter Cooper in 1857, for "the advancement of science and art." "Art," however, did not so much mean the fine as the decorative and industrial arts, although from the beginning it encouraged lectures on art and had an art school. Considerably later it developed its own museum of decorative arts down on Astor Place in New York, which has now moved to the old Carnegie mansion on upper Fifth Avenue.*

Other institutions can make claims to "first" and "oldest" in this area. There is, for instance, Bowdoin. Bowdoin College was founded in Brunswick, Maine, in 1802 and named after an important post-Revolutionary Governor of Massachusetts, James Bowdoin II, whose Huguenot ancestor, Pierre Baudouin, had originally settled in Maine after the Revocation of the Edict of Nantes. The family moved to Massachusetts and prosperity but kept Maine connections and real estate. Governor Bowdoin's son, James III, was a diplomat and art collector in Europe. When he died in 1811 he left his acquired and inherited paintings, upon the death of his wife, to the college named after his father, though he himself was a Harvard graduate (1771). Like almost any other such American collection of that time, it consisted of priceless early American works, portraits of Bowdoins going back into the seventeenth century, and dubious European Old Masters.

The collection, though as such it can be said to date long before most others still extant in America, did not have a true home until mid-nineteenth century. It came to the college finally in 1813, when the widow Bowdoin died, but there was no place to put it until the college

* A curious marriage of institutions has taken place in Washington. There the old Corcoran Gallery, after years of misuse as government offices, has been restored as a gallery, put under the jurisdiction of the Smithsonian Institution, and opened with an exhibition of material from the Cooper Union. The building is known as the Renwick Gallery in honor of its architect. In other words, what was in fact America's first true public art gallery has been rescued and restored as such under the auspices of two primarily nonartistic organizations. Odd.

set aside a new room in its new chapel in 1850. Since then it has constituted a true enough art museum and as such is certainly one of the oldest in America. A fine new gallery opened in 1894 still houses those paintings that have survived expert scrutiny with reputations intact. The collection, centered around the Bowdoin portraits, now covers the whole range of art from antiquity to the present. Perhaps its most curious exhibits are copies of Poussin and others once thought to be originals. They now turn out to have been made in mid-eighteenth century by the pioneer Anglo-American artist Smibert, precursor of Copley in Boston. As such they are almost as valuable as originals would be and far more unusual, probably the first Old Masters of any kind ever visible in Colonial America.*

Equally venerable in its own way is the Albany Institute of History and Art, which can trace itself back to a Society for the Promotion of Agriculture and Manufactures founded in New York ca. 1790. Chancellor Livingston and other worthies who helped found Trumbull's Academy of Fine Arts also had a hand in this. It was meant to encourage practical inventions, *not* the fine arts, and papers on sheep raising and steamboats were read. When the capital of New York State moved up to Albany, the Society followed in 1800. In 1824 it met and married the Albany Lyceum of Natural History, and in 1898 it joined up with an Albany Gallery of Fine Arts. By the twentieth century the Albany Institute, whatever its original intentions may have been, found itself possessed of an art collection. By 1907, when the present building was built, the collection consisted mostly of American nineteenth-century academics. The collection is still there, but the academics have been weeded out and the Institute is now famous for its early eighteenth-century Hudson River portraits by the so-called Patroon Painters. If it insists, the Albany Institute can claim to be America's oldest art museum, dating back to 1790–1791. But it doesn't seem to insist; and of course it really isn't.

Then there is Mr. Peabody and all those institutes of his. Most of them by now have things in them that are considered art, like the glass flowers in the Peabody Museum at Harvard. None of the institutes was really meant to be an art museum, however. The one that probably has the most and best art in it is the oldest one, the present Peabody Museum in Salem, Massachusetts. It was founded in 1799, long before Peabody, as the Salem East India Marine Society. This was a fraternal and benevolent organization to help support the widows and orphans

* Smibert exhibited them to the public in his Boston studio in mid-eighteenth century, antedating Peale by three decades; so these copies give Bowdoin a claim to being "America's oldest art museum."

of member sea captains, of whom, given the nature of the business, there must have been many. It was also devoted to collecting navigational data and curious souvenirs of trips to the Pacific. In 1825 the mariners erected headquarters and there deposited their souvenirs. It must have been the storehouse of picturesque junk described in the fiction of native son Nathaniel Hawthorne as "A Virtuoso's Collection." This was supposed to contain stuffed animals such as the wolf that ate Red Riding Hood and Shelley's skylark, as well as historical objects like Nero's fiddle and Peter Stuyvesant's wooden leg.*

By mid-nineteenth century Salem's China trade was dying and the Society's seafaring members began to become extinct, like Ashmole's dodo. Mr. Peabody's generosity revived the organization along more definitely scientific and historical lines, and it changed its name in 1868 to the Peabody Academy of Science. It is now (since 1915) the Peabody Museum of Salem and though essentially interested in local and marine history and Pacific ethnology, it contains as fine a collection of marine paintings and Oriental and Polynesian arts and crafts as one would care to see. It is still a thriving institution full of charm, character, art, and the salty aroma of early Salem and its far-flung sea-borne commerce. This Peabody Museum does go back to 1799 and is in fact a museum with art in it; but it wasn't founded as an art museum and it isn't really one now. It's one more specimen of the takeover by art of science and of the quandary involved in defining "museums of art."

All the other Peabodys have somewhat the same history. The one in Baltimore, essentially divided now between a stately and pungently Victorian library and a busy and famous conservatory of music, also has contained from its foundation an art gallery. The great stores of primitive objects jammed into the Peabody Museum in Cambridge, Massachusetts, are more and more liable to find themselves on exhibit as works of art. This kind of thing is true everywhere and anywhere: historical societies, historic houses, scientific displays of ancient or exotic objects all turn into objects of beauty.

And then there are libraries. They too have buildings and in those buildings are portraits and murals and furniture and illuminated manuscripts and prints and even just plain pictures. Before the opening of the Boston Public Library in 1852, such libraries as there were owed their being to private generosity. They were either attached to colleges or they were subscription libraries maintained by shareholders. A few were originally private libraries open, to some extent, to public

* The New-York Historical Society is the proud possessor not of Stuyvesant's but of Gouverneur Morris's wooden leg. One story is that he lost his real one hopping out of the wrong bedroom window.

use and maintained by endowment, like the Loganian Library in Phil-
adelphia. A certain number of the subscription libraries bore, and still
bear, the resounding appellation of Athenaeum. It was the kind of
name that sounded appropriate to a generation of early nineteenth-
century classicists. Athenaeums sprung up in most cities of the Eastern
Seaboard. The one in Hartford, that three-headed castellated combina-
tion, is among the latest of its kind. One of the oldest is in Boston.

The Boston Athenaeum has a special relationship to the history of
art museums, since out of its womb sprang, like Minerva from the head
of Jove, the great Boston Museum of Fine Arts. The Boston Athenaeum
was primarily devoted to books, considered in Boston more important
and more moral than the dubious allurements of the senses represented
by painting and statues. Charles Callahan Perkins, one of the principal
founders of the Boston Museum of Fine Arts and well known as an art
critic, the same C.C. who helped prevent the Athenaeum from buying
Jarves's gold-background pictures, expressed the Boston attitude: "I do
not intend to suggest that a cultivation of the sense of the beautiful as
revealed to us in art is equally important with that of developing our
faculties by the reading of . . . good books. Such a proposition would be
absurd."

So it was natural that the visual arts should be cultivated as a sort of
footnote to a depository of good books. The Athenaeum, conceived of
as a club-library by a group of literati called the Anthology Society
(instituted 1805), was incorporated in 1807. It found a true home in
1822 in the former mansion of James Perkins. The Athenaeum added
to this an annex with a third-floor gallery. This gallery originally con-
tained only seven paintings, five of them by or after Stuart. Artists such
as Allston, Sully, and Stuart used it for a studio. But beginning in 1827
annual public loan exhibitions were held, mixed bags of painting and
sculpture, ancient and modern, American and European; and gradually
the permanent collection increased.

In 1849 the Athenaeum moved into splendid new quarters built
especially for its use, containing both a sculpture gallery downstairs
and a painting gallery on the third floor. The twenty-third Athenaeum
exhibition of 1850 opened these galleries to a select public. In no time
at all the conflict of books, art, and space became acute. The Athe-
naeum, after all, was devoted to the more important activity of a li-
brary. Sculpture went first and was kicked out of the first floor. As the
permanent collection of paintings increased, there was less and less
room for it. This led inevitably to the creation of the Boston Museum
of Fine Arts, largely under the prodding of such Athenaeum trustees as
C. C. Perkins.

By the time of the Civil War, America had no true museum of fine

arts. The Wadsworth Athenaeum and the museum at Yale contained mostly American works of recent vintage. The Pennsylvania Academy of Fine Arts had a few older things; the New-York Historical Society had lots of older things; but neither one was a true public museum on the order of those already established all over Europe.

BOOK II

Pioneers, O Pioneers!

Chapter I

i

THE TRUE HISTORY of the art museum in America therefore dates from the year 1870. That was the year in which both the Metropolitan Museum of New York and the Boston Museum of Fine Arts were founded, if not opened for business, to be followed by the belated Corcoran in 1874, the establishment of the Philadelphia Museum as a by-product of the Centennial Exhibition of 1876, and then by a constantly increasing flood of foundations and creations and constructions up to the very present.

It would be frivolous to try to trace the history of each separate museum in chronological order. The history of a few can stand for many; but certain centers do have a richer concentration of art than others and certain stories do have more character. Culture in America, until the twentieth century, was largely a tale of three cities — Boston, New York, and Philadelphia in various degrees and fashions and in various periods. Other cities like Hartford and New Haven, Baltimore and Washington, Cincinnati and St. Louis made their special contributions during the century. In general, however, in the case of art and art

museums, as in literature and music, those three cities have the oldest, longest, and most interesting histories.

Boston, for instance, had a school of native portraiture going back into the seventeenth century. There is that small group of grim, striking Jacobean Puritan canvases, portraits of medieval intensity and rigidity that hang mostly in historical societies and convey so strongly not only the force of character but also the Colonial attachments of early New Englanders. This tradition persists all through the eighteenth century and through the work of artists such as Smibert, Feke, Badger, and Blackburn, to culminate and end with Copley.

When Copley left for England in 1774, the native tradition of New England portraiture suffered the same sort of amputation as the aristocratic tradition, cut off with the exile or dissolution of the old theocratic oligarchy. In business and in public affairs a new group of entrepreneurs, many of them natives of smaller towns like Salem, members of the so-called Essex Junto, stepped into the vacuum created by the Revolution and evolved in their descendants the Boston Brahmin, the patron of the city's intellectual flowering in the pre–Civil War period. Unlike the earlier Bostonian, who seemed to have an eye for the purely decorative values of portraiture, the society of the Brahmin was essentially literary. During the Revolution Boston, like New York, seems to have been more or less painterless, the practice being in the hands of very minor limners. Then in 1805 Gilbert Stuart, after his palmy days in Philadelphia as court painter to the Government under Washington and the Federalists, moved to Federalist Boston. He could be said to carry on there the tradition of Copley as local master of the portrait; but the true, newer Boston spirit in painting was represented by Washington Allston, intellectual, romantic, poet, idealist, Harvard graduate. He came to Boston for good in 1818 and began to talk about art, which seemed to be more important than actually painting it in Boston. He was a brilliant talker and his reputation was enormous.* Regarded by Bostonians as the greatest of American artists, he spent years laboring on an immense West-like machine called *Belshazzar's Feast* (now in Detroit). Although Bostonians supported him and his picture with fervid admiration, he could never finish it and felt himself always an exile on the bleak and rockbound coast of unappreciative America. He was a most interesting failure. As a failure, he was a great success.

William Page (1811–1885), who more or less succeeded Allston as Boston's intellectual painter in residence, was an equal failure. He too

* When the Corcoran erected its Neoclassic building in the 1890s, the name Allston was carved on the facade along with those of Phidias and Raphael. Allston is the only American there.

talked art and did not finish his great masterpiece, *Jeptha's Daughter*. However, unlike Allston, he was not fervidly admired. He was extraordinarily lax in his sexual standards, particularly in the choice of wives. He also spent his later years in Italy, not in Boston. Though Boston considered Italy to be a garden suburb, it was after all not Boston itself.

Finally there was William Morris Hunt (1824–1879), the very epitome of the intellectual Boston painter, although like the South Carolinian Allston and the upstate New Yorker Page, Hunt was not a Bostonian but a native of Vermont reared in Connecticut. He talked like an angel, he charmed all, especially the ladies, with his romantic aspect and rich beard. Like his brother, the architect Richard Morris Hunt, he was a social lion; but just like Allston, he suffered from a mixture of idealism and frustration. His greatest work was a large allegorical mural for the state capitol in Albany called *The Flight of Night*. Unlike Allston and Page, he did actually finish it; but something went wrong with the physical conditions of the painting and in a short time it completely disintegrated. Nothing is left of it now but preliminary sketches. Even before this disaster, Hunt committed suicide in a pool on the Isles of Shoals, home of his poet friend Celia Thaxter and summer resort of many a New England intellectual.

Then there was the strange doctor-anatomist William Rimmer, whose father claimed to be the lost Dauphin of France and who liked to create muscular male nudes without genitals. He is better known as a sculptor, but he left a few haunting canvases of Poe-like intensity, like the well-known *Flight and Pursuit*. He too talked well and taught well but did not do very much actual work.

All these representatives of the tradition of intellectual art were fascinating people, good examples of the Silk-stocking as opposed to the Leather-stocking tradition of American culture. They managed to paint, for all their talk, a rather fragmentary gallery of curious pictures; but in general, despite their grandiose ambitions and great contemporary reputations, they seem literary, more like characters in a novel than professional painters. They were what the nineteenth century thought painters should be like.

Things in Philadelphia were, as might be expected, diametrically opposed. Nobody much cared to talk about painting or gave any consideration to ideals and theories. What was required of painters was good solid craftsmanship combined with good taste. It was a thoroughly eighteenth-century attitude, like that of England before West. As in the case of furniture makers, the proper garnishing of a gentleman's house was the criterion — portraits that looked good and made the sitters elegant. Artists who could produce such pictures were patronized. Others weren't.

Art and artists being what they are, however, the succession has been insecure and the incumbents troublesome. There have been considerable fluctuations in taste and appreciation. Beginning with the Swede Gustavus Hesselius and his well-married son John, the succession, often dynastic from master to pupil, father to son, comes down through the Hesselius pupil Charles Willson Peale and his numerous family, notably son Rembrandt; Gilbert Stuart, during his brief period as Court Painter in Philadelphia, his student Thomas Sully (1783–1872), and Sully's son-in-law John Neagle; Thomas Eakins (1844–1916), Cecilia Beaux, Adolph Borie, Walter Stuempfig, and Franklin Watkins until his untimely death in 1972. Some of these artists have been and still are famous, others not. Some have erred in the direction of flamboyance and overelegance (Sully and Watkins) and been criticized for it. Others, like Peale and Eakins, have, much more fatally, erred on the side of rugged honesty and have been socially punished, which did not prevent them from continuing to paint portraits, even of the best people. But nothing for two centuries has for very long interrupted this flow of Philadelphia faces. Talk about art may never have been much admired, but social flair, as in the case of Stuart and Sully, was. Lack of it, as in the case of Eakins, was always a formidable disadvantage.

As a sort of offshoot, a school of still life painting, beginning with the earlier Peales and going on through trompe l'oeil masters like William Harnett and Peto, was also a specialty of the city, like scrapple. In mid-nineteenth century, Philadelphia's primacy as a center of popular magazine publishing encouraged illustrators — Darley, Frost, Abbey, Pyle and his pupils like N. C. Wyeth and his son Andrew and *his* son James. In general, Philadelphia's leading practitioners have been one hundred and eighty degrees out of phase with whatever was fashionable in New York. For instance, Thomas Sully very successfully continued the English tradition of portraiture in the mode of Lawrence while New York was infatuated with the nativist landscapes of Cole and Durand. Later on Eakins, most sternly independent of creators, stubbornly persisted while New York rejected nativism for an extreme of cosmopolitanism. At the present time Andrew Wyeth is no exception to this general rule.

In New York it was mostly a matter not of individuals but of schools, groups whose rise and fall, booms and busts, cohesion and disruption created art history there. The Patroon Painters of the eighteenth century, whose works are now enshrined in the Albany Institute, bloomed and were forgotten. Individualists like Trumbull, Morse and Vanderlyn tried and failed. It was only when those artists from or via Philadelphia, Thomas Doughty and Thomas Cole, opened up, as pioneers, the world of native American landscape represented by the Hudson River School that New York painting began to have a style

and character of its own. For fifty years, from 1825 to 1875, the eagle screamed, profitably, from its nest in Manhattan. Morse's National Academy was its fortress, the Century Association its waterhole, the Art Union its advertising agent. Then the boom collapsed. The Hudson River School paintings joined those of the Patroon Painters in the attic. Now New York was all for French Salon art and the artists who survived best were those who best imitated cosmopolitan fashions. Men like William Merritt Chase, who had mastered the swaggering brushstrokes and expatriate sensibilities of painters like Sargent and Whistler, dominated the New York scene; and a peculiar individualist like Ryder chose to paint as a recluse in a dingy garret.

Groups of neo-Impressionists challenged this sort of domesticated expatriatism with a more advanced sort of expatriatism. Then at the turn of the century a new group of nativists, the Ash Can School, took over the field of New York art, proclaiming, like the Hudson River School, the local beauties, not this time of river scenery but of urban low life. Like Doughty, most of the members of the Ash Can School came from or via Philadelphia and, like Cole, they reopened the rich and prosperous vein of American Romantic Realism, which tended to dominate American painting with some cosmopolitan competition for almost another half century. As the fashion for the Hudson River School was built up before and then killed off after a major conflict, the Civil War, so the Ash Can School artists and their Romantic Realist successors built up popularity before and were then killed off after another major conflict, the Second World War. As the Hudson River School moved west in its later phases to include, in the works of painters like Bierstadt and Cole's pupil Church, the Rocky Mountains and the Andes, in a similar fashion the roughneck-nativist genre of the Ash Canners had a last hoorah in the Midwestern chauvinism of Benton, Curry and Grant before it was overwhelmed by still another New York school, that violently antinativist and pro-European cabal of Abstract Expressionism that still, as of 1970, continued to dominate New York taste and such establishers of reputation as the Metropolitan Museum, as witness the great Geldzahler show of the Centennial celebration period.

It is thus no surprise that in Boston, with its tradition of literary painters, the Museum of Fine Arts should have begun in a library. In New York the Metropolitan had nothing specifically to do with such an existent institution like, say, the New-York Historical Society, which had all the pictures, or the National Academy, which had all the artists. Instead, it was the result of a sort of spontaneous combustion within, again, a group, a group not of artists but of enlightened laymen who decided it was high time for New York to have a public art gallery.

ii

The climate was right, as it had not really been before the Civil War during the high tide of nativism. Now the interest of most American collectors and intellectuals was directed towards contemporary European art, not the art of those obscure rebels the Impressionists, but the art recognized everywhere in the Western world as representative, the art of the French Salon. As means and taste and expertise increased, the taste for Salon art changed to a taste for Old Masters. In almost every case, the great collectors of the turn of the century in America worked up from Bouguereau to Rembrandt.

But in 1870 there were no real collections of Old Masters in New York, at least nothing to compare with the Bryan collection in the Historical Society downtown in its crowded headquarters. There were, however, scores of collectors, during the period from 1870 to 1900, who specialized in what was always thought of as Modern Art. New York entered upon its second great period of art boom and bust. First there had been the Hudson River School. Now there came Modern Art, the work of European Academic artists; first nativism, the Leather-stockings, then cosmopolitanism, the Silk-stockings. By 1880 artists like Frederick Church were out of fashion. Most of the Metropolitan's Kensetts were gradually relegated to the staircase. Paris set the styles now in painting as it did in clothes and furniture and architecture.

By the mid-nineteenth century Paris had become the center of a vast and profitable industry. This was the production, mass production, of thousands and thousands of pictures suitable for the middle-class home and geared to middle-class tastes. They were technically perfect — slick, fantastically detailed, full of button-and-buttonhole realism. They were also full of message — moral, religious, patriotic, sentimental, historical, and cultural. Subject matter was of overwhelming importance, what was painted being always more important than how. And a delightfully salacious vein of pornography ran like a scarlet thread throughout. Since in the nineteenth century it was almost impossible for the average respectable middle-class male to get any idea of the female form divine outside of a whorehouse, art generously filled the vacuum.* All this, of course, done up under a thin, titillating drapery of purity and uplift.

Paris was the center, but there were humming subcenters all over Europe. Competing factories flourished in Düsseldorf and Munich, in

* A publication called *La Nue au Salon* carefully reproduced each and every one of the nude pictures exposed at the annual exhibition, to the delight of a worldwide subscription list.

Venice and Florence, in Brussels and Amsterdam. They also produced their crop of Academic painters, piquantly flavored with a touch of national idiosyncrasy. The pre–Civil War collector, if not interested in American painting, favored the more old-fashioned English artists such as those two American expatriates, Charles Leslie and Gilbert Stuart Newton. A semicharlatan like Old Paff, in whose window Trumbull saw his first Cole, could palm off spurious Old Masters on the innocent New Yorker of that period; but from 1850 on purveyors of contemporary European art began to find a foothold.

In 1849 the Düsseldorf Gallery was established in New York City, stocked with German canvases whose owners had been frightened by the 1848 disturbances and thought their precious wares might be safer across the Atlantic. John Durand, son of the painter Asher Durand, a founding father of the Hudson River School, cites this as the beginning of the "eclipse of American Art." But the Düsseldorf Gallery was not an outstanding success. In 1860 it was part of the collection exhibited by Derby's Institute of Art in its glorious new building on Broadway, along with Jarves's Primitives. The collection was sold off at auction in 1862.

In the same year of 1849, Goupil and Vibert at 289 Broadway announced the creation of an International Art Union to compete with the booming American Art Union. There was a small difference: the American Art Union was not run for profit; the International Art Union was run for the profit of Goupil and Vibert. It specialized in the "chefs-d'oeuvres of The European School of Art," and far more than the Düsseldorf Gallery, really foreshadowed the eclipse of American art. The International Art Union also had its free gallery, and in a burst of generosity and publicity announced the creation of scholarships for young Americans to study abroad. This Union folded in 1863; but Goupil and Vibert went on to higher things and it was this firm, transformed into Knoedler's, that dominated the boom in foreign art after the war. Under the leadership of Goupil, American art was buried under tons of imported Modern Art.

A priceless publication called *Art Treasures of America** presents this panorama of Salon art as flaunted across the width of America during the Gilded Age. The atmosphere is fairly suffocating . . . the conservatories, the plush, the statuettes. The taste is consistent; everywhere from the Pacific to the Atlantic, Bouguereau, Detaille, Meissonier, Cabanel. Mr. Shinn exhales in rapture over, for instance, the house and collection of John Jacob Astor in New York. "A city palace

* Earl Shinn [Edward Strahan, pseud.], ed., *The Art Treasures of America, Being the Choicest Works of Art in the Public and Private Collections of North America* (Philadelphia: Gebbie and Barrie, ca. 1879–1880).

made dreamy and languid with luxury, like the stately pleasure dome of Kubla Khan, filled with the scent of conservatory flowers and wrapped in the silken ease of hangings and draperies, softened in winter with currents of perfumed warmth and shrouded in summer with the aristocratic *noli mi tangere* of Holland furniture covers, such is the shrine of a collection which includes a few of the gem-pictures of the 19th century." To wit: *The Death of Caesar* by Gérôme, *The School of the Vestals* by Leroux, and otherwise Bouguereau, Detaille, Lefebvre, Meissonier, Meyer von Bremen, Toulmouche, and the inevitable Zamaçois and Ziem.

Or in Philadelphia, after New York the principal center of this sort of collecting, the dream house of Henry C. Gibson, where "instead of a large hall, we have a series of little chapels. Each is lighted by a ceiling of glass. . . . Three or four little marble rooms from Pompeii seem to have floated over the sea . . . and anchored upon a bed of roses; for the conservatory is adjacent, and the scent of warm hot-house earth steals in from its quadrangle to hint of the stability and reliance of terra firma." The pictures? Achenbach, Rosa Bonheur, Bréton, Cabanel,* Corot, Couture, Detaille, Diaz, Dupré, Fortuny, Fromentin, Gérôme, Isabey, Jacque, von Kaulbach, Madrazo, Meissonier, Meyer von Bremen, Munkaczy, Pasini, van Marcke, Villegas, Willems, Zamaçois, Ziem. If Mr. Gibson seems to be a bit luckier than some — hardly more discriminating in his Boudin, Corot, Courbet, Daubigny, Millet — that's something of an illusion. These are the handful of names from the list of favorites that have endured, respected and remembered through the eclipse of Salon art that followed the eclipse of American art. They have been hung right along in museums. But as for A. T. Stewart's De Cock and de Nittis, his Frère and his Jacque, his Madrazos and Merles, his Muller and his Preyer — where are they now? Where are the Willems and the Worms, the Knaus and the Koekkoek everybody had to have?†

Even out in San Francisco, Crocker and Stanford collected. As Mr. Shinn gurgles, "The (perhaps impertinent) astonishment of visitors who find on the extreme western end of the transcontinental road a community fully conversant with modern art and furnishing Goupil with his best customers. . . ." But there they were, galleries full of Boldini, Bréton, Cabanel, Gérôme, Knaus, Madrazo, Meyer von Bremen, Toulmouche, Verboekhoven, Willems, Worms and inevitably Bouguereau. Whatever else you had, you had a Bouguereau.

* *The Birth of Venus,* that apotheosis of the barroom nude. The Gibson version was a copy of the 1863 original, which, according to author Shinn, was painted "with that absence of soul which evades responsibility."

† Stealing right back into the light of galleries and museums, just since this book was begun!

A few collectors, like Mr. Borie of Philadelphia, showed eccentricity. Being of French descent, he had the whim of collecting old-fashioned French painters like Delacroix. He had four Delacroixes and even a Géricault. Alone among American collectors of this sort, he had a Fantin-Latour. Otherwise it's Domingo, Hamon, Merle, Fortuny, Roybet. Fairman Rogers had his Eakins, though Mr. Shinn doesn't mention it, preferring to concentrate on Mr. Rogers's ingenious system for lighting his gallery by gas turned on by an electric switch. He also concentrates on Mr. Rogers's Hamon, Isabeys, Pasini, and other such "gems."

What were the Havemeyers collecting then? Achenbachs, A. and O., Delaroche, Gérôme, Jacque, Meissonier, Pasini, Troyon, Willems. Or the great J. P. Morgan? Diaz, Hamon, von Kaulbach, Toulmouche, Troyon, Villegas. The Drexels, in New York and Philadelphia, had Boldini, always a favorite, the inevitable Bouguereau, the Swiss Calame, Diaz, Gérôme, Koekkoek, Meyer von Bremen. In Baltimore William T. Walters was famous not only for his bric-a-brac but also for the huge Delaroche *Hemicycle,* a sort of panorama of portraits of all the famous painters and architects of the European past, which, according to Mr. Shinn, "seems . . . to transport whole Vaticans and Louvres to these shores." He also was proud to own Gérôme's equally famous *Duel after the Masquerade.* He, too, of course, had Achenbach, Bonheur, Bréton, Cabanel, Corot, Couture, Daubigny, Decamps, Delaroche, Detaille, Diaz, Fortuny, Frère, Fromentin, Gérôme, Hamon, Isabey, Jacque, Knaus, Meissonier, Merle, Millet, Muller, Pasini, Alfred Stevens, Tissot, Troyon, Vibert, Villegas, Willems, and always, always, Zamaçois and Ziem.

There were the collections of Vanderbilt and August Belmont and Caroline Wolfe, the latter left to the Met, wrenched from its setting in a house that "would be called *hôtel* in Paris or *palazzo* in Florence" and whose interior "flows over with choice curios . . . harvested from all the World's Fairs of Europe," such as the "bronze figures . . . bearing lamps" in the "similitude of patient Nubian slaves . . . both almost nude" in the "unprotected dignity of their elegant forms" (Cabanel, Merle, Knaus, Bréton, Meissonier, Willems, Worms, Ziem).

The collection of Marshall O. Roberts, a founding board member of the Met, is startling and peculiar for its inclusion of English paintings. It was of course old-fashioned, dating from "long before the creation of a majority of our American galleries." Hence those uncouth Britons, "so unexpected in an American gallery, the Yankees having declared an art-divorce from the old country." Marshall O. Roberts also represented the older generation of collectors of American art — nine Huntingtons, six Leutzes, including *Washington Crossing the Delaware,* Church, Cole, Kensett, Eastman Johnson, even a leftover Sully. Boughton, an Anglo-American painter (*Pilgrims Going to Church,* also in Detroit),

was much admired and collected. Roberts had no less than six. Robert L. Stuart, another founder of the Met, had three. But in general, England and America were overwhelmed by the Continent, especially the Parisian continental. Whether way out there at the end of the railroad in San Francisco, up north in Canada (the Drummond collection in Montreal), or in Boston and Providence (and Taunton and Watertown) , or in the Midwest where St. Louis and Louisville and Cincinnati receive most of Mr. Shinn's attention, it was at best Corot, Doré, Daubigny, Millet, Rousseau; and otherwise Bouguereau, Cabanel, Couture, Detaille, Gérôme, Zamaçois, Ziem.

The galleries and the conservatories and the palazzi are gone; where are the pictures? Mostly in the basements of museums. It seems in retrospect, in mid-twentieth century at least, to have been one of the more massive aberrations of taste. But who can tell? Until very recently the collectors of Cole and Kensett and Bingham have also seemed to be betting on losers. Examples of nineteenth-century "gems" are beginning to creep out of their basements. The Met, as of the seventies, once again hangs things from the Wolfe bequest, a Max, an Alfred Stevens (*After the Ball* or *The Confidence* is one of those pictures reproduced in *Art Treasures*). Now we seem to be in for a reappreciation for this kind of painting parallel to the revival of the Hudson River School. After half a century of utter scorn and disdain, it begins to seem that Mr. Shinn's collectors weren't the dolts we once assumed they were. Whether a Salon renaissance takes place or not, the lesson remains obvious: a whole generation of collectors can be deluded into thinking that its taste represents an absolute and incontrovertible standard of what is best, most worthy and most important.

Americans of the period invested millions and millions in the Salon industry. Native manufactures could not compete. John Durand's "eclipse" was almost total. Yet, ironically, this period between 1870 and 1900 produced some of the very best painting done by Americans, either by stubborn originals like Eakins, Ryder and Homer or by brilliant expatriates like Whistler, Cassatt and Sargent. Most of the collectors embalmed in *Art Treasures* ignored all six of these artists. Fairman Rogers had his one Eakins; three Homers are nestled in *Art Treasures,* two in a Smith and one in a Clarke collection, both of New York. Whistler is mentioned enthusiastically by Shinn, but he indicates that all the Whistlers in America at the time were owned by Whistler's relations in Baltimore, people who did not have collections but merely a picture or two. The other three, Cassatt, Sargent, and Ryder, are not even in the index.

Mr. Shinn's collectors, ignoring Impressionists and Nativists and Expatriates, gloated over their Gérômes; and it was naturally assumed that all these beautiful collections of Modern Art would eventually go

to the local museum . . . if any. They did. The collectors of them are generally the founders and patrons of the new art museums.

Unfortunately, just about the time these collections were becoming ripe and falling like plums into the laps of the various aspiring young museums of the country, a most sinister plot, ignored by most American collectors and museum officials, was hatching right in Paris itself. The Impressionists through the seventies and eighties were at work totally transforming the art of painting, and in the process totally liquidating the great Parisian Salon Industry. Boom turned into bust. By 1900 it had already become flagrantly obvious to everyone of discernment (except perhaps the rulers of the Met) that the Industry was doomed and that the millions of dollars spent on Isabey and Ary Sheffer and the two Leloirs had been thrown away. Canal stocks and Confederate bonds could not have been more worthless than these innumerable collections of Modern Art. By now it's almost impossible to find one of them intact.* Come the Revolution, most of the reputations of these Salon artists and the schools they represented were guillotined. M. Goupil had, it seemed, sold the American public a bill of goods. The American museums were stuck with thousands of refugees from this Terror.

* The Charles and Emma Frye Museum in Seattle still maintains, like a fly in amber, a complete and authentic collection of this kind. It consists largely of German Salonists like von Kaulbach and Knaus, but a few Boudins and even a Manet got in by mistake. Don't miss it.

Chapter II

i

ONE THING, then, that the group of men who founded the Metropolitan had in common was their interest in Modern Art. This certainly gave the critical impetus to the boom in museums. The effect was that of the advent of spring; suddenly everywhere the earlier reluctance thawed, museums began to pop up like crocuses, and nowhere did the change of climate occur with more startling rapidity than in New York.

The chronology of the founding of the Met* is spectacular in its speed. The Civil War ended in 1865. In 1866, at a jubilant Fourth of July celebration in the Paris of that Copperhead Napoleon III, so soon to lose his throne, John Jay, grandson of America's first Chief Justice, John Jay (whom Trumbull once served as secretary), made a speech. In it he intimated that it was high time America, like most European

* Special thanks for all information on the history of the Metropolitan must go to Calvin Tomkins and the researcher to whom he is most indebted, Winifred Howe. Similarly for the Boston Museum of Fine Arts everyone must be permanently indebted to Walter M. Whitehill. (See book list in Appendix for details, titles, etc.)

countries, had a National Gallery. His words inspired a committee of those present to look into the matter and make recommendations. Their recommendations were forwarded back to the Union League Club in New York, of which Jay was about to be elected President.

October 1869: The Art Committee of the Union League Club finally decided to sponsor a public meeting to expose the ideas first presented by Jay to the city at large. In November this meeting was held; William Cullen Bryant, poet and publisher, grand old man of New York culture, presided. A new Committee of Fifty was formed. Out of this Committee a board was carved, largely from members of the Committee.

January 31, 1870: The board was elected. April 13: The museum was incorporated by the state legislature. May 24: A constitution was adopted. A campaign to raise two hundred and fifty thousand dollars was started. By March 1871, one hundred and six thousand dollars was squeezed from one hundred and six donors, of whom only J. T. Johnston, William Blodgett, and A. T. Stewart gave over five thousand dollars. The Museum's first collection, a group of Dutch and Flemish paintings, was bought in Europe by Blodgett.

1872: A home was found in a former dancing academy on Fifth Avenue and in February the Metropolitan Museum of Art opened its doors to the public. The Dutch collection formed the core of the holdings. The other works of art were mostly loans.

In other words, it was hardly more than five years from the first suggestion in 1866, when the Museum was just a vague idea without pictures, boards, officers, building, anything, before it was a reality, complete in all respects, like an embryo. How different from the centuries-long background of the Louvre or the British Museum. The creation of the Met was surely one of the swiftest in history, breathtaking and a little mysterious.

Who were the organizing geniuses at work? No one person can be held responsible. No Napoleon sent out armies to ransack the world for masterpieces. No previous, well-established institutions backed the effort. No royal collections made the Met their home. No one great millionaire gave the board security and help. It was a group effort, and the effort started from scratch.

The nature and composition of this group of Founders can best be estimated by examining the role of that Committee of Fifty organized at the first public meeting of 1869. Not all the board members came from it, but most of them did. The Committee was obviously designed to be a cross-section of the city's leadership, representing politics, arts, education, the church, and business. Considering the intentions and the effect of this Committee, it is a rather odd list. For one thing, to modern eyes it presents very few immediately recognizable names. Nei-

ther John Jay nor William Cullen Bryant was on it, having already fulfilled their function as public speakers and presiders. Some of the few artists and architects listed — Frederick Church, John La Farge, and the two planners of Central Park, Frederick Olmsted and Calvert Vaux — would be familiar to anyone who knows anything about American art and architecture. The architect Richard Morris Hunt would be another. James Lenox of the Lenox Library and Henry G. Marquand, whose surname is all over Princeton, might be familiar to some. A. T. Stewart, department store magnate, James B. Colgate, whose father's name is attached to the college, might ring a bell; but it is doubtful if the names Andrews, Barlow, Blodgett, Brown, Butler, Cannon, Detmold, Dodge, Field, Gifford, Gordon, Green, Griswold, Hoe, Johnston, Kennedy, Olyphant, Prime, Rood, Roberts, Stuart or Vinton would immediately conjure up any very definite associations outside of family circles or devotees of the diary of George Templeton Strong, where most of these names appear. With the exception of Rutherford Stuyvesant, there are no famous Knickerbocker appellations on the roster, no De Peyster or Van Rensselaer or Livingston. None of "Our Crowd," even in the diluted form of August Belmont, who wrote Johnston an insulting note of refusal when first asked to join the board. No writers except George W. Curtis, a few other artists and architects less well known than those already mentioned, but not many. Except for A. T. Stewart, none of the Great Moguls of the age, no Astor,* no Vanderbilt. William Aspinwall, relic of a previous generation of millionaires, represents the world of Philip Hone and Edith Wharton's *False Dawn*. Edith Wharton's kinsman, representing her Old New York, Frederic Rhinelander, came on the board almost immediately in 1870 and stayed to become President before his death in 1904. Theodore Roosevelt, Sr., father of Teddy, was also an early trustee from 1870; but neither of these men was of the original Fifty or on the very first board. At first glance, to modern eyes, the Committee of Fifty seems like a collection of second-string worthies, chosen as substitutes for bigger fish who got away.

In fact it was anything but a heterogeneous or second-string group. It was an extremely homogeneous and rather special group. Most of the names on the list may not be instantly familiar a century later, but most of them are embalmed in the *Dictionary of American Biography*. There they emerge in a sort of composite picture as a collection of businessmen or professionals, some self-made, some of one or two generations of wealth, of respectable but seldom prestigious family background, much of this family background from New England originally, who, having made their fortunes before the Civil War, had turned to

* W. W. Astor was elected trustee in 1876.

reform on the one hand and collecting on the other. Two causes — the Union and New York civic reform — concerned most of them. Only a few were active politicians, but nearly all of them were reformers. Two kinds of collecting — books and pictures — interested most of them. Some had really distinguished libraries; these were later founder-members of the Grolier Club. The art lovers are those, beloved by Mr. Shinn, who had galleries of Modern Art.*

The real bond that brought these men together and caused them to respond to the call for a museum was their membership in two clubs: the Union League and the Century Association. At least four-fifths of them were Centurians and about two-thirds were members of the Union League, most of these being also members of the Century.

This is no place for a full-scale disquisition on clubs in America or in New York, but the influence of club life on the founding of the Metropolitan Museum of Art can hardly be ignored. The first suggestion was made by John Jay, President of the Union League Club. The Art Committee of that club made the first formulations of policy. All but four of the founding trustees were members of one or both clubs. This can hardly be coincidental. As we can say that in Boston the museum blossomed in the sanctuary of the library, so in New York we can say it leapt from the bosom of the club. Two clubs.

Most clubs are purely social clubs, that is, admission is on the basis of status: social, hereditary and financial. In most American cities such social clubs were first founded in the period between 1830 and 1860 (the Philadelphia, 1834; Somerset of Boston, 1851; Pacific Union of San Francisco, 1852). In New York the oldest and best was and is the Union (1836), not to be confused with the Union League. The kind of names missing from the Committee of Fifty — Livingston, Van Rensselaer, Astor, Vanderbilt — are not missing from the roster of the Union Club. The Century Association (not club) dates from that same period (1847); but it is not a social club in the same way as the Union. That is, social prominence is not a criterion for membership. The Century was a direct outgrowth of the National Academy of Design and the confraternity of rebellious young anti-Trumbull artists gathered about Morse. They began with various sketch clubs and drawing associations. One of these, the Drawing Association, a working group, evolved into the National Academy as a result of dictatorial pressure from Trumbull. Another, the Old Sketch Club, a more purely social enterprise,

* For instance, of the Committee of Fifty, A. T. Stewart, Marshall O. Roberts, Robert L. Stuart and Gov. E. D. Morgan (as well as J. P.) are given pride of place by Mr. Shinn. The collections of the Robert Hoes, Sr. and Jr., Aspinwall, Marquand, and a few others are at least mentioned. Only the Modern Art in Marquand's collection is described. Blodgett's collection is cited as having been dispersed since his death in 1875. Poor ruined J. T. Johnston doesn't make it at all.

enlarged itself to supposedly one hundred members and therefore became the Century. It was intended to be a group of artists who liked people and people who liked artists. It was never a purely professional or esoterically esthetic company. A large proportion of the members from the beginning had been men like Luman Reed, who would certainly have been a founding member if he'd lived. His son-in-law, Jonathan Sturges, was a founding member. These were successful men of action who yet had real sympathy for and understanding of the arts. Of the arts, painting loomed largest and it was important members of the Hudson River School such as Kensett and Durand who most conspicuously represented artistic professionalism in the membership. Merit and intellect counted at the Century. As Lord Palmerston said of the Order of the Garter, membership in the Union was usually divorced from any mere damn merit.

The Union League (1863), on the other hand, was political and reformist. Most of the older clubs like the Somerset, the Union, and the Philadelphia were hotbeds of Copperheadism during the Civil War. They all had a number of well-liked Southerners in their membership; and no doubt influenced by England, there was much Northern upper-class sympathy for the Confederacy. The canard that members of the Somerset drew down the shades when Shaw's Negro regiment passed by may not be true,* but the story is representative. Union Leagues were founded everywhere to counteract this tendency, founded obviously by ardent antislavery Republicans. For years afterwards diehard Democratic members of the Philadelphia Club refused to walk on the west side of Broad Street where the Union League still stands. Copperhead members of the Somerset liked to refer to their local Union (League) Club as the Sambo Club.

Some of the Committee of Fifty, such as Rutherford Stuyvesant and A. T. Stewart, were indeed members of the Union (not Union League) Club. Many of them, especially William J. Hoppin, a founder of the Century, were active members of the New-York Historical Society, as were so many members of the Union Club. At the time of the original organization of the Museum, Hoppin wistfully pleaded in a letter for "coöperation" between the Historical Society and the Committee. Nobody seems to have paid the slightest attention. The two organizations proceeded throughout as though they existed in two different cities. Perhaps from a social point of view they did; at least it seems obvious that the Committee and the Society chose to ignore each other. As a result, the Met never got any of the Society's collection and the Society's collection never got its grandiose museum. Too bad.

* For this and all information about Boston clubs, see Alexander W. Williams's admirable *A Social History of the Greater Boston Clubs* (Boston: Barre, 1970).

There was, however, a mysterious bond between the two organizations. In 1865, under the chairmanship of Frederic de Peyster, the Society formed a building committee. In 1866 a magnificent structure, looking much like the Louvre, was designed by Richard Morris Hunt for the site on Fifth Avenue where the Met now stands. A special subcommittee for fund raising was appointed. A. T. Stewart, John Johnston, William Aspinwall, all key members of the Committee of Fifty, all founders of the Met, were members also of this money-raising group. What happened? We know that they were completely unsuccessful and that the Louvre in Central Park was never built. But why the total lack of "coöperation" thereafter? Somebody obviously fought with somebody, but the animosity has been completely concealed behind the draperies of Victorian reticence. Mr. De Peyster was *not* a founder of the Met.

ii

The speech William Cullen Bryant made at that first public meeting in 1869 covers all the arguments for the foundation of a museum; covers them not only thoroughly but with literary flowers. First he raised the emotions of the audience by proclaiming the position and riches of America as a world power, something then quite novel. He dubbed New York the "third great city of the civilized world," which was also a novelty as of 1869. He then tickled the reformist inclinations of nearly everyone present by castigating the uses to which the riches of America were being put; that is, being put into the pockets of New York's Boss Tweed. Since this group pretty well represented those who were out to get Tweed, and did, this must have gone over well.

Bryant then proceeded to summarize what everybody had been saying for years: (1) If every European country, even a "third rate" (*sic*) power like Spain could have museums, surely the richest country in the world could afford at least one. (2) "We require an extensive public gallery to contain the greater works" of our artists. (3) "When the owner of a private gallery of art desires to leave his treasures, where they can be seen by the public," where can he deposit them? (4) "Our artists swarm in Italy" because there are no models for them at home. But what about the art students too poor to go abroad? Finally (5), the population explosion of the city breeds *vice*. The museum must "encounter the temptations . . . by alternative entertainment of an innocent and improving character" (national prestige, encouragement of native artists, refuge for collections, education, uplift).

What was not covered by Bryant was covered by the next speaker, Professor George Comfort of Princeton. He spoke of practical museum

matters like loan exhibitions, departments of decorative arts, lecture series for the public, work with schoolchildren, enriching the lives of the poor, and in fact just about every activity that a museum of art does in fact undertake at the present day.

In these two speeches the whole program of the American museum for the next century was outlined in general and in particular. It was decided from the beginning that the museum was to be universal, not special; not a "gallery" in the English sense, but a "museum." It was to emphasize decorative and industrial arts, like the Victoria and Albert in London, and think of itself as an educational institution rather than merely as a depository of the beautiful.

The only trouble was, of course, that the Metropolitan Museum of Art had no art, didn't know where it was to get any or with what monies, and then had no place to put it. Such minor obstacles were to be overcome in the next couple of years largely through the efforts of two men, John Taylor Johnston and William J. Blodgett.

The possessors of these two not overwhelmingly distinguished names were about as representative of the Founders as could be possible. They were both millionaires, Blodgett self-made, Johnston on the basis of his Scottish father's modest fortune. Johnston made his money in railroads; Blodgett, beginning with varnish, went on to real estate. They were both members of the Century, and Blodgett also of the Union League. They both collected art — not just Modern Art, but also American art (Johnston owned Homer's first famous oil painting, *Prisoners at the Front*) and even what would nowadays be considered "serious art." They were also alike in another more unfortunate way: both their collections were dispersed in the seventies, Johnston's by sale because of his losses in the depression of that decade, Blodgett's after his premature death, with the sad result that their pictures did not go to the Met.

Johnston was an obvious choice for the Presidency. He was not only rich, a successful organizer, honest, influential, involved in good works, and a clubman, but also a true friend and patron of art and artists on the order of Luman Reed. At the time of his election he was traveling up the Nile with his family, but he hurried home. His friend Blodgett meanwhile was forced to resign from business for reasons of health and was recuperating by travel in Europe. He observed the rich pickings available because of the disturbances of the Franco-Prussian War and notified Johnston that the time was ripe for acquiring pictures for the Met. He and Johnston together put up the money to purchase two such collections, borrowing to cover the whole cost, and placed the matter before the trustees: would they accept the collection? If not, Blodgett and Johnston would split it up between them for their own galleries. After considerable hesitation and some irritation at the high-handed

rashness of the venture, the board accepted the Blodgett pictures, thereby more or less liquidating the Museum's scanty funds. But at least the Museum now had a collection of its own to show to the public.

Thus when the opportunity came to rent temporary headquarters in the former Dodsworth Dancing Academy at 681 Fifth Avenue between Fifty-third and Fifty-fourth Streets, the Museum had the Blodgett collection to put into it. The collection consisted of one hundred seventy-four pieces, most of them seventeenth-century Dutch and Flemish. The popular hit was Frans Hals's portrait of the slattern *Malle Bobbe*. The Italian pictures, Guardi and Tiepolo, extended the range and are still exhibited; in fact more than a dozen of the Blodgett pictures are now hanging in the recently reinstalled European collection. Loans and a few random gifts helped round out this first showing; but some of the loans were not altogether desirable. Johnston, writing enthusiastically to Blodgett about the opening, commented, apropos of a colossal statue, *Dancing Girl* by one Schwanthaler, "It may be very fine, but eight feet of dance is a trial to the feelings. Hereafter we must curb the exuberance of donors except in the article of money, of which latter they may give as much as they please."

The new Museum, after its opening in February 1872, was a great success. Even artists had to admit that they liked it, though George Templeton Strong, New York's testy nineteenth-century diarist, had his usual caustic opinions. He had greatly admired and envied Johnston's collection in his private gallery down near Washington Square. "How superb it is, how rich he must be, and how much wiser of him to spend his money this way than on race horses, four-in-hands and great ostentatious parties!" The Met's collection received few of these rapturous accolades when Strong visited it in September 1872. He found the collection "larger, and (alleged) Old Masters . . . more numerous" than he'd expected. "There seems to be nearly an acre of high art. In very few of these pictures did my unskilled eye detect anything to admire; High, Old Low Dutchmen preponderate largely." However, Turner's famous *Slave Ship*, on loan from the Johnston collection, moved him to compare it to a Beethoven symphony; all was not lost.

The one thing the Met had trouble getting was money. Millionaires were wary, and it was board members like Johnston and Blodgett who had to keep bailing out the boat. But in one way the board was superlatively successful. It managed to persuade the city not only to give their museum a site, but to build a building on it for five hundred thousand dollars. Despite, or perhaps because of, the fact that most of the Committee of Fifty were Boss Tweed's deadliest enemies, when a representative of the Met (George Comfort) went to see Tweed, one look at the list of names on the submitted request and in no time all

the funds for the Museum's building were made officially available. Perhaps Tweed hoped to placate his reformist enemies; perhaps he hoped for the kind of rich graft attendant on other expensive public buildings. In both cases he was disappointed. Tweed was tried, convicted in 1873, and died in jail in 1878. The new building was erected without corruption, ground being broken in 1874. Not only did the city provide site and building but also other funds for operations. The failure to raise money for a building is what had stopped the Historical Society. The Met avoided the problem. In the arrangement with the city, it was made clear that though the building might belong to the city, the collection belonged to the Met and was to be controlled exclusively by its board. It was a splendid and successful example of municipal and private "coöperation"; ironic that it took place under the most corrupt government New York has ever known.

iii

Johnston and Blodgett emerge as the principal figures of the very earliest days of the Metropolitan. Johnston as President brought the Museum through from a gleam in the eye of clubmen to its new building in the park, and beyond, giving it generous infusions of his own money along the way. Even the loss of his fortune and collection failed to dampen his activity and enthusiasm. His friend Blodgett was equally important, since it was due to his initiative that the Museum had a collection at all, and a pretty good one at that. Traces of the personalities of the two men remain in a series of letters between Johnston and Blodgett — humorous, ebullient, intelligent. They create a most pleasant impression, so refreshingly lacking in pomposity and smugness and self-righteousness and all the other deadlier Victorian virtues. Blodgett, however, died in 1875; and though Johnston continued as President for many years until his health forced him to resign in 1889, two other figures emerge as dominant in the nineteenth-century affairs of the Museum, Cesnola and Marquand.

No more flamboyant figure has ever clattered across the stage of American art than General Emanuele Pietro Paolo Maria Luigi Palma, Conte di Cesnola (1832–1904). He was, as his name clearly indicates, an Italian, a soldier, and a nobleman. If his military rank was not really General but Colonel, and his title of nobility not really Conte but Cavaliere, that is merely one indication of the problems of any biographer facing this spectacle of mixed achievement and fraud. He may not have been a Count, being a younger son of his father the Count, but he was undoubtedly noble, and his family, though poor, could proudly trace itself back into the thirteenth century as castle-

owning fiefs of the house of Savoy. Cesnola's father had fought for Napoleon, his uncle was a celebrated exile-martyr of the struggle against Austria, his mother was from a wealthy noble family. Luigi, this being the name he preferred, was almost inevitably brought up as a soldier.

He may not have been a general, but he was a colonel, a rank earned by hard and dangerous action in the Union Army. As a youth he fought in Italy against the Austrians and in Crimea against the Russians. Sometime before 1860 he came to America and nearly starved. At one point he seems to have actually attempted suicide. In the course of trying to support himself by giving lessons in languages and the flute, he met and married a modestly well-to-do orphaned American girl, Mary Reid. When the Civil War broke out, he saw his opportunity and before long was actively campaigning as a commander of cavalry in Virginia. In Italy his military career had been marred by some forgotten escapade. In America he was always in trouble with his superiors. At one point he was dishonorably discharged on suspicions of purloining Government property, some pistols; but he was reinstated. Then he was severely wounded and captured. He endured months of dreadful captivity in the notorious Libby Prison in Richmond until he was exchanged. Whatever his rank, he was a very real soldier indeed; he was even awarded a Congressional Medal of Honor.

He always swore that Lincoln, shortly before he was assassinated, gave him his verbal assurance that he would be brevetted brigadier general. We have only Cesnola's word for it. In any case he called himself General ever afterward. His military career at an end and his political pull diminished in the postwar Republican regime by his noisy support of McClellan rather than Lincoln in 1864, he found himself without prospects. He managed, however, through the influence of powerful friends, of whom he always seemed to have many, to get himself appointed American Consul to Cyprus on condition that he finally become an American citizen. He'd fought all the way through the war as an Italian.

Cyprus was scarcely a diplomatic plum, but it made Cesnola's fortune. Arriving there in 1865 and having very little to do, despite taking on the vacant consulships of Russia and Greece, he became interested in archaeology and shortly began to devote his enormous energy and enthusiasm to unearthing every ancient object on the island. Pretty soon he had a vast collection of bits and pieces, some of them of considerable size, interest, and value. After the failure of attempts to peddle Cyprus wine in America, Cesnola thought he might remedy his precarious financial situation by selling his archaeological finds. His first offer was made to Hamilton Fish, President of the New-York Historical Society. Fish never answered his letter. He then turned to Eu-

rope, sending some of his items to the Parisian dealers Rollin and Feuardent. Eventually both the Berlin Museum and the Hermitage Museum in St. Petersburg began to show interest.

In 1870 *Putnam's Magazine* published a series of articles on the art galleries of New York. Among those was the famous collection of John Taylor Johnston so much admired by Strong. The article mentioned Johnston's participation in the founding of the new museum. Cesnola saw the article and wrote Johnston and told him of his "most valuable and richest private collection of antiquities existing in the world." Would the "New York Art Museum" be interested? There was no immediate response, since in fact the new Museum had no money to buy anything, especially in view of the purchase of the Blodgett collection. In 1872, however, *Harper's Monthly* printed a great spread about Cesnola's finds written by Hiram Hitchcock, one-time proprietor of the lavish Fifth Avenue Hotel and always one of Cesnola's friends and supporters. Hitchcock had also just previously given one of the Met's first public lectures on the same subject. This time the Museum was interested; Johnston had already alerted the board of the existence and value of the collection.

Meanwhile Cesnola had smuggled his antiquities out of Cyprus and the hands of its acquisitive Turkish rulers. The Turks had specifically forbidden the American Consul to remove any of his finds. Cesnola got around this prohibition by shipping the stuff out under his authority as Russian Consul. The collection went to London, where emissaries from the British Museum eyed it. But nobody would meet Cesnola's offer to sell it as a whole. Berlin and St. Petersburg turned it down; the British Museum and the Louvre wanted only parts of it. Junius Morgan, father of J.P., London partner of George Peabody (who was the former partner of Elisha Riggs, father of George Washington Riggs, partner of Corcoran), and traveling William Blodgett looked the collection over, and in late 1872 the Museum bought it as a whole, which was what Cesnola had been hoping. After the Blodgett collection, that was the most important accession to the Met's holdings.

The Museum not only got the antiquities, it got Cesnola. In order to display the Cypriote finds at all, the Museum had to move from Dodsworth's Dancing Academy to larger quarters in the Douglas mansion on West Fourteenth Street. Cesnola came over to unpack and install his treasures himself. Gradually over the years, as discoverer of and authority on what had become the Museum's greatest attraction, he consolidated his position until eventually, as Secretary and Director, he dominated the affairs of the Metropolitan.

When his collection had been installed, Cesnola returned to Cyprus to dig up another one, and it was during this second period of excavation that the most scandalous of his frauds was consummated. It was

one thing to call yourself a General when you were only a Colonel; it was another thing to pretend you had discovered a treasure when you hadn't.

In 1873 the great German archaeologist Heinrich Schliemann, excavating on the site of Troy, found a hoard of ancient gold artifacts. It was a world sensation and made Schliemann not only the most respected but the most popular of diggers. Shortly after this, Cesnola in Cyprus produced another such hoard, a mass of gold and silver objects. He gave a most circumstantial and detailed account of his discovery, complete with maps and diagrams and dimensions of the vaults at Curium where the treasure was supposed to have lain. This find was, despite the hopes of Cesnola, neither as rich nor as notorious as the one found at Troy; but Cesnola did get a lot of publicity and the Met, after some hesitation, did buy it from him. If the Curium hoard didn't make him the world figure he hoped, like Schliemann, it certainly made him a figure in New York. He had become an essential element in the operations and image of the Museum. He soon became an official. In 1877 he succeeded William Hoppin (who had so vainly pleaded for cooperation with the Historical Society) as Secretary, and finally in 1879 he became, at a low salary, Director as well, the Museum's first. He held both these positions for almost a quarter of a century until his death in 1904.

It was certainly the éclat of the discovery of the Treasure of Curium that established once and for all Cesnola's reputation with the Metropolitan's trustees. Unfortunately the find seems to have been a falsehood; that is, the objects themselves were genuine, and genuinely from Cyprus, but Cesnola evidently could not have found them together in a buried temple vault as he claimed. He must have assembled them here and there, some as his own discoveries, some as mere purchases.

The story of the Curium Treasure Caper spans several decades. Cesnola made his "discovery" in 1873. He described it in his book on Cyprus published in 1877. The description was so convincing that everyone assumed he must be telling the truth. In 1883 a German painter and photographer named Max Ohnefalsch-Richter, who had earlier come to Cyprus as a newspaper correspondent and, like Cesnola, become infatuated with archaeology, tried to follow Cesnola's footsteps from dig to dig and was shocked to find all sorts of discrepancies. The biggest discrepancy was at Curium, where he could find no trace at all of the temple vault at the place where Cesnola said he had unearthed it. Ohnefalsch-Richter's reports were published and the aroma of deception began to taint Cesnola's reputation in archaeological circles. Finally Richter came to America in 1893 and blasted Cesnola in the newspapers. Nobody confuted him, but by then Cesnola was too strongly entrenched at the Met to be affected. The Treasure was quietly dismantled.

Meanwhile Cesnola had proved invaluable as Director of the Museum. Not only did he himself install his collection on Fourteenth Street, he also, with the help of some hired hands and a brace of hardworking trustees, packed it up, unpacked it, and reinstalled it in the new building when the Museum finally moved up there in 1880.

Both in the Douglas mansion and in the queer new Vaux building, the Cesnola collection took up what seems now a space disproportionate to its esthetic and archaeological worth. Pages of the Annual Reports were filled with the enthusiasms of the board for Cesnola and all his works. The Blodgett collection definitely took second place.

Fortunately for the sanity of the trustees and the security of Cesnola, it was a good decade before these doubts as to the authenticity of the Curium Treasure began to circulate. But almost as soon as the jubilant fanfare attending the move to the new building subsided — speeches, the attendance of President Hayes himself, an almost full display for the first time of the whole vast Cesnola Cypriote collection — doubts began to be raised about the authenticity of that collection. The principal attack came from a French art dealer, resident in New York, with the rather odd name of Feuardent ("ardent fire"), perhaps a French translation of the German Feuerbrenner. The ardent Gaston, who had already had some rather touchy dealings with Cesnola as a member of the firm of Rollin and Feuardent, which had first handled the Cypriote antiquities, accused Cesnola of constructing whole statues out of unrelated parts, putting the wrong heads on the wrong bodies, notably a hermaphroditic Venus with breasts and a beard, adding modern items to make statues more interesting, notably a small hand mirror added to a statuette of a girl, and generally faking his objects up to please the public. The newspapers joined in the fray, shouting pro and con. Clarence Cook, an important art critic, blasted Cesnola as a fabricator, and it was a scandal.

Cesnola rampaged in Latin fury, calling Feuardent all sorts of things — the mildest being "French Jew art dealer" — many of which got into print. The trustees restrained Cesnola from suing but backed their Director and his collection with firm, if rather blind, faith. The obvious thing to have done would have been to get impartial experts to look at the disputed objects and pass judgment, which is what Feuardent had sensibly suggested. The trustees did everything but. First they got a group of well-known men, none of whom knew a thing about archaeology, to testify to Cesnola's good reputation and sterling character. They said *they* couldn't see anything wrong with the statues. When this whitewash failed to satisfy Feuardent and Cook, the trustees thought up a most peculiar form of trial by public scrutiny. Two of the disputed statues were stuck up in the Great Hall of the Museum and the public was invited to examine the statues for itself. The public

proceeded thereupon to chip, probe, pour acid, and otherwise permanently disfigure the statues, and generally could find no fault with what was left of them.

This second whitewash-by-public proved more effective than whitewash-by-committee, but Feuardent was not satisfied. Finally, since Cesnola wouldn't sue him, he sued Cesnola for libel. The trial began as a sensation, but was delayed for so long and went on for so long and went so endlessly into details of art restoration that the public grew bored. In the end Feuardent lost his suit. Whitewash-by-trial succeeded and nobody thereafter accused Cesnola to his face of fraud until Ohnefalsch-Richter in the 1890s. The fact remains, however, that what Feuardent suggested, examination by impartial experts, would have been the practical and honorable thing to do and would in fact have exonerated Cesnola, for in this case he was not guilty of any fraud. Except for a bit of early, amateurish cosmetic work, afterwards removed, the more important of his statues from Cyprus are still on exhibit and thoroughly genuine.

The ruckus about the Curium Treasure came too late to do Cesnola any real harm. The Treasure was quietly put away or broken up into individual exhibits. After Cesnola's death his collection was whittled down and intermingled with the Museum's increasingly rich displays of Mediterranean antiquities. But to this day the main body of Cesnola's findings, the large statues such as the "bearded Venus," have a conspicuous place of honor in the Met. The large hall that leads toward the restaurant court is completely occupied by half a hundred of the most impressive of the Cypriote objects — statues, sarcophagi, architectural details. They make a rich and curious display. Upstairs a comparatively few objects, pottery and jewelry, are dispersed among the thousands of such objects (so many of them given by Henry Marquand) that the Museum now exhibits. No "Treasure of Curium" however. Of Cesnola's original collection of over thirty-five thousand objects, the Met acquired over sixteen thousand. Of these, probably no more than a hundred all told are still visible.

So in the end if Cesnola was not a general, he was in fact a valiant soldier. If he was not a count, he certainly exhibited all the worst qualities of noble blood, imperious, autocratic, hot-tempered, touchy as he was. And if he did not, like Schliemann, unearth a marvelous gold hoard, he did save for posterity a valuable selection of most interesting archaeological specimens. If he hadn't rescued them, they would undoubtedly have been destroyed or dispersed by the rapacity of the natives and the Turks or been spoiled by the neglect of the English. It was in a minor way the same problem as the Elgin Marbles; if Elgin hadn't "stolen" them, what would have happened to them? In the twentieth century, after Cesnola and his critics were all dead, the Mu-

seum hired a reputable scientist, Sir John Myres, who had helped Ohnefalsch-Richter compile a catalog of the neglected collection of the Museum in Cyprus, to make a scholarly catalog of the Cesnola collection. This appeared in 1914. Though frankly admitting that the case of the Curium Treasure remains an unsolved "mystery," Myres gives the General (well, Colonel) due credit for his saving and bringing together the largest and one of the richest groups of Cypriote artifacts in the world. He makes clear that though Cesnola lacked any real conception of archaeological science, so did everyone else at his time. Schliemann himself was guilty of dreadfully destructive things at Troy.

Cesnola's position as an archaeologist remains to this day controversial, with much to be said on both sides. French writers on the subject, perhaps inspired by their compatriot Feuardent, are usually full of vitriolic scorn for such a "pseudo-général d'operette." The English, on the other hand, look on him with tempered benevolence. About one thing there can be no doubt: his lifelong devotion to the interests and welfare of the Metropolitan Museum of Art.

iv

Henry Gurdon Marquand (1819–1902) was a very different sort of person. No General, Count, or archaeological swashbuckler he. He was entirely in the tradition of Johnston and Blodgett, an intelligent man of business with esthetic sensibilities. Like Johnston and Blodgett, he sported a rather dreary set of sidewhiskers. Like them he made his money in real estate and railroads after graduating from an inherited family silversmithing business. Like them he was a member of the Century. Like them he had his mansion and his collection. His mansion was designed by Richard Morris Hunt, and it was fraught with bibelots and pictures. One was first ushered into an immense three-story interior court with a skylight roof, grandiose double staircase, fountain ("Boy Struggling with Goose"), grandiose fireplace. As a contemporary rhapsodist put it, "One stands in astonishment at the daring of the architect who has sacrificed so much space to magnificence." Off this court gave the Greek Drawing Room with its Alma-Tadema piano and his famous *Reading from Homer*. There was a Saracenic Room (tiles) and an incredible Japanese Room, all carved to order by Japanese from quebracho, an especially tough Brazilian wood. Into the fantastic orientalism of the ceiling were worked English mottoes like "Noiseless falls the foot of time." Bedrooms had adjacent maid's rooms. The conservatory . . .

Marquand differed from Johnston and Blodgett in being more durable but more recessive. Whereas these two predecessors give an

impression of ebullient and extroverted energy, Marquand seems by comparison sensitive, withdrawn, perhaps rather sternly melancholy. He differs from them most in having built up, really for the first time in America, a collection of absolutely first-rate Old Masters. The seemingly innumerable Murillos and Titians and Raphaels of the pre–Civil War period have vanished; but Henry Marquand's Vermeer and Vandyke and other such are the real things, treasures of the Met, glories of world art, still among the most famous paintings in the Museum and in America.

It is hard to discover just how this special flair for finding and acquiring the best came to him. His connection with the Museum is like that of any other trustee: membership in the Committee of Fifty, and though not on the very first board, a trustee as of 1871. He succeeded Frederick Rhinelander as Treasurer in 1883 and Johnston as President in 1889 when Johnston had to retire because of ill health to Honorary President for Life.

In the same year of 1889 Marquand presented his collection of over thirty paintings to the Museum, and for the first time the Metropolitan could really begin to be compared to at least a good provincial European museum. With the exception of a few isolated items, the bulk of the Museum's holdings, as well as its really good things, were included in those three basic groups: the Blodgett-Johnston purchase of 1871, the Cesnola collection, and the Marquand gift of Old Masters. Otherwise there were individual objects such as the Roman sarcophagus from Tarsus, given in 1870 by the Turkish Consul, J. Abdo Debbas, the Met's very first gift, or the statue labeled *California*, a chaste nude holding a divining rod by Hiram Powers, donated by a Vanderbilt. There were two Piero di Cosimo hunting scenes, given by Committee of Fifty member Robert Gordon as early as 1875 and the two Manets given by farsighted Erwin Davis in 1889, the first such in any museum collection. There was an enormous amount of decorative art — ceramics, laces, gems, armor, ironwork, woodwork. Jarves, for instance, gave not his unwelcome gold-background pictures but a fine collection of glass in 1881 in memory of his father, manufacturer of Sandwich glass. Jarves's glass was, of course, not Sandwich, but Venetian.

There was a good deal of American art. When the Hudson River School artist John F. Kensett, one of the few well-known artists actively involved as a founder of the Metropolitan (Art Committee of the Union League, founding trustee), died in 1872, much of the contents of his studio was presented to the Met by an heir. There were pictures by Cole and Church; but not by latecomers like Homer and Ryder, Whistler and Cassatt. There was one Eakins, presented by the artist in 1881. There was one Sargent, his fine sad portrait of Henry Marquand. As for Modern Art, the place was deluged with it. Europeans from the

English Alma-Tadema to the Spanish Zamaçois proliferated. Nobody could have then accused the Museum of not encouraging contemporaries.

Then, as now, encouraging contemporaries had its risks. There was the scandal of the Biondi *Saturnalia,* a huge and overrealistic clump of statuary by an Italian protégé of Cesnola depicting "a night of orgies" in ancient Rome. Just like the Rosinquist *F-111* under Hoving, this *Saturnalia* caused an uproar under Cesnola. It was removed. Biondi sued; the case was settled out of court. Cesnola suffered.

And there were other troubles. A newcomer on the board as of 1889 was Robert de Forest, railroad lawyer and son-in-law of John T. Johnston. Along with a group of other younger trustees, he resented Cesnola's autocratic dealings with the public and employees and especially his refusal to listen to anybody on the board except his supporter, President Marquand. An example of Cesnola's high hand was his refusal to let a workman visit the Museum in work overalls. "Sensitive and Refined Plumber Affronted," read the headlines. Cesnola retorted that the Museum was a school of manners as well as of esthetics. "There is no more spitting on the gallery floors," he said, and he won his point that certain standards of decorum must be maintained. (How would he react to the present dress of the young?)

In 1895, just after the Ohnefalsch-Richter fracas, these Young Turks, led by de Forest, made a strong effort to unseat Cesnola; but against the opposition of Marquand, who said he'd resign if Cesnola went, and a declaration of faith in a letter from J. P. Morgan, already becoming a power in Museum Affairs, the move was defeated. Cesnola stayed on, by now unassailable despite all the attacks on him. He and Marquand, the most diverse couple it is possible to imagine, seemed to be fast friends and partners.

Gradually around the core of Blodgett, Cesnola, and Marquand the Metropolitan began to accumulate not only collections but even money. A spectacular accession of both was the Catharine Lorillard Wolfe bequest of 1887. Miss Wolfe, the only woman to subscribe to the Met's first money-raising drive, and who lived in her hôtel (or palazzo) with Nubian slaves for lamps, left her entire collection to the Metropolitan, plus two hundred thousand dollars to care for the collection and add to it. Her pictures were of course Modern Art, all flattered unctuously by Mr. Shinn in *Art Treasures*. The money, however, went to acquire more perdurable goods, such as Renoir's *Mme. Charpentier,* bought in 1907 over the protests of many of the board, the first important Impressionist painting (except for the Davis Manets) in what is by now the Met's superlative collection of them.

In the Douglas mansion as of 1875 the collection had been dominated by room after room of Cesnola. Otherwise there was a room of

Blodgett Old Masters and two rooms of loans, one of Old Masters, one of Modern Art. By 1903 things really hadn't changed all that much. Except for the addition of the Marquand masterpieces and a few other isolated items, a big accretion of Egyptian things and some other antiquities, masses of decorative art and masses of casts of architecture and statuary, the collection still remained essentially the same: Blodgett, Cesnola and now Marquand. This state of affairs lasted until the new order began with the death of Cesnola in 1904 and the accession of J. P. Morgan as President in the same year. Marquand died in 1902 and there was a two-year interregnum during which former Treasurer Frederick Rhinelander carried on, as President, the tradition of droopy side-whiskers and cooperation with Cesnola. But as the catalogs and descriptions of the museum of that time make only too clear, the Metropolitan was no Louvre.

As of 1903 the classic collection had acquired much that was new but had suffered greatly by the domination of Cesnola, who saw to it that his own collection kept pride of place and who added to it largely second-rate pieces bought from Italian friends. A Marquand Room enshrined his masterpieces, fifty of them by now, and as a result held most of the really valuable and beautiful paintings the Museum then possessed. There was a special gallery of American "historical" art — Stuart, Peale, Cole, Durand. Otherwise the paintings consisted of Modern Art, which in this case also included a few good eighteenth-century masters, Italian, French, and English.

By far the largest number of paintings were those gems of nineteenth-century creativity beloved by Mr. Shinn. Most of the individual paintings of this sort belonging to the Met as of 1903 had already been pointed out by Shinn in 1880 when they were in private hands. The Caroline Wolfe collection is an example. It was housed separately at the Metropolitan in two galleries under the conditions of the bequest, those baleful conditions that are the curse of museums, that burdened the Historical Society in the case of the Bryan collection, and that still shackle the Met in the case of the Altman and Lehman collections. Besides the Wolfe there was also the Vanderbilt Collection, deposited at the Met on what turned out to be permanent loan. Then there were the Met's own pictures. In these three areas Modern Art was only too well represented. Here were Bonheur and Couture, Decamps and Diaz, Gérôme, Knaus, Meissonier, Ziem, and Zamaçois. Also, to be fair, Delacroix and Turner in with Bouguereau, Cabanel, Koekkoek, and Meyer von Bremen. The French eighteenth-century paintings by Pater, Boucher, and Oudry must have felt very uncomfortable in such bourgeois surroundings. To the staircase, along with the Kensetts, were relegated the nine Fagnanis, *The Muses,* each an American debutante of the 1870s. The one Courbet is tucked away nearby. The 1903 catalog is rich

in biographical detail. The note on Manet is revealing. After the vital statistics the note reads, "An eccentric realist of disputed merit, founder of the school of 'Impressionistes.' "

By then, whatever the quality, the Metropolitan was important for quantity. Two wings had been added in 1888 and 1894 to Vaux's first peculiarly unfinished-looking central section, all brick and glass skylights and awkward decorative adjuncts. The building became almost immediately overcrowded, too small to handle all the laces and casts and porcelain and students and Sunday crowds. The hope that the Museum would be a great force in education and industrial art and convert the machine age to "good taste" was encouraged by a vigorous school program, which occupied much of the time and energy of the trustees. It was for this purpose that the huge collection of casts had been assembled. They took up lots of room.

The advent of the new century and the new order at the Metropolitan was marked by a series of dramatic events. In 1901 a solitary and somewhat eccentric millionaire named Jacob S. Rogers, who seemed to have no real interest in art or the Museum except for an annual membership, died and left his fortune to the Metropolitan. When litigation with his disgruntled kinfolk had been concluded, the Museum got a fund of nearly five million dollars, the income to be used for purchases. This was the first really sizable endowment, except for the Wolfe Fund, that the Museum had ever had, and it made an enormous difference in the level of acquisition from then on. Most of the Museum's really choice antiquities, for instance, were bought by Rogers Fund money. For the first time the Met could bargain as an equal on the world art market. In 1901 Morgan returned to the Executive Committee after an absence of several years and his increasing influence began to be dominant as his life became increasingly dominated by his collecting. In 1902, the year Marquand died, the new order was symbolically declared by the erection of the Richard Morris Hunt Neoclassic wing-facade on Fifth Avenue.

It was this new period, beginning with Morgan, that brought the Metropolitan to maturity as one of the world's great museums. As Richard Morris Hunt might have said that he found the Met an institution of brick and left it one of marble, so Morgan could have said that he found it a provincial catchall and left it a treasure house. This first era, from 1870 to 1900 (or 1904), was concerned largely with sheer survival, the struggles of birth and childhood. In 1870 America was almost, if not quite, a country without an art museum. By 1900 there were dozens of museums but few of them could be called excellent. In 1900 the Metropolitan was not excellent, but thirty years of constant growth had laid a firm foundation for later excellence.

Chapter III

i

THE BOSTON MUSEUM OF FINE ARTS is a twin of New York's Metropolitan Museum of Art, but most certainly not an identical twin. It can consider itself first-born on the basis of date of incorporation. The BMFA dates from February 4, the Met from April 13, 1870. However the Met actually began to exhibit, as such, in its rented dancing academy as of 1872. In Boston, the Museum remained cooped up in the nursery of the Athenaeum until July 3, 1876, and had no real separate existence of its own until it moved into the new building on Copley Square. On the other hand, the Met didn't move into *its* new building until 1880. So primacy here is pretty much a matter of choice or bias.

The basic differences from the beginning, a bit like the differences between those pioneers Peale and Trumbull, were those of class. Boston, like an English older son, came into the world with all sorts of inherited advantages. The Met came into the world naked. Even the backgrounds of the first significant creators of the two museums reflected this difference. John T. Johnston, William Blodgett, and Luigi de Cesnola were all emphatically self-made men. Despite respectable

backgrounds, they were the authors of their own fortunes. A similar triumvirate in Boston — Martin Brimmer, first President; Charles Callahan Perkins, original instigator; and Charles Greely Loring, first Director — were all emphatically men of family, descendants, not ancestors.

The Met emerged without any help from any sister institutions, unless you count the Union League and the Century. The cradle of the Museum of Fine Arts was so surrounded by fairy godmothers that it almost suffocated. It was conceived and delivered inside the Athenaeum;* Harvard and the Massachusetts Institute of Technology hovered about; and the original board was so top-heavy with ex-officio institutional members that it is a wonder the museum was able to assert any independence at all.

The BMFA was favored; but the Met was lucky. The BMFA inherited a collection, prestige, the backing of Boston's Best and its best institutions, everything but public assistance and cash. The Met inherited nothing, but beginning with the gift of its land and new building and the support of same by the corrupt Tweed Ring and on through such later surprises as unknown Mr. Rogers's bequest of five million dollars, the Met has gambled and won. From the very beginning there has been a fine Wall Street flamboyance about Manhattan's Museum — boom and bust, glitter and scandal. Always a touch of that museum man manqué, that inheritor of Peale, P. T. Barnum. Blodgett's taking quick advantage of the collapse of Napoleon III to snag the Met's first pictures, John T. Johnston's bankruptcy and loss of his beloved *Slave Ship,* the riotous splendor of the Marquand house, Cesnola's antics — all this has a certain circus quality.

Boston from the beginning was scholarly, intense, serious, but poor. Neither surprises nor disasters were characteristic. The BMFA never seems to have had enough money, ever. A long thread of complaint weaves through the relationship and rivalry of the two sister institutions, the Met always jealous of Boston's reputation, Boston always jealous of the Met's money. As of 1920, for instance, the BMFA moaned, "The means do not yet exist with which to keep adequately in motion this great engine of culture." Expenses were two hundred thousand dollars, income only one hundred and sixty thousand dollars. Whereas the Met was spending six hundred thousand dollars and got half of that from the city.

* As the Century dominated the first committees and boards of the Met, so did the Athenaeum those of the BMFA. Of the first trustees, all but three were Athenaeum shareholders; Brimmer and Perkins were important in Athenaeum affairs. Everybody except William Rogers, founder of MIT and a foreigner from Philadelphia, was a Harvard graduate.

ii

Nothing like Cesnola and his career of publicity happened to Boston. There is a curious and coincidental comparison between the first two Directors of these first two Museums. Both men, Cesnola and Loring, were of comparatively good backgrounds, "minor nobility" one might say, of Italy and Boston respectively. Both were amateur archaeologists, Cyprus and Egypt. Both were generals, fictitious or genuine. But, whereas Cesnola swashbuckled over two continents and tarnished his genuine attainments with devious publicity stunts and false claims, Charles Loring, genuine in every respect, leaves such a faint spoor in history, even that of his own museum, that it's difficult to observe any trace of it.

Charles Greely Loring (1828–1902) was a sickly boy — he had "delicate lungs" — who was therefore excused from following family footsteps in the business world of Boston and was permitted a trip up the Nile. There he became infatuated with ancient Egypt and planned to devote his life to its archaeology. When the Civil War came along, however, despite his invalidism, he participated actively as a member of General Burnside's staff and was eventually and legitimately brevetted Major General. In 1876, on the strength of his knowledge of Egypt, renewed after the war, he was called to the Boston Museum of Fine Arts to install its antiquities and act as first curator, then Director. He stayed on the job about as long as Cesnola did at the Met, retiring and dying in 1902. As opposed to his more notorious contemporary, there seems to be little to say about General Loring except that he had a small beard, that he was devoted to his work, that the board and the staff were devoted to him, and that he did much to encourage and develop the museum's Egyptian collection. Happy the museum director who has no history! Loring is generally given credit for the early establishment and growth of the museum. His work may not have been exciting, but it was well and truly done.

The other two men of the Boston triumvirate are less anonymous. Their characters and personalities, particularly compared to those of Blodgett and Johnston, reflect many of the differences between the two museums. The true progenitor of the BMFA was Charles Callahan Perkins (1823–1886), that same C. C. who along with his brother Edward was instrumental in preventing the Athenaeum from buying the Jarves Collection. This unfortunate blot on the Perkins esthetic escutcheon is not really characteristic. It was not because Charles was ignorant of Italian art that he prevented his native city from acquiring what would have been the jewel of its museum's art collection. Though

Jarves may have been a native, too, he was far from being a proper Bostonian. To "proper Boston," especially in the wake of that sale of that dubious Titian to a New Englander, Jarves appeared very much as a parvenu adventurer.

There was certainly nothing parvenu about Charles Perkins. To understand his position in Boston and especially his relation to the Athenaeum and its art ambitions, one has to go back to his great-uncle Colonel Thomas Handasyd Perkins. Colonel Perkins, as he was always referred to in his later days, was the model of the kind of second-growth aristocrat who took over Boston after the collapse of the pre-Revolutionary oligarchy of Colonial church and state. Perkins was the dominant figure in that group of families, many of Salem or Beverly origin like the Cabots and the Lees, who rose like a bunch of hard-bitten Aphrodites from the sea, made their fortunes in the China trade, then settled down to take over the commercial, social, and institutional fortunes of Boston. No one was more domineering, richer, better connected, tougher, or more arrogant and cautiously generous than Colonel Perkins. To this day he remains a sort of father figure of Proper Boston, the ideal ancestor, prototype of the seagoing family founder. His eldest daughter married a Cabot. His somewhat less conspicuous brother, at one time his partner, was the James Perkins who gave his house on Pearl Street to the Athenaeum in 1822 shortly before his death. There the Athenaeum built its gallery, the first such in Boston. When the Athenaeum decided to build this gallery, it was Colonel Perkins and his nephew James, Jr., also of Pearl Street, who each put up eight thousand dollars towards its completion. One of the best pictures still belonging to the Athenaeum is a grand portrait of the Colonel by Thomas Sully. It was originally ordered of Gilbert Stuart; but Stuart was so dilatory that he never managed to get around to finishing it before he died, so Sully was called in. When the Athenaeum's gallery was finally opened for its first exhibit in 1827, the best picture of the seven it owned was Stuart's eventually finished, and posthumous, portrait of brother James Perkins, Sr.

Charles Callahan Perkins was the grandson of this James, born and brought up on Pearl Street near his grandfather's former house. By this time the Perkins family could afford to expand. Instead of going into the China Trade, Charles was permitted to go into art. He originally meant to be either a composer of music or a painter, or perhaps both, and to that end, after graduating from Harvard in 1843, he spent about ten years studying in Paris and Rome. Evidently convinced by this experiment that he was not cut out for creation, he returned briefly to the United States and then went back to Italy for another ten years to make his reputation as a writer on art. Two books in particular,

Tuscan Sculptors (1864) and *Italian Sculptors* (1868), made him a big man in the small world of art scholarship. One might imagine that with such a background his books would be pleasantly chatty little affairs, full of the dilettantish picturesque. Not at all. They are immensely detailed descriptions of every single piece of post-Roman sculptured stone visible in Italy at that time. The books are full of footnotes, historical backgrounds, and learned references to literature and documents. There are C.C.'s detailed sketches of most of the important monuments; well-written books, too, in a style that for all the denseness of reference still makes good, solid — and opinionated — reading.

So when it came to Italian art, C. C. was no dilettante. However, despite his European success, he was infused with the same sort of missionary zeal as the despised Jarves.* He, too, wanted to come back to his benighted country and encourage the growth of "germs." He did. He came back in 1869 just at the right moment. It was becoming obvious to the trustees of the Athenaeum, even in their handsome new Cabot-designed building,† that they had to choose between books and art. It was chiefly due to the influence, exertions, and expertise of Perkins that the new museum became a reality. As a testimony to this influence, he was made Honorary Director for life and, until his death in 1886 in a carriage accident, Perkins was the dominant figure not only in the affairs of the Museum but in the whole active art world of Boston.

iii

Martin Brimmer seems much more like Henry Marquand in character than like Johnston or Blodgett. However, like Johnston, he was the first President of his Museum from 1870 to 1896. In *The Proper Bostonians* (1947) Cleveland Amory remarks, "Hutchinsons and Gores, Royalls and Vassalls, Dudleys and Pinchons, Brimmers and Bromfields, once names to conjure with . . . have all fallen by the wayside." Martin

* As evidence of the persistence of artistic feuds, it is amusing to notice how cavalierly Steegmuller treats Perkins in his biography of Jarves and how cavalierly Van Wyck Brooks treats Jarves in writing of C. C. Perkins in his *New England Indian Summer.* Brooks declares Perkins to be an infinitely better writer than Jarves. Steegmuller emphasizes the underhanded meanness of the Perkins brothers in their dealings with Jarves. So it still goes.

† The new Athenaeum building was a Perkins family affair, too. The architect was young Edward Clarke Cabot, grandson of Colonel Thomas. He had never designed a building before, but his sketch, and just perhaps his ancestry, so impressed the Athenaeum trustees that they gave him the commission. He went on to become a successful Boston architect.

Brimmer was obviously then the last not the first, the finale not the founder, of his family. The fourth Brimmer to bear the name Martin, son of a Boston mayor in days when mayors were gentlemen, childless, frail, club-footed, he represents the ultimate blooming of a pre-Perkins Bostonian society, the world of Colonial grandees painted by Copley, not the comparatively parvenu world of the China traders. He was fortunate, in a literary way at least, in having as a nephew-in-law that off-beat genius John Jay Chapman, who has left vivid memorials of Brimmer as a calm, kind, stern, sad, opulent "hidalgo."

John Jay Chapman (1862–1933), a New Yorker and a grandson of that very same John Jay who first proposed a museum for New York in the Paris celebration of July Fourth in 1866, went to Harvard and there became heavily involved with the Brimmers. The Brimmers had adopted two orphaned nieces, children of a brother of Mrs. Brimmer and an Italian wife. The Brimmers brought them up in Boston as daughters. John Chapman was entertained by the family and became close to the eldest of the nieces, Minna, in a mutual study of Dante. They pursued this avocation in, of all places, the Athenaeum; and there in an upper room of this chaste temple of wisdom, Dante flourished and passion smouldered. Smouldered, but was never expressed by either party. Perhaps the setting inhibited them. Chapman was obviously a rather peculiar young man. He gathered that his Minna was desperately in love with someone but he couldn't make out who it was. It never seems to have occurred to him that it was he himself. He was frantic with jealousy and at a house party decided that a perfectly innocent male friend of Minna's was the guilty party. He thereupon beat his fellow guest within an inch of his life, then rushed back to his room and in remorse stuck his bare hand into a fire of coals. The hand was so badly burned it had to be amputated.

"I hope we have seen the last of that unfortunate young man," murmured Martin Brimmer. But no. Brimmer took his niece Minna off to Egypt to get her away from Chapman. There they collaborated on a book later published as *Egypt;* but it did no good. Minna cropped her hair as an expression of grief and eventually the Brimmers had to give in. Minna and John were married. It would be nice to say they lived happily ever after, but in fact a sort of fatality seemed to pursue the family. Minna died after the birth of a third son, their second son was drowned, and the first son was killed as an aviator in the First World War. Chapman went on to another wife, a career as a writer of radical articles for high-toned magazines, and a long membership in the Century, all based in New York. Back in Boston the Brimmers died out.

Chapman's memories of Boston and the Brimmers are among his best writings. There are few more evocative pieces of prose than his nostal-

gic recreations of the Brimmer household* and of Martin himself, the "best of old Boston," who perhaps because he came from an older dispensation could be dignified without being "sanctimonious."

Mr. Brimmer was "the figure-head of philanthropy, art and social life in Boston." As for the large and anti-intellectual Mrs. Brimmer, she liked "luxe." She "dressed visibly." One of her friends commented, "I've just seen Marianne Brimmer going down the street looking like an escaped sofa." Luxe also consisted of stately dinner parties — places for twenty at a table heavy with roses, silver, and "a colony of cut-glass wineglasses at each plate." After dinner, guests enjoyed "a short session in the crimson parlor where Story's marble statue *Medea* was enthroned," then the drawing room where the intellect and birth of Boston forgathered.

Somewhat like Henry Marquand from his palace on Madison Avenue, Brimmer moved from Beacon Street to preside over Boston's Museum a few blocks away. As the Marquand house was stupefying in its "luxe," but also comparatively gaudy, so too the collection of the Met, drawn so largely from those hôtels and palazzos where Modern Art and the conservatory flourished, was far more brilliant than that of the BMFA but had lots less bottom. But it was not the paintings that gave Boston its earlier reputation but its archaeology, Classical and Egyptian, and its Oriental collections. It was here that the influence of Loring and Perkins, both interested in statuary, was decisive.

Actually it was a collection of armor that really started the museum off. In 1869 a Colonel Timothy Bigelow Lawrence left a collection of arms and armor to the Athenaeum. There was obviously no place for it there. His widow offered to give twenty-five thousand dollars to house it in new quarters. This then was the scruple about which the new Museum was actually formed. Harvard had a lot of prints it didn't know what to do with, MIT had architectural casts, and the Lowell family had some Egyptian statues. The usual public meetings and fundraising drives were held after incorporation under the direction of Brimmer, Perkins, and the first Treasurer, Henry Kidder of Kidder and Peabody.

The first actual exhibition held in the name of the Museum was an odd one. It was held not in the Athenaeum's gallery but in a jeweler's shop and it consisted of nothing less than a collection of Cypriote antiquities belonging to Cesnola! The BMFA bought the collection in 1872 and for a while, just like the Met, most of its total possessions were Cesnola finds. As of 1872, out of five hundred thirty-nine items given or loaned to the fledgling institution, three hundred forty-nine had once

* John Jay Chapman, "Mister Brimmer" in *Memories and Milestones* (New York, 1915), and quotations in Mark DeWolfe Howe's *John Jay Chapman* (Boston, 1937).

belonged to Cesnola. But that was the end of Boston's dealings with the General. It never got anything else from him. A few cases in a back room of the Classical collection are still full of little Cypriote items bearing that familiar designation, "Cesnola Collection."

The exhibition that really counts as first was a later one in the same year of 1872 held in two rooms of the Athenaeum picture gallery. For the next few years the Athenaeum acted as Museum. Meanwhile the city gave the Museum land on what was to be Copley Square, but nothing else. The trustees had to raise every cent of money themselves, just over two hundred sixty thousand dollars, from some thousand private donors. A piece of building was built. Like Vaux's first building for the Met, it was an extravaganza of brick and fancywork. It ended up a very model of Ruskin Gothic, full of gables and pointy windows and terra-cotta plaques. The building was opened to the public in 1876, and in a remarkably short time (1879) the facade was completed and the Museum's collection began to outgrow its housing. The building itself was not universally admired. One wag intimated that if architecture was frozen music, the Museum was frozen "Yankee Doodle."

Despite its favored background as inheritor of the Athenaeum and darling of Harvard and MIT, the early collection of the BMFA was no better than that of the orphaned Met. It had the Athenaeum's paintings, a few of which were excellent but most of which weren't, a few other donated paintings, some Egyptian statues originally acquired by John Lowell, founder of the Lowell Institute, the prints from Harvard "on deposit," some examples of decorative arts and casts, casts, casts. These casts, and indeed art in general, did pose a problem. Art might be uplifting, but the best art, that of Greece and the Renaissance, was full of nudes, many of them displaying uncovered male genitals. The Museum board searched its soul before the first opening. Finally it was voted to procure and apply fig leaves wherever appropriate and Boston's conscience was clear. A later and more acute problem of this sort came up in connection with a Greek carving, a stela depicting a nude athlete in relief profile, very conspicuously endowed. Fortunately the piece was in fragments so that the top could be exhibited without the bottom. It was not until the late twentieth century that the fragments were reunited and could be shown together in mixed company.

The Lawrence armor collection, which started the whole thing, was destroyed in the great fire of 1872, one suspects to the secret relief of the board. The insurance money was used to buy objects of art. A pseudo-Tudor room given by Mrs. Lawrence to contain the armor survived and was put in the new Copley Square Museum, filled with objects of art. But what the Museum had most of was not so much objects of art as trustees. There were not just the Museum's own, which included almost as a matter of course the Presidents of Harvard (Charles Eliot for most

of the Museum's earlier years) and MIT (beginning with founder William Rogers), but also a great swarm of ex-officios. Harvard and MIT, besides contributing Presidents to the regular board, also had three appointees of their own. So did the Athenaeum. The Lowell Institute had one, and then came the Mayor of Boston, the Superintendent of Schools, and a representative of the Public Library. This system persisted right down to a very few years ago, when the number of trustees from Harvard, MIT, and the Athenaeum was reduced from three to one apiece. The emphasis on education is obvious, as opposed to the more political and architectural ballast of ex-officios on the board of the Met.

Very shortly, beginning in the mid-eighties and going on into the twentieth century, Boston became the beneficiary of some very original Bostonians indeed. With the growth of its Oriental collection along with that of its more archaeological Classic and Egyptian departments, the BMFA soon began to acquire the reputation for expert excellence it maintains to this day.

The original impetus behind the Museum and such founders as C. C. Perkins was fundamentally Puritan — uplift rather than a mere pandering to the delight of the senses; a broadened Puritanism that added, as a latecomer, even the suspect visual arts to the arsenal of moral persuasion (with the aid of a few fig leaves). The more important books and learning having been taken care of, beginning with Harvard in 1636 and climaxing in the Public Library of 1852, it was time for music (C. C. Perkins's Handel and Haydn Society in 1815) and science (MIT, 1861). Art was to be the final jewel in the crown of Boston's cultivation.

But the motives of some of those who were to supply some of the principal jewels to the crown were extremely suspect. Uplift of a Puritan sort was not quite what they had in mind. The men who established the glory of the Museum's Classical and Oriental collections — Fenollosa, Bigelow, Warren — were far more ambiguous than C. C. Perkins. Their attitudes were less affirmations of Boston's spiritual primacy than they were criticisms of the whole Protestant Ethic.

iv

Edward Sylvester Morse (1838–1925), Ernest Francisco Fenollosa (1853–1908), and Dr. William Sturgis Bigelow (1850–1926) were the three men who, like Perry, opened up Japan to the methods of Western science, art, and archaeology, and incidentally to the BMFA. Between them they made the Museum's Japanese collection the best in the Western World. None of them began as artists or experts. Morse was a

biologist, Fenollosa a philosopher, Bigelow a bacteriologist. The three of them organized a renaissance of ancient Japanese art within Japan itself and a birth of true appreciation of Japanese art in the West; and they brought back tons of beautiful booty to Boston, a place of which at least two of them took a rather dim view.

Of the three, Morse was the most influential and the least characteristic. He was a scientist pure and simple. Numb to the higher and more subtle reaches of art, religion, and history, he was an insatiable collector of objects and information. He was not a Bostonian. He was a poor boy from Portland, Maine. A favorite older brother had died, and at the funeral the grim officiating divine had said that the deceased would surely go to hell because he hadn't been properly baptized. This had a traumatic effect upon the bereaved parents. The mother swore she would never set foot in a church again. The father became morbidly and overconscientiously Baptist. Young Ned sided with his mother. He loathed religion and turned to science. As among the first Americans to welcome the theories of Darwin and the first to preach that gospel to the Japanese, his bias had an enormous effect on Japanese education. He became, while still a boy, a passionate collector of shells; but he was a very poor student otherwise. As he passed through school after school, usually in disgrace, his father became increasingly angry and thus by contradiction confirmed his ornery son in his career as a scientist. His father tried to prohibit all his shell collecting, so naturally he became a conchologist. He eventually became an assistant to the great Swiss naturalist Louis Agassiz at Harvard. In 1867 he was among the first scientists connected with the Peabody Institute at Salem, newly reorganized after the gift of George Peabody. He helped set up a museum there in the old East India Company building (ethnology, natural history), removing the ancient lumber, such as Red Riding Hood's wolf and Shelley's skylark, and preserving the more authentic souvenirs, such as Pacific islanders' war clubs.

Meanwhile he kept on collecting shells and became especially interested in brachiopods and their Darwinian evolution. Brachiopods, shelled* sea animals somewhat like scallops, are common both as fossils and as present-day living specimens. Morse started studying them as fossils, and also alive along the Atlantic coast, with the idea of compiling their evolutionary history in support of Darwin's theories. A trip to California opened his eyes to the possibilities of the Pacific. He decided to go to Japan in 1877 for a three-month study of brachiopods.

Morse had no original interest in Japan as such and never did develop any true awareness of its esthetics and religions. According to his biographer his artistic tastes stopped at pictures of horses by Rosa Bon-

* They are not, it would seem, real shellfish but crustaceans. Or so I am told.

heur, a good limerick, and music by a brass band. But this is unfair. He was enthralled by good rousing opera and by Frederick Church's panoramas of the Andes. Still, even this hardly prepared him for the nuances of Japanese art. He was an omniverous and uncannily acute observer and collector. As soon as he arrived in Japan, on his way by train from the boat at Yokohama to Tokyo, he saw out of the train window a heap of brachiopod shells. He instantly recognized them as being about five thousand years old and realized the pile must be a prehistoric kitchen midden, the refuse pile of an ancient settlement. Sure enough, on closer examination he was proved right. Japan had never even heard of archaeology, and such acuteness seemed to the Japanese, as it might to anyone, miraculous. One presumes the new Japanese railroad train wasn't going all that fast.

As a result of this spectacular coup, Morse, though still pursuing brachiopods, also got involved in archaeology. Almost immediately he was offered the job of setting up a school of zoology at the brand-new Imperial University of Tokyo, which opened in April 1877. He rather reluctantly agreed to a two-year contract and went home to bring back his wife.

As a scientist Morse is generally considered the father of Japanese zoology and archaeology. The Japanese loved him. Unlike most Westerners, he accepted them just as they were, as human beings, without regarding them as curiosities to be admired or heathens to be converted. His pupils went on to become the first and foremost of Japanese natural scientists. He was able to lecture to his Japanese students in English because before the University was founded a preparatory school had been organized for the special purpose of teaching future university students English. Most of his pupils had been there. His Darwinism, still suspect in Christian countries, was acceptable to the non-Christian and ancestor-conscious Japanese, who saw no particular objection to being descended from monkeys or any other animal. His vivid lectures on the theory of evolution had an enormous vogue and an enormous impact on Japanese scholarly thought.

His connection with the Boston Museum was as fortuitous as his connection with Japanese archaeology. He liked to walk through the streets of Tokyo for exercise but felt he was wasting his time. As a hobby he began to collect pottery. He noticed as he walked that stores sold pretty, cheap little dishes made in the form of shells not unlike brachiopods, so he began to collect them as he collected everything. He proudly showed this collection to his Japanese friends and observed that for all their politeness they were not impressed. He soon gathered that pottery collection was an ancient and honorable and very expert obsession among the educated Japanese. At ceremonious occasions pottery experts kneeled, passing rarities from hand to hand, guessing

origins, dates and names of potters. Morse knew nothing about pottery, knew no Japanese, and had no sensitivity to art objects of any kind; but he was able to memorize all the potters' marks, classify them, and keep all this information in his head — along with brachiopods, archaeology, and a dozen other things. He studied with a great living Japanese pottery expert, and before he left Japan at the end of his two years he had not only set up the Department of Zoology at the University, started hundreds of young Japanese scientists on their careers, made intensive studies of brachiopods, unearthed all sorts of ancient artifacts and founded the science of archaeology in Japan and kept a detailed descriptive diary of his travels in the country, but he also became one of Japan's leading authorities on pottery. He amassed a great collection covering the entire history of the art with all sorts of priceless examples.

However he did miss his morning coffee and New England; and despite urgings to stay, he went back home. He became Director of the Peabody Institute at Salem in 1880 and only returned to Japan once more to collect pots and objects for an ethnological display in Salem. The present collection in Salem owes much of its value to Morse. His great collection of pottery was eventually bought by the Boston Museum and magnificently cataloged by Morse. As for Morse, he continued to chase after every butterfly and wrote innumerable papers on such far-flung subjects as "Mars and Its Mystery," "Ancient and Modern Methods of Arrow Release," "Can City Life Be Made Bearable?" and "Latrines of the East."

Blunt, eager, ornery, eternally boyish up into his mid-eighties, a self-educated Yankee, Morse would seem to be the very last person to deal with the elusive and formal Japanese. Yet for years he was revered there, and his Japanese "grand-students," pupils of his original pupils, continued to visit him while he lived and to visit his grave after he died. Morse was the kind of man who would rush out of the house in the morning without his tie or appear at a morning lecture dressed in the evening clothes of the previous night's lecture. When a great fire devastated Salem in 1914 and threatened his house and laboratory, Morse was found in his study by would-be rescuers calmly trying to master the art of playing the South Seas nose flute. His best remembered book, *Japan Day by Day* in two fat volumes with hundreds of his own illustrations, though it describes in minute detail crafts and customs, makes little or no mention of history or scenery or art. One of the first Westerners to see the great temples of Nikko, he paid little attention to them in his search for nearby shellfish.

v

One of the problems the fledgling Imperial University faced was the inability of "guileless Orientals" to judge the credentials of "inscrutable Occidental" applicants for professorial jobs. Bankrupt sea captains and spurious snake oil salesmen put themselves over as experts on the University officials, who naturally turned to Morse for help. He was able to recommend scientists from his own experience, but when they asked him for a philosopher, he had to turn to his friend Charles Eliot Norton at Harvard for advice. Norton recommended his prize student, Ernest Fenollosa.

Fenollosa came from Salem, where his father was a Spanish-born musician. The elder Fenollosa, a musical prodigy whose full name was Manuel Francisco Ciriaco Fenollosa del Pino del Gil del Alvarez, had come to this country from Málaga at the age of fourteen as part of a ship's band. He settled to make a living in Salem at the special instance of patron George Peabody, who was himself an amateur cellist. Manuel Fenollosa did fairly well as an occasional orchestral player and teacher of music. He did better by marrying Mary Silsbee, the daughter of one of the city's most prominent China Trade families; so that, like so many residents of that town, Ernest was brought up surrounded by Oriental influences. Quite unlike Morse, Ernest Fenollosa was by temperament sensitive to esthetics, not only a philosopher but Class Poet at Harvard in 1874, and a student at the new Boston Museum School of Art.

He arrived in Japan in 1878 and was welcomed by Morse. Fenollosa traveled around with Morse on his pottery and shellfish hunting expeditions and became totally enthralled by Japanese culture. In fact, he deserted Western philosophy to take up Eastern religion and cultural history as his principal life interest.

Japanese art was rapidly becoming fashionable in Europe at just this time. Meanwhile in Japan the young were turning away en masse from their own culture and fine arts, interested only in the novelties of Westernism. A few artists, descendants of long lines of practitioners, who, though masters of ancient skills, were starving to death, and a few noblemen who had managed to hang on to their castles and possessions instead of selling them for cash to survive welcomed Morse as a collector of pottery and Fenollosa as an appreciator of the true fine arts of Japan.

Just as Morse became, in a few years, a world expert in his field of Japanese pottery, so in an incredibly short time Fenollosa became an expert in all fields of Japanese art. He organized a one-man renaissance

of traditional values and skills, founding schools of art history and a union of artists, and almost single-handedly turned the fatally destructive tide of Westernization. He made Japan realize what was being lost and neglected and ended up an official of the Tokyo Fine Arts Academy and as Imperial Commissioner of Fine Arts (1886–1888) — a truly remarkable feat for this Salem-born son of a Spanish-born father in the inordinately chauvinist climate of imperial Japan.

Instead of returning home like Morse, Fenollosa stayed on, became a convert to Buddhism, made his living as a teacher of art history, built a beautiful Japanese-American house where his children by his Salem bride were raised, and made a fabulously valuable collection of Japanese art and artifacts, picked up in most cases for almost nothing from people who had no idea of the worth of what they were selling.

vi

A third man soon joined this twosome of Oriental Yankees. This was Dr. Bigelow. Unlike either Morse or Fenollosa but like Brimmer and Perkins, Bigelow was a born member of the Beacon Hill aristocracy. His grandfather and his father had both been famous men of medicine, the first a well-known botanist and early practitioner at the Massachusetts General Hospital, the second, also at the Hospital, involved in the first use of ether as an anesthetic. The second Dr. Bigelow was also incidentally the man chosen by the Museum trustees to apply fig leaves to the nude casts before the opening in 1876.

It was taken for granted that William Sturgis Bigelow would be the third doctor in this medical dynasty. He was named for his mother's China-trading father, which may have had some subtle influence on him; but he began by following paternal footsteps — Harvard and study abroad under Pasteur and others. He became interested in bacteriology and returned to Boston to set up his own private bacteriological laboratory. His brilliant but dictatorial father ordered him to stop fooling around and practice medicine properly at the Massachusetts General Hospital. Actual medical practice so disgusted the esthetic William that he dropped the whole thing and more or less ran away from home to Japan. He'd already become interested in Japanese art in Paris. He'd heard Morse lecture on Japan after Morse returned to America and had got to know him. When Morse went back to Japan in 1882, Bigelow went with him. There he found a kindred spirit in Fenollosa. Morse, Fenollosa, and Bigelow made a famous trip through the then almost inaccessible hinterland of Japan, amassing an untold wealth of objects — Morse pots, Fenollosa paintings, Bigelow objects of art, especially samurai swords.

The three used to gather each evening at some Japanese inn and, sitting shoeless on the matting, display the loot of the day. They were accompanied by a young Japanese interpreter named Okakura. One night Morse, in the middle of one of these feasts of acquisition, suddenly said, "Many fine things of Japanese art are now on the market, like those we are buying. It is like the life blood of Japan seeping from a hidden wound. They do not know how sad it is to let their beautiful treasures leave their country."

This so impressed the listening Okakura that he resolved to devote his life to preserving Japanese art for the Japanese; and he was so successful that already in 1884 the government promulgated a restrictive law known as *Koko Ho* by which all national treasures were to be registered and kept at home. But meanwhile of course Morse had got his pottery, Fenollosa his paintings, and Bigelow his swords, and they all ended up eventually in Boston.

Bigelow, like Fenollosa, became a complete convert to the Japanese way of life, including Buddhism. He stayed on in Japan after Morse went home for good, absorbing mysticism and esthetics; and though he did eventually return to Boston to live and die as a respectable if sybaritic Boston bachelor of means and social position, he remained Japanese at heart. Though his funeral took place at Trinity Church in Boston, he lay in his closed coffin dressed in the robes of a Buddhist devotee. He was buried from Trinity Church but his ashes went to lie beside those of Fenollosa, overlooking Lake Biwa in Japan. Bigelow is generally assumed to be Santayana's inspiration for the character of Dr. Alden in *The Last Puritan*. Dr. Alden cruised about on his yacht, the *Black Swan*, which was adorned with gilded Buddhas, collecting artifacts for the Boston Museum and seeking Nirvana in drugs and contemplation. Alden, like Santayana and no doubt Bigelow himself, took a rather dim view of Boston and its residual Puritanism.

As for Fenollosa, he too eventually left Japan and came to Boston. He returned in 1890 to become first Curator of Japanese Art, a lot of it his own collection, at the Museum.* There he wrecked his career by indulging in a scandalous affair with a much younger assistant, the beautiful and already twice divorced Mary McNiel of Alabama. He was forced to leave the Museum. He tried returning to Japan in 1896, but he found the climate of esthetic life changed. Now, as a Westerner, he was no longer welcome. The University had no place for him and he was reduced to teaching in a secondary school. So he returned to America for good in 1900 and began a new career as a successful lecturer and

* The second Curator was a Cabot, like the architect of the Athenaeum building. The names Cabot and Lowell weave through the history of art and the BMFA in Boston with admirable consistency. God doesn't come into it much.

advisor to collectors of Oriental art. His most famous advisee was Charles Freer, creator of the Freer Gallery in Washington. Fenollosa died on a trip to London in 1908. His great work, *Epochs of Chinese and Japanese Art,* was the first attempt in English at a knowledgeable survey of the whole range of Far Eastern art; but it was left unfinished in a rough pencil draft. It was completed and published by his second wife, but it was full of errors and opinions that revision would probably have corrected. The second Mrs. Fenollosa, looking about for someone to help edit her husband's posthumous literary remains, picked out the poet Ezra Pound. He worked up Fenollosa's translations and studies into several influential books and Fenollosa's Orientalism became one of the dominant motifs in the poetry of Pound and that of other Imagists like Amy Lowell. The later Yeats also showed the Fenollosa influence, and in fact Imagism in particular and much of modern poetry in general (Eliot, Pound, William Carlos Williams, Marianne Moore) was based on the conception of the Oriental ideograph, the single graphic symbol full of suggestions, introduced into English literature via Fenollosa and Pound.

Amy Lowell's brother Percival, later a famous astronomer, was also one of these converts to the Morse-Fenollosa-Bigelow Japan. He too went there, first in 1883, and wrote about it. Much later he in turn converted Morse to the idea that Mars might be inhabited, hence Morse's writings about "Mars and Its Mystery." The ebullient Isabella Gardner and her shadowy husband also came to Japan to visit Fenollosa and Bigelow. An even more famous pair of trippers were historian Henry Adams and painter John La Farge, Adams seeking surcease after the terrible suicide of his wife, who was Bigelow's cousin, and La Farge looking for artistic inspiration. Fenollosa took them firmly in hand and refused to let them look at any art less than two hundred and fifty years old. La Farge found in Japanese mountain scenery an appropriate background for his mural in New York's Church of the Ascension. The pair then moved on to the South Seas.

Meanwhile the BMFA had been getting together its vast and valuable collection of Oriental art. There was almost no room for all this in the old Copley Square building. When the Museum moved to its new building on the Fenway, opened in 1909, it at last had an opportunity for a proper display of at least a good many of the best of these treasures. Okakura, the young Japanese who had helped stem that "seeping" of Japanese "life blood," served at the BMFA as Curator from 1910 to his premature death in 1913. To this day the Japanese collection there is considered the best in the world outside Japan and the Oriental collection as a whole probably the best in the United States. It all started with brachiopods.

‥
vii

"Original works will generally be beyond our reach . . . but through casts we can acquaint ourselves with the best . . . at a very moderate cost." This, in an 1886 report made by trustee J. Elliott Cabot, succinctly expresses the ambitions and limited hopes of the founders of both the Met and the BMFA in respect to the Antique. The Laocoön, the Elgin Marbles, the Venus de Milo weren't going to be available to Americans. Therefore, as the founding fathers of the American Academy in New York and the Pennsylvania Academy in Philadelphia had already decided, let us buy casts, suitably adorned with fig leaves.

The first doubts were planted, germs of another sort, by Cesnola. Here suddenly was a whole mess of the "original." Thousands of genuinely antique objects, some of them big statues, some of them really quite Greek looking, were made available right here in barbarous America. Boston and New York grabbed. New York got the lion's share and slumbered more or less contentedly for the rest of the century.

New York might be able to rest on its laurels, but Boston couldn't. It still put its hope and faith in casts. Then, just about the time Mr. Cabot made his declaration, a Boston renegade named Edward P. Warren (1860–1928) set out to make a liar of Mr. Cabot. He did it largely to spite the Boston of which Mr. Cabot and his kin were such splendid representatives. C. C. Perkins and many another Bostonian, including Jarves, left Boston for Italy, though they tended to carry Boston with them. Fenollosa and Bigelow fled from Puritanism to the nirvanas of the Far East. Warren sought spiritual refuge in Classic Greece. "I have always said and believed that it was hate of Boston that made me work for Boston. The collection was my plea against that in Boston which contradicted my pagan love." That is to say, Ned Warren was a homosexual. Warren's collection of statues, many of them of naked youths, were quite deliberately designed, as he admitted, to be a "fundamental challenge to American conceptions" and a general rebuttal to the whole idea of the fig leaf.

Warren was the younger son of a very successful paper manufacturer, himself a trustee of the Museum in the 1880s and a donor and lender of paintings. Ned Warren's older brother, Samuel, Jr., carried on the family traditions. He ran the paper company, served as trustee from 1892 till his death in 1910, and was the third President of the Museum from 1901 to 1907. Not so younger brother Ned. He left his background of paper manufacturing, Calvinism, Beacon Hill, and Harvard for Oxford and then a permanent residence in the more sympathetic England of the 1890s, the England of Oscar Wilde before the Fall. There in an

eighteenth-century mansion in the town of Lewes (pronounced "Lewis") in Sussex, Ned created a sort of twilit paradise of neo-Greek seclusion. No modern conveniences marred the atmosphere of "Lewes House." Only candles served for light and quill pens for correspondence. A group of like-minded Oxonians lived there, supported in style by Ned (and the paper company), emerging only on horseback accompanied by their numerous dogs or in canoes. They patronized youth at the local swimming baths, the nearest thing they could find to a classic palestra, where they appeared without bathing suits and taught young men how to swim, taking pictures of them as they did so.

Warren also became an avid and expert collector of antiquities. He was aided in particular by two of his companions, John Marshall and Matthew Prichard. "Lewes House" became filled with treasures. Serious collection began with purchases from the Van Branteghem sale of Greek vases in 1892, and soon the house in Sussex became a center for an international search for Classical rarities. It seemed that originals were still very much available, whatever Mr. Cabot might think.

Meanwhile back in Boston, Edward Robinson (1858–1931) had left the Harvard Law School and immersed himself in antiquity. He came to the Museum in 1885 as Assistant Curator in Classical Archaeology, which meant pretty much casts. In 1887 a Department of Classical Antiquities was established and Robinson was its first Curator. A few Roman busts and Greek vases had been bought, but mostly it was casts, casts.

When Samuel Warren, Jr. became a trustee in 1892 it naturally occurred to him that his brother Ned's collecting might benefit the Museum. It did. Though the Warrens were merely well off and Ned's collecting caused his brother some financial concern, the Warrens provided an annual sum of a thousand English pounds to be spent on buying antiquities. This was to be matched by an equivalent sum provided by the Museum. Robinson was of course a key figure in this alliance. Marshall, inhabitant of "Lewes House," served as the technical expert and principal buying agent for Warren and Robinson, combing Europe for possible purchases.

In just one decade, from 1895, when the first substantial group of antiquities was bought by the Museum, till 1905, when Robinson resigned, this team of the two Warrens, Marshall and Robinson managed to shift the Museum's emphasis from plaster to marble and laid the foundation of what is still one of the two most important Classical collections in America. The other one, that of the Met, was built up by the same team, minus Samuel Warren, when Robinson moved southward after 1905.

The "brouhaha" that broke up the Boston team and sent Robinson

off was caused by a conjunction of several factors. The two most impor-
tant were plans for the new building and a dispute over the importance
and position of casts there. Robinson had risen from Curator to second
Director, succeeding Loring in 1902. Though always vitally interested
in the acquisition of Classical originals, Robinson was also stubbornly
devoted to casts and their educational values. The board decided not to
continue to enlarge the Museum building on Copley Square but to
move to a new site, free of the noise, dirt, and inconveniences of the
central city. In 1899 land was bought out in the then almost rural
reaches of Huntington Avenue, across the Fenway from Isabella
Gardner's dream palace, "Fenway Court," always an artistic rival of the
Museum.

However, the new building was not started until 1907. Copley Square
was closed and deserted in May 1909 and the Huntington Avenue
headquarters was occupied in November. During this period of con-
struction the collection suffered. Money formerly available for acquisi-
tions had to be set aside for the needs of Huntington Avenue. After
1904 the purchase of Classical antiquities stopped. In his report for that
year President Samuel Warren bluntly stated, "The purchases of classi-
cal antiquities, begun in the year 1895, have come to an end." This
naturally did not please those like Robinson, Warren and Marshall,
whose principal interest was Classical antiquities.

It became obvious that the board's plans for the new building did
not include a massive display of casts. Casts took up an enormous
amount of room. There were those who hated them, much preferring
lesser originals to any amount of famous replicas. Principal advocate of
this anticast point of view was Matthew S. Prichard, like Marshall, a
denizen of "Lewes House," one of the most indefatigable in giving
swimming lessons to the local youths. Prichard had come over to serve
as Secretary to the Director at the instance of Ned's brother, Samuel. At
the moment, as of 1902, the classics and "Lewes House" were pretty
much in control of things in Boston, what with Robinson as Director,
Samuel Warren as President, and Prichard as Robinson's secretary and
then Assistant Director in 1903. Unfortunately Prichard and Robinson
took diametrically opposed views, especially as to the value of casts.
Robinson stood for education; Prichard stood for art.

According to Prichard, "The aim of a museum of art is to establish
and maintain in the community a high standard of aesthetic taste." Its
function is "to collect objects important for their aesthetic quality" and
show them so as to delight the beholder. "*Joy, not knowledge*" is the
aim of museum exhibition; a pagan rather than a Puritan view. As for
casts, to hell with them. They were the "pianolas" of the visual arts,
mere base reproductions, having as much business in a museum as a
music box in a concert hall. The one message a cast should give to the

public is that "the original does *not* look like this." Nowhere have the divergent aims of the American museum, education versus art, instruction versus joy, come to a more clear-cut issue.

The results were ironic. Prichard's opinions prevailed. Casts were rejected as furnishings for the new Museum. Robinson quit in anger. He went to New York where, using Marshall and the "Lewes House" crowd as his purchasing agency, he transformed the Metropolitan's Cesnola-cluttered collection into the greatest collection of Classic *originals* in the New World. Prichard also left the Boston Museum before the opening of the new Palace on the Fenway. In this palace, planned by architect Guy Lowell, originals, not casts, were to supply whatever Classical instruction or joy there was to be had there. But the move temporarily crippled Boston's collecting of the antique; and by the time the Museum recovered, New York, under the guidance of those renegades Robinson, Marshall and Ned Warren, had moved ahead.

Ned Warren more and more retired to his sanctuary and improved his outstanding collection of Classical gems, many of them of a scatological nature. The old circle broke up. Prichard had moved out into the world. Marshall actually married. Before Warren died in 1928, he published two books of verse under a pseudonym and a magnum opus in three volumes called *A Defence of Uranian Love* in a very limited private printing. His effort to remove fig leaves from the Bostonian psyche may or may not have been successful; but he and his friends certainly gave the Boston Museum its start as a repository of beautiful antique originals and made of it "a fountain of joy" more pagan, surely, than Puritan.

. . .

viii

The third of the Museum's great collections, the Egyptian, had an earlier genesis than either the Classic or the Oriental collections. It too began with a weary wanderer and exile from Boston, in this case still another Lowell. John Lowell (1799–1836), everybody's cousin but nobody's ancestor, began life as a delicate, introspective, and scrupulous youth. For all his intellectual leanings, he followed the proper family footsteps and began a successful career at the Lowell mills in Lowell, Massachusetts (where Whistler chose "not to be born"). But then in 1830 his beloved wife died and soon thereafter both of his small children. He couldn't face life at the mills and he began to travel.

Eventually his travels took him to Egypt, where in the company of the Swiss-French painter Gabriel Gleyre, master of Monet and Renoir, he went up the Nile, Gleyre painting, Lowell collecting. They got dysentery, they fought, and Gleyre took off on his own with a Nubian

mistress, unwillingly leaving behind some two hundred of his paintings, which Lowell claimed as his due (services rendered for Gleyre's salary and travel expenses). Lowell also made the largest collection of Egyptian antiquities hitherto brought together by one private individual. Camped at Luxor in the ruins of a palace and not feeling very well after his dysentery, he drafted an elaborate will, leaving most of his money to found the Lowell Institute. This was to be an engine of uplift, lectures, scholarships and classes. No lecturer was to be allowed to open his mouth under the auspices of the Lowell Institute unless it was obvious that he "accepted the Bible as a divine revelation." Mr. Lowell did not become a worshipper of Isis as Bigelow did of Buddha. From Egypt he went due east across the desert and then across the Red Sea. En route his ship was wrecked. Though he was not drowned, the experience was too much for him. He made it as far as Bombay and there he died.

Boston was enriched by the Lowell Institute, which continues to this day, but on a nondenominational basis, usually run by a Lowell and represented on the Boston Museum board by a trustee. The family inherited the collection of Egyptian antiquities, some of them massive statues, not the kind of thing one would want around the house. They were more than delighted, no doubt, to send them over to Copley Square when the Museum opened there in 1876.

Another early Egyptian acquisition was something that could be called the Hay-Way collection. It was assembled by an Englishman named Hay in the 1820s and 1830s and bought by a Bostonian named Way in 1871. Way promptly gave it to the infant Museum and it was the installation of this collection on the third floor of the Athenaeum that first brought Loring to the Museum. Since Director Loring was a specialist in the field of Egyptology, he saw to it that the Egyptian collections kept steadily increasing. No particularly glamorous or curious figures or events attended this increase; but beginning in 1885 the Museum subscribed as a partner to an English research group, the Egypt Exploration Fund, and until 1905 shared profitably in the loot. In 1902 a separate Department of Egyptian Art was established with Albert M. Lythgoe (Harvard, 1892) as its first Curator. He had joined George Reisner (Harvard, 1889) in Egypt before he came to the Museum and when he became Curator he and Reisner quietly enlarged and enriched the BMFA. They worked first at the expense of Mrs. Phoebe Hearst, mother of William Randolph. When she could no longer afford it, their Museum excavations were sponsored by Harvard and the Museum jointly. Reisner continued his efforts, oblivious to wars and depressions, until he died, almost literally with his boots on, in Egypt in 1942. He is to the Museum's Egyptian collection what Fenollosa or Warren is to the Oriental or Classic collections. But there

was no nonsense about Reisner — no Buddhist meditation or Uranian loves. A passion for archaeology alone was what seemed to animate him. As for Lythgoe, he turned traitor after the Battle of the Casts in 1905 and left with Robinson for the pastures, greener with currency, of New York as the Metropolitan's first Egyptian Curator. Once again Boston's loss was New York's gain.

ix

On this tripod of Oriental-Classic-Egyptian the reputation of the Boston Museum of Fine Arts rested and still rests. Though because of the departure of Robinson and Lythgoe the archaeological holdings of the Met, long inhibited by the jealousy of Cesnola, rapidly caught up with and passed those of Boston in quantity and value, those of Boston remain to the present certainly second, and in areas of taste and expertise, in many ways first. The only other museum included in the same all-around archaeological category with these first two is that of the University of Pennsylvania in Philadelphia.

Unfortunately the populace judges museums not by their statues and mummies but by their Old Masters. The general idea is that the museum that has the most and most famous Italian Renaissance and Dutch paintings is the best museum, and no amount of Chinese bronzes, Greek vases, or Egyptian tombware is going to make up for the lack of Raphaels and Rembrandts. As of, say, 1903 and as compared to the Met, the BMFA was undoubtedly weak in this particular and most important area. At this time, before the great exodus of curators, Boston was undoubtedly superior to the Met downstairs where the antiquities were. Upstairs, however, where it counted most with average visitors, Boston was inferior. Inferior especially by the tastes of that day. Visitors expected either black Old Masters or snappy Modern Art hot from palazzi. Boston could not compare to the Met in either area. They had no Marquand to give them Vermeers and they had no Vanderbilt to lend them "gems." The collections of Modern Art in the city of Boston, as listed in *Art Treasures,* were small potatoes indeed compared to those of New York or Philadelphia. Only three collections receive Mr. Strahan's accolade: those of Mr. Brimmer, first President of the BMFA; Mr. Kidder, first Treasurer of the BMFA; and a Mr. Wigglesworth.

According to a list of paintings drawn up in careful copperplate handwriting, what the Boston Museum had as of 1903 was:

(1) First and foremost, the Athenaeum collection, not given them but "on deposit" or loan. This consisted originally of about one hundred items, including a few of what are still the Museum's most famous paintings — the celebrated Athenaeum Portraits of George and Martha

Washington by Stuart, for instance — and also a good deal of junk. To this day about a dozen of these Athenaeum paintings are usually kept on display; others are in storage or for occasional exhibit. The rest have gradually been returned to the Athenaeum. A few priceless Old Masters, Italian Primitives and a charming Greuze along with some notable American paintings; a splendid Trumbull, *The Sortie from Gibraltar,* his attempt to mine the ores of British as well as American patriotism; the famous Neagle *Pat Lyon,* the blacksmith painted at his forge instead of in a frock coat, which the Museum refused for years and only allowed on its walls as of the mid-twentieth century.

(2) Other early American paintings, Copleys and Stuarts from Faneuil Hall of Boston of worthies like John Hancock and Sam Adams; Allstons from his studio or donated by his friends. (The Museum's first gift was the big Allston *Elijah Fed by Ravens,* given by the Hooper family, kin of Mrs. Henry Adams. It is still on exhibit.) The early American collection of 1903 was far superior to that of the Met; but in 1903 nobody much cared.

(3) Modern Art: Most of the Great Names were represented: four by Diaz, four by Couture; Dupré, Fromentin, Gérôme. But Boston then and now went in more heavily for Millet than for anyone else. Even then they had eight of them. They also patronized local talent, contemporary Americans, particularly those with Boston connections like Hunt and Page. They even had two Homers and two Whistlers, very advanced for a museum in those days.

(4) A nice English collection: five Lawrences, three Reynoldses, two Turners, including the *Slave Ship,* still one of the high points of the Museum.

(5) Old Masters: Boston could boast a couple of Rubenses and a couple of Rembrandts, a beautiful Roger van der Weyden given as early as 1893, Crivelli, Botticelli, A. Carracci, Tintoretto, Veronese, a Velásquez, and a Goya. (In 1904 the first El Greco to hang permanently in an American museum came to Boston. As the snobbish young Royall Tyler wrote in a 1904 letter, "I went to the Museum to see the El Greco which is well hung and a beautiful picture. For a small collection they have some good things, but a lot of truck too.") This was a respectable showing for an American museum of that time; but it was not up to the small but dazzling array of Marquandery at the Met.

There's no neat way to cut off the history of Boston's "First Period." The death of Loring in 1902? The brouhaha of 1905 when Robinson left? The opening of the new building in 1909? Somewhere in this period the Museum in Boston, responding to the pressures of the new century, outgrew its Ruskin shell on Copley Square, established itself as a Palace of Art on the Fenway, built itself a solid foundation of ancient

art, dethroned the cast, encouraged education in its flourishing Museum Art School — and took second place to the Met. Money talks.

In second place, as a universal survey of archaeology, decorative arts, Oriental and Occidental paintings, the BMFA probably still firmly remains. Its collection of European paintings is overwhelmed nowadays by the richness of both the National Gallery and the Met. But no other American museum covers the *whole* range of the collectable in art with such intelligent depth. The imprint of the founders is still strong; on the one hand the educational and intellectual energy of Perkins, Cabots and Lowells persists, giving to the Museum an atmosphere of cerebral but somewhat formidable culture. Yet everywhere in the corners are reminiscences of a different sort: the non-Puritan residue of jugs from Cyprus dug up by Cesnola; naked youths once beloved of Ned Warren; and that "life blood" of Japan siphoned off by Morse, Fenollosa and Bigelow.

Chapter IV

i

ALL THROUGH THE nineteenth century Philadelphia shared the some-
times dubious honor with New York and Boston of being a center of
American art. Though its museum did not actually begin until 1876–
1877, it then emerged grandiose and full-fledged, temporarily putting
to shame the more tentative beginnings of the Met and the BMFA.
Like New York with its American Academy and its National Academy
and its Historical Society and like Boston with its Athenaeum, Phila-
delphia had its pre–Civil War engine of uplift in the Peale-inspired
Pennsylvania Academy of the Fine Arts (PAFA). New York's Academy
succumbed under the dead hand of Trumbull. Philadelphia's Academy
persisted. New York's Metropolitan got itself started without any for-
mal assistance from art-loving sister institutions. Its relations with the
Historical Society were notably cool. The BMFA, on the other hand,
was directly fathered by the Athenaeum and mothered by every other
institution in town. The relationship between Philadelphia's Museum
and other local institutions was more involved and complicated.

The Met and the BMFA are both "universal survey" museums.

The present Philadelphia Museum is not such a universal survey. It has a chronological limit. Nothing purely archaeological or dating much before A.D. 1000 is supposed to be in it. Though strong on twentieth-century art, it does not try to keep up with the truly contemporary. Though it has some magnificent American art, it tends to skim over the earlier phases of it, and indeed many of the later phases. On the other hand, there is a disproportionate amount of decorative art there. These limitations, which make it difficult to compare the Philadelphia Museum with either the Met or the BMFA, or indeed most American big-city museums, are the result of a long and involved history. As things now stand, the whole range of art in Philadelphia is displayed not in one central museum but is deployed through three separate institutions. The Philadelphia Museum covers the arts from A.D. 1000 on, the University Museum covers art and archaeology before then, and the Academy reserves for itself a more detailed survey of American painting and sculpture, especially eighteenth and early nineteenth centuries.

This division of labor was not the conscious product of early founders and planners but the result of almost accidental factors. It just happened. The process still continues and the relative jurisdiction of the three organizations, to which has been recently added an Institute of Contemporary Art, is still not completely formalized.

This peculiar tripartite state of affairs was due originally to the early presence on the Philadelphia scene of the Pennsylvania Academy of the Fine Arts, which the newer Museum could neither supersede, as the BMFA did the Athenaeum Art Gallery, nor ignore, as the Met ignored the collections of the New-York Historical Society. For the whole period up to the Civil War, the PAFA served Philadelphia as its one preeminent art organization — art museum, art school, art exhibition hall, art salesroom. It combined in one a repository for Old Masters and contemporaries, an outlet for artists and a group of antique casts for students, a permanent collection and a place where connoisseurs could show their possessions on loan and thus advertise their good taste. Though it did not serve any one of its various functions completely, it did serve them all to some extent some of the time.

Like the American Academy in New York, after which it was obviously modeled, the direction of the PAFA was entrusted not to a group of quarrelsome artists but to a company of respectable citizen amateurs. As in the case of the Met, a large committee of such respectables got together and created a board. They met on the day after Christmas in 1805 — an odd time — in Independence Hall and nominated officers and trustees. The trustees, like those of the Academy in New York a few years previously, immediately concentrated on casts from the antique. One group of such casts, the gift of Joseph Allen Smith, a South Carolina

dilettante and traveler, was already in hand. Another group was procured in Paris by the eighteen-year-old Secretary of Legation, Nicholas Biddle. The Directors then caused to be built a charming domed Neoclassic building on Chestnut above Tenth* to hold them.

The building was officially opened in April 1807 as a museum featuring casts and some huge pictures by native Benjamin West lent by native Robert Fulton. The exhibits were popular with the public but aroused consternation in the breasts of Philadelphia's numerous and cantankerous living artists. They had assumed that the Academy was to continue the tradition of Peale's unsuccessful Columbianum of 1794 as an association to promote exhibitions and sales of their own works. In fact, only two artists, Peale and the sculptor Rush, were made members of the Academy and no others were invited. Most of the board were lawyers.

The rejected artists speedily formed themselves into a new Columbianum or Society of Artists (prefiguring the similar formation of the National Academy in reaction to the American Academy). They issued a manifesto. It was obvious that, contrary to expectations, the new Academy was intended "only for a museum; and consequently not likely to become of much importance." The Society of Artists particularly objected to the showing of "antique statues, such being only useful to students," and "considered as extremely indecorous and altogether inconsistent with the purity of republican morals." This indicates what museums were up against from pre–Civil War artists and perhaps from most living artists at any time.

Altogether about a hundred artists joined and under the pressure of the Society of Artists, the first Annual Exhibition was held in May 1811, organized by the Society but held in the Academy's new building. It was a resounding success socially, artistically, and financially. About five hundred works of art were shown, at least half of them by living American artists. The only problem was the indecorous presence of casts. It was not so much males looking at female nudes but vice versa that disturbed "republican morals"; especially the thought of chaste females looking at uncovered male genitals in mixed company. Instead of paying twelve and a half dollars for fig leaves, the cheap way taken by the Academy in New York, a special day was set aside with what was unctuously described as "tender gallantry" for women to go in unescorted and presumably feast their eyes in private on privates. But when the exhibition of 1811 came along, this system was objected to by the Society of Artists. "There never ought to be any public exhibition where both sexes cannot with propriety be admitted together." Obvi-

* This casual Philadelphian reference to addresses means that the building was on Chestnut Street west of Tenth Street.

ously poor business for poor artists to have even one day when the male pocketbook would be denied access to the show. The Academy finally succumbed and withdrew the casts. It wasn't until the twentieth century that America was safe for the exposed male genital. Nude females were acceptable if sufficiently "chaste" in deportment, like Hiram Powers's *Greek Slave*. For men, fig leaves were the only answer. The PAFA eventually succumbed and installed them in 1856. How curious that it was the artists who objected to the impropriety as of 1811, not the respectable trustees.*

From 1811 to modern times, with a few interruptions and parentheses, the PAFA has continued to have Annual Exhibitions. Throughout the pre–Civil War period these followed the tradition of the first one: a mixed bag consisting of the Academy's own collection, loans from the private collections of Philadelphia collectors, and even on occasions from out-of-town collections like those of the Boston Athenaeum and of Joseph Bonaparte of Bordentown, New Jersey. There were also new works for sale by living artists. The Academy's own collection remained a hodgepodge of casts, busts, Wests, Old Masters (some dubious, some genuine), and Modern works bought or presented. The Academy went in heavily for busts — works by William Rush (including a splendid self-portrait) and masterpieces by Houdon. The loans covered the whole field of art as it was then understood, Renaissance and Modern, European and American, the antique in reproduction or even in a few originals. The exhibitions included bits of silver or tapestry or paintings "embroidered in crepe" by ladies. Mr. Magragh in 1813 exhibited a vase carved from the wood of the tree under which William Penn signed his treaty with the Indians.

Great names are scattered at random through the catalogs, a few perhaps genuine, most spurious. The Academy's own collection was full of Old Masters, the most authentic and numerous being minor Dutchmen, most of which now seem to have vanished. The catalogs, never very informative, give no clues as to the genuineness and provenance of most of these masterpieces. Some pictures from the collection of Joseph Bonaparte, family portraits by David and Gérard, were certainly genuine. Other pictures supposed to be from his collection (though not so listed in the catalog) may also have been authentic. The Academy still has two fine Vernets bought from the final auction of the Bonaparte estate in 1846.

The great Philadelphia collection of Old Masters, corresponding to that of Robert Gilmor in Baltimore, was the one made by Richard

* Fig leaves were not peculiar to Victorians. In 1555 the Pope ordered that Michelangelo's whole *Last Judgment* be properly draped in the interests of decency. One of Michelanglo's pupils did it, less than fifteen years after the master painted it, fig leaves on a truly grand scale and placed by Renaissance Italians, not Victorians.

Worsam Meade, father of George Gordon Meade, the hero of Gettysburg. Richard Meade managed to create for himself a semipermanent job as "naval agent" in Spain at Cadiz (1804–1816). He there amassed a group of paintings that he and everyone else thought very magnificent, as indeed they would have been if genuine. Unfortunately he was foolish enough to make large contracts with the Spanish government. He went bankrupt and came back to the United States a ruined man; but his widow kept hold of the collection and deposited it at the Academy, where it was exhibited regularly at the Annuals. This is the source of most, but not all, of the Great Names that star the catalogs in midcentury. The later Meades were army and navy men who had little interest in and no resources for the collecting of art, and the Meade collection was dispersed. The Academy's loss was the Union's gain. But one cannot help wondering if any of the Great Names were legitimate?

As for Modern Art, everybody sooner or later got exhibited at the Annuals. Most of the Salonistes from Achenbach to Zamaçois appeared there, beginning in the 1850s and 1860s. The emphasis, however, from the very beginning was on American art in general and Philadelphia artists in particular. Most of the well-known names of pre–Civil War American painting are represented: Washington Allston, for instance, whose enormous and finished *Dead Man Revived* was a sensation when exhibited in London in 1813. It was enthusiastically purchased by the Academy in 1816, the new building being mortgaged to raise the thirty-five hundred dollars required to pay for it. It is still on exhibit there today. Trumbull, Vanderlyn and Morse; Mount, Bingham and Catlin; the Hudson River roster, Cole, Durand, Kensett, Church, all had their years.

ii

But the artists who really dominated the Annual were Philadelphians, the so-called Pennsylvania Academicians. This body of Academicians, mostly painters, was created in 1812. At first consisting of most of the well-known American artists then alive ("Will" Rush, Thomas Sully, three Peales, Jarvis, Stuart, Allston, Vanderlyn, West, Copley, Trumbull), it later developed into a more exclusive and more obscure group of locals, the out-of-towners and foreigners being relegated to an honorary status. Supreme among these Academicians and exhibited continually in almost every prewar Annual were two family groups, the Peales and the Sullys. Charles Willson Peale, as chief instigator of the whole thing and the only painter on the first board, appeared not only with new canvases during his lifetime but in later exhibitions as a revered American Master. His sons, the gifted but unfortunate Raphaelle and

the more fortunate but less gifted Rembrandt, were also on exhibit year after year. Altogether the work of over a dozen Peales of one kind or another graced the Academy walls.

Thomas Sully was also included in the first exhibit of 1811 and the first group of Academicians in 1812. Through the final exhibits in the old building in 1870 he was represented almost annually. His follower, rival, and kinsman, John Neagle, was equally prominent from 1821 on. Neagle had married a girl who was both Sully's stepdaughter and niece. Sully's own daughter Jane exhibited under her maiden name and then under her married name as Mrs. Darley. (She married the musician brother of America's first important book illustrator, Felix Octavius Carr Darley.) Even Sully's short-lived nephew Robert, who worked in Richmond, Virginia, as well as his even more short-lived son Thomas Wilcocks also exhibited.

Below these dominant family eminences flourished an undergrowth of minor Philadelphia artists, mostly painters, some native-born, some settlers. As the first and most continuous interrelated group of American artists to be connected with a museum and with an art school and academy, it deserves some notice. Few of these artists have survived by reputation, but during their lives they were made Academicians of the Academy, joined the board as artist directors, determined the Academy's policies, and chose its exhibits and sold their produce to a whole group of avid local collectors, some of whom were in turn Directors of the Academy. A tight little world, the only such self-supporting "provincial center" of art in America at that time that paralleled those of Europe.

Bonfield, Doughty, Furness, Hamilton, the Haseltines, the Lambdins, E. D. Lewis, the Morans, T. B. Read, W. T. Richards, Rothermel, the Sartains, Schussele, Shaw, the Smiths, Waugh, Weber, Williams, Winner, Wood — these men (and a few women) were bought by local collectors like Baldwin (locomotives), the Careys (publishing), Childs (engraving), Claghorn, Cope, Dreer, the Drexels, Earl, Fisher, Gibson, Godey (*Lady's Book*), Joseph Harrison (railroads in Russia), LeFevre, Macalester, Towne, and Whitney, some of them remembered for their professional achievements, many of them, like the artists they helped, buried under the lava of time and changes of taste.

A few names — Doughty, the Philadelphia progenitor of the Hudson River School; Thomas Moran, the Philadelphia painter of Yellowstone and the Grand Canyon — are emerging again as part of the revaluation of earlier nineteenth-century American art evidenced by the Met's Centennial. Others, like W. T. Richards, William Winner, James Hamilton, and Edward Moran, are developing a more specialized reputation. Three traditions — marine painting, family kinship, and

foreign birth — serve to characterize and isolate some of these names from the mass.

Philadelphia is a long way from waves and beaches and shipwrecks, but a whole line of artists, beginning with the first exhibits of the PAFA and continuing till mid-twentieth century, has carried on this unlikely succession of Philadelphia marine painters. From Thomas Birch (1779–1851) and his celebration of naval victories during the War of 1812, through George R. Bonfield (1802–1898), James Hamilton (1819–1878) and his even more Turneresque pupil Edward Moran (1829–1901), the meticulous realist William Trost Richards (1833–1905), the expatriate T. Alexander Harrison (1853–1930) and the stay-at-home Xanthus Smith (1839–1929), and finally through splashy Frederick Waugh (1861–1940) and even perhaps through the Academy-trained modernist John Marin (1870–1953), these ducklings hatched by the PAFA have been taking to water in a way most unlikely for comparatively landlocked Pennsylvanians.*

As for a tradition of families, that could not be more Philadelphian; and many of Philadelphia's painters come in groups — bevies, prides or flocks. The Peales and the Sullys are merely the most numerous and conspicuous. There are many others.

The Hesselius family, Swedish-born father Gustavus (1682–1755) and American-born son John (1728–1778), who first taught Charles Willson Peale, begin the tradition. John Claypoole (1720–1796), first native-born Philadelphia painter, his son John, Jr. (c. 1743–c. 1800), and his nephew and pupil Matthew Pratt (1734–1805) continue the tradition. Pratt was not only Benjamin West's first American pupil in London but also his relation by marriage. John Claypoole, Sr.'s daughter Mary married James Peale, brother of Charles. Of their six children, the pioneer woman artist Sarah Miriam Peale (1800–1885) best carried on the family reputation.

There are many, many such painter families connected with nineteenth-century Philadelphia. There are the expatriate Haseltines, painter William, sculptor James, and William's son, the sculptor Herbert. The Smiths and Lambdins moved to Philadelphia from Pittsburgh. James Reid Lambdin had established a museum in Pittsburgh in imitation of Peale. His son George became a well-known genre painter. Russell Smith made his first reputation as a painter of theatrical scenery. He named his son Xanthus so he wouldn't be confused with any other Smiths. Son Xanthus painted seascapes; daughter Mary painted chickens.

* Brooklyn, not Philadelphia, has shown most interest in the revival of these marine painters, with an exhibition of Hamilton in 1966 and of Richards in 1973.

There were the British-born Moran brothers, Edward (marines), Thomas (mountains), and Peter (animals), most of whose wives, children, and in-laws (the Ferrises, Stephen and Gérôme — Stephen having married a Moran sister) were artists exhibiting at the Academy. The Sartains, too, came from England. John, the father, was an engraver. Three of his children made respectable careers as artists: Samuel, an engraver; Emily, who was one of the early winners of the Mary Smith Prize given annually by the Academy to a distinguished woman painter in honor of Russell Smith's chicken-painting daughter; and William Sartain, who moved to New York and was a founding father of the antiacademic Society of Artists there along with William Merritt Chase and John La Farge.

Samuel Bell Waugh was a respectable portraitist, a lesser Sully, and did a famous panorama of Italian scenery known as *Waugh's Italia*, exhibited with acclaim in the 1850s. His son Frederick became a successful marine painter and his daughter Ida also exhibited for many years. Even Eakins, whom one tends to think of somehow as in esthetic isolation, was tightly enmeshed in this Philadelphia web of art-and-family. His worst enemy and his sister's husband, Frank Stephens, was a sculptor of sorts who studied at the Academy. His own wife Susan, a student at the PAFA, daughter of an engraver, William Macdowell, was a painter of skill. Susan's sister Elizabeth was an artist, and their brother James married a daughter of Peter Rothermel, historical painter and best friend of scenic artist Russell Smith, whose daughter Mary is commemorated by an Academy prize won by Emily Sartain, whose brother William taught my Academy-exhibiting great-aunt Minnie Theodora, whose grandfather was painted by Neagle, who married the niece of Sully, who studied with Stuart who studied with West whose wife's kinsman Matthew Pratt was the nephew of first native-born painter James Claypoole . . .

All these people were friends, enemies, kinfolk and clubmates in this flourishing art world that had the Academy as its center. They studied there and taught there and exhibited there. They organized protests against the stuffiness of the lawyer trustees and then themselves became the stuffiest of artist trustees. Along with the Old Masters and the European Moderns and the recognized painters of New York, Boston, and Baltimore, these natives provided the raw material for the Annual Exhibits up to the Centennial of 1876 — the first such sizable and coherent group of living artists to be shown in what could somewhat loosely be called the first American museum.

...
iii

Presiding over all this was the august Board of Directors. In Philadelphia an organization is known not so much by the function it serves as by the board it keeps. Some worthy causes there begin with a flourish, like Peale's Columbianum, then fade away because they can't support a decent board. Others almost cease to breathe but persist because they have superlatively prestigious boards. The Academy was most fortunate in its early board. Though only two artists, Peale and Rush, were on it, this was not the point. The point was that the gentlemen, whatever they may or may not have known about art, were either men of family or men of achievement or preferably both. It thus became a privilege to be on the board with them. One might be able to speak to them in public, and, who knows, they might even answer back. For this inestimable privilege a gentleman could even put up with the occasional troublesome quarrels with artists and the nuisance of having to show an interest in pictures. Thus the causes of duty, culture, beneficence and personal reputation were served; and it was important to have one's name on the list of Directors. Certainly no artist-dictator like Trumbull could have dared to dispute the board's authority.*

The first President of the board, from 1805 to 1813, was George Clymer, obviously qualified for his post as director of Philadelphia's artistic life and of the nation's foremost artistic institution by having signed the Declaration of Independence. His successor, Joseph Hopkinson, who reigned from 1813 to 1842, was even better qualified, being the *son* of a Signer, thus adding the distinctions of birth to those of achievement. Joseph was also famous in an esthetic way for having written, in an odd moment, the words of "Hail Columbia." This may mean little nowadays, but for almost a century "Hail Columbia" was a rival to "The Star-Spangled Banner" as our national anthem. Actually Joseph was a prominent wit, lawyer, and citizen, who had dallied with the intellect in his youth as a writer of Shakespearean criticism for the *Port Folio,* America's first successful intellectual magazine. He even collected art.

This tradition of birth and achievement was ably carried on by such later men of family as Joseph Ingersoll (President from 1846 to 1852), George Pepper (1884–1890), and Edward Coates (1890–1906). A few well-known art collectors like Edward Carey (1845), Henry Gilpin

* An example: As of 1878 the group of Pennsylvania Academicians was dissolved, much to their discomfort. This was at the whim of the then President Claghorn, who as John Sartain wrote in a bitter letter, "constituted himself the entire institution, law or no law." So much for temperamental artists.

(1852–1859), and dictatorial James Claghorn (1872–1884) had their day. The first Directors, bearing names august in Philadelphia then as now like Tilghman, Rawle, McKean, Meredith, Rush (not the artist, but the doctors) and Coxe, were enough to establish the board on a high plane. The trustees were mostly doctors, lawyers, and "gentlemen of letters and leisure," that is, men of inherited wealth. One or two artists continued to be permitted, following the tradition of Peale and Rush (the artist, not the doctors). An interesting note was the prominence both on the original organizing committee and on the board itself of leaders of the Jewish community. Moses Levy was on the first board; the well-known Hyman Gratz was later Treasurer; Simon Gratz, Zalegman Phillips, and Samson Levi were among the group of organizers, along with the usual quota of Biddles. This would not cause remark now or before the Civil War; but it would have in between.

Under such auspices the Academy was almost bound to survive. It did, but had its ups and downs. One problem was the location of the building. It was way out of town, up there above Tenth Street, and except at the Annuals, few people bothered to visit it. Then the building itself began to decay. The roof of the dome leaked and buckets had to be set about to catch the dripping. This was neither cheerful nor good for the works of art. Besides, it rotted the floor.

Finally the roof was repaired and the old shingles were prudently stored down in among the casts. This offered a perfect opportunity for the insane brother of the caretaker, Mrs. Suis, to creep in one night in 1845 and set the place afire. Heroic efforts by water-drenched volunteer firemen saved West's huge *Death on a Pale Horse* from destruction; but a Murillo from the Meade collection, supposedly once the property of Spanish royalty, as well as most of the Smith and Biddle casts, were lost. Though the building was repaired and enlarged, it became increasingly dilapidated and old-fashioned. It was now way downtown in a very commercial part of the city and in the 1860s the board decided it was time to build a new building.

The old Academy closed in 1870 and a new Academy was erected way up on socially déclassé North Broad Street at Cherry. Rather as the new BMFA way up on Huntington Avenue was conceived by a Lowell, so the new PAFA way up on Broad Street was designed by a Furness. The Furnesses were descended from the famous Unitarian William Henry Furness. One of his sons, William Henry, Jr., was a refined and fairly successful and perhaps unjustly neglected portrait painter, another was a world-famous Shakespearean scholar. Still another, Frank Furness, was a radical architect who, as teacher of Louis Sullivan, who in turn taught Frank Lloyd Wright, is considered the grandfather of advanced American architecture. Furness worked in a style of flamboyant late Victorian fantasy. The new building of the PAFA is his most conspicu-

ous monument. Built in a vein of what might perhaps be called Moorish Gothic, it was for years an object of scorn and now remains one of the few survivors in America's museum world of an original building preserved almost as originally built. It has just been restored as of the Bicentennial to pristine glory.

By the time this new palace of art opened, however, one of the most significant esthetic events in America's art history had occurred, the Centennial Exhibition of 1876. The new PAFA and the new art Museum in Memorial Hall opened almost simultaneously, and the art world of Philadelphia was presented with a dilemma that has not been completely solved to this day: what to do about the new Museum and what to do about the old Academy?

iv

It would have been impossible for the PAFA to ignore the new Museum as the New-York Historical Society did the Met. The new Met and the new BMFA struggled along in rented or borrowed quarters and then opened in mere pieces of unfinished new buildings that took many years to complete, in fact never were completed, since the one in Boston was destroyed before it was done and the one in New York keeps on growing. The new Museum in Philadelphia found a home in one of the most grandiose buildings yet raised on the continent. This was the huge, glass-domed, Berlin-Classical Memorial Hall, built as a permanent leftover of the Centennial, which housed the enormous collection of art, most of it foreign, exhibited at the fair in 1876.

The exhibition itself was the sensation of its decade and the art collection a shocker, a bit like the Armory Show of 1913. For the first time stay-at-home Americans, in America, got a chance to see masses of European Modern Art. The result has already been unfolded. Everyone put their old Hudson Rivers in the attic and concentrated on Achenbach, Bouguereau, Couture, Ziem and Zamaçois. Philadelphians also put their Bonfields, Doughtys, Hamiltons, Lambdins, Lewises and Rothermels in the attic and, like Mr. Gibson with his Pompeian rooms, followed along in the wake of fashion.

The new Museum was not, however, called the Philadelphia Museum of Art, as it is now. It was, rather significantly, called the Pennsylvania-Museum-and-School-of-Industrial-Arts. All that. There was nothing accidental about the name. In the first place the name declared the kind of museum it was to be — *not* a museum of Fine Arts but a museum of Industrial or Decorative Arts. In the second place it made it clear that this was to be a state, not a city, museum. True enough, the Academy also was called "Pennsylvania," but in 1805 that

meant something different than it did in 1876. In 1805 Philadelphia was the dominant cultural, social, and financial capital of the state (though not the nominal political capital) and could feel proprietary and representative. By 1876 things had changed. Upstart western cities like Pittsburgh now existed, and to the Philadelphians of 1876 the state of Pennsylvania was no longer a safe provincial backyard of their city but a wild west full of barbarous outsiders. To serve on a board with, ex-officio, the Governor of the State, representatives from the State Senate, not to mention such local pariahs as the Philadelphia Common Council (common indeed!), was anything but an honor. No gentleman in fact would like to consider such a potentially demeaning thing.

The new Museum was not supposed to be a competitor of the Academy, however. It was not modeled on England's Royal Academy, much less on France's Louvre, but directly on London's South Kensington Museum (now the Victoria and Albert). This Museum was also the result of an Exhibition, that of 1851 famous for its Crystal Palace, and was aimed not at connoisseurs of painting but at industrial designers. Its emphasis was on crafts and manufactures, its ambition to elevate the taste of the home and marketplace. Obviously much in the thoughts of the founders of both the Met and the BMFA, the South Kensington influence did inspire the collection of all that bric-a-brac in both museums; but both Met and BMFA were gradually and inexorably pushed in the direction of Fine, not Applied, Arts. Not so, in the beginning at least, the Pennsylvania Museum. It was umbilically tied to the School of Industrial Art that was part of its title and was specifically created to provide material and exhibits for the students of the school to study.

As soon as the foreign paintings were cleared out of the vast gray halls of the new building in Fairmount Park, arts and crafts moved in: masses of ceramics, textiles, wood and enamels, architectural casts, furniture, tools, ethnographic material, anything that might possibly interest a student of design. The Cooper Union's Museum in New York, of a later date, was closer in spirit to the Pennsylvania Museum than the Met. The great domed million-dollar building was filled not with art collectors but with students and a rather unsophisticated local public that came to see the hideous Oriental curiosities and such displays as a graphic panorama of the destruction of Pompeii, complete with dead bodies. Theoretically, the Academy could go right on with its Annuals and its schools and its permanent collection of Old Masters without fear of competition.

But like a snake into Eden, a sinister note of the Fine began to intrude into this paradise of the Applied. Over the years a Mrs. Bloomfield Moore presented a great collection to the Pennsylvania Museum, beginning in 1882. It consisted mostly of decorative material, furniture, enamels, ivories, jewelry, plate, metalwork, glass, pottery, porcelain,

books, fans, textiles, and costumes, but also, alas, of a few paintings. One entire room of Memorial Hall was devoted to Mrs. Moore's ceramics. But what about the paintings? At first there were only half a dozen of them. Then in 1883 came a hundred more. In 1899 still twenty more Moores came in.

But before the last of the Moore accessions, a far more significant donation came to the Museum, one that was eventually to disrupt the intentions of the founders and spoil the former friendly accommodation with the Academy. A gentleman named William P. Wilstach, who had made his in saddlery and hardware, determined to immortalize himself. He collected art, and like all such collectors exhibited samples of his good taste at the Academy Annuals. These pictures were either local artists — Bonfield, Hamilton, Richards — or Salonistes — Achenbach to Ziem — that he picked up on two or three jaunts abroad under the guidance of a Philadelphia expatriate painter, Robert Wylie. Mr. Wilstach stunned the Paris Salons of 1868, 1869, and 1870 by buying off the cream of the crop from under the noses of Europeans, "disappointed princes and maddened dealers," as Strahan so inimitably put it. After Wilstach's death in the early 1870s, his widow carried on, increasing both the collection and the Wilstach fortune. Wilstach wanted his widow to give his beautiful things to the city of Philadelphia and build a gallery to house them in the middle of Fairmount Park, to be modeled after the new Gallery in Dresden and to be an inspiration for the populace as well as a conspicuous memorial to Mr. Wilstach. However, it was suggested that if, after the forthcoming Centennial, there should be a suitable permanent building left over . . . Of course there was: Memorial Hall. So when Mrs. Wilstach eventually died in 1893, the collection went into Memorial Hall, accompanied by a handsome bequest for maintenance and future purchases.

It was, however, in typical Philadelphia legal fashion, all made as complicated as possible. The pictures were not left directly to the Museum. They were left to the city of Philadelphia, to be administered by the Commissioners of Fairmount Park and then to be housed, as a quite separate entity, in the Pennsylvania Museum. Memorial Hall, being located in Fairmount Park, came under the jurisdiction of the Commissioners, who under the city government presided over the Park, including the board of the Museum, who presided over the Directors of the Museum, who presided over the Museum.

But enough. The point of all this is simply that, unlike nearly every other such collection of Philadelphia art,* the Wilstach collection was

* The Moore collection of pictures never seems to have been taken very seriously. However a Breughel, hitherto unattributed, uncleaned and unnoticed, was discovered among the Moores during the 1920s.

not left to the Pennsylvania Academy. Perhaps a member of the board did not answer when spoken to by Mr. Wilstach. In any case, the happy days of separation of functions were over. There were now to be two rival arbiters of taste in the city. Even in the matter of boards things got confused, for the Board of Commissioners of Fairmount Park, despite its political tie-up, was very good indeed, and even the Museum board improved over the years as Commissioners condescended to serve on it. It was indeed a predicament.

v

From the very beginning of its history, the PAFA had been the somewhat unresponsive beneficiary of collectors. A collection that could and should have been a predecessor of the Bryan and Jarves collections, that of Joseph Allen Smith, had a significant role to play in the actual foundation of the Academy. Smith was an elegant South Carolinian who like many of his kind had settled in Philadelphia. From 1793 to 1807 he made a grand tour of Europe and the Mideast, hobnobbing with the Czar as the first genteel American visitor to Russia and spending considerable time in Italy. While there he conceived the idea of a museum collection for America, although there was then no art museum in America or indeed strictly speaking in Europe. (The Louvre was just getting under way at the time.) Nonetheless, he brought together a group of casts and pictures and stored them in expectation of sending them back to Philadelphia. At this juncture Napoleon descended on Italy. The Smith collection was impounded in its storehouse and threatened with confiscation. However, the casts were allowed to come to Philadelphia in 1800 and were first exhibited in Peale's Museum in Independence Hall. They were there as of 1805, one of the main reasons for the founding of the Academy and the building of the Academy's home as a place to put them.

The pictures had a more adventurous history. They too were eventually allowed to leave Italy, in 1812; but by then America was at war with England and the American ship, the *Marquis of Somerueles,* on which Smith's pictures were being transported, was captured and taken as a prize to Halifax. The Academy begged to have the works sent on to Philadelphia, and an enlightened Admiralty Judge in Halifax, Sir Alexander Croke, agreed to the proposition. The grateful PAFA presented one of the pictures not to the Judge, but to the Captain of the British ship that made the capture. His descendants gave it back to the Academy in the twentieth century. The others were displayed on Chestnut Street, though they got thoroughly soaked by sea water in transit. (A group of engravings seems to have been totally liquidated

that way.) The pictures, rather dubious Italian Old Masters, having suffered trial by water, were then probably destroyed by fire along with the casts when the Academy burned in 1845. In any case, only four pictures from the Smith gift survive — dubious Italian Old Masters. A sad end to America's first attempt to create a museum collection; total deaccessioning by time and the elements.

The Academy continued to receive gifts and to make purchases, but the largest of the gifts came after the Civil War and the opening of the new building and so, significantly, *after* the opening of the new Museum. The Joseph Harrison Collection (1878) was full of valuable Americans. Other collections continued to be given, none more conspicuously than that of Henry Gibson, which at his death in 1891 left its conservatory and came to rest in a specially designated Gibson Gallery in the Academy, still so designated. The fact that the Gibson Collection, including that luscious Cabanel *Venus* at once so pure and so sexy, was almost entirely European Salon art and the Academy was supposedly beginning to concentrate solely on American art made no difference to Mr. Gibson and other Philadelphia collectors. The museum in Memorial Hall could have its Wilstach Collection, but it damn well wasn't going to get anything else.

Meanwhile the Academy very gradually turned towards America and away from Cabanel and Raphael. Europeans ceased to be exhibited, with a few surprising exceptions. (It is odd to see pictures by Degas suddenly turning up at the Annual of 1895.) After 1876 the loans from collections begin to disappear, the works now being those of contemporaries, and for sale. The Old Masters, instead of being distributed at random through the galleries, were now all concentrated in a special room with, or as part of, the Academy's own possessions. By 1880 the transformation was complete. The Annuals no longer had any older pictures or loans. They were devoted to works by Modern American artists. Prices were listed from 1880 on. Illustrations appeared in the catalogs, tentatively beginning in 1885. You could always go in to see West's *Death on a Pale Horse* and other permanencies between Annuals.

Philadelphia artists continued to dominate the Annuals, but the old Academicians died off and the whole system was discontinued in the 1870s. Sully, Neagle and Rembrandt Peale were dead. This was a new Philadelphia now dominated, more in retrospect than in reality, by names like Eakins and Cassatt. But in fact these two were not exhibited all that frequently. Eakins taught at the Academy school, first as assistant and then Director (1882). Then he, too, like the casts before him, ran afoul of that confrontation of the chaste female and the exposed male. It was his insistence on completely nude male models in life classes that provided his enemies, artists and board members alike, an

excuse to get rid of him. He continued to exhibit, however, and to serve on juries; but his wife Susan Macdowell exhibited as frequently as he did.

A new undergrowth of artists even more obscure than Bonfield, Hamilton, Rothermel and Xanthus Smith took over as jurymen and artist directors of the Academy in its later phase. How many now know the names, much less the works, of Newbold Trotter, Prosper Senat, Thomas Craig, James Sword, and Charles Linford? Literally hundreds of women painters suddenly emerged. Not only Mary Cassatt and Emily Sartain and Cecilia Beaux, but others like Phoebe Natt and Eleanor Matlack. New York began to be represented significantly in the Annuals. Of the two hundred and eighty-two artists exhibited in that of 1890, one hundred and fifty-five were Philadelphians, seventy-two New Yorkers, fifteen Bostonians, and eighteen Americans living abroad. Of the total, one hundred, over a third, were women. There had always been women exhibitors like Sarah Peale and Jane Sully, but never so many.

The PAFA Annuals from 1890 to 1930 became one of the two or three important art events of the country. Artists could make a reputation there; every important artist of the time exhibited at some time or another. The 1904 catalog gives a very good idea of the stature of the exhibitions and exhibitors. By then the catalogs were profusely illustrated with photographs of what were obviously considered the stars of the show. The illustrations of 1904 begin with Sargent's luxurious *The Misses Hunter,* go on to a Cassatt *Mother and Children,* Homer's *Eight Bells,* Eakins's *Archbishop Elder,* Hassam's *Church at Old Lyme,* and Chase's portrait of Edward Steichen. The catalog lists works by Anshutz, Beaux, Henri, Innes, La Farge, Saint-Gaudens, Sloan and Whistler.

Meanwhile, during the high tide of the Academy as a focus of Modern American painting, what was happening to the Museum? Nothing much. It stood out there in Memorial Hall, full of china and textiles and views of Pompeii. The Wilstach Fund was used to buy some fine pictures and some not so fine. People in Philadelphia art circles took a disdainful view of it. A description of the collection as of 1911* sneers at it as "badly hung and poorly catalogued" and containing "more than the usual quota of false attributions. In a general way it may be said that the collection is one of names . . . a great many very distinguished painters being represented by inferior and often doubtful examples."

This is probably an unfair estimate. By 1911 the core of the collec-

* Helen W. Henderson, *The Pennsylvania Academy of the Fine Arts and Other Collections of Philadelphia* (Boston: Page, 1911). Note that the Museum is just one of these "other collections." Henderson concentrates on the Museum's ceramics in her commentary about these "other collections."

tion, those Salon pictures snatched from the clutches of disappointed princes and maddened dealers, had become old-fashioned. Though most were still on view in 1911, none is on view now. In fact, in 1954 the great Director of the by-then Philadelphia Museum, Fiske Kimball, disposed at auction of almost all the Museum's old decorative art and of the Wilstach Salonistes and Americans.

Kimball's statement is so disarming and so germane to modern developments that it deserves quotation.

> During the 19th century too many pictures accumulated in museums. . . . Even as cut down there are still too many paintings in the Louvre. They used to show forty works of Poussin, now they show ten. . . . Meanwhile in people's houses a painting has become a rarity. Why not give a person a chance to buy, from the Museum's surplus, and have one he likes at home? The Philadelphia Museum of Art has many more paintings than it can show well, even in its great new building. This is particularly true of those of the 19th century. Then there are old paintings replaced by finer works of the same masters or periods. The courts have ruled that all these don't have to be retained forever but could wisely be sold off to return to individual ownership and enjoyment. . . . Memorial Hall . . . is to be abandoned as an art museum. More than 200 paintings belonging to the City are to be sold — not great masterpieces, but . . . agreeable and valuable pictures. It is a unique opportunity to get yourself something choice and delightful.

Nobody complained. Nonetheless the original bequest, which Mr. Wilstach hoped to leave as a perpetual memorial, was dispersed and the Museum lost lots of things that it probably wishes it had now, especially the works by Philadelphians. At least they've had to reacquire examples in recent years. The quotation at the end of the preface of the Wilstach Collection catalog of 1900 stands as an ironic reminder: "When we build, let us think that we build forever. . . . See, this our father did for us." Memorial Hall is now empty of art, much of the original Wilstach bequest is sold and gone. So much for what our father did for us.

vi

There is a third museum of art in Philadelphia besides the by-now Philadelphia Museum of Art and the old Pennsylvania Academy. This is the University Museum of the University of Pennsylvania, which is more or less its present official title. It is devoted to archaeology. It was

founded in 1887 and is located in a big building in West Philadelphia as part of the urban complex of the University. It contains results of famous digs in the Middle East, Spanish America, and elsewhere. It is generally acknowledged to be, after the Met and the BMFA, the best all-around collection of ancient and archaeological art in the country.* It is the third leg of Philadelphia's tripod of art. However, it is not strictly speaking an art museum at all and has manfully resisted the insidious trend toward the merely beautiful. The emphasis of the exhibits at present is very strongly on scientific archaeology, and it is definitely a teaching museum for the University, not just a gallery for the public.

The Pennsylvania Museum made a feeble gesture towards the antique by buying and displaying a nice Scandinavian clutch of Greek vases called the Hammer Collection. To this were added quite a few other items of the kind. Some of the Museum's ceramics and artifacts had archaeological or ethnographical significance. The Academy had not only all those casts, but some real marbles, or pieces thereof, notably a battered Ceres brought back from Greece by one Commodore Patterson in the early nineteenth century. It stood out in front of the old building on Chestnut Street. This was about it in Philadelphia until the University Museum of Art and Sciences (one of its titles; they varied from time to time) came to the rescue.

As in the case of the British Museum or the Peabody Institute at Salem, nobody was thinking of art when they founded the University Museum. The Academy was modeled vaguely on the British Royal Academy. The Museum was modeled specifically on the South Kensington Museum. The University had in mind the British Museum. Digs, that was the point. If what came up had esthetic value, so much the better, but science was what counted.

It all began in 1887 on the porch of a summer house in New Hampshire, where the Philadelphia banker Edward W. Clark and the archaeologically minded clergyman John P. Peters had a fruitful conversation. Peters, an Old Testament scholar and professor of Hebrew at the University of Pennsylvania, was interested in an expedition to the sites of ancient Babylonia conducted by a New York editor and Assyriologist, William Hayes Ward. Peters hoped banker Clark would help back some more such expeditions. Clark was interested, and he not only backed the project himself but got the University of Pennsylvania to sponsor the digging also. The Provost (the de facto President) of the University at the time happened to be William Pepper, an avid ama-

* The Oriental Institute in Chicago is splendid but confined to Asian archaeology. The Classic Collection of the Rhode Island School of Design in Providence is superior. The archaeological collections of the American Museum of Natural History in New York are now treated and exhibited as art; so the University Museum has many rivals.

teur archaeologist. Naturally, the first thing was to have a meeting of worthy rich citizens and create an organization. This was all done in 1887; and in December, the month when Philadelphia seemed to prefer to build philanthropic boards, something called the University Archaeological Association was created. This was under the auspices of the University of Pennsylvania but consisted of many well-to-do, scientifically minded men and women who had nothing to do with the University.

Within three years forty thousand dollars had been raised, expeditions had been sent out to Nippur, a forgotten city of Babylonia first spotted by Ward, and some twelve thousand specimens had been amassed. Naturally this demanded that some sort of archaeological museum be devised to display specimens and advertise the digs. This was the origin of the University Museum.

Under the direction of a bewildering complication of boards, University and non-University but all of wonderful social éclat and prestigious family connection, the new University Museum evolved in an atmosphere of local beneficence and national fame, a spoiled darling among America's museums. Even the PAFA couldn't match this patronage. Money poured in for dig after dig and specimens poured back in at such a rate that nobody knew what to do with them. In 1889 a temporary small museum was opened in College Hall, that grand, green, gloomy masterpiece of Victorian Gothic that dominates the University's campus. By 1890 the collection had been installed in the new library, a fantastic château by Frank Furness, his other extant masterpiece along with the Academy. Plans for a separate building were evolved in 1893 and a site acquired, but the first part of it wasn't completed till 1899 and the true history of the Museum as such really begins with the new century.

Nonetheless, the Museum, or the Association, or the Department, or whatever it was, was one of the best-known cultural organizations in the country and one of the most prosperous. At the Columbian Exposition in Chicago in 1893, the University Museum had the only Old World archaeological exhibit; and during the 1890s, when the New-York Historical Society collections were moldering unseen, those of the Met were dominated and inhibited by jealous Cesnola, and those of the BMFA were just beginning to develop, the parvenu Pennsylvanians were riding high.

It was not smooth riding, however. As seemed to be the rule in these earlier days of archaeology, there were frustrations, animosities, and above all, scandals. The 1889 expedition to Nippur, backed by Philadelphia money, was not conducted by Ward, the previous discoverer of the site, but by the Reverend Peters himself. Among his associates were John Henry Haynes, a New Englander who had been with Ward on

the first expedition, and a German, Hermann Volrath Hilprecht, who had come to Philadelphia as an editor of a Sunday school magazine but quickly established himself as an archaeological authority and teacher of Assyriology at the University. This particular expedition was something of a disaster.

The climate was unbearable. Haynes, Hilprecht, and others came down with "fever" and in fact Haynes never fully recovered. Native diggers were hired and the local Sheiks immediately packed the payroll with their relatives, a quarrelsome bunch. Many of these also came down with fever. A quarrel over a horse with the superintending Turkish military erupted into guerrilla warfare, and even the digs proved disappointing. Everyone left in disgust. But the Pennsylvania archaeologists refused to give up and in later expeditions were more than rewarded. A so-called Temple of Bel was discovered and in it a section perhaps overromantically designated as the "Temple Library," which contained thousands of clay tablets inscribed with cuneiform Sumerian writing. Though Turkey insisted on keeping many of them and Hilprecht managed to acquire quite a few for himself, which he eventually took back with him to Jena (now in East Germany), a vast store came to Philadelphia.

These tablets, the oldest great body of literature still preserved, have kept experts busy translating to this very day. Hilprecht, as the Museum's Curator of the Babylonian Section, was one of the first and most eager and expert of these translators, and he made his reputation and career at the Museum and the University mainly on the basis of the Nippur finds.

However, rather like Cesnola, Hilprecht seems to have been, for all his gifts, something of a megalomaniac. He wrote books, just like Cesnola, describing the discoveries at Nippur, taking credit for most of them, casting aspersions on poor Haynes, who had really done most of the work, and making claims for the "Temple Library" and the objects found there that were, like Cesnola's claim about the Treasure of Curium, "open to doubt." Objects he seemed to imply had been found in the Temple Library had not been found there at all. Other objects that Peters and others thought should belong to the University seemed to become the private property of Professor Hilprecht.

Like the Curium scandal, this one smouldered for a long time before it finally exploded. Meanwhile Hilprecht had made his position in Philadelphia impregnable by his learning, efficiency, self-publicizing, dogmatism, and ability to arouse interest by lectures. Though the lectures were quite hard to understand because of his heavy German accent, they nonetheless packed the crowds in. Philadelphians, like New Yorkers and Bostonians, were terribly excited about archaeological discoveries at that time.

Eventually Peters, who had retired from archaeology to take up clerical duties in New York, let loose a blast accusing Hilprecht of fraud, misappropriation of art objects, and general misrepresentation of what really happened at the Nippur excavations, as described in the Hilprecht books. This was in 1905, the same year as the schism over casts in Boston that caused Robinson to go to the Met. In Philadelphia the presidency of the University Museum was then held by a woman, the pioneer feminist and Egyptologist Sara Yorke Stevenson. She was, if not the first, surely one of the first women to head the board of a major American museum. The Secretary of the board was still another Furness, a William H. Furness III. Both of them were active in trying to get Hilprecht investigated and removed, but other Museum trustees balked. Thereupon both President and Secretary resigned, along with one hundred twenty-five other members of the Museum. Hilprecht, supported by such powerful friends as Chairman Samuel F. Houston and Vice-President John Wanamaker (as Cesnola had been supported by Henry Marquand), was investigated and vindicated. Sara Stevenson turned her attention to the Art Museum, becoming a beloved patroness of it. The 1910 appointment of a new young Director, George Bryon Gordon, who presumed to tell Herr Doctor Hilbrecht what to do, was more than the Professor could stand. He resigned in a huff and left for Germany, taking his own private collection of tablets with him. There they remain — much to the discomfort of later interpreters who have to keep going to Jena to find pieces of things otherwise in Philadelphia.

The affluent days of the Museum after 1900 and the opening of the new building under the guidance of Harrison saw an enormous increase in the building itself, the spread of worldwide expeditions, and the growth in prestige of the University Museum as one of the city's and the nation's important institutions. But the question as to whether it was a museum of science or a museum of art remains unsettled. The present-day compromise is curious but a little dubious and perhaps unsatisfactory. What is a magnificent Chinese crystal ball doing in a museum of science? What is a case of Indian Stone Age implements doing in a museum of art?

Around 1900, as the new University Museum moved from the Furness Library to its own building, Philadelphia had the richest but strangest museum life of any city in the country. It had lots of everything, but it didn't really have an art museum. The Pennsylvania Academy in its by-now aging Furness building was primarily an art school and an exhibition hall for new American art. It had a clutch of Old Masters and Old Americans, but it wasn't a true museum of art. The Pennsylvania Museum in grim gray Memorial Hall was primarily a school of design and an exhibition of arts and crafts. It was packed with artifacts and it did have its Wilstach Collection, a not very happy

or welcome guest. But it was not a true museum of art. The new Cope and Stewardson building of the University Museum, brick Romanesque with Oriental touches, was very handsome and had beautiful things in it, but it was primarily a teaching museum for archaeologists. It wasn't really a true museum of art. So, despite all this early art activity and its primacy as an art center and all these various repositories of art of one kind or another, Philadelphia didn't really have a true museum of art until after 1930, when the collection moved out of Memorial Hall into a new building and the name was changed to the Philadelphia Museum of Art and fine art triumphed over applied art at last.

Nowadays the Philadelphia Museum of Art is most certainly a full-fledged museum of fine arts. The status of the other two legs of Philadelphia's museum tripod is still ambiguous. Between the three of them the history of art does get pretty well covered, ancient and modern, foreign and domestic, but not in the full, unified, and central way in which the Met and the BMFA cover art in their respective cities.

Chapter V

i

NEW YORK, BOSTON and Philadelphia may have dominated the world of American art in the nineteenth century, but they certainly didn't monopolize it. Buffalo, New York, for instance, had an art museum of a sort as early as 1862, about a decade before the other centers; and the city has been very proud of this fact, as well it might be.

The beginnings of the museum in Buffalo (now called the Albright-Knox after two later donors of buildings) began in the most typical possible way. A local artist named Thomas Le Clear and a local art dealer named Josiah Humphrey organized an exhibition of art in 1861. Like so many American first exhibits of art, it was a great success. According to a pleasantly ironic description of the time, "American Hall was engaged, draped and somewhat inartistically extemporized into an art gallery. . . . Portraits of old citizens were borrowed, artists at home and abroad were asked to contribute, and as a result the hall was strewn with a collection of works of art. Men of influence were quietly smuggled in and requested to say a kind word for the exhibition. Ladies of taste were asked to lend the light of their countenances

to the doubtful enterprise." It was all so exciting that everybody decided Buffalo must have a regular permanent museum of art. Of course there were no pictures, no building, no money; but these little deficiencies, as in the case of the Met, could no doubt be easily remedied.

An official inauguration of the enterprise in December 1862 brought out ex-President Millard Fillmore, a name to conjure with. He presided over the ceremonies and a local bard read a dedicatory poem "with telling effect." Poppenburg's Band furnished music for a large, but naturally "very select" audience. The outstanding pictorial hit was a great Bierstadt marine, still (or once again) on display in the 1970s. Since the Buffalo Academy, as it was then called, owned no pictures and since the New York dealer, for whom Humphrey was acting as agent, demanded the return of the works on loan, the men of influence and ladies of taste had to create a fund out of which eleven works were immediately purchased. One of William Page's sensual versions of Venus, as of 1864, caused much controversy.

By 1871 excitement had subsided and the Academy was nearly defunct. However a timely gift saved it; and though by 1900 the Buffalo Academy could not rival the Met, it did still exist as a museum, even if it was still in rented quarters. And it was still older than any true big-city American art museum except the Hartford Athenaeum.

An elegantly Neoclassic building by the local architect Edward B. Green, built in 1902–1905, declared the coming of age of the Museum. This was its first permanent home. A new modern wing, or rather companion building, was built in 1962, balancing the old (Albright) with the new (Knox) to form what is today one of the most charming museums in the country. And one of the oldest.

ii

The history of the Gibbes Gallery in Charleston was, as appropriate to that storm-struck and romantic city, by no means as fortunate. The Carolina Art Association was formed in 1857 to give an exhibition in 1858 with the eventual idea of establishing a permanent gallery. To that extent Charleston foreshadowed developments in Buffalo. Three exhibitions were held in Charleston, in 1858, 1859, and 1860, and they were completely after the model of the Pennsylvania Academy's Annuals of that time — a mixed bag of loaned Old Masters, modern Europeans, and Americans with an emphasis on local talent. The same roster of Great Names appeared as in Philadelphia: no Raphaels or da Vincis or Rembrandts, but those favorites of the period, Snyders, Teniers, and Wouwerman; Greuze, Largillière, and Watteau; A. Carracci, C. Dolci, G. Reni and S. Rosa. These were all loans from the

town houses and plantations of Charlestonians. A few pictures were for sale, and a few canvases belonged to the Art Association, most notable of which were a picture by native Charlestonian J. B. Irving, of which the full title read *Sir Thomas More on his Way to Execution Takes Leave of his Daughter Margaret Roper, Who Has Met Him at the Entrance of the Tower of London*, and an equally proud possession, a picture by Leutze especially commissioned by the Art Association, the title of which reads *The Flag of South Carolina Rescued by Sergeant Jasper at the Battle of Fort Sullivan on the 28th of June 1776. Off Sullivan's Island Are Some of the British Men-of-war, among Them Sir Peter Parker's Flag-ship, the 'Bristol' of Fifty Guns, Swinging Round.* (In those days it often took longer to read the title than it did to look at the picture.) The Association felt it had its money's worth. There is a statue to Sergeant Jasper on the Battery in Charleston and another one in a square in Savannah; but Leutze's masterpiece no longer memorializes him.

The American painters represented in the exhibition ranged from Stuart, Copley, and West to Moderns like Doughty and Paul Weber of Philadelphia and Vanderlyn and Huntington of New York. Native son Allston was represented, but Thomas Sully bore the crown with no less than seven pictures, more than any other artist. Some dozen Charlestonians, of whom George W. Flagg seemed to be most popular, were hung, including Mr. Irving of the More picture. Charles Fraser, the miniaturist, and Thomas Wightman were others in evidence then that are still in evidence at the Gibbes now.

The most mysterious pictures exhibited were a selection of sixteen belonging to a Mr. Pickering Dodge. They were rather minutely described in the first catalog of 1858 as ranging from Roman and Byzantine works through sixteenth-century Italian. In the catalog of 1859 they are listed as "Removed by owner." Dodge was a native of Salem, Mass., who had married the daughter of Samuel Gilman, Charleston's best-known Unitarian clergyman and author of *Fair Harvard*. Dodge had acquired his pictures during a diplomatic tour in Italy and brought them down with him to Charleston when he married there. Perhaps he had an intuition that 1859 was a good year to pull out. In any case he left, taking his pictures; and all but a few seem to have disappeared. The only two other such collections of Italian Primitives on view in the United States in that period were those now-famous ones of Jarves and Bryan. Charleston, perhaps without realizing it, was way ahead of its time. We know what happened to the Primitives of Bryan and Jarves, but what happened to those of Pickering Dodge? If they were genuine and if they survived, where are they? Two of them, bought in Washington from a descendant by Larz Anderson, are now in the house-museum of the Society of the Cincinnati there. Three others

have been glimpsed by living personal friends of this now-defunct descendant. That leaves eleven unaccounted for. It's a nice mystery.

It was probably very fortunate for the Dodges that Pickering took his pictures away. In 1861 a fire totally destroyed the Art Association's building. Only one of their own pictures was saved, Irving's *Sir Thomas More*. They lost their Leutze. Then came the war. It wasn't until 1879 that the Art Association revived and began to put on exhibitions again in rented quarters. In 1888 James S. Gibbes left money for an art building. This was built and opened in 1905. It remains Charleston's art museum, the Gibbes Gallery. If you count back to 1858 (or 1857), it's one of the older museums in the country. It also contains some of the oldest pictures painted in the United States, the delicate portraits of that genteel lady in distress, Henrietta Johnston, who supported her family by painting them in the first decades of the eighteenth century. The ancestors limned a bit later by the itinerant Swiss Jeremiah Theus are also there in pop-eyed state, along with the miniatures of Fraser, two fine Sully portraits of Robert Gilmor, the Baltimore collector, and his wife, and various other canvases, including a Doughty and a Haseltine. The Gibbes is almost more of a Charleston historical collection than an ordinary museum of art, which gives it the very special charm and cachet that tends to adhere to everything in the city. Like every other museum in America, however, it plans to build a new wing, which may possibly change its character.

Charleston's upstart neighbor to the south, Savannah, also has one of the country's older art museums. If it had been started in 1875 as scheduled, it would be a rival of the Met and the BMFA in primacy, if not in richness of collections. Actually it didn't open until 1886.

Its story goes back to 1818, when the Telfair family built a beautiful and intriguing Regency house on one of the city's innumerable squares. The house was designed by a young English architect of genius named William Jay. In 1875 the last of the Telfairs, a formidable maiden Miss Mary, died, spreading her fortune around to charities and leaving her house, furniture, and a tidy sum to start an Academy of Arts and Sciences in the city of Savannah. Mary had already seen to it that the Georgia Historical Society was housed in a fine new edifice called "Hodgson Hall" in honor of her late brother-in-law. The Academy was to be in honor of the Telfairs, and no doubt about it. House and contents were left specifically on condition that a plaque be put on the front steps with "the word TELFAIR . . . in larger letters" than the words "Academy of Arts and Sciences."

There was one hitch: various remote descendants of earlier Telfairs, relatives with whom Miss Mary was not "on terms of intimacy," sued. The first court supported the claims of one group of relatives; the Supreme Court of Georgia reversed the decision in favor of another

group of relatives on the grounds that Miss Mary was the victim of "monomania" in giving all her money away like that. Finally the U.S. Supreme Court ruled in favor of the original will, and in 1883 Savannah not only got the house and all the original money, but forty-seven thousand dollars' worth of interest that had accumulated during the suits. The house was remodeled and finally opened to the public in 1886. Jefferson Davis was among the first visitors. The first gift to the museum, way back in 1880 before the lawsuits were even settled, was the replica of a statue of a Confederate soldier.

The museum was under the jurisdiction of the Georgia Historical Society. The President of the Society, General Henry Jackson, poet, orator, and lawyer, and his two Vice-Presidents, also Confederate Generals, were nonplussed. Though more than competent to handle matters of history, genealogy and literature, they knew nothing about art. There seemed to be no artists at all in Savannah at the time and not even any art connoisseurs. Luckily at this juncture a determined Teuton portrait painter named Carl Brandt came along. He took charge as Director from 1883 to his death in 1905. It was he who remodeled the house to make a museum of it, filled it with casts and German Salon pictures, many of them Brandts, and kept the place open and tidy, if not exactly abreast of the times. Brandt despised both American and French art, so as a result there was almost none in the Telfair.

When Brandt died, though there were Curators to succeed him, the real genius of the place was the Detroit-born artist Gari Melchers, constant exhibitor at the PAFA Annuals and friend of most of the advanced American artists of his day. He had married a Savannah girl, and he got all his friends to sell their pictures cheap to the Telfair. As a result the museum has an increasingly valuable and delightfully fresh and colorful collection of American Impressionists and Ash Canners — artists like George Bellows and Gifford Beal, the Eight and the Ten and various obscure but charming Europeans of a similar sort. Melchers died in 1932 and since then time has more or less stood still at the Telfair. The effect of the original Telfair mansion is preserved in two great rooms full of furniture and portraits. There's a fine collection of silver made in Savannah in the 1820s by Frederic Marquand, brother of Henry of the Met, considered the best surviving work done in the city. The house itself in its very odd, very English way is a monument all its own.

In an introduction to the first number of the first volume of the journal of the Georgia Historical Society (1917), there is an exordium on the Society's own Hodgson Hall that could equally well apply to the Telfair Academy. "In a commercial, not to say sordid age, there exists here in our midst alongside the great stream of business, politics, and social riot, more or less frivolous and vulgar, a peaceful, placid little

realm, sequestered for the resort of quieter and less material pursuits."
The Telfair is no longer under the jurisdiction of the Historical Society, but it remains a sequestered resort, remote from social riot.

<div style="text-align:center">

...

iii

</div>

Of the older Eastern Seaboard cities, Washington and Baltimore are now among the richest esthetically. Though by now Washington has become, next to New York, *the* great repository of art in America, for a long time it was definitely a "provincial center." In fact Baltimore and Washington have curiously parallel histories. Both began very early, before the Civil War, to plan and project museums. Both contain the very earliest museum buildings surviving in America. Both owe much of their art to private collectors endowing private museums of their own to hold their own private collections. And both failed to get full-fledged all-around public art museums until quite far on into the twentieth century.

Baltimore, as is appropriate to the older city, began first. Its Peale Museum, started by C. W.'s most successful son, Rembrandt, began in 1814. Collector Robert Gilmor was incidentally and appropriately its first President. A handsome building, looking rather more like a city mansion than an institution, was built and there was exhibited one of the two "mammoths" dug up in New York State by indefatigable C.W. along with various other specimens of natural history, the usual series of portraits of Heroes by various Peale hands, and an especially extensive gallery of paintings by Rembrandt Peale himself. Because of this, the Baltimore Museum was in a way more truly an art museum than the parent institution in Philadelphia.

The year 1814 was a very poor time to start anything in Baltimore, since the British were about to attack the city. To make matters worse, Rembrandt Peale was a very decided and conspicuous pacifist and conscientious objector. The War of 1812 was very unpopular with some and aroused great conflict, especially in Baltimore.* There were violent antiwar protesters and violent counterprotesters. A Baltimore mob tried to lynch an antiwar editor and in the process crippled and nearly killed Light-Horse Harry Lee, the father of Robert E. Lee. Rembrandt was not lynched, and in fact seemed to suffer no retribution; but being unpopular politically was no help to his Museum. The shaky financial basis of the enterprise, which involved heavy debts and high interest, started the Peale Museum off with what proved an insurmountable

* Incidentally, in this war it was the conservative, pro-British Federalists who were so belligerently antiwar.

burden. Nonetheless, Rembrandt persisted. The Museum, like so many others, was successful at first. Rembrandt, always a tinkerer like his father, got interested in gas lighting, installed it in the Museum, and helped found what is now the Baltimore Gas and Electric Company. But like most Peales, Rembrandt was a poor businessman. He was forced out of his share of the gas company, lost all his money, and got fed up with the Museum and turned it over to his brother Rubens.

Desperate attempts were made to attract the public. Signor Hellene, the one-man band so popular in Philadelphia, played in Baltimore, too. Live animals as well as stuffed ones were exhibited, even a rhinoceros, so that the Museum was the city's first zoo. The eagle got loose and was eaten by the tiger. Rembrandt concentrated on touring exhibits of his great gloomy canvas *The Court of Death* and recouped his fortune. Rubens gave art exhibits in the Museum from 1822 to 1826 but had to evacuate the original Museum building in 1830 and close for good in 1833. He retired to rural Pennsylvania and finally in his later years took up painting, like all his brothers and sisters and cousins and uncles and nieces and nephews. A Baltimore brother-in-law named Alexander Robinson did everything in his power to prevent all this disgraceful art activity from tarnishing the family respectability, and eventually debt, opposition, competition and loss of interest on the part of both public and Peales brought Baltimore's first Museum to an end.

The building, not America's first but by now America's oldest museum building, became Baltimore's first City Hall. When the new City Hall was built opposite, the old Peale building deteriorated, was almost torn down as a derelict, then was rescued and charmingly remodeled. It is now packed with Peales — Charles Willson, Rembrandt, Rubens, Raphaelle, Sarah Miriam, and others. In fact, Maryland is knee-deep in Peales, both at Annapolis and in every Baltimore institution.

About the time the Peale Museum was collapsing, another quasi-artistic enterprise was founded in Baltimore. This was the Maryland Institute of the Mechanic Arts. It was launched in 1826 as a school of design similar to that attached in 1876 to the Pennsylvania Museum. It had nothing to do with fine arts originally and had no museum. But in 1851 the Institute got a splendid new building with a big exhibit hall, and, as always, the fine arts crept in. Before long the Institute found itself exhibiting pictures and especially statues (Baltimore has always been strong on statues and was nicknamed the "Monumental City") as well as machines and designs. Then in 1857 along came Mr. Peabody with his various curiously scattered beneficences. He'd spent a good deal of his earlier life making money in Baltimore and was duly grateful. His institutes elsewhere were purely scientific, but in Baltimore three of the arts, the musical, the literary and the visual, got a helping hand. A magnificent library was built, still very much in use though

now operated by the city, a conservatory of music was started and still flourishes, and an art gallery was opened. The art gallery was quiescent for years; but after 1873 it became a place of exhibit for contemporary American art, though it was not strictly a museum. However, it began to develop a permanent collection of painting and sculpture of its own from gifts and purchases, and when it closed in 1924 it had a sizable cache of American and a few bits of European art on its hands.

Meanwhile, much like Mr. William Corcoran in nearby D.C., Mr. William Walters in Balto. began to form a private art collection. He too began with pre–Civil War Americans. He too took a vacation in Europe as a Southern sympathizer during the war. He too returned to America a convert to Modern Art. But, unlike Mr. Corcoran, he did not build a gallery or open it to the public. He hoarded his art and gradually the collection went in for higher things — Old Masters, Medieval manuscripts, Oriental art, ancient sculpture and artifacts. His son Henry continued the collection and built a special gallery to hold and exhibit at least some of the increasingly marvelous hoard. It was open to the public for a few weeks each year. Not much, but still there it was; and everyone knew it was there and hoped someday it would become a museum for the city of Baltimore.

But still the city of Baltimore had no museum. When people wanted to leave their collections, the old problem faced by Luman Reed and others arose: Where? George A. Lucas, for instance, a friend of Mr. Walters, also went to Paris during the Civil War. He was so seasick he swore he'd never cross the ocean again. He stayed in Paris, became an expert on modern art, helped Walters with his collection, and made a collection of his own. He became a personal friend of almost every competent artist in the city, some of them now immortal, and bought their pictures, often right from their studios. When he died in 1909, he left his collection to his friend Walters. Walters didn't want it and presented it to the Maryland Institute, by then a regular art school. The Institute didn't want it and presented it to the new Baltimore Museum of Art, which got started in 1914, opened in 1923 in a residence on Mt. Vernon Square, and eventually in 1929 moved into a fine new building in Wyman Park.

When the Peabody Gallery finally closed down, it turned over its collection to all these various art agencies, especially the Museum, the Maryland Historical Society, and the Maryland Institute. The Museum and the Society have kept and even exhibited some of their Peabody pictures; but the Institute seems to have just lost theirs. Since all earlier American art is now rapidly increasing in value, the Peabody and the Institute are both busy trying to find this collection; but neither of them permanently exhibits art anymore.

Not until the Museum moved into its building in 1929 and settled

down properly with its Jacobs and Epstein collections of Old Masters and its Cone Collection of modern masters, not until Henry Walters in 1931 at last left the Walters Collection to the city and the public, did Baltimore actually have a proper big-city art museum. It now has two. But for all these earlier efforts it took a long time, and Baltimore was really much later than many younger and smaller cities in getting established as a true center of art. Its museum story properly belongs to the twentieth rather than the nineteenth century.

iv

The story of Washington's museums would seem to be the exact opposite of the story of Baltimore's. Yet Washington, just like Baltimore, didn't really have an all-around proper collection of public art until the twentieth century; and much of its nineteenth-century art history seems to be, like that of Baltimore, a tale of bumbling, ineffective good intentions.

One John Varden started a typical Peale-like museum in Washington as early as 1829 — curiosities, some art, the usual stir of initial success dying into eventual failure. In 1840 something called the National Institute was founded in expectation of taking over the management of Mr. Smithson's bequest whenever Congress got around to accepting it. In eager anticipation, they acquired a vast amount of scientific bric-a-brac as well as a nice small nucleus of pictures, mostly portraits and a few odd art items from Varden's Museum, notably a *Turkish Battle Piece*. The Institute established itself in the brand-new U.S. Patent Office Building. Whatever paintings the Government had managed to collect were also put there.

The National Institute, however, was disappointed. The Smithsonian decided to run itself without benefit of Institute, and the Institute withered away. Its collection (Stuart, Peale, Copley, and Healy) stayed in the Patent Office till 1862. The Institute then disbanded and some of the pictures came to the Smithsonian; but not, alas, all. A few of the most valuable ones, the Stuarts especially, seem to have "vanished," like some of the Peabody collection in Baltimore.

Meanwhile the Government and the Smithsonian made a great to-do about patronizing the arts. A big art gallery was part of the original plans for the Smithsonian's new building. As early as 1847 lots of fuss was made about buying George Catlin's Indian collection, but in fact nothing was done. Two other collections of paintings of Indians, those of Charles Bird King and John Mix Stanley, were in fact acquired and hung in a large upstairs gallery in the new building, Renwick's Romanesque fantasy, in 1858. Some of the stuff from the Patent Office,

with some further additions, was hung downstairs. Most of these works, like the collection of the National Institute, were portraits, but there was a Ribera belonging to Dr. Robert Gibbes of South Carolina and a Dutch picture of cows that had belonged to Smithson.

Then in 1865 there was a terrible fire at the Smithsonian and almost all the collection, especially the Indian group, was destroyed. Lucky that the Institution had not in fact bought the Catlins or they would have been destroyed, too.

After 1865 the Smithsonian seemed to more or less give up. It had to start all over again, since the remodeled building was entirely taken over by science. As soon as the Corcoran started in 1874, the Smithsonian, with relief, deposited its remaining paintings and sculpture there and lent its prints and drawings to the Library of Congress. Copies of the Indian pictures had been put in the Peabody Museum in Cambridge, Massachusetts. There they still hang, ethnology, not art.

Until 1896, when the Government began to recall its deposits from the Corcoran and the Library of Congress, the Smithsonian for all its good intentions and high-toned oratory had really done nothing to establish the National Gallery or the National Collection of Art that the founders had projected.

Though Mr. Corcoran's rebel sympathies did delay the opening, his museum, started in 1859, incorporated in 1870, completed in 1871, was finally on view in 1874, and in a fancy building indeed, although already old-fashioned by the standards of, say, Frank Furness. In this building, also designed by the same James Renwick who did the Smithsonian's Sir Walter Scott castle, were displayed Corcoran's by-now also old-fashioned American paintings. However, the Corcoran had money and it made up for lost time by quickly buying Art Treasures. Soon the Salonistes joined the Nativists. By 1890 the collection was one of Modern Art representing the tastes of two antipathetic generations. There were also a very few Old Masters (J. Breughel, A. Canale, Murillo, Reynolds). As the only true art museum in the nation's capital throughout the rest of the nineteenth century, the Corcoran had a reputation that perhaps somewhat exceeded its deserts. The museum moved into a new imposingly marbled building in 1897. However, even by the standards of 1900, it was hardly a properly representative big-city museum.

The Corcoran, like the PAFA, inaugurated a series of exhibits of contemporary American art and bought items exhibited, thus keeping up with the times. But it was not until two decades later, in 1925, when Senator William A. Clark from Montana left the Corcoran more money and his collection, that the museum could really be said to have arrived. The Clark collection was full of Old Masters, some very fine, though the total effect has always been a bit musty. Thereafter, till the

arrival on the scene of the new National Gallery, the Corcoran repre-
sented art in Washington and could be considered one of the nation's
oldest all-around art museums.

<center>

v

</center>

In 1906 the Smithsonian got possession of a bequest from Harriet
Lane Johnston, a niece of the only Pennsylvania-born President,
bachelor James Buchanan. She had been his hostess in the White
House, traveled much abroad, and collected a small group of Old
Masters. This was the real beginning of what is now the National
Collection (as distinguished from the present National Gallery). This
bequest and some later ones inspired the Smithsonian in 1910 to move
all its pictures into the big North Gallery kerneled in the center of the
huge Museum of Natural History — moderns and ancients, Old Mas-
ters and Americans. There they constituted, as a rival to the Corcoran,
what was *then* called the National Gallery.

So until Mellon came along, Washington in the early twentieth cen-
tury had about the same establishment of museums as Baltimore did
after 1930: two separate galleries, each with Old Masters and Moderns,
one entirely private (Corcoran, Walters), and one mostly publicly
supported (Smithsonian, Baltimore Museum). In neither case had a
true museum been developed until much later than in cities like Cincin-
nati or Chicago. Philadelphia in its tripartite way seems more akin to
its southern neighbors.

When what is now called the National Gallery opened, still under
the auspices of the Smithsonian, as World War II was about to begin,
the Corcoran and the Smithsonian's older collections both became
somewhat obsolete. Neither museum could expect to compete with the
fabulous Old Masters of Mellon, Kress, and Widener. The old National
Gallery changed its name to the National Collection. Eventually in the
1960s it moved out from among the dinosaurs and habitat groups of the
Natural History Museum and into beautiful new quarters in the same
grand Doric-columned old Patent Office Building at F and Eighth
Streets where the National Institute had begun. It now revels in vast
marble reaches and red carpets and concentrates hard on American art
since 1870 — right back where it started from.

As for the Corcoran, it also has been forced back to its origins. Mr.
Corcoran's taste has been vindicated and his pictures reevaluated. The
museum is proud to own and show one of the finest pre–Civil War
selections of American painting in the country. With the revival and
remodeling of its first gallery, open now as a museum of arts and crafts
under the joint auspices of the Corcoran, the Smithsonian, and the

Cooper Union of New York, even the Salonistes have come out of hiding. Though the individual pictures don't seem very compelling, the total effect is certainly gorgeous.

In the great welter of esthetics that characterizes Washington now, the Corcoran Gallery and the National Collection seem rather like still, small voices from the past of the city's art history, but clear voices just the same. In fact, no one interested in American art can afford to miss either of them. Historically, they represent two of America's older collections, and in the case of the Corcoran, one of its oldest art museums. What the Smithsonian should do is concentrate the city's collections of American art. Taking over the Corcoran, it should put all the pre–Civil War works there and give the Clark collection to the State of Montana. All the art from 1870 to about 1945 should be in the Patent Office, especially those Whistlers locked up in the Freer. The Hirshhorn should be the chief repository of art from 1945 on. The various American paintings now at the National Gallery should be divided between Corcoran and Patent Office. There are of course a few legal obstructions. As it is, American art is frustratingly scattered all over Washington.

Chapter VI

i

THE PHENOMENON of the college art collection, the teaching museum, is peculiarly American. England, as exemplified by the Ashmolean at Oxford, had shown the way, but the continental European universities, most of them founded in cities already rich in art, have not as a rule seen the need for museums of their own. The Amerbach Kabinett was turned over to the University of Basel, but that was rather a matter of storage than of patronage or instruction.

America, on the other hand, has now over a hundred college art museums and they increase almost daily. Most of them, like their colleges, are not in art-rich cities but out in the art-poor countryside. But urban or rural, colleges, universities, secondary schools, and art schools all now have their own museums, all intended to be "teaching museums," not just public galleries.

The great thing about the teaching museum is that it is relieved from the necessity of having to collect masterpieces. "Representative specimens" will do, even if excellence is preferred. On the other hand, the average college museum usually feels it has to cover the whole range of

art and design. The result is that many college museums tend to suffer from being too widespread in their efforts at universal survey and too economical in their purchase of representative specimens. Hopes therefore should not rise too high in the breast of a visitor to the average institutional museum. Art yes; masterpieces no. Be grateful for small but numerous blessings.

Fortunately there are enough exceptions to prove the rule. Though none of the teaching museums is a giant, some of them are gems, especially, but certainly not only, those at the older Ivy League and Seven Sister colleges, where the museums tend to be not only very good but comparatively ancient. Yale, Princeton, Harvard, Vassar, Smith, and Wellesley all now have fine museums housed in fine buildings. They offer not only coverage but excellence. Bowdoin and Oberlin are in the same league. The Rhode Island School of Design museum in Providence is in another league; for though it is true enough a teaching museum attached to an institution of learning, it is also the city museum. The list of other perhaps lesser excellences is endless. Ball State Teacher's College (as it used to be called) in Muncie, Indiana, has a surprising cache of Old Masters, as does the not far distant Notre Dame. Bob Jones University in South Carolina has probably the best group of Benjamin Wests in America and many other prizes. The Universities of Kansas, Georgia, Michigan, Arizona, California, Miami in Florida, and many more all have good galleries, some older, some newer, some ranging the whole field of art, some, like the University of Georgia museum, specializing in one area (American in Georgia's case). The indefatigable museumgoer could spend a full and busy year just traveling about the country looking at every such scholastic art gallery — beginning, of course, with that of the Pennsylvania Academy, which is after all primarily a school, and Yale, both of them oldest of their kind in the country.

Several of these museums claim to have been founded back before the Civil War. The one at the University of Michigan, for instance, flaunts the date 1845; but this does not mean for a moment that a great columned art building flung open its doors in that year. All it does mean is that the founders of the university began to collect "specimens" in some tentative, idealistic, heterogeneous fashion. Only a handful of the university museum collections, like those of Yale and Bowdoin, truly go back before 1870. Some others date between 1870 and 1900. The vast majority came into being, in any formal sense, only after that. It is in this area of the college museum in fact that the post–World War II museum has been expanding most busily. Every year a brand-new branch of a state university sets up a brand-new art center and starts hanging pictures. For instance, the University of Wyoming opened a new art center in 1972.

ii

After Yale and Bowdoin, perhaps the most ancient of superior college museums is that of Vassar. The museum there is unique in that it was founded at the same time and by the same person as the college. Matthew Vassar considered art education a suitable function for his Female Academy. So in 1864, before New York or Boston had true art museums, Matthew Vassar personally went about creating one for his college.

Matthew Vassar, who made his money by an unlikely combination of brewing and whaling, both based in Poughkeepsie, New York, on the Hudson, and who was a classic rough diamond and self-made man, determined that his females would get art in the original, not just in reproduction. To this end he formed an art committee whose chief ornament was Samuel Morse, a trustee of Vassar, by that time a telegrapher, not an artist. Morse and his committee carried on the tradition of art prose by writing a deliciously flowery report stating, "the first miracle of beauty on which man was made to gaze was the magnificent naturalness of Eden," and "a brain . . . finds that the build of a mountain, the bend of a billow or the sheen of a lake are one with the rules that should fashion the essay, oration or sermon." What this obviously was leading towards was a collection of Hudson River masterpieces by members of Morse's own National Academy of Design; and that's just what Vassar got. Elias Magoon, clergyman and art fancier, had a collection of this kind, and Matthew Vassar bought it as the cornerstone of his Academy's museum. It was displayed in a special gallery of his grandiose new building, and there females could absorb the lessons given by the bend of a billow to their heart's content. Some forty of these paintings from the Magoon collection (Casilear, Church, Cole, Cropsey, Doughty, Durand, including one of his called *Where the Streamlet Sings in Rural Joy*, still survive, as well as an equally precious and numerous group of English watercolors. The Museum is more than happy to own both groups now; but there was a while during which the Department hung its head in shame over Mr. Magoon's bad taste in American art and wished he'd not been so interested in the build of mountains.

There was a minor Old Master in the Magoon collection, but it wasn't till well along in the twentieth century that Italian Primitives and Baroque allegories and Chinese jades and eventually Moderns began to bolster the Magoons. Now Vassar has one of the more elegant and prestigious of university collections.

Smith College, Vassar's somewhat younger (1871) sister and rival,

also was lucky in getting a real museum with real pictures in it. Only six years after the opening of the college, a fund for the purchase of art was set up. An Eakins was the very first picture acquired. In 1881 a Northampton gentleman of means named Winthrop Hillyer gave money for an art building and for purchases. In that same year Dwight Tryon, one of the more successful landscapists of the American Impressionist School, came fresh from Paris to teach art at Smith and soon took over as Director. He in turn left money for a second building in 1925. Up to 1921 the museum specialized in American art. After that, under the influence of the next Director, Alfred Vance Churchill, Smith began to acquire European art, mostly French. Now the college has a third building (1973) with many of the older pictures still in it and a choice small universal survey collection. This fortunately continuous story of art possession, teaching, and exhibition, though it began later and more modestly than the story of art at Vassar, has achieved somewhat the same character of selective elegance and modest richness. No clump of Hudson River artists distinguishes the Smith collection, but rather a splendid group of French Romantics, Impressionists, and Moderns precociously acquired by famous Director Churchill in the 1920s.

The point of Yale, Bowdoin, Vassar, and Smith is, historically, that they actually had pictures and actually exhibited them in an actual gallery before 1900. Many another college museum, though it can and often does dig up an early "date of foundation," will be found on examination not to have had anything much in the way of art or art facilities. A typical example might be that of the University of Illinois. As early as 1876 John M. Gregory, first Regent of the University, went abroad and came back with two hundred and fifty casts. These were installed in University Hall, and that was that until a College of Fine Arts started up in 1931. Now the University has its lovely modern Krannert gallery full of prestigious pictures. What it can't (and doesn't) claim is a founding date of 1876.

In 1888 a big picture called *The Wise and Foolish Virgins* by German Saloniste Karl von Piloty was shown to the public in the post office of pioneer Lincoln, Nebraska. The officiating body was a local organization called the Haydon Art Club and the excitement was intense. Farmers streamed into town to take a look. Special trains had to be run from nearby communities. This was the first of more or less annual shows put on by the Haydon and its successor, the Nebraska Art Association. By now this has all resulted in a rich collection of American art in a splendid building, the Sheldon Gallery of the University of Nebraska. Though 1888 will certainly do as a date of foundation and a painting was actually bought from the first annual (a second one not till 1896), purchases didn't really begin in earnest till after a Hall

bequest of 1928. The true permanent collection or museum is of still more recent vintage.

Washington University in St. Louis had an art school beginning in 1879 and a gallery from 1880. However this is all background history for the City Museum. The present museum of Washington University is a later and separate development. On the basis, however, of its first museum, Washington is ahead of both Harvard and Princeton; but they too both began the serious collection of art and opened real museums before 1900. As early as 1882 Alan Marquand, son of the Met's President, Henry, came back to Princeton, where he'd been an undergraduate, to instruct in art history. A certain William C. Prime wanted to give his ceramics to Princeton, so in 1889 a piece of brown brick building featuring a stately arched doorway and high steps — and nothing much else — was erected. It was never finished but it did house the Prime potteries and other objects (Greek vases and good prints left by Junius Morgan, nephew of J.P., and items of Cypriote antiquity from the Cesnola collection given by Alan Marquand in 1890).

Like all museum buildings, the one at Princeton rapidly became cramped. For decades the gradually increasing collections of art objects had to be stored in cellars and rotated in the few galleries of the truncated Chinese-Romanesque middle section of what was to be, and never was, a considerably larger edifice. Finally in 1966 a new building on the site of the old one was opened and under the expert direction of Patrick Joseph Kelleher the University was able to begin showing what years of modest acquisition had accumulated. Now the museum is generally recognized as one of the more important universal survey teaching museums in the country.

Harvard suffered by being in the shadow of the Boston Museum of Fine Arts. The Gray prints that Harvard didn't know what to do with had been one of the reasons for the founding of the Boston Museum in the first place. Nonetheless the University found itself suddenly the recipient of a gift from a widow, Mrs. William Hayes Fogg. She left her fortune, acquired in New York by her husband, to Harvard to found a memorial art museum. Fogg wasn't a Harvard graduate, indeed had no known connections with Harvard or Cambridge or even Boston. Nobody seemed to know much about him except that his widow's lawyer was a Harvard graduate and used his influence. Rather reluctantly, one can't help but feel, the University built a building, opened in 1895, and installed as director an expert on Gothic architecture, Charles H. Moore, who evidently considered his position a sinecure. The Gray prints were brought back from the Boston Museum of Fine Arts so that there would be something to put in the new building.

Under the influence of that ineffable snob, Charles Eliot Norton — who found American shadows, much less American sunshine, unbear-

ably crude — a good collection of English watercolors had been got together, as well as a few Ruskinian Italian Primitives. A group of Greek vases was loaned by Ned Warren. The Italian Primitives had been collected by the future Director, Edward Forbes, then just out of college. After the 1895 opening, the Museum persisted in what certainly sounds like dingy dimness until 1909, when Forbes became Director. A new order then began and he soon turned his comparative sow's ear of a gallery into a silk purse. By now it is generally recognized as being one of the two leading college museums of the country (Yale being the other one).

The most likely later rival of these earlier teaching museums would certainly be the Allen Memorial at Oberlin in Ohio; but it is almost entirely a twentieth-century creation. True, the University did receive a Ming vase, the first donation, in 1894; but the collection actually began in 1904 with the Olney bequest, pictures of "uneven merit" (that usually means Salon art and dubious Old Masters) that stayed in Cleveland till 1908 and then were installed in the Carnegie Library until 1917, when the Allen Memorial, built by Dr. Allen's widow, was finally opened. So in fact Oberlin doesn't join that choice group of collegiate pioneers that can point with confidence to a real art museum opened and functioning in the nineteenth century.

As might be expected, New England, the wellspring of American education, has been the area of "first" and "best" and even until recently "most" college museums. Mount Holyoke, for instance, claims a museum dating from 1837; but 1901, when the Dwight Art Memorial opened, would be more accurate. Wellesley had a Farnsworth Memorial in 1889, but a true art museum wasn't started there until the first Director, Alice Van Vechten Brown, took over in 1897. She gradually built up the collection, especially the Classical Department, to its present eminence. It is all now housed in the Jewett Arts Center (1958).

The West Coast has probably now taken the lead in numbers of college museums. At least one dates before 1900. Way out there at the end of the railroad, Stanford University, founded by Senator Leland Stanford of California in memory of his beloved son Leland, Jr., who died in 1884 on a grand tour of Italy, included an art museum from the very beginning in 1891. Some items collected by Leland, Jr. himself were and are on display* as well as things acquired by his parents, including Cypriote items from the Cesnola collection.† The museum has been from the start a mixed bag of archaeology, ethnology, and art. It was destroyed by the earthquake in 1906, along with much of its

* These included a porcelain model of Leland, Jr.'s last breakfast, complete down to simulated fried eggs. It was thought to be reminiscent of da Vinci's *Last Supper*.

† It would be interesting to know how many different museums — Albany, Boston, Stanford, Princeton — have such Cesnola items.

contents; one-third of the some five thousand Cesnola pieces Stanford bought from the Met in 1896 got damaged. The main part of the building was restorable, and it still stands as one of the older college museums in the country.

Despite these various exceptions, the university gallery in America is on the whole a modern accomplishment, though certainly a Victorian conception. The true development parallels the Golden Age, that great burst of museum patronage and building that took place in America between 1900 and 1945. The earlier history of the college museum is curious but, like the Fogg in early days, rather dim.

BOOK III

Westward the Course

Chapter I

i

ONE OF THE MOST significant developments in the history of the art museum after 1870 was the sudden emergence of museums west of the Alleghenies. It would be difficult to overestimate the importance of this happening in American cultural history. Though many of the Midwestern art museums were founded after 1900, some of the very best of them — Chicago, Cincinnati, Detroit, Saint Louis — were open and in business well before that; and this fact in itself is of interest. After all, the century or two of artistic life in Boston, New York, and Philadelphia might have been expected to result in the creation of museums of some sort at some time. But for a city like Chicago, barely grown to maturity by 1871 and then completely destroyed by a fire, to start planning a museum and a collection as early as 1879 does show a special brand of determination, imagination, and optimism. It also shows how vital the whole idea of the museum had become after the Civil War. Suddenly it was imperative that a proper city should have a proper art museum as a sign of cultural maturity. If the older cities of the Eastern Seaboard could do it, so could the newer cities of the central valley.

They could and they did — on the usual hopeless but successful American basis of no art, no artists, no collections, no buildings. Nothing but grit, taste (steadily improving), and lots and lots of money.

The more important city museums of midcontinental America spread westward in three "tiers" — lines or series east to west: a Northern or Lakeside Tier from Buffalo through Cleveland, Toledo, Detroit, Chicago, Milwaukee to Minneapolis; a Central or Overland Tier of Columbus, Dayton, Indianapolis, Des Moines, and Omaha; and a Southern or Riverside Tier, with Pittsburgh as its beginning and then westward through Cincinnati, Louisville, Saint Louis, and Kansas City. There are many other art museums en route, college museums, some of them, like that of Oberlin, more prestigious than many of the smaller city museums; special museums like the Butler Institute in Youngstown, which concentrates exclusively on Americans, or the Walker Art Center in Minneapolis, which concentrates on the contemporary; smaller museums of all sorts in smaller cities like Akron and Zanesville in Ohio, Evansville in Indiana, Davenport in Iowa, Muskegon and Grand Rapids in Michigan. But the important museums of the region are generally acknowledged to be these seventeen: *Northern:* Buffalo, Cleveland, Toledo, Detroit, Chicago, Milwaukee, and Minneapolis; *Central:* Columbus, Dayton, Indianapolis, Des Moines, and Omaha; *Southern:* Pittsburgh, Cincinnati, Louisville, Saint Louis, and Kansas City.

Some of these midcontinental museums are monsters, among the greatest in the country (Cleveland, Detroit, Chicago). Others are comparatively modest (Milwaukee, Dayton, Louisville). All of them are general, not narrowly specialized, and most attempt to cover the whole range of art in time from Egypt to the present, in space from America eastward around back to Japan, and in material from painting and sculpture through decorative arts, folk arts, and ethnology.

Besides Buffalo's venerable Academy of 1862, five others of the central area actually opened their doors in the nineteenth century: Chicago, Detroit, Cincinnati, Saint Louis, and Pittsburgh. Others were incorporated and organized before 1900 or had direct origins in local art associations or schools (Columbus, Indianapolis, and Minneapolis). Others belong strictly to the twentieth century.

As a spectacle of esthetic glamour, taste, civic energy, personal generosity, and above all swift accomplishment, there's nothing in the art history of this country or indeed the whole world to compare with the massive flowering of art museums in the Midwest. It's something that the region can look upon with almost unadulterated pride and the rest of creation with awe and amazement.

ii

The Art Institute of Chicago is generally thought of as the queen of these midcontinental museums. Its history, its building, and even some of its present collection go back before 1900. It is top-heavy with masterpieces of European painting, both Old Masters and Impressionists, and though its primary position in the Midwest has been seriously challenged by the Cleveland Museum, the Art Institute of Chicago safely ranks with the first half dozen city museums in the country. Its history seems to recapitulate the history of the Anglo-American museum in general. Yet the Institute certainly has a Chicago flavor all its own.

Two stories set the scene. One is a bit of dialogue from a play of the 1870s. When asked superciliously by an Eastern grande dame whether Chicago had any "culture," a native replies, "Well, ma'am, we haven't got much yet, but when we do grab it by the tail, we'll make it hum." The other tale is fact, not fiction, though perhaps also too good to be true. When Charles Hutchinson, President of the Art Institute, returned from Europe in 1890 with a treasure trove of Old Masters bought in Italy from the Demidoff collection, New York reporters quizzed him about them. What, for instance, was the subject matter of the pictures? Mr. Hutchinson opined (Americans at that date were always supposed to "opine") that that was too deep a question for a busy man to go into at the moment, but the reporter could certainly be sure the masterpieces were "corkers." Gotham art writers had a field day over the word "corker" and its connotations of Innocents Abroad.

However, the masterpieces of the Demidoff collection were and are corkers, and thirteen of them hang in the Art Institute to this day (Rembrandt's *Girl at the Dutch Door,* Hobbema's *Watermill**).

When Peale organized the Columbianum in 1794 and the Pennsylvania Academy of Fine Arts in 1805, Philadelphia had been an art center for nearly a hundred years. Still it is surprising that there were enough artists in the city to get together and quarrel at such an early date. It might seem more surprising in the Chicago of 1866, just after the Civil War, when the population had been barely thirty thousand in 1850. But by 1870 there were already almost three hundred thousand inhabitants, and presumably enough artists to combine and form a Chicago Academy of Design, modeled on the National Academy of De-

* Since there seem to be only five Hobbemas left in the Netherlands, the choiceness of this acquisition by the Institute compares with that of Marquand's Vermeer at the Met; there are nine of those at home.

sign in New York rather than the Pennsylvania Academy. The Chicago Academy was intended primarily to advance the careers of local artists, show off their works so they could be sold, and organize a school conducted by member artists. This organization suffered much the same fate as the Columbianum or the British Society of Artists, and for the same reason — the contentiousness of artists.

There had been the usual random sproutings of art before the Civil War, rather precocious ones considering Chicago's pioneer condition. When the artist George Healy first came to the city in 1855 high plank sidewalks caught at the crinolines of the ladies with exposed nail heads and tripped up unwary gentlemen. In between, the streets were seas of mud, crossed only by wobbly boards. Shacks grew up next to the mansions of the newly rich.

Exhibitions, some organized by a Chicago Art Union, took place in the 1850s. There was a notable show in 1859, contemporary with that of the Charleston Art Association. Various Sanitary Fair benefits were put on during the war. There was the emergence and subsidence of a Western Art Union and a Cosmopolitan Art Association after the New York examples. Healy had a one-man show in 1862 and various gentlemen of means, William B. Ogden, William Blair, Walter L. Newberry, were looked up to as art patrons. The artists they patronized were very obscure indeed, almost all of them portraitists.

A few names emerge. George Healy, in the mid-century between Sully and Sargent perhaps the most internationally celebrated of American portrait painters, settled for a decade in Chicago. Born in Boston in 1813, he went to Paris in 1834 and became famous almost immediately, painting King Louis Phillippe and other notables of Balzac's human comedy. With the collapse of the Bourbons, his French patrons were no longer in power and he was induced to come to Chicago by patron William B. Ogden, first mayor of the Windy City. Once there he had so much work that he nearly had a nervous collapse, and he left for a more relaxed Europe again in 1866. There he remained for most of the rest of his life, painting royalty again, in Rumania this time, and generally prospering. However, he always had a soft spot for Chicago, and in 1892 he returned to see the Columbian Exposition. He died there in 1894. He was not personally involved in the founding of the Chicago Academy of Design, but he gave it his blessing and some pictures.

Not as well known, but more actively involved, was Walter Shirlaw (1838–1909), whose name is still remembered as a founder and first President of the rebel Society of American Artists in New York in the late 1870s. He was born in Scotland and began his career in New York as a bank note engraver. He then lived for a while in Chicago as an employee of the Western Bank Note and Engraving Company and as a

practicing artist. He was secretary to the infant Chicago Academy of
Design in 1866 but soon left to study in Munich. Leonard W. Volk
(1828–1895), an upstate New Yorker, came to Chicago in 1857 and
stayed there the rest of his life doing busts of worthies. The worthiest
were Stephen Douglas and Abraham Lincoln. He made a good thing of
it, in that age so enamored of busts. He was the principal organizer of
one of the pioneer exhibits, that of 1859, and was a President of the
Chicago Academy of Design.

The Academy itself rented a gallery in a business building on Clark
Street and held an exhibit plugging the works of the thirty-five member
artists. Unlike most such initial exhibits, it was a flop, despite Healy's
gift to it of some of his pictures. The artists then all fought and the
organization dissolved. Undaunted, the artists reorganized immediately
with Volk as President and a group of self-appointed "Academicians"
like those of the PAFA. They opened an art school in 1868 under
Shirlaw, with casts, and the school did well. Then the Academy held
another exhibition (an "Annual" also) in 1868 with one hundred
eighteen paintings exhibited. They made four thousand dollars in
sales, and decided to incorporate that year.

In 1870 they held still another grand exhibition with a spectacular
reception attended by all of society; the chef d'oeuvre of the paintings
was Healy's large *Peacemakers,* a group portrait of Lincoln and his
principal military advisors, famous in its day. There were portraits by
Cogswell, Gollman, Pine, Pebbles, and other talents and even a few
landscapes. By now the Academy boasted a hundred members, a flour-
ishing school, a group of casts, and a lecture series on such subjects as
"What is Truth in Art?" Rosy success beamed on the infant endeavor
as 1871 began. Then everything was destroyed in the Great Fire —
school, casts, new building, everything.

Though feeble efforts were made to start up again, the panic of 1873
cut off support. The organization continued but could do nothing
without money. The artists squabbled and in desperation the board
appealed to a group of businessmen to help them out. In 1878 the
Academy was reorganized, but the businessmen on the board soon
found they could not work in harness with the quarreling artists. The
businessmen seceded in 1879, set up their own organization, and incor-
porated themselves as an Academy of Fine Arts. Not long after, the old
Academy collapsed and its effects were bought by the new Academy.
William M. R. French, brother of the sculptor Daniel, was the first
secretary; and after the brief presidencies of George Armour in 1879
and Levi Leiter in 1880–1881, young Charles Hutchinson took charge
in 1882 at the age of twenty-eight. In that same year the name of the
organization was changed to the Chicago Art Institute and under that
name and under that same direction of French and Hutchinson the

Institute survived and thrived till French died in 1914 and Hutchinson died in 1924 after more than forty years of service.

French, born in 1843 in New Hampshire, where his ancestors had been distinguished in the law, started life as a civil engineer. He moved to Chicago in 1867 and set up a surveying office there, but the combination of the 1871 fire and the 1873 depression were too much for him. He dropped surveying and took up lecturing on art. He became famous as a witty speaker who illustrated his talks with clever chalk sketches improvised to suit the subject matter. As of 1878 he was involved in the fortunes, or rather misfortunes, of the older Academy of Design as secretary before joining the seceders in the same capacity in 1879. As seemingly permanent Director of the Institute and great man of art in the city, he remained till his death a lively, opinionated, albeit increasingly old-fashioned presence on the city's cultural skyline.

Charles L. Hutchinson (1854–1924) was also born in New England, but his father moved west when Charles was a boy and he was educated and brought up in Chicago. His father, Benjamin, was a famous and flamboyant entrepreneur and gambler in commodities, always "cornering" some staple, making fortunes, then going broke. He was known as the "Napoleon of the commodity market." However, he made a more sober reputation and fortune as a banker and founder of the Corn Exchange, and Charles was expected to succeed him. This he did with lifelong success as banker, meat packer, and member of innumerable boards of directors.

Charles, however, during his long lifetime the "First citizen of Chicago," was a very different sort of person from his Napoleonic father. He deliberately sacrificed time and opportunities to make money in an inexhaustible cultural boosterism, beginning in his twenties and lasting right up until his death. Any worthy project that might better the life and improve the image of the Second City* received his blessings, efforts, and cash. Out of an inordinate welter of good works, two in particular emerged — the Art Institute and the University of Chicago. It wasn't so much that Hutchinson was interested in art, though he was, or in scholarship as that he thought they were good things and Chicago ought to have them. Truly Charlie Hutchinson (everyone called him Charlie) made culture in Chicago hum.

In these efforts, both at the Institute and at the University, he was assisted and abetted and advised by his bosom friend Martin Antoine Ryerson (1856–1932). As Charlie differed from his flamboyant father, so Ryerson differed from his extroverted friend. Though Ryerson, too, was a spectacularly successful businessman with an hereditary lumber

* Chicago surpassed Philadelphia as second largest city in the nation as of the 1890 census. Los Angeles forged ahead as number two in 1970.

fortune and a spectacularly active do-gooder, he was also a sensitive
esthete who had that gift of the true collector, an infallible eye. It is
said that in making his marvelous collection of Old Masters, which now
forms the backbone of the Institute's marvelous collection, he only
went wrong two times — buying canvases that later turned out not to
be masterpieces — when in these instances he listened to the advice of
experts.

Charles and Martin were both childless. The city was their heir and
the Institute and the University their favorite children. Charles was
President, Martin Vice-President of the Institute, and Ryerson suc-
ceeded Hutchinson as President in 1925. Martin was President of the
board of the University; Charles was Treasurer.

There is an instructive series of photographs in the splendid Ryerson
Library of the Institute, two albums of pictures of the Ryerson house
before and after, so to speak. The first album shows the comparatively
small but at that time stylishly up-to-date Richardsonian Romanesque
house in its big tree-shaded yard, furnished elegantly but also rather
modestly with comfortable furniture and objects of art but without
significant paintings. As opposed to the grandiosity of mansions erected
by other magnates in the 1880s and 1890s, especially the "cottages" of
Newport, it is almost a bungalow — and in infinitely better taste. The
second album shows the same house, with much the same furniture and
decor, at a later period, perhaps the 1920s, after his collection had been
made. In the identical setting, over the same ample fireplaces and up
the same modest staircase, are the wonderful Italian Renaissance works
and other brilliant pictures that Ryerson picked out for himself over
the intervening years.

Martin and Charles, Damon and Pythias, went abroad with their
wives every year and collected. Sometimes they went as far afield as the
East, where we have two elephants, one topped by Ryersons, the other
by Hutchinsons. But usually it was Europe. Other summer hours were
spent on the shores of Lake Geneva in Wisconsin, where they had
"cottages"; and these also got coated with pictures. It was on one of
these trips to Italy in 1890 that they had seen the Demidoff collection
with its "corkers" and bought it. Just like the Johnston-Blodgett pur-
chases of 1871, Hutchinson and Ryerson didn't wait around for trustees
to decide or other money than their own to be raised. Eventually vari-
ous individuals were persuaded to buy individual Demidoff pictures
and then donate them to the Institute. There they all are today, still
among the greatest works of art in any American museum.

Another similar occasion occurred in 1906 when Mary Cassatt saw
the magnificent El Greco *Assumption* at Durand-Ruel's gallery in Paris.
Mary first urged her friend Mrs. Havemeyer to buy it, but Mrs. Have-
meyer was afraid it would be too big for her to hang anywhere; so it

remained on the market for forty thousand dollars, a very tidy sum indeed in those days. Ryerson and Hutchinson also saw it and wanted it. Director French wasn't so sure. When told about the picture he thought it absurd to pay that much. He "did not remember ever seeing an El Greco in European art galleries." But Ryerson and Hutchinson told him it was too bad and too late because they'd already bought it. Eventually the purchase sum was made up by another of Chicago's generous donors, Mrs. Sprague. Just a couple of years after the BMFA's El Greco of 1904, the far more overwhelming El Greco of the Institute made its appearance in America. Both American museums were, as Mr. French noticed, ahead of most European galleries.

Like the earlier Blodgett-Marquand masterpieces of the Met, the Demidoff collection has served as the focal point of Chicago's Old Masters collection. Before 1890 the Institute didn't have anything much except its ubiquitous casts. In 1882 it had bought the south corner of Van Buren and Michigan Avenues looking out over the lake and the Illinois Central railroad tracks and built a handsome building of the same brown Romanesque style as the Ryerson house. Burnham and Root were the architects and the building was soon overcrowded with exhibitions, mostly local loans and the few Salon pictures that made up the "permanent collection." The first acquisition was a big *Beheading of John the Baptist* by Charles Pearce, given by a "group of gentlemen." It was later presented to a clinic of the University of Chicago as being appropriate to a Baptist institution and to surgery.

The formal opening of the new building in 1887 was the social event of the century. Everybody was there — Fields and Palmers, Ryersons and Hutchinsons. The hit of the show was Dupré's *Song of the Lark*, then on loan, later a possession, always a favorite, and still on view. Sunday openings came as early as 1888 in the progressive Midwest.

Then in 1892–1893 came the great fair. Just as in Philadelphia, one of the Chicago Fair buildings, a World Congress of Religions Hall, was built to be permanent and designed as a future home for the Institute. The museum moved there in May of 1893, the bronze lions were put out front, and there the Institute and its lions have been ever since. The original building on Van Buren was sold to the Chicago Club and it, too, has been there ever since.

It took a long for the new building to be completed according to plans, especially the Grand Staircase, which didn't get properly inserted until 1911. The collection was richer in quantity than quality. Downstairs was all casts, over three hundred of them; they weren't disposed of till the 1950s. There were a few real statues intermingled and a good deal of miscellaneous decorative art. Upstairs were the Demidoffs and the Field collection of Salon and Barbizon paintings. The Nickerson collection in 1900 increased this load of "pompiers" — *modern* art

then, one must never forget. In other words, as of 1900 the Institute was as typical and representative an American art museum of the period as one could hope to find.

Not till the twentieth century, with the El Greco and the 1922 Potter Palmer bequest of glowing Impressionists, and finally in the thirties, with full possession of the Ryerson Italians, did the Institute become the wonderful repository it is.

A myth seems to have grown up, spawned perhaps unintentionally by Aline Saarinen's *Proud Possessors*, that the Institute owes everything to Mrs. Potter Palmer. Mrs. P. was certainly a dynamic, picturesque, and stylish figure. She certainly dominated society in Chicago over the turn of the century and certainly was a genius at organization. Her efforts in this line during the Exposition were useful, and the Palmer collection certainly had beautiful and advanced pictures in it. Mary Cassatt was a friend of Mrs. Palmer as she was of Mrs. Havemeyer.

However the Institute owes its creation and success almost entirely to the early triumvirate of Hutchinson, Ryerson, and French, not to Mrs. P. There is even a good deal of gossip to the effect that Mrs. P. didn't really like Impressionists all that much. She was known to have turned back a famous Renoir (let us say) that she had on trial because it didn't match the color scheme of her boudoir. According to gossip, it was *Mr.* Potter Palmer who liked and understood Impressionists, and he derived his taste not from his wife but from his mistress.

Whatever the myths and gossip surrounding the Potter Palmers, it was the surveyor turned popular art lecturer, William French, the cultivated booster, Charles Hutchinson, and the lumberman with the infallible eye, Martin Ryerson, who were the true progenitors of the Midwest's most prestigious museum. They were not Robber Barons trying to show off. They were civic leaders trying to make culture hum in Chicago, and succeeding.

iii

Detroit is a much older city than Chicago, and at the end of the nineteenth century it had settled down to modest success and an almost Philadelphian sense of genteel lack of ambition. It was, everyone felt, not going to be a boom town like vulgar Chicago to the west and Cleveland to the east. Rather, it was a delightful place to live in its simple but comfortable tree-shaded lakeside way. Perhaps it had better turn its mind to thoughts of cultural rather than economic supremacy.

As far back as 1701 Detroit existed as a fort and a trapper's depot, and by 1800 it was still a French Canadian log-built village dominated by the Catholic Church inside the walls of a fort. A representative of

the French royal family was sent over to superintend in mid-eighteenth century, and French sermons were still given on Sundays in a city church as late as the 1950s. This first French Detroit was totally destroyed by fire in 1805 and a new Yankee Detroit, a lake port, evolved, not in the boom-town patterns of Chicago and Cleveland but more slowly, with traces of elegance and reminders of its French heritage — mostly place names, now outrageously mispronounced.

Art came wandering out to Detroit as it did to other cities in the form of traveling exhibitions of masterpieces. William Dunlap's big meretricious show-work *Calvary* passed through in the late 1820s. There were the usual sporadic art shows before the war in the 1850s, just as in Chicago; but Detroit does not seem to have been a very active creative center. The only well-known artist the city claimed during the nineteenth and earlier twentieth centuries was Gari Melchers (1860–1932), the same Melchers who was later so influential in Savannah. His father Julius, a German immigrant, was a professional sculptor, pupil of Carpeaux in Paris, who settled in Detroit and did figures on the old city hall. He also supposedly created the first cigar store Indian for a tobacconist friend. Another contribution of Detroit to Indian lore was the work of John Mix Stanley. Though born in New York, Mix started painting in Detroit in the 1830s. His Indian Gallery was destroyed in the Smithsonian fire of 1865.

A general lack of esthetic upsurge did not prevent Detroiters from dreaming dreams, as evidenced by the extraordinary statements of newspaperman James E. Scripps (1835–1906). An English-born son of a bookish family (his grandfather edited something called the *True Briton* and his father was a bookbinder), James became famous as editor of successful "penny papers." Then along with others of his numerous family he was a creator of America's first newspaper chain. But he was also a collector of rare editions and prints and he decided in the 1880s, more or less on his own, that Detroit was to be the art capital of the country. He wrote in 1889:

> The pride I naturally felt in Detroit led me to anticipate for the city . . . some special fame. . . . It was plain that she could never hope to win, like New York or Chicago, the prestige of a great commercial metropolis. Boston was already the literary center, and Cincinnati was asserting her claims to first place as the musical. The country was just waking up to an appreciation of the fine arts and as yet the place where their temple would be set up was an open problem. Why might not Detroit aspire to the honor and become the Florence or the Munich of this continent?

All that was required was a bit of grit and gold.

The fact that Detroit had no art and no artists and not even any real

collections of art didn't stop Mr. Scripps. He thought the way to go about making the city a world-famous art center was to buy some Old Masters and give them to a city museum created to hold them. He did. Detroit obstinately refused to become an artistic mecca; but on the basis of a noisy contraption then unknown to Mr. Scripps, it did indeed become a commercial metropolis. In the process, Mr. Scripps's pleasant tree-shaded small city of two hundred thousand people was as effectively wiped out as the old French fort. The museum survives to bridge the gap between the city of Scripps and the city of Ford.

The actual origins of the museum that Scripps so generously endowed with Old Masters goes back to another newspaperman, William H. Brearley. He, too, thought Detroit should have art and he was the chief figure in starting, organizing, and financing a great show called the Detroit Art Loan Exhibition in 1883. A special building had to be built to house the vast collection of almost five thousand objects, almost a thousand of which were oil paintings. Acres and acres of Salon pictures were exposed in room after room to startled and delighted Detroiters of a premotor age. There was a Colonial Room, rather advanced for the time, full of genuine old portraits by Copley and Stuart and good eighteenth-century American furniture. There was a supposed Raphael portrait of Martin Luther (an unlikely conjunction). There were Sully portraits of Biddles loaned by the local Biddle, William S., lots of pre–Civil War American paintings, and vast quantities of art objects. The Exhibition was widely advertised and heavily patronized, but a short fall season threatened to cut the jamboree off before any money could be made.

To the rescue came the Charles Haseltine collection. This group of spicy modern masterpieces belonged to the art dealer brother of the Philadelphia painter William and was then profitably on exhibit in Chicago. The board decided to bring it to Detroit to save the day and put the Art Loan Exhibition in the black. There was one problem: among the pictures were seven notorious nudes. The ladies of the committee, numerous and powerful, were prepared to be shocked. A special viewing was arranged. Mrs. Morse Stewart set the seal of approval on the venture: how could anybody be offended by such *little* nudes? Why they just looked like dolls! Two of the seven pictures, however, were declared "too awful" to be shown. Presumably they were life-size and hence not to be confused with dolls. These were hidden away and not uncovered even to the bribes of various surreptitious husbands.

As a result the Exhibition ended up with a surplus, most of which (twenty-five hundred dollars) was recklessly thrown away on the purchase of a high-toned picture of Classical content called *The Story of Oenone* by Francis Millet, which had been, for some reason impossible to fathom nowadays, the popular hit of the show.

In the back of everyone's minds, especially the busy mind of William Brearley, was the thought that the success of the Art Loan Exhibition would inspire the creation of a true permanent museum. The money raised was supposed to go towards that purpose. After buying *Oenone* there wasn't much left, so Brearley proceeded to acquire real money for his real museum. Senator T. W. Palmer broke the ice by offering to give the princely sum of ten thousand dollars if a total of forty thousand dollars could be raised to match. Brearley managed to inspire thirty one-thousand-dollar subscriptions, including a contribution from his newspaper enemy Scripps, who up to that point had been openly scornful of both the Exhibition and the plan for a museum. A group of forty Donors incorporated themselves in 1885 as the founders of a Detroit Museum of Art, so 1885 becomes the official date of origin, as 1879 is of Chicago or 1870 of New York and Boston.

The Palmer-Brearley sum of forty thousand dollars was not enough to build a proper museum building, so by superhuman efforts Brearley squeezed money up to the sum of one hundred thousand dollars out of a broad cross-section of the community and in 1888, five years after the Art Loan Exhibition, the new building was complete. On September 1, 1888, the Romanesque edifice, which Julian Street later suggested looked more like a waterworks than the local waterworks did, opened for business. The permanent collection had been started by none other than the Pope himself. Leo XIII had presented a large Italian seventeenth-century *Mystic Marriage of Saint Catharine* to the Art Loan Exhibition. Then came *Oenone* by reckless purchase. George Scripps, newspaperman brother of James, gave the Rembrandt Peale *Court of Death*.

In 1889 James Scripps made the Museum his superlative present of some seventy Old Masters, mostly bought in England and the Continent in the mid-eighties, after the Art Loan Exhibition. Though not all seventy were what they were supposed to be at the time, many of them were and are, notably a big Rubens and a small Nuzi (an Italian Primitive), still among the gems of the Detroit collection. Other pictures, predominantly Dutch, of this original group of pioneers are still exhibited. James Scripps's widow gave still more in 1909, the remainder of the collection. George Scripps contributed things from time to time, and James's daughter, Mrs. Edgar B. Whitcomb, and her husband became collectors of choice Italian and French works that also came to the Museum. So a great many of the city's best pictures go back in fact or by family association to James's dream of making Detroit the Florence or Munich of America.

Scripps incidentally chose to collect Old Masters not just because he liked them but because he thought Detroit needed them. In another

statement almost as naïve as his hopes for Detroit as a temple of art, he tells why he bought what he did. He thought that to try to purchase a lot of Modern Art — the then-fashionable Bouguereaus or Salonistes beloved of Strahan — would cost too much money. Old Masters were no more expensive and far more durable. They also attracted art students. "At present the fashion sets toward the style of Diaz and Bouguereau," he quoted an art authority as saying. "How long this may last we cannot tell. He would be a bold man who should undertake to prophecy what will be the stature of these men one hundred years hence. But Murillo and Claude have lasted two centuries. . . ." So Mr. Scripps bought Rubens instead of Bouguereau.

Something called the Witenagemote Club bought and presented a Melchers called *The Vespers*; then in 1888 Frederick Stearns, famous for being the world's first subscriber to a telephone service, presented a mass of Oriental gimcrackery, the most popular piece being a fierce and realistic statue of two sinewy Japanese wrestlers in action.

A first Director, painter John Ward Dunsmore, quickly came and went. He opened the Museum with a big retrospective of native son Gari Melchers, began an art school in 1889, took over the direction of it, and left his post as Director of the Museum — partly, it is said, because of a squabble with that formidable women's committee over undraped statues.

The first real Director was Armand H. Griffiths, who reigned from 1891 till he was forced to resign in 1913. Griffiths holds the same place in Detroit that French does in Chicago or Cesnola in New York. A dynamic young jack-of-all-trades, he was essentially a popularizer. He became famous, like William French, as an art lecturer but unlike French unfortunately sacrificed his Museum to his lecturing. Starting so strongly with a good collection of Old Masters, a big collection of Oriental and other bric-a-brac, a sizable Romanesque building, and a flourishing art school, the Museum then more or less stood still. Griffiths, though he did get money from the city and did get the Museum into the papers all the time, did little to build its collections. He and the board supinely accepted everything that was offered, afraid of hurting people's feelings. Exhibitions were held more for their notoriety than their excellence; many of them were really business affairs, with paintings from commercial galleries for sale. Griffiths discouraged the school and it faded away in about ten years. Though people thronged to hear Griffiths lecture on Sundays, they didn't throng to the Museum on weekdays. By 1900 it had become a rat's nest of curios and casts and copies and specimens of natural history; there was a "chamber of horrors" full of moose heads and other such memorabilia. The Detroit

Museum of Art, as it was still called, failed to equal the museums of Florence as an attraction to artists and as *the* temple of fine arts in America.*

<center>

iv

</center>

The basis of the success of nearly all early American museums seems to have consisted of an alliance between two or three dominant men: an active president good at stirring up interest and money in the community, a sensitive collector of sound taste and large pocketbook willing to make really significant donations, and finally a director, usually something of a showman, competent and devoted and with long tenure and close association with his president.

Alas, the triumvirate in Detroit of Brearley as booster, Scripps as donor, and Griffiths as long-time popular director fell apart almost at the beginning. Brearley, who was really responsible for organizing the seminal Art Loan Exhibition and then for raising the funds for the museum, quarreled with the board over the site for the building and severed his association with the Museum. Scripps, after his initial generosity, does not seem to have been as active during his later years. A fatal custom of rotating presidents almost yearly prevented the kind of continuity that seems essential in the development of a museum and deprived Griffiths of the kind of guidance and control he seemed to require. There were also acute questions of finance. Detroit, not being a great commercial metropolis but merely a moderately prosperous small city, didn't have great fortunes. Griffiths did manage to squeeze some money out of the city government, but mostly he had to depend on private generosity. Then even this civic money was cut off by a taxpayer's suit in 1914 that contested the city's right to support a privately owned and controlled institution. Meanwhile, while automobile money was still being accumulated, the Detroit Museum was poor. Then, once the Museum was entirely in public hands, it suffered from politics and penury.

However, despite all this, as of 1900 the Museum presented a picture not much different from its more fortunate sisters: like Chicago it had a core of good Old Masters, a plethora of Modern Art, and a superfluity of casts. It had like Boston an obviously obsolescent building in an increasingly unpleasant urban neighborhood. Like the Met, the Detroit

* Julian Street in his *Abroad at Home* of 1914 goes on, after the waterworks comparison, to describe the interior. "Its foyer contains some sculptured busts . . . the group represents I take it, prominent citizens of Detroit . . . Hermes, Augustus, The Hon. T. W. Palmer, Mr. Frederick Stearns, Apollo . . . I do not want to put things into people's heads, but — the old museum is not fireproof. God speed the new one!"

Museum of Art was in the clutches of a Director who could not be ousted despite rising criticism and whose continued presence hindered the growth of the collections. Boston got its new building in 1908; Cesnola died in 1904; nothing happened in Detroit. Griffiths was not ousted until 1913, and then he was not succeeded by a truly professional Director, William Valentiner, until 1924. Meanwhile the Museum was taken over by the city in 1919 and its name changed to the Institute of Art; but the new building up on Woodward Avenue was not opened until 1927. Almost immediately came the Depression and the war and it is only since then that the Institute has been able to grow and improve as the museum of the country's fifth biggest city should.

This second phase in the history of the Detroit museum in which William Valentiner and his successor Edgar P. Richardson act the role of Great Director, while Ralph H. Booth and Edsel Ford, Henry's crushed, sensitive, and rebellious son, act as Great Patron belongs to the later, greater period of America's museums. As of the turn of the century, there sat the Detroit Museum of Art in Romanesque, waterworks somberness, full of junk and some masterpieces, but one of the four nineteenth-century public art museums in operation by 1890 west of the Ohio River. It exists today as one of the grandest; yet a curious shadow does still seem to hang over its reputation. This is surely the result of its slow growth and bemused earlier history. For instance, Eloise Spaeth, in her invaluable guidebook, *American Art Museums* (1969 edition), begins the work with a survey of what she calls the Big Seven. Chicago and Cleveland are among these; but though she includes Brooklyn, she doesn't include Detroit. Yet as a big-city universal survey museum, Detroit is obviously richer and more complete. It has an incomparably better European collection than Brooklyn and a far more complete collection of antiquities than Chicago. The Detroit Institute of Arts is old for America and pretty splendid for anywhere.

v

The basic American tradition of the private museum built to house the private collection of an individual but opened to the public is exemplified by the beneficence of Mr. Corcoran in Washington, D.C. Two rather quaint examples of this kind were and are among the oldest and most prestigious of Midwestern museums. The Walker Gallery in Minneapolis (ca. 1879) is still going strong. The Layton Gallery in Milwaukee (1888) is now absorbed in the new Milwaukee Art Center but maintains a separate board and identity. The stories of these two museums and their collections present curious and instructive examples of the effect of changes of taste and the pressures of time on

American art collecting — and perhaps warnings for the future of such modern establishments as the Hirshhorn Museum in Washington, D.C.

Thomas B. Walker (1840–1928) was about as typical a mid-nine-teenth-century self-made man as one could hope to find. He came to Minnesota in 1863 as a surveyor, in the same decade and for the same reasons that William French came to Chicago. Walker, however, did not turn into a lecturer on art. Instead, in the process of surveying he saw and acquired timberlands in the north woods. In a few years he was rich enough from lumbering operations to build a fine pointy Victorian Gothic mansion in what is now downtown Minneapolis at Eighth and Hennepin and to start collecting pictures. He added a special room to his house and opened it to the public as early as 1879. People came to the front door as if to call and Mrs. Walker had to hire a special maid to let in the crowds. Ladies were required to leave their parasols in the hall. As time passed the art room sprouted into a full-fledged attached gallery. Until Walker moved to another house farther out of town in 1916 and the Art Institute opened in 1915, the Walker Gallery served as the city's Temple of Fine Arts.

The Lowry house on Lowry Hill, where Walker moved, did not have a gallery, and Walker stashed his collection in the Public Library. Since T.B. was the principal founder and patron of the Public Library, this was appropriate. Meanwhile a Society of Fine Arts had begun and was flourishing. It had been incorporated as early as 1883 with an art school (1886) and an arts center for exhibitions. At first T.B. was active in it as one of the founders and was President of the Society from 1888 to 1893. But as plans for a full-fledged city museum began to mature, a rift developed between the city's Establishment and the dynamic but ego-tistic T.B. Obviously, if the trustees of the new museum dealt with him at all, it would have to be on Walker's own terms. They would have to accept his collection in toto as the core of theirs and probably have to accept Walker as President.

The problem was that by 1910, when the city fathers were ready to start a museum, it had become obvious that the Walker collection was not all that the innocents of 1879 had thought it to be. It was, rather like Walker himself, an archetype, the model of the nineteenth-century rich American's collection, embracing aspects of the Luman Reed, the Robert Gilmor, and the Wilstach tastes. That is, there were American paintings, a whole lot of very dubious Old Masters, and the usual plethora of Salonistes. There was also a mass of decorative art. Some of this, notably the Chinese jade, turned out to be more valuable than the paintings.

Given the forceful character of T.B. it would have been impossible to pick and choose out of this mixed bag. Rather than face the issue, the founders of what was to become the Minneapolis Institute of Arts

avoided it. After initial gifts of a site and one hundred thousand dollars, a famous organizational dinner was held in January of 1911 at which two hundred fifty thousand dollars more was raised, literally overnight; but the dinner was carefully scheduled for a date when the founders knew that T.B. would be out of town. They got no money or pictures from Walker even as loans to their rich opening show of 1915.

The Institute moved into its building with only a score of paintings to its name; but the devotion of two men, their fortunes, and their families soon changed all that. Clinton Morrison, who started the whole thing off by donating the land on which the new classic McKim, Mead and White building was to stand, also donated a daughter and son-in-law. The son-in-law, John Van Derlip, was first President and held office for twenty years. When he died in 1935 he enriched the museum with a large collection of Renaissance paintings. His wife died before him and left a three-quarter-of-a-million-dollar fund. The other great early donor was William H. Dunwoody, who started off the original fund drive with his one-hundred-thousand-dollar gift and then left the museum a million dollars for acquisitions. First Joseph Breck of the Metropolitan served as Director before he went back to take the place of William Valentiner as head of the Met's Decorative Arts Department. Then for years Russell A. Plimpton ran the Institute, buying masterpiece after masterpiece using Dunwoody and Van Derlip funds. Charles Hutchinson of Chicago was an original trustee and helped teach Minneapolis how to grab culture by the tail. Minneapolis learned in no time to make it hum. Charles Freer of Detroit, another pioneer trustee, gave them some of his Oriental treasures.

The Walker collection stayed in the Public Library. There were abortive plans to add a wing here and a wing there to either the Library or the Institute. But in 1927 Walker built his own gallery, a square, practical warehouse on the site of his second house, feebly decorated in plaster with bits of Nabisco Spanish. Outside it was awful. Inside it was efficient. Walker put his collection there, printed an absurd catalog that began with pages of praise of the collection by experts such as Edith D. Glen, Educational Director of the local YWCA, and various venal French dealers,* started a foundation to take care of it all, and died.

Then came the Depression. Lumber and the Walker Foundation were especially depressed. The Walker Gallery remained in evidence, open and cared for by a few old Walker family retainers but otherwise quiescent. Family members kept it afloat with their own funds. Then in

* Professor Neuhaus of the University of California said, "It teems with great works of art." French art specialist Seymour de Ricci said, without a blush, that ninety percent of the pictures were genuine. Mrs. F. E. Ewe expressed thanks for the special tour given the Monday Study Club.

the late thirties a Walker granddaughter came back from college with an art education and began to stir things up. She married the director of WPA art projects in Minneapolis, who became the director of the Walker Gallery, and T.B.'s warehouse of painting became a center for all sorts of exciting exhibitions and happenings and a local focus for contemporary art.

After the war experts were allowed in to reevaluate the Raphael and its like and much of the junk was weeded out. The Foundation began to revive and used its funds to buy modern art. Soon the Walker Gallery emerged significantly on the national scene, particularly under the direction of H. Harvard Arnason, who came there in the 1950s as one of the country's most dynamic patrons of avant-garde cosmopolitanism. A great new building was erected on the site of the old gallery in 1970–1971, joined like a Siamese twin to the Guthrie repertory theater. Gradually almost all the Walker Old Masters and Salonistes and Americans, good and bad, were sold off except for the Chinese jades; and the Walker Gallery is now the Minneapolis counterpart of the Museum of Modern Art in New York, to complement the more historically oriented Minneapolis Institute of Fine Arts. The Walker family and its Foundation have continued to support the Gallery throughout this metamorphosis, though not without misgivings.

The Layton Gallery in Milwaukee, Wisconsin, had similar origins. Frederick Layton made his fortune not in lumber but in meat. His father was an Englishman who immigrated to Milwaukee and became a prosperous butcher. The son followed his footsteps and moved on into meatpacking. When the fortune was made came the inevitable jaunt abroad. Layton had already hinted at a public gallery for the fair city of Milwaukee. On his travels he met an English architect, George Ashdown Audsley (1838–1925), and after his return home he caused to be built a fine square English-Victorian-Classic building and filled it with his collection: Salonistes with a slight but not necessarily fortunate English accent. This building, opened in 1888, remained for decades the esthetic glory of the city. Next to it a humble but spirited competitor, a Milwaukee Art Society, came into being. It established itself in a shop-like center in 1911 and from 1913 on, under the publicity-conscious direction of Dudley Crafts Watson, it flourished and made itself famous. For instance, it brought itself to attention by welcoming the European Cubists of the Armory Show soon after their controversial 1913 appearance in New York. After 1916 it was called the Milwaukee Art Institute, obviously with a future museum in mind.

Not so the Layton. It acquired various new works courtesy of Mr. Layton and some of his friends. The best of these turned out to be Americans, like Eastman Johnson and his now famous *Stagecoach*. Most of the new pieces, however, like the old, were European "gems." As

time went by and the Art Institute grew, crowding its quarters and beginning to acquire a permanent collection of its own, the Layton stood still and slumbered in its delightful classic hall. Soon the Institute began to push the Layton out. The Layton Gallery had always had a flourishing art school attached to it. In 1953 the school left for roomier quarters. The Institute moved in, like a cuckoo into the foster nest. In 1957 the Institute and the Layton merged and they both moved to the lakefront and into a striking cantilevered city-built and Saarinen-designed War Memorial Center. On the top floor are quartered various benevolent and protective societies, and there the Kiwanis has lunch. On the bottom a new art museum somewhat uneasily now combines a small, chic, rapidly improving collection of historic art from ancient to very modern. The Layton has a separate series of rooms devoted entirely to a fine survey of American art.

The crime of the century, as far as Milwaukee and architecture are concerned, occurred when the deserted Layton Gallery was sold and razed for a parking lot. Can Saarinen really make up for that? Like Mr. Walker's memorial, Mr. Layton's is by no means now what the founder had in mind. It exists quasi-autonomously as part of the new museum. At least, unlike the Walker collection, Milwaukee's present Layton collection is actually based on or about a group of pictures actually brought together by Layton himself.

The past and future of all such private memorial collections is exemplified in the somewhat checkered careers of the Walker and the Layton. To preserve or keep up with the times? To obey the wishes of the donors or of modern directors? These are the questions. The answers vary.

vi

"Nowhere on the banks of the Mississippi does the love of art flourish so conspicuously as in Saint Louis, that admirable meeting-place of Southern luxury and Northern enterprise." So Mr. Strahan unveils for us the gorgeous holdings of S. A. Coale (Cabanel, Diaz, Max, Meyer von Bremen), D. Catlin, Dousman, O'Fallon, and others who so avidly patronized Modern Art as then understood on the banks of the Father of Waters. Along with Cincinnati and Louisville, Saint Louis was a center of Western riverside culture during the period of museum making.

Like Philadelphia, Saint Louis had its group of local artists dividing into two generations, a prewar circle whose high tide was the art boom of the 1850s and a far less distinguished postwar group that flourished between 1870 and 1910. Chicago could boast the temporary but glitter-

ing presence of George Healy. Saint Louis did even better. Although George Caleb Bingham did not settle there permanently, he came and went and is certainly a native of Missouri, in fact the state's most important nineteenth-century artist. Then there was the German-born Karl Ferdinand Wimar (1828–1862), painter of Indians, whose last work is the still existent set of murals in the Saint Louis Courthouse. The names of these two artists are current and their paintings are avidly acquired by any museum that can get one. But as the Rothermels and Winners in Philadelphia clustered about the Sullys and Peales, so in Saint Louis a whole clutch of lesser figures — Leon Pomarede, Henry Lewis, Joseph R. Meeker, Alban J. Conant, Manuel de França (a Portuguese who moved west from Philadelphia), Ferdinand Boyle, and many others contributed as settlers or visitors to a brief prewar flowering centered about a fugitive Western Academy of Art.

None of these artists was more picturesque or firmly settled in the city than Leon Pomarede, who came to New Orleans from France in the 1830s, worked his way upstream to Saint Louis, where he decorated the cathedral, and then in the 1840s created a vast panorama of the Mississippi, exhibited to great acclaim across the country but destroyed by fire in Newark, New Jersey, in 1850. Leon stayed in Saint Louis decorating Missouri churches and in 1892 at the age of eighty-five was killed falling off a scaffold while doing murals for a church in Hannibal. Most of his contemporaries painted portraits; Wimar was Pomarede's pupil and assistant.

In 1874 an aspiring young artist named Halsey Ives (1847–1911) arrived in the city from his native New York State, via Nashville, to teach drafting at the Polytechnic School. He became a member of the faculty of Washington University, that outpost of New England culture planted in the barbarous West by the Congregationalist minister William Greenleaf Eliot (1811–1887), kin of the Adamses, grandfather of poet T. S. Eliot. In 1875 Ives started a free evening drawing class in a room of the University's main building. This was so successful that the University in 1879 officially set the class up as the Saint Louis School of Fine Arts and as a department of the University.

As an adjunct of the school, a museum was planned and "specimens" acquired; and in 1880, thanks to the generosity of local magnate Wayman Crow, a two-story rough stone quasi-Renaissance building was opened at Nineteenth and Locust as the St. Louis Museum of Art and home of the school, with Ives as the director.

It was very much a one-man show. From the beginnings of his drawing classes in 1875 to his death in 1911, Ives *was* the Museum, so busy in fact with teaching, administering, propagandizing, and lecturing — like French and Griffiths he was a famous Sunday speaker in his museum — that he did very little painting. Many of his pupils became professional

artists, but none of them seems to be very well known now. The second, postwar crop of Saint Louis–born or trained or resident artists, products of the School of Fine Arts, never made much of a national reputation. Edmund Wuerpel, who was born in Saint Louis in 1866, studied there, and, after the usual fling in Paris under Bouguereau, returned home to teach, was probably the best known of them. He painted juicy landscapes with titles like *An Evening Song.* This seems to be characteristic of the Saint Louis School of that period. The equally juicy landscapes of his contemporary F. O. Sylvester (1869–1915) were dubbed *The River's Golden Dream* (Mississippi of course), *The Light that Makes the Heart Glad,* and so forth. Edward M. Campbell, another of the school, gave us *The Hour when Daylight Dies.* Water and poplars and evening shades in forest glades were much admired by all these men.

No one magnate or patron, like Charles Hutchinson in Chicago, nursed the infant St. Louis Museum through its earlier history. Wayman Crow died in 1886. Mr. Coale, so touted by Mr. Strahan as being the largest collector in the city, did not seem to notice the Museum. Of Strahan's favorites, David Catlin and Charles Parsons were prominent on the board. The Catlin collection of Salonistes eventually came to the Museum after his death in 1916, too late to do it much good.

The important date in the history of the Museum in Saint Louis is 1904. This was the time of the Great Exposition celebrating the Louisiana Purchase, when "Meet Me in Saint Louie, Louie" was the song hit of the nation; much to the disgust of natives, who always pronounce the "s" — Saint *Lewis.* Neoclassical buildings were created in the hills and vales of beautiful Forest Park. Ives was an old hand at expositions, having been chief of the Fine Arts Department in Chicago in 1893.

The Crow building, like all such early museum buildings, was beginning to be overcrowded and obsolete, though it had grown to twice its original size. Following the example of Philadelphia and Chicago, Ives persuaded the builders of the Saint Louis exposition to construct something permanent with the future of the Museum in mind. This building was in fact where the art of the Exposition was shown in 1904, with several temporary annexes to hold superfluous riches not only from the United States, Great Britain, France, Italy and Germany but also from Portugal, Bulgaria and Argentina. Most of the paintings were Modern Art, but Rembrandt and Hals, Solomon van Ruisdael, and Joshua Reynolds got in there somehow, and in the French section there were Monet, Degas, Renoir and other Impressionists (along of course with Meissonier, Diaz, Dupré, etc. etc. etc.).

One of the more interesting displays was that of Japan, which included many contemporary works by Imperial Court Painters showing how the revival of ancient techniques sponsored by Fenollosa had taken

hold as of the early twentieth century. Master ceramists, product of the revival inspired by Morse, also exhibited. The most socially distinguished of the exhibitors were H.R.H. Carlos I, King of Portugal, who could paint a nice cow, and his Queen Amelia.

The U.S. selection was huge, occupying most of the central permanent building and obviously chosen under the dominant influence of Director Ives. Paintings from the budding permanent collection of the earlier St. Louis Museum were featured, such as that popular favorite, Kuehl's *Ein Feste Berg*. Locals like Wuerpel, Allen and Miller were represented, too. The rest of the American display covered Modern Art in depth. On view were Homer, Eakins (he was on the jury of selection and was represented by both the Gross and the Agnew Clinics), Sargent, Whistler, and in fact almost all Americans of merit living at the time. The Grand Prize was given, almost of course, to Sargent. John La Farge got a special medal for his services to art. Gold medals, of which there were many, went to Cecilia Beaux and Frank Benson and Gari Melchers as well as to Hassam and Eakins.

Just as in Philadelphia or Chicago, when the Exposition moved out, the Museum moved in. The school peeled off to become an integral part of Washington University. The old building was deserted. One problem remained: finance. Private support proved insufficient. University support was no longer available. Through the efforts of Director Ives and his influential board, a solution was found. The legislature legislated a charter and tax and, as of 1909, the Museum reopened and was rechristened the City Museum of St. Louis, the first art museum in America supported not by municipal appropriations, but by municipal taxes — one-fifth of a mill on every city tax dollar. Thus, instead of quite properly claiming to date from say 1879, the actual beginnings of the older St. Louis Museum, the present Museum contents itself with the date of rebirth, 1909.

Bit by bit, item by item, year by year, alongside staples mostly borrowed from the past of the Museum and from Washington University (like the original matrix of Salon art from America, England, France, Germany, Russia, Norway, and Sweden, Saint Louis being nothing if not international in its tastes), genuine Old Masters, relics of antiquity, and beautiful furniture were inserted into the by-now City Museum of St. Louis. Not by windfalls, like that of the Demidoff collection, but slowly and steadily Saint Louis assembled its good things, Italian and Dutch paintings, oriental objects, many given by natives Samuel and Lionberger Davis, Americans bought by Bixby funds. The old-fashioned Modern Art of the older Museum was gradually pushed out, not only by Old Masters but by newly acquired Binghams.

Daniel Catlin, mentioned in *Art Treasures*, remained a patron and board member until 1916; but the name that most prominently links

the older Museum to the newer is that of William Keeney Bixby (1857–1931). He came from Michigan to Saint Louis, made his fortune in the nineteenth century, and settled down to become the city's most universal boardsman and collector. He not only collected art but also rare books and belonged to all sorts of local and national organizations involving arts and letters as well as every club and worthy cause in town. He was on the board of the older Museum and President of the new one from 1909 till his death in 1931. He is principally memorialized by the Bixby Funds for American and for Oriental Art. The family, however, is famous nowadays because his son Harold, more interested in aviation than art, backed Lindbergh in his flight to Paris in 1927 (hence *The Spirit of St. Louis* as the name of Lindbergh's plane). Another son, William H., was on the Museum board in the 1930s.

The Museum still sits in the handsome Classical building of 1904 that crowns a hill in Forest Park and is still tax supported. As such it remains special in the history and development of the American museum. Many museums, like New York's, receive annual municipal money, and some, like Detroit's, are actually owned by the city. But not many are directly tax supported.*

As for Washington University, that Congregationalist flower of cultivation, it now has its own teaching museum, one of the best in the country, housed in a splendid glass cage called Steinberg Hall on campus at the end of Forest Park. But this is a later revival of the 1940s, and the pictures in it are not, with some exceptions, traceable to the older Museum. It is the City Museum, not the present-day Washington University collection, that is the true heir of the old St. Louis Museum of Wayman Crow days.

The other great Missouri museum, the William Rockhill Nelson Gallery of Art and Atkins Memorial of Fine Arts (a cumbersomely full title) way out west in Kansas City, practically on the frontier as far as Saint Louis is concerned, is a completely twentieth-century affair. It opened in 1933 and is chronologically the latest of all the larger first-rank Midwestern museums of art.† From the Saint Louis point of view this parvenu late date is only to be expected of K.C.

* The disadvantages of such tax support have become obvious in modern times as Saint Louis has become suburbanized, like every other city. Just recently, however, suburban communities voted, though by a narrow margin, to tax themselves for the benefit of the Museum.

† Chicago and Saint Louis, 1879; Cincinnati, 1881–1886; Detroit, 1885–1888; Toledo, 1901; Indianapolis, 1906; Cleveland, 1913–1916; Minneapolis, 1914–1915.

vi

The Museum of Indianapolis, now risen in splendor like the Phoenix, also claims to be old: 1883 is the date claimed, but the proper date is 1906. Along with other nineteenth-century Midwestern museums, it had its roots in an Art Association. The Association was, as usual, in the Midwest, a ladies' club. The origin of art academies and museums in the East was almost exclusively male. Females were not invited to the openings of the PAFA exhibits until the 1840s. Only one woman, Catharine Lorillard Wolfe, was an original subscriber to the Met's first money drive. In the Midwest, however, women were active at the beginnings of many art museums and nowhere more so than in Indianapolis.

Indianapolis, rather like Detroit, is a city of successive phases and layers that seem to have little to do with one another. There is first a prehistoric period from the city's foundation in 1820 till after the Civil War. Like every other town of any size (and some of almost no size) of that time in America, Indianapolis had its group of painters: itinerant limners who did heads cheap and moved on, and industrious citizens, usually more sophisticated in technique and higher in price, who settled and made a career of portraiture. Indianapolis, planned in 1820 as a possible state capital, was a miserable frontier village of fewer than two thousand inhabitants in 1833 when Jacob Cox, tinsmith, and his brothers arrived there to start a hardware store. Stumps had only been cleared from a few main streets, there were no sidewalks, the mud was knee deep when it rained — all after the pattern of Chicago as of 1855 when Healy first came. A visitor commented that he'd seen many dreary frontier towns but "none so utterly forlorn" as Indianapolis in 1833. It was hard to get to, furthermore, since the roads leading to it were as bad as the streets when you got there. For decades Indianapolis remained remote, and a certain quality of self-centered Hoosier isolationism seems to have persisted right to the present.

Though Jacob Cox, born in New Jersey in 1810, was a successful businessman, he yearned to be an artist. He gradually turned over tinsmithery to his brothers, started getting commissions for his sturdy, matter-of-fact portraits, and about 1840 finally opened a studio and set up as a professional. In 1843 he held a sale of paintings along with a temporary resident, twenty-two-year-old Worthington Whittredge (1820–1910) of Cincinnati, later a famous painter of the Hudson River School. While in Indianapolis Whittredge painted portraits of the recently arrived Beecher family (of which Harriet of *Uncle Tom's Cabin* fame is the best-known member) whom he'd already known in Ohio.

Whittredge soon left, but Cox stayed on and managed to support himself. The Art Union in New York took him up, as it did Bingham, and at last in 1860, at age fifty, he went to New York and had his very first formal art lessons at the National Academy of Design. He returned home to become over the years a civic father; his studio was described as "the hub around which the majority of the city's art activities revolved." A lucrative Indianapolis industry was painting portraits of Governors for the State House. Cox did no less than six of these. Besides portraits he indulged in local landscapes and what he and others of the time liked to call "fancy pieces," works of allegorical or sentimental nature.

Another lucrative artistic industry all over America at this time was the panorama. In Saint Louis Pomarede had done his panorama of the Mississippi. Having no river of panoramic size, the artists of Indianapolis chose the subject of temperance — the drunkard's decline from sober wealth to a pauper's grave. Cox was assisted in the making of one of these in 1853–1854 by a boy of less than twenty named Henry Waugh. He was a nephew of Samuel Bell Waugh of Philadelphia, portraitist, Academician, creator of Waugh's Italia, and father of modern marine painter Frederick. Henry arrived in Indianapolis as a member of a theatrical troupe. He was both actor and scene painter. After helping Cox with the panorama, he decided he must go abroad to further his education. In order to make money for the trip he joined the circus as Dilly Fay, "the parlor clown," got to Rome, where he lived for about six years, and then unfortunately died on his way back to America. A romantic career cut short.

Another protégé of Cox was J. Oriel Eaton, who wandered into the Cox studio in the 1840s dressed in his father's cast-off clothes and clutching two very bad pictures he'd made — "frightful daubs," Cox called them. He'd run away from the farm convinced he had the makings of a painter, and despite all the evidence to the contrary, Cox believed him. Eaton quickly absorbed what Cox could give him and went on to Cincinnati where he became a successful portrait painter and married a Cincinnati girl. Finally he followed fame to New York, where he settled in Yonkers, painted strong portraits of Columbia professors and Herman Melville, and became famous for sentimental pictures of children. The painter Oriel died young and before his talents really had a chance to mature, but his portrait of Melville remains the best of that extremely challenging subject.

A contemporary of Cox in the portrait business, also successful but in a more modest and mediocre way, was Barton Hays. He too had pupils. One of them, in 1866 and later, was the son of a prosperous local shoe store owner. The student's name was William Merritt Chase (1849–1916). When Hays had taught him all he could, Chase went to New

York to study with Oriel Eaton. Then, in 1870, the Chase family moved to Saint Louis, where William followed and set up as an artist. He secured the patronage of S. A. Coale and Charles Parsons, two of the important collectors of Modern Art mentioned by Strahan. Parsons was later one of the pioneer patrons of Halsey Ives's museum. These men and some others decided that Chase had to go abroad to study, just like the gentlemen of New York and Philadelphia who sent West off to Rome. The gentlemen of Saint Louis sent Chase off to Munich. There he roomed with Walter Shirlaw, the former banknote engraver who had been so active in forming the Chicago Art Academy. Chase also became a bosom friend of Duveneck and Twachtman, the luminaries of Cincinnati art.

Chase only went back to Indiana for rare visits. Instead he went on to become America's most famous resident painter. He was a friend and coequal of the expatriate Whistler and did the definitive portrait of him, which Whistler called a "monstrous lampoon." He knew Sargent and was a devotee and acquaintance of Manet. It was Chase who first heard of the two Manets later presented to the Met by Erwin Davis, the first Manets in any museum. Chase was a famous teacher at New York's Students League and at the PAFA in Philadelphia. Before the Ash Canners and the 1913 Armory Show he was an undisputed arbiter of New York esthetic elegance with his stylish clothes and exotically decorated studio. Among the earliest pictures acquired by the Indianapolis Museum were Chases. Now that his reputation has been refurbished after the inevitable decline and every museum in America again shows a Chase if they have one, the unswerving loyalty of Indianapolis to its most famous native painter is once more justified.

The Golden Age of Indianapolis was the age of Chase, when the city was a center of literature and to a lesser extent of painting. Beginning in the 1870s with the first Hoosier writers and culminating in such nationally famous figures as James Whitcomb Riley and Booth Tarkington, Indiana in general and Indianapolis in particular became a distribution center for best-sellers and authors. Bobbs-Merrill, one of the few successful publishing houses with headquarters away from the East Coast, was founded. Everybody read the *Graustark* books by native son George Barr McCutcheon or *Alice of Old Vincennes* by native son Maurice Thompson.

To parallel this turn-of-the-century literary flowering there was a much more modest flowering of painting. It was not only Chase who studied with Cox and Hays and then went to Munich and Paris; a whole flock of other Hoosiers did likewise. Unlike Chase, many of these returned to Indiana and from the 1880s to the mid-1920s there existed something called the Hoosier Group or School or Colony, centered in Indianapolis and closely tied in with the Museum and school.

The principal figures in the Group were Theodore Steele, J. Ottis Adams, William Forsyth, and Otto Stark, primarily landscapists who celebrated the pastoral beauties of the Indiana cornlands and the Wabash River valley as the painters of Saint Louis did their larger Mississippi. None of them was famous outside of Indiana; but beginning in the 1890s they were recognized, especially in Chicago, as a separate and identifiable constellation. They controlled the visual arts in Indianapolis, taught, exhibited, won prizes, got on juries for exhibitions, and supplied the "hub" for this later period that Cox had supplied for an earlier one. They were particularly prominent in an Indiana Artists Annual held under the sponsorship of the Association and then the Museum from the 1890s on.

This Art Association of Indiana, which preceded the Museum in Indiana, put on all sorts of shows, not merely those of the Hoosier Group. Even before the official date of its origin in 1883, it was in existence and sponsoring lectures on ceramics and other arts and crafts. In 1882 there was a fine exhibition of almost five hundred loan paintings. In 1884, after incorporation, the Association attempted to float an art school, which soon foundered. In 1885 the first exhibit of the Hoosier School occurred under its sponsorship. From then on annuals were held in diverse locales such as the Denison Hotel, the Columbia Club, Masonic Hall and the Propylaeum.

Quite suddenly, and to the amazement and delight of one and all, one John Herron died and left all his money to the Association to build an art museum. Nobody ever seemed to have known or even heard of Mr. Herron. It was like the five-million-dollar bequest of obscure Mr. Rogers to the Metropolitan in New York. Herron was a farmer, born in England, who eventually settled in a small town in Indiana called Mount Carmel. There he prospered and by inheritance and energy built up a fortune based on real estate and farm properties in various places. He had no children and at an advanced age moved to Los Angeles to spend his final years, escorted and nursed by a niece of his late wife, a Miss Turrell. The boardinghouse where they lived in Los Angeles turned out to be infested with bedbugs. When Miss Turrell complained, the landlady obligingly saturated the house with kerosene. Sparks from Mr. Herron's pipe ignited the kerosene, and though Miss Turrell managed to drag her uncle from the flames, he died. Miss Turrell, incidentally, later held the post of librarian in her uncle's museum.

When the news of Herron's bequest was received in Indianapolis, a mass meeting of the Association was held at the Grand Opera House in May 1895, "that the public might share the Associations's joy." But it took a long time to get the money and then do something with it.

The will was contested. Then a committee had to be formed, which

proceeded to fight over where to put the new building. Finally it was decided to buy the old Talbott place, the so-called "Tinker House," and eventually build there. In 1902 the John Herron Museum was at last opened in "Tinker House." Again the board wrangled over just how to use Mr. Herron's money and what to build with it. The building that replaced the charming old "Talbott-Tinker House" did not open until 1906, more than ten years after Herron's death.

The new Museum, like so many other fledgling American museums, now had a building, but that was about all. The Museum lacked the one thing vitally necessary to get any American art museum started properly: a dynamic director who would stay with the institution and build it up from scratch. At the John Herron Museum directors came and went, including Frederic A. Whiting, later great first director of the Cleveland Museum. Nobody seemed to have collected pictures in Indianapolis, even Gems of Modern Art. The museum's permanent collection, when it finally opened in its brown arts-and-crafts Mission-style Classical building in 1906,* consisted of some one hundred modern pictures, many of them by extremely obscure turn-of-the-century Salonistes, foreign and domestic.

What Indianapolis had most of when Mr. Herron's Museum rose from his ashes was a collection of American modern paintings, a good many of them by natives of Indiana. Most of the painters' names don't ring bells nowadays. Faulkner, Gruelle, Ketcham, Loomis, Meakin, Parton, Poore, Scott and Sharp are not to conjure with. Most of these pictures were eventually exiled to the walls of public school classrooms. The Museum also had a small collection of perhaps less mediocre Americans, some of them also natives of Indiana. William Merritt Chase was represented as early as 1889 by *After the Shower*. The later Hoosiers, Adams, Forsyth, Stark, and Steele, were on hand; and as the years went by the collections of their works grew and grew. Jacob Cox only began to be acceptable at the Museum in the 1920s. There was the portrait of James Whitcomb Riley by John Singer Sargent, which the infant Museum, just moved to "Tinker House," acquired with monies raised by a public reading by Riley of his poems — always a surefire crowd pleaser in those days. And the Museum had its Duveneck and its Hassam and its Twachtman.

Lacking as the Herron was for so many years in dynamic long-term directors, it was a long time before the institution acquired anything really worthwhile. The first good older European pictures in the collec-

* The building in Indianapolis that really should have been the museum was the chaste Greek Public Library, designed by the architects of the new Detroit Museum, Cret, Zantzinger, and Borie. This was often referred to, in a day when Neoclassical buildings were admired, as the most beauitful Greek building in America. Nobody ever said that about the Herron.

tion were two small Turners acquired in 1913. By now the Museum has a whole room full of Turners, in fact one of the definitive groups in the country, the Pantzer Collection.

Indianapolis got its first outstanding director, Wilbur D. Peat, in 1929. There had, indeed, been a period in the mid-twenties when the Museum had no director at all and things were taken care of by the Curator, artist Anna Hasselman. The Hoosier Group, who had so dominated and guided the affairs of the Museum and its renewed school from the beginning of the century, died off in succession, Stark and Steele in 1926, J. O. Adams in 1927, and Forsyth in 1935.

Wilbur D. Peat was born in China in 1898 of American parents. He graduated from the Cleveland School of Art in 1923 and was Director of the Akron Art Institute from 1924 to 1929. From then on it was all upward and onward in Indpls. Year by year, item by item — the hard way, as in Saint Louis — Old Masters of significance, valuable Impressionists, durable Americans were acquired. Evans Woollen, who had been President of the board from 1907 and fills in memoriam the role of Permanent President, lived long enough to see this transformation before he died in 1941. By then famous local author Booth Tarkington had become active on the board, as well as G. H. A. Clowes (pronounced "Clewes"), who was developing a private collection rivaling any in America in its riches. El Greco, Hobbema, Cuyp, Van Gogh, Copley, Stuart, Vandyke, Rembrandt, and Titian began to push out the Partons and the Poores. Another earlier and active boardsman was Kurt Vonnegut, Sr. It is striking from a literary point of view to see the names Kurt Vonnegut and Booth Tarkington decorating the board of the same art museum: echoes of the Golden Age of Indianapolis letters.

Since Wilbur Peat did not resign until 1965, a year before his death, this whole period of development from an extremely minor collection of second-rate contemporary Europeans and Americans to a respectable all-around city art museum took place under his direction and inspiration. He is really the creator of the present Indianapolis Museum of Art, as it is now called, or at least he brought the "John Herron" to the point where it could become the "Indianapolis."

Cinderella, however, was not turned into princess until 1970. By this time the town of Tarkington, whose decline he himself lamented in *The Magnificent Ambersons,* had been totally obliterated and transformed into the City of Lilly. Eli Lilly and Company has made the city one of the country's pharmaceutical capitals. An Eli Lilly, grandson of the original founder and head of the company, had been a faithful backer of the Museum in its earlier days. He had been a member of the board in the earlier years of the century, but his name then disappears until 1960. In later years he was once again the great patron of the institution. When his brother John died, the heirs gave John Lilly's

mansion and its beautifully landscaped grounds to the Museum.

With the help of the Lilly Foundation, a dynamic new Director (Carl Weinhardt), and a sudden upsurge of civic interest and money giving inspired by this munificent present, a big new white modern fountain-fronted dreamhouse was created in 1970 on a part of the Lilly estate. Then the Clowes Collection, held for years in family hands and visible to lucky visitors only on Thursday afternoons, was given by Clowes's heirs to the new museum. A special Clowes Pavilion was built to house this along with the other fine earlier paintings acquired by Peat. Now the Indianapolis Museum of Art, which dropped the "Herron" when it moved, has at last achieved maturity and can stand comparison with the other museum glories of the Midwest. It is really more beautiful than any of them in its magic garden and more fabulous for being so suddenly created and enriched. The fact that the main gates of the Museum directly face the gates of the Country Club, so that trustees can come right over after lunch, does not affect the enormous increase — tenfold since the opening — of public attendance. The Lilly Foundation, one of the nation's largest, with capital assets probably approaching a billion dollars, has agreed to match, two dollars for one, any money raised by the Museum elsewhere.

Of all the new developments in the American museum world, that of Indianapolis is perhaps the most striking. Instead of just the auto races, Indianapolitans can now boast of their Art Museum. And they do.

Chapter II

i

ONLY A FEW STATES of the Union — Massachusetts, New York, California, Ohio, and now Texas — can claim to be "museum states." Of these multimuseum states, Ohio is one of the most remarkable. There are the five sizable and flourishing big-city museums — Cleveland, Toledo, Dayton, Columbus and Cincinnati — as well as a group of lesser museums like the prestigious college museum at Oberlin, the odd but rich Institute of American Art in Youngstown, and town or city museums in Akron, Canton, Zanesville, and elsewhere. The Cleveland Museum is the most famous of these Ohio museums, nowadays richest in art and in endowments and always reckoned among the top half-dozen of the country. The dowager of Ohio museums, however, is that of Cincinnati, oldest in the state and one of the oldest in the country. Cincinnati opened its museum in 1886. Unlike almost any other such early museums, it is still in its original building, on its original site; though alterations and additions, as in the case of the Met, have hidden the original structure behind an enveloping embrace of later construction.

Cincinnati had a richer and more indigenous artistic life than other Midwestern cities. Though all these Midwestern cities had their early artistic life, none had anything comparable. Healy was internationally known, but he was only a visitor in Chicago. Gari Melchers was famous in his day but he never lived in Detroit as an artist. Bingham lived in Saint Louis and was certainly a Missourian, but he also lived in other places and was just as partial to arch-rival Kansas City, where he died, as to Saint Louis.

Though Cincinnati never supported or kept a resident artist as famous or indigenous as Copley was to Boston (though he too left) or Eakins to Philadelphia, the Queen City supported a vigorous art life all through the Victorian era and beyond and exported a score of painters, including J. Oriel Eaton and Worthington Whittredge. Yet there is a paradox here, for as literature was more influential than painting in Indianapolis, so music was in Cincinnati. Mr. Scripps made that clear in describing his plans for Detroit as the Florence of America. Cincinnati by the 1880s was considered *the* musical city of the whole country. It was never considered the American capital of painting.

Though Cincinnati's official date of foundation is reckoned to be 1788 and it was named after the Society of Cincinnati in 1790, it was still a village of less than a thousand inhabitants in 1805 and by 1820 only a small town of slightly over ten thousand pioneers. As early as 1815, however, one Edwin B. Smith seems to have been painting portraits in the Queen City (still only a Princess then, and hardly a city). Then about 1820 a Western Museum was founded here; and just as Peale's Museum was the true progenitor of organized art on the East Coast, so the Western Museum was of art in the Midwest.

It began, again like Peale's, as a museum of science founded and patronized by Dr. Daniel Drake, Cincinnati's Benjamin Franklin of art, culture, and learning. It was first housed in an infant College of Cincinnati, and there John J. Audubon was briefly employed as taxidermist. The Museum languished until it was taken over by a French entrepreneur named Dorfeuille, who livened things up with paintings, Indian relics, and souvenirs of murders. Even more enlivening was a group of moving waxworks, and in 1828 a spectacle called Dante's Inferno was unveiled, with corresponding Elysium. Though the Elysium was declared to be "executed with great taste and [above all] accuracy," it was the Inferno that packed them in, demonstrating the general theatrical principle that vice is always more thrilling than virtue.

In the same year, 1828, bustling Mrs. Trollope, mother of the future novelist Anthony, came to Cincinnati with her visionary scheme for a Bazaar where expensive English knickknacks were to be sold. Though

the population of the town had now swollen to nearly twenty-five thousand, Cincinnati was still not exactly the cosmopolitan world capital that Mrs. Trollope thought it should be. Her fantastic Bazaar, built at great expense on the model of the Prince Regent's pavilion at Brighton, put her in debt. Nobody seemed to want English knickknacks. She soon went bankrupt. Naturally Mrs. Trollope did not like Cincinnati, but she did like Dorfeuille's Western Museum and left a graphic account of it:

> He [Dorfeuille] has constructed a pandemonium in an upper story of his museum in which he has congregated all the images of horror that his fertile fancy could devise; dwarfs that by machinery grow into giants before the eyes of the spectator; imps of ebony with eyes of flame; monstrous reptiles devouring youth and beauty; lakes of fire and mountains of ice. To give the scheme more effect he makes it visible only through a grate of massive iron bars, among which are arranged wires connected with an electrical machine in a neighboring chamber; should any daring hand or foot obtrude itself within the bars, it receives a smart shock, that often passes through many of the crowd. . . . Terror, astonishment, curiosity are all set in action. . . . one of the most amusing exhibitions imaginable. There is also a picture gallery at Cincinnati but it would be invidious to describe it.

Mr. Dorfeuille employed a talented young clockmaker and modeler in wax to create these infernal wonders. From 1829 to 1834 a Vermonter named Hiram Powers built these mechanical monsters and in the process learned to be a sculptor rather than a clockmaker. Powers married a Cincinnati girl and along with two other young future sculptors, Henry Kirke Brown of Boston and Shobal Vail Clevenger of Middleton, Ohio, studied more seriously with another foreigner, Frederic Eckstein.

Eckstein was a professional artist, a sculptor who had been taught his trade by his sculptor father, Johann. Johann had worked for the court of Frederick the Great; in fact had made the death mask of the famous sovereign. Both father and son immigrated to the United States during the revolutionary troubles of the 1790s, settling in Philadelphia. The Ecksteins were among the artists involved in the founding of the Columbianum and the Pennsylvania Academy. The son went westward and made a splash in Cincinnati in 1825 by exhibiting his busts of Jackson and Lafayette. Frederic Eckstein attempted to form a Cincinnati Academy of Fine Arts in emulation of the one in Philadelphia, but it soon failed. Mrs. Trollope brought with her a French-born artist named Auguste Hervieu who had practiced in England. He decorated

the Bazaar with murals and tried to start an art school with Eckstein as his partner. According to Mrs. Trollope, the partners split on the subject of discipline, the Frenchman, surprisingly, supporting strict Europian decorum among his pupils, the German allowing as how American children couldn't be coerced in that fashion.

Neither Eckstein nor Hervieu contributed much actual art to Cincinnati. Hervieu returned to England and obscurity and Eckstein moved to Kentucky; but Eckstein's pupils, Powers, Brown, and Clevenger, became famous. Powers in his spare time began to do busts. (During the pre–Civil War period portrait busts making Yankee lawyers and businessmen look like ancient Romans, which in fact they did, were the rage.)

Powers did busts of Judge Jacob Burnet and his law pupil, Nicholas Longworth — both now prizes of the Cincinnati Museum. Burnet, founding father of the city, had arrived in town from New Jersey in 1796 and filled every available office in the new state of Ohio before his death in 1853. Longworth, also from New Jersey, came in 1803 when Cincinnati was a log village of some eight hundred inhabitants, studied with Burnet, married a well-connected widow, and began to practice law. The payment for his first case consisted of two secondhand copper stills. He traded these for thirty-three acres of wilderness land. He bought Judge Burnet's cow pasture for five thousand dollars. It wasn't too long before the pasture was worth a million and a half dollars and the thirty-three acres two million. By 1850 he was paying the highest real estate taxes of any man in America except William Backhouse Astor of New York.

Nicholas Longworth's principal interests, however, were art and agriculture. He planted vineyards on the hills overlooking the city and in the same marvelous year of 1828 began to produce marketable wines from his native Catawba grapes. (Mrs. Trollope, incidentally, never seemed to have heard of Longworth and his wines, though he was already the first citizen of Cincinnati.) As an art patron, he trundled over the mountains Benjamin West's enormous *Ophelia*. This had been one of Robert Fulton's collection, exhibited at the PAFA opening in 1811. The canvas had been saved from the fire of 1845, like West's *Pale Horse*, but it was considerably damaged. Longworth bought it and restored it, and it is now in the Museum. (A companion piece, English artist Benjamin Haydon's huge *Christ's Entry into Jerusalem*, was also rescued from the PAFA fire and taken to Cincinnati. It contains portraits of Wordsworth, Keats, and others of the English literary circle of the time; but it is the property of the Cathedral of Cincinnati and, though originally shown in the Museum, is not there at present.)

Longworth not only bought art but helped local artists. His most

famous object of patronage was Hiram Powers. Longworth sent Powers to Washington, where he made a great reputation doing busts of politicians, and then Longworth and some South Carolina patrons sent Powers on to Italy. Powers never came home again.

Hiram's great triumph was the extremely chaste and totally nude statue *The Greek Slave* (1843). It was the most celebrated marble of its day, bar none. Elizabeth Browning, friend of both Jarves and Powers in Florence, celebrated its political overtones in a sonnet that closed with the lines "Strike and shame the strong / By thunders of white silence, overthrown." (The "strong" were Turks and all infidel tyrants.) *The Greek Slave* was sent on a tour of the United States in 1847, the ground having been carefully prepared. In Cincinnati a convocation of clergymen was induced to give approval, and nudity — chaste, female, politically virtuous — was generally vindicated. It was in fact one of the major assaults on American prudery, but not on American virtue. Powers continued to turn out chaste nudes and robust busts. His example inspired young Cincinnatians to frenzies of creation.

For instance, Shobal V. Clevenger, who had briefly studied with Eckstein along with Powers, left the farm to work on gravestones in the Queen City. Like everyone else, he married a native girl. He, too, tried his hand at busts and attracted Longworth's attention. He toured the country making portraits of William Henry Harrison and Henry Clay, of Washington Allston in Boston, Philip Hone in New York, and Joseph Hopkinson, President of the PAFA, in Philadelphia. He, too, was sent to Europe by Longworth, where Powers befriended him and Clevenger did a bust of Powers; but instead of a long expatriate career of marmoreal success, he got consumption and died on his way back to America in 1843.

Henry Kirke Brown first learned to model in Cincinnati, but he soon left for the East Coast. He went to Europe in the 1840s and returned to New York as a famous teacher and creator of equestrian and other public statues.

Longworth also helped painters. In the 1820s a German immigrant named Martin Baum built a magnificent Neoclassic mansion in town at Pike and Symmes. After serving as Mayor of Cincinnati, Baum went bankrupt; and in 1830 his mansion fell into the hands of Nicholas Longworth. This is another structure Mrs. Trollope never seems to have noticed, though how she could have missed it one cannot possibly imagine. Longworth settled into "Belmont" and at the end of the 1840s commissioned a young painter named Robert Duncanson to decorate the front hall with murals. Duncanson created some pretty fantasies — romantic landscapes, half pioneer, half Rococo — then went on to a career of portrait painting in Cincinnati and elsewhere. What makes

him unusual is that he seems to have been the first successful black painter. (His father was a Scotch immigrant to Canada. His mother was a mulatto.) He later worked in New York and England and died in Detroit in 1872. But his charming murals are still in Cincinnati in what is now the Taft Museum. David Sinton, tycoon and hotel proprietor, one of the original backers of the Art Museum, bought the house some time after Longworth's death. It came into the hands of his daughter and her husband, Charles P. Taft. The murals had long been covered up by later wall decorations, but the Tafts discovered, uncovered, and restored them; and they remain exotic yet native features of Cincinnati's present-day precious "house museum."

There was a whole school of Cincinnati painters in those boom days of the 1840s and 1850s before the war. Cincinnati by then had become a real city, with well over one hundred thousand inhabitants as of 1850. It was officially dubbed the "Queen," especially by Longfellow in his poem praising the wine Longworth made from Catawba grapes:

> *And this Song of the Vine,*
> *This greeting of mine,*
> *The winds and the birds shall deliver*
> *To the Queen of the West,*
> *In her garlands dressed,*
> *On the banks of the Beautiful River.*

Cincinnati felt good all over. It was in fact the oldest, richest, largest metropolis of the Midlands (Chicago as of 1850 had fewer than thirty thousand inhabitants) — Porkopolis or the Athens of the West, depending on how you chose to look at it.

After the example of Philadelphia, two families in particular, the obscure Frankensteins and the well-known Beards, flourished during this period. No less than four Frankenstein brothers and two sisters came from Germany to paint in Cincinnati during the 1830s and 1840s before moving en masse to Springfield, Ohio. The Beards began in Buffalo, then moved to Painesville, Ohio, near Cleveland. One brother, James, came to Cincinnati to work as a portrait painter. He married an heiress named Mary Carter, daughter of a Colonel Carter. James sired four sons, then left for New York. There he switched from humans to animals and, along with his brother William Holbrook Beard, cornered the market in bears. The Beards did bears playing cards, drinking and carousing, and celebrating the collapse of stocks on Wall Street and made themselves rich and famous. The four Cincinnati-born sons of James also became well-known artists of one kind or another. Worthington Whittredge; William Henry Powell, who studied with J. Beard and did a great mural in the rotunda of the Capitol alongside those of

Trumbull; Thomas Buchanan Read, poet and portraitist; Alexander Wyant, protégé of Longworth and Hudson River School member, and many others came and then went.

Museums like Dorfeuille's, exhibitions of paintings, and art schools also came and went. It was not until after the war that Cincinnati began to settle down esthetically, have real schools, and at last a real art museum. Nicholas Longworth died in 1863. His famous Catawba grapes had been killed off earlier by a blight, and his vineyards became the site of Eden Park, a municipal pleasure grove overlooking city and river. "Belmont" came into the hands of Sinton and the Tafts. But Longworth's interest in art was continued by his son, grandson, and other members of the family; and a new crop of artists even more famous than Powers and his prewar contemporaries studied, painted — and most of them left.

ii

Art in America between the Civil War and the First World War continued to be dominated by the East Coast, but of all the newer cities westward, Cincinnati during that time produced the largest crop of well-known artists. True enough, it remained a place artists came from rather than went to or stayed in. True enough, most of these Cincinnati artists, famous in their day, are now comparatively obscure or even forgotten. No special group came back from studies abroad and repatriated themselves to create a self-conscious Cincinnati School parallel to the Hoosier School of Indianapolis. None of the Cincinnati artists had a contemporary reputation as enormous as that of the Manhattan Hoosier William Merritt Chase. Still, Cincinnati-born or trained artists — Frank Duveneck, John Henry Twachtman, Robert Henri, Robert Blum, Kenyon Cox, Henry F. Farny and many others — were significant figures in the art world of this period and are still hung and bought by museums today.

The central personage of the whole post–Civil War group, the most famous of them at the time and also the most closely identified with the art of the city itself, was Frank Duveneck (1848–1919). Duveneck came from humble, hardworking German immigrant stock, and his name was really Decker, not Duveneck. But his own father died when he was an infant and his stepfather adopted him. Duveneck's mother had at one time been a servant in the household of artist James Beard and presumably picked up some inklings of the life artistic there. Stepfather Duveneck operated a beer garden in Covington, Kentucky, across the river from Cincinnati. Stepson Frank began his career as a child by making a sign for this beer garden. He graduated from store signs to

easel pictures at about the age of twelve and in his teens did decorative work in German Catholic churches as an apprentice. He worked around home, then farther afield all over the country. While engaged to help decorate a Benedictine monastery in, of all places, Newark, New Jersey, he was favorably noticed by the superior, Father Cosmos. Father Cosmos wrote Frank's parents that the talented boy must go study religious painting in Munich, home of all good things including art. When Duveneck reached the age of twenty-one, he was allowed to go.

Munich for a brief period of about fifteen years from 1870 to 1885 was the mecca of American art students. When Duveneck went to Bavaria in 1869, he was one of a mere half-dozen American students there. Ten years later there were over a hundred. The great influence at the time was Wilhelm Liebl, champion of "realismus" against the older academic school of historical painting as practiced by that same Piloty whose wise and foolish virgins caused such a stir in frontier Lincoln, Nebraska. Chase studied with Piloty; and though Duveneck didn't actually study with Piloty's rival, Liebl, he emerged in a few years as an ardent and successful disciple. Church painting was soon forgotten. Slashing brushwork, lots of brown pigment, studies of poor city children and old country crones, a general atmosphere of Frans Hals exuberance and vitality — these became and remained the Duveneck trademark, derived from Liebl. He began winning medals and a reputation. By 1872 he had already painted what is still considered his representative masterpiece, the so-called *Whistling Boy*, now in the Cincinnati Museum. (It is, incidentally, not a whistling but a smoking boy.) This lively portrait of an independent street urchin, so reminiscent of Dutch or Spanish seventeenth-century masters, typified Duveneck and the general effect of the Munich School on its American students. It was the style taken up by Chase when he arrived in Munich a few years later. Duveneck stuck to it, more or less, all the rest of his life.

When his money ran out, Duveneck had to return to Cincinnati in 1874. There he set up a studio with some other young artists, including Henry Farny, who later became a specialist in pictures of the Far West and its Indians. Duveneck taught at a Mechanics Institute and a whole group of his pupils, including Cox, Blum and Twachtman, not only became his bosom friends but went on to distinguished careers elsewhere.

Meanwhile in 1875 an exhibition by the Boston Art Club, inspired and founded by richly bearded William Morris Hunt, made Duveneck nationally famous. Pictures like the so-called *Whistling Boy* seemed a revelation of novelty, force and Continental sophistication, especially as contrasted with the romantic literalism of Hudson River School painters. One of Duveneck's Cincinnati pupils, John Henry Twacht-

man, became especially devoted to the master; and when Duveneck
went back to Munich in 1875, he took young Twachtman with him.
Twachtman was a family friend; in fact the two families had come from
the same village in Hanover. Farny went along with them. By that time
Chase was ensconced in Munich and was sharing a studio with Shirlaw,
the former Chicago banknote engraver. Both became intimate friends
of Duveneck, a sort of Midwestern trinity nicknamed by contem-
poraries in Munich the Father (Duveneck), Son (Chase), and Holy
Ghost (Shirlaw). In 1877 Duveneck, Chase, and Twachtman went to
Italy, where they nearly starved and lived for weeks on beans. Then
Shirlaw (1877) and Chase (1878) returned to the United States, and
Duveneck, dissatisfied with the increasingly academic atmosphere of
teaching in Munich, set himself up as a teacher there and immediately
attracted a score of American pupils. These included Twachtman and
an elegant expatriate Bostonian, Miss Elizabeth Boott, relation of
"everyone" in Boston and intimate friend of Henry James.

In 1879 Duveneck took his troupe of pupils, "Duveneck's Boys," to
Florence, where Miss Boott lived with her dilettante musician father in
a beautiful villa full of beautiful old things. (The Boott villa and
family were the models for the Ormonds in Henry James's *Portrait of a
Lady*.) Duveneck and Lizzie Boott began a long romance, the unlikely
conjunction of the big, blond, bearlike son of immigrants, brought up
in a beer garden, and the dark, *raffinée* esthetic amateur brought up in
Italian palazzi and among expatriate artists and rentiers. Mr. Boott
frowned on this uncouth suitor. Henry James was most disturbed. He
found Duveneck "not a gentleman." (James was probably as much in
love with Lizzie Boott as he could be with anyone and no doubt hoped
she would live in a permanent state of sympathetic spinsterhood.)
Eventually in 1886, after much backing and filling, Duveneck was al-
lowed to marry Lizzie. She was then all of forty. Duveneck was famous
now, friend of Whistler in Venice and London and of the by now also
famous Chase in New York. For a short while the Duvenecks were
important figures of the world of rich and sensitive expatriate Americans
and their titled English and European friends. They had a child; and
then suddenly Lizzie died in 1888.

The death of his wife more or less broke Duveneck as both a man
and an artist. He left Europe, deposited his child with Boott relations
in Boston, and settled back home in Cincinnati, still famous, but less
and less productive. The style of Munich, made popular in the United
States by Chase and himself, so exciting in the 1870s and 1880s, had
become old-fashioned with the triumph of French Impressionism in the
1890s. Duveneck spent the last years of his life, till his death in 1919,
teaching at the Art Academy in Cincinnati, collecting honors and
awards, dominating the school and the museum, and enjoying the local

bohemian circle centered about his old friend Farny. When he died the contents of his studio were left to the Museum and are still exhibited there in a special room.

The other famous artists with Cincinnati connections have more tenuous links. John Henry Twachtman (1853–1902), though he was born there and studied there under Duveneck, did not come back to settle after he left for Europe. He did marry a local girl and spent a few years painting in suburban Avondale; but he deserted both Cincinnati and the dark shades of Munich for the more luminous paint of Paris and the countryside of Connecticut, where he lived in Greenwich alongside his fellow Impressionist Julian Alden Weir (1852–1919).

Robert Henri (1865–1929) really has very little to do with Cincinnati, especially as an artist; but he was born there (as Robert Cozad), and most of his formal education took place there. His style of painting — dark backgrounds, portraits of street urchins and old crones in a slashing manner — is so like the bravado of Duveneck that one would swear they had been teacher and pupil; though in fact Henri studied in Philadelphia at the PAFA with Eakins and Anschutz.

Henri was the founder of that group of artists called the Eight, or the Ash Canners, who stunned the New York art world when in 1908 they exhibited at the Macbeth Gallery. They had been preceded by another group, the Ten, who exhibited together from the 1890s on with equally great renown. Of the Eight — most of them Philadelphians who went to New York to paint the American scene — their leader Henri was from Cincinnati. Of the Ten — most of them Bostonians who went to New York to practice American Impressionism — two, Twachtman and Joseph De Camp, were from Cincinnati. Bellows, who joined the Eight and began his career painting like Duveneck, was also from Ohio. There certainly seems to have been a strong tinge of Buckeye spirit pervading the American art world around the turn of the century.

iii

Meanwhile, rather apart from real creative life, Cincinnati's Museum was started. The Museum in Cincinnati began with a committee of women who got together as early as 1854 with the express purpose of founding a museum. The leader was Mrs. Sarah Peter. Born Sarah Worthington of Chillicothe, daughter of a Governor of Ohio, later twice widowed, she settled in Cincinnati in 1853 after residence in the East and abroad and immediately set up a salon built about the arts. She and her Lady's Academy of Fine Arts of 1854 made a collection of what they called "masterpieces and copies" and opened a small private

gallery to show them; but the Civil War interrupted and the group disbanded.

Then in 1877, just as Sarah Peter died, the group was reactivated as the Woman's Art Museum Association and this time the committee was successful. In 1878 it put on one of those loan exhibitions that always seemed to precede the founding of museums in the Midwest. It was, as usual, a success. At a second show, an Industrial Exposition in 1880, a local millionaire named Charles West announced he would give one hundred and fifty thousand dollars toward building a museum if his gift could be matched. Melville Ingalls, railroad magnate and lawyer, David Sinton, hotel owner and capitalist, Reuben Springer, retired grocer and philanthropist, and Joseph Longworth, son of winemaking Nicholas, all contributed generously. The matching sum was made up, a site in Eden Park, the former Longworth vineyard, was chosen, the museum was incorporated in 1881, and the building was finally opened in 1886, by which time unfortunate West, Springer, and Longworth were all dead. Ingalls was President of the Museum's board. Sinton lived on till 1900, to the age of ninety-two.

The dedication on May 17 was an occasion for tumultuous civic rejoicing. The newspapers went wild. "A NOBLE GEM added to the City's Crown of Hills," proclaimed the *Gazette*. "Dedication of the West Museum, A Gift by the People to the People. Addresses by President Ingalls, Mayor Smith and Director Goshorn amid Auspicious Surroundings of Music, Sunshine and Flowers." The *Gazette* apostrophized the "May Day, perfect without an if, the golden sunshine that made the very hills look glad." The *Sun* was no less rapturous. "CINCINNATI'S HOME OF ART." Townsman poet, T. B. Read, was quoted: "I have seen — in waking visions — / The rich dome of art expand." "Every car that went to Eden Park was filled with the most cultured and educated people. . . . The broad drives of the park were completely occupied by the brilliant equipages of wealthy citizens." And the *Post:* "A JOY FOREVER. An incomparable Palace of Imperishable Beauty." Inside, the Great Hall with its Grand Staircase was bedecked with flags, palms, and the portraits of deceased donors West, Springer, and Longworth. The Philharmonic Orchestra, the Apollo Club, and the chorus of the College of Music performed "needless to say . . . with fine effect."

The Incomparable Palace of Imperishable Beauty, a cross between the domed Germanic Classicism of Philadelphia's Memorial Hall and rough-hewn Richardsonian Romanesque, was attached to a new School of Art, originally backed and supported by the Longworth family and, after 1900, under the guidance and influence of Frank Duveneck. Inside the Palace, under the rather lax direction of the Ohio-born Goshorn, a vast accumulation of sundries began to pile up.

The fatal policy originally announced by the Society of Saint Tammany in post-Revolutionary New York — the acceptance of any gift from "whatever clime" — dominated Cincinnati's accession policies. Arrowheads, pottery, mineral specimens, all were welcome. The Great Hall was full of casts and palms and served most usefully as a regal setting for parties, during which ladies could sweep down the Grand Staircase with maximum effect. The Cleneay Archaeological Collection of stone implements of the Ohio River Valley vied as attractions with the Longworth collection of drawings of the German Neoclassical-Romantic Karl Fr. Lessing. There was a fine specimen of dolomite and some Turner sketches. There were equally fine specimens of Salon art from Achenbach to Ziem. There were many oriental items, many copies of European paintings, and a few originals — Longworth donations of Il Guercino, Il Spangoletto, Carracci, Dolci, and such. The Longworths also gave native son Hiram Powers's *Eve Disconsolate,* another very chaste nude. The Doane collection of musical instruments, now one of the prides of the Museum's collections, was on loan as of 1888–1889.

Even more remarkable was the loan that same year of the Morse collection of Japanese pottery, now the pride of the Boston Museum. Pottery in fact was always prominent in Cincinnati. The energetic daughter of Joseph Longworth, Mrs. Bellamy Storer, began a famous art-ceramic studio and factory called the Rookwood Pottery, and from the beginning till the present examples of Rookwood have been part of the Museum's displays.

Two of the largest exhibits were the fire-singed Benjamin West *Laertes and Ophelia* and the equally fire-singed Benjamin Haydon *Christ's Entry into Jerusalem.**

Glutted with the superfluous, the Museum nodded up on its beautiful hill, replete with palms and casts and copies, acquiring local artists and Rookwood pottery and happy in a haze of pleasantly parochial somnolence. Wings accrued, the Schmidlapp first in 1907, and then more and more. The name Emery began to replace that of Longworth as dominant. A 1910 Emery bequest gave the museum a Constable and a Courbet, a Hobbema and a Reynolds — and many a Saloniste. But casts were still being bought. The Robert Blum memorial collection had its separate room; Duveneck loans and gifts kept coming in. Farny made the board but was put in charge of real estate. Works by Homer,

* There were some good things scattered about, a Courbet here and a Whittredge there, those interesting Lessings and the Turner "Liber Studiorum" of sketches; but the general embrace of the Museum was too large and too loose. A fantastic plan that expanded the Museum's scope to include literally everything, natural history, ethnology, crafts, the "Arts of Life" (industry) and the "Arts of Pleasure" (poetry, dance, graphics), was actually printed in an early bulletin. It was many years before the casts and the copies and the bric-a-brac were weeded out. The Museum still has a basement full of arrowheads and stone artifacts it can't get rid of.

Chase, and La Farge, artists of the Ten like Metcalf, Benson, Hassam, and Twachtman, local boys like De Camp and Cox and board member Farny were acquired. Good things did come in, but they were few and far between.

Then came a real coup in 1927: a bequest by Mrs. Thomas Emery provided a core of Old Masters parallel to the Marquand and Scripps and Ryerson "cores." The prize was a Mantegna, but there was also a Titian, a Velásquez and a Murillo, a Rembrandt, and a Vandyke. Nonetheless, by the time the Depression came along, Cincinnati seemed to have somehow missed its opportunities during the great days of acquisition.

The Depression and the following war nearly closed the Museum entirely. Then in 1945 a new energetic Director, Philip R. Adams, took over. Full of ideas and backed by a new board and new patrons, among whom Emerys of a later generation were still prominent and a Miss Hanna the most generous, the Museum was transformed. Out at last went the casts and copies and palms and arrowheads. Out also, alas, went the Great Hall and the Grand Staircase — a permanent loss to museum architecture. The envelopment of wings became complete, so that by now nothing is left of the old building, inside or out. Magnificent gifts like Mary Hanna's in 1946 of Dutch, French, and English paintings have transformed the European collection. The antiquities, especially those of the Near East from Roman times on, now form one of the best and most chronologically complete exhibitions of the kind in America. There are choice Orientals, including one of the oldest rugs in existence, a great Chinese spread that dates back at least to the twelfth century.

Cincinnati now has a fine universal survey museum. Although it is not as dazzling as that of Cleveland or as sumptuous as the Art Institute of Chicago, what makes it special is the strong local accent — the Duveneck Room, the Farny Room, the panels made by the Rookwood Pottery for the Sinton Hotel, as well as a Vouet that long hung in its lobby, prudently overpainted in drapery by a later hand. (When the drapery was scraped off, a nude Baroque Venus was unveiled.) There is the marvelous local Doane collection of musical instruments, collected by a somewhat eccentric but wildly successful composer of Victorian gospel hymns. And there is all that pottery made by the daughter of donor Longworth. But perhaps the most delightful of all these local touches is a big room dominated by two big murals, one by Saul Steinberg and the other by Joan Miró. These murals were originally commissioned for another hotel, John J. Emery's magnificent Terrace Hotel of 1948. John Emery is the modern representative of the family whose benefactions have helped so much to make the Museum what it is today — and whose fortune originally was involved in the somewhat

odd field of candle making. Along with the Sinton Hotel Vouet, the Emery Hotel Miró is one of the main attractions of Cincinnati's splendid and delightfully parochial Museum.

Nothing adds to the esthetic richness of a community like a second museum. Half the charm of art in Boston is the dispersal of interest among the BMFA, the Gardner, and the Fogg in Cambridge; or in Philadelphia the existence of that "tripod" of the PAFA, Art Museum, and University Museum, with the later addition of the Barnes. Cincinnati has the Taft Museum. This as a museum belongs to the twentieth century, opened to the public in 1932; but as an esthetic creation it goes back to Martin Baum and his mysteriously anonymous and excellent architect of the 1820s, back to Nicholas Longworth of "Belmont" and his Duncanson murals of the 1840s, back to David Sinton and his daughter and Taft son-in-law of a post–Civil War date, and the final refurbishing and furnishing of the house, first by the Tafts and then by Director Siple of the Museum in the twentieth century. What strikes one most forcibly is size and magnificence. To think of this mansion rising in the Cincinnati of Mrs. Trollope! How *could* she have missed or ignored it with its impressive and graceful portico, its high-ceilinged, stately rooms, and its charming back garden? And then to have this already beautiful house stuffed with Rembrandts — two of which were recently stolen but recovered — and Hals and Gainsborough and Sargent (and of course Duveneck) and Chinese porcelains and Renaissance enamels and Duncan Phyfe furniture. The Taft Museum evokes as nothing else could the early and continuing cultivation of the arts in the Queen City.

iv

Although the Columbus Gallery of Fine Arts claims a founding date of 1878, it was not really in operation till 1931, when it came into being in the building it still occupies on Broad Street, in what is now downtown but was then still residential. Columbus in those Thurberish days was evidently a small city in spirit, a capital-university town more like Madison, Wisconsin, than the other two Big C's of Ohio. Nowadays it has become a third Big C, and its museum has found itself caught between two periods. Until recently it has been a fine small-city museum in a suddenly emergent big city, rather on the order of Indianapolis before the Lilly transformation. A new wing added in 1974 helps bring it up to date; but there is a considerable gap between the Columbus Gallery of Fine Arts and the great emporiums of neighboring Cleveland and Cincinnati.

The Columbus Gallery differs from every other important civic museum in America in that the true catalyst, the real spiritual founder of it, is a local artist of national importance. Peale's PAFA and Trumbull's Yale Museum are not civic museums. Hartford is only indirectly obliged to the Colonel. Thomas Le Clear and Halsey Ives, who are responsible for the museums of Buffalo and Saint Louis respectively, can hardly be called artists of national importance. George Wesley Bellows (1882–1925) of Columbus, though he wasn't a director or donor or even a trustee of the Columbus Gallery, was the scruple about whose paintings and personality the pearl of the museum formed. The fact of his existence as much as any other single thing converted what was previously a small-town art association into a rather odd but certainly flavorful and first-class small-city art museum.

A committee of women got together as early as 1878 and started things off with their Columbus Art Association. Something called a Columbus Gallery of Fine Arts was actually incorporated at the same time. A school, which still flourishes back of the present-day museum, was opened in 1879. The Columbus Gallery of 1878 was merely a board charged with the responsibility of obtaining grounds and "erecting buildings thereon"; but since the building wasn't actually erected till 1931, it can be seen that the board took its time. Meanwhile exhibitions were held here and there and now and again. In 1888 engravings lent by *Harper's Magazine* were shown at G. W. Early's Piano Parlours; but nothing really began to happen until the twentieth century — and Bellows.

Bellows was a prodigy. After a successful enough career as a schoolboy and undergraduate at Ohio University, where he was famous largely as a baseball and basketball player, he suddenly decided he wanted to be an artist. He seemed to show no particular talent. In that respect he was anything but a prodigy. He'd done nothing but adolescent illustrations for school publications. Nonetheless he left college without graduating and in 1904 appeared in New York to study art. He came under the spell of dynamic Robert Henri, that other Buckeye boy, and in a couple of years emerged as a famous artist. Just like that. He began painting pictures of street urchins, a *Cross Eyed Boy* of 1906 that anyone would swear had been done by Duveneck. Then he rapidly adopted the Ash Can manner and matter to his own ebullient personality. Though he did not in fact exhibit with them in 1908, he was by then a full-fledged member of the group and went on to his premature death in 1925 as a triumphant exponent of American Romantic-Realism, low life in a high key.

During his lifetime he was widely acknowledged as the Great American Artist, with emphasis on the "American." The fact that he never went abroad even for a visit, that he came from the Midwest, that he

was an athlete who played pro basketball and baseball during his early years in New York to help pay the studio rent, that he was a roommate of Eugene O'Neill one winter in New Jersey, that he was an all-around nice guy — all this helped to create and buttress his reputation in the early decades of this century.

Columbus was one of the first to honor the hometown boy. He had an exhibition there as early as 1906, before he'd really formed his style. He organized a Columbus show of the Ash Canners in 1911, and the nonexistent Columbus Gallery bought a famous picture of his, *Polo Game at Lakewood, New Jersey*, at that time. He spent a winter at home in 1912. Thus, though he never returned to paint or settle in Columbus, he certainly kept in touch. The lack of a decent place to hang one of the town's most celebrated citizens emphasized the need for a proper museum.

Two local friends in particular saw to it that the Gallery in name only became a Gallery in fact. These were an artist named Alice Schille and a banker named Francis R. Huntington. Schille was a resident painter of charm and talent who, like Jacob Cox in early Indianapolis, was the "hub" around which the artistic activities of Columbus centered. She taught, painted, exhibited in Columbus, sponsored shows of Ohio artists, and tirelessly battled for a museum. Huntington was a friend of both Schille and Bellows. He was a hereditary member of the Gallery board and President of it from 1923 till he died in 1928; before his museum opened. But he had seen to it that there was enough money, and he and Schille between them saw to it that there were enough pictures. From the opening date in 1931, Depression or no Depression, to the very present, the collection of the Columbus Gallery has been built around three names: Bellows, Howald, Schumacher. The opening exhibit consisted of the gift by Ferdinand Howald of his wonderful cache of American and French modern art. To this was added the loan of Frederick Schumacher's Old Masters and of Emma Bellows's collection of her late husband's pictures. The Schumacher loan eventually became a gift; much of the Bellows collection also came to the museum. Howald, Schumacher, and Bellows still remain central to the Columbus Gallery's possessions and acquisitions.

Ferdinand Howald and Frederick Schumacher were both foreign-born (Howald a German-speaking Swiss and Schumacher a German-speaking Dane) and both made their money in mines. Otherwise they were in total contrast. Howald was a recessive bachelor, dogmatic, sensitive, interested in the most advanced art of his time, original Cubists like Picasso, Braque, and Gris, Americans influenced by these men such as Marin and Demuth. He did not collect Bellows. Schumacher was an expansive and ebullient parvenu who liked to spread his wings and crow, exulting in the local prestige that his rather conven-

tional purchases gave him. The present Columbus collection, a fine solid group of Italian and northern Old Masters from Schumacher plus a few choice Primitives from Howald, a generous showing of American art centering around Bellows and the Ash Canners, and one of the finest selections of avant-garde French and American art of 1910–1930, comparable only to the Cone Collection in Baltimore, still makes a nice balance, a bit spotty by the omniverous standards of the typical big-city museum, but at once catholic and choice for a small-city collection. There have been other generous donors. But the spirits of Howald, Schumacher and, above all, Bellows, that local boy who so very triumphantly made good, still dominate the Columbus Gallery of Fine Arts.

v

Dayton is like Columbus, only smaller. Its museum does not pretend to be a Grand Emporium of culture. It is dominated by the influence of an individual, not an artist in this case. Although women have played pivotal roles in the foundation of Midwestern museums, no civic museum has been as pervaded by the influence of a local woman as the Dayton Art Institute was by that of Mrs. Harrie Carnell.

Dayton, of course, had its nineteenth-century ladies' clubs and its local arts associations — a Dayton Society of Arts and Crafts founded in 1902 was succeeded by a Montgomery County Art Association in 1912, a Dayton Art Association in 1917, a Dayton Museum of Arts incorporated in 1919, and finally a Dayton Art Institute after 1923. Shows were put on. One of these, a watercolor exhibit in the basement of Memorial Hall in 1913, suffered an odd fate. There was a flood and the water-colors were all washed away, thus carrying the possibilities of the medium too far. There was even a "permanent collection" of a few pictures bought from these various shows. When the museum was incorporated in 1919, it moved into the old Kemper house downtown. Then in 1928–1930, at almost the same time as Columbus, the by-now Dayton Art Institute built and moved into its beautiful new building, just in time to face the disasters of the Depression.

The Dayton Art Institute was kept going by Mrs. Harrie Carnell in person. The important name here, however, is neither Harrie nor Carnell but Patterson. Mrs. Carnell's first husband was a Patterson and the Pattersons ran the National Cash Register Company and the N.C.R. ran Dayton. Mrs. Carnell gave the museum site and gave the building, which was designed by Edward B. Green as a golden U-shaped Renaissance palazzo. It is a charming building that looks down a flight of golden steps to the river and the Dayton skyline. Unfortunately, free-

ways now interrupt the view with concrete and traffic noises. Mrs. Carnell also offered an endowment fund subject to a matching gift from the citizenry. When the Depression struck, the matching pledges turned out to be largely uncollectable; so until her death in 1944 Mrs. Carnell just picked up the tab and paid the yearly deficits. She left nothing to the museum in her will, however, and there were some dim years there after her death. Beginning with annual gifts in 1955 by Charles F. Kettering, a new Director as of 1957 (Thomas C. Colt, Jr.), and revived civic and industrial patronage, the Institute has come to life again.

Because the Carnells and the Pattersons were interested in Oriental art, the Dayton museum has a choice small collection of it. Because Mr. Colt saw the opportunity of building up the collection in a special area, the Dayton museum has a splendid group of Baroque paintings, including two Rubenses. Innumerable Pattersons have been on the board. An unusual name on the earlier list, corresponding to the odd touch of literary fame on the board of the Indianapolis Museum, is that of native son Orville Wright. His chief interest, however, like that of the younger Mr. Bixby, was aviation, not art.

vi

No museum in America has had a happier history than the Toledo Museum of Art. From its start at the turn of the century to the present it has reflected the energy, taste, determination and plain good luck of various continuing teams of exceptional Directors and exceptional donors. Like Dayton's, it is an entirely twentieth-century institution, going back no earlier than 1901. The team that originally created it was composed of Director George Washington Stevens (1866–1926) and glass manufacturer Edward Drummond Libbey (1854–1925).

Stevens was a prototype of the pioneering First Director in that he began as anything and everything but a trained scholar in the arts. He had been an actor, a poet who published two books of bad verse, a soldier and a newspaper and advertising man. But he was a skillful amateur painter and was very active in something called the Tile Club of Toledo, a later imitation of an original and famous Tile Club that flourished in New York in the 1870s and 1880s.

The idea of a Tile Club was that artistic fellows were to gather for festivities and the decoration of clay tiles with inspirations of the moment. The tiles would be baked like cookies and the artists would then see what happened. What happened to the tiles the clubbers made no one knows. Mahonri S. Young, Director of the Columbus Museum, descendant of Morman leader Brigham Young, and stepgrandson of

J. Alden Weir, one of the more prominent members of the New York Tile Club, suggests that the tiles were destroyed when the members threw them at each other. In any case, the meetings were very convivial.

The Tile Club of Toledo was equally convivial, and in its precincts the idea of starting a museum was hatched. Where else could the members exhibit their tiles, or whatever? The founder of the club was Thomas Parkhurst, an artist who spent half a century in Toledo painting Impressionist seascapes; but Stevens was the leading spirit of it. He was also, fortunately, a friend of Edward Libbey. Libbey had come originally from Massachusetts and the New England Glass Company of East Cambridge, where the father of J. J. Jarves started his career before moving to Cape Cod. The New England Glass Company failed in the 1880s and Libbey went to Toledo. Soon, in collaboration with the inventor Michael Owens, he became one of the country's leading glass manufacturers. Libbey and Stevens stirred up interest in an art museum and raised a small sum of money, and so a Toledo Art Museum was actually founded and incorporated in 1901. It moved into the old Brown house and there withered. The short and almost mythical tenure of a first director did nothing to help the fledgling survive. In desperation Libbey and his board called on Stevens to administer first aid. Stevens knew nothing about museums, but he and his wife had ideas; and from 1903 when he took over to 1926 when he died the Toledo Museum was bursting with ideas.

The Museum had no collection, practically no money, and before Stevens took over, almost no visitors. Seven people had come to look at what the Museum had to offer in the concluding month of the previous regime. What it had to offer was a mummified cat and one picture as a permanent collection and a few loan paintings and items of decor. It was a while before the museum had anything more. The Saint Louis Exposition of 1904 helped. A picture by Mosler, one of the Cincinnati artists, was bought then. An enormous Russian academic painting that had been one of the hits of the Chicago Exposition of 1893 was still hanging around the country and made a great stir when exhibited at the Toledo Museum. It took up lots of room and so helped cover the walls. But still the early days of the Toledo Museum were very primitive. Mrs. Stevens in her delightful book of reminiscences describes a grand opening at the Brown house that took place in a blizzard. Everyone showed up in formal dress and things went splendidly. When the party was over, the Stevenses noticed that the rooms were rather chilly. They went down to the cellar to find the janitor laid out dead drunk. The furnace had been kept going during the reception by Mrs. Stevens's mother. All dressed up in velvet and lace, she broke up a chair to make kindling and shoveled on the coal herself.

The Stevenses fueled public interest not with chairs but with an

encouragement of mass art education. This art program, still flourishing along with a very active music program, has made the Toledo Museum a center for schoolchildren, local industrial designers, adult amateurs, and every sort of culture lover. The citizens of Toledo, young and old, flocked to the Museum when it was still in its old home and continue to flock there now that it is in its handsome columned building, basically designed by Stevens himself with the architectural expertise of the same Edward B. Green who later did the Dayton Institute building for Mrs. Carnell.

The new Museum was built by funds given by Edward Libbey and matched by local subscription. Its opening in 1912 was the biggest event in Toledo's social history. The national acclaim resembled the furor over the opening of the Kimbell Museum in Fort Worth in 1972. There were Libbey enlargements over the years; and when Libbey died in 1925, he left the Museum a large bequest and his wonderful collection of Old Masters. Mrs. Libbey, who had already given her ancestral homestead for a site, gave most of the money Libbey had left her. The Museum had at last fulfilled the dreams first dreamt at the meetings of the Tile Club in the 1890s, all due to the persistent energy of Stevens and the persistent generosity of the Libbeys. Unfortunately Stevens only lived a year after their fulfillment. His place was taken by his long-time assistant and quasi-adopted son, Blake-More* Godwin, who was Director until 1959; and Libbey's place was taken by friend and art collector Arthur Secor.

Godwin's directorship in turn was taken over by his long-time assistant, Otto Wittmann, so the Museum has had only three Directors (not counting the first fugitive one) in its seventy-year history. No single individual has taken on the role of Libbey or Secor as patron; but a Libbey Foundation, of which Godwin has been a dominant trustee, helps keep the Museum comfortable. The flourishing program of civic education set up by Stevens covers all aspects of art teaching and appreciation and brings hundreds of thousands of Toledans into the Museum every year. There are in fact few places in America where the local museum is as popular and prominent. The Toledo Museum, for all the chaste Greek marble grandeur, is a happy, welcoming place with a splendid assortment of masterpieces, like the Velásquez *Drinker* or Holbein's *Catherine Howard,* most of them originally in the Libbey collection, and a wonderful display of glass, ancient and modern, that can rival any in the world. The whole Museum can be taken in easily and yet constantly revisited. If one had to limit oneself to one day in

* Hyphenated last names are common, but hyphenated first names seem to be a specialty of museum directors. Henry-Russell Hitchcock, formerly of Smith, is another example.

one museum in one country, the Toledo Museum of Art would be the sensible one to choose — not too vast, not too special, not too skimpy or confusing, covering everything in quality, if not in overwhelming quantity.

vii

But the great museum, the Grand Emporium, the museum in Ohio that compares most favorably with Boston and Chicago, is the Cleveland Museum of Art. Except for Dayton, which wasn't incorporated until 1919 (although in embryo it goes back further), Cleveland is the youngest (founded 1913, opened 1916) of Ohio's Big Five; but it is by now unquestionably preeminent.

No two cities could present a greater contrast, particularly in the arts, than Cincinnati and Cleveland. Cincinnati looks eastward towards Philadelphia and Baltimore and southward towards Kentucky and Virginia. Cleveland looks back single-mindedly to Connecticut and still considers itself a western outpost of the Nutmeg State. While Cincinnati from the beginning aimed to be the Athens of the West and spent much nineteenth-century energy on beer, music, portrait painting and bad poetry, Cleveland stuck to business. Its exports were not painters like J. Oriel Eaton but millionaires like J. Davison Rockefeller.

The history of nineteenth-century painting in Cleveland can be symbolically summed up not in one artist but in one picture. It is a very famous picture indeed, if not necessarily a good one. *The Spirit of '76,* as the picture got to be called, that trio of battered Revolutionary musicians, was exhibited at the Centennial in 1876 and swept to immortality as an icon comparable to Leutze's *Washington Crossing the Delaware* or Colonel Trumbull's "shin piece." The creator of the *Spirit,* in case you've forgotten, was Archibald M. Willard. It is the only picture of his that anybody has ever seen or heard of. He did paint others, of course, notably a vast canvas for an eccentric named Charles E. Latimer who had the idea that the English system of measurement — inch, foot and yard — was divinely ordained. He created an Anti-Metric Society to defend the faith and Willard painted for him a *Divine Origin of the Flag* (perhaps it should have been "of the Inch"). It is not now on exhibit at the Cleveland Museum of Art, nor is anything else by Willard; but a later copy of *The Spirit of '76* is owned by City Hall. The putative original of the *Spirit* (there is a good deal of fuss about which version is actually the original) was bought by the father of the model for the drummer boy and taken to Marblehead, Massachusetts.

Willard, who had studied briefly with Oriel Eaton in New York,

taught at the Cleveland School of Art after it was founded in 1882; was active in a club of Old Bohemians that included other Cleveland artists, nearly all with German names like Loeb, Bohm, and Gottwald; and lived till 1918. He never painted anything else comparable in reputation to his *Spirit,* but neither did anyone else in Cleveland until the twentieth century and Charles Burchfield. As far as the nineteenth century is concerned, Cleveland is a one-picture city.

Clevelanders may not have painted, but they collected, which is a lot better for museums. Before the Civil War Hinman B. Hurlbut, a banker, built himself a splendid mansion on Euclid Avenue, had Neagle paint him looking like a Philadelphia gentleman, and collected art, mostly the American art then fashionable or later European Salonistes. In his will, as of 1881, he left a sum of money to build an art museum. Without consulting Hurlbut or one another, two other Cleveland millionaires did likewise. John Huntington, a Standard Oil executive, left money in his will of 1889 to create a John Huntington Art and Polytechnic Trust. The "Art" meant the building and support of a museum, which the Huntington Trust did and still does. In 1890 a real estate man named Horace Kelley also left money and a trust for the express purpose of founding an art museum.

One would think, under these encouraging circumstances, that a Cleveland Museum would have been thereupon built. Not at all. Hurlbut's money was settled on his widow and by the time she died there wasn't enough left to build a museum. The Kelley Foundation and the Huntington Trust were so set up that it was legally impossible to get the two together as a unit to build a museum, though there was sufficient money in both legacies, *if* added together.

A fourth family of millionaires entered the picture, two separate generations of Jeptha H. Wade. Jeptha the First had started life in New York State as a carpenter, then graduated to itinerant limner, painting portraits as far afield as Louisiana. Finally, like that other artist, Samuel Morse, he became interested in telegraphy and by 1866 was president of Western Union. Before he died in 1890 he had showered Cleveland with beneficence, including in 1882 a park off Euclid Avenue. In this park he reserved a special plot that his grandson, Jeptha the Second, set aside in 1892 as a site for a museum.

The Wade site was turned over to the Kelley Foundation. Then for years and years lawyers huffed and puffed and struggled and pushed to get all these good works to work together — the inadequate Hurlbut Fund, the adequate monies belonging to the Kelley and Huntington Foundations, and the land donated by the Wades. Finally they found a way out. The Huntington group rented Wade land from the Kelley group and built a part of a building on it. The Kelley group stuck another part of a building onto the Huntington part on their section of

Wade land, and the pieces were joined together as the Cleveland Museum of Art under a third special board. The Hurlbut Fund was used to buy pictures.

So at last the Museum, incorporated in 1913, was opened in 1916. Thanks to this fortunate delay the Museum moved right off into a "new building," a splendid pleasure dome of classic marble, without having to go through those years of purgatory and confinement in a Victorian "old building" full of casts and palms and mooseheads.

That was not the end of the good luck. A later but far more impressive Cleveland collection than that of Hurlbut was the collection of Liberty E. Holden. Liberty was a tough gentleman born in Maine and poverty who began his career as a schoolteacher and college professor in Kalamazoo and elsewhere. He escaped from this educated penury by moving on to law and real estate speculations in Cleveland at the time of the Civil War. His real estate included large portions of land along Lake Superior that turned out to be full of iron. Iron mines there and silver mines in Utah helped feather the Holden nest. Ownership of the Cleveland newspaper, the *Plain Dealer,* and of a Hollenden Hotel were profitable sidelines. A splendid house out on the lake in Bratenahl was equipped with an adjacent art gallery called, like the hotel, the Hollenden Gallery. (Hollenden was an antique British form of the name Holden.) In the Hollenden Gallery was one of the choicest collections of art in America of that time. It can be safely called unique. It was the only collection of Italian gold-background and Renaissance art that up to that time had been deliberately bought in America rather than merely "acquired" like the Yale collection or received as a gift like the NYHS Bryan collection.

The Holden Collection was acquired from J. J. Jarves in 1883. This was a second Jarves Collection, over fifty paintings brought together after he lost his first one to Yale. It was just as good and just as authentic. It would be nice to think that at last the Jarves ship had come in. Unfortunately the Jarves luck held. Instead of giving him the twenty-five thousand dollars he wanted in cash, Holden gave him some cash but also some real estate and mining claims. How disappointed Jarves was when his land and his mines proved worthless, as opposed to the ones still in the possession of Liberty E. Holden. In exchange Holden had the Jarves pictures, which he thought weren't worth twenty-five thousand dollars in any case, even though one of them was supposed to be a Leonardo da Vinci. The Leonardo wasn't. It is now labeled Napoletano, thus reducing its value by approximately five million dollars. However, the collection as a whole is priceless and has probably increased in value by about a thousand percent in the succeeding century.

How did it happen that Holden had the astuteness to buy what he

himself despised and what no one else of his time would touch? The credit must be given to his wife Delia (née Bulkley), of a family in itself distinguished in Ohio politics. It was evidently her eye, trained by European travel and friendships in Italy, that picked the collection out when it was exhibited in Boston; and she persuaded her husband to get it against his better judgment.

In the Hollenden Gallery with the former Jarves Collection was another one, that belonging originally to a Cincinnati artist named Miner Kilbourne Kellogg (1814–1889). He was born in upstate New York but his parents took him to the ill-fated Utopian colony in New Harmony, Indiana. Eventually he ended up in Cincinnati, studied with Eckstein in the 1820s, and became a friend of Hiram Powers. Like Oriel Eaton, he set up as a portrait painter. He traveled about and became a protégé of President Martin Van Buren, who sent him to Italy as a diplomatic courier. From there he traveled to the Near East, where he painted exotic and suggestive subjects such as *Oriental Princess after the Bath*. His friend Hiram Powers hired him as press agent to handle the fabulously successful tour of his nude *Greek Slave* across America. It was Kellogg who got convocations of clergymen to approve of the statue's high moral tone, and for four years the *Greek Slave* broke taboos and attendance records and coined money. In the 1850s, having fought with Powers, Kellogg was back in Florence painting and collecting "masterpieces." Finally in 1885 Kellogg turned over everything to Liberty E. Holden on condition that Holden give him a hundred dollars a month for the rest of his life. In return Kellogg acted as Holden's private art expert, planning and building the Hollenden Gallery and advising on further purchases. When the Holden Collection went to the Cleveland Museum, the Kellogg Collection went with it; but it now seems to have disappeared except for fewer than half a dozen paintings. As usual, the Raphaels and da Vincis were mislabeled.

Liberty Holden was chairman of a premature building committee for the Museum as of 1905. He died in 1913, too soon to see the opening in 1916. Then the Holden Collection donated by his widow was the new institution's principal possession and it still remains one of its choicest, a curious link across time and space with Connecticut, where all proper Clevelanders come from, and Yale, where all proper Clevelanders go to college, a line back to the Trumbull Gallery and its Jarves Primitives and to the very origins of the museum in America.

From 1916 on the Museum flourished in the hands of only three Directors, like Toledo over an even longer span. These were Frederic A. Whiting (Director from 1913 to 1930), William M. Milliken (1930–1958), and Sherman E. Lee (1958–). The Museum has been supported in the style to which it early became accustomed by Holdens, Severances, Wades, and many others, in several generations. For instance, a

granddaughter of Liberty Holden, Mrs. R. Henry Norweb, was President of the board in the 1960s and original and principal donor to the Museum's Pre-Columbian collection. There has never been one of those postnatal declines that characterized Detroit or Cincinnati. However, the story of the rise of Cleveland to its present eminence is not a tale of the nineteenth century. In fact, the gist of the Museum's story is that it had the good fortune *not* to be founded before 1900, though the money and the intention and the site and even part of the collection were all ready and waiting. This is in direct contradiction to the history of so many American museums that began with nothing, built a building, and then tried to fill it. Thanks to the law's delays, the Cleveland Museum of Art began fully equipped; the law's delays, as in the case of the Telfair and its accrued interest, can sometimes be a blessing.

. . .

viii

This whole story of art and art museums in the Midwest was one of the grand cultural upheavals of the American nineteenth century. As such it is an especially important chapter in the country's social history, an indication of the march of civilization westward and of an increasing emancipation from the dominance in matters of taste by the East Coast big cities.

However there were other museums, most of them in the East, besides those of the greater urban centers, that sprang up before 1900. There was, for instance, the grandiose pile of the Brooklyn Museum, opened in 1897 as a museum of Everything for Everybody. Very gradually over the years art pushed out science as it so often does. Where there were once floors of stuffed animals and minerals there are now floors of art objects — including the Egyptian collections of the New-York Historical Society that finally came to rest across the river in 1948. Now the Brooklyn Museum is a museum of art, not of everything; and it is one of the largest and best in the country.

The museums of Worcester, Massachusetts (1896–1898), and of the Rhode Island School of Design in Providence, Rhode Island (1880–1894), already mentioned, are also early and very important. There is the quaint G. W. V. Smith Museum in Springfield, Massachusetts, opened in 1895 and still preserved almost exactly as it was when it began — the only museum in America that still looks the way it used to both as to building and contents, even as to display. May it be spared the busy hands of some forward-looking, meddlesome director! The Springfield Museum of Fine Arts nearby is the city's real art center. It wasn't founded till 1933, but it has a well-rounded small collection and is full of local color. Then there is the M. H. de Young Museum in San

Francisco, founded in 1895 . . . But enough is enough. All these museums, Brooklyn, Worcester, Providence, San Francisco, are very much alive and very much respected. However, they don't represent any such special and unified movement in the arts as do the combined sproutings of all those Midwestern museums.

If 1900 can be used as a rough dividing line, a sort of watershed, then it can be said, with a good many small qualifications, that before 1870 America had no museums and after 1900 the American museum was an established fact. By 1900 the skeleton, the basic structure of the world of the American art museum, had been formed. The art museum was at last an accepted part of American urban life; and it was assumed, almost taken for granted by then, that any proper big city or major college or university had to have an art museum.

Nothing that has happened since has really altered the basic pattern developed during this period from 1870 to 1900. The three areas of richest concentration — New England, the Northeast (Middle Atlantic), and the Midwest — began soonest, were richest then, and are richest now. The precocious stirrings of the West Coast, witnessed first in Sacramento, have continued. The major change since 1900 has been the increment of museums in the South (Richmond, Raleigh, Atlanta, Birmingham) and in the Plains, notably Texas. To a minor extent the Rocky Mountain West has also seen a growth — Denver, Phoenix, Santa Fe. But all this has been a filling in of flesh and muscle, not an alteration.

The major enrichment took place between 1900 and 1945. Though it was true enough that America "had its museums" by the turn of the century, it was also true that, again with qualifications, they weren't really very good. They were there, they were big, they were crowded with objects and people, but they were also full of what Royall Tyler so succinctly described as "truck." The policy of not hurting people's feelings, of being forced to obey the whims of donors, generally prevailed. It is only in quite recent times and in major museums that unrestricted giving has been required rather than merely hoped for. "Observing the wishes" of patrons is, it often seems, the sign of a weak, not a thoughtful, institution.

Basic to this twentieth-century Renaissance of the American museum was a change of emphasis and a change of taste. First there was the change from the idea that museums were just educational institutions rather than depositories of beautiful things. The Robinson-Prichard battle, which still rages, between casts and originals, between learning and joy, was gradually resolved in favor of joy, but not without a fight. The educationists felt then and many of them still feel that it was not the intrinsic worth of the art object but what you could do with it as an illustration that was important. This attitude still prevails in college

museums. In civic museums it meant that casts, or even copies, as in Cincinnati, were really just as good as originals since they were just as good as tools for instruction. And so much cheaper! As originals began to be available, and to hell with the expense, the attitudes changed. Casts were thrown out along with all the needlepoint and ironwork and industrial art that took up so much space.

As for the change of taste, this has had peculiarly drastic effects on American museums. Since they began without purchase funds or collections of princely art, they took what patrons gave them. The taste of patrons for Salonistes and the patriotic fervor of boards willing to help local artists filled the halls with Bouguereaus and American academics like Millet and his *Story of Oenone*. Much of this "truck" eventually had to be stored or deaccessioned, though a lot of it is now reemerging. Still, all these shifts of emphasis from casts to originals and Modern Art to Old Masters have been expensive and wasteful. There is a strong possibility that reemphasis on education for the people and chauvinist purchases of Modern Art will reproduce all the problems of the nineteenth century.

If the good stuff of all the American museums could have been gathered together — the best Colonial paintings in Boston and the PAFA, the Old Masters of Marquand and Ryerson, the better antiquities of Cesnola and Ned Warren — America might have been able to show, even at an early date, a single museum respectable by European standards. But without forethought or plan, the decision was made between 1870 and 1900 that America was not going to put all its rather inferior eggs in one basket and build a single collection of National Treasures (from whatever clime) like Napoleon's Louvre, so full of stolen goods, or Benjamin West's National Gallery. On the contrary, America was going to spread its blessings out all over the landscape. Every city in every state was to have its own municipal treasure. It wasn't in fact until the very end of the Golden Age in 1941 that America finally did open a National Gallery of National Treasures.

This dispersion of effort, so unlike the English and French and Russian but parallel to the German or Swiss pattern (the Italian is similar in effect but so different in cause), also had its influence on the early museum. All these new museums, or at least their millionaire patrons, began to compete with each other. Furthermore, they competed for the same sort of things — leftovers of the Cesnola collection, Egyptian mummies, Dutch Old Masters, pseudo-Raphaels and da Vincis — at the same time. It was easily possible for a patron to make a killing like Hutchinson and his Demidoffs, or Scripps or Holden; but these were exceptional. It took many years to flesh out the collections of most of these earlier institutions.

This striving by every big-city museum to be a universal survey

Grand Emporium, begun in 1870 and still going on, has naturally put an enormous strain on the resources of the various communities and their rich men. If every museum has to have its Egyptian, Greek, Roman, Oriental, Near Eastern, European from 1000 to 2000 and American collections, obviously some of them are going to be thin in spots — like Chicago in Classical art. This means that in cold sober fact the idea of the American museum, as begun in 1870 from scratch, was and still is a perfectly hopeless idea. Half a hundred large cities, most of them founded after 1800, and two hundred colleges, all beginning from nothing, without historic art of their own, all attempting to build up superb collections covering the *whole* field of world art — what absurd extravagance!

The truth is, however, that the extravagance has paid off and the idea to an extraordinary extent has been realized. With the rather significant exception of the art of Greece and Rome, of which adequate collections exist only in New York and Boston (and the Getty Museum in Malibu, California), America is now covered with admirable institutions full of beautiful originals from everywhere, active in educational effort, palatial in physical plant.

How in the world did this happen? It happened because after the Civil War some Americans began to make not comfortable but outrageous fortunes and some of them devoted parts of these fortunes to the arts and to museums. The Age of the Moguls and the Robber Barons, though it began around 1870, culminated after 1900. By then the fortunes were made. What has transformed widespread outposts of art scattered in lonely indigence across the continent to the present proliferation of magnificence is the American industrial boom of the twentieth century. Art follows money.

The founders of museums in the early days, the Johnstons and Blodgetts and Marquands, the Brimmers and Perkinses, the Hutchinsons and Ryersons, the Longworths and Sintons, were not fabulously rich men, at least by later standards; though they were rich, especially for their day in their cities. They were gentlemen of taste and enterprise and above all civic enthusiasm. They thought America should have art museums and by God they saw to it that America got art museums. They did their best to fill the museums with the kinds of thing they thought museums ought to have. They were on the whole far more enlightened and sympathetic men than the later Moguls. They did an enormous job with small means. They are the Founding Fathers of visual cultivation in America, comparable to the political Founders of the Revolution.

But the glory of the American museum nowadays is the result of the gifts of a different breed of men, not always so enlightened and certainly not very sympathetic, but unquestionably Titanic. Sometimes

selfish, ostentatious, and sacrificing civic interest to personal aggrandizement in art as well as in industry, they nonetheless performed that miracle of sow's ear into silk purse on a national scale, turning a network of rather pathetically ambitious institutions full of "truck" into depositories of grandeur. This is the less virtuous but more flamboyant phase of the history of the American art museum from 1900 on.

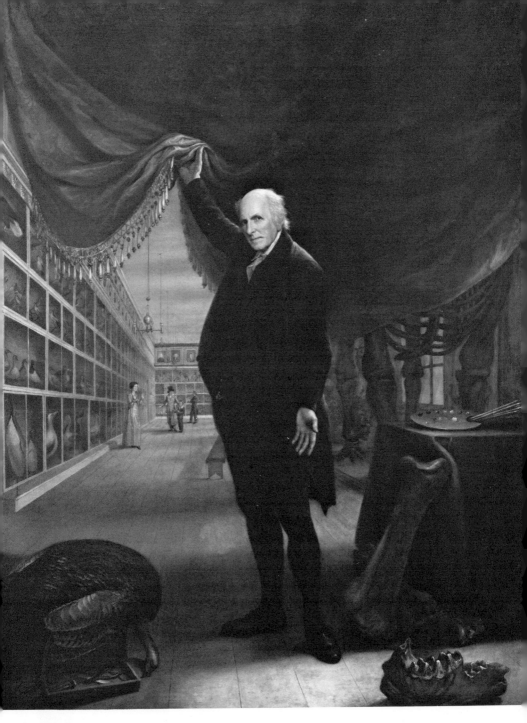

Self-portrait of Charles Willson Peale unveiling his Museum: faces above, fauna below. Painted in 1822, when Peale was in his eighties. The setting is Independence Hall. Courtesy of the Pennsylvania Academy of the Fine Arts, Philadelphia, Pennsylvania.

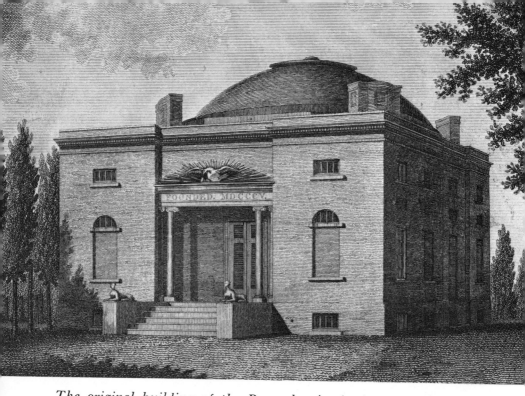

The original building of the Pennsylvania Academy at Chestnut above Tenth in 1806. Architect is believed to have been John Dorsey. Courtesy of the Pennsylvania Academy of the Fine Arts, Philadelphia, Pennsylvania.

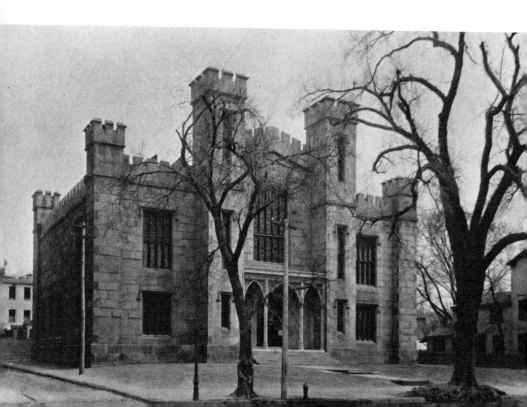

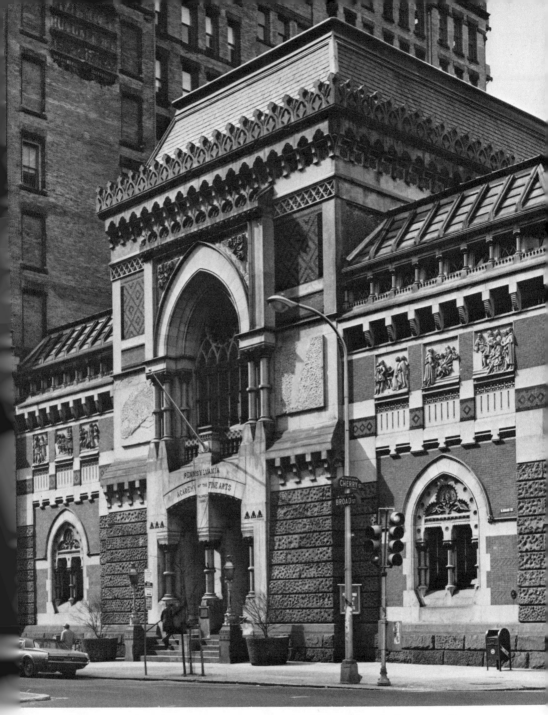

The Pennsylvania Academy of 1876. Architect: Frank Furness. Courtesy of the Pennsylvania Academy of the Fine Arts, Philadelphia, Pennsylvania.

The original tripartite building of the Wadsworth Athenaeum in Hartford, erected in 1842–44. Architect: Ithiel Town. Courtesy of the Wadsworth Athenaeum, Hartford, Connecticut.

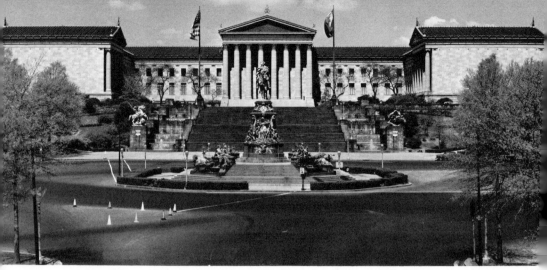

The Philadelphia Museum, which opened in 1928. Architects: Zantzinger, Borie, and Trumbauer. Courtesy of the Philadelphia Museum of Art, Philadelphia, Pennsylvania.

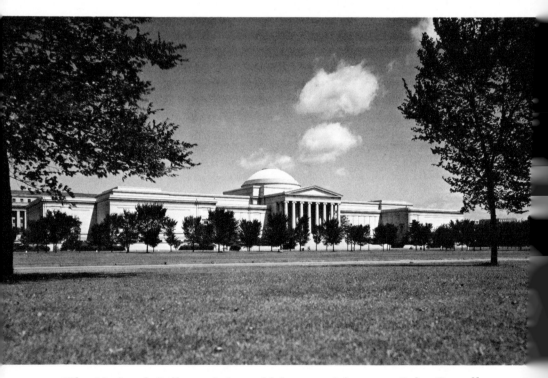

The National Gallery of Art, which opened in 1941. John Russell Pope was the architect. Courtesy of the National Gallery of Art, Washington, D.C.

"Greek Garages"

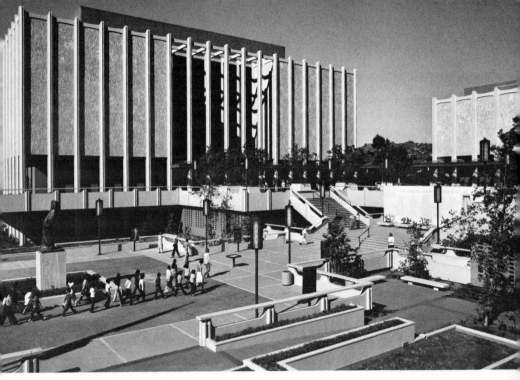

Ahmanson Gallery, Los Angeles County Museum (LACMA), which opened in 1965. Architect: William L. Pereira. Courtesy of the Los Angeles County Museum of Art, Los Angeles, California.

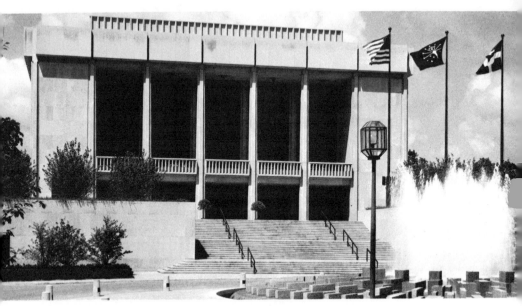

The Indianapolis Museum of Art (formerly the John Herron): Krannert Pavilion and Sutphin Fountain. Opened in 1970. Architects: Richardson, Severn and Scheeler. Courtesy of the Indianapolis Museum of Art, Indianapolis, Indiana.

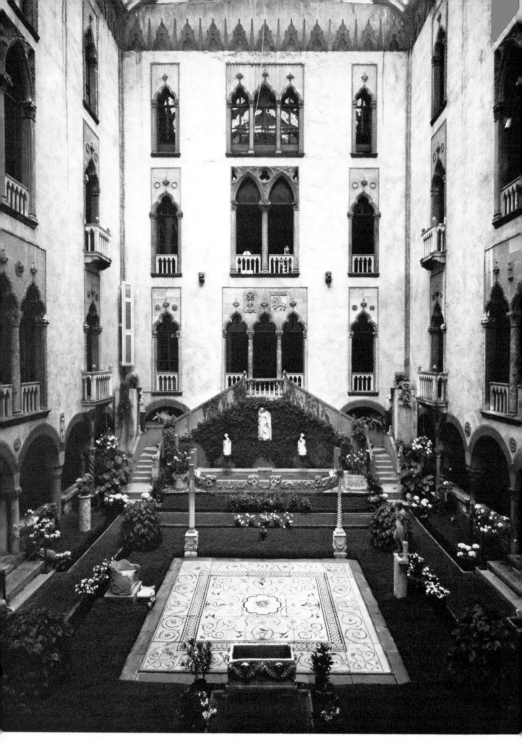

"Venetian palazzo turned inside out": south view of *"Fenway Court."*
Completed in 1903. Willard T. Sears was the architect. Courtesy of
the Isabella Stewart Gardner Museum, Boston, Massachusetts.

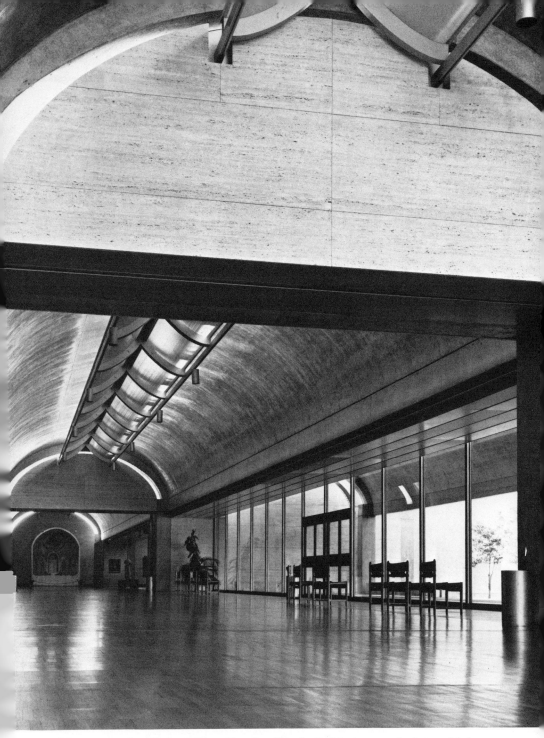

"Serene, pale, light-diffused": the Kimbell Museum of Art, which opened in 1972. Architect: Louis Kahn. Courtesy of the Kimbell Museum of Art, Fort Worth, Texas. Photograph by Robert Wharton, Fort Worth.

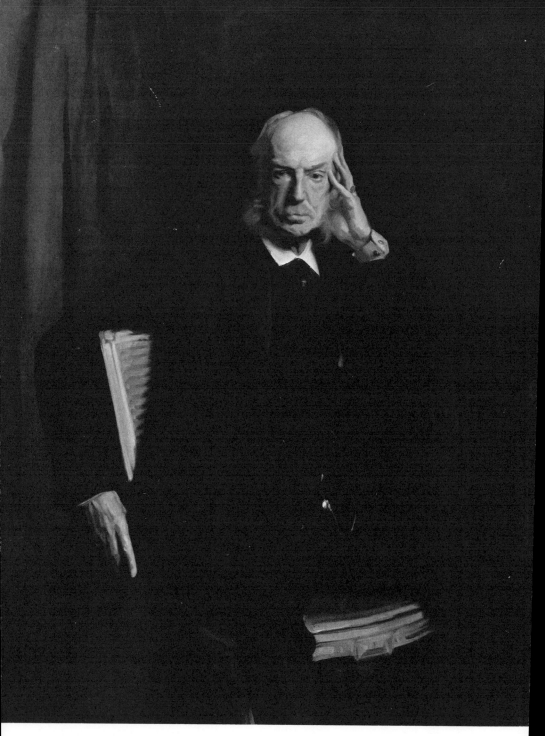

The burdens of possession: portrait of Henry Gurdon Marquand by John Singer Sargent, 1896. Courtesy of The Metropolitan Museum of Art, New York, N.Y. Gift of the Trustees, 1896.

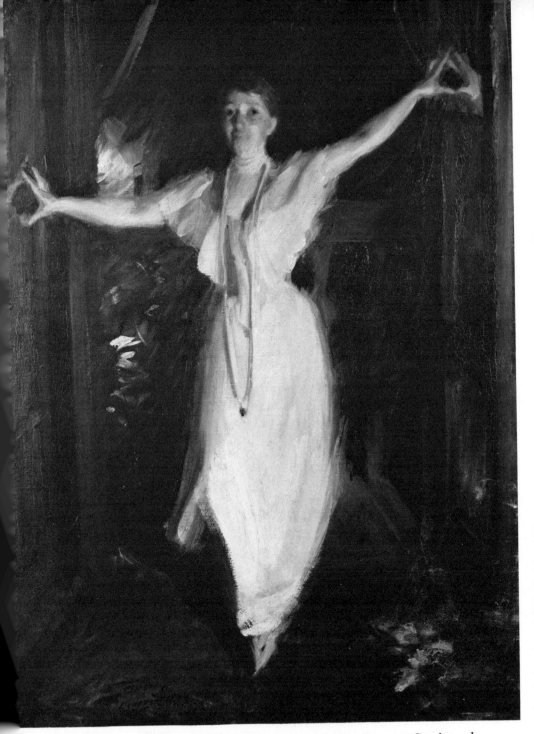

The zests of acquisition: portrait of Isabella Stewart Gardner by Anders Zorn, 1894. Courtesy of the Isabella Stewart Gardner Museum, Boston, Massachusetts.

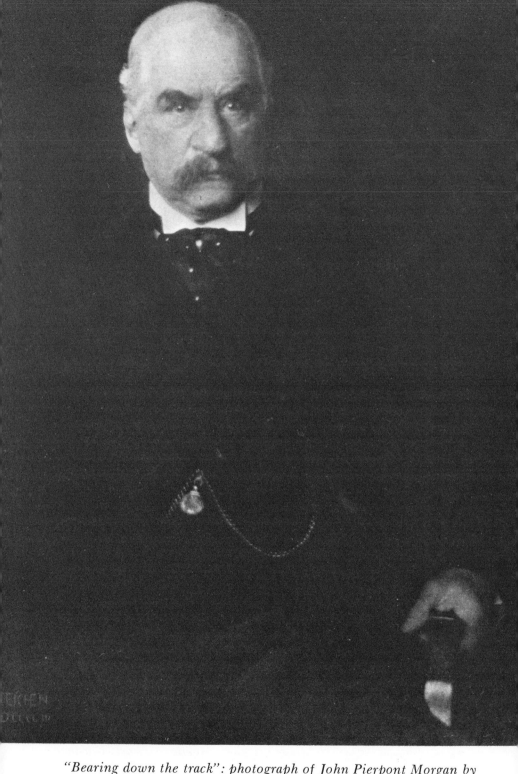

"Bearing down the track": photograph of John Pierpont Morgan by
Edward Steichen, *1906. Courtesy of The Metropolitan Museum of
Art, New York, N.Y. The Alfred Stieglitz Collection, 1933.*

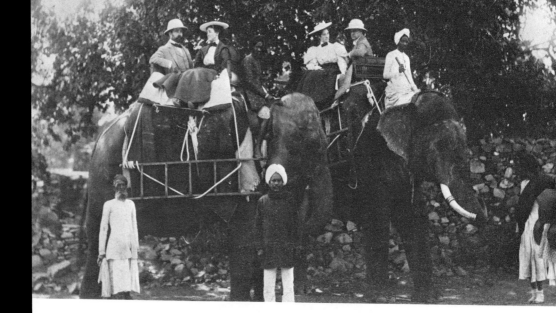

The Martin A. Ryersons and the Charles L. Hutchinsons in India, on two elephants. Courtesy of The Art Institute of Chicago, Chicago, Illinois. Ryerson Library Collection.

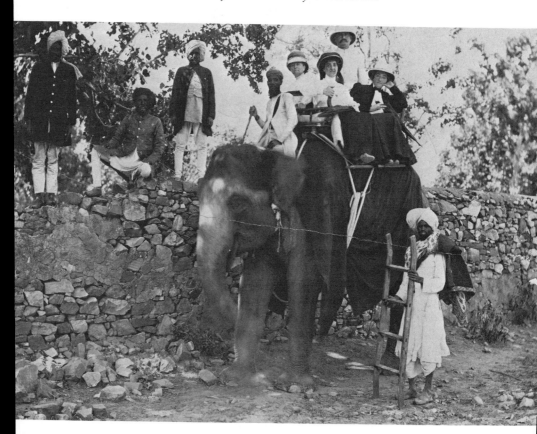

Claribel, Etta, and Mr. and Mrs. Moses Cone in India, on one elephant. Courtesy of Mr. Edward T. Cone.

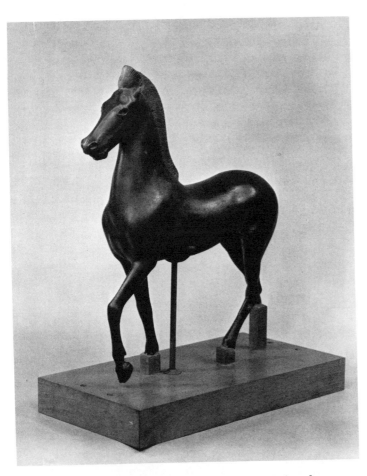

"The Greek Horse." Bronze. Now variously considered Hellenistic or Roman. Courtesy of The Metropolitan Museum of Art, New York, N.Y. Fletcher Foundation, 1923.

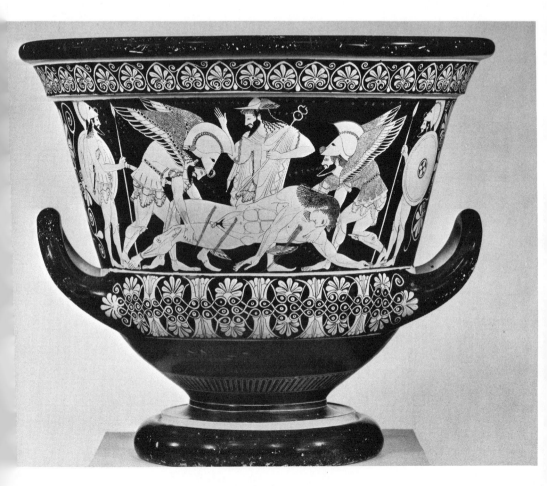

Calyx krater (or mixing bowl) by Euxitheos and Euphronios, c.
515 B.C. Courtesy of The Metropolitan Museum of Art, New York,
N.Y. Various donors.

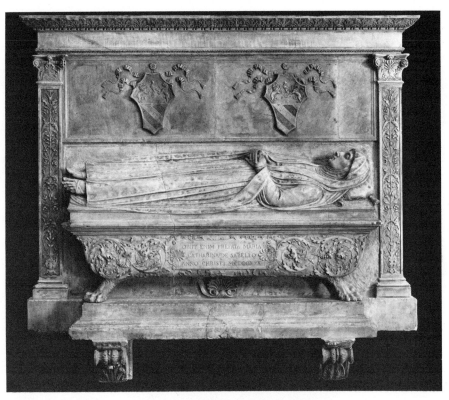

Tomb monument, Tuscan, 15th century (?). Once attributed to Mino da Fiesole. Purchased through Philip Gentner from the Maria Antoinette Evans Fund. Courtesy of the Museum of Fine Arts, Boston, Massachusetts.

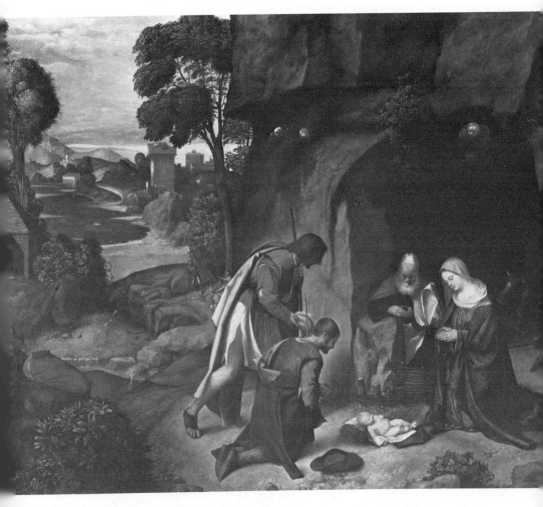

The Adoration of the Shepherds *by Giorgione, the attribution of which caused the rift between Duveen and Berenson. Kress Collection, 1939. Courtesy of the National Gallery of Art, Washington, D.C.*

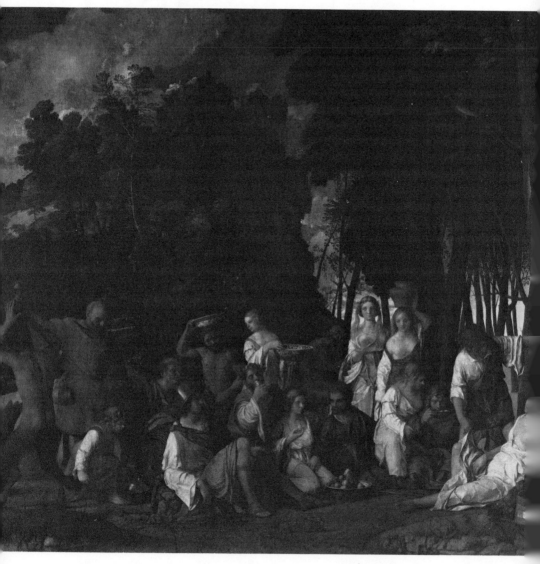

The Feast of the Gods *by Giovanni Bellini, formerly in the collection of the Dukes of Northumberland, Henry Smithson's legitimate kinsmen. Widener Collection, 1942. Courtesy of the National Gallery of Art, Washington, D.C.*

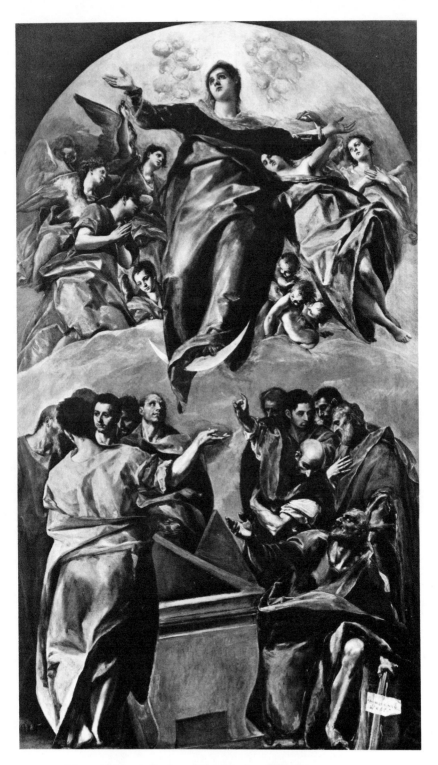

Assumption of the Virgin *by El Greco, 1577.*
Picked out by Mary Cassatt and picked up by
Hutchinson and Ryerson, over the murmurs of
Director French. Gift of Nancy Atwood Sprague.
Courtesy of The Art Institute of Chicago, Chicago,
Illinois.

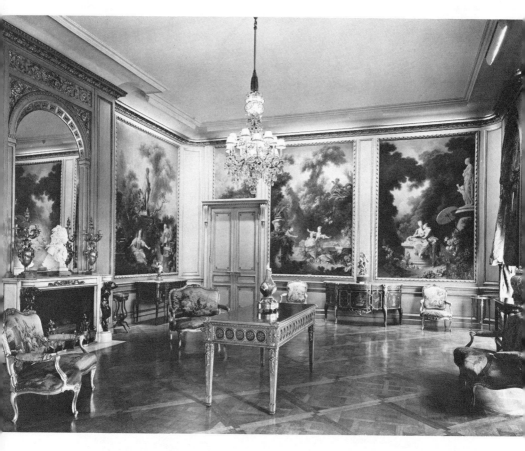

"Douceur de la vie en l'ancien régime": *the Fragonard Room at the Frick, southeast corner. Rejected by Mme. du Barry, resurrected by J. P. Morgan. Copyright the Frick Collection, New York, N.Y.*

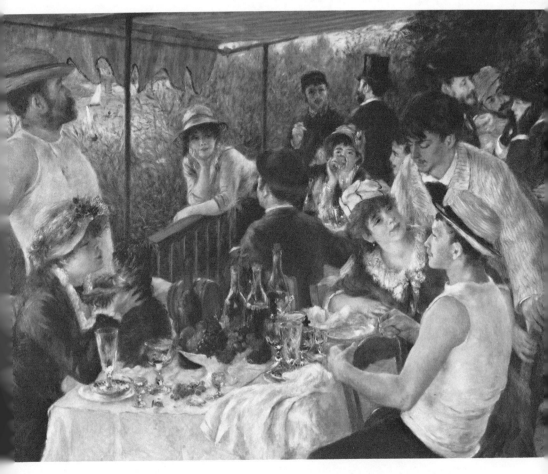

"Douceur de la vie en la Belle Époque": *Pierre Auguste Renoir's*
The Luncheon of the Boating Party, *1881. Courtesy of the Phillips*
Collection, Washington, D.C.

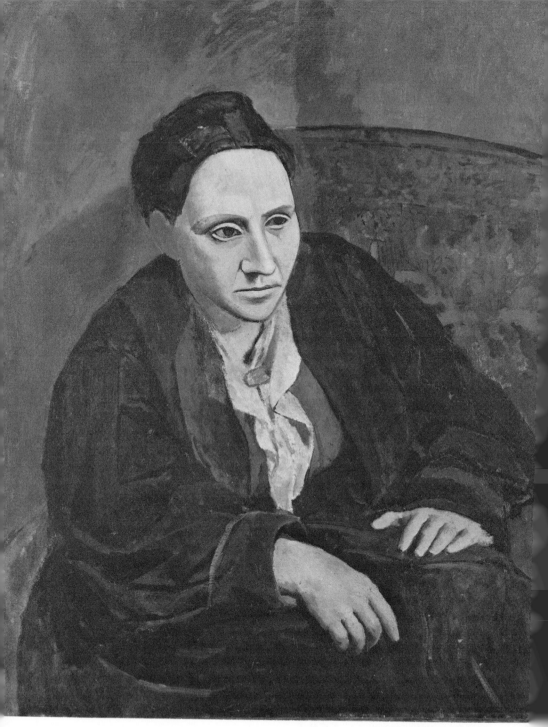

Portrait of Gertrude Stein by Pablo Picasso, 1908. Courtesy of The Metropolitan Museum of Art, New York, N.Y. Bequest of Gertrude Stein.

Portrait of Dr. Claribel Cone by Pablo Picasso, 1922. Courtesy of the Cone Collection, Baltimore Museum of Art, Baltimore, Maryland.

Blue Balls *(second version, 1938) by Rudolf Bauer. Courtesy of the* Solomon R. Guggenheim Museum, New York, N.Y.

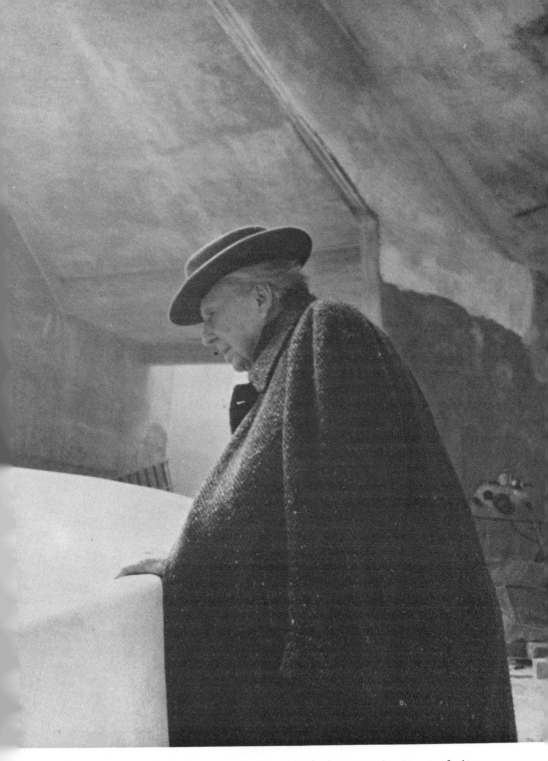

Frank Lloyd Wright in 1959, during his last visit to the Guggenheim Museum. Wright died shortly after this picture was taken, in his ninetieth year. Photograph by William H. Short. Courtesy of Mr. Short.

BOOK IV

The Age of the Titans

Chapter I

i

JOHNSTON AND BLODGETT, Perkins and Brimmer, Hutchinson and Ryerson — Morgan, Carnegie, Frick, Mellon, Rockefeller. The mere juxtaposition of these names underlines the differences between the world of the American museum between 1870 and 1900 and between 1900 and 1945. The first names were well enough known in their time and place but never nationally famous. The second names are still nationally famous — or infamous.

Whether cast as villains by the Muckrakers or heroes by the Apologists, these latter five are the stars of the show. They all also happen to have had, in very varying degrees and ways, an important impact on the American art museum. They are representative of a new kind of donor, and as there were many other Titans so there were many other donors. But as these were the Great Titans, so at least three of them were the Great Donors. Morgan and Mellon were the most important patrons of the two American museums now considered most important, the Metropolitan of New York and the National Gallery in Washington. Carnegie founded the only art museum in that once art-rich city,

Pittsburgh; and though Rockefeller despised art, the fortune he made went and continues to go into a rich variety of significant art museums.

In some ways these men are similar, all creators of enormous fortunes by means of monopolistic skills of organization (and often coercion), wielders of enormous influence during their lives, and givers of enormous sums to various kinds of good works. Unlike some of their contemporaries, they were builders and imperialists, not gamblers, destroyers, and pirates on the order of Gould and Fisk. They craved efficiency and stability, a workable economy, not just personal power and pelf. They regarded the enormous power they did in fact acquire as an obligation, a stewardship. They were as spectacular in their giving as they were in their getting. Carnegie and Rockefeller remain the most beneficent private philanthropists in all recorded history.

As people they differed tremendously. Morgan and Rockefeller literally couldn't stand the sight of each other. Frick and Carnegie had one of the bitterest fights in the chronicles of industry. Morgan despised Carnegie. Mellon simply avoided having any real personal contact with any of them except Frick.

They are usually thought of and pictured by detractors as crude parvenus who scrambled to the top of the heap over the bodies of their victims. "Ruthless" is the key word, used again and again. As art fanciers, according to this picture, they were insensitive and vain, only interested in valuable booty and self-aggrandizement. They had no idea of what they were getting and cared less, so long as their acquisitions represented good investments. Their charities were at worst inspired by showmanship or at best by belated guilt.

This black picture is balanced by an equally biased bright one presented by sympathetic, or rather sycophantic, biographies in which these firm but kindly gentlemen are portrayed as motivated almost entirely by altruistic motives, making money only to hold it as trustees for God, Country, and Humanity. They were beloved by their wives, children, and remoter relatives, looked up to with reverence by their subordinates, and in general deserve only the thanks of the Republic. They were fond of simple pleasures and a good clean joke.

It would still seem to be almost impossible to reconcile these two portraits in black and in white. One thing, however, certainly can be said. Some of them knew a lot about art. What they got was the very best and their giving of it to the public instead of keeping it for themselves and their families like the nobility of Europe transformed American museums from minor to major, from provincial catchalls to institutions comparable to those of Europe.

ii

One other thing that these three of the five Titans who collected art had in common was the perhaps accidental fact that they were *not* "parvenus." John D. Rockefeller and Andrew Carnegie, who were in fact rags-to-riches Horatio Alger heroes, were not interested in art. Morgan and Mellon, sons of millionaires, were. Frick was poor and ragged enough himself; but his grandfather, who started him off in life, was a minor millionaire.

Of all these collectors, John Pierpont Morgan (1837–1913) was the least parvenu. Though he has come to seem the very personification of Wall Street and New York finance, he was, like most of these other men, from a comparatively small town. When John Pierpont was born in Hartford, Connecticut, it was still scarcely more than a village. Mr. Wadsworth had not yet founded his Athenaeum. Morgan's grandfather Joseph, however, had already been there for twenty years, growing up with the community, and had prospered as an owner of stagecoaches, a successful hotel keeper, and at last, like any good citizen of Hartford, as a promoter of fire insurance companies. Before Joseph, the Morgans had been for a century and a half farmers in the Connecticut River Valley. After Joseph, the Morgans were rich and stayed rich.

Joseph's son and John's father, Junius Spencer Morgan, began humbly enough as a partner in a Hartford dry goods store but soon graduated to a partnership in the well-known house of J. M. Beebe in Boston. After spending his boyhood in Hartford and environs, John Pierpont went to English High School in Boston. Then in 1854 his father was transferred to London as the partner and eventual successor of none other than George Peabody, America's greatest international financier of that time. Peabody, who founded all those institutes and played the cello in Salem with the father of Ernest Fenollosa, was already part of that earlier web of American art donors. Junius collected paintings for his home at Prince's Gate in London, so his son was the inheritor of a tradition going back through and before his father. Junius had married a Pierpont, daughter of poet and religious rebel John Pierpont, a typical Unitarian intellectual of the New England Flowering who sought out unpopular causes and enjoyed a life of high-toned martyrdom. The Pierponts were birthright members of the Connecticut branch of the Theocracy. Jonathan Edwards, great early eighteenth-century theologian, had married a Pierpont, and Edwardses and Pierponts and their kin have been presidents of universities, notably Yale, and authors of books ever since. Financially through his father and intellectually through his mother, John Pierpont Morgan

came into the world well endowed. He worshiped his rich father and longed to follow in his footsteps. He, too, would be an international financier. He, too, would collect art.

J. P. Morgan had another early connection with art and the art world. His first wife was the daughter of Jonathan Sturges, son-in-law of early collector Luman Reed. Sturges, like Reed, was a notable friend of artists and one of the founding fathers of the Century Association and of the Metropolitan. Pierpont fell in love with Sturges's daughter Mimi. They were engaged to be married, but before the wedding could take place she fell into a thoroughly Victorian decline from consumption. Morgan insisted on marrying her, though she was so weak she had to be carried to and from the ceremony. He took her immediately to Europe, hoping for a cure; but it was too late and she died after a little over four months of marriage. J.P.'s interest as an original subscriber to the Metropolitan and early (1862) member of the Century attest to this Sturges connection.

His second wife was a Tracy, beautiful, fashionable, but not notably interested in art.* He settled down to years of dutiful financial apprenticeship and a convivial but thoroughly conventional social life. He was just a typical young Wall Street man of the time. But he was not all that young, having reached thirty by the time he settled down with his second wife and his modestly increasing success. There is really nothing in his history between the time he moved to New York in 1857 and his emergence into some sort of prominence in the mid-1870s to foreshadow either the Titan or the patron. He worked under older, greater men like his father Junius or his Philadelphian senior partner Anthony J. Drexel. He did begin to buy pictures in a modest way, Salon gems like everybody else. By 1880 he had enough to satisfy Mr. Shinn-Strahan and to warrant the inclusion of a J. P. Morgan collection in *Art Treasures*.

The early Morgan was a rather handsome, stocky, solemn, yet often jolly fellow fond of parties, horses, and hymn singing. The later Morgan was a Holy Terror. The transition from one to the other, caused by an overwhelming increase in power and wealth, a personal disfigurement due to an inflamed nose that made him increasingly shy and self-conscious, and a seeming estrangement from his wife, all helped produce this later Morgan, the man with eyes like the headlights of a locomotive bearing down the track, Morgan the gruff who hardly ever spoke to anyone except in grunts and who retired to play solitaire as host of his own parties.

After the turn of the century, when he had consolidated most of the country's railroads, completed in 1901 the formation of the world's

* But he kept a picture of his first wife by his bedside all through his life.

largest business enterprise, the United States Steel Corporation, and forced Wall Street's other Titans to combine in stopping the panic of 1907, Morgan had obviously become something of a megalomaniac. Titan he was, but Robber Baron never. His ruthlessness and power madness, though genuine enough, were devoted to supporting and sustaining an American Establishment of which he was the chief ornament, not to a mere seizing of plunder. Much has been made of the name of his steam yachts — always named *Corsair* (derived from the poetry of Byron)* — to prove him a pirate at heart. He was anything but a pirate. He was American capitalism's Admiral of the Fleet, barking orders from the bridge to well-trained lieutenants, defending the bastions of invested wealth *against* pirates.

If Morgan had lived in a country like England with King, House of Lords, and Established Church, he would have devoted his life and efforts to their welfare. He did the best he could with American substitutes. He devoted his life and efforts to making America safe for the investor, foreign and domestic, to sustaining the credit of the U.S. Treasury when needed, and to assisting the House of Bishops of the Protestant Episcopal Church of the United States, which was the nearest thing to an Established Church available to him.

For English kings he had to substitute those presidents of whom he could approve. Cleveland seemed to be the most approvable, Democrat though he might have been. For House of Lords he substituted boards of directors, dominated preferably by partners of the House of Morgan, gentlemen all. Though his religious belief was certainly profound and sincere, it was immovably orthodox and conservative. He dearly loved old hymns and old bishops; the quip was that he also collected Old Masters and old mistresses. He regularly attended the diocesan convention of the Episcopalian church, traveling wherever it was held in a private car or two with a gaggle of pious ladies, which did not seem to include his wife. In the city of the convention he would rent a mansion with attendant staff for himself and his guests. In one case, when the facilities were inadequate, he added an extra bathroom. He went to all the sessions of the conventions, despite the distractions of the stock market and the occasional competition of the America's Cup yacht races in which he had an undying interest. On one occasion during a convention he interrupted a bitter battle among delegates by rising to sing, or perhaps bellow, one of his favorite hymns. The delegates one by one rose to join him and the quarreling ceased. His favorite hymns, so appropriate to a monopolistic banker, were "Blest Be the Tie That Binds" and "How Firm a Foundation."

He also took his gaggle of ladies up the Nile in his own houseboat,

* The original manuscript of Byron's "Corsair" is in the Morgan Library.

attended not by bishops but by archaeologists. His daughter Louise often went along, but not his wife. When he lay dying in Rome, his wife didn't bother to come to see him.

Did or didn't he have mistresses? A Philadelphia joke about him concerned his friendships with various ladies with the old Philadelphia name of Mrs. Markoe. There were supposed to be three of them, his church Markoe, his art Markoe, and his bed Markoe. If he did have such typically Edwardian arrangements, they were shielded with typically Edwardian reticence. When someone remarked to Morgan that he personally didn't like to do things "behind closed doors" Morgan barked, "Why? That's what doors are for." Nobody could be sure whether his very public friendships with beautiful actresses like Maxine Elliott were just theatrical or something more personal.

<p style="text-align:center">. . .
iii</p>

One reason Morgan didn't succeed in his plan for having America run by boards of gentlemen was that too many nongentlemen were in the competition. Andrew Carnegie (1835–1919) was neither a gentleman by birth nor a collector of art, but he was certainly a competitor to be reckoned with. Ideas, not things, were Andrew's passion. But he did, almost incidentally, found an art museum in Pittsburgh as part of his grandiose Carnegie Institute; so he does count as a patron of American art. He gave the city a gallery and an endowment, plus a good many casts and things to put in the gallery, though no pictures.

The personality of Carnegie could not make a greater contrast to that of Morgan. He was about as thoroughly a self-made man as it is possible to be. He was born in Scotland to a family of impoverished but radically well read weavers. Relations had gone to jail for their attacks on the English Establishment. Carnegie imbibed these sentiments almost literally at his mother's breast. He also imbibed a determination to get ahead and a character fit to the enterprise. When things got too bad in Scotland, the Carnegie family moved over in a body to Allegheny City, Pennsylvania, where Mary Cassatt was born. Living on a very different social plateau from the Cassatts — Mary's father had been the first mayor of the city — the Carnegies and their numerous fellow Scotsmen lived in poverty and hope. When young Andrew arrived in 1848, complete with towhead and Scotch burr, a gang of Rebecca Street toughs who called themselves the "bottom hooshiers"* attacked Andy en masse to make an Amurican out of him. They

* "Hooshiers" or "hoosiers" evidently were "toughs." The appellation was probably adopted by the natives of Indiana in a vein of frontier braggadocio.

certainly succeeded, for nobody was ever a more ardent American than Carnegie. This gang consisted of the sons of other recently arrived immigrants, many of them also from Scotland, and it is almost terrifying to read their names: Oliver, Phipps, Pitcairn, and others who seemed to become not just successful but fabulously rich. What a gang!

Andrew rose from hooshier to benefactor via apprenticeship as a bobbin boy and telegraph messenger. There, too, he was associated with boys who became billionaires (Pitcairn, Oliver and other members of the Rebecca Street gang). He then became secretary to Thomas A. Scott of the Pennsylvania Railroad, who eventually became President, before Alexander Cassatt (brother of Mary and also native of Allegheny City). After a good many moderately successful years of railroading, Carnegie piled up a nest egg of investments and bought into steel. It wasn't too long before he dominated steel manufacturing, first in the steel capital Pittsburgh, then in the nation, finally in the world. He never lost his radical impulses and his reverence for the word, as represented in the past by Robert Burns and Shakespeare and in the present by such personal friends as Matthew Arnold, Herbert Spencer, and the scholarly Viscount Morley. He first learned to love Shakespeare as a telegraph delivery boy. He frequently delivered to the Pittsburgh theaters and was allowed free access to performances. Col. Anderson, an affluent citizen of that hotbed of arts and finances, Allegheny City, generously loaned books from his private library to worthy working lads. Andrew was the most assiduous borrower and from his experience learned to love libraries and devoted much of his fortune to building them.

Brought up as he was in a climate of free thought, he remained a lifelong agnostic; so unlike Morgan. His formidable mother, though nominally a Swedenborgian like her husband, was more of a seeker than a finder. Andrew was originally a Swedenborgian like the neighboring Pitcairns (who remain to this day the leading American Swedenborgian laymen) but unlike them did not persist in the faith. He remained, however, an ardent republican, so antiroyalist that he later backed a chain of English newspapers devoted to the overthrow of the monarchy. How *very* unlike Morgan, that friend of Edward VII! As a descendant of workingmen, suckled on the gospel of the rights of the workingman, he found being one of the most powerful employers of America sometimes embarrassing. He used his wealth for the improvement of the poor, but when the rights of the workingman happened to conflict with the Carnegie Steel Corporation . . . ? His attitudes, let us say, remained ambivalent and uncomfortable.

When he had made his pile, he was able to go back to Scotland and remodel for himself a great castle called Skibo, complete with elevators and a swimming pool with sliding roof. At Skibo bagpipes relentlessly

woke the guests for breakfast and organ music soothed them while eating it. But the rights of the workingman remained a problem. When his workmen struck, he usually closed up shop and waited for the strike to end, refusing to hire scab labor. However, when he got entangled with Henry Frick, things became different. Frick was by no means a radical thinker or friend of the workingman. The dreadful events of the Homestead Strike, for which Carnegie had to take much of the blame but for which Frick was directly responsible, drove a wedge between the incompatible partners. This incompatibility was the root of the vicious quarrel that was only resolved by Morgan's formation of the United States Steel Corporation.

iv

Henry Clay Frick (1849–1919) was still another kind of Titan. He was a German,* German in his doggedness, efficiency, passion for work and for doing things right. German, too, in his grim autocracy and brusque, no-nonsense, repressive dealings with subordinates. Rights of the workingman indeed! They had the right to work as hard as Frick and to get ahead if they could. But no nonsense about shorter hours and higher pay and unions. No fooling about with English philosophers and Scottish castles and libraries as lights of the soul. Frick's only passion outside of work was for art. His childhood was dominated by the figure of stovepipe-hatted grandfather Abraham Overholt, patriarch, owner of A. Overholt & Co., manufacturers of flour and YOUGHIOGHENY Whiskey, famous all over the country as Old Overholt. Abraham was the great man of Westmoreland County. His example inspired his grandson to rise above the level of his industrious but poor father John Frick. Henry finally got a good secure job in Grandfather Overholt's distillery, keeping the books.

Like Andrew Carnegie, Frick amassed capital, some of it saved, some of it borrowed from the Overholt family, some cautiously lent him by the Mellons in Pittsburgh. He invested it not in whiskey but in coke. Coke, made out of coal, was used to make steel. Pretty soon, after dogged work and hanging on through the 1873 depression, Frick emerged as master of coke as Carnegie was master of steel.

In the process of getting started, young Henry Frick met young Andrew Mellon. Frick had already borrowed his first ten thousand dollars from the Mellons. Then he came back for more. Thomas Mellon, Andrew's fearsome progenitor, sent an investigator to look into the character and prospects of young Frick. The report has become something of a

* The family actually originated in German Switzerland.

classic: "Lands good, ovens well built; manager [Frick] on job all day, keeps books evenings, may be a little too enthusiastic about pictures but not enough to hurt."

Carnegie grew to depend on Frick for his coke. They were each other's best customers. Rather than fight they combined. Despite later severe quarrels, often about labor relations, and a basic fundamental antipathy of character, the ebullient Carnegie brought the dynamic Frick in as head of his whole operation. The most notorious incident of this partnership was the Homestead Strike of 1892. By then Carnegie had almost retired from Pittsburgh. That is, he had moved his winter residence to New York in 1867 and he spent all his summers in Scotland. He kept close sharp watch on what his steel makers were doing in Pittsburgh, but he wasn't actually personally in charge there; Frick was.

The workers struck at a big Carnegie-owned steel mill called the Homestead, largely over the issue of unionization. Instead of closing the plant and waiting, after the Carnegie fashion, Frick decided to keep the plant open with scab labor. To protect the plant he surrounded it with a stockade, barbed wire, and searchlights. The citizens of Homestead organized themselves into a standing army to keep the scabs out and prevent anyone at all from entering the plant. Frick hired about three hundred Pinkerton detectives and brought them secretly up the river by night in barges with the intent of landing directly at the plant and occupying it by surprise. Instead of being surprised, the armed Homesteaders were there waiting. They attacked the barges with rifles, cannon, and flaming oil on the water and prevented the Pinkertons from landing. A few men on both sides were killed in the process. Eventually the Pinkertons, besieged in the barges, gave up. They were allowed to land, being assured of free passage; but a mob attacked them as they came ashore, wounding many and killing a few more. Eventually the reluctant Governor of the state called up the militia, the Homestead irregular army gave up, the strike was called off, and Frick ended victorious. An attempt by a foreign radical agitator to assassinate Frick, quite unrelated to the strike, shocked the public and swung public sympathy to his side. His sangfroid during this incident made him something of a hero. Carnegie, off in Scotland with his literary guests and bagpipers, was forced to stand back of Frick, though one feels he was privately furious and never forgave Frick for his anti-labor brutality.

When J. P. Morgan bought out both Carnegie and Frick to form United States Steel, Carnegie retired for good, throwing himself at last into his philanthropies. Frick continued to be modestly active in business, based in New York, but became more and more absorbed by his art collection. He acted as a general go-between during the U.S. Steel

negotiations as the only man both Morgan and the Rockefellers would speak to as an equal. Bouncy Andrew and grim Henry never saw each other again after their final rift in 1900, though they both lived in New York and both died in 1919.

Henry Clay Frick and Andrew William Mellon (1855–1937) remained good friends till Frick died. Even the Hutchinson-Ryerson pair couldn't match the Mellon-Frick pair as picture buyers. The important difference was that the first pair gave their pictures to the local city museum; the second pair didn't. In contrast to lordly Morgan, chipper Carnegie, and dynamic Frick, Andrew was a cool shadow; frail, distinguished, silent, secretive. Terrible Scotch-Irish father Thomas, who believed in business enterprise as he believed in a vengeful God, brought up his five surviving sons to fear Thomas and God and revere God and money. Thomas, brought over from Northern Ireland as a baby, progressed through real estate, law, and a judgeship to banking. On the way he carefully chose a well-to-do, sober wife. Love was of no apparent interest to him, but during his rather exasperating courtship his intended insisted on the proper rituals, making him look at albums and natural beauties. This waste of time almost made Thomas give up the project; but finally an unexpected kiss brought a difficult state of affairs to a fortunate conclusion and Thomas and wife lived together happily ever afterward as a permanent flouting of all sentimental Victorian ideals of love and marriage. If ever a man deliberately and self-confessedly married for money and advantage it was Thomas Mellon.

Four of the five living sons of this mercenary and successful union made good. The two older brothers became respectable Pittsburgh millionaires. The two younger ones, Andrew and Richard, forced the already substantial Mellon family fortune into the economic stratosphere. Along with the Rockefellers and the Du Ponts, the Mellons still have one of the largest family fortunes in the country. Unlike the Rockefellers and the Du Ponts, the Mellons have never really specialized. Banking, steel, railroads, oil, a monopoly of aluminum, everything fell into the web woven in Pittsburgh by the spidery Andrew. By 1921 when he was catapulted out of obscurity by being named Secretary of the Treasury by Harding, he was already sixty-five, incalculably rich and totally unknown outside of Pennsylvania. His name had, it seems, never previously been mentioned by the *New York Times*.

Mellon had been following his father's footsteps in banking and investments, just as Morgan had followed his. But whereas the senior Morgan was a collector of sorts, the senior Mellon wasn't. In fact, one gets the strong impression that picture collecting was regarded as a frivolous pastime by the senior Mellon and his contemporaries in the steel country. But despite this lack of encouragement, both Frick and Mellon took a seminal trip to Europe together in 1880 when Frick

reached thirty and his first million. He and the slightly younger Andrew examined the mansions along Fifth Avenue in New York with prospects of their own in mind. Then they looked at pictures abroad. Though there does not seem to be a record of this grand tour, the end result of it was significant: the Frick mansion and museum along Fifth Avenue in New York and the National Gallery on the Mall in Washington. Nothing in Pittsburgh.

Once Andrew emerged from obscurity he became very famous indeed. Few cabinet members have lasted so long and had more reputation during their tenure. He was the dominant member of the Harding and Coolidge administrations and was called "the greatest Secretary of the Treasury since Alexander Hamilton." He managed the Government's finances from 1921 to 1932: too long. Popular during the years of Republican prosperity as balancer of the budget and reducer of taxes, he became unpopular during the Depression. He was sent abroad as Ambassador to England and then retired at the advanced age of seventy-eight. His few final years were devoted to the establishment of his gallery.

Andrew, with his cautious mustache, ascetic hooked-nose features, and sober but rich attire, and Frick, with his military bearing, brisk white beard, soft-spoken courtliness, and gimlet eyes, were neither of them very representative of the bloated Morganatic capitalist of the cartoons or of the crude self-made man of fiction. Though it is doubtful if Morgan would have considered either of them gentlemen of his own sort, they were certainly dignified, if fragile, specimens of eastern millionairism.

v

John D. Rockefeller (1839–1937) was much of the same stamp — lean, ascetic, sober, secretive. But there was no question of Rockefeller being a gentleman in the Morgan sense. He lacked the social flair and exuberant charm that made Andrew Carnegie popular among the upper classes. His Baptist suspicion of high living and fancy ways kept him from worldly indulgences and high society. Like Carnegie, he was a mother's boy; but whereas Carnegie's mother was a radical tyrant who ruled her son's life to such an extent that he never married until she was dead and he was over fifty, Rockefeller's mother was a Protestant martyr, an upright and abused wife to a flamboyant and errant husband. The senior William Rockefeller did this and that up in New York State where J.D.R. was born. He moved his family to the Cleveland area in 1853 and spent his later life wandering about the country as a snake oil salesman. He was a loose and high liver but thought of

himself as a sharp trader and brought up his boys to be equally sharp. Their mother saw to it that her boys were pious. Both sharp and pious John certainly became. Of the three who survived and flourished, the obscure Frank, the successful and popular William, and the great John Davison, John, the oldest, was obviously his mother's favorite. She instilled in him her narrow but fervent creed that despised all culture except that centered on religion and the Bible and with it the asceticism that frowned on frivolities such as theatergoing and novel reading. Making money was of course encouraged; working in the vineyard of the Lord so as to become a Trustee of His blessings and Steward of His bounty — this Protestant ethic was held in some form by all these men, but more consciously and grimly by John than by the others.

To that end he almost managed to corner and control the refining, distribution, and eventually the production of oil, though there was stiff competition from Mellon's Gulf Oil and others. Standard Oil, however, became the first trust and the first and most notorious of America's turn-of-the-century near-monopolies. It was founded as early as 1870, long, long before the automobile gave it a special reason for being. Oil then was used mainly for lighting and lubrication.

John was at heart a bookkeeper. He liked to keep things tidy. He began as such in his teens in Cleveland in the grocery business. He did well, switched to oil refining soon after the oil discovery in 1859 in Titusville, Pennsylvania, developed into America's first oil boom, and gradually lured or coerced his competitors into becoming his associates or his victims.

Rockefeller disdained the gauds of worldliness. His houses, though they grew larger and larger, first in Cleveland on Euclid Avenue or out at Forest Hill, then in New York on West Fifty-fourth Street (in the area where the Museum of Modern Art now stands), and finally at Pocantico, north of New York City, were always simple and usually in plain bad taste. His favorite dish was milk toast. Brother William Rockefeller, who did collect art and is mentioned in *Art Treasures*, belonged to a select club of gourmets called the Corsairs, who got together to guzzle with Morgan. But brother John D. kept thin and healthy on his milk toast and an apple a day, living almost to a hundred. His only indulgences seemed to be skating and driving horses. He had the lot next to his house on Fifty-fourth Street flooded and frozen in winter. There he twirled sedately in his top hat. Later on he took up golf. He evidently never read anything but the Bible and Lew Wallace's *Ben Hur*. There is no record of his having looked at a picture for pleasure.

He began his giving by tithing to his Baptist church in Cleveland. This tithing gradually expanded into a vast panorama of good works, mostly medical and educational. It was he who rejuvenated and re-

founded the ailing Baptist University of Chicago, of which Hutchinson and Ryerson were local ornaments as boardsmen. His money rooted out hookworm in the South and yellow fever in the tropics. But for him there was none of the gorging on precious objects characteristic of Morgan or the doting on Rembrandts practiced by Frick.

The first meeting of Morgan and Rockefeller produced instant dislike. Rockefeller's comment, "I looked at him," though a bit cryptic, does convey the lizardlike scorn with which the increasingly mummified apple-eating Midwestern lower-middle-class Baptist gazed on the increasingly bloated gourmandizing cosmopolitan upper-class Episcopalian. The final negotiations for the formation of U.S. Steel, which involved the crucial purchase of iron mines on Lake Superior owned by Rockefeller, almost broke down because of this antipathy. Rockefeller refused to deal with Morgan. Morgan was so arrogant and rude to J.D.R., Jr. when he came to call that only the intermediary tact and determination of Henry Frick saved the day.

Rockefeller and most of his henchmen may not have collected art, but eventually a lot of their money did seep into museums. In the panorama of art now on display in New York and Washington, nearly all the important later museums and their contents are derived from money made originally by these or similar Titans. In New York, the Whitney (Vanderbilt railroads, Whitney streetcars, Payne oil), the Museum of Modern Art (Rockefeller oil), and the Guggenheim (Colorado copper) were all founded on the basis of this out-of-town wealth. The Met was transformed by Morgan. In Washington there were the Clark Old Masters at the Corcoran (Montana copper), the National Gallery (Pittsburgh aluminum), the Phillips (Pittsburgh steel), and the Freer (Detroit railroad cars), not to mention all the other Titanic donors to these and other museums. It was in many cases the massive phenomenon of millionaires becoming too big for their home towns, where they were not always appreciated (as in the case of Rockefeller in Cleveland), and their moving up to the big time. New York and the nation's gain was the loss of Pittsburgh, Philadelphia, Cleveland, Detroit, and points south and west.

There is a wonderful book to be written someday about these five terrifying men — Morgan, Carnegie, Frick, Mellon, Rockefeller — not just as individuals but as an interlocking group. Steering between the Scylla of Marxism and the Charybdis of pro-Capitalism, an impartial historian might be able to see just what they really did, what their true relationships and interactions were, and what was really constructive and destructive about their careers. The time still doesn't seem to have quite come when Americans can look on the very, very rich impartially, soberly, and honestly. There is still a bit too much vague suspicion, covert envy, or bemused jocularity in what is written about them. They

were, after all, perhaps the most important figures in America at the turn of the century. They created modern America as an industrial giant, for better and for worse. They formed a gallery curiously comparable to the founding fathers of the state — Adams, Hamilton, Franklin, Washington and Jefferson — if hardly as sophisticated, sympathetic or literate as men and personalities, or even as ingratiating as the founding fathers of the art museum.

As literature and philosophy were the avocation of most of the earlier men of the Revolution, so art was that of at least three of these later founding fathers. Their reputations remain controversial. Their donations in the form of hospitals, libraries and museums remain as memorials to what was best about them.

Chapter II

i

WITH HIS BACKGROUND, Pierpont Morgan was bound to become a collector of some sort, but the direction of his collecting was not really toward paintings. It was already set in earliest youth when he made a childhood collection of the autographs of Episcopalian bishops (what an odd boyish effort!) and when abroad as a scholar he picked up bits of broken medieval stained glass from the debris around cathedrals. (Some of these were eventually incorporated into the windows of the Morgan Library.) From the signatures of bishops developed the superlative collection of autographs, manuscripts, books, and illuminations now housed in the Morgan Library. From the bits of stained glass developed the collection of all those costly treasures now mostly at the Metropolitan.

Morgan began late as a serious collector. His nephew Junius Morgan II told him about a Thackeray manuscript owned by a young friend. Morgan bought it in 1888 and from this went on to other manuscripts, first editions, medieval books, prints, and what have you. The book as a thing fascinated Morgan, rather than the book as a thought that fasci-

nated Carnegie. The outcome of this side of his collecting interest has been the Morgan Library, which is not strictly an art museum as I have defined the term in this book but which comes very close with its prints, illuminations and rich Renaissance decor.

From 1890 on, however, Morgan began to ransack Europe not only for books but for objects, buying whole collections to get one specimen, outbidding rivals with the same ruthless assurance and decisiveness that made him invincible in finance. Though this process of buying whole collections inevitably brought him a good deal of junk, he knew what was good and what wasn't. There are famous stories that demonstrate the accuracy of his eye. Morgan dealt with Henry Duveen, uncle of the now more famous Joseph. Young Joseph also tried his hand with Morgan by offering him a collection of miniatures that included six especially good ones. Morgan looked at the collection, picked out the six good ones, put them in his pocket, mentally subtracted the proper price of the six from Duveen's total, and left the rest of the miniatures on Duveen's hands. Uncle Henry chortled that young Joseph wasn't man enough yet for Morgan. In fact he never was until, after Morgan's death, he was designated a seller of those parts of the Morgan collection not given to the Metropolitan.

The accumulation of objects was kept in Europe, some of it at his London house in Prince's Gate or at his country place, "Dover House," some of it on loan to the Victoria and Albert or the National Gallery in England or to French museums. In 1909, no doubt under pressure from Morgan, Congress included in a tariff bill bearing the name of Senator Aldrich, father of Mrs. John D. Rockefeller, Jr., a clause permitting works of art that could be classed as antiques (over a hundred years old) to come into the country duty free. For Morgan to have attempted to bring all his loot home before this might have been ruinous, even for a Morgan. But now America on one side of the ocean had lowered customs duties and England on the other side of the ocean was raising death duties. It was time to move. He could afford it now, but for him it turned out to be too late. He didn't get around to packing and shipping until 1912. The collection was stored in the basement of the Met, but there was no room upstairs to exhibit it. The city fathers balked at appropriating money for any sort of "Morgan wing." They felt that Morgan could damn well afford his own wing. Morgan grew progressively more annoyed and when he died in 1913 without ever seeing his collection unpacked and on display as a whole, he did not will it to the Museum. Instead he left it to his son with instructions that the collection be "permanently available for the instruction and pleasure of the American people."

Finally in 1914 the whole collection was exhibited at the Metropolitan. After that his son John Pierpont Morgan (who properly if con-

fusingly did not use the "junior" after his father's death) gave a mass of items to the Met in 1916 and 1917. He also sold a great deal. Only about forty percent of the total went to the Museum. The most prestigious of the few Morgan paintings, the great Raphael *Colonna Altarpiece,* the wonderful collection of medieval statuary and artifacts, the dazzling store of eighteenth-century snuff boxes and watches, the Italian majolica, bits of ancient glass and bronze — all this and more is still on view there. Anything you see at the Met nowadays with the accession number 17.190 is apt to be part of the Morgan hoard.

Other things went to the Wadsworth Athenaeum, lifting that museum at once from a small provincial collection into the category of a first-class museum of all the arts. The great Morgan Library, housing his treasures on paper, had been finished in 1906 and was used regularly by Morgan as his business office. When he gathered the tycoons of 1907 together to try to stem the panic of that year, they were all locked in the Library overnight until they finally agreed at five o'clock in the morning to dip into their own reserves to help prevent the disaster. Some of *them* had to sell their pictures.

Unfortunately, a good many of the best things in the Morgan collection were among the lots that were sold. Fortunately, on the other hand, most of these ended up in other American museums. The wonderful Fragonard panels, painted for Madame du Barry but rejected by her perhaps as being too frank in their depiction of various amorous conditions or merely for being old-fashioned, were bought and brought from obscurity by Morgan to be installed in Prince's Gate. They were then reinstalled in the Met in a room duplicating the London setting; but they are not there now. They are in the Frick Museum as one of its proudest possessions. Frick also bought the cream of Morgan's collection of Renaissance bronzes. The Havemeyers bought the beautiful Vermeer Morgan had purchased on the spot without even having previously heard of Vermeer. (Vermeer, like El Greco, was a rediscovery of the late nineteenth century, not part of the Academic canon.) The Havemeyers gave the Vermeer to the National Gallery, as Widener did the Mazarin tapestry, also bought from the Morgan estate.

The junior Pierpont Morgan said he had to sell much of his father's collection because he was "poor"; that is, in order to keep the estate solvent and supplied with ready cash for taxes and other obligations. Morgan, by Rockefeller, Carnegie, or Frick standards, was, as Rockefeller once remarked, "not even a rich man." The estate was estimated at a mere sixty-eight million dollars, which hardly seems very poor. But since the collection was worth almost as much, about sixty million dollars, no doubt there were problems with death duties. The Metropolitan did get its Morgan wing, and the wing was filled with Morgan trophies, medieval downstairs, French Louis upstairs. Still this was not

all that the Museum might have had. With great generosity and good sense the junior Pierpont in 1943 lifted the restriction that all the Morgan gifts had to be kept together for fifty years (till ca. 1967). By now the Morgan collection is dispersed all over the galleries — thousands of objects upstairs and down in the basement. There is no Morgan wing these days, and compared to the names of some other donors like Altman and Blumenthal, the name Morgan does not now obtrude on the visitor. But there is little doubt that the Morgan bequest, belated and diminished though it was, began to make the Metropolitan the great museum it is. What was not done by Morgan as donor was done by Morgan as President.

ii

Morgan reigned — and reign is certainly the proper word — from 1904, the year Cesnola died, until his own death in 1913. His reign marked the emergence of the Metropolitan as the first of American museums. This was not just because of his own gifts and administrative abilities but because of his ability to buy people as well as things. He bought Sir Caspar Purdon Clark from that model for all early American museums, the Victoria and Albert. The story runs that the Secretary of the Victoria and Albert had entered bids on some porcelain and tapestries, then gone off on a trip. When he returned to his museum he inquired about his porcelains. He was told that Morgan had bought them. What about the tapestries? Morgan had bought them too. "Good God!" said the Secretary. "I must speak to Sir Purdon." "Sorry sir, but Mr. Morgan bought him too."

Much more significantly, he bought the disgruntled Edward Robinson from Boston and also Arthur Lythgoe, one of the key figures in Boston's Egyptian department. This was the beginning of the great increase and refinement of both the Classical and Egyptian departments in New York — at the expense of Boston. The Robinson-Lewes House group now worked for Morgan instead of Sam Warren. Cesnola was out of the way at last. Morgan himself collected Classical and Egyptian antiquities and grew more and more obsessed with Egypt as he grew older. The Met benefited in innumerable ways from those Morgan boat trips, complete with ladies, up and down the Nile. The coincidental shower of unexpected gold from the Rogers bequest in 1903 provided funds for all this archaeology. When Purdon withered and died in the New York climate, Robinson took over as Director in 1910, third in line from Cesnola and the first native American in that post.

Even in the area of painting, in which neither Morgan nor Robinson

was primarily interested, Morgan's administration had a profound effect. Along with the genial but ailing Clark, Morgan bought from England Roger Fry. Roger Fry (1866–1934), who became the foremost English art critic of his day, hated Morgan as much as John D. Rockefeller did, but for different reasons. Rockefeller hated him because of his worldly ways. Fry hated him because of his brutal strength. Fine flower of Bloomsbury sensibility, with his total intellectual superciliousness combined with a sort of nervous irritation at the equal superciliousness of sheer power, rank and birth, Fry had more or less made up his mind to despise crude America, sight unseen. When he found he was treated by Morgan as a sort of errand boy and purchasing agent, his fury increased and concentrated on Morgan personally. It was hard enough to have to put up with that sort of thing in England, but in America! Morgan had no intimation of Fry's furies and of course cared less. He treated him the way he might treat one of his junior Wall Street cupbearers. He used him.

Fry nonetheless served the Met well during the short time he was there, pointing out the glaring deficiencies of the painting collection, setting up for the first time a sophisticated standard of acquisition, and seeing to it that rare Italian Renaissance pictures and at that time even rarer Impressionists were purchased. He scandalized the board of trustees in 1907 by buying and hanging the Renoir *Mme. Charpentier*. The picture still hangs, still one of the Museum's masterpieces, still a monument to Fry. Finally Fry had the impudence, by Morgan standards, of daring to criticize one of Morgan's curious art dealings. Morgan personally bought for his own collection a picture that Fry had already picked out and reserved for the Met. Fry complained. Morgan exploded. Fry left.

Under Morgan the Classical, the Egyptian, and the painting collections, above all the collections of decorative art of all ages, had turned the corner from the provincial second-rate to the international first-rate. When finally Morgan's own things, especially the medieval and the classic French, joined the Museum shortly after the equally magnificent Altman bequest of 1913, the Metropolitan could begin to claim a superb and well-rounded display of just about everything. Morgan even made his contribution to Oriental art by buying and giving the once famous Garland collection of Chinese porcelain. In that field, as in some others, notably French furniture, Morgan's contributions have been eclipsed by those of Altman and later donors. But no other President of the Board and no other one collector has had quite the same total impact on the Metropolitan, and hence by example on all the museums of America, as did the great Pierpontifex Maximus.

...
iii

By comparison, the effect on museums of Andrew Carnegie's generosity is miniscule. It is, however, significant in two ways. By establishing Pittsburgh's only art museum in 1896, Carnegie made his adopted city a pioneer in the world of "western" museums along with Buffalo, Cincinnati, Detroit, Chicago, and Saint Louis. He also supplied funds for an International Exhibit that for decades made Pittsburgh a center of contemporary art.

The years just before and after 1900 were a propitious time for such a venture. The International in Pittsburgh presented an immense variety of artistic styles. The roll call of exhibitors, jurymen, and prize winners in the first exhibit of 1896 lists most of the well-known painters in the Western World at the turn of the century: Degas and Monet; Homer, Eakins, Whistler, Chase, Duveneck; Hassam and Twachtman; Burne-Jones and Watts from England; Daubigny and Diaz, Boldini, Gérôme and Cazin representing Barbizon and the Salon — almost any name you can think of appeared then or in the shows immediately following. The exhibition remained a sensation. During the first decades of its life it rivaled or eclipsed the shows of the PAFA and the Corcoran, confined as they were to Americans, as a maker of reputations and as a "window on the world" of art, especially Europe.

Gradually, however, as time went by and Europeans became more radical and less acceptable in their experiments, the Carnegie Internationals failed to keep up. By 1920 the shows had become woefully out of date, the choice of foreign pictures especially being in the hands of academic pooh-bahs who prevented the public from seeing anything that wasn't perfectly safe and respectable. A change and reform did start in the mid-twenties. Matisse was exhibited from 1924, along with Signac, Derain and Vlaminck. Matisse won first prize in 1927, Derain in 1928. Picasso first exhibited in that year and finally won first prize in 1930, though not for a Cubist work. Nothing abstract of his appeared until 1934. Things once more settled down to routine till 1950; but by 1930 the International had lost its leadership to agencies such as the Museum of Modern Art and the Whitney and its great days were over. The shows persisted down to the last one in 1970; but the excitement and prestige of the first two decades has never been regained.

Between shows the Carnegie did not have much to offer. Carnegie had given building, money, casts; but he had not given pictures. The museum made purchases from the shows and received a few donations. Some of these were good, but too many were not. All of them were modern, and they got to be worse and worse rather than better and

better as time passed and the quality of the International itself declined. By about 1920 some hundred paintings had accumulated, surrounded by a forest of casts and other reproductions. There were lucky bargains. Monet, Pissarro, Boudin, Sisley, Homer, Inness, Whistler (but not Eakins or Sargent) had been bought hot off the walls. But too many of the pictures were by Academics whose reputations have not survived. Only a very few older pictures were on hand even as late as the twenties: a Benjamin West and a Gilbert Stuart among the group of a half-dozen so-called "historical pictures." It was not a collection worthy of the city of Frick and Mellon, of Cassatt and Stein.

From the 1920s on good "historical pictures" began to seep in from lesser local donors. The Dalzell Memorial pictures given from 1925 to 1929 were the first sizable group of Old Masters, mostly English, to join the purchases from the annuals. Native John White Alexander painted dim murals all over the grand staircase. There was no notable evidence of the work or influence of native Mary Cassatt, much less of that other prominent woman native, Gertrude Stein. In later times the prestigious modern collection of G. David Thompson failed to come to the museum for the usual petty personal reasons; but he gave many individual good things. But good things were few until recent times, when as late as the 1960s what has been vulgarly described as a "slice of the Mellon" finally came home. Andrew's daughter Ailsa Mellon Bruce, who died in 1967, left a huge and marvelous collection of porcelain, and Andrew's niece Mrs. Richard Scaife donated not only a superb collection of paintings but finally bequeathed a great new wing to hold them, just opened in late 1974. Pittsburgh finally got a museum in keeping with its tradition as the city of collectors; but the city didn't get it from its great collectors themselves.

iv

Henry Frick's monument is, of course, in New York. He stayed in Pittsburgh much later than Carnegie did, but he finally went east in 1905, though he always kept his Pittsburgh residence "Clayton." He first rented a Vanderbilt mansion like one of those piles he and Mellon had so coveted on their first trip to Europe. Then he built his own beautiful French hôtel at Seventieth Street and Fifth Avenue in 1914. Upon his wife's death it became a public art gallery opened in 1933; and there it sits today, everybody's favorite New York museum, a hot house flower of total esthetic charm and grandeur sprung from the coke and steel of the Smoky City.

Frick began his collecting where every other American seems to have begun, in the field of "modern art." In the late 1880s and early 1890s he

invested in Meyer von Bremen (1887), Bouguereau, Breton, Jacque, and other such. A surprising exception is his 1895 Monet. Otherwise it was all Diaz and Ziem until just before the new century when he got his first Rembrandt. A nice genre picture of that time, done preferably by Charles Dana Gibson, might be a picture of a millionaire gloating over "His First Rembrandt."

The Frick collection as it now stands is almost entirely a twentieth-century accumulation. From 1902 on the Salonistes drop out and it's all Hobbema, Reynolds, Gainsborough, El Greco, Vandyke, Titian, Hals, and Rembrandt, Rembrandt, Rembrandt. It was Frick who said that railroad stocks were the "Rembrandts of the investment world." Luckily Rembrandts weren't the railroad stocks of the art collecting world. Frick's last purchase was the famous Vermeer *Lady with a Letter* of 1919, the year he died. In twenty years he had graduated from the world of Strahan to the world of Duveen and from the now comparatively worthless canvases of Meyer von Bremen to the literally priceless Holbein *Sir Thomas More* and the Bellini *St. Francis* and other world masterpieces that make Frick's palace such a house of earthly delights.

Did Frick really know and appreciate what he was getting, or was he just the tool of dealers and monster of ignorant vanity portrayed by the Muckrakers? There is a devastating vignette of him presented first by Anna Burr in her biography of James Stillman. It describes Henry seated on a Renaissance throne reading the *Saturday Evening Post*. He also liked to have "The Rosary" rendered for him on the great gilded house organ.

But just because he may have had limited tastes in literature and music doesn't mean that he didn't know art. Morgan quite obviously knew a lot about art, whatever Fry might have thought; but he preferred a good old hymn tune to opera any day of the week. It is impossible to believe that Frick and Mellon, whatever their esthetic limitations, didn't know painting. Artificial as the Frick hôtel may be, reflecting in no real way the personality of its builder, the rarefied product not of the native soil of Mennonite Pennsylvania but of the world's most expert art dealers, it is nonetheless a very perfect blossom of taste and expertise, a true expression of New York's ability to buy the best of Europe.

Henry Clay Frick, the ruthless steel master of Homestead, the heir apparent of Old Overholt Whiskey, may seem an inappropriate creator of such rarefied grandeur. When he decided that the smoke from his factories was bad for his pictures and deserted Pittsburgh for Fifth Avenue, the move may have been sad for Pittsburgh, but surely good for American art. One can not honestly say he chose unwisely in making his collection so centrally available in such a choice display case. Miss Frick, his daughter, still keeps "Clayton," and nearby, alongside

the bosky ravines of Frick Park, has recently built a tiny gem of a new Frick Museum. This is known locally as "Frick Two." "Frick One" was a collection loaned to the University of Pittsburgh, of which Fricks were benefactors. A pretty Italianate building was built to house the collection, but a fight with the University caused Miss Frick to remove her pictures. In Pittsburgh the Frick Museum in New York doesn't count. It is Frick Zero.

Chapter III

i

THE OTHER GREAT PITTSBURGH collection, the other big one that got away, was the Mellon collection. Since the Mellon collection forms the core of America's great National Gallery, it deserves a chapter of its own. Like everything else in Andrew Mellon's life, his art was assembled with a minimum of publicity. Just as few people knew he existed before he moved to Washington as Secretary of the Treasury, so few people knew about his collection. He had it in Pittsburgh, then he moved it to his Washington apartment and friends saw it there; but it was certainly not on public display.

The idea of a national gallery for the nation's capital was an old one. The Smithsonian had been entertaining the idea for decades without getting anywhere. Corcoran obviously considered his Gallery a sort of national gallery. When the Clark Old Masters came there in 1925 it did have some pretensions of the sort. The Wideners in Philadelphia went as far as making a model for a possible home for their collection on the Mall. Mellon was more specific and determined. As Secretary he was responsible for the construction in the 1920s of a great triangle of

Roman Government buildings between the Mall and Pennsylvania Avenue. It was natural for him to think of putting a culminate Roman building as the very apex of his triangle of marble.

In the mid-twenties Mellon first began to talk of the plan to intimates like David Finley, a lawyer who worked for him in the Department and shared his increasing passion for paintings. Mellon began to collect not just for his own pleasure but with a national gallery in mind. In 1930, by a curious series of circumstances, it was discovered that the Soviet Union, needing cash, was willing to sell some of the best paintings in the Hermitage. Mellon was able to buy a score of them — Botticelli, Raphael, Titian, Velásquez. He didn't want them to be seen publicly until he could unveil his gallery. They were stored in a room at the Corcoran where Mellon and Finley would go every month or so to gloat and inspect. While he was Ambassador in England Mellon took the cream of his collection to decorate the Embassy in Prince's Gate, that same Prince's Gate where the Morgan collection had once nestled. After 1932, when he was no longer officially employed, he devoted himself to the project of his gallery. He was already almost eighty and had a scant five years left to live.

Under Franklin Roosevelt a suit for nonpayment of income taxes as of 1931 was brought against Mellon. Somewhat like Mr. Morgan's reaction to his congressional investigation by the Pujo Committee in 1912, Mr. Mellon was displeased and disillusioned; but again like Morgan he did not alter his determination to have his art go to the American people. He was far more direct about it than Morgan, but he did wait until the final court proceedings in his tax case were terminated in 1936. The actual verdict clearing Mellon did not come through until after his death, but in December of 1936 he wrote a letter to F.D.R. offering pictures, a gallery to hold them, and an endowment to keep and augment the collection provided Congress would vote money for upkeep and administration. The offer was accepted with joy; there was none of that congressional malingering that attended the Smithson bequest.

The gallery was to be under the general auspices of that same Smithsonian, mother of all arts and sciences, but to be run by a completely independent self-perpetuating board of trustees of which the Smithsonian would name one ex-officio member. There were to be four such ex-officios: the Chief Justice of the Supreme Court (then Charles Evans Hughes), the Secretary of State (Cordell Hull), the Secretary of the Treasury (Henry Morgenthau, Jr.), and the Secretary of the Smithsonian (Charles G. Abbott). There would be five regular trustees. The bill passed by Congress was signed by Roosevelt in March 1937. The board was appointed in June; excavations were started in July. The design of the exterior had been decided on by Mellon's chosen archi-

tect, John Russell Pope. A special sort of pink Tennessee marble was to be used for the walls. David Finley had been picked out as first Director, to take office in 1938. And then in August 1937 Andrew Mellon died. His architect Pope died within twenty-four hours. Neither lived to see their dream completed.

ii

The Gallery finally opened to the public in March 1941, the year of Pearl Harbor. Mellon had specified that his name was not to be attached to it. It was to be a *national* gallery, not a personal one like the Corcoran or the Freer or the Phillips, all of which were by then open to Washingtonians. Nonetheless, the native Washingtonians and "cliff dwellers" have always insisted on calling it the Mellon Gallery. Mellon's modesty had the purpose of attracting other great donors who might be willing to give to a national but not necessarily to a Mellon museum, just as Frick and Mellon would not at that time have been likely to have given to a Carnegie Institute.* The Mellon collection was rich and beautiful, but its some hundred paintings would by no means fill the "largest marble building in the world." Nor did the collection cover the entire history of European painting from the beginnings to the twentieth century, despite its masterpieces. Fortunately, another great donor had been attracted before the opening: Samuel Henry Kress.

Kress was the second of the Five Great Donors whose collections make up the bulk of the holdings of the National Gallery: Mellon (Italian, Dutch, English), Widener (ditto), Kress (Italian, Dutch, English, French eighteenth century) and Dale (French nineteenth and earlier twentieth centuries). Many others have given much, but by far the largest percentage of the paintings and sculpture now housed in this Palace of the People were contributed by these four. The fifth of the Great Donors is Lessing Rosenwald, whose sumptuous collection of prints rounds out the Gallery's magnificence.

David Finley, Mellon's hand-picked first Director, belongs in another series of twentieth-century celebrities that parallels, but later in date, that of the billionaire donors. The first directors of the older museums were certainly local celebrities, but the great directors of the twentieth century have often been national and even international ones. Some of them in charisma and picturesqueness have rivaled the great orchestral conductors of the same period like Stokowski, Toscanini and Kous-

* Later on Mellon money did go to Carnegie foundations (Carnegie-Mellon Institute, once just Carnegie Tech).

sevitzky. Finley belongs with this group of stars by virtue of position and accomplishment; but otherwise he is entirely in the tradition of those first American directors of the nineteenth century who happened into directing from other worlds, not through the modern channels of college art training and curatorship.

Finley probably had the most unlikely background of any of these first directors. His father was a long-time congressman from South Carolina and Finley was obliged to follow family footsteps by going into the law via the University of South Carolina and Georgetown. In 1922 he became a lawyer member of the War Loan Staff under the Treasury and soon became a protégé of the Secretary. When Mellon confided his ambitions for a national gallery, Finley enthusiastically supported the idea and devoted his holidays to the study of art in European museums with the idea of helping Mr. Mellon in his great scheme.

A judicial and rather stately Southern gentleman, Finley carried out Mellon's wishes after his death, principally by his heroic work in attracting — one might even say coercing — Kress and Widener into giving their collections to Mellon's museum. Without these two collections the National Gallery would have been a failure, with Mellon's Old Masters, gorgeous though they might be, rattling around in a waste space of unfulfilled marble ambitions.

<div style="text-align:center">

...

iii

</div>

The first of the collections to be added, in time for the opening in fact, was that of Kress. The Kress boys were natives of Pennsylvania. They sprang from somewhat the same countrified Pennsylvania Dutch stock that produced Henry Frick; but there was no whiskey in back of them, no father-grandfather images. The Kress boys were self-made. The various brothers were born in various small dots on the map in the eastern part of the state near Allentown where the original Kress had moved from Nuremberg in the eighteenth century. Samuel began life like Liberty E. Holden as a schoolteacher. Somehow, perhaps because he never married, he managed to save enough money to open a small notions store up to Nanticoke near Wilkes-Barre in the coal region. He was joined in the business by his brother Claude and gradually this tiny beginning bloomed into a two-hundred-store chain of five-, ten-, and twenty-five-cent emporiums located largely in the still unexploited area of the South.

Samuel went abroad after he made his pile and in Italy came under the sway of a Count Contini-Bonacossi. The count had a passion for the art of the Italian Renaissance that he managed to communicate to Sam Kress. The Count not only collected but, as luck would have it, bought

and sold pictures, too. He bought them and sold them to Kress. He convinced Kress that it was no use trying to buy just masterpieces by masters. What Kress ought to do is evolve a sort of stamp collection representing all the schools and phases of the Italian Renaissance by buying the works of obscure but available painters, most of whom the Count just happened to have in stock. This ambition was achieved in a remarkably short time, and the Kress collection came to resemble in plan and material the similarly instructive ones of Jarves and Bryan. True, it did contain some terrible pictures; but it had plenty of beauties, too.

Kress managed to acquire masterpieces in spite of himself. He kept them in his New York apartment at 1020 Fifth Avenue and nobody seemed to know about it. Finley had never seen this cache, though he'd met the modest Mr. Kress on a steamer. Kress did mention that he had "a few pictures," but Finley only stumbled on the treasure by way of mutual friends who told Finley he better hurry on up to New York before Kress decided exactly what he wanted to do with his pictures. There were advanced plans for a special museum in New York, complete with architectural projects. Finley went up to Kress's apartment, talked to him for seven hours, and got the collection for the new Gallery.

There were the usual difficulties. As Finley puts it, "at first Mr. Kress had expressed a wish that his collection be shown as a unit" and there followed that tussle most dreadful to all museum directors. Mellon had very specifically instructed that no such segregation be permitted in his Gallery. It was here no doubt that Finley's legal acuity came in handy. In the cases of the Kress, the Widener and the Dale collections, a solution to the dilemma was found. Though the whole collections could not and would not be kept together, special rooms could and would be devoted to certain groups of pictures placed in proper chronological order, next to similar rooms from other collections, but still identifiable as Kress or Widener or Dale rooms. There were more than enough superlative early Renaissance pictures to make up a whole suite of such Kress rooms. At least a score of the more than thirty galleries devoted to Italian painting and sculpture are still in effect Kress rooms. In fact a few of them (rooms eighteen through twenty-one, for instance) are definitely labeled as such by chaste carvings over the doors — an accolade not given to any other donor to the Gallery, even Widener, much less to Andrew Mellon.

Finley not only got the Kress collection, but he got Kress. Along with Otto Eggers, who succeeded Pope as architect in charge, Finley worked out special rooms to hold Kress and Widener works so that unlike some museums where the building came first and the paintings had to be fitted in, the works and their donors had a strong influence on the

design of the galleries planned to contain their donations. Kress was so pleased and excited by the whole idea of the Gallery that he devoted the rest of his active life to it. He was President of the Board of Trustees for a decade from 1945 to 1955, set up a foundation to continue buying works of art, and extended his interest to include purchases for the Gallery in French seventeenth- and eighteenth-century areas. When not long after all this Samuel became almost totally paralyzed, his hitherto uninterested brother Rush Kress joined in and in his turn bought and donated. In fact, Rush became an even more knowledgeable and enthusiastic collector than Samuel. There is hardly a period or nationality, except the nineteenth century, in which Kress beneficences aren't overwhelmingly represented on the walls of the Gallery, and the name Kress appears on accession cards more frequently than any other.

Having made their fortune in chain stores, the idea of applying the same technique to art seemed to occur naturally to the brothers. Many of the earlier donations to the Gallery, acquired under the tutelage of the Count, were turned back to the Kress Foundation when it substituted better examples. The original collection when it first went on display revealed the rather consoling fact that there were as many bad painters in Italy during the Renaissance as there have been anywhere else. This consolation is now lost to us and nothing but the best hangs in the Kress rooms. But instead of storing all these rejects or just selling them, the Kress Foundation had the brilliant idea of donating whole collections to other less fortunate museums all across the country. Over a score of such lucky places (Seattle, Portland, Raleigh, Houston, Columbia, Atlanta, Birmingham, Memphis, Denver, Miami, Tulsa, Allentown, and others) boast Kress rooms, glowing with European art from 1300 to 1800 with a strong emphasis on Italian early Renaissance. Southern museums have been particularly favored, notably the state museum in Raleigh, North Carolina — a reminder of the Kress brothers' early success with their stores throughout the South. In place of five-, ten-, and twenty-five-cent stores we now have five-, ten-, and twenty-five-thousand-dollar pictures, and the same happy principle has been applied to repay communities for their commercial support. There has been enough of this surplus to spill over into college and university museums, too. The whole country is beautifully filled with Kress chain-store art.

iv

The Widener Collection, which was not on view at the opening in 1941, was something quite different from the Kress collection. It was, for one thing, no secret. It was famous over two continents as the

grandest collection in American private hands. It was hung in the grandest private house. The Mellon and Frick collections were still obscure when Peter A. B. Widener died in 1915, leaving his house, "Lynnewood Hall," to his son and his collection of great dark Old Masters to his son's care and disposition. He did not convey personal ownership. The collection could be sold or it could eventually be given to a museum in one of three places: New York, Philadelphia, or Washington. The inclusion of Washington on this list, where as of 1915 there was no fit repository for a collection of this magnitude, shows that Widener was thinking along the lines of some sort of future national gallery.

The Widener story as a whole can only be told in its specifically Philadelphia context. The essence of the problem as of the 1930s was that though the Philadelphia Museum desperately wanted the Widener Collection, Philadelphia would not take Joseph Widener, Peter's son, with it. Though elected to every board, Joseph was still not included in such ultimately celestial social rewards as the Philadelphia Club and the Assemblies. On one shoulder Joseph sported the epaulettes of riches, civic honor, and boardsmanship. On the other he sported a great big social chip. Nevertheless, he knew that Director Kimball and his new Museum and the whole city expected his collection and needed it desperately if the Museum was to be the truly first-class place it ought to be. Widener dillied and dallied; he would and he wouldn't. If the National Gallery had not come into being just exactly when it did, Philadelphia might have had the Widener Collection.

The persuasive Finley got to Widener at last. There was the usual battle. Widener insisted the collection not only be kept together but associated with all the priceless furniture and decor with which it had been surrounded in "Lynnewood Hall." But Finley managed to wheedle Widener into accepting the compromise of "special rooms" for special paintings and a whole basement especially planned to hold the Widener tapestries and furniture — the only decorative art the National Gallery contains.

But there was still one hurdle to be overcome. Peter Widener in his will had specified that the Wideners were not to pay any taxes involved in a gift or bequest. Pennsylvania had a five percent tax on the assessed valuation of all such gifts. In an effort to get the collection for Philadelphia, Kimball and influential Philadelphia friends had the law amended so that only gifts going outside the state would be so taxed. Finley and influential Pittsburgh friends tried to have the exemption extended to any federally sponsored institution, like the Smithsonian, let us say. Kimball succeeded; Finley failed.

But higher powers intervened. The President influenced Congress to agree to pay the Pennsylvania tax no matter what it might turn out to

be. Luckily the collection was valued by Depression standards and the government had to pay "only" some three hundred thousand dollars. Philadelphia lost the Widener Collection; Washington got it and part of it was installed and put on view in December of 1942. Widener inspected it from a wheelchair; he died in 1943, and the remainder of the collection left "Lynnewood Hall" for the Gallery. Like Morgan and Mellon, Widener never had a chance to see all his treasures on public display; a curiously recurrent fatality.

Chester Dale belonged to a younger and different generation of collectors. Aggressive, tough, vital, emancipated, a friend of artists and a business partner of his own French art dealer, this Wolf of Wall Street foreshadows the modern chromium-plated style of Norton Simon rather than harking back to the heavier style of a Morgan or a Widener. He differed from all these other tycoons by being actually born in New York, making his fortune there as banker and dealer in public utility securities, and then, ironically, leaving his collection outside of New York. In the 1920s he and his artist wife Maud made a tremendous reputation as brave pioneer collectors of advanced French art; only moderately advanced since they stopped short of Cubism. They kept their collection at first in various New York residences, then farmed it out to several different museums — the Chicago Art Institute, the Philadelphia Museum, and the National Gallery. The various directors hung about like a circle of buzzards waiting for "final distribution." Dale succeeded the ailing Kress as President of the five-man board of trustees of the National Gallery (1955–1962), and when he died in 1962 the Gallery not only got all the loans already made to it but everything else from Chicago and Philadelphia. Pennsylvania was once more a loser.

Lessing Rosenwald's gift also bereaved Chicago and Philadelphia. Born to the purple of Sears, Roebuck in Chicago and to the fringes of "Our Crowd," Rosenwald moved to Philadelphia in 1920 to take over the Philadelphia branch of Sears. He rapidly established himself as a city father, was patron of every Jewish good work, and was one of the most cultivated and beloved of its book and art collectors. He went to Washington to work during the war and once again Finley got his man. Though in fact the Rosenwald graphics have been kept in the specially constructed housing in Jenkintown outside of Philadelphia where Rosenwald lives, they are the property of the National Gallery and the Gallery's Curator of Prints takes care of them there. But some of the more than twenty thousand woodcuts, engravings, etchings, mezzotints, and lithographs have been on exhibit at their new home in Washington since the first gifts in 1943.

As the only living member of the Great Five, Rosenwald, the benign sage of "Alverthorpe" (the name of this Jenkintown estate), continues

to refine and add to what has become one of the world's richest individual — and now national — collections of the sort, rivaled in America only by the similar collections of the Morgan Library, the Fogg, or the Huntington Library in California. But there once again as in the other cases of the Gallery's Big Five — Pennsylvania's loss, the nation's gain.

<div align="center">*v*</div>

After the pattern set by William Corcoran, two other rich men, Charles Freer (1856–1919) and Duncan Phillips (1886–1966), set up two very different and very personal museums in the capital during the twentieth century.

Despite the great difference in generation between the two men, the two museums are almost contemporaneous as public institutions. Freer was born poor in the mid-nineteenth century in the mid-Hudson River Valley. He made his fortune building railroad cars in Detroit. A more unlikely Detroit railroad car manufacturer never lived; and in fact it was financial figures rather than actual manufacturing that concerned him. Like Rockefeller and Frick, Freer was a born bookkeeper. He was also a born esthete, a bachelor who built up around himself, especially after his early retirement from railroad cars, a world of almost paralyzing refinement — one flower in one vase, screens to prevent the smells of cooking from intruding into the dining room, works of Oriental art not on display but brought out one by one for discreet inspection by worthy connoisseurs. This Silk-stocking world, with its understatement, avoidance of everything blatant (and vital), its formal grace and muted sensibility, was the background for Freer's collection of Oriental riches and those American painters beginning with Whistler who shared his predispositions. Freer ended up with what was probably the largest and choicest private collection in America of both Oriental art and of work by Whistler. Freer managed to buy the controversial Peacock Room that Whistler had created for an English magnate while that magnate was out of town. When the patron came back and saw what Whistler had done to his dining room he refused to pay half of Whistler's fee. Whistler took revenge by painting his patron into the room's decor as a proud peacock clutching at gold coins. The original English decorator of the room in its pre-Whistler form took one look and actually went crazy, dying shortly thereafter in a lunatic asylum.

The room was placed in a special building back of Freer's Detroit house. To this Queen Anne shingled mansion, still extant, Freer brought back from increasingly long and adventurous trips to the

Orient a collection rivaling that of the Boston Museum. His guide through this delicately tricky world, so full of chicanery and forgery, was one of the original begetters of the Boston collection, Ernest Fenollosa.

It was pretty obvious that Freer was not going to give or leave his collection to the then rundown Detroit Museum in its old "waterworks" building. The standard of Oriental art set by Stearns's papier-mâché Japanese wrestlers could hardly be expected to appeal to the fastidious Freer. In 1904 he offered his collection to the Smithsonian with various restrictions. He would keep the collection during his lifetime and would provide money for a building and endowment afterward. The building, unlike Mellon's gallery, would bear his name. Like Mellon's gallery it would be maintained by the government. Though the Smithsonian had its so-called "National Gallery" and was receiving gifts of art for it at this time, the idea had been to build up a collection of largely American art, not to be responsible for an entirely separate one of Oriental art. The Smithsonian backed and filled until the personal intervention of Theodore Roosevelt "forced" the Smithsonian to accept the Freer gift as of 1906. It was rather like John Quincy Adams "forcing" Congress to accept the original Smithson bequest or cousin Franklin inducing Congress to pay the Pennsylvania state tax on the Widener gift.

Fenollosa helped Freer to refine and augment the collection with the object of making it worthy of the nation — and a rival of Boston — and Freer was brokenhearted when Fenollosa suddenly died in 1908. It was Freer who paid to have the ashes of his friend and advisor installed on the grounds of a temple on Lake Biwa. Freer persisted on his own until his health and his mind began to fail at the time of that World War I which so effectively destroyed the precious world in which Freer had tried to live. He died in 1919 along with Frick and Carnegie.

There doesn't seem to have been any connection between the elegant Freer and the grandiose Frick; but there is a sort of likeness between the museums they personally founded — rich, refined, rather impersonal in effect. Freer's museum opened in 1923. The collection is much too large to be seen all at once in the rather small Neo-Renaissance palazzo that now bears his name. Rather, as in his own house, the collection is brought out not object by object but section by section to be viewed by those worthy of appreciating it. The Peacock Room is installed permanently, but the other Whistlers and the fragile American paintings, such as those of Dwight Tryon of Smith College or Boston's own Abbott Thayer, make evanescent appearances now and then when the galleries aren't all being used for Oriental things. Thomas Dewing, that member of the Ten who devoted his talent to

portraying almost moribund ladies of exhausted gentility languishing in a stupor of refinement in airless chambers or suffocated summer gardens, best typifies the Silk-stocking world of that first fine flower of old, preautomobile Detroit, Charles Lang Freer.

It is a shame that the increasingly desirable American art should be shut up by law in that increasingly inhospitable museum of Oriental art. Surely lawyers can figure out some way to pry it loose and have it on permanent exhibit in the new National Collection museum where it properly belongs. After all, it's part of the Smithsonian too. Meanwhile America's best and largest collection of Whistler just doesn't get seen in public very often, much less the Tryons and the Dewings.

vi

Duncan Phillips was a more robust and less fin de siècle person than Freer. He represented the world of the twenties and its liberating freedoms. He was born in Pittsburgh. His mother was a Laughlin, of that same terrifyingly energetic Scotch and Scotch-Irish immigration as Carnegie and the Pitcairns that made Pittsburgh America's industrial center. The Jones and Laughlin steel company was one of those that managed to escape the monopolizing grasp of Carnegie.

When Phillips was a boy the family moved to Washington. He went to Yale and had his eyes opened to the new art of both America and France, so different from the dark canvases of the Hudson River School and the French Salon artists he had lived with as a child in his Laughlin grandparents' house in Pittsburgh. He was rather at loose ends after his graduation in 1908 until World War I, when the sudden death of both his father and beloved brother crystallized his determination to memorialize them by creating a collection and a gallery in their memory. His 1921 marriage to Marjorie Acker, a niece of the well-known artist Gifford Beal, gave him a worthy partner in this commemorative life work.

Marjorie Phillips, herself a practicing artist, joined her talents and tastes with those of her husband. The result, first during the long years of their work together and then with Marjorie Phillips carrying on alone after Duncan's death in 1966, is one of the most personal of all America's art museums.

The Phillips collection is varied but concentrates on the artists the Phillipses really loved — Daumier and El Greco, Braque and Bonnard, Marin and Hartley. The collection mixes old and new, American and European, in a way that is informal and intimate and yet comprehensive over the period between 1870 and 1970. What some consider the greatest of Impressionist paintings, the big Renoir *Luncheon of the*

Boating Party, shares the glory of the house with Eakins's searching and melancholy *Miss Van Buren* and a chapellike chamber of glowing Rothkos.

A book of reminiscences by Marjorie Phillips gives a vivid impression of how this engaging couple went about their lifelong task of museum building. It is full of glimpses of the artists they met — Matisse, Dufy, Bonnard — most of whom they admired and liked. That other Pittsburgh native, Gertrude Stein, did not, however, make a good impression. Dismissing the pictures in the gallery by saying she'd seen these artists before, she began her lecture there with "When in a picture gallery what I look for is a bench, is a bench, is a bench." In comparison with the grandeurs of Mr. Mellon's gallery, the austerities of Mr. Freer's, and the somewhat frusty antiquities of Mr. Corcoran's, the Phillips Collection is refreshingly alive, alive above all with the charming personal imprint of the couple themselves. The dark roots of Pittsburgh have never produced a more colorful and fragrant blossom.

Later additions to the Washington scene, the *raffiné* Bliss donation of Dumbarton Oaks, which belongs to Harvard and displays precious bits and pieces of Byzantine and Pre-Columbian art in a jewel-box of a gallery set in a magnificent Renaissance garden; the exciting museum of African art in the Capitol Hill section house of black intellectual Frederick Douglass; and now that triumphant and flamboyant three-ring-circus Chutzpah Palace on the Mall, the Hirshhorn Collection, with its stirring prodigality of brand-new excitements — all this has helped make Washington the second art city of America, next to New York. How different it all is from 1876.

Washington, however, still lacks that Boston "bottom" — any adequate collection of archaeological art from Egypt, the Near East, or Classic antiquity. Until this vacuum is filled, the city can't hope to be a complete rival as a museum center to Boston, New York, Philadelphia, Baltimore, or Chicago, much less London or Paris. Surely some great millionaire could be induced to remedy this one defect in Washington's otherwise superlative panorama of the visual arts.

Chapter IV

i

MEANWHILE IN PHILADELPHIA a renaissance was taking place that transformed the Pennsylvania-Museum-and-School-of-Industrial-Arts into the Philadelphia Museum of Art, one of the largest and most beautiful — and most frustrated — of American art museums. This renaissance was basically the achievement of two men. One was an Old Philadelphian boardsman named Eli Kirk Price. The other was a very non–Old Philadelphian museum director named Sidney Fiske Kimball.

Price was not much interested in art, but he was terribly interested in the beautification of Philadelphia. He was a member of every esthetic board in town, the art museum, the PAFA, the University Museum. His real passion was Fairmount Park, of which he was an august Commissioner. His grandfather of the same name had been one of the principal creators of the Park, largest of in-city American pleasances, and Eli was determined to complete the design of the Park by a daring plan, originally thought up by one of the city's more farsighted Mayors, to link the park to the very center of the city by a magnificent boulevard (now existent and known as the Benjamin Franklin Parkway). Though Fair-

mount Park at the turn of the century was close to the city, lying as it still does between the built-up urban brick rowhouses of North and West Philadelphia and the suburbs of the Main Line and Chestnut Hill, it was not easily acccessible. From the city one had to zigzag through a pattern of gridiron streets to reach the entrance to its hills and dales, liberally sprinkled with statues put there by the Park Commissioners. To end this difficulty a swathe was to be cut through diagonally from the very hub of Philadelphia at City Hall, just completed by the turn of the century with its gigantic tower crowned by a statue of William Penn (hoisted into place in 1894), out towards a rocky hill, then occupied by the reservoir of the waterworks, one of the very first such in America.

The boulevard, planned by French-American architect Jacques Gréber, was to be a typically Parisian grand gesture, a double-laned tree-lined Champs-Élysées interrupted in the middle by one of William Penn's original "squares" or small parks, named after Penn's secretary and Philadelphia's first man of science, James Logan. It had an awe-inspiring enough beginning in the craggily monstrous City Hall, but it needed some suitable climax at the other end. Price determined that a new art museum, a new Parthenon on its Acropolis, was to sit on top of the rocks in place of the reservoir, dominating the long French vista and suitably marking the entrance into his park. The esplanade was to be flanked by Neoclassic institutions as in Washington. It would strongly resemble Mr. Mellon's triangle of Roman Government buildings on the Mall.

Price may not have been a true art lover but he was a consummate boardsman. Though he seldom permitted himself to be president of anything, he knew just how to handle things behind the scenes, cajoling or coercing board presidents, city politicians, potential donors, and architects, who make up the personnel required for a civic effort of this magnitude. With quiet, modest, bewhiskered arrogance based on impregnable social and financial position, he told everyone in Philadelphia what to do, and they did it. When a bus stop was put right in front of one of his clubs, he told the police to move it and they moved it. When the city fathers balked at the expense of the boulevard and the new museum, he told them to appropriate millions and they did it. When the presidents of the city's other art institutions, the PAFA and the University Museum, showed signs of restiveness at the grandiose threat of this new museum, he told them to shut up and keep out of it, and they did. In order to ensure that the immense Parthenon he had in mind would be completed, his hand-picked architects (the firm of Zantzinger and Borie joined by Horace Trumbauer, who had built "Lynnewood Hall," Widener Library, and so many other great edifices) were instructed to see to it that first the entire foundation and ground

floor would be built, then the two-storied side wings. Price knew the city fathers would have to finish his museum; they would never have the gall to leave a building incomplete with two high ends and a low middle.

Having secured his boulevard and his climax-of-the-vista, the Museum, it was of course necessary to have something inside it and somebody who could fill it and run it. Before it was finished, somebody was found. This was Fiske Kimball.

Kimball, who dropped the Sidney early in life, was born in 1888 of modest parents in suburban Boston. He was trained at Harvard more as an architect and historian of architecture than as an artist or art historian, and this architectural bias had a determining influence on the evolution of the new Philadelphia Museum. He and his wife Marie were both deeply involved in research on Thomas Jefferson as architect. After graduating from Harvard in 1909 (M.A. in Architecture, 1912), teaching in the Midwest, and working on Neoclassic American architecture, he moved to the University of Virginia as first Chairman of a new School for Architecture. From there he went in 1923 to New York University to organize the expansion of its Department of Fine Arts.

In 1924 Kimball was just settling down to his job and exploring and enjoying the delights of theatrical New York when he was offered the Philadelphia job by John D. McIlhenny, President of the board of the Art Museum. Reluctant to leave New York and obligated to his new employers, he hesitated and finally declined. But the offer was made again in 1925 and this time Kimball accepted.

ii

Kimball was seemingly a most inappropriate man for the job in Philadelphia. Ebullient, loud, fond of raucous dirty stories and ill-considered remarks, enamored of New York chic and sophistication, he was everything Philadelphians least admire. He had no "family"; he was awkward in gesture, homely in face and inclined to drink and eat too much. He was almost a genius of tactlessness, and he was not a true scholar of art. It was his boyish enthusiasm and driving energy that appealed to boardsmen Price and McIlhenny and his very awkwardness and tactlessness intrigued people who were too used to the cautious and subservient approach of those who wanted money or social approval. Other museum directors were ruefully amazed that Fiske could get more out of patrons by insulting them than they could by years of discreet flattery.

In his exuberance Kimball had a way of breaking things. At his first dinner at the McIlhenny house in 1925 he broke one of his host's

priceless Hepplewhite chairs. Ladies were offended by his "unneces-sary" stories. Despite all this, or perhaps just because of it, he became a social lion, a sort of engaging bad boy of the arts who was permitted extravagances of conduct that no native Philadelphian of the time would have been allowed unless his ancestors and position were im-pregnable indeed.

Kimball needed all the help he could get. The old Museum, still in Memorial Hall, had not been able to make up its mind whether it was to be essentially a collection of industrial and decorative arts — a Vic-toria and Albert — or a gallery of fine arts. The Director at the time Kimball was appointed had been Langdon Warner, a famous oriental-ist. He liked his job because it permitted him to spend most of his time in China while he turned over the running of the Museum to his assistant, Samuel Woodhouse. Woodhouse was frank in his intention to make the Museum a center for design, not paintings; and in fact the only real collection of painting the Museum had was still the Wilstach.

Meanwhile here was a huge new building going up, very specifically intended to be an *art* museum. The Wilstach Collection, increasingly old-fashioned, would never be adequate as a proper collection for the new headquarters, much less the casts and views of Pompeii and the masses of lace, ironwork, and pottery still in Memorial Hall.

But there *were* three great private collections in Philadelphia: the Johnson, the Widener, and the Barnes. If Kimball could get all three, his problems would be solved, at least as far as the area of European painting was concerned. The Museum would, with all three collections in it, become a rival for the Metropolitan. The Johnson Collection covered the spectrum from Renaissance to modern, but was richest in early Italian and Flemish painting. The Widener, with its Italian mas-ters of the High Renaissance and its Rembrandts and Vandykes, would cover the sixteenth and seventeenth centuries as well as the English eighteenth; and the Barnes, with its masses of Renoirs, Cézannes, and Matisses, would represent the Modern School of Paris. If only these three could be brought together along with the best of the Wilstach and some nice things from other prospective donors! But in all three cases Kimball was faced by very difficult and peculiar problems.

iii

In the case of the Johnson Collection the problem was legal, not personal. Johnson had died in 1917 before Kimball came. It was John-son's will, not his character, that made things difficult. In the case of the other two prospects it was most certainly character, not the law, that made for trouble.

All three founders of all three collections, Peter A. B. Widener (1834–1915), John Graver Johnson (1841–1917), and Albert Coombs Barnes (1872–1951), had been self-made men. All were born in the Philadelphia area. All were graduates of that special Philadelphia hothouse of talent, the Central High School, alma mater of Thomas Eakins, Sloan, Glackens and innumerable other poor bright boys who made their way not only into the arts but medicine, finance, security and success.

Johnson was the son of a not particularly adroit blacksmith in suburban Chestnut Hill. He went into law after graduation from school, interrupted by a brief service in the Civil War. He soon became an expert on corporation law, estates, property, mergers — the whole area of legal entanglements surrounding the careers of the new millionaires. Between the Civil War and the First World War he built up a reputation as perhaps the greatest corporate lawyer in America. Sometimes, as in the Northern Securities antitrust case of 1902–1904, he lost. More often, as in the antitrust suit against United States Steel in 1911, he won. When Frick and Carnegie feuded, it was a toss-up as to which man would get to Johnson first. Frick did. Frick won. Ruthlessly honest, a brutal but not devious opponent in court, Johnson became the legal equivalent and preeminent advisor of the Titans, especially Morgan. The Muckrakers seemed to avoid him, perhaps because he was so obviously not a crook.

Johnson married a widow of reduced financial but high social position who brought along three children by a first marriage and an involvement in society and good works. She was by birth a Powel. An ancestor had built the beautiful eighteenth-century Powel house on Third Street, now preserved as one of the sights of Society Hill. Two of its chaste rooms are in museums, one at the Met in New York, one at the Philadelphia Museum. Johnson loved his wife and his stepchildren but refused to have anything to do with society or good works. The family lived together in a big ugly house on South Broad Street, not a particularly good address. There Mrs. Johnson entertained her friends in the parlor while Johnson worked in his study. Aside from a jovial family dinner hour in the evening (Johnson, unlike Rockefeller, was very fond of good food and drink) and then an hour spent with his paintings, his life was totally devoted to his profession. He was interested only in law, family, art, and an occasional poker game with cronies.

Johnson's education in art was gradual but painful. In 1892 he published as a slim volume a series of articles written for a Philadelphia paper describing a museum tour in Germany and Holland. In the course of his travelogue he says, "Art gives us real delight only . . . from what is really worthy. Whilst in the stage of development our opinions

are in a course of such incessant change that we are more worried than gratified." His disenchantment with the "pompiers" was manifested by remarks such as ". . . one of Bouguereau's waxworks . . . stories by Meyer von Bremen stale with repetition." Of a private Dutch collection, "Concerning the Koekoeks, Roeleofs and Achenbachs . . . silence is charity." "Flowers by Preyer, unlike any on which the sun ever shone; sheep by Verboeckhoven, which might have been manufactured in a porcelain factory."

Though affluent enough, Johnson was by no means in the same league with Frick or Widener. He shunned dealers like Duveen and Knoedler and bought for himself, acquiring not the big black masterpieces but the smaller jewels of Italian and Flemish "Primitive" painting ignored by the Titans. By the end of his life his house was so cluttered he had to buy the house next door for the overflow. This in time also became unlivably crowded. Visitors interested in art would be treated to somewhat the same kind of show that entertained the guests of Charles Freer in Detroit; but disorder and casualness rather than oriental elegance were characteristic. "Go up and get the Botticelli leaning against the bathtub," Johnson would tell a servant, and the Botticelli would be brought down and placed on a chair for contemplation and discussion. Artist George Biddle recollects exploring the house to discover "Two Chardins in his boot closet, many examples of the Barbizon School in his bathroom; and Sargents, Manets and French Impressionists in the corridors of the servants' stairway."

Tall, rangy, mustached and lowering like a buffalo, Johnson was totally without the "forensic eloquence" expected of the nineteenth-century lawyer. So was he also totally without the yearning for magnificence characteristic of a Morgan or a Frick. Art was an absorbing avocation, not a part of personal panoply. But when he died, already a widower, instead of leaving his collection to the then Pennsylvania Museum, he created a dreadful legal tangle. The Johnson Collection was left not to the jurisdiction of the Fairmount Park Commission but directly to the City of Philadelphia. It was to be kept in his cluttered rundown house on South Broad Street. "The art objects shall not be removed . . . unless some extraordinary situation shall arise," in which case they could be placed somewhere central in the city or in Fairmount Park available to the public. The will had been corrected and revised till it was a mass of confusion. It was hardly the masterpiece of the world's greatest corporate lawyer.

The city was directed by the Johnson will to pay the state tax — some five hundred thousand dollars. Then the city didn't know what to do with the pictures. They were locked up in the Johnson house for years and allowed to gather dust. When Kimball came on the scene they had as of 1922 been made partially visible there, though the house

was flagrantly unsuited to the purpose, being too small, ill lit, badly planned, shabby, and a fire trap.

The question remains as to why Johnson didn't leave his pictures either to the Museum or to the Wilstach Collection. Obviously he didn't think enough of either of them to trust his treasures to them. There seems to be no evidence that he ever expressed himself on the subject. Unlike Mr. Wilstach, he would never have been in the position of being snubbed by a boardsman. Johnson was unsnubbable, wouldn't have given a damn, and in any case was accepted with open arms by the Establishment of which he was the chief defender. But when Kimball came to the Museum in 1925 the Johnson collection was *not* in it.

iv

The Widener Collection was in grandiose "Lynnewood Hall." Peter Widener, who created the collection, was not a blacksmith but a butcher. His father was a freighter and a brickmaker of the same Pennsylvanian German background as Frick and Kress. Widener went from Central High not into law or art but into meat. He began at the chopping block. Then a contract to supply mutton for Civil War troops started him off financially and he used his capital to buy into street railways along with his friend and partner, William L. Elkins.

People in the age of the automobile tend to forget how circumscribed the life of urban working people could be before the Civil War. They could take trains to other cities, but within their own city limits they could only go as far as their feet would take them. Country people had horses and wagons, rich people had carriages or could afford cabs. Poor city folk walked until the rather late advent of the horse-drawn conveyances enabled workers to hold jobs at a distance from home. From 1870 on especially, the development of urban public transportation was as lucrative a source of gold as California mines.

There emerged a whole group of Trolley Car Kings, multimillionaires and monopolists only somewhat less ruthless, notorious, and rich than the Big Five. Widener and Elkins in Philadelphia, Yerkes in Philadelphia and Chicago, and Ryan and Whitney in New York took over the business of public transport in their respective cities and made a killing. The extent to which they practiced bribery and corruption varied somewhat between the comparatively straightforward Widener and the totally dishonest Yerkes; but none of them was irreproachable.

Johnson was the lawyer for the Widener and Elkins transactions. What began as a business relationship developed into friendship. Johnson was evidently the first one to become interested in art. Widener followed, then Elkins. An Elkins daughter married a Widener son, and

their son, Harry Elkins Widener, a precocious book collector, was drowned on the *Titanic*. His parents erected the enormous Trumbauer-designed Widener Library at Harvard University as his memorial. The three pals, Johnson, Widener and Elkins, played poker together and then argued about art. Widener was all for great masterpieces by great masters. Elkins had tastes equally conventional but more subdued; his collection, which leaned toward the English eighteenth century, ended up in the Museum. Johnson preferred the unexpected and unexplored.

Charles Tyson Yerkes (1837–1905), another graduate of Central High, began his career as a broker. He got into trouble in Philadelphia first by embezzling city money and going to jail and then by a sexual imbroglio. He was divorced in an age when one didn't divorce. Then he remarried and fled to Chicago. With the financial backing of Widener and Elkins, he monopolized traction there. His methods were so flagrantly corrupt that even Chicago became too hot for him. He sold out to Widener and Elkins and took refuge in London, where his efforts to take over transportation failed and he died. His grandiose but dubious art collection had to be sold at auction. Most bought the big pictures with the big names and doubtful attributions. Johnson bought something obscure but genuine. Yerkes is supposed to be Theodore Dreiser's original model in his fictional accounts of unscrupulous turn-of-the-century magnates.

Thomas Fortune Ryan (1851–1928) was equally unscrupulous but more successful. He stayed out of jail and monopolized the transportation of New York City, much to its detriment and his profit. He was helped by Widener and Whitney. He gave great sums to Catholic charities and collected rich objects, but evidently not pictures. William Collins Whitney (1841–1904), scion of a distinguished New England family, started as a reforming lawyer and politician. He helped break up the Tweed Ring and went on to become an outstanding Democratic Secretary of the Navy under Cleveland. He married the sister of his Yale classmate Oliver Payne, Standard Oil partner, and used his own and his wife's millions to join Ryan and Widener in their joyous looting of the New York subways. He died before Ryan and the later revelations of malfeasance, so just how corrupt Whitney was is still a matter of interpretation. His son, Harry Payne Whitney, married sculptress and heiress Gertrude Vanderbilt, the founder of the Whitney Museum, so that his name and fortune, if not his personal interest, have influenced the world of American museums. He himself seemed to collect houses rather than pictures. He left ten residences scattered about the country when he died.

Widener, Elkins and lawyer Johnson stayed in Philadelphia and piled up art. Widener originally built himself a mansion on North Broad Street, an address even more socially impossible than Johnson's

South Broad Street. Nobody lived on North Broad Street. Old Widener didn't give any more of a damn than Johnson, but he did want a fit place for his art, so eventually he moved to the suburbs like everybody else and built "Lynnewood Hall" northwest of town in an area called Elkins Park. Widener and Elkins had made an extra killing developing real estate out that way at the end of their trolley lines. Widener moved all his family and all his pictures into his Trumbauer-built palace.

Peter Widener had also died before Kimball came to Philadelphia, and the custodian, but not the owner, of the collection was son Joseph, who had inherited the responsibility after his much more popular and aimiable if less esthetically acute older brother George died on the *Titanic* along with his nephew Harry. Unlike father Peter, Joseph did give a damn about such things as good addresses and social acceptance. As heir to the richest man in Philadelphia, living in the city's most magnificent mansion and surrounded by the greatest art collection then in private hands in America, Joseph expected to be treated like a prince; to be treated in Philadelphia the way Morgan was treated in New York.

But there was a difference. Joseph Widener was no Titan of Finance. His personality was rigid and autocratic but essentially rather feeble. He totally lacked the charismatic charm of a Carnegie, the almost baleful dynamism of a Frick, or the awe-inspiring forcefulness of a Morgan. And then he lived in Philadelphia, where millionaires are expected to toe the mark. Despite a well-born wife whom everyone liked, Joseph suffered the penalties of being arrogant without being affable — or clubbable. His brother George had been accepted; his nephew George was accepted. Joseph wasn't.

Fiske Kimball did his damnedest. He had the advantage of not being Philadelphian and hence not being potentially guilty of disparaging Widener. Kimball respected Widener's real devotion to art and knowledge of it. It was Joseph who refined his father's rich but uneven collection and who transformed "Lynnewood Hall" from its original somewhat tasteless opulence into a museum of choice furniture and decoration. Joseph Widener was a successor to Johnson as Fairmount Park Commissioner responsible for the Wilstach Collection. He spent Wilstach money well but never once gave the Museum a cent of his own. Though Kimball hinted that he had arranged special new rooms in his Museum just to hold Widener paintings, Widener never lent, much less gave, a single one to the Museum.

When the Johnson Collection came to the city, and it was forced to pay the big state tax on it, the then Mayor, a very different sort from the planner of the Parkway, said to Widener with consummate tact, "I hope no one else will leave the city any more truck of that sort."

Widener remembered. Just the same, what was he to do with his

truck? Nobody else in the family wanted to live with it in "Lynnewood Hall." The only part of the house the children could stand was the cellar, a wonderful place for roller skating. True, the house was a gorgeous setting for elaborate parties, but in between it was a stately and breathless morgue haunted by footmen where nobody dared sneeze for fear of breaking something. He could of course sell the collection, which is no doubt what his heirs planned to do. If the Mellon gallery hadn't come along just exactly when it did, Joseph might have had to turn it over to Fiske Kimball. Despite the battle over the tax in the Pennsylvania legislature, which Kimball won and Finley lost, and despite all Kimball's promises to keep the collection together and intact with its decor, Washington won. Revenge triumphed over local patriotism, and Philadelphia was made to pay and pay and pay for those snubs.

v

As for the Barnes collection, there could never have been any serious thought of the Museum getting it; but Kimball tried.

Barnes was also a self-made man, also a graduate of Central High (1889). Though he liked to exaggerate the poverty and tribulations of his childhood for public effect, nonetheless as the son of a one-armed Civil War veteran living in humble neighborhoods in North and South Philadelphia, he was certainly not richly born. His father had worked in the same slaughterhouse as P. A. B. Widener; that was the end of the connection. Son Albert was brilliant and made his way through the University of Pennsylvania Medical School. Like George Bellows, he helped support himself playing semipro baseball. He studied briefly in Germany and returned with a secret formula for an antiseptic that he manufactured and marketed from 1903 on under the name of Argyrol. Argyrol was a solution of silver nitrate, rusty brown in color, that seared the nose and throat in a satisfactorily therapeutic manner and sold enormously until the advent of antibiotics. Barnes unloaded his holdings with perfect timing in the summer of 1929.

After he began to make money, he moved to the Main Line and had a brief fling at fox hunting, which may have given him something of the same experience of snubbing that Joseph Widener experienced. He was evidently not a very expert horseman. Then, like every other rich American of the time, he began collecting Salon art. However, the Ash Can painter William Glackens was a friend and schoolmate at Central High. Barnes renewed the friendship in 1910–1911 and was gradually converted, in the company of Glackens and his circle, to an appreciation of more advanced esthetics. In 1912 he sent Glackens to

Europe with commissions to buy some modern art. Glackens came back with a score of canvases — Renoir, Van Gogh, Degas and others — at what are now incredible bargain rates. Applying his keen scientific mind to his paintings, as Johnson had applied his legal mind, Barnes began to philosophize on art in a quite different way from Johnson. Excellence in a picture, Barnes thought, should be a matter of fact, not of theorizing. He set himself to discover what the fact was — something imbedded in the actual paint on the actual canvas, the actual organization of the vision presented. But this excellence was not, or should not be, something divorced from ordinary experience and available only to the educated few. It must be a vital and dynamic part of the real joys and aspirations of the average man.

Barnes took a course in philosophy under John Dewey at Columbia in 1917–1918 that developed into a lifelong friendship and collaboration between the art collecting medicine manufacturer and the philosopher. It was hard to know sometimes who was master and who was disciple. John Dewey dedicated his *Art as Experience* of 1934 to Barnes and gave him all credit for the esthetic theories in it. The preface so explicitly gives him this credit that it is impossible to pretend it could be mere flattery or friendliness. Dewey's book is certainly the most famous and influential product of the mind of Barnes as art critic. On the other hand, Dewey and Glackens are among the few men who retained the support and intimate affection of Barnes throughout their lives.

There were two persons imbedded in the contradiction that was Albert Barnes. One, the Inner Barnes, was the open, eager, vital, sensitive, creative lover of modern art who wanted to rid esthetics of its snobbish cant and bring the flame like Prometheus down from the Olympus of experts to the hearths and hearts of ordinary people. To this end he wrote his books, established his foundation, built his museum, and assembled his collection. Those who knew this side of him, especially his pupils and his philosopher friends, adored him.

The other, outer man, the Terrible Tempered Doctor Barnes, was the insanely touchy and vindictive tyrant who would not stand for one word of contradiction or criticism or even advice, who wrote enraged and bawdily insulting letters to innocent people daring to ask for admission to his gallery, the Barnes who fought vendettas to the death with every institution in Philadelphia, notably the PAFA, the University, and above all the Museum.

It all really began in 1923. By that time Barnes had assembled the core of his great collection, including the works of Modigliani and Soutine, artists whom Barnes claimed to have discovered almost singlehandedly. He was the first to buy both of them in any quantity. Modigliani was already dead, a tubercular pauper. Soutine was a

pauper but very much alive. When Barnes paid him some three thousand dollars for a group of pictures, he was so exhilarated that he rushed out, called a taxi, and drove down from Paris to Nice on the Riviera. He never needed to suffer financially thereafter.

Barnes gathered together his treasures, including his Soutines and works of other artists never before seen in Philadelphia, and at the invitation of two artist champions of modernism, Arthur Carles and Henry McCarter, proudly showed his darlings to his fellow Philadelphians. The reaction was shocked outrage. Critics accused everyone concerned of insanity. Barnes reacted characteristically. He bombarded his disparagers with rebuttals, writing to one female art critic that she would never amount to anything unless she had sexual relations with the iceman (in those days the symbol of door-to-door virility). He refused thereafter to have anything to do with critics or the PAFA — which after all had sponsored him. He never got over the wounds inflicted by this event, which in fact made him famous, brought young people in droves to the Academy, rallied all forward-looking art lovers in the city to the side of Barnes and Soutine, and was altogether the most veritable success of scandal possible.

Forward-looking art lovers then tried to approach him or get together with him on artistic projects. When his work *The Art in Painting* came out in 1925, R. Sturgis Ingersoll, leader of upper-class Philadelphia's esthetic avant-garde, himself a notable collector and later President of the Museum, wrote Barnes that his book "comes so close to being the only intelligent book on the subject that it should have a wide and useful scope. Your contribution to life here [in Philadelphia] is immense." A friendship developed, but after a brief honeymoon Barnes turned against Ingersoll.

Fiske Kimball had the same experience. All was well until Kimball asked Barnes for a loan of pictures for the opening of the new Museum. Barnes wrote back that he refused to act as a sideshow to the Museum's circus. From then on the Museum was the whorehouse on the Parkway, a "house of artistic and intellectual prostitution."

Barnes and his alma mater, the University of Pennsylvania, tried to work out mutual courses of art instruction; but this always meant that Barnes and his disciples would do all the instructing. The University had doubts. Barnes demanded total surrender to his one-sided plan. The alternative was a war that went on for years, though the University remained almost to the end of his life a potential beneficiary of the Foundation.

He also managed a fight with Joseph Widener. Widener had bought for the Museum — with Wilstach money, of course, not his own — a magnificent Cézanne. Kimball, in a typical bit of tactlessness, publicly praised his new Cézanne and referred to Barnes as having a smaller

picture, "a second version." This hint of condescension was enough to throw Barnes into a fury. He wrote insulting letters public and private attacking the museum's Cézanne as a no-account sketch that had been rejected by all thoughtful buyers and lambasting Widener as a dilettante ignoramus for having wasted the Museum's money on such a daub. Later the two men found themselves on the same ship to Europe. Their deck chairs were side by side, but they never spoke to each other.

Barnes's most famous quarrel and significant defeat was a tangle with the English philosopher Bertrand Russell. Russell was stranded in America during World War II without a job or prospects. Barnes, always reverential toward philosophers, adopted him, brought him to Philadelphia, and gave him a five-year contract for a series of lectures at his school. Unfortunately, Barnes couldn't stand Lady Russell, the philosopher's third wife.* When Lady Russell insisted on attending her husband's lectures and knitting there, Barnes ordered her out. Russell was furious. Barnes tried to fire him but Russell sued for breach of contract and won. Barnes finally met his match.

The slightest contradiction of the Master meant banishment from the presence. His lifelong friend Harry Hart, whom Barnes had offered to hire as a young man to edit a journal of art he had in mind, once ventured to ask, half humorously, whether maybe critics had a point when they said that Modigliani and other such artists were crazy. According to Barnes's own stories, a lot of them did sound pretty crazy. Barnes fired him. The fact that they continued to be friends is a testimony to Hart's good nature and really deep admiration for the Inner Barnes. Most people who tried to work with him and for him were fired or quit.

Barnes built his marble Renaissance gallery in the Main Line suburb of Merion where he lived, filled it with his art, turned everything over to the Foundation, of whose Barnes-picked board he remained de facto dictator, and tried to organize a school that was supposed to revolutionize not only art teaching but society as a whole. Since he never could build up a decent faculty and no one would stay with him except a few devoted female adorers, the school has never been what Barnes intended. Philadelphia however is still full of matrons who as girls went there, studied with Barnes, and remain starry-eyed. Any artist who had his own ideas fought and left. The Outer Barnes in the end destroyed the hopes and dreams of the Inner Barnes. What was left was the collection.

During Barnes's lifetime few people could get in to see it. There are

* His first wife was Alys Smith, descendant of James Logan of "Stenton," sister of Mary, Bernard Berenson's wife.

stories of his gleeful rejection of the socially and esthetically important. He refused the appeals of one dowager on the stated grounds that the last woman he'd let in the place had given him the clap. This was the general tone of Barnes's correspondence with those he wanted to offend. This kind of thing was balanced by other stories of his generosity either to the poor and humble, particularly blacks, or to those too great for him to resent or insult, like Thomas Mann or Albert Einstein. Even after his death this policy of eccentric exclusion persisted. My experience was typical. I wrote from Princeton asking for permission and never received an answer. I then wrote from Wyoming and was given a date for the following February. Ten of us arrived on that date and were allowed in from twelve to two. We skipped lunch but had the place to ourselves.

After Barnes's death a campaign was begun, initiated by one of his bitterest enemies, Walter Annenberg's *Philadelphia Inquirer*, to open the gallery to the public. As a tax-free institution, the newspaper said, the Foundation owed more to art lovers than it was giving them. In 1960 the law forced the Barnes Foundation to admit four hundred people weekly — regardless of high birth, museum connections, or frivolous attitudes. The school continues. The collection hangs exactly as it did when Barnes died. No changes are permitted. Good and not so good things jostle each other. The kind of weeding and rearrangement so badly needed can never be done without another legal battle. Barnes was killed when he went through a stop sign and met a truck in 1951 at the age of nearly eighty. Once more, as in the case of Russell, he had met his match. His collection remains his best monument; but not one picture ever was or will be in the Philadelphia Museum of Art.

vi

Meanwhile the Museum, which did not officially become the Philadelphia instead of the Pennsylvania until about 1938,* still kept its collections divided between its two headquarters. The old Memorial Hall was not finally cleaned out until 1954–1955 and the new building, which was opened with great and prolonged fanfare in 1928, remained partially unfinished until the Bicentennial compelled completion. Nevertheless, it has persisted and flourished in its own somewhat haphazard fashion. When the new building opened, it didn't have the Johnson, the Widener, or the Barnes collections in it, but it had a

* The situation is very confusing. The new building was always known as the Philadelphia Museum, but for years the corporation and board continued to be that of the Pennsylvania Museum. Finally in 1938 the "Pennsylvania" disappeared without notice and everybody and everything became "Philadelphia" from then on.

loan of seventy pictures from the Johnson; the Elkins collection, which was hung temporarily in the unfinished building to meet a legal deadline in 1925, was there, the McFadden collection, mostly English portraits, and many individual gifts from many individual donors. The Philadelphia got into business with Russia, like Mellon, and bought a magnificent Poussin from the Hermitage. The Wilstach Foundation, under the canny direction of Joseph Widener, began to develop significantly and was gradually moved from the old building into the new building, shedding Salon pictures on the way.

Above all the Museum became famous, or perhaps notorious, for its Kimball architectural bias. Room after stately room from English country houses, American Colonial mansions, and French hôtels filled the second floor. A Romanesque cloister, a Chinese and a Hindu temple, a Japanese teahouse, all served as beautiful examples of both architecture and decoration and did contain representative objects of art.

But there were problems. Since the building had been built before anyone knew what was to go into it, the exterior didn't fit the interior. Windows outside failed to match room windows inside. Rooms are beautiful but they don't hold many paintings or exhibit them always to the best advantage. Rooms take up an enormous amount of space and require a great deal of expert upkeep. They also tend to fix the pattern and design of a museum once and for all. You can move plain exhibits from gallery to gallery, but you can't move whole temples. They are extravagant, confining, hard to take care of, easily vandalized, and difficult to light. In general, they are not favored by modern museum directors; but they are beautiful and they do make a background for art and furniture of a given period that nothing else provides.

Kimball the architect, one feels, had his way over Kimball the artist. The Museum is now stuck with his bias, and internally it remains his creation, for better and for worse. It is the most monumentally charming of all American museums, visually graceful and decorative; but it is not convenient and there is lots of waste.

Outside its beauty is also monumentally charming. Nicknamed by modernists the "Greek Garage," it nonetheless remains the most graceful of America's Neoclassic museum buildings, full of subtle Greek curves in wall and pillar that relieve the heaviness so apparent in much of Washington's Mellon-Roman grandeur, filling its site magnificently, its tawny stone a pleasant relief from the usual glaring or grimy white marble of so much American museum architecture. One need only compare it to the severe dinginess of Boston or the crude magnificence of New York to see the differences. Outside the unprejudiced eye can be delighted, even if the style is out of date and the design poor for a museum. Inside every vista pleases, even if most of the art that should be there is not.

At last the Museum did get the Johnson Collection. In 1933 the trustees and the City gave up South Broad Street as hopeless. The collection moved into a series of galleries all its own on the main floor with its own guards and own finances and own curator and own board and own air-conditioning. There it has remained, despite recurrent sessions in court marked by the guilty perplexity of judges who know they are not following the wishes of the world's greatest corporate lawyer. The house on South Broad was finally torn down. The collection is in Fairmount Park and available to the public; in fact the collection forms the core and glory of the Museum, but it does not in fact belong to it, or even belong there.

Fiske Kimball directed the Museum, *his* Museum, for thirty years until 1955 when age and increasingly erratic and irascible conduct forced his resignation. He was succeeded by the curator of the Johnson Collection, Henri Marceau. There is now a third director, Evan H. Turner.

In front of a great window in the great staircase hall that looks down the great Parkway to the great City Hall used to be three small busts. Eli Kirk Price, who forced the city fathers to build both Parkway and Museum, R. Sturgis Ingersoll, President for many years and champion of modern art, and Fiske Kimball were the three. There are and were no busts of Johnson, Widener and Barnes. If the Museum had the dozen Widener Rembrandts and the hundred Barnes Renoirs, it would now be in a class with the Metropolitan or a consequently denuded National Gallery in the area of European painting. Instead it must content itself with being in a class with the dozen best Big-City Emporiums, though its chronological bias (nothing before A.D. 1000) cuts it off from competition with museums like Boston's. It has the virtues of its weaknesses. It is full of all those rooms, some of them rather empty and dusty, but all beautiful. It is full of separated collections like the Johnson, the Tyson and the Stern, which makes for confusion and repetition but also for an intimacy and individuality lacking in more ruthlessly regimented and chronological displays. It has the greatest collection of Eakins, got from his widow by Kimball, which should be at the PAFA. It is chock-full of eighteenth-century Philadelphia furniture. Like Cincinnati, unlike Cleveland, it is a museum with a strong local accent. But there remains a vacuum caused by the great art that got away.

The Museum reaches out beyond its own building. There is a small gem of a Rodin Museum on the Parkway that the Museum administers. This was created by a movie theater magnate named Jules Mastbaum who fell in love with the art of Rodin and caused Philadelphia architect Paul Cret, who also designed the "new" Detroit Museum, to place a charming French *pavillon* along the tree-lined Jacques Gréber Park-

way. The first full-sized cast of the symbolic Gates of Hell greets the visitor, and inside are all kinds of Rodin casts and sketches. The Museum also controls a whole series of fine old houses in Fairmount Park, full of furniture. Then there are other houses of the same sort, James Logan's "Stenton" out in a wilderness of rowhouses, the National Trust's "Cliveden," or the Powel house down in Society Hill, also full of furniture. There are the PAFA and the University Museum and odd caches like the Rosenbach Foundation, a beautifully furnished rare book museum in a beautifully kept old house near Rittenhouse Square; the Atwater Kent Museum full of dolls and hatboxes and other souvenirs of Old Philadelphia; a splendid new portrait museum down near Independence Hall with much of the remains of Peale's Museum in it, thus making it the oldest public display of paintings in America (unless one counts the Smibert pictures at Bowdoin) going back to Peale's studio of the 1780s. Hospitals and clubs are full of Peales, Sullys and Eakinses. The Pennsylvania Hospital has its own huge Benjamin West. The Jefferson Hospital has Eakins's *Gross Clinic.* John Wanamaker's is full of 1900 Salon paintings.

In other words, art in Philadelphia is by no means confined to Kimball's Greek Garage. But the garage remains the single best concentration of the fine arts in a city where art is especially diffused.

Chapter V

i

ONE FORM OF ART diffused all over Philadelphia is statuary. Generals on horses, virtues in scanty robes, wild animals and such are strewn hither and yon, especially in Fairmount Park. The most spectacular display is that of the Calder family. William Penn on top of City Hall and most of the sculpture below were created by Alexander Calder I (1846–1923). The handsome fountain halfway out to the Museum in the middle of the Parkway in Logan Square was created by Alexander Calder II (1870–1945). And now the museum inside and out boasts big mobiles and stabiles by Alexander Calder III (1898–1976).

Baltimore, always considered by Philadelphia as its favorite younger sister, is similarly art saturated, and so bedizened with statues that it was long familiarly known as the Monumental City. Native sculptors have abounded, though none as famous as the Calders, and it is thick with a variety of institutions either devoted to art or with art in them. Its foremost repositories are the Walters Gallery (which has finally sprouted a wing that permits the public to see more of its treasures, most of which have been buried for years in the cellar) and the Balti-

more Museum. The Peale Museum is full of Peales, the Maryland Historical Society likewise, the former Garrett Mansion, "Evergreen House," now acting as the rare book depository of Johns Hopkins University, is surely one of America's more charmingly informal house museums.

But what most art lovers come to Baltimore to see is the Cone Collection. The Cone Collection is in the Baltimore Museum and for every visitor who explores the riches of the Walters Gallery there are ten that go out to Wyman Park to see the Cone ladies' Matisses.

There surely have never been two more unlikely collectors of advanced art than Claribel and Etta Cone. Their father was a German-Jewish Forty-Eighter (actually he immigrated in 1846). He began in the hallowed Jewish tradition of door-to-door peddling through the South, established himself in Tennessee in a small store (like the Kress brothers), then moved to Baltimore where his wife's family were centered. Herman and Helen had thirteen children, of whom twelve lived and prospered, eventually shifting from the family business of wholesale groceries to cotton milling based in Greensboro, North Carolina. The family center, however, always remained in Baltimore, where the two strikingly different sisters, older Claribel (1864–1929) and younger Etta (1870–1949), grew up and spent most of their lives.

Their siblings married, but Claribel and Etta did not. They followed the two divergent patterns for old maids of the period. Claribel was independent, forceful, undomestic. She became a doctor in a day when women doctors were not very common. She ended up not in practice but in research, teaching, and administration, being at one time president of a Woman's Medical College in her native city. Etta was reserved and dutiful. She lived for many years in the shadow of her elder brothers and sisters, notably Claribel, and was as domestic as Claribel was not. She assumed the role of family caretaker, guardian of the lares and penates of her parents' house on Eutaw Place. Claribel was too positive, Etta too negative to encourage suitors.* Claribel was scientific; Etta was musical; but neither had any particular talent in the visual arts.

In 1896 revered older brother Moses gave Etta five hundred dollars to be used in brightening up the family house on Eutaw Place. She brightened it up by buying four paintings by the pioneer American Impressionist Theodore Robinson, neighbor, follower, and friend of Monet. These canvases were considered daring in Baltimore then. They are still in the collection and were the first steps leading on to

* Etta, however, was reportedly once courted by the sculptor Mahonri Young, descendant of Brigham. She turned him down because she thought every other man compared unfavorably with her oldest brother, Moses.

Matisse. The next step was a trip abroad in 1901 where Etta and her friends were met at the boat in Naples and taken on an extensive and instructional tour of Italy and its art by their talkative friend Leo Stein.

ii

The Steins, Leo and Gertrude, had arrived in Baltimore in 1891 as orphans to live with relatives. Though the Steins and the Cones weren't actually relatives,* the two families in numberless Balitimore ramifications were close friends, and the two Cone sisters and the Stein pair became very intimate. It was Claribel's example that induced Gertrude to study medicine. Leo was the bright boy of both families, always full of opinionated talk and avid interest in the arts. The Steins, in common, it would seem, with every other art lover of the time, had been born in Allegheny City, Pennsylvania; but the family moved from that hotbed of talent first to Europe and then to California. Leo and Gertrude were really cultural products of Oakland, not Pittsburgh. Leo left Baltimore to go to Harvard, Gertrude to Radcliffe. When Leo settled in Italy before 1900 to write a book on Mantegna, which never got written, Gertrude joined him there. She never finished her medical studies either. She left just before getting her degree in Baltimore. The two had incomes derived from street railways — those picturesque San Francisco cable cars that have become the symbol of the city nowadays. Their married brother Michael managed the railways and the money. Eventually, after a few years of wandering, Leo and Gertrude settled together in Paris. As of 1903 they occupied the famous studio on the Rue de Fleurus where Leo thought for a while he was going to be a painter and where Gertrude began to determine to be a writer. The Cone sisters kept coming to Europe and being instructed in art, somewhat condescendingly, by the Steins.

In 1905, at the Autumn Salon, a group of mad young painters derisively nicknamed "Les Fauves" (the Wild Beasts) were exhibited to the universal fury of the French art world. Some of them — Puy, Manguin, Friesz — are known today only by specialists. Others — Matisse, Derain, Rouault — have reputations that show no sign of fading. The Steins (no one is quite sure which Stein) had the intuition to pick out Matisse from the group and buy the first of his pictures to be sold from that year's Salon, *La Femme au Chapeau*. At about the same time Leo was introduced to the work of an obscure and starving young Spaniard named Pablo Picasso. Works by Matisse and Picasso were hung on the

* Eventually a Stein cousin married a first cousin of the Cones.

walls at the Rue de Fleurus. There over the years the visiting Cones saw them and began to like them. Etta was put to work typing the manuscript of Gertrude Stein's first book, *Three Lives*, based on characters she had known during her life in Baltimore. Etta conscientiously tried to type letter by letter without understanding the work until given formal permission by Gertrude to read it.

The ladies were introduced to Matisse, whom they found respectable and charming, and to Picasso in his dirty studio, whom they found alarming and interesting. He was painting Gertrude's portrait. They took him American funny papers from the *Baltimore Sun* and picked up drawings from the messy floor of the studio for which they paid a few dollars apiece. They weren't quite sure that "Madame Picasso," his beautiful mistress, Fernande Olivier, was all that she might have been.

These introductions led to a lifelong friendship between the Cone family and the Matisse family and to one of the world's greatest Matisse collections, bought by the ladies under the guidance of the artist himself. They bought other things, too, including Picassos; but unlike Gertrude they did not really follow Picasso into his Cubist period. Neither in fact did Leo Stein, who quarreled violently with his increasingly famous and egocentric sister. They split up over Picasso and over Leo's new wife. Both Leo and Gertrude told Dr. Barnes that the other was "crazy." Leo took the Renoirs and went off to live in Italy.

Gertrude stayed on the Rue de Fleurus with the Picassos. She there became the patron saint of young American expatriate writers like Hemingway. She tried to imitate the broken planes of Cubism in her broken sentences; but Etta couldn't continue with her manuscript typing and Gertrude found a new typist. This was Alice B. Toklas, whom Etta jealously disliked, habitually misspelling her name as a sign of condescension. Claribel had no such sentiments and continued her visits to Gertrude; but Etta gradually dropped her and vice versa. The halcyon days of the youthful quartet from Baltimore — Leo, Gertrude, Claribel, Etta — traipsing about Florence and discussing Giotto and Cézanne ended in quarrels or alienation. But during the first years of the century and the first years of Post-Impressionism before the war, the Steins, the Cones, Dr. Barnes (who was a constantly visiting friend-enemy of the Steins), and the Russian collector Shchukin were the principal pioneer patrons of the once derided and then adulated Wild Beasts of the School of Paris. Parisians waited until their reputations were safely established by foreigners.

Two other Steins, sensible businessman brother Michael and his lively San Francisco wife Sarah, joined the group, living in Paris and buying Matisses. They took back to America the first Matisse ever seen there when they had to return to see what the earthquake of 1906 had

done to the cable cars. The Cone sisters' purchases before the war were modest and their real collecting didn't begin till afterward.

When the First World War came, Etta stayed in America caring for her family, Gertrude stayed in France, and Claribel got caught in Munich. She took so long getting at her insanely elaborate packing that she missed the last train out. She didn't return to Baltimore till 1921. By then the Cone parents were long dead and the sisters settled for good in the Marlborough Hotel on the same Eutaw Place where the family house had been. Etta lived in one apartment; Claribel had another one next door that she used for her paintings. She had still another downstairs where she slept. A bachelor brother Fred who also collected lived next to Etta. Everyone ate with her, paying her as though it were a boardinghouse and punctiliously ringing the doorbell on arrival as though at a stranger's.

iii

In the twenties the Cone ladies found themselves rich from their investments in Cone mills, such as the Proximity in Greensboro. They resumed their annual trips to Europe and brought back not only Matisses but trunkloads of laces and scarves and bric-a-brac. Much of the latter never even got unpacked. One half-full trunkload of linen came to Baltimore, stayed in the trunk, was sent back to Europe again and filled to the top with new linen. Claribel had great difficulty convincing the customs that she'd already paid duty the year before on what was in the bottom of the trunk.

Claribel grew stout and imposing, swathed in voluminous garments and several of her brilliant shawls. Silver skewers and combs were stuck in her braided hair. When she swept into a concert, she always had an empty seat reserved next to her to accommodate the innumerable handbags, reticules, and paraphernalia without which she never moved. Like Gertrude, she had her coterie of young art lovers to whom Claribel laid down the law in her melodious and forceful voice. She had to be sure of being comfortable wherever she went and frenzies of packing and preparation occupied the days before a trip. She made long lists of what must be done and what must be taken. It was austere, handsome, horse-faced Etta who did it all. She was the one who arranged things, superintended meals, handled finances. She kept up with the endless family correspondence. In the cluttered apartments on Eutaw Place the two separate collections of Etta and Claribel grew and grew. Every wall was covered, every Italian chest and Renaissance table.

Though the collection was already famous in Paris, only the Cones'

friends knew much about it in Baltimore until Claribel died in 1929. She left her collection to her sister but with the intent that it should go to the City of Baltimore and its new museum of art "if the spirit of appreciation of modern art in Baltimore becomes improved." This bequest stirred up the newspapers and they stirred up the town. Since Etta long outlived her sister, collecting to the very end in 1949, Baltimore had plenty of time to adjust itself to the appreciation of modern art. Etta's last purchase was the Picasso portrait of Michael Stein's son Allan, done when he was a boy in 1905. Etta bought it by long distance from the ailing Allan, who was living in Paris. By the time it reached Baltimore, Etta was dead. By then, long and friendly relations with the Baltimore Museum made it obvious that the collection would go there. It did. A splendid new wing was built and opened in 1955, and in a rather stark setting, so unlike the brocade-draped confusion of the Marlborough,* the half a hundred Matisses in various media and the masterpieces by Cézanne, Degas, Derain, Manet, Monet, Picasso and Renoir can be seen by all those visitors who do increasingly come to Baltimore to see them. Tail tends to wag dog. The Baltimore Museum is overshadowed by its Cone wing, though the rest of the collection, notably the Epstein and Jacobs Old Masters and the fine galleries of American pictures and furniture, is not to be ignored.

As for the various Stein collections, they were dissipated and scattered all over the world from Leningrad to Utah, from Oslo to Australia. Gertrude left her portrait by Picasso to the Met. Many of the items in the Cone Collection once belonged to the Steins. Some are in the Barnes Foundation. But whereas the things the Steins bought are long dispersed, the things the Cones bought are intact in Maryland.

iv

The Cone sisters are famous enough, but the most famous of all America's art collectors and museum founders is another woman, Isabella Stewart Gardner, chatelaine of "Fenway Court." Her fame, one suspects, is based far more on her picturesque character than on any real understanding of her contributions to American artistic life. In the wake of all that has been written about her it is a temptation to be "revisionist" and to try to debunk rather than to praise. Compared to the contributions of a Marquand, a Morgan, or a Mellon, hers are

* A new Cone Room, full of Cone bric-a-brac and re-creating the original atmosphere, has just been opened, much to the satisfaction of the family, who tended to resent the antiseptic atmosphere of the painting galleries as uncharacteristic.

comparatively minor; and claims for her collection as being "first and finest" have certainly been exaggerated by writers enthralled by her piquancy. The Holden collection in Cleveland, for instance, antedates that of Isabella. The Scripps collection in Detroit and the Demidoff collection in Chicago were both bought and donated before Isabella began to collect seriously. The Gardner is not unique as a personal museum and does not compare in scholarly esthetic value to either the Freer or the Frick or in vital charm to the very personal museum of the Phillipses. Sheer personal force and charm created it, and the residue of that force and charm maintains it in popularity or one might still say in notoriety. The Gardner collection, like the Cone Collection, has a sort of éclat that more comprehensive assemblages lack. Visitors come to it as much out of curiosity as out of any interest in the paintings.

The paintings are very very good, however, and how and why Mrs. Gardner got them does make a quaint story. Though she was not a Bostonian, and proud of it, her Museum is very Bostonian, the fine flower of that long, strange, unreciprocated love affair (how many native Tuscans or Romans yearn for Boston?) of the Hub for Italia, nurse of the gentler arts. Whether represented by Hawthorne's *Marble Faun* or the Italian novels of Henry James (in which the villa of the Bostonian Lizzie Boott Duveneck serves as background for one and the "Palazzo Barbaro" rented by Isabella serves for another), by sculptors like Story and painters like William Page, the bonds between Boston and Italy were strong throughout the nineteenth century. Above all in the writings of C. C. Perkins, J. J. Jarves, and Charles Eliot Norton, Italy was brought to Massachusetts and flourished, or tried to flourish, in that rather uncongenial northern climate.

The careers and interrelationships of Perkins and Jarves have been explored. As far as Boston is concerned, Norton had a longer and more lasting influence than either of them. As a lecturer on art at Harvard he converted generations of students to the gospel of beauty, as he understood it. He was the true center of Italian studies in Cambridge and all the esthetic manifestations of the New England Flowering and its aftermath bear the imprint of his influence, for better and for worse.

The Nortons were not nineteenth-century China traders like the Perkinses, much less parvenu glass manufacturers like the elder Jarves. They came from the far older and more holy tradition of New England theocratic rule represented by families like the Edwardses and Pierponts, seventeenth-century Prophets in Israel who for generations from an original John Norton (1606–1663) laid down the law in the New Jerusalem. It was exactly in the tradition of such ancestors that Charles Eliot Norton (1827–1908) laid down the law on art; art as uplift, art as something moral, good, worthy rather than anything sensual or, God

forbid, carnal. Norton derived his gospel from the writings and talkings of his friend, the English lover of Italian architecture, John Ruskin. The transition from Calvinism to Ruskinism passed through Unitarianism and demonstrates the nineteenth-century conversion of Boston from Hell Fire to High Thought on into High Art.

Norton's father, Andrews Norton (1786–1853), scholar and rebel in his day, was one of Unitarianism's most prominent exponents. Carlyle dubbed him the "Unitarian Pope." He wrote a great book, *Evidences of the Genuineness of the Gospel,* and married a rich girl, the daughter of merchant Samuel Eliot. Eliot set up his daughter and son-in-law in a mansion in Cambridge called "Shady Hill." Charles was brought up there, lived there, and finally died there. From "Shady Hill" radiated waves first of religious and then of cultural light, mixed with uncertain quantities of sweetness. Father Andrews seems to have been as grim in his liberalism as his forefathers had been in their conservatism. Charles, though the gentlest of souls, was dogmatic and superior in his love of Dante and disparagement of anything afterward, though he never seemed to go quite as far in crackpot anti-Renaissance sentiment as his master Ruskin.

Norton, everyone said, was strong ethically but "weak" esthetically. This no doubt means that Norton, like Bostonian C. C. Perkins, would have considered it as a matter of course absurd to believe that the image could be more important than the word, the thing than the book. Art was important not of itself but as something to be talked about, as moral lesson or historical specimen. He never lectured about *objects.* His friends were literary, not visual, artists. Emerson, Lowell, and above all Longfellow were his intimates. Longfellow's massive translation of the *Divine Comedy* was inspired by this sort of Nortonian Pre-Raphaelitism. Norton and Lowell listened to Longfellow read his translation aloud, line by line, for their criticism and approval. The Norton-Ruskin attitude towards art and its morality may be alien to many in the twentieth century, but it is not so different from the Dewey-Barnes "art is life" theories or from orthodox Marxism. But somehow the vital link with real life seems to have been lost in Norton. In retrospect it is a bloodless attitude, high but thin.

Charles obviously ought to have been a clergyman; but his youthful interests were more literary than religious. He drifted about vaguely for his first forty years, after obligatory graduation from Harvard in 1846. He dabbled ineffectively in business and did various literary odd jobs. In 1855 he made a pilgrimage to Europe. On the boat going over with him was John Jackson Jarves. Jarves gave him an introduction to his friend Ruskin, and Norton's career was given its direction. A blissful tour of Switzerland in the company of the Master converted him completely to Ruskin's Pre-Raphaelite doctrine of the ethical in art, art as

expressed by the devout but earthly artisans of the Middle Ages with their gargoyles and gold-background paintings of virgins. The unity of labor, art and society that Ruskin professed to discover in happy conjunction during the centuries just before, but definitely not after, the Renaissance was to be transported back to the Anglo-Saxon world, now trampled into the mire by machine-made industrialism. Norton set himself the task, like Jarves, of converting the heathen of North America, that truly barbarous land (where even the shadows were vulgar). In Boston the Pre-Raphaelite movement was not a quasi-socialist craft movement like that led by William Morris in England but a precious idolatry of a foreign and distant past, refuge and antidote to a brutal present; Silk-stocking esthetics at its most exasperated. Norton became something of a caricature of this attitude. It was understood that on his arrival in Heaven he would murmur, "Oh! Oh no! So overdone! So Renaissance!" Behind this precious snobbism those like John Jay Chapman who loved him found a man who was able to lead generations of undergraduates into a world of the spiritual and the beautiful.

v

Norton became the first professor of fine arts at Harvard in 1873. His early lectures were attended by numerous culture-hungry Boston ladies. Isabella Gardner was one of these, beginning in 1878. She and Norton became lifelong friends, teacher and pupil. Norton's influence directed her first to Dante and book collecting, then to painting. "Fenway Court" is as much a realization of Norton's preaching (Renaissance though some of its contents may be) as it is of Berenson's salesmanship or Isabella's own yearnings.

The influence of Norton came to Mrs. Gardner somewhat late in life, as Ruskin's influence had come rather late into Norton's life. She began as a homely but spirited heiress of a self-made iron manufacturer millionaire in New York City. Her father David Stewart was of Scottish descent and a true enough Stewart from one of the many branches of the clan that included Mary of Scotland as its choicest ornament. Isabella never forgot this and embellished and flaunted her kinship to Mary in the face of Bostonian ancestor-proud amusement. Her mother, a Smith of Smithtown on Long Island, might have been a more legitimate source of ancestral pride; but not in Boston.

Isabella was taken abroad to be finished, met a Julia Gardner in school, went to Boston to visit her and in no time was married to Julia's brother, John Lowell Gardner, Jr. When she came to Boston as a bride in 1860, she seems to have found the atmosphere rather chilly. Despite the backing of her socially entrenched in-laws, Isabella was evidently

made to feel something of an outsider. She devoted herself to her household and then to her child, born in 1863. When the child died before his second birthday she was completely prostrated. After the miscarriage of a second child shortly afterward, she was told she could never have another. She suffered a nervous collapse into what seemed like permament invalidism. The doctors advised a trip to Europe. She was taken to the ship by ambulance and carried aboard on a stretcher.

In Europe the Isabella of legend was born. She regained her health and above all her spirits and returned the ebullient and rather freakish dynamo of legend. She also returned with a taste for European beauties that eventually centered on Italy and especially Venice. For the next twenty years she scandalized or delighted Boston with her famous escapades — the extravagant dresses and carriages, the rather risqué friendships with handsome artistic young men, some of whom may, who knows, have actually been lovers! She wore diamonds on her head at the end of quivering insectlike antennae and pearls about her waist or alternately a bandeau in her hair at the Symphony inscribed "Oh You Red Sox." She drank beer and smoked at the Pops Concerts instead of sipping sherry, and paraded lions from the zoo on a leash. In a day when it was so easy and delightful to shock a decaying Victorianism, she delightedly shocked it. In the process she made many enemies, most of them female. Once when asked to contribute to a Charitable Eye and Ear Clinic she said she didn't know there was a charitable eye and ear in all of Boston.

Like John Chapman and his Minna, and under the influence of Norton, she had her fling with Dante and passion. She too read the poet, not at the Athenaeum but in her mansion at 152 Beacon Street in company with the outrageously handsome young F. Marion Crawford, who was about to become a famous author and was nephew of Julia Ward Howe of "The Battle Hymn of the Republic." Were Isabella and Marion lovers? In any case they certainly read Dante together. Crawford had been brought up in Italy and returned there to write and live. This was just one more nudge given in that direction to the restless Isabella.

Among her numerous young men was a small, sultry, curly-locked Harvard undergraduate somewhat fictitiously named Bernhard Berenson. She may have met him at one of Norton's lectures, introduced by Norton himself. Bernhard was in any case a rather rebellious student of Norton's. As can be seen quite clearly in his later reminiscences, he detested Norton and thought that Norton detested him. Nonetheless it was Norton who helped direct Berenson to Italy and if "Fenway Court" is one fine flower of Norton's influence, so Berenson's Florentine villa, "I Tatti," might be considered another.

Berenson grew up far from Florentine villas. His father, whose orig-

inal name was Valvrojenski, had been a Jewish lumberman in Russian Lithuania. Lumber and Jews fell on hard times, Valvrojenski immigrated to Boston with his family, including his brilliant ten-year-old son, and changed his name to the more manageable Berenson. Father Berenson became a peddler. Young Bernhard, who dropped the German "h" in later life, was educated in public schools and self-educated at the Boston Public Library, where he read omnivorously in every direction. Accepted at Harvard, where his expenses were paid by anonymous patrons of whom Isabella may have been one, he joined a circle of literati that included that Spanish-born stepchild of Boston, George Santayana. They both became members of something called the OK Club, which combined brains and Boston, and had among its members Adamses, Coolidges, and Teddy Roosevelt. Berenson graduated with éclat in 1887 and decided to go abroad to find himself. Isabella was one of the people who helped finance him there, since Harvard had given available scholarships to other candidates now lost to fame. Berenson blamed this oversight on Norton's inimical influence. Berenson really had no idea what he wanted to do. In general he thought he might be a writer. He wandered about Europe looking for but not finding himself. Isabella evidently got impatient with this seemingly fruitless search and about 1889 cut off her support and the soulful correspondence that went with it.

Several years passed. Berenson finally narrowed his interests down to art, and then down to Italian art of the Renaissance. During this period he ran away with the Quaker-born wife of an Anglo-Irish Catholic businessman. She had been born Mary Smith, descendant of James Logan of Philadelphia after whom the Square in the middle of Price's Parkway was named. (The fountain by Alexander Calder II now sits there.) She was the sister of litterateur Logan Piersall Smith and of philosopher Bertrand Russell's first wife. Mary's husband, Frank Costelloe, refused a divorce. The pair lived in Italy on a shoestring supplied by Mary. They looked at every work of Renaissance art they could discover there and became experts in the process. Under pressure from Mary, Bernard produced a series of small but pregnant books on Italian Renaissance painting.* Costelloe died and Mary and Bernard married, he having been rather casually converted to Catholicism en route.

In process of being made respectable again by, so to speak, bell, book and candle, Berenson dared to resume his friendship with Isabella. They met in London in 1894. Isabella had become more and more

* The first of these was *Venetian Painters of the Renaissance*, 1894. He sent a copy to Isabella and so broke the five-year silence. Later books in this series covered Florentine (1896), Central Italian (1897), and North Italian (1907) painters.

infatuated with Italy and had begun to dabble in the collection of art. She had already bought rare books, rare bibelots for the house on Beacon Street, and the paintings of modern artists like Whistler and Sargent, whom she met and admired. A few largely dubious Old Masters were purchased after 1892, more as mementos than with any idea of forming a collection. By the time the two met in London, Berenson was becoming recognized as an authority. As such he could recommend various wonderful pictures to his Isabella. Almost before she knew it, she was involved in one of the most intense and peculiar collecting collaborations in art history. From 1894, when she got her first masterpiece through Berenson, Botticelli's *Death of Lucretia*, to the opening of "Fenway Court" in 1903, she built up a comprehensive nucleus of paintings from which almost none of the great names of Italian painting, except the always unavailable da Vinci and Michelangelo, are missing.

It was a queer way to do business. Bernard would write his Dear Lady, telling her he had something priceless that she must have immediately. She had to hurry, other mysterious buyers were after it. On the basis of mere photographs she must cable him at once, yes or no, in a prearranged code. For example YEUP would mean, "Yes, buy the Titian *Rape of Europa*." More often than not the first look she ever had of her pictures was when they arrived in Boston after purchase. How different from the lordly, leisurely, months-long perusal of paintings by Frick and Mellon, the lightning swoop of eagle-eyed Morgan, or the molelike caution of John G. Johnson. If Berenson had indeed been the crook he has sometimes been accused of being, what an opportunity! Here was a rich woman, backed without question by a complaisant husband, having no previous knowledge of art and relying implicitly on the word of a man whom she hadn't seen since he was an undergraduate. She was expected to buy pictures by great names from him, at far from negligible prices, all by mail order. Her husband evidently never helped or interfered. He was for years Treasurer of the BMFA but seemed to have no particular interest in art. It was a situation that could easily have resulted in one of the great esthetic swindles of history.

But Isabella was lucky in her man. Though not all the attributions have stood the test of time, most of them have. Titian, Botticelli and Raphael remain to this day Titian, Botticelli and Raphael. The attrition has been minor. Only one or two of the important paintings, notably the *Head of Christ* attributed to Giorgione, now thought to be probably a copy from Bellini (but experts still disagree), have suffered serious devaluation. The values of the genuine masterpieces like that initial Botticelli or the Titian *Rape*, bought in 1896 through BB, so

beloved by generations of famous European painters,* have increased astronomically.

Isabella's father died in 1891, leaving her a modest fortune. John Gardner died in 1898, leaving her a rich widow. She decided to abandon the Beacon Street house as a possible site for the already envisaged museum and build a new house out on the Fenway, quite near the future site of the new BMFA. The Fenway, a former swamp, was being converted by Frederick Law Olmsted, designer of Central Park along with the Met's architect Vaux, into a pastoral riverside, a sort of pseudo-Thames of meandering waters, rustic bridges and many bulrushes. It was confidently expected that Back Bay and fashion would extend out in that direction. This was a perfectly logical and reasonable supposition in the age before the automobile. (What actually happened was that the automobile moved fashion out of Back Bay and into remoter suburbs.)

Isabella and her husband had bought many chunks of Venetian palaces, and driving her long-suffering architect Willard T. Sears as a female Pharaoh might have driven a slave, Isabella personally superintended the creation of a strange fantasy, a Venetian palazzo turned inside out, like a glove. Neither the Grand Canal nor the Fenway saw its facade, which was turned in onto a storied garden court. This inward-facing exotic dream palace is exactly the proper symbol of Nortonian Boston's love of Italian art — something sheltered, strange, removed from the real world of cotton mills and railroads, a beautiful fragile bloom of anti-Modernism quite after the precepts and prejudices of Norton.

It was all built in secrecy. Many of the workmen were Italians who couldn't speak English. Isabella's favorite Italian major domo was made foreman and summoned workers to the presence by toots on a trumpet. Isabella herself demonstrated, from a ladder, how to produce the effect of aging pink plaster on the walls of her courtyard. At first she refused to allow steel beams to be used because they had not been used in Venice. Later she gave in. Nobody was allowed a glimpse of the pleasure dome, even after she moved there as of 1901. She wanted to test the acoustics of a music room, complete with audience, but didn't want to ask any of her friends. Instead she gave her preview musicale to the inmates of an asylum for blind children. It was a rainy day. The orphans arrived and their little rubbers were carefully arranged in rows so that they could find them afterward. The acoustics were a success,

* Rubens made a copy of it in Spain. Vandyke sketched Rubens's copy and the sketch is now at the Gardner. Velásquez put the picture into the background of his *Spinners*, etc.

but an officious servant, seeing all those old rubbers lying around, bundled them up and removed them. Hours were spent after the concert by everyone, including Isabella, trying to fit the blind infants with their proper rubbers.

Finally on January 1, 1903, the great day of the opening came. First a reception was held in the music room (since demolished). Isabella stood at the head of a curving staircase and Boston's best were forced to come up one by one and pay homage to her. After a concert, doors were opened and the select but avid assemblage wandered out into the flower-filled and candlelit court and the surrounding rooms filled with masterpieces.

Refreshments were of Bostonian frugality: champagne and doughnuts. Edith Wharton, who had come up especially for the event, complained of the skimpy fare in French; she assumed Isabella would not understand. Isabella understood and let Edith know she would never be asked again.

It was Isabella's finest hour, her triumph over resistant Boston, her compensation for the death of her child, the climax too of her collaboration with Berenson. Though she lived for a quarter of a century more, dying nearly totally paralyzed in 1924, and though the museum was altered and improved throughout her lifetime, she became increasingly worried about finances. A nasty brush with the still unenlightened American customs in 1908, just before the passage of the Payne-Aldrich bill that permitted the Morgan collection to enter duty free, cost her one hundred and fifty thousand dollars, embittered her, and made her more cautious about buying. Her purchases after 1903 became gradually fewer and fewer, and after 1916 she really stopped dealing with Berenson.

Berenson made Isabella and her museum. Isabella made Berenson. By the time she finished collecting, he was rich from the percentages he made from her purchases — about five percent on each painting. He had become a formidable figure in the booming world of art collection. He had ceased to be Isabella's chief advisor around 1907. By then the age of the great millionaire collectors was well under way and Berenson had been hired by Duveen to act as his "authenticator" at a yearly salary. By 1913, when Berenson was hired to catalog the John G. Johnson collection's Italian pictures, the buying of Old Masters by Old Millionaires was at its very height and Berenson's reputation was established as preeminent in his field.

Relieved by Duveen of the necessity of actually selling paintings on a commission basis, Berenson delivered, and often changed, his Olympian dictates on authenticity of authorship. Was that picture a genuine Giorgione or not? If so, the millionaire would buy it from Duveen for

half a million dollars or more. If not, Duveen couldn't unload it at any price. Sometimes Berenson said yes, sometimes no; sometimes he was unable to make up his mind, or much worse, changed it! Fatal! Suppose the millionaire had already paid Duveen his half million for the supposed Giorgione! Berenson grew to feel guilty and tarnished by this trade and in 1936 finally broke with Duveen over just exactly this business of a supposed Giorgione. Having first said that the beautiful *Adoration of the Shepherds* was by Giorgione and Kress having bought it, Berenson then changed his mind and said it was an early Titian. This was more than Duveen could stand. They fought and severed their relationship. Then later on BB, as he was always nicknamed in later life, once more changed his mind. Most of the *Adoration,* he now said, was probably by Giorgione after all. This picture is now so listed in the National Gallery.

By the time of the rupture, BB was rich enough and famous enough not to care. He bought his beautiful villa outside of Florence, decorated inside with pictures and outside by gardens. Everyone in the world came to visit him and get advice and counsel. For example Leo Stein, lounging loosely about Europe looking for something to do, bored with old art, was told by BB to look at Cézanne. Leo looked and that was the beginning of the whole Stein-Cone interest in modern art. Kenneth Clark, later Director of the British National Gallery, and John Walker, later Director of the American National Gallery, were disciples and residents at "I Tatti." They have both left records of the later, greater BB, not untinged by malice. He had mistresses, the most faithful being his universally beloved secretary Nicky Mariano. Even his wife loved her. He had other resident disciples like the English writer and garden designer Geoffrey Scott, author of the *Portrait of Zélide,* with whom both BB's wife and his mistress Nicky fell fruitlessly in love.

Only the Second World War, when suddenly BB found he was not only an enemy alien in Italy but a Jew under Fascism, disturbed this triumphant expatriatism. Though BB had to hide out, narrowly escaping imprisonment and death, "I Tatti" emerged unscathed and he resumed his career after the war. Works scholarly and personal enlightened the world from the study and the garden. By the time he died in 1959 at the age of ninety-four, BB was a world figure. His principal rival in Isabella's confidence as scout and buyer of art, Richard Norton, son of Charles Eliot, who lived in Rome as a teacher at the American School of Classical Studies, is almost forgotten. Isabella's French dealer or the London gallery, agents through which her purchases were usually transacted, are now familiar only to specialists. But the triangulation of Isabella and BB and BB and Duveen is the most picturesque and well-publicized crossing of ways in the history of American arts.

Books keep coming out with references to some aspect of this uneasy equation, an equation perhaps a bit more fun to write about than it is really important in the annals of the American museum.

As for "Fenway Court," there it sits, formally opened to the public in 1925 as a museum after Isabella's death the year before. Opened and still remaining *exactly* as she planned it and left it. The dead hand sits upon it hard, sometimes oppressively, sometimes happily. There have been times when "Fenway Court" — overpoweringly full of the scent of flowers, cobwebs seeming to swathe the capricious clutter of bibelots, dark walls plastered with fading masterpieces — seems like nothing so much as a sumptuous mortuary chapel, an Egyptian tomb for a defunct princess. At other times, and especially lately under the care of its new young director, it seems happy, joyous, romantic, a refuge at once a bit campy and old-fashioned and yet genuinely, eternally entrancing. What can be done — relighting, restoring, recleaning, reattributing — has been or is being done. What can't be done — any addition to or subtraction from the collection, any drastic rearrangement — has at least prevented the kind of desecration that does alas sometimes ruin other older collections. The placement and sequence of flowers is not, as some people think, part of Isabella's ironbound instructions; the retention of those obstructive curios is. But then that's part of the charm. Nowhere, not even in the Phillips collection, does the presence of the founder hover more palpably. It is still Isabella's house. One can almost hear her whisper "Vulgar creatures!" when busloads of middle-aged female tourists chatter and clatter over the mellow red tile floors in envious adulation. Scornful perhaps the ghost of Isabella might be, but delighted nonetheless. If nobody came, if nobody was envious and worshipful, her ghost would be forlorn. Denied the immortality of a living child, this envy and adulation is her immortality.

vi

A quite different offspring of Norton Italianism is the Fogg Museum as it developed under Edward Forbes. It stands today with Yale's as one of the two acknowledged most important teaching museums in the country. Like Yale's, it is rich in gold-background pictures. They did not come to the Fogg from Jarves or Berenson but from Forbes. The Forbes family of Boston, whose American line stems from an eighteenth-century Scotch clergyman active in St. Augustine, Florida, of all places, were Boston China traders and partners of the Perkinses. They stuck to business longer than the Perkinses, branching out into railroads and AT&T, and no Forbes was, like C. C. Perkins, prominently active in the arts before the twentieth century. The head of one branch of the

family as of the nineteenth century, John Murray Forbes, was a great friend of Emerson and an Emerson daughter married a Forbes son. Edward Forbes, the first of the Forbeses to go wild and desert to the arts, was thus a grandson of Emerson. This branch of the Forbes family has its own islands — the Elizabeth Islands off Cape Cod — where they go in the summer to pursue high thought, sail boats and herd sheep. Edward married into still another island. He wed a great-niece of Celia Thaxter, poetess born and brought up as a lighthouse keeper's daughter on the Isles of Shoals, a rugged group of rocks off Portsmouth, New Hampshire. Celia got to be very famous in her day and knew everybody. The bearded artist William Morris Hunt drowned himself on the Isles of Shoals while visiting Celia one summer, and Childe Hassam, most popular member of the Ten, painted the Isles and Celia innumerable times.

Edward Forbes admitted that he'd never been inside the new but somnolent Fogg Museum before his graduation from Harvard in 1895. But he had studied with Charles Eliot Norton and in 1898 on a trip to Italy he looked up Richard Norton, Charles's son and Isabella's friend, in Rome. Under his influence Forbes became fascinated with gold-background Italian painters, especially in their technical methods and materials. He began to buy pictures, but since he had no proper place of his own to hang them he thought of loaning them to the Boston Museum of Fine Arts. Richard Norton suggested the Fogg instead. The Fogg needed pictures badly; the BMFA didn't. The Fogg would be more grateful. Gradually a nucleus of genuine gold-background paintings began to intrude into the Fogg's miscellany of casts, photos, and prints. When the occupancy of do-nothing first Director Moore ended, Forbes moved into his place, as of 1909. He found a building with, as he said, "a lecture hall in which you could not hear, a gallery in which you could not see, working rooms in which you could not work, and a roof that leaked like a sieve."

Forbes soon remedied all this and from 1909 till his retirement in 1944 and his death at ninety-five in 1969 the Fogg benefited from his constant loving care and interest, and also his donations. It is unusual to have a director, as opposed to say a president, who is also a principal donor.

Among the first things Forbes did when he took over at the Fogg was to seduce his friend Paul Sachs (Harvard, 1900) away from New York and banking and up to Cambridge and art teaching and curatorship. From 1915 until he retired in 1948 and died in 1965, Sachs along with Forbes dominated the Fogg. The two couldn't have been more different. The only things they really had in common were an intense interest in art and in Harvard; and rather oppressive family backgrounds. Whereas the Forbes family figures prominently in Cleveland Amory's

Proper Bostonians, the Sachs family has, along with the Rosenwalds, its niche in Stephen Birmingham's *Our Crowd.* As partner in the family investment banking firm of Goldman Sachs, Paul Sachs could have looked forward to a career of increasing New York opulence. It was even more of a wrench from family tradition than that of Edward.

Forbes was a tallish, gangling, countrified-looking man with the air of a professor who having got off at the wrong streetcar stop has never quite realized the fact. As he himself said, he had been born twenty minutes late and had spent his life trying to catch up. This seeming befuddlement was very deceptive. No one knew better than Forbes just what he was doing, what he wanted and how to get it. Half the more valuable objects in the Fogg Museum were secured by the rustic wiles of Edward, above and beyond those he actually gave himself.

Most of the others came through the more urban wiles of Sachs. Short, dynamic, elegantly dressed, brisk, nobody ever doubted that Paul Sachs knew what he was doing. His primary interest was in the area of graphics. Beginning before he came to Cambridge, he went on to become, along with Rosenwald, one of the world's great experts and collectors in that field. He is remembered best at Harvard however for his institution of an originally rather informal series of courses in "museumology," that is, not the usual curriculum of historical scholarship but actual study in how to deal with actual museums. As a result many of the outstanding American curators and directors of the last decades have been pupils of Sachs or of the program he instituted.

Sachs bought and lived in Norton's "Shady Hill" when he moved to Cambridge. There he brought up his family, as Norton had been brought up and had brought up his. There Sachs gathered together the same company of students and friends, carrying on the Norton tradition of art and entertaining, but in a thoroughly modern manner, quite without the Ruskinian eccentricities of the previous regime. Sachs was an intensely social person, in contrast to the somewhat more introverted Forbes. He liked people of any kind, but especially young people seriously interested in the arts; and he and his wife were prodigal in their help and hospitality. The sessions of the museum course took place at "Shady Hill," which was converted from the Victorianism of Norton days into a lived-in museum of beautiful prints and drawings. He had no idea, however, of making a personal collection. Along with people and prints, he loved institutions — notably Harvard. The chief beneficiary of this love was the Fogg, which not only got from Sachs prints and drawings but heads of Buddha, classical statuary, a Tintoretto that once belonged to Ruskin, two fine Poussins, Italian Primitives — a whole amazing range of objects.

Forbes lived in a Forbes enclave called Gerry's Landing on the Charles River in Cambridge, where in the midst of other Forbes houses

he built a rather incongruously pompous Neo-Georgian mansion. His wife got so tired of trying to manage the mansion that she built her own smaller, stylish, modern house nearby, full of orchids. Edward kept busy with the Fogg, raising money for Harvard, teaching the restoration of Old Masters, being a trustee of the BMFA from 1903 to 1966, painting, involving himself in all sorts of musical activities including composition, as well as a successful project to redeem the banks of the Charles River from squalor to beauty, and paid very little attention to housekeeping. "Shady Hill," on the other hand, flourished and became one of the more memorable landmarks of Cambridge. It was turned over to Harvard after Sachs left it in 1949, whereupon Harvard tore it down, surely one of the nastiest bits of academic vandalism on record. Though "Shady Hill" has vanished and the big Forbes house has passed out of Forbes hands, the memory of the men themselves, that unlikely team of Forbes and Sachs, remains green not only in Cambridge but throughout the world of the American museum where their students remain prominently active. For instance, the present Director of the newly rebuilt Minneapolis Museum is not only a graduate of Harvard but a member of the family, Samuel Sachs.

vii

Meanwhile, in the same year that Forbes took over the directorship of the Fogg, the Boston Museum of Fine Arts at last reopened in its new building. By 1909 the brouhaha and its echoes of bitterness and dissension had been put aside. Robinson was down in New York. Prichard, who might possibly have been thought of as his logical successor since he had been Assistant Director and was victorious in the battle of the casts, as champion of Joy versus Instruction, was also gotten rid of. First he was demoted to the peculiar position of Bursar, a designation never encountered before or since in the annals of the BMFA. Then he moved to a most uncongenial job at Simmons College and finally left America for good. His patron and supporter, President Samuel Warren, resigned in 1907. Decks were cleared, feuds were forgotten, and under a new director and a new president the new building was off to fifty years of sure and steady progress as America's "second best museum."

Prichard, who so stormily and briefly emerged from the violent shades of "Lewes House" and then went back into obscurity, plays somewhat the same fugitive, irritant, and catalytic role in the history of the BMFA that his fellow Englishman Roger Fry does in the history of the Met. Far more amiable than Fry, Prichard nonetheless had the same quality of being a gadfly outsider. As Fry ranted against the denseness of Morgan and his fellow millionaires, so Prichard did against the cold

roast Boston of the museum trustees. Fry found consolation in the salons of New York hostesses of the Edith Wharton circle. Prichard found consolation at "Fenway Court." He immediately became one of Isabella's "young men." He was a constant visitor, he wrote to Isabella constantly even while still in Boston, and the correspondence continued right up into the twenties, when Isabella died.

Nothing reveals Prichard's character, the nature of his bond with Isabella and the reason he left the Museum more clearly than a letter he wrote her in 1910 on the death of his patron, ex-President Samuel Warren. The letter is quoted in full by Walter Whitehill in his history of the BMFA. In part Prichard says,

> You know . . . what the Museum was when Sam Warren became its president. It was despicable and despised. A few families had a special cult for it, regarded it as their appanage, practiced their influence on it. . . . On Sundays it was visited by loquacious Italians, but on week days the temple was closed to all save the initiated who appeared to bully the director and oversee their family tombs. For it was recognized that one room belonged to this family and another to that . . . it was the last sanctuary [unless the Athenaeum was another] of the Boston aborigines, and totem and taboo were imprinted all over it.

Nothing might have changed, Prichard says, if it hadn't been for the move to the new building, inspired by Warren. But due to him the Museum's

> holiness was wrecked, its altars torn down. . . . Warren opened its windows and ventilated it with the air of the world's experience. . . . He was opposed by his trustees, by Boston society, by Boston artists. . . . He destroyed its character as a private, tribal, family institution to make it a public matter. He transferred its aim . . . from privilege to people . . . from science to art, from knowledge to feeling, from investigation to enjoyment.

Even worse, "There was a gradual devolution of authority from Trustees to the staff, from prejudice to knowledge. . . . He was a great liberator."

Obviously anyone who harbored such sentiments was not going to go far in the administration of the BMFA. The sentiments were of course as exaggerated and picturesque as Fry's diatribes on the stupidity of Morgan. Neither Fry nor Prichard was cut out for work in American museums of the early 1900s.

After Robinson resigned in 1905 and Warren in 1907 the old animosities were swept away, or under the rug, and a new era of progress and stability began under a series of impeccable presidents and dutiful

directors, of slow but steady acquisitions and the gradual enlargement and embellishment of the new building. For fifty years all was, or seemed on the surface, serene. There were none of the grand splashes of great gifts and great collections that characterized the Met, but bit by bit and item by item the BMFA increased its holdings. Three rather dim directors — so dim that none of the three has appeared in the *Dictionary of American Biography* — succeeded Robinson: Arthur Fairbanks (Director from 1907 to 1925), Edward Jackson Holmes (1925/6–1934), and George Harold Edgell (1934–1954).* They steered the ship through what seems in nostalgic retrospect like a placid cultural ocean, each making his special contribution and having his special character. Fairbanks was a classical scholar and archaeologist. Holmes was a collector and donor of Oriental art. Edgell's primary interests were in architecture and painting. The departments of their special interest especially thrived under each directorship. In a day unlike the present, when the director was considered not the master but the servant of the museum and its board, these men in their various ways served well.

Nobody seems to know just why and how Fairbanks was chosen. He broke all sorts of already established precedents. For one thing he was, incredibly enough, not a Bostonian and not even a Harvard graduate. True, he was a New Englander, born in New Hampshire and graduated from Dartmouth. But still! After an early career devoted largely to the teaching of the classics at Dartmouth, Yale Divinity School, and then in Iowa, he ended up at the University of Michigan, from which he was snatched to take the place of resentful refugee Robinson. Fairbanks was not involved in local feuds. He was a sound scholar and a sound administrator and generally, like Loring, a man without very much profile. For a period of nearly twenty years he presided over the new building in its formative stages. A great Evans Memorial Wing was built in 1915 and soon filled. It was donated by a woman with the un-Bostonian name of Maria Antoinette in memory of her self-made husband, a rubber king named Robert Dawson Evans. Presidents and trustees came and went, all respectable. John Singer Sargent, that expatriate Philadelphian, having been once seduced from his proper style and media to create vast murals for the new Boston Public Library, along with that other expatriate Philadelphian Edwin Abbey was once again misdirected to create murals for the new Museum. He died in 1925 just before the installation of the last of these mistakes. The Museum School flourished under the teaching and influence of Boston members of the Ten, Benson, Tarbell, and friends, until they resigned

* This may be unfair to Edgell, who hasn't been dead long enough to qualify for the *DAB*.

in a huff in 1912–1913 over the officious interference of the School's administration and the School slid into a decline of several decades. The Oriental Collection saw the brief tenure of Okakura (Curator 1910–1913), who had once accompanied Bigelow, Fenollosa, and Morse on their shopping sprees and heard them deplore the draining away of Japan's "life blood." He also joined the circle around Isabella and wrote an elusive and allusive poem in her honor. Another Japanese, Kojiro Tomita, lasted longer. He came to Boston and the Museum in 1908 and stayed more than sixty years.

Nothing like the excitement of 1905 marred the public record of Fairbanks; but a suppressed scandal may possibly have hastened his resignation. This was the peculiar case of the Mino da Fiesole tomb. One of the important accessions of 1924 was a fifteenth-century Florentine tomb, supposedly the work of the famous sculptor Mino da Fiesole. It portrayed an emanciated lady lying on top of a flowery sarcophagus. Over her were two panels bearing identical coats of arms. The Latin inscription on the front of the sarcophagus indicated that she was a member of the Savelli family. After the tomb was put on exhibit, people began to have doubts. The biggest doubter was Edward Forbes. He sent photographs to his friend the sculptor Joseph Coletti in Rome asking him to look about. One of the problems was that the tomb was supposedly Florentine, but the Savelli family was Roman. Coletti, in the process of looking about, ran into a Roman sculptor named Alceo Dossena, who gaily admitted that he had created the tomb as an essay in the style of the Renaissance, turned it over in course to his dealer and did not realize the dealer had sold it to the Boston Museum as an original.* Back in Boston the tomb was buried in the basement. The Treasurer of the BMFA, who had been induced to pay out a lot of scarce Boston money for that tomb, was furious. And then, perhaps just coincidentally, both the President and Director Fairbanks resigned.

Time passed. The succeeding Director, Holmes, came and went. The Treasurer, William C. Endicott, finally died in 1936. Almost immediately in 1937 a third Director, Edgell, brought the tomb up from the basement and said he didn't care if it was genuine or not. It was pretty, he liked it and he was going to exhibit it. The trustees, however, insisted on some preliminary modern tests. X-rays were applied; slices of marble were sheared off and examined microscopically. What was discovered was that Dossena couldn't possibly have created the tomb. The sarcophagus itself was unquestionably of fifteenth-century marble carved in the fifteenth century in Florentine style, if not necessarily by Mino. But the two coats of arms above it were something else again. One was palpably a modern forgery. The other was ancient all

* Not long afterward Dossena sued his dealer for this kind of malpractice.

right, but Roman, not Florentine. In Florence contemporary Carrara marble was generally used for sculpture. In Rome sculptors just went out and "pilfered" pieces of old Roman marble. The marble for the Savelli escutcheon had come from an ancient Greek quarry. In order to match the *Roman* coat of arms, the inscription was changed and the modern escutcheon manufactured. There was something wrong with the Latin of the altered inscription, too. This variously doctored but undoubtedly very lovely artifact, good in part, "like the curate's egg," as Walter Whitehill felicitously puts it, was exhibited with flair and explanations by Edgell. When Perry Rathbone took over he reversed Edgell's judgment and, convinced it was a forgery, put it back into the basement. It appeared briefly on TV as part of a Public Broadcasting series on the arts and now once more lies broken and forgotten among the other rejects in the cellar. One of the oddest things about it is Dossena's forthright but fraudulent claim to have created it; a fraudulent forgery. Either that or the scientific tests were mistaken. The tomb even appeared in a catalog of his works.

What is really important about it is that it did *not* cause a scandal. So very very unlike the constant froth of newspaper publicity and brouhaha that seems to surround contemporary museums, this incident was handled more or less in private, behind the secrecy of closed doors, which is, as Morgan remarked, what doors are for.

Fairbanks's successor, Edward Jackson Holmes, is one of the more curious choices for a director in all American museum history, not because of his personality, which seems to have been amiable but somewhat indecisive, but because of his position. He was a grandson of poet, doctor, wit, and Brahmin Oliver Wendell Holmes. He and his mother, a Wigglesworth* who had remarried as Mrs. Fitz, were famous collectors of Oriental art and generous donors to the Museum. He became a trustee in 1910. According to custom, he was chosen as purely temporary and interim Director (1925) on the resignation of Fairbanks, but he liked the job so much he decided to stay on (1926) for nearly ten years. When he resigned from the directorship in 1934, he became President of the board.

This kind of shifting between the roles of trustee, director, and president is almost unheard of in museum circles. There is a vast gulf fixed between the first two roles. Traditionally trustees are well-to-do gentleman collectors who hire the director, he being traditionally a well-known scholarly expert. Then they all proceed to battle for years over who is really going to run the museum. The propriety of a great donor being the man who has to approve or disapprove of the donations of others is always open to question; though this was the case at the Fogg

* A Wigglesworth collection was one of the three in Boston described by Strahan.

with Forbes and nobody complained. Nobody complained at the BMFA, either.

George Edgell, who succeeded Holmes, is representative of those who though not natives become more native than the natives. He was born in Saint Louis, like Norton's cousin, T. S. Eliot. He adapted perfectly to Cambridge, unlike Eliot, who had to go farther upstream to a mythical medieval England in order to find his spawning grounds. Edgell, once he got to Harvard and graduated there in 1909 (Ph.D. in 1913), never left the shadow of alma mater. He taught in the Art Department, following the footsteps of Norton as a popular undergraduate lecturer and scholar of Sienese painting, and was then rather surprisingly made Dean of the School of Architecture by President Lowell. No one was more surprised than Edgell, who quite frankly admitted that he knew nothing about architecture. Nobody still seems to know why Lowell appointed him. But his amiable personality, together with Lowell's influence on the Museum board, recommended him as successor to Holmes.

During his twenty years' incumbency, Edgell helped fill in Boston's laggard collection of paintings. He was the first Director whose interests were not in some way archaeological. The Spaulding bequest of 1948 helped bring the Museum's collection more or less up to date — up to Impressionism and Post-Impressionism anyway. Though Edgell was personable, he hardly occupied the place in the museum world of such prima donnas as Taylor of the Met or Kimball in Philadelphia. Nor was he as well known as Forbes and Sachs over at the Fogg. The Director of the BMFA, no matter what Prichard might have thought, was still subservient to the trustees. Sam Warren had not changed things all that much.

viii

It was during the tenure of Edgell that most of the Karolik Collection came to the Museum. It includes one of the most exciting collections of nineteenth-century American art in existence, as well as beautiful furniture. Karolik was a most unlikely amateur of Americana. He was a flamboyant Russian émigré opera singer who married a rich old lady, Miss Codman. They lived in high style in Newport. Mrs. Karolik inherited Codman furniture from Boston and this started the pair collecting. Over a twenty-year span they vastly enriched the BMFA.

It was only in 1955, when Perry Rathbone took over at BMFA, that things really did change. Rathbone was a charismatic director, he was something of a dictator and definitely belongs among the prima donnas. He did, for the first time in Boston's history, tend to outshine and

overmaster the board. And he was, also for the first time in Boston's history, a real museum man. He was a graduate of the Sachs special course (Harvard, 1933). He had worked up the ladder of curatorships and directorships, from Detroit in 1934 as assistant to Valentiner and on to Director of the City Museum of St. Louis from 1940 on, where he made a great reputation. When he took over the BMFA things began to hum. The Bulletin broke out in colored covers for the first time in history, events and happenings and exciting exhibitions and fund raisings and membership drives and new millionaires on the board began to bring Boston further into step with the twentieth century. The final climax of the Rathbone regime was the Centennial of 1970, counterpart of the Met's Centennial with which this book began; I will close this book with an account of that Boston Centennial.

During the directorships of Fairbanks, Holmes and Edgell, the most consistently generous and knowledgeable donor to the Museum, and the Fogg also, was Denman Ross. Ross, like George Edgell, was born abroad, that is, in Cincinnati, Ohio. But his family moved to Cambridge when he was young. He was brought up there, graduated from Harvard in 1875, attended Norton's first lectures, and settled down in Cambridge to a rather special career as an artist (fair), a teacher of design* and a collector (superlative). As a painter he might be considered a minor follower of the Ten. His friend Isabella acquired several of his pictures. He loathed contemporary art and used his influence to keep it out of the BMFA and the Fogg. As a long-time trustee of the Museum and collector he ranged the field from ancient to almost modern, from west to east, but was most spectacularly represented by his Asian objects, Chinese and Hindu. He almost single-handedly created the Boston collection of Indian art. During his long career as donor he presented well over eleven thousand objects to the BMFA, from paintings by Whistler and Monet to Roman, Medieval, Chinese, Japanese, Persian, and Hindu works of art in every conceivable medium. His name is all over the accession cards in Boston and Cambridge. A portly and mustached bachelor, he affected in later years a stately pace and measured delivery in a hoarse-voiced but emphatic whisper. Apropos of a man who balanced an orange on the tip of his nose, he handed down the ultimate esthetic judgment so appropriate elsewhere, "Trivial in conception; Ma-a-sterly in execution!" Or the dictum that "No gentleman in Cambridge . . . WALKS . . . except upon Brattle Street."

In other words, Ross was to twentieth-century Boston what Henry James and his like had been to late-nineteenth-century London. In no

* His theories of color and design had much influence on the later work of that other native of Ohio, George Bellows.

small measure his kind of life was made possible by the presence in cities of the Eastern Seaboard of flourishing art museums and by the world of connoisseurship and collecting that gathered about such museums during the years from 1900 to 1950.

C. C. Perkins and J. J. Jarves, Norton and Longfellow and Dante, the Brimmers and John Jay Chapman, Norton's pupils Isabella and Bernard and their innumerable friends including the two great Henrys, James and Adams, the artists William Morris Hunt and Childe Hassam, and their friend Celia Thaxter; Warren and Prichard and the "Lewes House" gang; Morse, Fenollosa, Bigelow, Okakura; Forbes and Sachs and Ross — the character of the whole world surrounding the BMFA is full of fascination. It is only at the very center that the color and glamour fade — the curious sort of silence that falls about the trustees, that endless respectable succession of Lowells, Cabots, Coolidges and Gardners, and particularly about the directors, all of whom except the short-lived Robinson and recent Rathbone seem somewhat characterless. There is a gap between Boston's artistic life, which is full of a sort of literary charm, and its museum, which is full of worth. Stranded like a white whale up on dingy Huntington Avenue, surely as cheerless a situation as any in America, handsome but in no sense beautiful, packed with magnificent art from "every clime" but not anxious to woo one with adventitious esthetic pleasures, the Museum as a whole seems to reflect the sober coloring of the strict trustees and their serviceable directors rather than the brighter plumage of some of its more picturesque donors and supporters.

The echo of Ned Warren's pleas for Uranian love is faint, as well as that of friend Prichard's for "joy." Does anyone seek Nirvana among the lacquers and sword guards of Bigelow and Fenollosa? Morse's pottery, shelf after shelf of it, is in storage, available only to the student. The Sargent murals, damned forever by BB's comment "very ladylike," do not do much to liven things up, though they are pleasant cameos. One feels that Robinson won in the end. Instruction rather than any abandonment to Joy is the prevailing mood of the Boston Museum of Fine Arts. But it is a wonderful museum, the very model of an American Big-City Universal Survey Emporium of All the Arts. Some museums may be bigger, some more beautiful, but none is better.

Chapter VI

(The Met)

i

DOWN IN NEW YORK the fifty years corresponding to that calm cultural ocean between Robinson and Rathbone at the BMFA were by no means so calm at the Met. Boom and near-bust, glamour and retrenchment characterized the regime of the Morgan and the post-Morgan periods from 1905 to 1955. However, just as in Boston, we have three directors whose terms of office almost coincide with those of the Museum in Boston.*

Though Morgan died in 1913, the Morgan era did not really end till about 1920. By that later date the transformation of the Metropolitan

* Robinson (1910–1931) is a bit later than his successor in Boston, Fairbanks (1907–1925). Winlock (1932–1939) occupies somewhat the same position of an interregnum as does Holmes (1925–1934); and Taylor (1940–1954) and Edgell (1934–1954) closed their careers in Boston and New York simultaneously.

had taken place. It was from 1920 until 1930 indisputably the one and only great museum in the United States. Its sole rival in excellence was the BMFA; but the Met had a national, not just a local, position. This national position was based not only on the leadership and generosity of Morgan but on a series of golden windfalls that fell upon the museum from the turn of the century on. Some of these windfalls, like the Morgan collection or the Havemeyer bequest, could be legitimately considered "local support" — the beneficence of New Yorkers. Granted, Morgan was a native of Connecticut and Mrs. Havemeyer, whose taste ran towards Impressionists, was a Philadelphian. Nevertheless, the Morgan and the Havemeyer fortunes were New York fortunes. Another series of special windfalls, the procession of extraordinary Jewish collections that has distinguished the Metropolitan, was also based squarely on money made in the city, though some of the donors themselves were not native-born. A good many of the windfalls, however, were either not from New Yorkers at all or were from people who could be called New Yorkers only by courtesy. The fact was that during these thirty years from 1900 to 1930 the Metropolitan was so nationally famous that gifts were liable to come from almost anywhere.

The first great windfall had been the totally unexpected bequest of Mr. Rogers of Paterson, New Jersey. For the first time in its history the Met had real money to spend. From 1903 on it ceased to depend entirely on trustees and good friends like Miss Wolfe. The Metropolitan Museum appeared on the world market in competition with older and wiser museums. Pluck and luck were no longer enough. The staff had to become professional. The era of General Cesnola was over.

It is curious and instructive to see the sudden difference in the kinds of things the Met would accept as gifts before and after 1905. For instance, in 1905 the Museum gladly received from trustee Edward Dean Adams a loving cup that had been presented to him by the American Cotton Oil Company. It was engraved with symbols expressive of Genius, Husbandry, Commerce, and Modesty. Much ado was also made about the acquisition of a painting called *Temple of the Winds* by Louis Loeb, one of those Old Bohemians in Cleveland who gathered about Willard at the turn of the century. It is a pleasantly typical specimen of the kind of American academic art that graced the annual exhibitions of the Corcoran or the PAFA. A year later, in 1906, Roger Fry had come along, blown the Museum's complacency wide open and turned the thoughts of trustees and curators from Cotton Oil cups to Italian early Renaissance masters and the Impressionists.

The Morgan gifts and the Morgan and Altman bequests infused glory into every single area of the Metropolitan's collection except, rather significantly, modern art. In 1906 George A. Hearn gave a nice collection of Old Masters and, more important, a fund of one hundred

thousand dollars to be used towards purchasing the works of contemporary Americans. Advanced French art was already represented in the Museum by the Davis Manets, and Fry had forced the trustees to spend Wolfe bequest money on Renoir; but otherwise, though Morgan and Altman left the Museum with a splendid foundation in older art, the Metropolitan continued to lag behind in newer art.

Morgan and Altman did more than give. They set an example. The example of Morgan devoting his latter years to the collection of beautiful things inspired many another rich man to do likewise. The example of Altman inspired a whole series of spectacular donations by other great Jewish collectors in New York — a kind of continuing generosity, for instance, that has not been characteristic of the BMFA.

Robinson continued as Director through the last years of Morgan, through the exhibition of his collection in 1914 and its final gift to the Met in 1917, and through its installation in a separate Morgan wing by 1918. Morgan was succeeded in the presidency by Robert de Forest. De Forest had been the leader of those "Young Turks" at the turn of the century who had tried to oust Cesnola and been squelched by Marquand and Morgan. De Forest was the son-in-law of Johnston, the Met's first President, and, like second President Frederick Rhinelander, an Old New Yorker. His principal interest was appropriately in American Colonial arts. He was a successful railroad lawyer, but no Titan — a genial, jolly man, rather on the order of diarist George Templeton Strong, very firm and positive in his tastes and convictions but with none of Morgan's Medici arrogance.

De Forest's great personal contribution to the Metropolitan and indeed to the taste of America was in the area of the American eighteenth century. In 1909 the Museum had participated in the city's Hudson-Fulton celebration by putting on its first great display of early American painting and furniture. In that same year the most important early collection of American antiques, the Bolles collection, came to the Museum as a gift from Mrs. Russell Sage. Finally Mr. and Mrs. de Forest gave the American Wing, opened in 1924. These events as much as anything else established the taste for the Colonial that swept the country during the teens and twenties. Far more effectively than any modernist styles (which have not been really popular with Americans in their homes as they have been in offices or factories), the Colonial Revival banished Victorianism and substituted the simplicity and symmetry of the late Renaissance as manifested in England and its colonies under the Georges for the riotous exuberance of the nineteenth century. To be sure, this Colonial Revival has been passé for decades as far as most serious critics of art and architecture are concerned; and to read most recent historians of the twentieth century in America is to get the impression that Americans of taste live in houses

full of metal tubes and glass. They didn't and they don't. They live and have lived for the last fifty years, especially on the Eastern Seaboard, in small museums of furniture in the styles of the eighteenth century, foreign and domestic; styles first made popular by people like the de Forests.

The team of Robinson and de Forest accomplished more than that. Robinson, a slim, grim, elegant martinet, built up for the first time in the Met's history a staff of true professionals. William R. Valentiner, later famous as Director of the Detroit Institute, began his American career as first Curator of the Decorative Arts Department established in 1907. Robinson was established in charge of the Classical Department, firmly assisted by Gisela Richter, first and foremost of the Museum's woman experts. Robinson and Richter both were devoted to casts and fought a long and losing battle to keep them on permanent display.

Arthur Lythgoe, who had left Boston right after Robinson in 1906, brought along Herbert Winlock, fresh out of Harvard, and they made of the Egyptian section, helped by a constant stream of discoveries of the Met's own expeditions from 1907 on, a vast storehouse of treasure equal to that of Reisner's in Boston. In these two areas, Classic and Egyptian, the Met soon made up for the delinquencies of Cesnola's last years. When Valentiner went back to Germany to fight in the First World War, Joseph Breck took over the proliferating area of Decorative Arts. Bryson Burroughs, who became Curator of Paintings when Fry left, may not have been a very good painter himself but he was a fine critic, writer and buyer, and a constant champion of the best in modern art. Into the hands of this competent group and into those of the countercamp of the trustees who ruled over them — the most exclusive club in the city by this time — fell plum after plum. It would be idle and repetitious to attempt to list, much less describe, all of them. But some are outstanding by the most exacting standards.

After the Altman (1913) and Morgan (1917) gifts, the single most spectacular windfall of art was the Havemeyer bequest, which came to the Museum just at the end of the boom in 1929. The Havemeyers were a well-established New York family of German origin who for several generations had done well as sugar refiners. Henry O. Havemeyer (1847–1907) did more than well. He became a Titan. Like Rockefeller in oil or Carnegie in steel, he rose to be King of Sugar, head of a suspect and spidery trust that paralleled the Oil Trust and the Tobacco Trust of that age of concentration. As a Titan he was labeled with all the familiar adjectives — ruthless, secretive, power mad. As an art collector he had taste, zeal, and pots of money. He delighted in Old Masters like every other Titan. He, too, had his Rembrandts, which still bear witness to Havemeyer tastes in the Met. But Havemeyer differed from most of these Titans, except for Potter Palmer in Chicago, in having a wife

who was as active a collector as he was. It was the contribution of Louisine Elder Havemeyer that made the collection so very special.

Louisine was a Philadelphian who had the great good fortune to meet Mary Cassatt early in life. The families knew each other and Louisine got to know Mary in Paris in the early eighteen seventies. Before she really knew what she was doing, she was buying Degas. Her first purchase in 1875 was before that second of the Impressionist exhibitions in 1876 that made Degas notorious. It was then that critic Albert Wolff of *Le Figaro* wrote, apropos particularly of the Degas picture of his American cousins in their New Orleans cotton brokerage office, "Try to make M. Degas see sense; tell him that art includes qualities known as drawing, color, technique, control — he will laugh in your face and call you a reactionary." Wolff failed to dampen Louisine's zeal. When she became Mrs. Havemeyer in 1882 and could afford anything she wanted, she let herself be guided by friend Mary, who was also guiding Mrs. Potter Palmer along the same paths. So developed one of the world's great accumulations of French nineteenth-century art. Meanwhile the Havemeyer mansion, fantastically decorated by Louis Tiffany, was filled to bursting with all sorts of riches oriental and occidental. Most of it came to the Metropolitan, making it all at once the repository of French nineteenth-century art that it remains.

That was just one of the windfalls. Far less famous but almost equally spectacular was the Isaac D. Fletcher bequest of 1917. Nice Mr. Fletcher left not only his pictures, which were "uneven in quality," but also a fund of some three million dollars. Fletcher was particularly far-sighted in not placing onerous restrictions on the display of his pictures. As a result the name of Fletcher may not be as obtrusive as some others about the Met, but to live in the Met is far more than to live in a name, to paraphrase Vachel Lindsay.

Some of the gifts of two of the special categories of Metropolitan givers, the out of town Titans and the Jewish Titans, were less anonymous. Some of these out of town windfalls were simply freakish. A John Hoge who died in Zanesville, Ohio, in 1917 left a million dollars to the Met for no documented reasons at all. He just thought that arts and artists needed help. His other important beneficiary was a fund for aging actors. Even more quixotic (but not "out of town") was the immense Munsey bequest that was left to the Met in 1925. Munsey, a native of Maine, was anything but a lover of art. He was an entrepreneur who went to New York and made great fortunes in the publishing of magazines and newspapers, then in chain stores and Wall Street. He bought newspapers, squeezed profits out of them, and threw them away like old lemons. Nobody has ever been so hated by newspapermen. Instead of leaving his money to help destitute journalists, as

he should have by rights, Munsey decided one day in 1921 that the Metropolitan Museum of Art was as good as any other institution; so he made out a will leaving it all his money. Despite Munsey's newspaper losses and the inevitable legal complications, the Met eventually ended up with ten million dollars. A later thing of the sort was the Foulds fund that came to the Museum from an ancient lady, Mrs. Thomas H. Foulds, who died in Glens Falls, New York, in 1959, aged ninety-four. She left the Museum her all, some four and a half million dollars. Money attracts money.

The fact is that during this period the Metropolitan as number one and only one had a sort of status that probably no single museum today, not even the National Gallery, can equal. Just as millionaires like Frick and Carnegie moved from sooty places where their fortunes were made to mansions on Fifth Avenue, so the collections of out of towners moved to Fifth Avenue and the Met. One sometimes wonders if the mere address didn't have a lot to do with this. The Collis Huntington collection, for instance, a whole list of fabulous paintings by great artists including Rembrandt and Vermeer, came to the Museum in 1925 via son Archer Huntington. Collis was one of the Big Four who bossed and robbed California after the Civil War; and though he did have a pied-à-terre in New York, a typical ostentatious palace-with-gallery, he certainly could not be considered a New Yorker. Edward Harkness was one of that Ohio family that so fortunately got in on the ground floor of Standard Oil by way of marriage and Flagler. Flagler enterprise and Harkness capital had made of Edward Harkness in a second generation one of the great American philanthropists. His wife was a connection of Arthur Lythgoe and through him Harkness became interested in Egypt. Lythgoe shepherded Harkness onto the board of trustees in 1912 and from then till he died in 1940 the Met got one good thing after another from the Harknesses, both husband and wife (in particular the Carnarvon collection, greatest of its Egyptian kind in the world, which came in 1926).

As for the Jewish collections, at regular intervals they have sailed in like great galleons bearing treasure of all sorts, especially and oddly more and more beautiful madonnas with each galleon: Altman (1913), Friedsam (1931), Blumenthal (1941), Bache (1949), Lehman (1975), all incredibly rich in art objects of all kinds and nearly all burdened with stringent restrictions.

Benjamin Altman, one of the city's great department store owners, gave Italian paintings, America's largest private collection of Rembrandts, one of the world's most gorgeous collections of Chinese porcelains, as well as the Renaissance Rospigliosi cup, which even if it isn't by Benvenuto Cellini is still world famous. Friedsam, Altman's junior partner and heir down at the store, concentrated on Medieval statuary

and the like. Blumenthal's most conspicuous monument is the Spanish sixteenth-century patio in which he once actually lived when it helped decorate his apartment. It now forms the forecourt of the Watson Library. Along with it came a mass of other art, mostly Renaissance and Gothic objects. The Bache collection, rather breathlessly acquired in a few short years with the help of Duveen, excels in Italian and Flemish paintings of the kind that were once labeled "Primitive." The Lehman Collection, finally in its own grandiose glass pavilion with portraits of Lehmans at the door, is also heavy in Italian virgins of incalculable worth as well as French nineteenth-century paintings and a superb assemblage of drawings.

All these collections except that of President Blumenthal were bound by those nightmare requirements that everything must be kept intact and together. The Metropolitan's handling of this dilemma has been different from that of the National Gallery. The administration did not try to argue or compromise. They took the Morgan collection gratefully and put it by itself in its own wing. Only that last-minute generosity of the younger Morgan in the year he died, 1943, when he lifted the fifty-year restriction, prevented the Morgan collection from being sealed up and made inviolable till 1967. No such time limit seemed to be set in the case of the Altman, Friedsam, Bache, and Lehman collections. For years, from 1913 till 1954, the Altman collection had its own curator, Thomas Hobby, who saw to it that the Altman collection was kept separate and together and uncontaminated. For a good many years a suite of collectors' memorial rooms, Altman, Friedsam, Bache, were strung along together in a sort of golden ghetto through the European paintings, complete with Rospigliosi cup and other addenda.

But Mr. Hobby is no longer there to supervise and it is quite surprising how these restrictions seem to have evaporated. The Wolfe collection, once so proudly isolated, was still in an alcove of its own as of 1954. By now it too is gone altogether except for a gem or two dug up from the storerooms in the wake of a new wave of reappraisal. The Altman things are still together and still not mixed with other things, but the rooms containing them are no longer all in a line but scattered appropriately about the Museum, Rembrandts near other Rembrandts, porcelains with porcelains. This is obviously all to the good. Bache and Friedsam are now completely dispersed and intermingled.

Once the Met did balk. This was at an offering that had all the characteristics of a windfall. It was a rich haul of paintings of all periods as well as of decorative arts. It belonged to an out of town Titan, and it was all tied up with restrictions. This was the collection, offered in 1925, of Montana copper king Senator William Clark. Though the hoard was rich and good, it wasn't quite good enough. The Met made a grand display of virtue, in this one case, by turning it

down because of the restrictions and was properly applauded by the newspapers. The Clark collection then went to the Corcoran, which at the time needed it badly to make of it a true museum worthy of Washington. But when better things like the Bache or the Lehman collections came along, virtue at the Met easily succumbed.

The Havemeyer and Friedsam bequests were the last of the windfalls of the golden age of the post-Morgan era. With almost ludicrous appropriateness fate struck the Metropolitan at the same time she was busy with Wall Street, Europe, Asia, and other such minor matters. The bulletins of the Museum show no particular awareness of the debacle of 1929. Prosperity, the Republican trustees no doubt believed, was just around the corner. But this time there was no Morgan to lock the country's bankers in his library and force them to turn the tide. The tide was too strong in any case. It was not until 1931, the year of the Friedsam bequest, that the blows began to fall. In the bulletin of May of that year the death of Director Robinson was announced, in June the death of President de Forest. There was a holocaust of trustees. George Baker died at the age of ninety-two. Miss Lizzie Bliss, who had been infuriating the Museum for a decade with her insistence on the importance of modern art, died too, making the Museum a rather reluctant beneficiary of a small group of modern paintings. Edward Adams (of the Cotton Oil cup), Charles Gould, and the sculptor Daniel Chester French (one of the last representatives on the board in the tradition of artist-trustees begun by John Kensett) also died. Then Henry Walters of Baltimore, a survivor from the age of the Titans who like Frick and John G. Johnson was sucked onto the board in the wake of Morgan, died. Baltimore at last got its Walters Gallery.

William Sloane Coffin and Herbert Winlock took over as President and Director respectively. They were no match for fate. Coffin died after only two years in the presidency. Winlock, elected as a protégé of Lythgoe and Robinson to forestall the ambitions of talented but cantankerous Curator of Decorative Arts Joseph Breck, was not the man for the job. He was the last of the Boston group that had been so overwhelmingly influential after Cesnola. Son and grandson of astronomers, though he was a native of Washington where his father had been Assistant Secretary of the Smithsonian, Winlock had Boston roots. His grandfather had been the director of the observatory at Harvard; he had graduated from Harvard in 1906 to follow Lythgoe directly to Egypt under the auspices of the Metropolitan rather than of the Boston Museum of Fine Arts.

Egypt is where Winlock preferred to be. He was, like Reisner, a man for digs, not offices. A rugged, genial outdoorsman whom everybody liked (in startling contrast to Breck) with a more or less one-track

mind, he was unsuited for the indoor job of running a great engine of culture through the rough seas of a depression. Fortunately the finances of the Museum were tightly in the hands of George Blumenthal, who succeeded Coffin as President. Thanks to Blumenthal's penny-pinching but acute financial direction, the Museum stayed afloat; but it was hard times all round.

With the extraordinary exception of the Rockefeller donations of and to the Cloisters, the age of windfalls was over for the time being. Attendance declined; membership dropped. The Met got shabbier and shabbier. Smaller but still rich bequests and gifts did come in. Ogden Mills died in 1937 and left some fine Dutch and Flemish paintings. There were exhibitions. Monies from earlier funds like those of Rogers, Fletcher and Munsey continued to be available for the purchase of good things. A new hall of armor was opened in 1939, reflecting the tastes of William Riggs and Bashford Dean. A great Titian Venus came to roost. On the whole, however, the period between 1931 and 1939 was the doldrums.

And the end of the doldrums was again prefigured by coincidental strokes of fate. In 1939 Winlock's health finally broke down completely and he was forced to resign. In 1941 Blumenthal died. A new Director, Francis Henry Taylor, and a new President, William Church Osborn, took over and with them a new era, the period of reconstruction, began.

ii

Francis Henry Taylor (1903–1957) was, like John Singer Sargent, a Newbold. That at least would be the Philadelphia way of putting it, for in Philadelphia everybody knows the Newbolds. Though they have never done anything very special, they always seem to have been there. Taylor's mother was a Newbold.* The Taylors were different. They were a distinguished medical family. As the Bigelows were holy in Boston, so were the Taylors in Philadelphia. Francis was expected to be a doctor, as Sturgis Bigelow was. After going to the hereditary University of Pennsylvania, however, Francis became infatuated with France. He taught at a school at Chartres, and there and later at the Sorbonne his infatuation narrowed down to French Gothic. He returned to do graduate work at Princeton, then in 1927 he joined Fiske Kimball as

* A cousin of Mary Cassatt married a Newbold. The cousin's mother rejected a portrait Mary Cassatt made because the "nose was wrong." Mary was furious and threw it into a closet where it was discovered years later by Louisine Havemeyer. Mary presented it to the Met, where as *Lady at the Tea Table* it is now one of the gems of the Met's collection.

Curator of Medieval Art at the Pennsylvania-about-to-become-Philadelphia Museum. In 1931 he moved to Worcester, Massachusetts, as Director of the city's Museum.

A miniature BMFA, a big-city museum in a small city — the population at that time was not more than two hundred thousand — the Worcester Museum is one of the country's older ones, created in 1896 by the Salisbury family, who gave it their funds and their pictures. There was enough money to permit Worcester to keep buying good things while the buying was good. This process continued to flourish under Taylor, and he is generally given credit for making Worcester not only the proud possessor of a splendid small universal survey collection but also turning the Museum into a very active center of art education. Worcester's proudest possessions are the best of American seventeenth-century New England paintings, the famous pair of Freake portraits, stiff but elegant in elaborate laces and brocades, and the delightfully melancholy portrait of Thomas Smith, hand on skull, skull on manuscript of morbid poem.

Taylor then came to the Met with a reputation as a pioneer, a person who stirred things up. He was the youngest director who had ever been appointed to the post — he was only thirty-seven at the time — and he certainly lived up to his Worcester reputation. In the end he was responsible for completely remodeling and rearranging the whole Metropolitan collection.

But first came the war. As the National Gallery spirited all its newly acquired works, almost as soon as they had been hung, away to the great Vanderbilt mansion, "Biltmore," in Asheville, North Carolina, so the Met took fifteen thousand items to Philadelphia. They were put into "Whitemarsh Hall," the former Stotesbury mansion. This rival to "Lynnewood Hall" had been built by Morgan's Philadelphia partner and decorated at fabulous expense by Duveen. When the Depression came and Stotesbury went broke, the decor proved not to be as valuable as Duveen had indicated and the house was left stripped and unsalable. It was, however, just the place for refugee art, far from German submarines and potential bombs.

As a result, the Met was more or less empty during the war. Taylor's job was to keep things going by exhibitions and events; but the removal and then final return of the collection in 1944 gave him the excuse he needed for changing the interior of the Museum. In a sort of gigantic spring cleaning, he announced this transformation in 1950 with impressive publicity — a great long-term project in various elaborate stages labeled I, II and III. Stage I, the complete remodeling of some ninety-five galleries and the rehanging in them of the European paintings, was actually completed by 1954. The rest of it went on for

years. In fact one could almost say it has never been finished, since Taylor's remodeling has merged right into Hoving's expansion.

This great plan was Taylor's major contribution to the Museum as Director; but his new broom was evidenced in other ways. His advent marks the end of regimes dominated by New England archaeology — Robinson, Lythgoe, Winlock — and the beginning of regimes dominated by medievalists — Taylor, Rorimer, Hoving — none of them New Englanders and two of them trained at Princeton. Taylor as a personality brought to the Met that swashbuckling, dynamic, colorful and dictatorial atmosphere created by the prima donna director, as exhibited so forcefully in Philadelphia by Taylor's former boss, Kimball. It is a bit like a heat wave moving up the East Coast; first the Bostonian Kimball in Philadelphia beginning at the end of the 1920s, then the Philadelphian Taylor in New York at the end of the 1930s, finally the New Yorker Rathbone in Boston at the end of the 1950s. They shared two things especially: not only were they commanding and colorful personalities, they were also essentially *museum* men, not amateurs like Cesnola or archaeologists like Robinson. (Taylor was, for example, inferior as a medievalist to his juniors such as Curator William Forsyth; his talent was for running things.)

As a more sophisticated version of Kimball, Taylor liked to overeat and tell outrageous stories and could be rude to trustees. But whereas Kimball broke things and seemed crude, Taylor was all wit and flair. He was a fluent linguist, especially in French, and liked to act the part of some member of the Bourbon family or a descendant of François Premier. This attitude of casual and caustic superiority, an arrogance not assumed like Kimball's but natural, disconcerted the trustees, used as they were to stubborn but still subservient scholars. Whereas Winlock yearned to be back in the sands of Egypt, Taylor liked being in the very center of the New York stage. He could combine captivating charm with temperamental fury. He alternately or simultaneously delighted and terrified the staff and cajoled and offended the board. The lower echelons of the Met's increasingly vast family adored him because of his personal and paternal acts of kindness. Higher and more scholarly echelons felt less secure. He instituted the office of Vice-Director, installing in that position another Philadelphian, the Orientalist Horace H. F. Jayne, former Director of the University of Pennsylvania Museum (he was a Furness), and in general did his best to weed out old survivors and replant the departments with fresh greenery.

He turned the Roman Court, pride and joy of the haughty Classical Department, into a restaurant. He tried to make himself master of the Cloisters, but Rorimer backed by Rockefeller checked that attempt at directorial expansion. He drastically changed the format and appear-

ance of the bulletin, transforming it from a fusty but informative newsletter into a journal of art scholarship, beautifully illustrated in color.

Then rather suddenly and surprisingly, after the opening of the newly remodeled galleries of European paintings in 1954, he resigned. Though he had been at the Museum for fifteen years, he was still a fairly young man. But he had become bored with administrative responsibilities. Worcester had offered him his old job and he took it eagerly, looking forward to a delightful but busy rustication among his old friends there. In just a few years, as of 1957, he was dead. Thus passed, at fifty-four years of age, one of the great directors of the country and of the century.

<p style="text-align:center">...</p>

<p style="text-align:center">iii</p>

All this time, beginning in the days of Robinson, the Metropolitan was hatching a completely separate museum, the Cloisters. It is very special. For one thing, though an integral part of the Met, it has its own curator-director who runs the establishment independently. For another, it is almost completely the donation of one man, John Davison Rockefeller, Jr. It represents the final capitulation of that puritanical family, in its second generation, to art. Ironic that John D. Rockefeller, Sr., was the only one of the five great Titans to withstand the blandishments. His descendants have been making up for lost time.

It wasn't an easy victory for beauty. Junior was full of compunctions. His first love was Chinese porcelains. In 1915 he wanted to pick up a collection of them for a mere million. This wasn't very much by Rockefeller standards, but it so happened he lacked the funds and wanted his father's help. An almost pathetic letter of self-justification survives: "I have never squandered money on houses, yachts . . . or other foolish extravagances. A fondness for these porcelains is my only hobby — the only thing on which I have cared to spend money. This hobby . . . is quiet and unostentatious. Is it unwise for me to gratify a desire for beautiful things which will be a constant joy to my friends and to my children . . . as well as to myself?" He got the money.

Junior, born in Cleveland in 1874, was then forty. The Rockefellers were well settled into their roles on the stage of the big time, but it wasn't till the next generation with Nelson and David that the family could really be considered native New Yorkers. In 1915 it was still an example of out of town money being invested in town. The particular Chinese porcelains Junior had his eye on, and eventually got, were for sale by Duveen from the Morgan estate; so there was a real laying on of hands and apostolic succession here. These porcelains led on into rugs, especially the so-called Polonaises woven of silver and gold thread in

the Near East for European royalty, and then from rugs into tapestries and from tapestries into medieval art as a whole and thence to the Cloisters. Since Morgan himself had been an earlier famous collector of such things, the succession is clear. Thus are family enmities curiously reconciled.

John D. Rockefeller, Sr. was introduced by a mutual architect friend to the sculptor George Grey Barnard (1863–1938). Barnard was a native of Pennsylvania whose mother was connected with one of the great early pre-Carnegie ironmaster families characteristic of the region. His father was a Presbyterian clergyman with a ministry that took him to various small towns in the Midwest. Barnard's first interest was in natural history and taxidermy. From stuffing specimens in Iowa he moved on to studying sculpture in Chicago at the Institute's school. From there he went in 1883 to Paris. In 1894 he exhibited at one of the Salons and was an instant success. His statue *The Struggle of the Two Natures in Man* made him famous overnight. He liked to claim that Rodin wept before his celebrated marble out of sheer admiration and jealousy. The statue was bought by a rich industrialist and presented to the Met, where for many years it was a dominant feature of the sculpture exhibit that cluttered the Great Hall. In 1900 Barnard returned to America and to the best of all possible artistic careers, that of the profitably employed artistic rebel. The conservatives, still at work on chaste nudes like those of Powers and frock-coated generals, helped his reputation by attacking him.

Barnard, an egotistical and self-assertive man full of grandiose ideas, belongs to that group of important American sculptors of the turn of the century not perhaps yet fully appreciated. His biggest commission came to him in 1902 when a new state capitol was being built in Harrisburg, Pennsylvania. Barnard was given a seven-hundred-thousand-dollar contract to supply some half-dozen great clumps of statuary to decorate it. He removed to a studio in France on the River Loing and there began chipping away on his masterworks. Unfortunately expenses outran income, since he took so long at his own carving instead of getting journeymen stonecutters to do the work like most other nineteenth-century American sculptors. In order to tide him over between payments from Harrisburg, he began to pick up bits and pieces of Gothic statuary lying about the countryside near his studio and sell them to dealers and patrons in America.

In the middle of his work a great scandal broke in Harrisburg. The construction of the capitol turned out to be a case of literally monumental graft. Funds were cut off and it looked as though Barnard might starve. But a group of enlightened businessmen came to his financial aid and he turned seriously to merchandising Gothic sculpture as a means of livelihood. He managed to get two of his Harrisburg

groups finished and installed, and in 1913 he returned to America where his reputation suffered no damage from the Harrisburg scandals. He set up a studio in the far north of Manhattan Island, still comparatively wooded then, and there created about it a one-man Gothic museum.

The core of Barnard's museum and the reason for its name was his acquisition and removal from France of large sections of several beautiful monastery cloisters. The most famous was that of the former Benedictine establishment of St. Michel-de-Cuxa located down near the Spanish border. This monastery, founded as early as 878, had been one of the greatest and most powerful of its kind. By the time Barnard got to it, it was long a ruin, liquidated by time and the French Revolution. Unlike most Gothic remains, some of the bits and pieces of Cuxa's twelfth-century cloisters, with richly and grotesquely carved capitals, had been rescued in the 1870s by a French fancier, pioneer in that area of collecting, and put up to decorate his garden. Another set of Cuxa cloister columns adorned the public baths in the town of Prades. Most of the Gothic items Barnard got, however, were found lying buried in the dung heaps of farms, used as parts of the masonry of storehouses and barns, tombs turned face down to serve as bridges over ditches, vaulted chambers converted into small-town movie theaters. Actually a certain amount of Barnard's stuff was simply bought from dealers, but his talk was all of his personal discoveries in country nooks and corners.

He constructed a big brick barn with a skylight shielded by a cloth "valerium" to produce the proper dim religious light. The outside walls had columns and arches stuck into them. Inside, three walls were surrounded by a two-story reconstruction of a couple of his rescued cloisters, and the rest of the area filled with Gothic virgins, tombs, altarpieces, and every other kind of Gothic handicraft except tapestries. Rockefeller had the tapestries. Outside was a garden surrounded by what Barnard had been able to take from France of the Cuxa cloisters, just in the nick of time in fact. After he had got the pieces from the public baths, the French Government suddenly woke up to what was happening. Like the Japanese Government under the proddings of Okakura, the French became aware of seepage. Everything like the Cuxa cloister material was to be labeled as a *Monument Historique* and not allowed to leave the country. Barnard got his cloisters out just a few days before the law went into effect.

John D. Rockefeller, who was now collecting not only tapestries but sculpture, disliked Barnard but fell in love with his cloisters. In 1925 Barnard felt the need of cash. He was contemplating an incredibly grandiose project involving something called the Rainbow Arch. This was a hundred-foot-high structure crawling with nudes to the glory of mankind and G. G. Barnard, which perhaps fortunately never got

built. Barnard put his Cloisters Museum on the market and Rocke-
feller, who by then did not have to consult his father, bought the whole
museum and its contents and presented it to the Metropolitan. He also
added half a hundred pieces from his own collection. Under the direc-
tion of Joseph Breck, Curator of the sprawling Department of Decora-
tive Arts (which included a good third of the objects in the Museum),
the Cloisters was refurbished and reopened in 1926 as a suburban ad-
junct of the Museum downtown.

Time passed. The neighborhood of the Cloisters soon ceased to be
woodsy. The Barnard building rapidly became overcrowded with
Rockefeller gifts. It was obviously time for a move. In 1930 Rockefeller
gave New York City Fort Tryon Park, at the very tip of Manhattan
Island; and on the crest of its highest hill he reserved a place suitable
for building a new Cloisters. He had never liked the dictatorial Joseph
Breck, nicknamed the "Prussian" by his underlings, any more than he
had the exuberant Barnard. Rockefeller never bought anything else
from Barnard, though like Jarves, Barnard made a second collection,
which ended up in the Philadelphia Museum. Breck was very much
involved in the early plans for the new Cloisters, but after he died in
1933, some say his days shortened by his chagrin at not being made
Director instead of Winlock, Rockefeller found a soulmate in Breck's
Assistant Curator James J. Rorimer (1905–1966). Along with the pa-
tient and sensitive architect Charles Collens of the Boston firm of Allen,
Collens, and Willis, Rockefeller and Rorimer worked over every detail
of the plans for achieving the most perfect possible medieval museum.
The rocks of Fort Tryon were an ideal site for it, and Rockefeller had
even gone so far as to preserve the Palisades across the Hudson as a
park so that no intrusions from the twentieth century would mar the
view in that direction.

Back at the Met itself things were less euphoric. No more windfalls.
Instead it was scrimp and starve. Plumbing, heating and ventilation
became antiquated and inadequate. Exhibits weren't changed and
gathered gloom. The skylights began to leak, and just like the PAFA
in the dim days on Chestnut Street before the fire, buckets were set out
to catch the drip when it rained.

Meanwhile Rockefeller, Rorimer, and Collens, impervious to Depres-
sion and New Deal, went on with their plans, which were painstaking
and elaborate in the extreme. A complete life-sized mock-up of wood
and burlap was built on the site of the new museum, the whole first
floor, so that Mr. Rockefeller, measuring rule in hand, could get a true
idea of what was going to be there. A beautifully handcrafted small-
scale wooden model of the whole as it might appear when completed
was made, each work of art in miniature placed on its pedestal and
artfully illuminated. Eventually in 1938 the new Cloisters was opened.

As a special gift in honor of the occasion Rockefeller presented his most precious possession, the wonderful Unicorn Tapestries, that fairy-tale wonder of late French Gothic weaving.

When the new museum annex opened complete with its cloisters, including those of Barnard, the Metropolitan became the foremost museum of Gothic art in the world, except for the Cluny Museum in Paris. In and about the four cloisters that made up the core of the new building — two inside and two outside enclosing authentic gardens — were a whole interlocking set of chapels, chapterhouses, great halls, and treasure chambers, full, but never too full, of priceless Barnard, Rockefeller, and other masterpieces from the Middle Ages. Though by now much of the contents may date from more recent times, a lot of it purchased by Rockefeller's munificent ten-million-dollar fund of 1952, the Cloisters as it stands is as much a monument of John D. Rockefeller, Jr. as Williamsburg. It remains the single most important of the family's belated but by now extensive intrusions into the world of art and art museums.

The Cloisters was a special triumph for young Rorimer, still less than a dozen years out of college when it opened. With the appointment of Taylor in 1940, the reign of the Medievalists began. Of the three, Taylor, Rorimer, and Hoving, Rorimer had the least formal scholarly training, but his long association with the building of the Cloisters provided him with an education in the field. Even when he became Director of the entire Museum, he kept a firm personal grip on his Cloisters. Rorimer was unique among Metropolitan directors in that he was completely a Metropolitan man. He had never worked anywhere else at all, an almost unprecedented oddity in the profession. Rorimer came to the Met at the age of twenty-two in 1927, right after his undergraduate training by Sachs at Harvard, and there he stayed till he died suddenly in 1966.

Rorimer was born in Cleveland, like his patron Rockefeller. He was the son of a very successful large-scale interior decorator. His original patronymic had been Rohrheimer, a German-Jewish name that had been anglicized in his branch of the family. Rorimer himself was absurdly sensitive about this change of name and would never forgive anyone who called him Rohrheimer. In fact this established a personal pattern of evasiveness, concealment, and subterfuge that made him difficult to work with. The Metropolitan's attitude on the subject of Jewishness was unquestionably ambiguous in any case. The older trustees had no doubt included many outright anti-Semites, but the important role played by Jewish collectors, critics, artists and dealers tended to modify these attitudes. The election of Blumenthal, who was unabashedly Jewish, was very much a first in such museum circles; but Blumenthal was well aware of the undercurrents of prejudice and was careful

not to seem overanxious to push Jewish appointments to the staff or the board. Because of Rorimer's sensitivity on the subject, Rorimer's appointment as first Jewish Director of the Museum had none of the impact of the forthright Blumenthal's presidency.

Perhaps the fact that he was a born Clevelander had something to do with Rorimer's extraordinarily close and productive relationship with Rockefeller. In any case, the wholehearted backing of Rockefeller and the continuing success of the Cloisters made the appointment of Rorimer as Director to succeed Taylor almost inevitable. The contrast provided a necessary relief. After the dynamic clatter and glitter of Taylor, the quiet sobriety of Rorimer was a blessed change. His directorship was a sort of plateau, a period of consolidation. Taylor's grandiose plans of reorganization were continued and fulfilled. It was a time of growing attendance, continuous accession, complete refurbishment, but not of windfalls, new wings, spectacles or scandals.

In fact during his directorship the Metropolitan finally came of age, was "finished." Its collection no longer had the glaring gaps so evident when Roger Fry first brought them to public attention. The situation was underlined by one of the few really notorious events of Rorimer's career, the purchase for two million three hundred thousand dollars at auction, by Rorimer himself, of the Rembrandt *Aristotle Contemplating the Bust of Homer*. The picture once might have come to the museum free. It was owned by the Huntington family of California and most of his father's pictures were given to the Met by son Archer; but *Aristotle* belonged to his mother, not his father. Unfortunately it was later sold to someone who appreciated its monetary value, and when the Met wanted it they had to pay for it. This was of course gilding the lily. The Met was already chock-full of Rembrandts. It could hardly be argued it needed just one more. This was, however, a superlative specimen, and no one of the Met's others quite matched the *Self Portrait* at the Frick or the *Old Mill* at the National Gallery. The Met could afford *Aristotle* and this purchase signified the kind of thing such a museum now had to acquire — marvelous single works to be added to the top of the collection, not lots of lesser works to fill in gaps down below. Crowds formed in line to look at the picture when it was put on view in 1961. Some howled over the extravagance, but on the whole it did the Museum's reputation more good than harm. The purchase was a harbinger of Hoving, a forecast rather than a typical gesture of the more subdued Rorimer period.

Rorimer's constant interest in training younger men bore fruit when he unexpectedly died in his sleep after a busy day at the Museum. Hoving had been one of his special protégés, trained first at that fountainhead of all Medieval studies, Princeton, and then at the Cloisters. His defection to city government as Parks Commissioner had been

a blow to Rorimer. Hoving's selection as Director to succeed him would have been a satisfaction. Whether or not his protégé's subsequent career would have been as satisfactory is, however, doubtful. Hoving harked back to Taylor, who was definitely not one of Rorimer's favorites. And the director as prima donna has never had a more prominent exemplar than in the successor to that devious, brown, ruminative good housekeeper, that director's director, James Rorimer.

Chapter VII

(The Anti-Met)

i

ART-LOVING TOURISTS to New York City go as a matter of course to the Metropolitan and the Frick, but these museums aren't specifically "New York." They derive from European precedents — the Louvre and the Wallace collection in London. The museums art-loving tourists visit that are very specifically "New York" are those Three Sisters of Modernism, the Musum of Modern Art (1929), the Whitney Museum of American Art (1930), and the Solomon R. Guggenheim Museum (1937). Although these official dates of foundation are somewhat indeterminate — the Whitney for instance was in embryo long before 1930 and didn't really open till 1931 and the Guggenheim did not really begin as a public museum until 1939 — there can be no doubt about the entirely twentieth-century quality of all three. They perfectly typify the spirit of Manhattan: advanced, stylish, up-to-date, above all "Modern."

All three came into being to support the then militant and rebellious cause of Modern Art, in three different aspects, and to combat the

lethargy and distaste for the new expressed by the columns on the facade of Morgan's Metropolitan. The Whitney and the Museum of Modern Art (MOMA) were blood relations, if not quite twins. The Guggenheim is a stepsister, no kin at birth but gradually growing closer in feeling over the years. Nowadays it's rather hard to tell them apart. At least their exhibitions of new works are very much alike. They are distinguished not so much by what they show as by their permanent collections and by their buildings and locations. But they were quite different when they began.

The Whitney and the MOMA were the direct result of those two most seminal of all art exhibitions of the American twentieth century, the Ash Can show and the Armory Show of 1913. These exhibitions, more properly called the exhibitions of "The Eight" (1908) and the International Exhibition of Modern Art (1913), were the final fireworks of the rebellions beginning in the nineteenth century that have characterized New York from its artistic beginnings.

The Whitney grew out of the exhibition of 1908, MOMA out of that of 1913. In both cases the leading spirits were women. The same group of artists, the Eight and their friends, helped. The women of the Whitney were founder Gertrude Vanderbilt Whitney and her secretary Juliana Force. The women of MOMA were Miss Lizzie Bliss, Mrs. John D. Rockefeller, Jr., and Mrs. Cornelius J. Sullivan. The artistic allies of the Whitney were legion, Robert Henri and most of his pupils. The artist who advised the founders of the MOMA in its earliest days was that unlikely member of the Eight, Arthur Bowen Davies.

ii

Gertrude Vanderbilt Whitney was a skillful sculptor of what might be called liberal Academic nudes. They bore titles like *Aspiration* and *Wherefore*. She did statues for fairs and exhibitions and was a respectable figure in the art world of New York after 1900 on the strength of her talent alone. She also represented the conjunction of three great fortunes. There was the thoroughly New York fortune of her great-grandfather, that rugged railroad man Commodore Cornelius Vanderbilt. Then there were the later fortunes of her husband, Harry Payne Whitney. He inherited Whitney money (streetcars) and Payne money (Standard Oil). Mrs. Whitney was thus a significant figure as a patroness. Though not advanced in her own work, she was a friend of the advanced art of others. She bought four of the seven canvases sold from the epochal 1908 show at the Macbeth Gallery and kept right on collecting the works of the Eight and their followers until she finally presented some five to six hundred works to her new Whitney Museum.

In 1929 she had tried to give them to the Met. Robinson turned her down cold and her angry reaction was to create a new museum to hold them.

She had originally set up a studio in Greenwich Village in 1907 and held informal exhibitions of her friends' work there. In 1914 she created an official Whitney Studio by converting the house next door into a gallery. In 1915 she formed a Friends of Young Artists that held shows at the Studio, and in 1918 she founded the Whitney Studio Club. Her secretary, assistant, and director of enterprises throughout was that woman so aptly named Juliana Force, married to an obscure physician.

Juliana, née Rieser, had been born equally obscurely in Doylestown, Pennsylvania. She started her career as a social secretary for another Mrs. Whitney, sister-in-law of Gertrude, then moved to Macdougal Alley and the various Whitney establishments there and on Eighth Street. She was a pert, petite, pugnacious redhead with a deep contralto voice, full of exuberance and administrative energy. She had a vein of earthy humor that appealed to artists and made a necessary bridge between Bohemia and the refined world inhabited by ladylike Mrs. Whitney. "Dynamism, sociability, wit" are the words used to describe her magnetism by those who admired her. Some were made uneasy by her favoritisms and her Machiavellian guile in dealing with the politics of art in New York City. But as a liaison between a lot of money and a lot of hungry artists, such political skills were vital.

The Whitney Studio Club was not exactly exclusive. The dues were only five dollars a year and delinquents were not pursued and ejected. Any serious artist proposed by a member could join, and there was no attempt to foster special credos or Isms. Even academic artists belonged; but artists of the School of Henri were the key figures. The Stieglitz Group (O'Keeffe, Marin, Dove, Hartley, Sheeler, Davis, Demuth et al.), always considered more radical and Europeanized than the Eight, though they did occasionally participate as individuals in Whitney exercises, were more aloof as a group. The core centered about the School of Henri. There were parties and feeds (sometimes desperately needed by less well known members) and exhibitions, particularly the one-man shows by one Whitney organization or another that often marked the beginnings of successful careers. Hopper, Du Bois, Sheeler, Sloan, Glackens, S. Davis, K. Miller, R. Marsh, and J. Curry were typical of those shown. These Studio and Club shows evolved into the Museum's Annuals and Biennials that still continue today. The Club also encouraged sales, promoted reputations, and tried to make the American public conscious of what younger Americans were doing.

For though the period after 1900 was as artistically ebullient in New York as it was everywhere in the Western World, American painters were not happy. The Golden Age of the Art Union was long gone,

when every American home hung a hand-painted oil painting or an engraving of same. First Goupil sold his Salon artists, then Knoedler's sold Old Masters, then came the Impressionists sold by Durand-Ruel. No true connoisseur would touch American art. Murals for state capitols were painted by Academics like Kenyon Cox and Edwin Blashfield and Edwin Abbey. Sargent and Chase did fashionable portraits. But on the whole it was European art, old and new, that had the prestige and dominated the market and brought the biggest prices. Such domestic market as there was was firmly controlled by the respectables of the National Academy through exhibitions, prizes, and juries. Younger or more independent artists didn't have a chance. It was this state of affairs that Gertrude Whitney wanted to change.

By 1928 things *had* begun to change. The Whitney Studio Club was in fact getting out of hand. Too many members joined; too many more wanted to join. The cosy, clublike atmosphere of the early days when everyone had been together at the Art Students League had been lost. The public and the critics were now paying attention to American art. Some even bought it. The Phillips Gallery after 1921 and the Museum of Modern Art in 1929, though they both concentrated on European art, did show new American art. They pointed the way towards the foundation of a Whitney Museum of American Art. Announced in 1930, opened in 1931, this new museum with its headquarters and galleries on Eighth Street had somewhat the same impact on Americans that the formation of the old National Academy of Design had had almost exactly a hundred years before. It was a symbol of reaffirmation of the strength and vitality and, above all, the nativeness of American art. Americans were no longer going to be thought of as mere distant followers of European fashion. There was to be an expression of the new, the real, the fresh, the dynamic. Whether radical or nostalgic, realist or abstractionist, art was to reflect the America of the present.

So at least the members of the Whitney Studio Club felt. After the Second World War much of the art that had seemed so revolutionary and exciting before was obliterated by the explosion of the postwar New York School. It is hard to recreate the cheery excitement that emanated from the Whitney's galleries on Eighth Street and filled the American art world during the twenties and thirties. The essential source of exuberance was the personality of Juliana Force and that long series of embodiments of Whitney generosity, first her own studio of 1907, then the Studio gallery of 1914, the Club of 1918, something called the Whitney Studio Galleries in 1928, and finally the Museum of 1930–1931.

iii

The Museum of Modern Art when it originated was as forthrightly Silk-stocking and Cosmopolitan in its bias as the Whitney was Leather-stocking and Nativist. It was intended to show and advertise the advanced artists of Paris to America. Whereas the central artistic figure of the Whitney was Robert Henri and his pupils and their pupils, the central figure of the MOMA was Picasso and his contemporaries. The conjunction of woman and artist in this case was Miss Lizzie Bliss and her devoted friend Arthur Bowen Davies.

Arthur B. Davies (1862–1928) was a most unlikely spark plug of modernism. As a person he was reticent and conventional: a high-stiff-collar gentleman. As an artist he belonged to the dream-impregnated tradition of Blakelock, Vedder and Ryder. One would expect him to be hidden away in a dark cluttered studio, oblivious to trends.

But all this was deceptive. Despite his proper appearance, Davies led the life of a de facto bigamist, with one wife and family back in New York State where he came from and another "wife" he took to Italy with him in his final years. His championship of modernism was demonstrated by his connection with the so very different Ash Canners in their 1908 show and by his direction of the Armory Show of 1913 after the defection of J. Alden Weir from the presidency of the organization that put it on. It was under Davies, working with his artist friends Maurer, Kuhn, and Pach, that the scope of the exhibition was broadened to include Europeans. The Europeans, of course, stole that show, made the Americans all at once seem provincial, and started America off officially on its career of eventually triumphant modernism. Davies himself went modern in his late years, applying cubistic distortions to his nudes. The effect was not necessarily happy.

His relations with Miss Bliss were also rather typically discreet and ambiguous. They were certainly most intimate friends, one of those Edwardian friendships of daily teas and intense conversations about art. It was Davies who guided her into the world of Post-Impressionism. There never seems to have been any hint that they were more than friends. Lizzie Bliss, so christened, though she preferred to be called Lillie, was a submerged maiden lady, typical of her time. Full of sensibility and brains, she was nonetheless a slave to a dominant mother and forceful father. Her father was a very successful businessman in New York, but a native of Fall River, Massachusetts. His mother had been kin of Bordens there, and the name Lizzie may, who knows, have had the same family roots as that of the Lizzie Borden who gave her father forty whacks. Lizzie Bliss gave her parents a lifetime of devotion. Her

father had been McKinley's Secretary of the Interior, and she aided and abetted her invalid mother in her patronage of music and acted as her father's hostess. When her parents were dead she came under the influence of Davies and switched from music to art. She formed one of the best and earliest American collections of what was then "modern," Impressionists and Post-Impressionists, and tried to force her taste down the throat of the Metropolitan. She had social connections with many of the trustees; her brother eventually became one of them. She herself acted as an advisor and in 1921 she and Davies engineered a show of advanced Frenchmen that caused a good deal of excitement, not all of it favorable. An anonymous group urged in print that all right-minded citizens write letters of protest to the Met against this debasement of culture and morals. Only ten such letters were received; but the Met did not go overboard for modern French art.

Lizzie had another ally. This was Mrs. John D. Rockefeller, Jr., born into the rich Aldrich family of Providence. John, Jr., himself had no use for modern art. Chinese porcelains, Persian rugs, Gothic tapestries, but certainly not Cézanne and Matisse and Picasso. Abby, however, joined Lizzie in trying to further the Cause. Mrs. Rockefeller's tastes tended naturally towards folk art, as testified by the splendid Abby Aldrich Rockefeller Folk Art Museum in her husband's reconstructed Williamsburg. But she also collected moderns. At first she concentrated on prints that could be hidden in drawers away from her husband's sight.

A third woman joined the battle, Mrs. Cornelius J. Sullivan. Her husband was a lawyer, an old associate of the pioneer collector John Quinn. Mrs. Sullivan herself had been an artist and teacher and ran a small gallery. The three ladies, despairing of moving the Met toward anything more advanced than Impressionism, decided that, like Gertrude Whitney, they needed a museum of their own. The trio asked to lunch a crusty Buffalo millionaire named A. Conger Goodyear. He was an unlikely but eager champion of the Cause, a hardheaded businessman who had worked to convert the Buffalo Art Institute and had gotten into trouble up there as a consequence. The ladies asked him to be President of their projected museum. They needed a man out front. He bought a new suit to meet them in and said yes.

Paul Sachs, an original trustee, recommended as first director a youth named Alfred H. Barr, Jr. Barr was born in Detroit of a clerical family, graduated from Princeton in 1922 (M.A., 1923), and then studied at Harvard under Sachs. He had taught at various Ivy League universities, male and female. When he assumed the directorship of MOMA he was only twenty-eight and still virtually unknown. Not for long. Despite a not overwhelmingly ingratiating personality, at least with strangers, his curious combination of lively esthetic sensibility and fer-

vent evangelical zeal for the Cause created a dynamic energy that made the MOMA the leader in art circles it still is.

Barr was thin, pointy-nosed, and more ascetic than esthetic in appearance. He could display a fantastical humor with familiars and be forbiddingly caustic and superior with others. On the one hand he could describe his emotions during a Princeton football victory over Harvard in terms of a listener at a symphony concert. On the other hand his smile could be described by an ill-wisher as comparable to "soil erosion." Nonetheless he seemed to have a genius for making the right friends and above all picking the right trends. Under him the MOMA was the first to patronize photography and films as serious art forms. Whether he exhibited abstracts or surrealists or African art or George Caleb Bingham, his taste was sure to be vindicated by time. The position of MOMA as leader of fashion and establisher of reputations goes back to its first decade under Barr. Many of the artists shown and bought by the Whitney are now forgotten. The Guggenheim's storerooms are full of now obscure abstractionists. The art and artists favored by Barr and his museum still tend to remain memorable.

The official opening date of the Museum of Modern Art was 1929. The first exhibit was held in modest rented quarters on the twelfth floor of the Heckscher Building at Fifty-seventh Street and Fifth. By 1939 the Museum was established in its own building on Fifty-third Street where it has been ever since. The first show — Cézanne, Seurat, Van Gogh, Gauguin, largely from three collections, Bliss, Dale, and Lewisohn — forcefully announced the keynote of the new institution. It was to be a place where the School of Paris would be introduced to New Yorkers. New Yorkers were enchanted. "The effect is breathtaking," exclaimed *Art News,* and the crowds flocked in. The long love affair between French Post-Impressionism and America was officially under way.

Not everybody was happy. New York artists were not happy. They thought a museum of modern art ought to be showing modern American art. So the second show was of the work of "Nineteen Living Americans": Burchfield, Demuth, Hopper, Kuniyoshi, Marin, O'Keeffe, Sloan, and other members of the Henri and Stieglitz circles.* People were still unhappy. The second exhibition was noticeably less popular than the first. There was the usual fuss about why only nineteen and why just these nineteen; the same fuss caused in 1970 by the Geldzahler show at the Met. Crowds did not flock. The third exhibition reaffirmed the pattern of foreign popularity. It was called "Painting in Paris" and included Picasso, Matisse, Derain, Bonnard, Braque, and Rouault. The

* The complete list: Burchfield, Demuth, Dickinson, Feininger, Hart, Hopper, Karfiol, Kent, Kuniyoshi, Lawson, Marin, K. Miller, O'Keeffe, Pascin, Sloan, Speicher, Sterne, Weber.

crowds were even denser. The criticism however was more mixed; conservatives were less wildly enthusiastic. At the end of the winter season the Museum, grimly determined to do its duty by home manufactures, showed Homer, Ryder and Eakins. Only a handful of visitors came. Nineteenth-century America was still déclassé.

The message was quite clear. New Yorkers wanted to see the art of Paris at the Museum of Modern Art. Since the Whitney organizations were already championing new America and the Met had adopted old America, why not a division of effort? The Met should house Old Masters of any kind, the MOMA and the Whitney, new masters. This was a sensible plan. In the end, though it was tried, it didn't work. As it turned out, this was all to the good; but as of 1930 it seemed proper.

William Sloane Coffin, when he succeeded de Forest as President of the Met in 1931, thought some sort of tripartite arrangement of museum affairs would be a good idea. He tried to get the three museums together but died before any real progress was made. Blumenthal, who succeeded him, wasn't much interested. Winlock was little more enthusiastic about modern art than Robinson had been. Lizzie Bliss died in 1931. Plans for cooperation were shelved.

The death of Miss Bliss had a momentous effect on the Museum of Modern Art. She left a few of her paintings to the Metropolitan, where they did little to change attitudes or broaden the collection. She left most of her pictures to the Museum of Modern Art. Suddenly the organization, just at its beginning, had a permanent collection of superlative value on its hands. It could no longer be content to be just an exhibition gallery. Final acquisition of the Bliss collection was contingent on the Museum's raising an endowment fund sufficient to house and take care of the collection. Miss Bliss forced MOMA to become a true museum, not what the Germans call a *Kunsthalle*, but a *Kunstmuseum*. Miss Bliss had collected great works, and many of the MOMA's most famous older pictures, such as notable Cézannes like his *Apples* and *Oranges,* the Gauguin *Moon and Earth,* the Redon *Silence,* and the Seurat *Fishing Fleet,* come from her.

But with this windfall the specter of dual identity appeared to haunt the institution, and this ghost has not yet been laid. How can one justify an aging permanent collection if one is a museum devoted to what is *modern?* How to reconcile keeping abreast with keeping nineteenth-century classics? As long as the Museum could concentrate on the new, as an art center or *Kunsthalle,* it had a legitimate, well-defined place in the art world. But once it began to store older pictures, then what was "modern" about it? Exactly the same dilemma faced the Whitney. Homer, Eakins and Ryder had already been embraced and canonized by the Met. It was just a question of time before Sloan, Glackens and Bellows became similarly saintly. From 1930 till just before

1950 such problems remained acute and affected the policies of all three museums. They still remain acute, but nobody seems to bother. Gertrude Stein once suggested that a museum could either be a museum or modern but not both. She may have had a point.

iv

When Francis Taylor became Director of the Met the whole business of a tripartite agreement was revived. Taylor believed that he believed in modern art. He did not turn his back on it like Robinson or Winlock. He thought it was "a good thing" and that something should have been done about it at the Met. The Great Museum should not be left behind. It must be aware of new trends. But of what trends? Many people involved in the art world in this period seem to agree on one thing: Taylor's otherwise expert eye was far from infallible when he applied it to the contemporary scene. Nonetheless, beginning in 1943, a plan was worked out whereby the Whitney was to move from its cosy but crowded nest on Eighth Street to a new Whitney pavilion. This was to contain all the American paintings of both collections, and the Whitney was to continue to exhibit and buy new things, aided by the Met's Hearn Fund. Meanwhile the MOMA was to concentrate on new European art and turn over its classics to the Metropolitan, the Louvre of America. The Whitney in the mid-thirties had begun to acquire specimens of older American art with the idea of becoming a true all-around American museum. In line with its agreement with the Metropolitan, it changed course and sold its older paintings. In the same vein the MOMA sold to the Met a group of twenty-six of its best older works.

Then it gradually began to dawn on both lesser institutions that the position of Jonah in the belly of a whale was not a happy one. It was obvious that the Metropolitan of Francis Taylor was only too likely to absorb and obliterate both Whitney and MOMA. There was a famous dinner at the Brook Club attended by representatives of all three that began amicably and ended in a violent free-for-all. The coalition never recovered. The Whitney withdrew in 1948 and the MOMA severed relations in 1952. In 1949 the Met activated its own program of contemporary American art under Robert Beverly Hale, and the idea of noncompetitive spheres of influence was buried, never to rise again. No one at the time foresaw the dominance of the Abstract Expressionists based in New York, but the museums couldn't have planned better for this emergency if they had tried.

v

As it turned out, the New York School had not one, not three, but no less than four museums attendant at its creation. The Guggenheim, quite separately from the two earlier museums, had emerged as a collection in the 1930s and from 1939 on as a place of permanent institutional exhibition. It, too, was a champion of the advanced.

"What is Modern Art?" began Mr. Goodyear in his summary of MOMA's first ten years. He didn't answer the question. He didn't know the answer. Someone who did know was Hilla Rebay, Baroness von Ehrenwiesen. Her dogmatic answers to this question created the Guggenheim Museum.

The Baroness, still another powerful museum-creating female, was a native of Alsace who moved eastward into Germany to study and practice art before the First World War. She became involved in one of those radical German groups that proliferated through the twentieth century until Hitler put an end to them. This one, located in Berlin, was called *Der Sturm* (The Storm). As the seedbed of MOMA might be considered the group of Les Fauves and that of the Whitney was certainly the Ash Canners, so the Guggenheim was conceived in the bosom of The Storm. The dominant creative talent of this storm was Wassily Kandinsky, the revolutionary Russian artist who first emerged in Munich as a pioneer abstractionist. During the war he returned to his native Russia, but his theories and practice were carried on in Berlin by a disciple named Rudolf Bauer. Hilla Rebay became the slave, intellectual and one presumes physical, of Bauer and devoted the rest of her life to advertising Bauer's theories and paintings. The theories, in some sense derived from Kandinsky, were based on the superior spiritual value of abstract over representative art. Free of the shackles of imitation and the material, the fancy, led by genius, could explore a realm of pure creation like that of music. It was a New Era. "Non-objective" rather than "abstract" was the English term, evidently coined by Hilla, to describe the work of Kandinsky, Bauer, and Rebay.

Somewhere along the line in the middle 1920s Hilla met Solomon R. Guggenheim. The Guggenheims were descendants of Swiss Jews who had lived for generations in a country village ghetto near Zurich. Two generations of Guggenheims, father Simon and son Meyer, with many dependents, immigrated to America in 1847. On the boat coming over, Meyer fell in love with his stepsister Barbara Meyer, and when they all landed Meyer and his wife (after 1852) followed almost exactly the pattern of Herman and Helen Cone.

They settled in Philadelphia and worked up from door-to-door

peddling to industry. Whereas the Cones ended up as textile manu-
facturers in North Carolina with various sons running various mills,
the Guggenheims ended up in Colorado and elsewhere with various
sons of Meyer variously but cooperatively running mines and smelters.
While the Guggenheim family was settled in Philadelphia, they dealt
in the importation of lace. They made the amazing shift to metals by
way of the purchase of a flooded Colorado silver mine. When they
struck it rich the whole family moved to New York and soon became
thoroughly intertwined with "Our Crowd" by ties of friendship and
marriage.

There were eleven Guggenheim children. Of seven surviving broth-
ers, five were active in Guggenheim enterprises. Solomon was one of
these five. He seems to have been the only one seriously interested in
art, having first been introduced to it through his wife Irene, née
Rothschild. Like everyone else, he began with what is usually euphe-
mistically referred to as Barbizon pictures, which really means Pom-
piers, Salon gems. He, too, graduated to Old Masters. Then he met
Hilla.

Hilla's first official connection with Solomon was as a painter of his
portrait, although theoretically by the middle twenties she had long
outgrown such primitivism.* At first both Solomon and Irene were her
friends. Soon Irene "cooled." This may have meant that she thought
the friendship of her husband and the Baroness was growing too hot;
but it probably was just another of the estrangements that almost in-
evitably occurred between Hilla and everyone who knew her. Described
in later life as a stocky hausfrau or as a battle-ax, she evidently had
more allure when younger. Everyone admitted her ability to charm
when she chose and her hypnotic personality. To Solomon she was
enormously and expensively persuasive. He financed her both person-
ally and as his agent in building the world's greatest collection of non-
objective art. She bought for him hundreds of Kandinskys and Bauers
and quite a few Rebays, too. A few other artists were also purchased to
be installed in the first-class compartment of the non-objective express.
The Frenchman Gleizes, the Hungarian Moholy-Nagy, the Englishman
Wadsworth made it; but no Americans were included in the first cata-
log. Hilla did, however, set herself up as a minor Maecenas to various
mostly obscure American talents. In the second-class compartments
were a group of artists she couldn't quite justify in theory but that she
and Solomon liked in practice. She got around this by categorizing
them as of "historical interest," forerunners. They were either the John

* Theoretically, but in fact she kept right on painting realistically. Peter Lawson-
Johnson, grandson of Solomon and present President of the Museum, has portraits
of himself as an infant painted by Hilla.

the Baptists of the new religion like Delaunay, Chagall, Klee, Modigli-
ani, who had been groping in the right direction, or Judases like
Picasso, who had started off right and then betrayed humanity by back-
sliding into representation. Friends of Solomon liked to maintain that
he was the master of his own collection. The best pictures were often
those hung in his own rooms. But those hundreds of Bauers were Hilla's
choice.

She was certainly infatuated with him. To what extent was Solomon
infatuated with Hilla? He was a gentleman who kept his private affairs
carefully to himself. He gives nothing away in correspondence. Hilla
herself vehemently denied that he was anything to her except a
Maecenas and a father figure. After all, he was thirty years older. But
no one can deny that the Guggenheim Museum as it stands owes its
origins to the Baroness von Ehrenwiesen and her ability to influence
Solomon R. Guggenheim.

The first exhibit of the Guggenheim collection occurred in 1936, and
in the most unlikely possible place, the Gibbes in Charleston, South
Carolina. Guggenheim owned a plantation near Charleston, a house on
the Battery, and other real estate there, so the connection becomes
clear. Still it was an odd place for this novel exposure of form and color
to take place. There was an expensively printed catalog. On the cover
was a color reproduction of Hilla's favorite Bauer, a composition en-
titled *Blue Balls*. Inside the preface by Hilla begins, "For thousands of
years astronomers . . . believed that the earth was the center of the
universe." Hilla, as the Copernicus of modern art, then goes on to
reject the antiquated theory that "the object in painting was the center
around which art must move." The catalog that follows lists, and il-
lustrates with small inserts, *all* the sixty-one works of Bauer, the twenty-
eight works of Kandinsky, and the five works of Gleizes that formed the
core of this heaven-and-earth-shaking show. Rebay included four
Rebays. There were also five Moholy-Nagys, two Légers and Wads-
worths, and one Klee. In the back of the catalog, as befitted their
secondary position, were listed the inferior "paintings with an object,"
not illustrated: three Chagalls, three Klees, Gleizes in his more unfor-
tunate objective phase, Delaunay, Modigliani, and even five Seurats.
These general proportions were maintained until Hilla lost control of
the Foundation. In the end the Guggenheim found itself possessed of
well over two hundred Bauers, almost two hundred Kandinskys, and,
fortunately, lots of Chagalls, Klees, Delauneys, and other low types
below the salt. Even Picasso was reluctantly included as an object les-
son.

There were following exhibitions in 1937, 1938 and 1939, each with
its similarly expensive catalog and effusive Rebay preface. The one in
1939 celebrated the showing of the collection in New York. In each

catalog Hilla can be observed in her finest frenzy. "Nonobjectivity is the realm of spirit . . . the cosmic sense, beautified by genius. Its experience is the culmination of culture." Or "A painted copy of nature . . . is not a real creation." (Abstractions of the French school are therefore impure.) "Spiritual life" is missing in "earthly reproduction and also in abstractions of nature. It is for this reason that abstractions are of no interest to the Solomon R. Guggenheim Foundation." As for individual artists: "Kandinsky and Bauer are already referred to by some people as classics." On the other hand, Surrealists are "vague intellectual criminals who try to hide their impotency." And as for Picasso, he was "the hasty producer of other people's inspirations, has nothing to offer in lasting value of spiritual content. He is essentially useful only to commerce and its constant need of mass production." He is included only for historical reasons and "to show how much more in comparison to him the great masters [Kandinsky and Bauer] have to say." These great masters "speak the language of eternity."

By 1939 Hilla comes right out and proclaims, "In this collection is represented . . . a genius, the greatest of all painters," none other than Rudolf, "whose every work . . . is an accomplished masterpiece." As for Picasso, "the future possibilities of his fame are doubtful and tragic." But as another startling illustration of the fortunate difference between what Hilla said and what Hilla did, she ended up buying twenty-four Picassos before she was done!

The year 1939 turned out to be the cutoff date for the greatest of all painters. Bauer had been set up in Berlin in a house-gallery of his own, all paid for by Guggenheim. Hilla was in America as full-time purchaser for the Foundation. She purchased everything Bauer painted. When Hitler took over, it is to Bauer's credit that he was classed among the degenerates. He was transported out of Berlin and set up in an establishment, complete with servants, on the Jersey shore in that enclave of summer places sacred to "Our Crowd." He almost immediately stopped painting for good. He lived on the bounty of a trust set up by Guggenheim, peremptorily reminding them of payments when due.

Unfortunately he had the bad taste to become amorously involved with his housekeeper, one Louise Huber. Hilla did not like this. In public and private she characterized the new "Frau Bauer" as a whore, fortune-hunter, and worse. Louise sued for libel. A private eye was hired by the Guggenheim lawyers to investigate the lady and Hilla's aspersions were corroborated. The suit was dropped; but Bauer continued to live on Guggenheim money till he died in 1953. Kandinsky is still universally admired as the founder of pure Abstractionism. The name of Bauer is not often mentioned.

vi

Meanwhile, in that same fateful year of 1939, the Guggenheim collection moved into its new home, right across Fifth Avenue from the Museum of Modern Art on East Fifty-fourth Street. This is the proper date for the foundation of the Museum, though the Foundation was already chartered by 1937. Hilla was Director.

These temporary quarters would obviously never do and a permanent home worthy of such spiritual treasures must be created. Hilla knew just the man to do it. She herself wrote to Frank Lloyd Wright in 1943 and soon the dream house became a projected reality. Wright had the commission that same year and Guggenheim bought part of the present site and announced the plan for the new museum in 1944. Hilla and Frank were by then on a first-name basis. The concept of the spiral as the Ur-Symbol of the Soul's Progress was the kind of idea Rebay and Wright could share.

From then on it was a long battle of Ur-Symbol versus building codes. Costs as well as symbols could spiral. Archaic New York laws stood in the path of genius. Genius clashed with genius. Before long Frank and Hilla had at each other as only two such egocentrics could have. The Foundation continued to exhibit in various temporary quarters, but its Bauers and Kandinskys became overfamiliar. Young artists studied them with intense interest, and their presence in New York was certainly of crucial importance for the development of Abstract Expressionism there; but critics and the public grew restive. The exhibits were badly installed and repetitious. Hilla was to blame. It was becoming obvious that she was not suitable as the director of an up-to-date artistic institution. The war inhibited construction.

Then after the war Solomon decided to lay low, expecting a repetition of the depression that followed World War I. It didn't occur, but money was not spent freely by the Foundation. Meanwhile the city fathers took a very dim view of the snail-shaped monstrosity. It violated every restriction in the book. Only the adventitious fact that the wife of all-powerful Robert Moses happened to be a cousin of Frank Lloyd Wright made the building possible. Moses didn't care for the thing himself, but he did like Cousin Frank; so to oblige him he rammed the building through the bureaucracy and at last the city permitted it to be built.

The usual strange fatality that so often, as in the case of the National Gallery, seems to dog museums dogged this one. In 1949, long before the building was completed, Guggenheim died. He left his money to the Foundation to complete and maintain the museum, and Solomon's

nephew Harry took over the direction. Harry had no particular interest in art. He liked horses and airplanes and was an early backer and friend of Charles Lindbergh (like Bixby in Saint Louis). However he regarded the completion of the museum as a sacred trust and as a proper memorial to the Guggenheim family. Study in England at Cambridge had given him a sense of dynastic traditionalism.

Harry very soon realized that Hilla would not do. She was becoming more impossible by the year. In 1952 he appointed a new director, James Johnson Sweeney, already famous as an expert on modern art, who had been briefly a director of the MOMA after Barr. The design of the building, which originally consisted of nothing much except the spiral gallery suitable for Bauers and a lush apartment for Hilla with circular chambers in it, was altered to suit the needs of an expanded site and a real working museum. Sweeney found himself caught between Hilla and Wright. Though Hilla was no longer director, she remained on the board and her basic conception of the museum persisted. She wanted her museum to be a shrine to Solomon and non-objectivity. Harry Guggenheim intended his museum as a shrine to the glory of the Guggenheim family. Wright intended his museum to be a shrine to Wright. Sweeney wanted to make a real art museum of it.

Sweeney began a great program of acquisition, beefing up the collection in the many areas of modern art where it was weak, notably sculpture, of which it had none (Hilla did not approve of sculpture; it was too "objective"), and works of those renegades of the School of Paris. He opened out the museum to the real world of art and broke down the claustrophobic barriers of pure abstractionism. Soon he and Wright were battling over office space and the color of wall paint and areas of jurisdiction. Things got so bad that Sweeney tried to resign before the building was even finished. Just before it was completed, Wright died. Just after it opened in 1959, Sweeney finally resigned. None of the original progenitors, Solomon, Hilla, or Frank, were present when the grand opening took place. Sweeney and Mrs. Wright were on hand, but they were not scheduled to speak for fear of some dreadful outbreak of hostility.

But in fact everybody's dream was more or less realized. Hilla had her spiral museum where at least Kandinsky, if not Bauer, held a place of honor. Harry certainly had his family mausoleum, a conspicuous memorial to Uncle Solomon. Sweeney had his museum of modern art as a worthy rival to MOMA.

But the victor in the end was Frank Lloyd Wright. His only building in New York City remains his most famous architectural triumph. The spiral of the Guggenheim serves as the background on the two-cent stamp printed to commemorate him. The "city of cockroaches" that he so despised was the scene of his final apotheosis. The building is what

people come to see, not the Bauers. Indeed the whole permanent collection is hardly ever visible now except during the summer doldrums. The winter exhibitions cover that same well-exploited frontier of the Advanced over which both MOMA and Whitney hover. It must be terribly difficult nowadays to remain an unknown radical artist if you have any talent or original ideas at all. As for the invisible permanent collection, it is one of the world's treasure troves of modernism. The emphasis is still somewhat heavily on Central Europe. Klees and Chagalls may outnumber Mondrians and Mirós, but the whole spectrum is represented. As for that charlatan Picasso, thanks to the addition of the Thannhauser collection in 1965, which is on permanent display, Picasso and his dubiously objective French friends are now, along with Wright, triumphant at the Guggenheim.

Hilla, who finally died in 1967, would have been furious.* She was furious enough when she left her directorship; furious, but solvent. She retired to a fine country house in Connecticut with hundreds of pictures, some hers but many others belonging to the Foundation or Mr. Guggenheim personally. The Foundation tried tactfully to get them back, but to no avail. When she died, the Foundation tried to sue, but also to no avail. Finally they bought a whole lot of pictures from a newly created Rebay Foundation for a million dollars, and then the Rebay Foundation let the Guggenheim Foundation have custody over all of Hilla's gains, well or ill gotten. Besides these, the Foundation is also supposed to inherit the Venetian palazzo of Solomon's niece Peggy, with all its pictures, thus creating a sort of Guggenheim "I Tatti." And meanwhile the Museum keeps on buying.

The three buildings of the three museums are famous sights of the city. The still up-to-date-looking early-modern building of MOMA of the 1930s, located in Rockefeller Country between Fifty-third and Fifty-fourth streets west of Fifth, with its beautiful sculpture garden, is certainly one of the town's favorite rendezvous. The Whitney tried moving up next to it in 1954 but grew restive; and with the avowed object of getting more room to show its permanent collection, in 1966 it moved farther uptown to Seventy-fifth Street and Madison. Whereas the Mittel European Guggenheim collection is housed in one of the city's most American buildings designed by one of the most Nativist of architects, the Nativist collection of the Whitney is housed in a building by the essentially Mittel European Marcel Breuer. The Breuer building makes a fine chocolate brown background for exhibits, but like the Guggenheim you seldom if ever get to see the permanent collection.

* There was a big Malliol show there in 1976. Non-objective indeed! But later in that same spring a massive retrospective, put on to celebrate the publication of a catalog by Angelica Rudenstine, displayed selections from the permanent collection up to 1945. It did indeed justify the Rebay taste and discernment — theories or no theories.

MOMA faithfully shows a comprehensive survey of every facet of "modern art" from the late nineteenth century up through World War II, so that there one does see at least some of the permanencies. In fact, with three floors devoted now to the permanent collection, it is becoming a true and splendid *museum* of twentieth-century art. The Sloans and Hoppers of the Whitney and the Kandinskys and Klees of the Guggenheim blush more or less unseen.

All three sisters, and the Met, too, have added to their holdings the works of those ruthless conquerors of the art world, the so-called Abstract Expressionists of the New York School. Alfred Barr at the MOMA was the first to recognize them, even before the war when the Whitney was still living in the world of Realism and the Guggenheim loading up on Bauers. A whole set of circumstances — the war, the influx of European refugee artists, the conversion of a whole generation of Americans to Hilla's doctrine of non-objectivity, a new generation of younger viewers and buyers — brought about this postwar revolution. Nonetheless the influence of these by-now middle-aged champions of novelty in backing and presenting was tremendous. From the 1950s on these museums did as much to establish the respectability of this kind of art as any other possible agency. The millions of dollars involved in the unsavory squabbles over the Rothko estate indicate how well established the New York School has now become.

So where now? How long and how far can the word "modern" be stretched? Can the Whitney still call John Sloan, the MOMA call early Cubism, or the Guggenheim call Kandinsky "modern"? Are they to play the role of *Kunsthalle* or *Kunstmuseum*? Can they continue to be largely showcases for new talent or should they give their continually increasing and valuable permanent collections more room and more time? The MOMA does best, but even so it exhibits only a fraction of its treasures. The American art of the Ash Can School is now prized by every museum in the country. The Whitney has the nation's greatest deposit of it, but you can't hope to drop in any day and study it. As for the Guggenheim and the Chagalls and Klees that are piled up in storage. . . . This is certainly art and ought to be seen, but it is not contemporary and it all becomes less so every year. Gradually the role of a museum of twentieth-century classics is going to be forced on the Three Sisters, "modern" or not.

vii

The New York scene is of course richer, more varied than just this confrontation between the old and the new, the Met and the anti-Met, would suggest. There are several other museums well worth the visit of

art-loving tourists if they have any energy left after seeing the Met, the Frick, the MOMA, the Whitney, and the Guggenheim. There is that splendid collection of Americans at the New-York Historical Society, plus Audubon and a bit of Bryan. Up on the site of Audubon's old country estate is the Huntington family's somewhat melancholy museum of the Hispanic Society in the middle of appropriately Spanish-speaking slums. It has archaeology and Hispanic masterpieces by Velásquez and Goya and is worth a pilgrimage. Nearby is the Heye Foundation's collection of Indian material. It is intended to be scientific but is richly rewarding esthetically. If you like beautiful coins, the Numismatic Society has its headquarters right alongside, too. Farther downtown is the Museum of the City of New York, history, but still a lot of ingeniously displayed art and artifacts. There are other Rockefeller projects, John III's Asia House and Nelson's Museum of Primitive Art (soon to be absorbed into the Metropolitan).

An attempt to buck the trend and to react against the frenzy of the Three Sisters for the Advanced was the Huntington Hartford museum on Columbus Circle. Hartford tried to counter by showing Dalis and Pre-Raphaelites, but this was one museum that failed. It was taken over as a cultural center by a New Jersey college and had interesting exhibitions, but it is now closed. If the trend is to be bucked, it will probably have to be the MOMA that does it. Sinister cracks in the picture window of Bauhaus have opened. A startling exhibit of drawings by nineteenth-century Beaux Arts architects shocked everybody in 1975. Bouguereau is coming out of the cellar. Maxfield Parrish next? But whither? What will be the future fate of museums devoting themselves to the contemporary? Watch the continuing story of the Museum of Modern Art, the Whitney Museum of American Art, and the Solomon R. Guggenheim Museum.

BOOK V

Filling in the Form

Chapter I

i

WITH THE OPENING of the Museum of Modern Art in New York and the National Gallery in Washington, one could say that the actual development, as opposed to the mere growth, of the phenomenon of the art museum in America came to an end. That is, growth since the Second World War has been spectacular, but it has been more of the same. The additions to the art scene of a National Gallery, of a Museum of Modern Art, of a museum of American art meant something special, new, different. The opening of still another big-city pride or private collector's joy does not change the picture, it merely enlarges it.

Thus it would be repetitious to attempt to chronicle the spread and diffusion of the art museum into every part of our nation by describing the individual vicissitudes of each new important museum, picturesque as some of these travails have been. Samples and examples will have to do. Growth has been largely a matter of Filling in the Form.

Filling in the Form has consisted of either the increase in bone, muscle, and flesh taking place in already well settled areas, the regions of New England, Middle Atlantica, the Midwest, or the extension of

the art museum into other areas, the South, the West, the West Coast. The kinds of museums founded in all these areas have followed the patterns already set. The local accents, however, have been strong and the characteristics varied.

The final date of the solidifying of the basic pattern, the skeleton, might be put at 1941 with the opening of the National Gallery; the secondary growth could be said to have gone on right from the 1870s. It continues to this moment. The foundation of most of America's older institutions has been chronicled, that of many of the new ones can't be chronicled; but a few significant ones should at least be mentioned. A brief mention does not indicate a lesser importance, merely that the museum, no matter how important, is not fundamentally different from others of its kind already described.

ii

In New England, outside of the larger centers of Boston, Providence and Hartford and aside from such famous smaller-city museums as that of Worcester, or the college museums of Yale, Smith, Wellesley and Bowdoin, there has been a proliferation of smaller museums and the continuous creation of more college museums.

Portland, Maine, for instance, has a museum, part of it in the Lorenzo di Medici Sweat mansion, an elegant old family house of 1800. It dates its origin to 1882 (the museum of Portland, Oregon, claims 1892). However, foundation is one thing, actual opening is another. Portland, Maine's museum opened in 1911, which is a very respectable date. The Currier Gallery in Manchester, New Hampshire, and the Berkshire Museum in Pittsfield, Massachusetts, are other examples of good smaller museums in smaller places. The two museums in Springfield, Massachusetts, already chronicled, are still others of the same. All these help to make of New England the most densely populated of the country's art regions: one can go shorter distances here and find more museums than anywhere else in the United States. Then there are all those other college museums: Colby in Waterville, Maine; Dartmouth in Hanover, New Hampshire; Amherst and Williams in Massachusetts; and so forth.

Williams not only has its own college art museum but has been the somewhat bewildered but very pleased beneficiary of a magnificent private museum, the Clark Institute, which was plunked down next to the college in Williamstown for no very clear reason. It is not part of the college but certainly serves the students. A small but rich assemblage of Western painting especially benevolent in Renoirs housed in a white marble rectangle, it was placed where it is at the whim of the

founder, Sterling Clark, largely because Williamstown seemed remote from any possible atom bomb. The Clark fortune was made in Singer sewing machines; another Clark brother, Stephen, active on the boards of MOMA and the Met, also collected. The Sterling and Francine Clark collection is quite separate, and the museum is one that, like the Phillips or the Frick, everybody always loves. An incidental pleasure of the Clark is that it is also one of the few museums that even as early as its opening in 1955 condescended to exhibit Pompiers. That corner of New England's Far West has become a center of visual culture, what with the Clark Institute, the Williams College Museum, and the two galleries, town and gown, in nearby Bennington, Vermont.

Another charming private museum is the Hill-Stead in Farmington, Connecticut. This was the residence of the Riddles. Mrs. Riddle (Theodate) was the daughter of a precocious collector of Impressionists in Cleveland in the 1890s, Alfred A. Pope. The house is the very model of the sort of neo-Connecticut mansion that old Clevelanders, yearning after their Nutmeg roots, have built in the better suburbs of Cleveland and is filled with beautiful furniture, beautiful Monets, and other such delights.

iii

Then there is New York State, an empire all its own in the world of the art museum. Between the pioneers of Buffalo and the great roaring art center of New York City there stretches a whole galaxy of Upstate museums of various kinds. These have been described by S. Lane Faison, Jr. in *Art Tours and Detours* (1964). One could wish that some other states in the Union were as fortunately chronicled. He covers not only splendid city centers like those of Elmira or Utica, college collections like those in Ithaca (Cornell) and Rochester, but also such tucked-away serendipities as the Hyde Collection in Glens Falls, a baby "Fenway Court" with a startlingly comprehensive display of paintings of all ages. New York exclusive of New York City rivals Ohio and Massachusetts as the foremost of the older states in number and excellence of art museums.

Altogether there are over a dozen such art museums scattered through the state and out on Long Island.* Syracuse, for instance, has two museums, a town museum, the Everson, and a college museum, the Lowe. The Lowes were inveterate founders of such smaller museums.

* A partial list of places that have galleries in them: Buffalo, Rochester, Syracuse, Utica, Glens Falls, Albany, Conajoharie, Elmira, Ithaca, Cooperstown, Poughkeepsie, Yonkers; and out on Long Island, Hempstead, Huntington, Southampton, Stony Brook.

There is another Lowe gallery at Hofstra University in Hempstead and a Lowe Museum attached to the University of Miami. Cornell's college art museum is now housed in a magnificent new building. The Hudson River Museum of Yonkers is housed in a magnificent old Trevor mansion. House and land were given to the town by the family. The land became a park, but the town didn't know what to do with the house. It was a white elephant. Then a real live elephant visiting Yonkers as part of a circus died and his carcass was bought, stuffed, and put in the house as its first exhibit, thus making a museum out of it. By now the Museum has gone on to perhaps higher if smaller things and contains a true art museum concentrating, as is appropriate along the Hudson River, on nineteenth-century American art.

Of these upstate museums, probably the most distinguished are the universal survey collection in Rochester, home of Eastman Kodak, and the clumsily named Munson-Williams-Proctor Institute in Utica. This is the fortunate possessor of the Root collection of twentieth-century American art. Edward Wales Root was one of those valiant John the Baptists of Modernism, along with other such brave collectors as John Quinn, Katherine Dreier, and Lizzie Bliss celebrated by Aline Saarinen in her *Proud Possessors*. Root and his like did much to create the atmosphere out of which the Whitney and the MOMA grew. There is a fancy new Philip Johnson building of 1960 to house these Root treasures, and altogether Utica has cause to be suffused with pride along with the Munsons, the Williamses, and the Proctors.

A special aspect of art in both New England and New York State, and increasingly elsewhere, is the restored village or folk art museum complex. It is hard to know whether such things are strictly "art museums" or not. In New England the personal collection of Electra Havemeyer Webb, daughter of the Havemeyers, is spread across acres of Shelburne, Vermont, and has everything in it or on it from a complete eight-hundred-ninety-six-ton paddle-wheel steamboat to a collection of Old Masters and French Impressionists, leftovers from the parent Havemeyers. It also displays a mass of cigar store Indians, weathervanes, wooden eagles, and sundry indigenous craftwork. Old Sturbridge Village in Massachusetts is another of the same, more strictly devoted to crafts and less to art. No Impressionists. Mystic, Connecticut, has a salty seaport museum, a whole small waterfront town with buildings full of objects associated with seafaring; this, incidentally, includes art of various kinds from figureheads to Chinese Export goods and the newly opened seaport art gallery, given in honor of Rudolph Schaefer.

In New York State perhaps the most famous of all such folk-art-and-craft collections are those of the New York Historical Association in Cooperstown. The Farmers Museum has lots and the Fenimore House Museum a lot more, ranging from utilitarian tools to paintings by

American masters. Then there are the great depositories of Williamsburg in Virginia and Greenfield in Michigan. More are created every year.

iv

The lower states of the Middle Atlantic region, New Jersey, Pennsylvania, Delaware, Maryland and West Virginia, are by no means as thickly fruited with good art museums as are New England and New York State. Down there the significant museums tend to be centered in Megalopolis — New York to Washington. Outside of the big cities, the museums are less important than those northward in similar smaller places.

In New Jersey the Newark Museum has always been distinguished for its advanced exhibitions; but like Brooklyn, it is really part of the metropolitan complex of greater New York City. However it does concentrate pretty heavily on New Jersey art and artists, particularly in its various yearly exhibitions. The New Jersey Historical Society in the same city has a very fine historical museum that includes paintings and furniture along with documents. Montclair in further suburbia has the country's largest collection of native son George Inness as well as other things. Beyond Princeton's college museum to the south is the State Museum in Trenton. It doesn't yet have a permanent collection, though it is trying hard; but does put on continually interesting exhibits in a very stylish modern building.

All about Philadelphia lies a ring of smaller towns and cities, the Red Brick Fringe of heavily Germanized and also Philadelphianized communities full of old red brick houses and small good colleges. Various kinds of museums sprout there, like the Pennsylvania Farm Museum of Landis Valley near Lancaster, Pennsylvania, another "craft village" that specializes in Pennsylvania Dutch folk art. Most of these don't fit the more restricted definition of "art museum," but some of them do.

In Bethlehem, up the Delaware, Lehigh University has an art gallery. In Allentown next door is the best known of all these Red Brick Fringe museums, since the Kress brothers gave a collection to their almost-native town. Reading has a small museum with science downstairs and pictures upstairs. Scranton has some pictures, and so has Greensburg, farther west. York and nearly every other such town you can think of has an historical society collection and preserves an historic house or two. Portraits, furniture. And so it goes.

There is the Washington County Museum of Fine Arts in Hagerstown, Maryland, just below the Pennsylvania line. It is a county rather

than a town museum. Like so many others, it was founded by Pittsburgh money. William H. Singer, a Pittsburgh millionaire who painted, or a painter who was a Pittsburgh millionaire, had a wife whose childhood associations clung to Hagerstown. Singer himself claimed to be the first Pittsburgh painter to be exhibited at the Carnegie Institute as of 1900. His father had been one of Carnegie's partners. Though the Singers actually spent most of their time in Norway, they thought enough of Hagerstown to give it, as of 1931, a full-fledged museum of art, complete with Old Masters, Americans, and Orientals. The Americans have survived best, along with a handsome room full of Norwegian Singers. In Harrisburg up the Susquehanna you will find those hunks of sculpture by George Gray Barnard.

South of Philadelphia lies Wilmington, Delaware, principality of the Du Pont family. It contains some really special esthetic surprises. The most special is "Winterthur," once a lived-in Du Pont mansion, now the Henry Francis Du Pont Museum. It is the largest and most beautiful collection of American decorative arts in the world. Art museum? If the Met's American Wing is part of such a museum, why not "Winterthur"? One could spend days, months, years in "Winterthur's" more than a hundred rooms packed with every kind of decorative art, a collection to which that worn word "fabulous" certainly might be properly applied. Up the Brandywine River is the museum in Chadds Ford, Pennsylvania. This is where another family, the Wyeths, live; and the museum, a converted mill, is a memorial to the fame of Andrew Wyeth and his family. It exhibits works by him and his relations and also by others of the Brandywine tradition, especially the founders of the Brandywine School, illustrators like Howard Pyle and F. O. C. Darley. There exist other museums based around the work of individual artists, but only the Peale Museum in Baltimore is like the Brandywine Museum in being based around the art of a *family*. Downriver in Wilmington itself is the Society of Fine Arts (now called the Delaware Museum), a too-small civic museum that contains the best room of English Pre-Raphaelites, the Bancroft Collection, in America. It sprang up in 1912 as the direct result of a Howard Pyle memorial exhibit at the Du Pont Hotel and is the great Pyle depository.

Meanwhile there are all those historic houses up and down the Eastern Seaboard, from Maine to Florida, with their portraits and their chairs. Again one could spend days, months, years trying to see all of them. Near Princeton alone there are half a dozen: "Morven," the Governor's residence; "Rocky Hill," Washington's headquarters; the Hopewell Museum; the beautifully restored "Trent House" and the Old Barracks in Trenton; "Pennsbury Manor" across the Delaware River near Morrisville. But of course they aren't art museums, are they.

v

This Filling of the Form has been going on outrageously in that other old-settled region, the Midwest. Here again growth has been so multifarious and exuberant that only samples can be given. The three Tiers — Northern, Central, Southern — have been completed only as of the late 1940s. Some of the more important additions date from the 1930s. Of all these, the William Rockhill Nelson Gallery and Atkins Museum of Fine Arts (to give it the full title for one last time) is the most spectacular. This great museum, opened only in 1933, is among the top dozen of the country and the peculiar glory of Kansas City. It is essentially the creation of Nelson, robust city father and progressive newspaperman. He was born in Indiana, but after making and losing fortunes as a contractor and cotton grower, he went into politics and newspapers and stayed there. He moved to Kansas City and started the *Kansas City Star* in 1880. From his publisher's office he controlled the city and the state, all in the interests of reform and beautification. Cleveland and Teddy Roosevelt, regardless of political party, were Nelson's friends. The Colonel, as he was usually called, was a mountainous volcano given to explosions of mirth and anger, and art was just one of his many enthusiasms. He bought a lot of copies of Old Masters and installed them as a Western Gallery of Art in the public library. Then in his will he left his fortune and his newspapers to his widow and his daughter with the proviso that on the death of the last survivor the newspapers be sold and all the money be put into an art foundation to create and support a museum. This came to pass in 1926.

Meanwhile an esthetic native lady, Mary M. Atkins, had left money in 1911 for an art museum, too. As in Cleveland, the two funds were separate but the buildings need not be, so part of the massive yellow classic pile is the Atkins Museum and the rest is the Nelson Gallery. The old Western Gallery of Art, with its copies, was in there for a while but is now long gone. A paneled room from Nelson's mansion, "Oak Hall," is still intact. Otherwise one of the world's greatest assemblages of Oriental art, under the eye of one of the world's greatest Orientalists, Director Laurence Sickman, is on display, along with everything else that a universal survey museum ought to have, especially European Old Masters.

The J. B. Speed Art Museum in Louisville, Kentucky, completes the Southern or Riverside Tier. Though actually older than the Nelson, having opened in 1927, it has only recently blossomed into a full-fledged universal survey city art museum. For years it was a picturesque hodgepodge of Louisville curiosities, housed in the usual "Greek

Garage." Being right next to the campus of the University of Louisville, it serves as a teaching as well as a civic museum and now has grown into a very respectable institution. Gradually it acquired Old Masters, a fine Medieval collection, Louis furniture, a complete paneled Elizabethan hall, Oriental art, some Impressionists, and some very original specimens of American art. Though perhaps the least of its particular Tier, competing as it does with Saint Louis to the west and Cincinnati to the east, it is worthy of the competition. It also has the kind of strong local accent and idiosyncrasy more characteristic of Southern museums than of some of the more glittering but impersonal museums of the northern Midwest.

As the Nelson Gallery makes a western terminus to the Southern Tier (Kansas City, Saint Louis, Louisville, Cincinnati, Pittsburgh), so the Joslyn Museum in Omaha, Nebraska, does for the Central or Overland Tier (Omaha, Des Moines, Indianapolis, Dayton, Columbus). It is a much more modest affair than the Nelson, but still very satisfactory.

Like many other American museums — the Brooks in Memphis, the Wells in Birmingham, the Speed in Louisville — the building is a memorial by a widow to her husband. The Joslyn is an example of Prairie Art Deco, opened in 1931, and like the Nebraska state capitol in Lincoln has a sort of moderne period charm that not many other museums possess. Reliefs celebrating pioneers and Indians decorate the smooth yellow walls along with inspirational inscriptions ("Come with clean offering into the Temple of Beauty"). Massive front portals celebrate the good qualities of Mr. Joslyn: *Labor, Caritas, Fides, Valor, Visio,* and *Spes.* Inside everything centers around a tiled Mediterranean court with fountain. The painting collection is a very compact but complete representation of European art from Italian Primitives (some of them gifts of Robert Lehman of New York) to Americans of the earlier twentieth century (including Midwesterners like Grant Wood). There is also lots of room for big Moderns. But the specialty of the house is its character as "gateway of the West." Miller, Bodmer, and Catlin and a whole ground floor devoted to Nebraska arts and history from Indians through Victorians make the Joslyn one of the very best centers of such Americana.

Southward in Lincoln is that university collection that began so auspiciously with the exhibition of Piloty's *Wise and Foolish Virgins* in 1888. You won't find the *Virgins* there now, but you will find a dazzling small museum designed by Philip Johnson containing a beautifully chosen and hung survey of American nineteenth- and earlier twentieth-century art.

The latest addition to the Central Tier, completing the chain, is the museum in Des Moines, Iowa, founded in 1948. Gradually it has built up a very small but nice group of paintings and especially sculpture. It

has a fine Goya and some Impressionists, but most of its pictures are American, from Ash Can to Mod. It also has a large number of prints. What makes a trip to Des Moines definitely worthwhile is the new wing added by I. M. Pei, which forms a glorious split-level sculpture gallery. Not only is the sculpture — Rodin, Bourdelle, Malliol, Barlach, Arp, Moore, Rivera and Calder — very grand, but the space, the light, and the views make a feast for the eye. One side, an upper level, looks out on a courtyard with a big pool; the other side, a lower level, looks out on one of America's most charming public rose gardens* and a somnolent oak-studded, hilly park. It is the kind of place in which one could spend an hour or two just being happy.

vi

Most glorious, most prestigious, most controversial of all these Western Anchors is the terminus of the Northern Lakeside Tier (Minneapolis, Milwaukee, Chicago, Detroit, Toledo, Cleveland, Buffalo), the Minneapolis Institute of Arts. Created without the blessing of T. B. Walker at that little dinner in 1911, it has always been one of the more important city museums of the country, also, like the Nelson, ranked among the first dozen. It is famous for its Oriental collections, its Old Masters, notably the Poussin *Death of Germanicus,* beloved by Napoleon, and its El Greco *Christ Driving the Money Changers from the Temple,* as well as the usual required Impressionists and Americans. What has made it controversial is the unconscionable time spent on its remodeling. It has been closed for years while being rebuilt, its paintings scattered about in town and out. The Poussin, for instance, was proudly exhibited in a special room of its own at the Louvre and other works have been lent to less fortunate museums. Finally and at last the wings are spread and the museum has reopened, and the controversy now centers about the architecture of the additions and whether all that frustration and fuss was justified. Samuel Sachs II, cousin of Paul, is the new Director.

This remodeling and sprouting of new wings is another kind of growth, one of the things that makes it so difficult to keep up to date on American museums. When you go to visit, a new wing is planned, being built, or just about to open. Sometimes it is an entirely new building, as in Indianapolis. Some other museums, notably those of Pittsburgh and the Walters collection in Baltimore, have been completely transformed by this process.

* Garden clubs in Des Moines seem to be dominated by men rather than by women; a step in the direction of Male Liberation.

By the addition of a huge new wing and the collection inside it, Pittsburgh, at the other end of the Southern Tier, has leaped into position as one of America's important institutions, just as of 1974. Gifts from Mellons, the porcelains of Ailsa Mellon Bruce, daughter of Andrew, and the paintings, mostly Impressionist, of Sarah Mellon Scaife, Andrew's niece, have finally made of Pittsburgh the art center it should have been long ago. What with the gradual emergence of Louis-ville and the splendors of Kansas City, and a very recent refurbishing of the Cincinnati Museum under a brand-new director, the Riverside Tier now rivals the Lakeside Tier in grandeur and excitement if not quite in prestige, scope, and number of its museums.

A similar wing transformation is the one in Baltimore. As of October 1974 the Walters finally opened its addition, and now for the first time the general public can see what specialists have long known was hidden in the basements. The whole spectrum of art from Egypt to the nine-teenth century is beautifully on display to join the already familiar Renaissance and Baroque paintings. Especially striking is the big group of nineteenth-century Barye animal sculptures and Salonistes, visible properly and together for the first time — the Delaroche *Hemicycle* and the Gérôme *Duel after the Masquerade* — which so stirred Mr. Strahan a century ago. It looks splendid. Baltimore now has on exhibit all the things you can't see in our nation's capital — Classic sculpture, Me-dieval stained glass and carving. It's hard to realize the Walters is not a civic collection but a private one like the Frick or the Phillips, the results of two generations of one family's acquisitiveness. Comple-mented by the Cone Collection and the caches in the Peale Museum and the Historical Society, Baltimore covers the whole history of art more thoroughly than Washington does. When the museum of the Rhode Island School of Design in Providence finally gets through its total remodeling, the sequence of Boston, Providence, Worcester, Hart-ford, New York, Philadelphia, Baltimore, and Washington will rival any other such series of art-filled cities in the world.

One of the more recent Centennial-Bicentennial rebirths has been that of the Philadelphia Museum after ten months of being closed. It reopened on its hundredth birthday (February 28, 1976) without any special programs like those in New York and Boston. A great showing of Philadelphia painting through the ages was the chief exhibit, but the newly refurbished and rehung galleries throughout are the chief cele-bration. They reflect great credit on the generosity of the city of Phila-delphia, which gave some eight million dollars, and on retiring director Evan Turner.

vii

A significant reason for the growth of both old museums and new has been the presence of great directors. Often museums have been made or marred by the qualities of one man, usually either the President of the board or the Director. Some older museums have been both ruined and revived this way. No museum is a better example of this process than the Detroit Institute of Arts. It benefited enormously in its earliest days from the passion of Scripps for his hometown and from the youthful enthusiasm of Director Griffiths. Then it declined as Griffiths became slipshod and interested more in personal publicity than in the welfare of his museum; and the presidency, instead of being in one strong hand, was rotated through a constant series of incumbents.

The man who revived the museum was William R. Valentiner. Like the Detroit museum itself, he does not seem to have been given his due. Perhaps his strongly Germanic personality and the coincidence of two wars against Germany during his lifetime have had something to do with it. His habit of authenticating paintings for a price, à la Berenson, though a common European practice, made him suspect and unpopular as an American museum director. Nonetheless, he rebuilt the museum in Detroit, first properly organized the museum in Los Angeles, and created the museum in Raleigh from scratch. These three museums remain his monuments.

After his beginnings in America as first Curator of Decorative Arts at the Met in 1908 and his leave of absence to fight for the Fatherland, he returned to America and in 1924 went to Detroit to superintend the building of the new museum opened in 1927. In its day this was considered a phenomenon. Instead of being built first and then filled, it was planned right from the start to house an organized, historically chronological collection, easy to view and comprehend. Valentiner worked with the architect Paul Cret, who did the Rodin Museum in Philadelphia, and though still very much in the tradition of the grandiose Renaissance monument, the Detroit museum had and still has an openness and friendliness about it that invites rather than intimidates the public.

Not only did Valentiner create a new museum, he brought to it the interest of Detroit's new owners, the automobile Titans. The old tree-shaded Scripps Detroit had been destroyed. It was in the period of Valentiner's directorship that Edsel Ford, unhappy heir to the tyrannical Henry, expressed his muted and somewhat abortive rebellion against his father by daring to become interested in real paintings. Henry, who thought history was bunk, was not interested in real paint-

ings. The famous story about him is that important dealers, feeling he was somebody who needed educating, had prepared for him a magnificent volume of colored reproductions of Old Masters they had for sale. Henry was delighted with the picture book; but when he was asked if he wanted to buy some of the originals, he was greatly surprised. Why would anybody want to buy original paintings when they could enjoy the reproductions in this lovely book? Henry did collect, but it was old machines and crafts and tools and objects from the world of the rustic America Henry Ford did so much to destroy. These are all now piled up in the Greenfield Village museum at Dearborn.

Edsel and his wife, however, collected Old Masters and gave them to the museum; and as Morgan led the Titans of an earlier period down this picturesque potential road to ruin, Edsel led the new millionaires of Detroit. Valentiner has been criticized for not getting his millionaires to buy even more expensive pictures than they did and for being satisfied with lesser representatives of historical periods in quantity rather than a few in quality — the "stamp collection" approach to art. He was even more violently attacked in the early 1930s when the huge Diego Rivera mural, a gift of Edsel Ford, was installed in the museum's garden court. There were portraits in it of both Valentiner and Edsel, plus lots of Workers. The murals survived, unlike those at Rockefeller Center. So did Valentiner and his museum. The fact remains that the Detroit museum is one of the largest and grandest and most complete of America's Big-City Art Emporiums, and surely much of the credit goes to Valentiner.

Valentiner then went on to help reorganize the collection of the Los Angeles County Museum, started off the Getty Museum in 1954–1955, and finally created the glowing collection, so rich in seventeenth-century paintings, of the North Carolina Museum in Raleigh, a collection most of which he bought before the museum was even opened. Though his writings may have been pedantic and his personality Teutonic, few men have had a greater impact on the formation of the American museum along historical-scholarly lines than William Valentiner.

Valentiner could never be classed among the prima donnas. The very model of the director as personality has been William M. Milliken of Cleveland. Nearly everybody agrees in the praise of him as one of America's very greatest museum directors, the man who took a good thing and made it even better. He was a New Yorker who came to Cleveland via Princeton and a spell at the Metropolitan as a Medievalist. He cut his teeth as Curator on the J. P. Morgan collection at the time of the First World War, then went to Cleveland where, from his arrival in 1919 as Curator of Decorative Arts to the end of his tenure as Director (1930–1958), he infused every corner of the museum with his

enthusiasm and knowledge and "eye." He was involved in every area of the collection and stirred up the whole city in his largely successful attempt to make the home of Willard and *The Spirit of '76* a real center of esthetic taste and creativeness.

His specialty was Medieval art, and the most famous of his acquisitions was a clutch of gorgeous artifacts from the Middle Ages bearing the romantic appellation of the Guelph Treasure. These reliquaries, crosses, altars, and ivories had been lurking about Germany for centuries; they now sit right in the very middle of the Cleveland Museum, surrounded in every direction by other gorgeous artifacts from other periods. He was by no means limited to the Middle Ages. For instance, Mrs. Norweb, descendant of Liberty E. Holden, whose diplomat husband was always being posted to curious parts of the world, came back from Latin America with a lot of Pre-Columbian art. Milliken at that time knew and thought little of it; but when Mrs. Norweb showed him what she had, Milliken was immediately converted, picked out the prizes, became an expert in the field, and built one of America's best museum collections of Pre-Columbian art around the core of the original Norweb gift.

Having handed over his Museum to the equally knowledgeable Sherman Lee, who has done for its Oriental Department what Milliken did for the Medieval, Milliken "retired" to a life of writing, collecting, traveling, and exercise that should have killed him off long ago. On the contrary, he has kept going into his middle eighties with all these vocations, including that of skiing. He only took up that sport when he was fifty and has been hard at it ever since. His interest in Cleveland artists, whose careers he did so much to foster by famous annual May Shows, has continued unabated. His delight in the social scene, whether that of European titles or local Clevelanders of style, has brought special glitter to the world surrounding his museum, the kind of glamour that adds spice and color to any great art institution.

John Walker of the National Gallery, who succeeded Finley as its second director, could be cited as a sort of epitome of the modern director. His career touched all the bases. In the first place he was born in Pittsburgh. In the second place he was a student of Sachs at Harvard. In the third place he was a protégé of Berenson and more or less boarded at "I Tatti." His recent autobiography, *Self Portrait with Donors,* gives a pretty picture of the kind of life and personality evolved by the new profession of Museology. It is very different from the amateur enthusiasm of a Griffiths or the more scholarly approach of a Valentiner. Here we have the museum director as arbiter of taste, tactfully moving among the rich with his butterfly net while controlling with an iron hand the ebullience and quarrelsomeness of a large staff of underling experts. This is the director as ringmaster of the circus, a

role that has certainly been played to the hilt by Hoving. One of its best performers has been Walker, director of America's suddenly created "greatest art museum."

Stars of a different and perhaps slightly more suspect kind have been the great art dealers, working behind the scenes of the art world, wheeling and dealing, badgering millionaires both knowledgeable and innocent, determining by their influence what was and was not going to hang eventually on museum walls. The most conspicuous of these dark stars has been Joseph Duveen, Lord Millbank. Duveen has been the hero-victim of a good-bad book, his biography, a *New Yorker* Profile, by the artful S. N. Behrman. It is good because it is so witty and such an apt caricature of a flamboyant personage. It is bad because it completely distorts the picture of art collecting in America and the role played in it by its hero. It makes quite untenable claims for his power and influence, claims in many cases made by Duveen himself. He was certainly the greatest individual art salesman of his day, but most of the great collectors used other dealers and could by no stretch of the imagination be pictured, as Behrman does tend to picture them, as gullible self-made men who didn't know what to do with their money and slavishly allowed Duveen to spend it for them. Morgan did not use him much; the others were as likely to rely on Knoedler's as on Duveen, and Duveen's claims to have thought up the idea of the National Gallery and talked Mellon into creating it seem to be sheer nonsense. What Behrman does with that vignette of Frick on his throne reading the *Post* is a miracle of mischievous literary license.

There is much too much in any case of the myth of the ignorant American millionaire stumbling around Europe waiting to be fleeced by devious dealers. There certainly were plenty of them, but most of the great collectors and their collections were not of this sort; and the great dealers and experts, Berenson, Duveen, and others, were not crooks and swindlers. The truly important collectors, helped by their dealers, performed an invaluable service to America and its museums. They knew and loved art and were as savvy and passionate about it as any Renaissance tyrant. They paid outrageous prices and they dealt in dead art, not live art. An aroma of bargaining and big business certainly clings to their transactions; but after all, they were great businessmen, just like the Medici.

In fact, the firm of Knoedler's seems to have played a more important role in creating the best American collections than Duveen. Unfortunately no one figure emerges as picturesquely as does the great Joseph. Knoedler's began as that universal purveyor of European Salon gems, Goupil. A Michael Knoedler was sent to New York in 1846 to start a branch of Goupil's. After the Civil War, Knoedler bought out the Goupil interest and changed the name. Gradually Old Masters ousted

new, and various representatives of the firm such as Roland Knoedler or Charles Henschel were the confidants of the Titans in their raids on Europe. There is a rich chapter of life behind the scenes buried in the files of this firm and others like it; but it is not, strictly speaking, a chapter in the history of the museum.

Another of these great dealers was Joseph Brummer, whose field of expertise was not Renaissance painting but the older objects of the Middle Ages and Classical Antiquity. His own wonderful collection did come to the Metropolitan by purchase.

The role of the dealer and expert on art, as the career of BB makes clear, is one of great moral, esthetic, and scholarly ambiguity. BB has beaten his breast and declared himself spiritually bankrupt because of his dabbling in this black magic. Nonetheless his worldwide reputation and his far from bankrupt financial position as represented by "I Tatti" stem from his role as an available expert. However, all American art museums have depended heavily on such art experts, and museum collections could not have been assembled without them and without equally expert dealers. They both deserve credit; but not credit for actually forming the collections and founding the museums, no matter what claims Duveen and his biographers have made. With the exception of the Thannhauser collection in the Guggenheim, none of the important collections in the important museums were made and given by important dealers. Their histories, no matter how closely identified, are at a discreet distance from the histories of the art museums themselves.

Chapter II

i

OUTSIDE OF THE WALLED bastion of culture in the Northeast and the brave log forts of the Midwest lies the howling wilderness of Greater America full of Rebels, Cowboys, Indians, Prospectors, and Wildcatters. But even here culture seeps and creeps, and beginning amazingly early these regions have been gradually softened up by the intrusion of organized beauty.

Three general large areas — the South, the West, and the West Coast — have been settled by the art museum at a slightly later date than the East and Midwest. The South began early but developed late; the Coast was precocious but did not begin to boom until after World War II; the West, in its various subsections, has been the parvenu, but like many such, a very spectacular one.

The South undoubtedly would have been among the earliest sections to develop museums if it hadn't been for the Civil War. As the history of the Gibbes and Telfair prove, intentions were good; conditions were not. During Reconstruction the South couldn't afford art. Northern fortunes made before 1900 transformed museums after 1900. The South

had no such luck. By the present time, when at last Southern fortunes on a grand scale are being made, art is scarce and prices astronomical. A Getty and a Simon still seem to be able to collect in the old magnificent way, but few others can. Nowadays Southern museums find themselves all dressed up with nowhere to go — fine buildings, bright directors, eager trustees, modest funds, but unable to discover or afford the kind of art they ought to have bought back in 1911. Nonetheless, the South is studded with art museums. Even if few of them truly compare to greater ones up North, the area is by no means the "Desert of the Bozarts" that Mencken maliciously called it during the 1920s.

The development of the art museum in the South did take a long time. For years, until the time of the First World War, the older trio of the Telfair in Savannah, the Gibbes in Charleston, and the Delgado in New Orleans represented the "Bozarts," and even they had little. The Delgado opened in 1911, a handsome white building set in a lush green tropical city park. For some years it was the only true city art museum at that latitude between Savannah and China. It had very little inside it.

Mr. Delgado, a somewhat mysterious sugar planter, gave the building but not any contents. Now its contents are peculiar but colorful. It has its Kress collection; it has one of the few intact exhibits of Salonistes, the Hyams Collection. It has lots of Latin American art. It has some antiquities, Occidental and Oriental. It is especially rich in all sorts of local painters of the past, French and Yankee. And it has, at last, a Degas. People tend to forget that Degas was half American. His mother was a Musson, a Creole native of New Orleans, though she lived much in France. Degas had a brother, René, who married his first cousin, a Musson, and some of the most human and beautiful portraits by Edgar are those of his blind Louisiana cousin and sister-in-law, Estelle. Edgar visited New Orleans in 1873 and on the basis of his visit painted that famous *Cotton Office* that so offended M. Wolff of *Le Figaro*. It is now in the museum in Pau. It ought to be in the Delgado. Instead the museum has a fine portrait of Estelle, bought at a whopping price by civic subscription. New Orleans is still full of houses built and lived in by the Mussons. What a pity the family failed to collect the pictures of Cousin Edgar!

ii

These three museums, the Telfair, Gibbes and Delgado, pretty well represent the Old South. The New South is represented by a whole string of institutions stretched across the Piedmont in Richmond, Raleigh, Atlanta, Birmingham, and then out to the river in Memphis.

This last, the Brooks in Memphis, Tennessee, is the oldest, having been opened as early as 1916, not long after the Delgado; but the richest are those two later eastern collections, those of the State of Virginia in Richmond and the State of North Carolina in Raleigh.

They are both special in being state, not city, museums. They are the most distinguished examples of this kind. They couldn't be more different otherwise. The Virginia Museum is surely one of the loveliest smaller universal survey exhibits in the country. Every prospect pleases, both cosy and stately. It has something of everything from ancient to modern, and all of it is displayed with almost startling flair. The strong point of the Virginia Museum is decor, the most beautiful things are jewelry and the most popular single exhibit is a glittering collection of Fabergé Easter eggs made in Pre-Revolutionary Russia. The other sections, too, Egypt, India, Classic, Byzantium, the Middle Ages, the French and English eighteenth-century, are rich in trinkets. Unfortunately, though what is there is fine, there is an awful lot lacking. One big room labeled "Baroque" covers European art from about 1500 to 1800, and the actual pictures in the French, English, and American permanent collections are not ones connoisseurs would travel miles to see. Though intensely enjoyable, it is a museum to charm the amateur rather than intrigue the expert. Joy, not instruction, reigns supreme.

The other state museum, that of North Carolina, is diametrically opposed. Though the Virginia Museum is supported by that state, it was almost entirely financed originally by private funds and filled by private collectors. The North Carolina legislature, having been coerced by a few strong-minded citizens to create an art museum, voted a million dollars to buy pictures and had the good sense to get William Valentiner from retirement to buy them. He did, and it is overwhelming. Then the Kress Foundation gave the Museum its largest and richest gift next to that in Washington. When the Museum opened in 1956 it was, and still is, one of the astounding museums of a limited sort in the country. It is not a universal survey collection like that of Virginia, but one of Western painting. The recent installation of a few Egyptian items doesn't change its nature. It has surely the largest and finest collection of Rubens, over half a dozen whoppers, in the country and also one of the richest assemblages of Northern Renaissance art. It has wonderful Spanish pictures, too, and a survey of French, English, and American painting of the past. Then there are all those Kress Italians, ranging through the centuries, as well as a bonus, a Kress room of northern paintings including a Rembrandt. Whereas the Virginia Museum soothes you with style and high-toned background music — organ music in the medieval room, Chinese plunks in the Oriental section — the North Carolina Museum offers you art and absolutely

nothing else.* It still remains housed in the drabbest, ugliest, least ingratiating museum building in all the country if not all the world, a foursquare government office building of the early 1900s situated on a nondescript side street near the Capitol. Windows have been blocked up and a simple marble entrance foyer has been added. Otherwise it is just galleries. But what pictures!

Richmond had one of America's earlier attempts at a private art museum, the Valentine Museum. Originally left to the city, full of plaster casts and arrowheads and opened in 1898 as a blend of the esthetic and scientific, it has now become a house museum with furniture and portraits. Many of them are by that odd local genius, William J. Hubard, and other even more obscure Richmond painters. Out back is the studio of a Valentine who became a successful professional sculptor after the Civil War. The garden is full of big magnolias. Houses next door are used for Indian relics, costumes, and a pipe collection.

Meanwhile the University of North Carolina in Chapel Hill created an art museum of its own, the Ackland Memorial, by now already bursting out of its handsome but too constrictive building. It has a collection ranging from antiquity to Mods. It too has its Rubens. If you want to see Rubens in America, go South; evidently the Titans of the North were too puritanical for his fleshy nudes and concentrated on Rembrandt instead. Mr. Ackland's tomb is in his own gallery, like Trumbull's. Now neighbor and rival Duke University has gotten into the act and a museum on its "old campus" fills in areas that neither Raleigh nor Chapel Hill cover, notably medieval sculpture from the Brummer Collection, Oriental porcelains, and Pre-Columbian art. So now the triangle served by the Raleigh-Durham airport is one of America's more conspicuously endowed art centers.

They are always going to build a new building for the North Carolina collection but so far have spent years quarreling about whether it should be in the center of Raleigh, which is certainly where it should be, or marooned out in some pretty, inaccessible suburb. The very pretty Mint Museum in Charlotte is so marooned. It is an old Neoclassic building of 1836 where coins were actually minted during the days of a gold mining boom in North Carolina that nobody now remembers. The gold in the Mint now consists of a small, bright, choice survey of painting and a big collection of ceramics out back in a new wing. Very choice. Very pretty. Very remote.

* It does have a most interesting special section for the blind, where touch, not sight, is the criterion.

...
iii

Much more truly New South are the galleries in Atlanta, Birmingham, and Memphis. Two of the buildings, after the pattern of the Speed and the Joslyn, are memorials by widows to husbands; but alas, neither the Wells in Birmingham nor the Brooks in Memphis can quite match Omaha or Louisville in the strength of its collections.

Atlanta's museum is the core of a magnificent, rather pompous civic center, full of auditoriums and staircases and fountains and big exhibition halls. Its collection has some rather high pretensions, too. The museum has great civic support and, like most Southern museums, its nice Kress Collection; but it also has its own very sad and special museum tragedy. A hundred and twenty-two of the city's art patrons were killed in 1962 when a plane carrying a museum tour crashed. A section of the galleries labeled "Memory Lane" is dedicated to these and other museum benefactors. The museum goes on bravely without their help, but one does feel it still has a way to go before it achieves the kind of good survey of painting toward which it obviously aims.

Birmingham's museum, on the contrary, seems to be more reconciled to its limitations. It, too, has its Kress, but not very much else in the way of European painting — a big room full of miscellaneous older works from many nations and periods, new rooms for expanding groups of later European painting and Americans. What it does have is Oriental and Pre-Columbian art, and for some reason lots of Wild West material — Remington bronzes and such. It also has cases of silver and porcelain birds and things that Southern ladies like. It is admirably situated right near a big new cultural center and is the terminus of a mall-like reconstruction of the city's main street. Nothing remote about it. Nothing terribly pretty about it either.

As for Memphis, it is far prettier than either the Atlanta museum or the Wells in Birmingham. The Brooks is modeled after the not much older Morgan Library in New York, set in a beautiful big city park. It has a good small Dutch collection and one of the biggest and best Kress collections — what would the South have done without Kress? — and a most interesting and offbeat collection of Americans of the nineteenth century. It should and might have had an outstanding collection of French Impressionists, desperately needed, but millionaire Hugo Dixon suddenly died and it was discovered that he had willed his pictures and his money to the creation of a Dixon museum in his own beautiful modern Neoclassic house surrounded by beautiful Neoclassic gardens. There, when the estate is settled and some of the best pictures brought back from the museum, will be located, impossible to get to but

certainly worth the try, one of America's choicest private collections of
French and English painting and furniture. When the azaleas and
magnolias are out in the romantic garden with its enormous trees and
stately vistas, the display inside and out should be breathtaking. Mean-
while the Brooks keeps a stiff upper lip and fills a splendidly spacious
new wing with inventive educational displays, exhibitions of local art-
ists, and everything except those Dixon Impressionists.*

These three museums of the New South represent the successes and
failures of museums of this area. They are outstanding examples of
civic interest and support, but their collections are lacking in strength
and depth.

<div style="text-align:center">*iv*</div>

Florida is another area in, but not really of, the New South that's
been hatching museums. Another Lowe museum, like those of Syracuse
and Hempstead, Long Island, serves both the University and the whole
big city of Miami as an art museum. It does very well as the former but
is hardly adequate as the latter. Miami is a big big city now. In the first
place, the museum is down in Coral Gables, remote from Miami
proper. In the second place, its Kress Collection, though full of interest,
is also much more of a study collection, with Masters of this and that,
than the kind of big-name Old Masters most big cities feel they ought
to have. It needs a new building, too.

There are other small, nice galleries in various Florida resort cities,
of which the Norton Gallery in West Palm Beach is probably the best.
It has really good pictures in a pleasant ambiance and sets a high
standard for similar efforts in Jacksonville, Clearwater, and other ref-
uges in lotusland; but the great Florida museum is the Ringling
Museum in Sarasota.

There is the Old South (Telfair, Gibbes, Delgado) and the New
South (Richmond, Raleigh, Charlotte, Atlanta, Birmingham, Mem-
phis), and then there is the Odd South. True to the regional character
of individuality and idiosyncrasy, the South sports some of the queerest
art museums in America. Of these the oddball splendors of the Ring-
ling are the most conspicuous. The Ringlings succeeded Barnum as the
great circus showmen of the country, and Barnum succeeded Peale as
the country's foremost exhibitor of curiosities. Now we come back full
circle with a museum of art originally created by circus money. The

* But there may be a happy ending. After delicate negotiations it seems that some
of the best Dixon Impressionists are going to return to the Brooks after all, a wise
and generous solution to the situation.

emphasis is perhaps appropriately on Italian Baroque. An Italianate villa with a long garden vista out to the blue waters of the Gulf of Mexico houses room after room of big, active canvases, including, again, some magnificent Rubens cartoons for tapestries and also big names like Rembrandt and Poussin. The collection is by no means confined to the seventeenth century, however. It also includes a complete small Venetian eighteenth-century theater used for various performances. Nearby is the Ringlings' own private palazzo, called "Ca' d'Zan," and then there is a circus museum. Altogether the enclave of the John and Mabel Ringling Museum and its dependencies is a real three-ringer.

Much more odd and far less fortunate than the Ringling Museum has been another Florida institution, the ill-fated Bass Museum in Miami Beach. In order to fill up a good but old library building when a new library was built, the city fathers of Miami Beach in 1963 allowed the collection of a New York winter visitor, a sugar magnate named John Bass, to be shown there, thus creating a city art museum. Bass contributed the art, much to the delight of his income tax advisors. The city had to pay for installation and upkeep. The Basses were trustees. The art was appraised at over five million, and Miami Beach was happy, except for a few disgruntled art lovers who thought that not enough care had been taken to scrutinize the works and the legal and financial aspects of the arrangement.

Suspicions grew and grew. Experts questioned the attributions and the authentications. Bass gave some more art in 1966 and loud cries of protest were raised but ignored by City Hall. There was a particularly unpleasant appointive Fine Arts Board, which the city council said they would dissolve if they kept on making unseemly noises. Finally the Art Dealers Association of America spoke up and questioned the authenticity of seventeen of the paintings attributed to Vermeer, Rembrandt, Hals, Botticelli, Goya, Rubens, El Greco, Gainsborough and Van Gogh. In 1969 they made a more sweeping charge that of the fifty-three alleged important Old Masters, two-thirds were fakes. Bass called the Association a "mischievous group."

This didn't mean that everything was bad or false; but the intransigent attitude of the Basses and the city council produced an equally intense attack. After long and bitter battles, as of May 1973 the city council had to close the museum "temporarily." Lawsuits were threatened; teeth were gnashed. The plaque on the facade proclaiming that "A thing of Beauty is a Joy forever" evidently needs some qualification. It is too bad the museum can't be reopened with proper labels, selective choices, and some fresh and genuine acquisitions, even if they won't be able to boast of Vermeer. Miami needs more art museums, being probably the largest city with the least art in it of any of America's boom

towns. Meanwhile "Viscaya," another Baroque Italian villa, built by the Deering family and also located south of Miami, is a spectacular house museum, perhaps the most exquisite man-made object in all of Florida. But not strictly an "art museum."

The Chrysler Museum in Norfolk, Virginia, is also full of Old Masters that have been looked at dubiously. It has also been slandered by that "mischievous group," the Art Dealers Association of America. This collection of the automobile heir Walter Chrysler, Jr., was first publicly installed as a museum in Provincetown, Massachusetts, at the end of Cape Cod. It made a very happy climax to the long journey out there and was an altogether cheerful and pleasant place. But were all those great names appropriate? To both its Old Masters and its Impressionists the phrase, so discreet, so lethal, "overconfident attributions" has been applied. Chrysler had married a Norfolk woman and rather after the pattern of Gari Melchers and his Savannah bride, Chrysler settled on his city-in-law as his esthetic home. He took over the nice, small, decent, thoroughly provincial Norfolk Museum, cleaned out most of its old collection, and installed his own collection in its place. Trustees resigned; but it now is the Chrysler, not the Norfolk Museum, and it certainly covers art history from ancient Greece to Abstract Expressionism. It makes a gorgeous, if cluttered, effect; and there are a great many lovely things there, notably some recent acquisitions. However, the cloud of that "overconfident" does tend to dim the vision. Is that *really* a Rembrandt? Is that a *genuine* Veronese? Nobody casts doubts on the glass collection or the roomful of American Primitives from the Garbisch Collection (Mrs. Garbisch was a Chrysler). The glass collection alone is worth a visit, and there will soon be a new wing devoted to Americana. No one can doubt that the museum adds immeasurably to the esthetic riches of tidewater Virginia, which doesn't have all that many esthetic riches. But . . .

No such shadows seem to obscure the view at the even odder and even more amazing collection at Bob Jones University in Greenville, South Carolina. What a place! Greenville is a smaller textile center snuggled up against the Appalachians and has a little art museum all its own. Bob Jones University is the creation of a dynasty of revivalist fundamentalist preachers originally from Tennessee. There are Bob Joneses number I, II, and III. The "Doctor" (number II) is the art fancier, and he sees no incompatibility between a literal interpretation of the Bible and hundreds of European paintings based on just such a literal interpretation. As a result, a really stupendous museum of some thirty galleries contains a stunning collection of religious painting from a few Primitives to a few nineteenth-century things. The emphasis is on Renaissance and the Baroque. It is sort of a cultural shock to see ensconced in this enclave of pure Protestantism the superb extravagances

of emotional Catholicism — exalted saints, rapt martyrs, the Church Triumphant. There are splendid Netherlanders, too, and by the time you emerge from the maze you are dizzy with color. This effect is achieved partly by the pictures and partly by the installation. A local textile firm, Wunda Weave, has helped provide purple carpets to go with gold walls and gold carpets to go with purple walls and there are no genteel reticences about the hangings. There weren't many genteel reticences about Renaissance Italy, either, and the pictures take to the flamboyance like so many ducks to water, or peacocks to pleasances. A side show is the country's best collection of Benjamin West, half a dozen of the pictures he actually completed for King George's dream chapel at Windsor Castle. If the King hadn't gone mad and West had completed the project, the result would have been one of the grand efforts of English Protestantism along with Handel's oratorios, Wordsworth's Ecclesiastical Sonnets, and St. Paul's Cathedral. As it is, the big neo-Rubens spectacles look pretty wonderful in the otherwise rather plain brown chapel of Bob Jones University. No doubt there may be whispers about "overconfident" applied to some of the other pictures, but nobody ever seems to have bothered to forge Benjamin West. He looks good in Greenville.

<center>v</center>

The southern Plains states occupy a prominent but ambiguous place culturally and geographically. The art museums farther north on or near the Great Plains tend to hug the rivers and the rolling eastern part of the region and belong culturally to the Midwest. The museum at Wichita, Kansas, with its nationally famous Murdock collection of American art is the only significant exception.

The Southwest, that is Oklahoma and Texas, is something else again. There is no doubt about the region not being Midwest; but a big quarrel exists about the title Southwest, which is more properly applied to the quite different region westward. The truth is that the Plains area, North and South Dakota, Nebraska, Kansas, Oklahoma and Texas, is a region all its own, distinct from Midwest or true Rocky Mountain West. It ought to be thought of and think of itself as such with chauvinist regional patriotism, an area west of the big rivers and east of the big mountains as individual in every way as the South or New England.

Within that area Texas is the cultural leader, and it rivals California as America's big new museum state. Like the older museum states, especially Ohio, it bristles with shiny big-city palaces of art. If their collections have yet to catch up with those of Cleveland or Cincinnati

in quality or quantity, it's just a matter of time. And money. That's the Texas attitude, anyway, and unlike the Southerners the Texans have had the money long enough and in large enough amounts to have been able to afford really expensive pictures.

Down there the issue of Leather-stocking versus Silk-stocking expresses itself as Dude versus Cowboy. Nowhere is this confrontation more naked than in Tulsa, Oklahoma. On the west side of town is the Thomas Gilcrease Institute of American History and Art. On the east side of town is the Philbrook Art Center. In the first you actually do see men in boots and big hats a-looking at all them Russells and Remingtons. In the other, gracious smart young matrons serve tea to visitors. The Gilcrease is the result of an infatuation cherished from boyhood for the Cowboy West by Thomas Gilcrease, who did not make all that money in cows, but in oil. His collection centers around those favorites of collectors in that field, Charles Russell and Frederic Remington, and then spreads out into every area of earlier American history with valuable documents and other pictures by other artists like Thomas Moran, who painted the West. A lounge dedicated to Gilcrease's daughter Des Cyne looks out through windows at a panorama of still wild-looking shaggy range and ridges. The nearby presence of a development called Gilcrease Hills doesn't impinge on this view.

Meanwhile on the other, the right side of town, in wolds and dells of rolling live-oak-studded parkland, amid large Tudory yellow stone mansions, sits the Philbrook. This is also oil, Phillips Petroleum, and has its Kress Collection and some other European art. The Renaissance palazzo presides over Renaissance terraces and not far off is another of America's charming public rose gardens. Somewhat out of key at the Philbrook is a large collection of good American Indian items. Nonetheless, the opposition and conflict between a European and a Native American orientation is obvious when one compares the Gilcrease and the Philbrook. Tulsa, a nice relaxed city for all its oil boom basis, half Southern, half Western, seems to accommodate this picturesque dichotomy gracefully.

Not so the Fort Worth–Dallas axis, where bitter enmity between the two cities over just this Dude-Cowboy issue has produced a most mixed-up and rewarding conglomeration of art museums. According to Fort Worth, Fort Worth is where the West begins and Dallas is where the East peters out. According to Dallas, civilization ends there and Fort Worth is just a rundown cowtown. Dallas, proud of its beautiful public display of azaleas that people crowd to see in the spring, its elegant, quietly exclusive residential sections of modestly tucked away mansions, and its famous stores like Neiman-Marcus, has liked to think of itself as pretty sophisticated culturally. Then along comes Fort Worth with not one but three brand-new art museums and Dallas is abashed.

The most famous of all the Fort Worth museums is the Kimbell. Kay Kimbell, who was not so much an oilman as a dealer in flour and commodities, seems to have been a shy gentleman who just loved beautiful women. He became infatuated with Salon nudes and then fell in love with the clothed English beauties of the eighteenth century as depicted by Gainsborough and contemporaries. He began to buy lots of these — good, bad, indifferent, genuine and false. So when he died he left an estimated fifty million dollars to found an art museum so that his gracious belles would have a home suitable to their station in life. His widow then made an equal gift and started to plan Kay's museum memorial. She dutifully toured the country studying art museums. When she got to Boston she had a visit with Perry Rathbone, who earnestly queried her about her findings. What did she think her planned museum needed? "Well," said Mrs. Kimbell reflectively, "Kay always did like ma-ahble." Marble his museum got. The Philadelphia rebel architect, Louis Kahn, otherwise famous for rather startlingly brutal architectural statements like the bare concrete walls in his addition to the art museum at Yale, designed for Fort Worth one of the most austerely beautiful modern museum buildings in the world, a serene, pale, light-suffused structure that evokes Greece and the Attic spirit without aping the Greek tradition in details. Into this bold but radiant vision has been placed an instant collection of painting and sculpture of superlative quality but still very limited quantity. The English beauties are housed there, but now selected and segregated.

This museum and its collection would make any city an art center, but in Fort Worth there is more. There's the Amon Carter Museum, which was originally created as a museum of Western art, just like the Gilcrease (that is, cowboy art by Russell and Remington). Oilman Amon Carter rivaled oilman Thomas Gilcrease as a collector of it. The Fort Worth tycoon Carter was the most xenophobic of Dallas-haters. In past years he had the power, as boss of American Airlines, to prevent Dallas and Fort Worth from sharing an airport. When he went to Dallas he always carried along his lunch in a paper bag to avoid being poisoned by the effete food there. No question but that he intended his museum to be a museum of *Western* art, hog-tied and branded as such.

However a very stylish, very uncowboy building by that dude Philip Johnson was built overlooking an exhilarating panorama of the city's skyline and the Remingtons and Russells were put into it. Gradually as time has gone by and Carter's sophisticated art connoisseur daughter Ruth Carter Johnson has taken over, the emphasis of the museum has shifted and broadened. Rather than being just a museum of Western art, the management now likes to say it is running a museum of Wester-*ing* art, a euphemism that covers any painting by any American artist

from anywhere. Mrs. Johnson has even considered housing in the museum her Mary Cassatt, which is most certainly not what her father meant by "Western art." This may violate the intentions of the founder, but Forth Worth is the immense gainer of an all-around museum of American, not just Western, painting. One fears, however, that Amon Carter joins similar rugged pioneers like T. B. Walker and Mr. Layton of Milwaukee as they all swivel in their graves.

The third museum of Fort Worth is really the oldest, the just rebuilt and reopened museum of the Fort Worth Art Association. This Association carried the torch of culture back when the city really was just a cowtown. There is a story that at an earlier exhibit of the Association, when some of Carter's Remingtons were on display, a docent snubbed a visitor's inquiry by saying, "Oh, that's not art!" Carter overheard and vowed to start his own gol-blamed museum. Kimbell then felt he had to follow suit. Now the Association's new Art Center concentrates on contemporary art, foreign and even domestic. So Fort Worth is very sensibly divided into three moderately noncompetitive areas. The Kimbell takes care of historic art; the Carter takes care of American art, particularly that of the past; and the Art Center takes care of European and other contemporary art. This is the arrangement that should have prevailed in New York with the MOMA, the Whitney, and the Met, if everyone had had sense and patience. There are bound to be future disputes as to the proper placement of, let us say, a Mary Cassatt; but on the whole the future of Fort Worth as a museum town is rosy. Now visitors come there just to see its museums, and billboards as you approach the limits advertise Fort Worth as "Museum City."

Meanwhile back east in Dallas there are two more art museums, bringing the area's total to at least five.* One is the city's own small, chic city museum, the Dallas Museum of Fine Arts, out in the fair grounds. It has a bit of everything and some, but not many, very good paintings and Oriental objects. It serves the best lunches of any museum in the world, all done by the Woman's Committee. The other museum in town is Southern Methodist University's Meadows collection of Spanish art. It, too, has a history. In this case, Spain includes not only Zuburan and Velásquez but also Juan Gris and Joan Miró. Algur (not Alger) Hurtle Meadows was still another oil millionaire who kind of liked art. The legend is that he had lots of debts owed him in Spain, and rather than try to collect in cash he decided to build up a group of valuable paintings to take home. It so happened that a decayed aristocrat was hanging about who had an old castle full of old art. Meadows acquired the art, brought it home, and gave it to Southern Methodist University. It was then discovered that the collection was

* There is still another, a small college museum in the nearby town of Denton.

largely fraudulent. Nothing daunted, generous Mr. Meadows gave the University money and told the museum to go out and buy itself genuine Spaniards, which it did with great success. Then, still undaunted, Mr. Meadows met some beguiling French people who seemed to have a lot of Impressionists on their hands. After sessions of enjoyable close bargaining, Mr. Meadows acquired a sizable new French collection. That same mischievous organization, the Art Dealers Association of America, sent delegates to Dallas for a show at the Dallas Museum, and Meadows entertained them at cocktails. He asked them what they thought of his collection. "Charming," said an urbane representative, "and a couple of them are genuine."

There are no Impressionists in the Meadows Museum at Southwestern, but its genuine Spaniards are a tribute to a supreme example of big-hearted generosity and a monument to Mr. Meadows, whose motto might well have been, "Twice bitten, once shy."

The museums of Fort Worth–Dallas don't begin to exhaust the riches of Texas. The big, smart, rich Museum is that of Houston, the big, smart, rich city of the state. It is a solid universal survey museum with lots of Italian Primitives, some of them part of a rather superfluous Kress Collection, a Remington room as a sop to cowboys, and a new wing. This has added, very recently and out back, a big glass tank designed by Mies van der Rohe in the best Bauhaus, which celebrates its architect and denigrates art. The Director was so mad about it he resigned. Nothing can be shown there except great glaring modern abstracts and huge pieces of welded sculpture. The rest of the Museum is so good and full, however, that this monumental faux pas can be overlooked. In any case, there is a great deal of big modern art waiting to be shown in museums, which are the only places except airports and the lobbies of skyscrapers where it can be properly shown.

The Houston answer to "Winterthur" is "Bayou Bend," under the protection of the Museum of Fine Arts. Smaller but far more digestible than its model in Delaware, it is the former residence and creation of redoubtable Miss Ima Hogg, who just died in her nineties, active to the last. (Her father, a Governor of the state, really did name her Ima in a moment of inattention; but there is no Ura.) Ima assembled furniture, decor, and a whole series of early American paintings dating from the seventeenth to the nineteenth centuries; and it all sits in the middle of a deep green, pine-shaded, Southern formal garden rather like that of Mr. Dixon in Memphis. It is alongside a sure enough bayou and represents the kind of Houston taste that pervades so much of the private sector of this cosmopolitan city and has to be seen to be believed.

In San Antonio, which is Old Texas, there are the Marion Koogler McNay Art Institute and the Witte Memorial Museum. San Antonio, more than any other city of the Plains, has its own art tradition going

back first to the Spanish and then to adventurous limners who came there from the mid-nineteenth century on when it was a dusty Latin village dominated by missions like the Alamo. Of these earlier artists, the Onderdonks, father Robert, who arrived in the 1870s, and son Julian, seem the most significant. They founded a local tradition of landscape art still existent and somewhat scornfully referred to nowadays as the "bluebonnet school" — painters who concentrate on the fields of purple wildflowers that break out beside the live oaks in the spring. The Witte Memorial Museum, which began life in the 1920s, was for years dominated by the presence of its curator, Miss Eleanor, daughter of Robert Onderdonk, and was intended by its indomitable founder Ellen Quillan to be a Texas museum — nature, lore, crafts — not an art museum only. It has now inevitably become a somewhat haphazard museum of art where you will find Onderdonks and other local artists as well as a good collection of nineteenth-century American paintings from all over, Oriental decor, Indian pots, stuffed animals, and lots of other things.

The McNay resembles the Witte only in that it, too, was founded by a woman. Marion Koogler was the spoiled but repressed daughter of a doctor who practiced in Kansas and bought a lot of land there. Marion studied art in Chicago and was swept away by the exhibition at the Art Institute of part of the Armory Show of 1913. When she was well over thirty she married a handsome twenty-year-old doughboy named McNay who took her to Texas during his service in World War I and died shortly thereafter. Memories of blissful visits to the Hotel Menger in San Antonio so affected Marion that she settled in the city. Meanwhile the Koogler lands in Kansas proved to be full of oil wells. Marion, brokenhearted but filthy rich, devoted herself to a series of mismarriages and to collecting art. She spent much of her time in Taos, studied Indian lore, painted Indians, and briefly married one of the Taos artists. She had built a gorgeous Spanish house in Alamo Heights north of San Antonio and eventually created there a sort of cross between "Fenway Court" and the Phillips — a small beautiful group of French Impressionists from Renoir through Cézanne, Gauguin, and beyond hung in a fairy-tale villa amid fountains and gardens. She died in 1950, leaving it all to the city; and since the opening in 1954 wings and works have been added. An Oppenheimer collection of Medieval and Renaissance painting and sculpture fits in seamlessly along with a lot of American art, including the best and largest selection of O'Keeffe paintings of New Mexico. There is also a choice group of Indian-Spanish items as souvenirs of her attachments to Taos. These and a fine lot of modern sculpture all help make the McNay (Marion kept going back to the name of her first love after her disastrous later mistakes) one of America's most thoroughly enchanting art museums.

There is more in Texas: Corpus Christi has a striking new art center; the University of Texas at Austin, like the University of Oklahoma at Norman, has a university gallery. El Paso has a Kress Collection and other art. Oklahoma City has art, too, and you never know in that part of the world when a new museum will suddenly spring up, armed to the teeth.

vi

Meanwhile in the *real* Southwest, in the desert world of Arizona and New Mexico, art grows wild, especially Indian and Spanish folk art. The chief museum centers, very different from one another, are Santa Fe (New Mexico) and Phoenix (Arizona). Santa Fe is a center of the indigenous; Phoenix is cosmopolitan. The Dude-Cowboy conflict here is between adobe and concrete.

In Santa Fe, Yankee refugees from Eastern Megalopolis have expressed their love of their new home by cherishing the relics of America's two oldest cultures, the pueblo-dwelling, rug-weaving Indians and the Spanish Colonial. To that end no less than five separate collections are on view in buildings ancient and modern, a rich compost of visual culture that has everything except a true big-city universal survey art museum. Some art of some sort, mostly Indian and Spanish-American artifacts, is visible in all the various parts of the Museum of New Mexico: the Palace of the Governors, which dates back to 1610 before those Pilgrims landed; the Laboratory of Anthropology; the Folk Art Museum; the Museum of Fine Arts; also in the separate Museum of Navajo Ceremonial Art. Of these the Fine Arts, opened in 1917, is most truly an art museum. It concentrates on the artists of New Mexico, Yankee and Indian, and is the place to follow the history of that remarkable flowering of painting that occurred largely between 1910 and 1940, not so much in Santa Fe itself as in neighboring Taos.

Taos was originally discovered by two Cincinnati artists, Joseph Sharp and Ernest Blumenschein, who met abroad. Sharp, one of "Duveneck's Boys" in Italy, first visited Taos as early as 1883. Blumenschein, on the advice of Sharp, came later in 1898 and eventually, along with a third pioneer, Bert Phillips, lived to become one of the Founding Fathers of the artist colony there, and one of the best-known painters of the local Indians. There were dozens of others, including Victor Higgins, who briefly and stormily married Marion McNay. But none achieved the national reputation of the visitors from outside — O'Keeffe, Hartley, Marin, Sloan, Hopper — whose paintings alas are not so much in Santa Fe as in San Antonio, New York and elsewhere. The collection in the Museum of Fine Arts consists mostly of

lesser-known but more local painters like Blumenschein; but they are pretty good, many of them, and certainly represent one of the most influential of such regional flowerings in the country.

The Museum of New Mexico joins the museums of North Carolina and Virginia in being state-supported; but it is not one museum so much as a group of museums. Of its other branches, the Museum of International Folk Art is most nearly purely esthetic — a vast welter of curious and mostly beautiful things from all over the world, peasant work from Austria, African fetishes, Colonial Spanish antiquities. The clever presentation raises the question of just what "folk art" is and where "fine art" begins and ends. This is all germane to the present quandary of art museums everywhere. Are there any limits to what can be considered "art" nowadays?

Up in Taos, a mere sixty or seventy miles away, is the most esthetically satisfying of all the showings of Southwestern Indian artifacts in the country, the Millicent Rogers Museum. This strongly resembles the McNay in San Antonio. It, too, was created by a beautiful, rich, much-married lady and it, too, is housed in a beautiful, rich, Spanishy villa. The lady was the granddaughter of H. H. Rogers of Standard Oil, so here is another example of how oil money has continued to seep into art.

In Roswell, New Mexico, there is a Peter Hurd museum that could be considered a western branch of the Wyeth museum at Chadds Ford, Hurd being a Wyeth in-law and his Wyeth wife also a painter. It contains the Oriental collection of poet Witter Bynner. You do not see many Hurds in other Southwestern museums, and there is a distinct cleft between the esthetic worlds of Taos and Roswell.

Art in Phoenix, Arizona, is by no means as indigenous. Phoenix is a boom town, a sort of winter resort Los Angeles of half a million people. It had only twenty-five thousand in 1915 when women in art clubs began to think about art exhibitions there. It opened a universal survey museum in 1959, just like any other proper metropolis. After all, this was and is the only such between San Antonio and San Diego, a matter of some thirteen hundred miles. The museum in fact boasts that it serves "the largest land mass of any museum in America." Soon, however, the Phoenix museum began to give the impression that it was trying to go too far too fast. Snide jokes circulated to the effect that if you didn't dare hang it and couldn't unload it, you could always give it to the Phoenix museum for a tax deduction.

The aroma of "too far, too fast" still unfortunately clings to the Phoenix museum, despite obvious efforts by intelligent directors and curators to obliterate the aroma by branching out into safer areas of modern art, Western art, and contemporary crafts. A nice collection of Oriental ceramics given by a Dr. Wong, a delightful assemblage of

Thorne miniature rooms, and a picturesque Spanish Colonial salon all help. But the core collection of Old Masters, which distinguishes the Phoenix Museum from all Rocky Mountain establishments except that of Denver, leaves something to be desired.

Much more successful is the nearby Heard Museum, which belongs in the same happy category as the Rogers in Taos and the McNay in San Antonio. That is, it, too, is housed in a pretty Spanish villa and it, too, is rich in beautiful Indian artifacts. It differs, however, in being very much more scientifically anthropological rather than merely esthetic. If you want to learn about southwestern Indians and their products rather than merely enjoying them, this is the place to go. No problems here, as at the Phoenix Museum, about "overconfident attributions."

The thirsty art lover stumbling in from the desert with cracked lips will be mightily refreshed in Phoenix. It's not quite as isolated as all that, however. Arizona State University in suburban Tempe has a well-known collection of American art and the University of Arizona at Tucson has a museum with still another Kress Collection and a large Pfeiffer Collection of Whitney-Americans from the 1930s and 1940s. Southwest Indian objects get shown all over the area, as they should, but Santa Fe–Taos, despite the Heard, remains the true center for anything like that.

As for the Northwest, in that vast and underpopulated area comprised of Idaho, Montana, Wyoming, Colorado, Utah, and Nevada, art is still a pretty rare specimen. It does not grow wild, except in the form of some Indian artifacts, and there's not very much tame art either. The only full-fledged general art museum in the whole area is the one in Denver. However there are a few smaller ones scattered about at extremely wide intervals. The only big cities are Denver in Colorado and Salt Lake City in Utah. Both have art.

Denver has an old (1923) art museum that has nineteenth-century antecedents in one of those pioneer art associations of the 1890s. Tubercular esthetes, gentlefolk, and intellectuals migrated to Colorado almost as soon as the gold rush days were over and have given Denver a cultural accent it might not otherwise have had. For a long time the museum's collection was squashed into the undignified rooms of a former business building. Now, as of the 1970s, the museum has burst forth in amazing glory, established in a semiskyscraper that looks as though a medieval donjon had been upholstered in gray quilted satin. The building, the fancy of Italian architect Gio Ponti, has odd crenellations and loophole windows in the wrong places and is altogether bizarre and original. It certainly doesn't look like every other museum. The views outward of the Rockies from the haphazardly placed windows tend to distract from the contents, but the contents are very satisfactory. This is the kind of big-city universal survey museum that

places like, say, Phoenix yearn to have. It has, like Houston, a some-what superfluous Kress Collection that merges into the other Old Masters given as a memorial to Simon Guggenheim, brother of Solomon, Senator from Colorado. Egypt, Greece, Rome, the Middle Ages, the Renaissance, the Orient, and a truly stirring display of American Indian objects all help to make of the Denver Art Museum the richest lode of art west of Missouri and east of California.

In Salt Lake City the Church (the Latter-Day Saints, nicknamed the Mormons) has always encouraged the arts, as opposed to tea, coffee, liquor and tobacco. Unlike certain Protestant denominations, there has been no Puritan disapproval of "graven images." The Church even sent native sons, including John B. Fairbanks, a member of a family that occupies somewhat the same pioneer painting position as the Onderdonk family does in San Antonio, to Paris in the 1890s to study art. He returned to do murals for the Temple. But Gentiles can't get into the Temple to see them and unfortunately the museum at the University of Utah, which serves as the only true permanent art gallery for the city, doesn't seem to pay any attention to native sons like sculptors Mahonri Young and Avard Fairbanks, son of John.* Why not? Instead the museum, housed in a spanking new arts building on campus, has a fine exhibition area, and some of its not very rich collection on view — Louis decor given them by the wife of perfumier Richard Hudnut, who happened to be a Utah girl, a few Oriental things, a few nice pictures ranging from the Italian Renaissance through Rubens to the French and American nineteenth centuries. It is a pleasant small museum and one that seems to be expanding hopefully and tastefully; but it's still a long way from being a proper big-city museum like that of Denver.

Meanwhile Brigham Young University down south in Provo has art. In nearby Springville, which as the "Taos of Utah" supported an early art colony, there is a gallery with Utah painters in it located in the high school. Still, Utah has no cultural institution in the realm of the visual arts that compares, say, to the Tabernacle Choir in music.

The most spectacular museum in the Rocky Mountain region is the Whitney Gallery of Western Art, a part of the Buffalo Bill Historical Center in Cody, Wyoming. The town of Cody is named after that famous hunting guide turned international showman, and the origins of the Center were mementos of his gaudy career. Gertrude Vanderbilt

* A later Jonathan Fairbanks, like Mahonri S. Young in Columbus, carries on this Mormon tradition of art, far from home, as Curator of American Decorative Arts at the BMFA. The Onderdonk tradition gets carried on by cousin Christopher Forbes, also far away in New Jersey, who has made a well-known instant collection of English Victorian art — the first such in modern times in America. His family owns Onderdonks.

Whitney, she of the Whitney Museum in New York, is the progenitor of this western outpost, and it remains far more legitimately than the Amon Carter Museum a real museum of Western Art. What makes it special are the series of informal sketches by both Remington and Bierstadt, brilliant on-the-spot studies of figures and landscapes that prove what fresh and colorful and expert artists both these men were when not manufacturing the finished product back home in the studio. These sketches are almost the only paintings of the Northwest that really and truly do look like the West. Nearly everything else painted there partakes of some inhibiting tradition or lack of painterly skill.

In Montana is the home-base museum of that other favorite Westerner, Charley Russell. His paintings do look like the West; the West of the Great Plains. There is a flavorful collection in Great Falls, Montana, that has a personal intimacy lacking in grander but more remote museum collections of his work. There is a surprisingly beautiful Indian collection at Browning, south of Glacier National Park. Montana State University has an art collection at Missoula, and that's pretty nearly it for Montana. The State University ought to have Senator Clark's collection, the one turned down by the Met and accepted by the Corcoran. It does Washington, D.C., no good at all these days, with the National Gallery next door. It would do wonders for Montana. Similarly the University of Wyoming's brand-new gallery at Laramie is building up a permanent collection of Americans, and the University of Colorado at Boulder has an art gallery in its University Museum. Older than all these and more distinguished is the Taylor Museum and Fine Arts Center in Colorado Springs. The Springs has always been a cosmopolitan place, and this is one of the oldest (1936) of smaller museums in the Rocky Mountain Northwest.

Though the Colorado Springs museum is really more of a flourishing and spacious art center than a true museum, it does have a nice collection of Whitney Americans and Colorado natives. It also gets into the Southwest act by having lots of Indian items and Santos — those crude but effective church decorations seen preferably in the setting of their adobe mission churches all over New Mexico. It has some of the Sloan paintings of Taos that ought to be in Santa Fe. The influence of Taos spreads all over the Southwest: San Antonio, Colorado Springs, Phoenix. It is too bad that the Museum of Fine Arts in Santa Fe itself does not have the lion's share of works painted in the region by the big shots. If only Georgia O'Keeffe, say, would bequeath the contents of her studio to the Santa Fe museum, paralleling the gifts by artists like Hans Hoffmann and Clifford Still to museums in California!

Way eastward, in South Dakota on the Plains, there is a brand-new (1970) South Dakota Memorial Art Center, the only significant museum between Cody and Minneapolis, Winnipeg and Omaha. It is

situated in Brookings, where the state university is, and can be thought of as a remote cousin of the museums in Chadds Ford, Pennsylvania, and Roswell, New Mexico. That is, it was started by a pupil of Howard Pyle and fellow student of N. C. Wyeth, Harvey Dunn (1884–1952), whose gift of his paintings of and to his native state provided the impetus for the formation of this pioneer regional gallery. North and South Dakota have long been among the few states of the Union without art museums of significance, and this new and vital effort raises the flag of visual culture at the center of hundreds of miles of vacancy in every possible direction. (Well, there is an Arts Association in Sioux Falls, fifty miles south, and an Art Center in Sioux City, Iowa, with a gallery, sixty miles still farther south.)

vii

As Southwest doesn't mean the Plains, so Far West doesn't mean the Coast. The Coast is an art world all its own, very rich, well-established, and zooming ahead. California is now generally recognized as the only real rival to New York City as a center for the production and consumption of contemporary art and artists; and the whole littoral is littered with art museums of all kinds, civic and private, university and general.

The Northwest Coast began to think about art as early as the 1890s when the Portland (Oregon) Art Association was founded. The museum dates from 1932 and has a medium-sized survey collection ranging from classical antiquities to totem poles, including an almost inevitable Kress Collection. It is not as exciting perhaps as some other West Coast institutions, but it has a sober, Bostonian quality of worth and dignity, a determination to cover art history thoroughly that reflects the predominantly New England settlement of the city. In 1896 Edward Robinson wrote a learned catalog used by the museum from 1897 on as an aid to its collection of once numerous plaster casts. The casts are gone, but Robinson's devotion to the Instructive still pervades the atmosphere. You could find out everything about Greek sculpture except, as Prichard suggested, what it really looked like.

Seattle by comparison is less instructive. Its art museum is the memorial to one family, the Fullers, who devoted their lives, mother and son, to Oriental Art. As a consequence the collection there is overwhelmingly Chinese and Japanese, one of the great collections of that sort in the country. Richard E. Fuller, the son, was for years both Director and President. Not even Holmes of the BMFA managed that, but then Fuller gave the museum to Seattle. There are some almost incongruous-seeming roomsful of Kress Italians. Lots of contemporary

pictures belong to the Museum, though nowadays not usually on exhibit in the modern white building in the middle of Volunteer Park. The Art Museum has an annex, a pavilion in the Seattle Center, the old grounds of the 1962 World's Fair where the Space Needle is. The modern art is displayed there and includes lots of works by those native sons Tobey, Graves and Callahan, who at one time made Seattle one of the more active scenes of avant-garde painting. Seattle is still an "art city." There are painters active there and art is scattered about in several places.

The University of Washington has a gallery, usually occupied by changing exhibits; and there's the delicious Charles and Emma Frye Museum on First Hill, with its complete collection of German Salonistes, plus a Manet or two, preserved as in amber. The Frye is also building a tiny but comprehensive survey of older American art. Like the Hyde Collection in Glens Falls, the Frye is one of those tucked-away treasures one might miss; but one shouldn't.

Tacoma has a struggling art center; Olympia has a State Capitol Museum with Indian artifacts. It also has an "historic house" dating from 1924. The University of Oregon Museum in Eugene is a real art museum with a collection of considerable variety and interest, Oriental, Occidental, and Indian.

viii

And then there is California. I refuse even to make the attempt to mention all the art galleries, college museums, and small-town collections that have "filled in the form" in that pullulating state. Suffice it to say that every single college of any pretensions and almost every single small town has something that might perhaps be called a collection of art displayed somewhere. California loves art.

Sacramento, the state capital, has the honor of producing the oldest of all these coastal museums. This is the E. B. Crocker Art Gallery, which claims with some justice to have been founded in 1871–1872, thus making it one of the very oldest in the United States. It did not really exist as a public art museum then but was the private collection, open to the public after a fashion, of Judge Crocker. He went abroad, bought pictures, patronized local artists and built a fine mansion to house himself and his loot. It is still there; but the year 1885, when the whole was presented to the city by Crocker's widow, is a somewhat more justifiable date of origin. That is still early for an American museum.

Edwin B. Crocker was one of four brothers who came to the Coast in gold rush days. One of them, Charles, was a member of the "Big Four" — the railroad giants who dominated the Southern Pacific and the

whole state of California during the last half of the nineteenth century. All their names — Stanford, Huntington, Hopkins, Crocker — are involved in the world of the American art museum at some point and to some degree.

Edwin Crocker's museum in Sacramento is the oldest and oddest of them all. First there is the lavish 1870 mansion itself, still full of mirrors, bibelots like a big collection of Rogers statuettes, family portraits, and a grand staircase. Then there is a representative collection of early California artists, for like every other part of the Union in those halcyon days, the just-settled Coast raised its crop of native painters. William Keith and Thomas Hill executed grandiose mountain landscapes, joined by Alfred Bierstadt, who though only a temporary resident was embraced and canonized in San Francisco as George Healy was in Chicago. There were two Nahl brothers, Arthur and especially Charles, who did landscapes and genre, and William Hahn, who painted big humorous animated slices of life, now invaluable records of California's earliest days. All these still hang in Sacramento as mementos of Crocker patronage. Then there is a strange collection of European paintings of the sixteenth through eighteenth centuries, picked up by Crocker in Europe as jetsam of the Franco-Prussian War and composed of startlingly obscure painters from Germany, Italy, Holland, and even Bohemia and Sweden. It is unusual and refreshing to see such minor masters in America, where museums try desperately to concentrate on the summits rather than the crevices of European art. These gems are beautifully displayed in a modern wing out back. Along with some Chinese ceramics and California Mods, they make of the Crocker a quaint sort of universal survey hideout. There is also, though not much on display, a remarkable collection of Old Master prints and drawings picked up by chance in Europe in the 1870s. Scholars travel to see these, and they are now what make Sacramento famous in the art world. The Salonistes, predominantly German, that Crocker really liked are mostly in storage.

The best-known painting in town is not in the Crocker but in the splendid domed capitol building. This is Thomas Hill's often reproduced panorama *Driving the Last Spike*, which depicts the joining of the railroad from east to west and contains portraits of President Grant and other worthies.

The great art centers of California are San Francisco and Los Angeles. They are very different. San Francisco is older, more sophisticated, better established and more museum conscious; but Los Angeles is more vital, more advanced and more spectacular. Eager young slingers of paint flourish in both environments, and the museums in both places are becoming more and more significant every year. In San Francisco there are three museums of art, the M. H. de Young Memorial, founded in 1895, the California Palace of the Legion of Honor,

founded in 1924, and the San Francisco Museum of Art, which claims
1921 but which did not open in permanent quarters until 1935. They
all began and continued quite separately until finally in 1971 the Le-
gion and the De Young joined hands. The reasons behind this long
separation and competition between two almost identical museums of
historic art are typically San Franciscan in their exuberance.

The youngest and also the oldest of the museums is the third, the San
Francisco Museum of Art. It goes way back into the early history of the
city as one of those art associations that heralded the growth of culture
all over America. A Mr. Woodward, who made his pile running a bar
called the What Cheer House, had first opened his art gallery and
gardens to the public in 1864, and permanently in 1869. The Art
Association sprang up in the 1870s and seems to have been more famous
for its receptions than for anything else.

One of the Big Four, Mark Hopkins, himself a dour and parsimoni-
ous gentleman, married an ebullient wife who insisted on high doings
and his building her a huge pinnacled mansion on Nob Hill. Native
author and grande dame Gertrude Atherton, the Edith Wharton of the
West, described this effort as "if several architects had . . . fought one
another to a finish."

When Mr. Hopkins died, Mrs. Hopkins gravitated towards the East
and built a summer castle in the Berkshires of Massachusetts. She hired
a youngish decorator named Edward Searles to pep the place up and
then proceeded to marry him, she being seventy-three and he forty-six.
The family disapproved, and when she died a few years later she left
Mr. Hopkins's seventy million to Mr. Searles. The family sued. Not
only did they collect, but in 1893 Searles tried to make amends by
donating the Hopkins mansion with all its towers and curlicues to the
city of San Francisco as a Mark Hopkins Institute of Art, adding a
Mary Searles Gallery and an endowment. Like the Association, the
Institute was more famous socially than artistically and gave glittering
masquerade balls every year until everything was completely destroyed
in 1906. The Association persisted, however, and emerged again during
the Panama-Pacific Exposition of 1915. This supposedly celebrated the
opening of the Panama Canal, but it was really designed to show off
San Francisco the Phoenix, the new city risen from its ashes. It was a
glorious fantasia of tasteful eclecticism, palaces of every style from every
century and country. The loveliest of all these was a Palace of Fine
Arts, designed by the now canonized California architect Bernard
Maybeck in a Neoclassic style of which he was not very proud. It con-
tained a famous art exhibit.

When the Exposition closed, the Palace was left, though made of
extremely perishable material. In 1916 the Art Association began to
exhibit and showed a selection from the Armory Show of 1913 there

and by 1921 had settled in the Palace as a precocious museum of modern art. Finally in 1935 it got its permanent headquarters in the newer Neoclassical Civic Center and there it has been ever since, gradually building up a permanent collection firmly centered on the Matisses of Michael and Sarah Stein. The Steins moved back home to their cable cars in 1935–1936 when Hitler began to loom, and their pictures were on view to friends and students in their Palo Alto house. A sort of Matisse-Stein cult developed. Miss Harriet Lane Levy had visited the Steins in Paris in the early days and like the Cone sisters made friends with Matisse and started her own collection. Mrs. Walter A. Haas, whose husband makes Levi's, the cowboy's favorite work clothes and modern youth's favorite formal attire, became a close friend of Sarah Stein and also began collecting Matisse. The Stein children gambled on horses, so pictures had to be sold to pay their debts. Mrs. Haas bought some of the best of them ("Why didn't I buy them all?" she says nowadays) and gradually bits and pieces of this ancient and influential Stein-Matisse conjunction began to come to the San Francisco Museum. Miss Levy left the Museum her collection; Mrs. Haas has loaned, donated and promised hers; and a few others have joined in to form a Stein Memorial that is the heart of the Museum. There are also gifts from later Crockers and the San Francisco Museum now covers the area from 1900 to the present with heavy emphasis on Les Fauves. Just recently it has been given almost thirty huge canvases by Clifford Still, pioneer Western Abstract Expressionist; and the museum is sorely in need of room for expansion to show the holdings and present the continuing exhibits of this lively Pacific Coast replica of MOMA, which is at once the oldest and the newest of the city's art establishments and which combines so many strands of vivid Californianism — Steins, cable cars, Levi's, Crockers, Still.

The other two museums also go back to expositions. M. H. de Young (1849–1925), whose name was probably Michel Harry but who always preferred to use just his initials, was a man enamored of expositions. He had been since the age of sixteen the publisher of what became the powerful *San Francisco Chronicle*. It began as a theatrical review and ended up as a parallel to Nelson's *Kansas City Star*, the most powerful organ of reform and publicity on the West Coast. Despite his reformist image, Mr. de Young was not above blackmail. He would catch his contemporaries in "compromising situations" and use threats of exposure for political and financial leverage.

Among the more fearsome of his contemporaries were a whole family of Spreckelses. Two brothers, Claus and Bernard, emigrated from Germany and along with the sons of Claus became, like the Havemeyers with whom they fought dinosauric battles, Sugar Kings. Their sugar was grown in Hawaii or made from western sugar beets. Of these

Spreckelses, Adolph was not only financially but also physically, socially, and esthetically one of the more important. He was a big, tough man but also an early collector of art. He had married a much younger woman whose maiden name was Alma Emma Charlotte Corday Lenormand de Bretteville. She was Danish by birth, a descendant of Huguenots who had immigrated to Denmark after the edict of Nantes, and she bore a general resemblance to Brunhilde. Despite all this Mr. Spreckels was maneuvered into one of de Young's traps. He was seduced into a "compromising situation" with another woman and at a judicious moment out popped the photographers and detectives from the woodwork. Mr. Spreckels was not one to take this sort of thing lying down. He leapt from the bed, beat the detectives and photographers to a pulp, and then went downtown and shot Mr. de Young in his office. Luckily for the history of San Francisco art museums, de Young was able to escape injury by hiding under his massive desk; but feeling between the two families was not improved by this incident.

Among other expositions, de Young was officially present at the Columbian in Chicago in 1893. He salvaged remains of this, brought them back to the coast, and fathered a Midwinter Exposition in 1894 located in the sandy wasteland that was to become Golden Gate Park. This was more a "fun fair" than a serious industrial exposition; but when it was done, de Young took over the remains and out of it created, beginning in 1895, his private mare's nest, eventually the M. H. de Young Memorial Museum. He acquired a leftover Egyptianate building, stacked it with souvenirs from the Midwinter Exposition, added wings and a tower, covered it all over with Nabisco Spanish (like the early Walker Gallery), and proceeded to cram it with junk.

By 1921, when he finally donated it to the grateful city of San Francisco, he had accumulated an extraordinary — one might say appalling — cache. There were singularly dreadful pictures, an anonymous "Saint" credited, by Mr. de Young at least, to da Vinci, a Benjamin West, and a string of Pompiers of an obscurity equal to, if not as engaging as, that of those Old Masters in Sacramento. The rest of the great rambling building was stuffed with curios from every clime — Oriental gimcrackery and occidental textiles that included Mrs. de Young's cast-off clothing, dominated by a hat on which nested no less than twenty-four cedar waxwings. There were mineral specimens and clocks and locks and casts and a room devoted to old pipes, old shoes and Mexican art. The Mexican material, so casually hidden away, was one of the few really valuable parts of the collection — a lot of Pre-Columbian statuary dug up by a Dr. Forbes in the nineteenth century and described in the 1921 catalog in the most unflattering terms as awkward, crude and undignified. These are now among the residual items exhibited by the museum, along with precious South Seas arti-

facts, publicized in the old days only for their cannibalistic associations. A few great corny Russian academic paintings are still visible, too, including that same *Russian Wedding* that once filled the empty spaces of the infant Toledo museum when its collection consisted of one mummified cat. It has the dubious reputation of being the most popular picture in the De Young museum.

Meanwhile, Alma Spreckels had also begun to think of starting a museum. She, too, was inspired by an exposition, that of 1915. She much admired the French pavilion there, a copy of the Palais de Salm in Paris turned by Napoleon into the Palais de la Légion d'Honneur. One of the successes of the 1915 show was dancer Loïe Fuller, an American who made her reputation in the wake of San Francisco's own Isadora Duncan doing numbers like the famous Butterfly Dance that relied on lighting effects and flowing gauze on sticks. Loïe was a friend of Rodin and introduced Alma. Alma bought up the studio just before the master died, pawning her jewels to do so, so as not to disturb Mr. Spreckels. In order to house her Rodins she then had constructed in the middle of another gorgeous man-made paradise, Lincoln Park, a replica of the exposition's replica of the Palais de la Légion in Paris. It was opened as a museum in 1924 and dedicated to the California dead of World War I. Mr. Spreckels died on the way out West to the opening. From then on it was Alma's baby.

The earliest stages of both rival museums, De Young and Legion, were clouded by disastrous directorships. The direction of the De Young at that time was in the hands of a charming gentleman who was permanently pickled in alcohol. Everybody loved him, but his museum remained the junk heap of yore. Into the Legion Mrs. Spreckels put a dynamic woman who turned out to be a drug addict. These two unfortunates were ousted and the directorship of both was taken over by a young gentleman out of the Sachs factory at the Fogg.

The two boards, totally controlled and largely populated by members of the de Young or Spreckels clans, were not on speaking terms. De Young was succeeded in power by four daughters, all of whom married well. The husband of one of them, George T. Cameron, took over the direction of the *Chronicle*. It was a San Francisco custom for every prominent dowager to lunch on Monday at the Mural Room of the St. Francis Hotel. Each lady had her special table, a box at the opera. The de Young and Spreckels tables were at opposite sides of the room. A friend of both parties, lunching with Mrs. Spreckels, greeted the de Young ladies as she and Alma left. "Those de Youngs seem very nice," commented Mrs. Spreckels on the way home. "But, of course you know we've never been intimate since my husband shot their father."

Nonetheless, both museums thrived under a new single directorship. But this early Director too had his vices. His attentions to younger

gentlemen became so flagrant that even the tolerant San Francisco of the Roaring Twenties became perturbed. He left, but not before cleaning out the De Young and starting it off on a respectable career as a true art museum.

Into this vacuum stepped Walter Heil. Heil was a German, a protégé of Valentiner in Detroit. He belonged to the same school of scholarly Teutonic exactitude. By this time it was getting into the 1930s. Heil was faced with the delicate problem of building up both collections simultaneously and competitively in the same areas, though the emphasis at the Legion was always strongly French whereas the De Young was slanted more toward a universal survey centering on Spanish and Italian painting. Like his master Valentiner, Mr. Heil seemed to be able to mesmerize the Kress Foundation into giving the De Young one of its best anthologies, rival to that in Raleigh. The Legion in turn was enriched by Archer Huntington. A childless couple, the H. K. S. Williamses, who lived much in Paris and were friends of Alma Spreckels, eventually gave the Legion their all, and there was the continuing generosity of Mrs. Spreckels herself. During a dim period Alma suddenly became Mrs. Awl. She so appears in the bulletin. Then in one issue the "Awl" is carefully penciled out by hasty staff members and from then on she's Mrs. Spreckels again.

As the 1930s progressed and Hitler became prominent, Mrs. Spreckels grew uneasy about Mr. Heil. Though he was certainly no Nazi, he had been the roommate and best friend in the Luftwaffe during World War I of a certain Hermann Goering, now also risen to prominence. It seemed dreadfully inappropriate in the director of a Palais de la Légion d'Honneur, even a California one. Mr. Heil discreetly became confined to the directorship of the De Young only, and his place at the Legion was taken by long-time assistant director Thomas Carr Howe, another Sachs pupil.

Then followed two decades of tripartite museum life in the city under San Francisco's three great directors. Grace L. McCann Morley at the San Francisco Museum of Art built up that institution as a vital champion of modern art. The Legion under Howe and the De Young under Heil competed for Old Masters; meanwhile the De Young added to its Primitive and Asian art and the Legion increased its holdings in the Impressionists. It would obviously have been better for the two to join forces or at least delimit spheres of influence, but as long as the respective ladies, never speaking, continued to lunch at the St. Francis, this was impossible. Finally, as late as 1968, death removed the dominant figures in both camps, Mmes. Spreckels and Cameron. The two museums were married at last under the directorship of Ian McKibben White. The De Young settled for grand universal survey, the Legion for French art exclusively; the only such all-French museum in the

country. They exchanged holdings, though several period French rooms at the De Young simply couldn't be moved. Then the De Young got the awesome Oriental collection of Avery Brundage, Chicago millionaire, boss of the Olympic games, resort resident of Santa Barbara. Everyone now seems to be happy.

Like Philadelphia and Fort Worth, San Francisco is a noncompetitive triangle; and surely a more satisfactory and delightful one cannot be imagined. There are special dividends like the view from the front of the Legion, worth the trip alone — the Pacific coast northward, the Golden Gate Bridge, the towers of the city eastward. The Brundage collection looks out through a big window right into the country's oldest and most opulent Japanese garden. However, the collections at the Civic Center are still no match for MOMA, and the De Young is no Met. Not yet.

These three museums are merely the core of the city's surrounding museum life. Across the Bay eastward, Oakland, like Brooklyn, has its own astounding enterprise, a new building (1969) by Roche and Dinkeloo, who did the Lehman Pavilion at the Met. Of the three museums that this new building contains, one is devoted entirely to California art. The other two show stunning state history and nature exhibits. The art museum is unique in being the only one in the country that presents the entire spectrum of local art production from the beginnings to the present. Although Santa Fe's museums do a good job in this respect, the NYHS has eighteenth- and nineteenth-century art, and various other historical societies have older local art, I know of no other one museum strictly confined to the esthetic produce of one state right through the years.

Here are not only the works of Keith, Hill, Nahl, and Hahn, of Bierstadt and others equally well known who wandered in and out (Arthur B. Davies, for instance), but also innumerable others more obscure, some of them charming painters, who have responded to the intense local color throughout a century and a half of professional artistic life. A happy day can be spent in Oakland and its three museums, resting in the roof gardens and especially having lunch in the restaurant where, as in Dallas, a women's auxiliary serves some of the best museum food available. More museums should follow this fine example instead of shoving visitors through bleak cafeterias like those at the National Gallery or the Cleveland Museum.

Unfortunately city finances in Oakland are precarious and there are dire threats to the Museum's budget. Any cuts would be a tragedy, as its triple-threat museum is the best thing the city has to offer the visitor.

There are also the usual college museums in swarm — Stanford, Mills, and others. The enormous new structure (1970) at the University of California in Berkeley is the most spectacular of these, or indeed of any

such college museums. It is a great concrete cavern, a cross between a Piranesi dungeon and the Guggenheim, where the sheer size and weight of the building totally overwhelms a rather paltry teaching collection. Like the Guggenheim, however, the building itself is worth a look. Big Mods do best there, and since Hans Hoffmann has given them almost fifty of his pictures (because California was good to him when he was first a refugee), the future of the museum would seem to lie in that direction. The Hoffmann gift, parallel to but preceding the Still gift to the San Francisco Museum, seems to have established a happy precedent in this part of the world.

ix

Then you take a deep breath and move southward. First you go by the Hearst Castle at San Simeon, which is far from being the mere kitsch that most easterners have been led to believe it is. Though undoubtedly fantastic and flamboyant, its gardens and mansion, created by one of America's first and foremost woman architects, Julia Morgan, are full of real beauties and treasures. The interior is a museum of choir stalls, tapestries, Gothic statues and carvings, Renaissance furniture (and Tiffany lamps), and even a few paintings. The whole ensemble is worthy of its incomparable mountaintop and seaview site.

After that you pass through Santa Barbara, where that elegant resort maintains a charming small universal survey museum of art. It opened in 1959 in a remodeled post office. The day of the opening an earthquake shook the classical statues from their new pedestals, but they were used to that sort of thing and were put back up with only minor injuries. A room devoted to nothing but portraits of women of all ages and conditions is a peculiarly happy specialty of the house.

Below Los Angeles is the Fine Arts Gallery of San Diego, one of the oldest and best museums of the West Coast. It began, like so many others, as the result of a fair. San Diego also had its celebration in 1915–1916 in honor of the opening of the Panama Canal and also had a splendid exhibition of art then and there. When the fair closed and the art left, the city fathers decided to fill the vacuum with art of their own. Generous donors Mr. and Mrs. Appleton S. Bridges gave the city an elaborate Neo-Spanish permanent building that opened in 1926. Alma Spreckels and Archer Huntington were among the first benefactors, but pioneer director Reginald Poland, aided and abetted by a trio of forceful sisters, the Misses Irene, Anne, and especially Amy Putnam, accounted for about ninety percent of the Italian and Spanish Old Masters that until very recent times made up the most serious collection of art in the whole southwest of the United States.

Next door now sits, since opening in 1965, the Timken Gallery, one of the most curious and important of all America's small art museums. It is a direct outgrowth of the San Diego Gallery but the relations between the two institutions exhibit a certain sense of strain. The surviving Miss Putnams, Anne and Amy, became more and more disenchanted with the San Diego museum. They were at best difficult ladies, living in almost New England seclusion in Daddy's mansion near Balboa Park, the center of all San Diego's cultural efforts. They studied languages (Miss Amy concentrating on Russian), gave all their gifts to the museum in strict anonymity, and almost never spoke to anyone except a few important people in the art world. When Reginald Poland retired in 1950, the Putnams severed relations with the museum. They kept on collecting, however, through the medium of a newly formed Putnam Foundation and lent their pictures to the National Gallery, the Metropolitan, and other such. It was feared that these pictures might perhaps never come back to San Diego; but Walter Ames, a San Diego lawyer, as head of the Putnam Foundation arranged otherwise. He was also the lawyer for another important San Diego family, the Timkens (roller bearings). Mrs. Bridges, who gave the original museum building, was a Timken. The Putnams, incidentally, had never spoken to the Timkens, though they lived nearby. Ames persuaded a later Timken to build a Timken Gallery. Then he persuaded the San Diego Gallery to lend to the Timken Gallery the best of the Putnam-donated Old Masters. To these the Putnam Foundation, continuing on after the death of the ladies, added the best of its later acquisitions. In the last decade there had thus evolved what is usually and properly referred to as a "jewel box" of a museum — four galleries of masterpieces of European art, French, Netherlandish, Spanish, and Italian — plus two other galleries. Part of the contents has been lent by the Fine Arts Gallery, but all has been collected by Putnam money. Most of the Spaniards, some of the Italians and Netherlanders, and none of the Frenchmen come from the Fine Arts. There are superlative examples of El Greco and Goya, Bosch and Breughel, Rubens and Rembrandt, Clouet and Claude, Boucher and Fragonard, Giotto and Crivelli, Titian and Veronese, Bellotto and Guardi — nearly half a hundred masterpieces magnificently displayed under filtered natural light and learnedly cataloged by Agnes Mongan, former director of the Fogg in Cambridge.

As replacements can be made, the Timken is supposed to return paintings to the Fine Arts. It is in no hurry. This means that the very cream of the crop of San Diego's Old Masters are at the Timken, not the Fine Arts. The latter has lots of lovely pictures left over, but tail wags dog. It's the Timken you mustn't miss. Besides the Old Masters, the Timken has a brilliant array of colorful late Russian icons collected by

Miss Amy and a small selection of interesting older American paint-
ings, a nice Benjamin West, for instance.

This Frick of the Pacific ought to be better known than it is; perhaps
when Elizabeth Mongan, sister of Agnes and formerly at Smith, finishes
her book on the Putnam sisters and their museum, it will become as
famous as it deserves to be. One thinks of Isabella and the Cone sisters
and Marion McNay and other American women who have done so
much for art during the last three-quarters of a century. California, like
Texas, is full of surprises and you never know what will pop up next.

x

As for Los Angeles proper (if you can use that word in this connec-
tion) or at least Greater Los Angeles, the same tripartite division evi-
dent up north seems to have accidentally emerged down south, though
one can scarcely call it noncompetitive. Los Angeles almost within a
matter of months found itself with three important museums of art, the
older Los Angeles County Museum of Art (LACMA) and the two new
museums, the Norton Simon Collection in Pasadena and the J. P. Getty
Museum in Malibu. There is also the special grace note of the Hunt-
ington Library in San Marino, small museums in Long Beach and the
usual quota of college museums — Scripps, Pomona and the University
of California in Los Angeles (not to be confused with the University of
Southern California).

Of the three art museums, LACMA is the oldest. There was a big
omnium-gatherum museum that began between 1910 and 1913 and
included, like Oakland, science, history, and an art gallery. William A.
Hearst gave it some art and in the 1940s William R. Valentiner came
out to shape things up. The Museum still bears his characteristic im-
print in the form of a fine small Netherlandish seventeenth-century nu-
cleus, given by Hearst and vetted by Valentiner.

The new LACMA opened in 1965 and makes a most pleasant impres-
sion. The division into three separate pavilions, one for the permanent
collection, one for changing exhibits, and one for administration and
services, is a felicitous idea that more museums should try to copy. Of
course it's all much easier in a climate where one doesn't have to worry
about walking through blizzards to get from building to building.
Everything is surrounded by a pool-studded plaza and a shrubby sculp-
ture garden full of Rodin. The Ahmanson Gallery, where the perma-
nent collection is installed, makes its own pleasant impression, built
about a multistoried atrium and arranged with ancient art below, later
European and American art farther up, and Mods on top. It is only
when you stop to think that a museum that could be the pride of a city

of six hundred thousand is actually representing a city of six million that you might have second thoughts.

However the sprawling, sunny, smoggy Greater Los Angeles area has suddenly been blessed by two outstanding phenomena and the whole picture of art there has changed. Up in the hills of Pasadena is the brand-new building of the former Pasadena Museum, where the once wandering Norton Simon Collection seems to have settled for good. Pasadena's history is a stormy one. For many years an art association struggled along putting on exhibitions in an inadequate older building. A group within the group determined to make a MOMA of the museum. They were given a splendid small assemblage of German Expressionists by a refugee opera singer named Galka Scheyer, and around this collection — many Klees and works by his colleagues in the "Blue Four," Jawlensky, Kandinsky, and Feininger — ambitious friends of the advanced determined to build a new institution. They raised money and in 1969 constructed a very handsome building. Galka's things were put into it along with lots of Big Mods, given and loaned.

Unfortunately, rifts began. One of the principal contributors to the building, the late Virginia Steele Scott, had her own ideas of what "modern art" should be. These did not match the ideas of the other lovers of the modern in Pasadena. Mrs. Scott withdrew and built her own private underground museum of her own private undergrowth artists. Meanwhile the population of Pasadena in general was very cool to the idea of a MOMA in their midst. The museum was not supported and began to head towards bankruptcy. Along came Norton Simon, whose superb Old Masters and Impressionists had been more than welcome guests at such museums as those of Princeton University, Houston, and the Legion in San Francisco. Norton paid the debts and took over the museum, putting his own pictures in place of most of the Mods. The local hosannas changed to screams when he dismissed the former trustees and docents, severed relations with the art association, stopped all educational activities, and renamed the museum the Norton Simon instead of the Pasadena. All this has been happening just as of 1975–1976, so the wounds are fresh. He evidently intends to move in most of the rest of his collection, so there simply will not be room for any Big Mods at all. But on the other hand Pasadena will have a collection of European art worthy of comparison to any in the country.

Down on the coast in Malibu, hours from Pasadena but still in Greater Los Angeles, an equally new museum has been opened by J. Paul Getty. There has been a collection there for at least twenty years, but the new building (1974) is one of those sights of the coast like Disneyland, the Hearst Castle, and the Madonna Inn in San Luis Obispo. When you hear that it is the reconstruction of a Roman villa,

you don't really get the picture. Most of the reexhumed villas now visible at Herculaneum and Pompeii are comparatively modest-seeming affairs. The so-called Villa of the Papyri on which Getty's museum is based was something else again. The Getty of Rome obviously created it and it is huge — a palace, a two-story monster with courtyards and great gardens and stately halls and three separate large collections in it — antiquities downstairs in room after room of frescoed and marbled splendor with intricately patterned floors and coffered ceilings, upstairs a complete panorama of Western Art from Primitives up through a few nineteenth-century paintings. It also holds one of the world's most discriminating selections of French Louis furniture. The painting collection is not up to that of Simon but is still impressive, including an accidentally discovered Raphael and many another Old Master.

Everyone is by no means enthusiastic. Modern architects are furious at this plum having evaded their clutches and all that money having been wasted on an archaeological and retardataire building. Others are offended by what seems the garish decor. But this is what Roman colors really must have looked like before time and volcanic action softened them. Also there is a good deal of criticism of the richly mounted and glisteningly restored Western paintings. Are the attributions "overconfident"? Are the pictures really worthy of such a hushed and holy setting? Mr. Getty could evidently have cared less, since he never did see his masterwork before he died, though he left it the bulk of his fortune. The total effect in any case is certainly a revelation of the Grandeur that was Rome, probably much more authentic than Mr. Mellon's Mall. The widespread triangulation of Simon, LACMA, Getty, flanked by Santa Barbara to the north and San Diego to the south, makes an esthetic entrée rather different from that of most American cities and richer than many — three museums surveying the spectrum of Western Art in varying but quite profound depth.

Then there is the Huntington Library in San Marino, right next to Pasadena. The Huntington, founded in 1919, is not strictly an art museum. It is one of America's most important rare book collections, a West Coast rival of the Morgan in New York and preeminent in the area of English literature. It has, however, America's finest deposits of English eighteenth-century drawings and portraits, the most famous examples being the *Blue Boy* by Gainsborough and *Pinkie* by Thomas Lawrence. The *Blue Boy* was bought by Henry Huntington, nephew of Collis, for over half a million dollars, one of canny Joseph Duveen's major coups. The subject is not a young nobleman but the decorative son of a rich ironmonger (dealer in hardware), showing that blood doesn't always tell. *Pinkie* is the portrait of a pretty young girl who was born of a family of Jamaica planters, hence an American, and was the

aunt of Elizabeth Barrett Browning, that friend of J. J. Jarves. Nearly all the portraits in this grandiose Great House, once the Huntington residence, have their special stories, and often the stories are really more interesting than the pictures. The Huntington story has its moments, too. Henry made his own fortune based on Los Angeles real estate and railroads, but his marriage to his millionaire uncle's millionaire widow helped consolidate Huntington fortunes. He built his marble pleasure dome for his new sixty-year-old bride, but she hated southern California. She would only consent to come if she could transfer directly from New York to the house in San Marino, so a special spur of the Huntington railroad was built right up under the porte cochere of the house, where Arabella could step out of her private car into the front hall. She wore widow's weeds in mourning for her first husband all through her second marriage but was buried along with Henry, her second best, in a handsome circular white marble mausoleum in an orange grove right in the library gardens — another "museum burial" somewhat on the order perhaps of that of Trumbull at Yale or Ackland at Chapel Hill. The gardens are breathtaking in their elaborateness, variety, and gorgeousness; and the library, in its own special big building, contains priceless items of art like illuminated manuscripts as well as Arabella's own not very special personal collection of Italian Renaissance paintings.*

Finally, halfway across the Pacific, there's a lovely art museum in Honolulu especially noted for its Oriental art. It has its Kress Collection, too, Classical antiquities, and Pacific Island art. It also has courtyards with exotic trees and flowers and troops of blue-jean-dressed, gum-chewing, Asian-American schoolkids who file through to see what sort of thing their ancestors have been up to. What are they thinking? The Honolulu Academy of Fine Arts dates from as far back as 1927 and is certainly the farthest western outpost of the American art museum. Puerto Rico doesn't properly belong in a consideration of U.S.A. museums, being a culture and country pretty much of its own. It does have fine art museums, very much oriented toward Spain, especially the Ponce Museum in San Juan. Canada, which we failed to conquer on several occasions, has really superb museums; and Mexico City is one of the great art centers of the world. When one says "America," these and the equally great museums in Central and South America have to be thought of.

But this is the story of art museums in the United States, including dozens I have not discussed in this round-up. They all have their special treasures and peculiarities. What is desperately needed is a sober

* For the details of Arabella's odd career see James T. Maher's *Twilight of Splendor* (Boston: Little, Brown, 1975).

Baedeker-like guide to every single one of them, with or without "stars," a simple, severe, Valentiner-like portable volume or series of portable volumes that assumes the reader knows who Giotto and Bosch and Seurat *were,* books that can tell the reader just where their pictures now *are.* Meanwhile the eager traveler can try to ferret out all the museums in the *Museum Directory* or Eloise Spaeth's invaluable guide or the Reader's Digest *Treasures of America* or the Christensen book or just hope to stumble on the more obscure collections by sheer accident. Someday, perhaps, the confusion of riches will be clarified.

Chapter III

i

IT WAS THE BEST of times, it was the worst of times — in other words it was 1970 and Boston, like New York, was celebrating the Centennial of its great museum. New York's lengthy celebration marked the beginning of Hoving's tenure, and a stormy debut it had been and continued to be. To some, the celebration in Boston seemed mainly a tribute to fifteen years of the directorship of Perry Rathbone, inheritor of the mantle of Kimball and Taylor.

Rathbone's basic creed seemed to be not unlike that of another Harvard graduate, Franklin Roosevelt: to create money, spend money. And always to complain there wasn't enough money. Since the Boston Museum of Fine Arts got only nominal help from the city of Boston and was almost totally dependent on private funds, it was obvious that in a day when private funds were not what they had once been a broader base of support had to be created. A quiet word passed among old friends on the board of trustees was no longer sufficient for meeting deficits and competing for acquisitions.

The way to solve this problem was to bring in many new supporters. (They turned out to be the old clannish types, however.) The way to increase membership was publicity and inducements. Make the Mu-

seum attractive; stimulate enthusiasm by exciting exhibitions and all sorts of interesting events. But these cost money. Spend money to make money was the theory.

For the first ten years of Rathbone's incumbency this program worked. Redecoration, reinstallment, continuous exhibitions, and regular membership drives by the Ladies' Committee kept things humming, attendance growing, and new supporters joining. One of the first of the Rathbone exhibits was a tribute to "Sport in Art," which included a live figure skater demonstrating her skills in the Rotunda. The first important exhibition of the new regime also excited great local interest. It was called "Sargent's Boston" and honored the centennial of the artist's birth. Whereas Philadelphia never seemed to pay much attention to its semi–native son, Boston enthusiastically adopted him. This is particularly odd since Sargent quite obviously carries on the essentially Philadelphian tradition of Sully and his fashionable portraits so full of well-bred worldliness and social charm. In a sense Boston patronized him to death by making a muralist of him and engaging him to do those murals for Boston Public Library, which killed him off.

In 1956 alone the BMFA had twenty-four special exhibits. A Ladies' Committee was created in 1955 for the first time in the Museum's history. It did wonders and started the first organized membership drive the next year. In 1959 the Museum put on its very first exhibit of modern art with the active assistance of Hanns Swarzenski. He was a scholarly Medievalist and the refugee son of refugee scholar Georg Swarzenski who fled to America in 1939 and was a Medieval expert in the Department of Decorative Arts at the Museum. Hanns followed in his father's footsteps and became Curator of his father's department in 1957.

This Rathbone program of expansion, excitement, and exhibitions was crowned by three resounding successes. In 1964 there was a memorial in honor of John F. Kennedy, a sort of historical-photographic survey of JFK's career, which though lasting only four days attracted nearly one hundred forty thousand people and made the attendance for that year the highest till then.

This 1964 record of eight hundred thirty thousand was special but the more ordinary 1966 attendace of nearly seven hundred eighty thousand was the highest of any normal year. However the overall yearly attendance declined from 1966. The reason for this was suspected. In 1966 the trustees voted to charge an admission of fifty cents. The 1966 attendance was not affected but that of 1967 was. By 1968 attendance had shrunk to not much more than five hundred thousand. In 1968 admission was raised to one dollar. Inflation and deficit were getting ahead of membership and support.

Many of the more conservative friends of the Museum objected to the crowds and to the methods used to bring people in. Advertisements they considered more suited to a supermarket than to an art museum told the people of Boston that *"This* is *your* family's *personal* museum." But it was going broke.

Something drastic had to be done. Using the forthcoming Centennial as a goal and incentive, a massive public drive for funds would be undertaken for the very first time in the Museum's history since the initial appeal in 1871. No more of those quiet words among trustees. This was to be a great splash using professional fund-raising methods, hundreds of eager volunteers, big contributions by foundations, the works. First steps were taken as early as 1965. Nothing like this had occurred in the Museum's history since its very beginnings, and the board and older friends of the institution were not the kind of people who could manage such an affair. The job was handed over to a comparative "newcomer," businessman George C. Seybolt. He was willing and able. A careful goal of $13.4 million (not just a round thirteen or fourteen) was specified and under Chairman Seybolt the Centennial Development Fund campaign was inaugurated in January 1967.

ii

It was against this background of increasing bravura and increasing threat that the Centennial celebration took place. It celebrated the BMFA's majestic and meritorious growth. It celebrated the Museum's first public fund drive, which was moving successfully forward to its goal. But back of these celebrations were the looming threats of deficit and inflation and the disturbing problems of conservation — only one special area, that of the Forsythe Wickes collection of French furniture, was properly air-conditioned. The celebration could not afford to be just a quiet self-congratulation; it had to be an important self-advertisement, too.

Like the Met's Centennial, Boston's was designed as a series of exhibitions and social events; but whereas the Met's enterprises before, during and after 1970 seemed to be conducted in a constant glare of glamour and controversy, Boston's began rather quietly. The program as planned was to consist of a preview called "Back Bay" in the fall of 1969, then the great official opening of February 4, the day of chartering in 1870, during which marvelous new accessions saved up over a period of years were to be revealed under the title of "Art Treasures for Tomorrow." This was to be followed in the spring by "Royal Images," an importation of masterpieces of Egyptian art never before seen outside their native country. The summer held the promise of a compre-

hensive exhibit of the works of Pennsylvanian Andrew Wyeth, billed as "painter par excellence of New England." In the early fall of 1970 the exchange of pictures from the Met was to be featured, followed by a rare and very special mounting of Japanese treasures, also never before seen out of their birthplace. This was to be called "The Art of Zen." From February 4, 1971, on into a new spring, a sort of modern *son et lumière*, a mixed-media spectacle called "Towards 2070," was to close the celebrations with appropriate jubilation.

In many ways the Back Bay exhibit was much like "Harlem on My Mind." It, too, was not an art exhibit but essentially a photographic study of a city neighborhood. Otherwise the contrasts were considerable. Both sections, Harlem and Back Bay, could be classed as "minority ghettoes"; but whereas the one was exclusively populated by poor blacks, the other had been exclusively populated by rich whites. Boston's Back Bay in the 1870s was an exciting radical experiment in town planning, a whole new city created on top of landfill in what had been swamps and harbor. It was at the time a successful experiment (unlike the later Fenway extension). A new, rich, cohesive, socially prestigious neighborhood was created as if by magic from scratch, succeeding Beacon Hill as the place to live and creating a concentration of wealth and civic power from which institutions like the BMFA could and did evolve. The Museum was very much a neighborhood affair, situated there, backed and supported by residents. The stylish and nostalgic survey of this singular creation of a city within a city, innovative then, imperiled but time-mellowed now, elicited nothing but applause and a determination by preservationists to Save Back Bay. How different from the Metropolitan's Harlem show!

It was the second exhibit, the official opening one, that was the climax of the year, corresponding perhaps to the Met's rather arrogant display of its own masterpieces. This Boston panorama of new treasures got most of the praise and publicity and in the end caused all the trouble. Like the opening of festivities in New York, there was a whole series of different openings for different people. A small discreet birthday cake with one hundred slim candles did not produce the problems of New York gigantism. Select parties on the fourth with the Mayor and Governor by day and a black-tie dinner by night for significant patrons corresponded in social brilliance, but not in public glare, to the Met's Ball. Then on February 8 there was the great public party and twenty-three thousand people set a new record for a single day's attendance. A whole string of parties followed for "special guests," where players of Isabella Gardner's favorite team, the Red Sox, mingled with scholars like Agnes Mongan of the Fogg.

What really caused a sensation was the unveiling of acquisitions. They ranged in time from millennia before Christ to just yesterday, from

Cycladic idol to David Smith sculpture, and covered all the ground in between. There were many startlingly beautiful and rare objects, but the two that delighted the celebrants and the newspapers were a "Gold Hoard" and a Raphael.

The Gold Hoard was a group of some one hundred thirty-seven objects supposedly found together in the Mediterranean area, location unspecified. They could be dated from the third millennium before Christ. Cornelius Vermeule of the Museum's Classical Department was firm in stating that the objects were all of that remote date and undoubtedly had belonged together. He was equally firm in refusing to say where they might have come from. They were bought in Switzerland through the generosity of trustee Landon Clay for the canonical "six figures." That was all that could be revealed. Almost immediately an international riot broke forth in newspapers, led by those of London who seem for some reason to have it in for the BMFA as the New York ones have it in for the Met. Was the Hoard a forgery? Greeks said so. Was the Hoard smuggled? Turks said it had been smuggled out of Turkey and must be returned forthwith.

It was all curiously reminiscent of Cesnola and his Curium trove. There seems in fact to be an almost sinister fate hanging over such troves. The first and most famous one, Schliemann's discovery at Troy, which had gone to Berlin, simply disappeared during World War II and has never been heard of again. Cesnola's was a fraud. An incredible tale of another mysterious Hoard evolved in the late 1950s. An Anglo-Dutch art figure published drawings in the *London Illustrated News* in 1959 purporting to depict something called the Dorak Treasure. The story is much too good to be true. The art expert was traveling on a train — it surely must have been the Orient Express — when he saw passing by a girl, obviously exotically beautiful, who had on her arm a great gold bracelet that he immediately spotted as being archaic work. He pursued her, made her acquaintance, and finally ended up in her apartment in Smyrna where he was allowed to sketch, but not photograph, this fabulously mysterious treasure. Thereupon girl and treasure disappeared, like the Trojan Hoard, and have never been heard of again. Naturally doubts were cast. Why sketches, which anybody could fabricate, rather than photographs? But what could be the point of the fraud, if it was one? Only the kind of publicity that Cesnola had once hoped to get from his supposed discovery at Curium, but not the kind of hard cash he got from the bemused Metropolitan trustees.

Misinformed newspapers hinted that this new Boston Hoard might be the Dorak Treasure, but it obviously wasn't. In the end nothing could be done to the BMFA. Turkey had no real claim on the loot (it might have come from one of seven countries). The Greek outcry of

forgery was false. Though some archaeologists seem to remain skeptical, Boston's treasure, in greatly reduced form, is still on display as a unit.

The Cycladic Idol, the David Smith sculpture, the Medieval Virgin, the Correggio, the Cassatt, the Korean fifth-century crown were all hits; but unquestionably the hit of all hits was the Raphael. Not since the Met's purchase of *Aristotle* had there been such national and international fuss made about a picture in an American museum. No single item of the Met's Centennial received as much attention, and few pictures have been so obviously appealing to the American public. A small, glossy portrait not much more than eight by ten inches, the BMFA picture portrayed a round-faced, innocent Italianate young girl purported to be Eleanora Gonzaga. As in the case of the Gold Hoard, there was a lot of mystery attached to the picture. Nobody knew who had owned it or who had bought it or where it was bought. As in the case of the Gold Hoard, the mystery added piquancy. All Mr. Rathbone would say was that it was authentically certified to be a genuine Raphael by the prestigious expert John Shearman of the Courtauld Institute in London, that it also cost "six figures," that it had probably been painted about 1505, early in Raphael's career, and that it was no doubt Eleanora. Period.

Eleanora's portrait also proved to be the straw that broke the camel's back, in a way quite reminiscent of the Mino da Fiesole tomb, but all out in public this time. The picture first went on exhibit in 1969 but was only officially spotlighted on February 4, 1970. However, ominous rumblings had already begun. As early as January, not Greece or Turkey but Italy was becoming restive. Signor Rodolfo Siviero, a world-famous art detective, head of Italy's busy department for the recovery of stolen or smuggled Italian art, accused the Museum of having taken out a precious drop of Italian life blood without getting the proper authorization. Rathbone suggested that Siviero was "leaping to conclusions," that the Signor had no way of knowing where the painting had been bought — perhaps in Switzerland, like the Gold Hoard.

The Centennial proceeded jubilantly if not without contretemps. The next big show was supposed to be the "Royal Images" exhibit of Egyptian statuary. Most of the statues had already been packed in Egypt in very special floatable cases to forestall shipwreck. Then suddenly at the last moment, a month before the opening, the Egyptian Government called the whole thing off. The Israelis had just bombed an Egyptian town using American planes. The Egyptians said the show would have to be "postponed" till "a happier atmosphere prevailed." The Museum recovered from its shock and responded brilliantly by putting on a big show of Afro-American paintings, perhaps the largest such exhibit ever mounted in Boston. It was stimulating in the right way. It produced favorable reviews but a serious questioning of just

what Black Art was and how did and should it fit into the mainstream of art in general. The artists ranged from the purest of Abstractionists and most sophisticated of technicians to brutally primitive propagandists. It was hard to see what they had in common other than racial origins, but they got a lot of recognition and the general consensus was that it was a shot in the arm for the careers of a group of unjustly neglected talents.

Summer shone on Andrew Wyeth and the record crowds that came to look at his depictions "par excellence" of New England. Numerically this was the most successful of all the Centennial shows, and curators who liked to think of summer as a slack time were mightily surprised, as was the Director.

An interregnum in the fall displayed holdings exchanged with the Met. Then, as Wyeth was a sop to popular taste, so the last important show of the Centennial was a sop to scholars. Students flocked. "The Art of Zen" recognized those ancient and honorable ties between Boston and Japan forged by Morse, Fenollosa, Bigelow, and Okakura. Like the "1200" exhibit at the Met, it was designed to prove to experts that the BMFA was, after all, really serious. The display was almost stupefyingly tasteful, elegant and sophisticated; but it also fitted in with the nascent religiosity of the Youth Movement. Treasures were sent over that, like those that did *not* leave Egypt, had never left Japan before and would never leave Japan again. Visitors talked in whispers if they talked at all in such an ambience.

The last frolic, which began on February 4, 1971, was the Mod free-for-all; but alas the happy jubilance was already obscured by dreadful storm clouds. For Mr. Rathbone had not succeeded in flouting Italian persistence as Mr. Vermeule had outlasted Turkish insistence. Things got worse and worse and worse. Gradually but steadily suppositions became realities. It must always be remembered that the artist in question was Raphael, the occasion was the hundredth anniversary of one of America's most truly great art museums and Mr. Rathbone stood at the very top of his profession along with the retired Mr. Milliken and Mr. Hoving.

In Italy Mr. Siviero moved from the general to the particular; in particular, charges against one Ildebrando Bossi. Bossi, an old gentleman with a controversial reputation as an art dealer, was accused of having sold the Raphael on the sly. The *London Sunday Times* was hot on the scent of blood. As early as March 1970 it had proclaimed: "For the second time in a month the Boston Museum of Fine Arts stands accused of buying illegally exported works of art." Siviero was quoted as saying that the Raphael sale involved one of the most serious losses suffered by the Italian artistic heritage in recent years.

Then in April 1970 England spoke again. Like Greece, it made ac-

cusations of forgery. That is, Sidney Sabin, a prominent dealer, and John Pope-Hennessy of the Victoria and Albert both broke into print saying that they didn't believe the picture was a Raphael anyway, which made Signor Siviero's gestures rather futile, did it not? Nothing happened, however. Dr. Shearman had unequivocally authenticated the painting. He had carefully examined the actual panel; the others had merely made judgments from photographs. Eleanora Gonzaga continued to reign supreme on Huntington Avenue, but no longer to reign securely.

Then in 1971, just as the Centennial was about to close, Eleanora's Boston reign ended. On January 8 the Raphael was seized not by the Italians but by the U.S. Customs. Making a melodramatic entrance, a group of Customs officials strode into the sacred precincts, had Eleanora taken down, and then, rather anticlimactically, not removed but stowed away in an air-conditioned vault in the Museum itself rather than exposing her to the killing airs of January in Massachusetts. This shocking denouement turned on the fact that in view of all the national publicity and Italian complaints, the U.S. Customs Bureau finally got around to checking through its files and at the time of the new year discovered there was no record of the picture having come into the country. Since under Morgan's Payne-Aldrich Act antique works were not dutiable, no monetary swindle was involved; but forms should have been filled in, bureaucratic conventions observed. For reasons that still remain totally obscure, this simply had not been done.

Willie J. Davis, Assistant U.S. Attorney, made a field day out of it. Here was the Eastern Establishment caught with its pants down. Representative Patman had been attacking foundations and institutions and other bastions of the Establishment and this was a golden opportunity to make his points dramatically. Meanwhile, by rather unfortunate coincidence, it happened that the then Italian Prime Minister, who bore the symbolic name of Columbo, was coming for a state visit to Washington. The gossip was that the United States wanted his help in stemming drug exports from Italy. As quid pro quo, Emilio Columbo wanted the Raphael back.

So in February, just exactly a year after the opening of the grand celebration, Director Perry Rathbone and Curator Hanns Swarzenski were called before a Boston Grand Jury. Their testimony was secret. The story as reconstructed by newspapers and bystanders, which may be quite incorrect and is certainly quite uncertified, runs as follows: Signor Bossi bought the picture from a Fieschi family in Genoa as far back as 1940. Then two museum representatives had met in Genoa in the summer of 1969 and bought the picture from Bossi. A curator had popped the small thing in his suitcase and flown back home without telling either the Italians or the Americans. According to museum gossip,

this was a fairly routine practice in dealing with small ancient objects. It saved a lot of trouble. Nobody had ever made a fuss before. When the Raphael arrived in Boston, it was greeted with huzzahs by the trustees, who knew nothing of its recent past history but saw that it could be made a center of Centennial attraction.

The Italians only found out it was missing because of the newspaper publicity. It had never been registered and in fact art people claimed that many experts did not consider it a real Raphael. Bossi had been offering it around Italy for years without finding a buyer. If it had not been for the museum's oversight in not declaring it to the U.S. Customs, nobody could really have done anything much about it and it might still be hanging in Boston. Old Signor Bossi died before anyone could really find out the truth from him. Willie J. Davis, crusading U.S. Attorney, faded from the scene. Mr. Columbo's tenure in office was surely not very long. If it hadn't been for the U.S. Customs. . . ! As it was, Columbo and Siviero got their Raphael. It is now sequestered somewhere in Italy and nobody knows yet whether it is really a Raphael.

Perry Rathbone left. Hanns Swarzenski, after two generations of valuable service by his family to the Museum, left too. George Seybolt, who had become President of the board, remained as President until the end of his term, then continued as a trustee. The great engine of culture drifted without a conductor. An interim director proved a failure and departed. Admission had risen to two dollars and fifty cents, fund drives had stalled. The $13.4 million had been reached, but not all in hard cash; and inflation continues. The Museum's contents had never been more beautiful in all its history, nor more beautifully displayed, even without a Raphael. But whither?

iii

The story of Hoving's darkest hour comes *after* the two Centennials. It reflects so many aspects of the turmoil in Boston that it can only be understood as a continuation and exasperation of the same problems, and the same mistakes. The Metropolitan Centennial was on the whole a success, despite the squawks; and Hoving came out of it with his prestige increased rather than diminished, even in the pages of the *New York Times*. A series of events beginning as early as 1970, however, almost destroyed him, and in almost the same way as the Raphael destroyed Rathbone — too much publicity, too little caution.

In November 1970, immediately following the Centennial, the Met spent over five and a half million dollars for a Velásquez. It was a portrait of Juan de Pareja, a painting assistant to Velásquez, who was a

mulatto and hence very desirable: any older painting involving negritude increases in value for just that reason. However, five and a half million is one of the largest sums ever paid for a single picture and the Met obviously couldn't afford it. It had to raise money somehow and one way was by selling other pictures. What would sell best and what the Met had most of was French art, Impressionist and Post-Impressionist.

A rumor, no more than that, began to float about New York that the Met was planning to sell some very famous pictures indeed. One was the Picasso *Woman in White,* formerly a prize of the Bliss Collection and reluctantly sold by MOMA to the Met during their brief days of collaboration. Another was a Gauguin from the Lewisohn Collection. Canaday, always on the lookout for a Hoving faux pas, printed a column in February 1972 drawing the public's attention to these rumors. The pictures, it was said, had been "deaccessioned" previous to disposal. This term, heretofore familiar only to museum people, suddenly became celebrated. Deaccessioning means an object has been stricken from the rolls of the museum's cherished recorded possessions and can be gotten rid of. How dare the Museum get rid of these popular favorites without letting anybody know? Hoving answered Canaday's blast with one of his own, calling Canaday a liar. But Canaday wasn't a liar. These particular pictures had been deaccessioned, though not actually sold. They were quietly reaccessioned. Victory to Canaday in the first round.

The second round: it was discovered that some similar French paintings, including a favorite Rousseau jungle scene, had not only been deaccessioned but actually sold. Many of these pictures were from the collection of Adelaide de Groot and some had been sold not to highest bidders but directly to the Marlborough Gallery, an affluent octopus of the arts with many international tentacles. Some others had been traded for modern American works. Why had no one known about all this beforehand? Why had things been sold directly to one dealer instead of being shown around to other possible bidders? Why had such low prices been achieved for the Met's pictures and such high prices for the new Americans? There was also the matter of the de Groot bequest. Adelaide de Groot, a rather self-important and cantankerous lady, died in her nineties and left over two hundred pictures to the Met and a lot of money to be used for archaeological digs. Many of the pictures had been on loan to the Museum for years, among the very first School of Paris moderns to be exhibited there. Most had been retired as the Met got better examples. When Miss de Groot bequeathed her pictures, she did not put binding instructions on them but she did "request" that the pictures not be sold. Instead, they should be given or lent to less fortunate museums.

The *Times* blew this up into a major scandal. Why, why, why? Actually Hoving was on perfectly safe grounds. There were no legal restraints involved; he had his trustees' approval, any museum must have discretion to deaccession and sell, as Fiske Kimball so gracefully did in the 1950s, even if in the end it should turn out to be a mistake.

But not if Canaday could help it. The art world of New York, led by the *Times,* went after Hoving with the obvious intent of getting him dismissed. Sometimes one got the feeling that the real kernel of discontent was that he hadn't gotten a good enough price for his wares. Deaccessioning became a dirty word signifying skulduggery, and Miss de Groot was canonized. It was not so much a Boston "brouhaha" as what Hoving himself liked to call a "kerfluffle."

Then in a burst of enthusiasm as rash as that displayed by Boston over its Raphael, the Met in the fall of 1973 announced the acquisition of a Greek pot. This was an ancient so-called krater or mixing bowl ornamented with a painting of a sad scene of mythological slaughter and signed by the greatest of all known Greek vase painters, Euphronios. In a worthwhile attempt to draw attention away from the overpopular Impressionists, which the Museum was selling, and towards the underpopular arts of Classical antiquity, Hoving produced his superlatives for this handsome jug, set up in a gallery all by itself. The *Times* had it as a cover story for the Sunday magazine with many a snide innuendo; Dietrich von Bothmer, the Curator of Classical Art, went into public raptures.

The Boston dramas of the Gold Hoard and Raphael were reenacted. In exactly the same fashion, the Met refused to explain anything — where the piece had come from, how much it had cost, who had sold it. The very same storm clouds that had overwhelmed Rathbone began to gather about Hoving. Rodolfo Siviero, that watchdog of Italian art, again got into the act. The jug had obviously been dug up clandestinely from an Etruscan site in Italy, sold surreptitiously and smuggled out of the country. New York, like Boston, must give back this ill-gotten gain. Life blood was seeping.

But things had been done more carefully this time. The piece had been bought in Switzerland, not Italy. The piece had been properly declared to U.S. Customs. A reputable dealer, Robert E. Hecht, Jr., an American living in Italy, was revealed as the agent. The seller was supposed to be one Dikran A. Sarrafian, an Armenian living in Beirut. He said the fragments of the krater had been lying around in an old family hatbox ever since his father had picked them up about 1920. Only the rather vague evidence of an ignorant *tombarolo,* an Italian excavator of illicit archaeology, could be cited against the evidence of Hecht, Sarrafian, von Bothmer and Hoving. Nobody in fact could do a thing and nothing in fact was done, except that the Archaeological

Institute of America conspicuously failed to elect von Bothmer to an office. President C. Douglas Dillon of the Met and his board of trustees stuck by their director as Marquand had stuck by Cesnola. Let Canaday rage as once the critic Clarence Cook had raged against General Luigi. The *Times*'s get-Hoving campaign flowered into a book, witty if not very kind, *The Grand Acquisitors* by *Times* staff member John Hess. Published in 1974 and favorably reviewed in the *Times* by an Englishman who admitted being a great friend of Canaday, this was the high water mark of the sea of troubles about Mr. Hoving.

It subsided. The Metropolitan had published a so-called "white paper" in 1973 (it actually had a brown cover) explaining, apologizing, justifying and listing and laying down elaborate guidelines for future deaccessionings and disposals. Nobody could do anything about Miss de Groot's wishes, since they were just wishes. The New York State Attorney General Louis J. Lefkowitz threw his weight around, but legally at least the Met was justified. In November 1975 the *Times* capitulated and published a generally laudatory article on Hoving in its magazine. Canaday retired from writing about art in the *Times* to writing about cookery. Hoving remains.* Remains, but remains, one should imagine, somewhat shaken, somewhat chastened. He announced that he planned to resign in late 1977.

The problems remain, too. To what extent is a museum like the Metropolitan, which receives money from the city and the taxpayer for its building and upkeep but none for acquisitions, responsible to the public for the handling of its art? Hess seemed to think it would be a good idea for trustees to be popularly elected. The trustees have always thought the art in the Met belonged to them as managers of the institution. To what extent are donors' *wishes* to be respected? To what extent *can* American museums afford to respect the overcautiousness of nations like Italy, Greece, and Turkey? They hold on to warehouses full of unseen art, but do not want to let anything go. What good is a little Raphael to Italy, or one more Greek vase? It's as though the oil-rich Arabs insisted on sitting on all their oil, even if they fail to use it themselves. Smuggling becomes inevitable. These are just some of the problems that remain unsolved. It is too late for this book to go into the final Annenberg kerfluffle.

But around the Met things are comparatively quiescent. Huge additions are being made. The Lehman Pavilion opened in 1975 to the disgust of all right-thinking *New York Times* art critics. The budget has been balanced. But again, whither?

* There were other kerfluffles: the deaccessioning of a famous Ingres, *Odalisque*, and the peremptory sale of all the Met's classic coins to pay for its classic jug. But these were not the principal complaints against Hoving.

iv

Whither indeed? The whirlpool of controversy and rancor surrounding Hoving and the Greek tragedy of Rathbone's precipitation from the topmost heights of the museum world just as he reached for the golden apple of the BMFA's first Raphael seemed symptomatic and symbolic of the crisis of the American art museum. The crisis is that peculiar American one of success, the perils and problems produced not by decay and failure so much as by overachievement and too much growth. No one can argue, no one can doubt that the hundred-year history of the art museum in the United States has been one of incredible achievement. In a brief century a country with minimal artistic traditions and almost no state help or patronage has emerged as "Museum Country" in much the same way as Fort Worth has suddenly emerged as "Museum City." That statement, so full of qualifications and dubieties, that "there are more good art museums in the United States than in any other country in the world" can be supported. The miracle is that it can even be made. No one could have said that in 1870.

And today no one can probably really know, for it would take one such human being years to be able to judge. Just to get to know the complete world of the American art museum would require a lifetime of devotion. There are so many art museums and they keep increasing still so rapidly that it is impossible to keep track of their existence, much less their contents. Every city, nearly every state, and most colleges and universities have something that serves as an art museum; and most of them have at least some really good things in them. No one can truly appreciate the totality of the awesome spectacle without traveling around and seeing this accumulation of beauties. It is that totality, the phenomenon as a whole that inspires the awe rather than just one or two of the individual items, glorious as some of those items may be.

This panorama of wealth and growth has been a major national achievement and we all can be justifiably proud of it. But can it continue to go on as it has been going on? And if not, then what? Americans are gradually beginning to appreciate what they have, including their art museums. Are they willing to work at keeping them as they have been at getting them? A cynicism about art skulduggery and politics, like the similar cynicism about national skulduggery and politics, a feeling that the growth of art museums has gotten out of hand, like the Met's top-heavy birthday cake, a lot of populist propaganda about elitism and relevance, a lot of scholarly revisionism about at-

tributions, with results like the Met's downgrading of half its Rembrandts — all these things are testings of the pride and position of the art museums. But much more basic and crucial are physical and financial facts. Inflation undermines endowments. Private sources dry up. City governments go bankrupt. Picture prices still soar. It is costing as much to stand still as it used to cost to go ahead. It's all very well to disparage "static depositories" as opposed to "dynamic institutions," but where is the cash for "dynamism" going to come from?

Where is more art going to come from? European sources seem to be drying up, too. Under the proddings of people like Signor Siviero, old art centers are more and more jealous of what they have; and they have less and less. What they do offer costs more and more. Though masterpieces still seem to be available to a Norton Simon, most smaller fry, such as the emergent Southern museums, simply cannot compete anymore.

Then there is that battle, still continuous, between Instruction and Joy. Are museums Universities of Vision or Churches of the Eye?* There is no reason they should not be both, but the demands are sometimes conflicting. Should museums put up with "representative examples" the way college museums do because they can be used as teaching material and the museums can't afford anything good anyway? Should museums be overrun by schoolchildren or left to the contemplative rapture of those who really are rapt about art? Is there not a limit to the number of people who can profitably coexist in one gallery at one time? Are spirals of rising attendance, more safety precautions, higher pay for more guards, and more money from the city not simply self-defeating?†

Basic to all this is the fact of the American museum. The museums are now *there*. America does not really need more and better museums. It has more and better museums. What the museum world and the public in general now have to face are the problems and perils of maintenance, not of growth. To keep what we have — whether it be old cities, wildernesses, rural amenities, clean shores and rivers, or art — is becoming more important than to get what we have not. That phase, as far as art museums are concerned, is beginning to be over. The history of 1970 to 2070 will not be like that of 1870 to 1970.

This is a peculiarly difficult adjustment for Americans. We have been so trained by our history and its successes to think in terms of expansion that we are not very well prepared to think of things in terms of

* Art museums are generally classified by the Government for tax exemption as *charitable* rather than educational institutions.

† The Philadelphia Museum in its grand reopening has had to *close* galleries because higher attendance means more security and costs more money.

protection. Keeping what you have demands entirely different skills, attitudes, and aptitudes from getting what you don't have. The self-made man who makes a million lives in an utterly different world from his son who has a million. Just going on making more millions won't do. The grandson who has more millions will eventually have to face the problems of having versus getting. This is the position of affairs that American museums must begin to approach.

There's no real reason why the Met or the BMFA should grow. They have everything a museum needs in the way of art objects. An item here or there, a better item, things in special new areas like Primitive art or nineteenth-century Russian art or, always, contemporary art. Perhaps the BMFA could get a *real* Raphael someday. But basically the older, larger American museums are finished products. This is not at all true of museums in Salt Lake or Miami. They do indeed have a way to go. Meanwhile, how are all museums to finance mere existence, much less growth? Titans no longer grow on trees. In Europe the state or the city has always supported museums as a matter of course, although it has not always done a superlative job of it, as a tour of Italian provincial museums easily demonstrates. It is not at all obvious that U.S. Government support would be the best answer. What are the alternatives? Massive popular support on a broad base means popularity contests. State or city support means politics and poverty. Support by the rich, if available, means control by the rich.

These problems loom very large on the otherwise brilliant horizon of the American art museum. Meanwhile, let us simple folk revel in what the good luck and hard work of others have created for us. The Bicentennial has produced a general housecleaning of museums everywhere, even brand-new ones. Visitors spill over from one public attraction to another and art museums have lured the patriotic tourist by all sorts of special exhibits. As a result, Americans will have seen more American art of more different kinds in the last years than ever before in the nation's history. What the Centennial in Philadelphia did for "modern" European art is being done a hundred years later in various places for American art.

In the sober light of the postcentennial era Americans will have to decide what they want to do about it all. Are they going to keep on being interested in American art and American art museums? The future of both can no longer be entrusted to just a few rich people. A sympathetic and moderately well educated public is the best safeguard for the future. This means both Instruction *and* Joy. The future of the museum derives from a short but exhilarating past. What will this future be like? Preservation and appreciation rather more than construction and acquisition would seem to be forecast. An instructiveness

aimed not at just special scholarship but at general joy will certainly have to be part of this future, a broad awareness of what these Churches of the Eye can mean to individuals and to the culture as a whole. In any case one can't imagine the period from 1970 to 2070 being dull in this often tumultuous world. Behind the facades of these Palaces of the People, life is indeed no place like home.

Appendix

A Thumbnail Guide to Art Museums
in the United States

Being a tour of the country arranged geographically so as to bring the hardy traveler to one hundred and fifty art museums, including all the more important ones. The tour begins in Boston, swings southward around to the West Coast, returns via the Midwest and New York State to New York City. At an average of five museums a week, it should take a mere thirty weeks. The tourist should be accompanied by Eloise Spaeth's guide, *American Art Museums* (latest edition, 1975), which gives all pertinent details. The Reader's Digest *Treasures of America* (1974) is more comprehensive but much less esthetic.

Key: museums not covered by Spaeth are marked "x." There are over fifty others that are covered by her but are not on my list. Besides that, there are at least seventy more. *The Directory of American Museums* (1971), available in most good libraries, lists them all, with details. One parenthesis, "(Cambridge," means the place is suburban to a larger center. College museums are starred, "*," and the name of the college

follows in parentheses, "*Fogg (Harvard)." If the museum has no regularly used special name, the college alone is given, "* (U. of Pa.)," abbreviated. All museums are general museums of either Western painting (N.C.) or of world art (Met) or a mixed variety of art styles and forms (Phillips) unless indicated by one or more of the following abbreviations: A = American art, Aq = Antiquity or Archaeology, AF = African art, AI = American Indian art, C = Contemporary art, D = Decorative arts or "house museum," E = English art, F = French art, O = Oriental art, S = Spanish art. A dash after the location means the museum bears the title of the locality, such as the Detroit Institute. Accepted abbreviations are used, such as MOMA and PAFA. Only the name, not the designation, is listed, such as Barnes, not Barnes Foundation. For such details, check Spaeth, or the Museum Directory.

I. *New England*
 1. Boston, Mass. BMFA
 2. Boston Mass. Isabella Gardner
 3. (Cambridge, Mass. *Fogg (Harvard)
 x4. (Salem, Mass. Peabody
 x5. (Salem, Mass. (D) Essex Inst.
 6. (Wellesley, Mass. *Jewett (Wellesley)
 7. Providence, R.I. RISD
 8. Worcester, Mass. ———
 9. Williamstown, Mass. Clark
 10. Williamstown, Mass. *(Williams)
 11. Northampton, Mass. *(Smith)
 12. Springfield, Mass. ———
 13. Hartford, Conn. Wadsworth Athenaeum
x14. Farmington, Conn. (D) Hill-Stead
 15. New Haven, Conn. *(Yale)

II. *New York City, N.Y.*
 16. Met & Cloisters
 17. Frick
 18. (C) MOMA
 19. (A) Whitney
 20. (C) Guggenheim
 21. (A) NYHS
 22. (S) Hispanic
x23. (AI) Heye (Amer. Indian)
 24. (Brooklyn, N.Y. ———
 25. (Newark, N.J. ———

III. *Middle Atlantic*

26. Montclair, N.J.	———
27. Princeton, N.J.	*(Princeton)
28. Trenton, N.J.	N.J. State Mus.
29. Philadelphia, Pa.	Ph. Mus. & Rodin (F)
30. Philadelphia, Pa.	(A) PAFA
31. Philadelphia, Pa.	(Aq)*(U. of Pa.)
x32. Philadelphia, Pa.	(A) Independence
33. (Merion, Pa.	Barnes
34. Allentown, Pa.	———
35. Chadds Ford, Pa.	(A) Brandywine
36. Wilmington, Del.	(D) Winterthur
37. Wilmington, Del.	Delaware
x38. Hagerstown, Md.	Washington Co.
39. Baltimore, Md.	Walters
40. Baltimore, Md.	Balto. Mus.
x41. Baltimore, Md.	(A) Peale
x42. Baltimore, Md.	(A) Md. Hist. Soc.

IV. *District of Columbia*

43.	Nat'l Gallery
44.	(A) Nat'l Collection
45.	Corcoran
46.	Renwick
47.	(O) Freer
48.	(A,C) Hirshhorn
49.	Phillips
50.	(Af) Mus. African Art
51. (Georgetown)	(Aq) Dumbarton Oaks

V. *South*

52. Norfolk, Va.	Chrysler
53. Williamsburg, Va.	(A) Abby A. Rockefeller Folk Art
54. Richmond, Va.	Virginia Mus.
55. Raleigh, N.C.	N.C. Mus.
56. Chapel Hill, N.C.	*Ackland (U. of N.C.)
x57. Durham, N.C.	*(Duke)
58. Charlotte, N.C.	Mint
59. Columbia, S.C.	———
60. Charleston, S.C.	Gibbes
61. Savannah, Ga.	Telfair
62. Greenville, S.C.	*(Bob Jones U.)

V. *South* (cont'd)

63. Atlanta, Ga.	High
64. Athens, Ga.	(A)*(U. of Ga.)
65. W. Palm Beach, Fla.	Norton
66. (Coral Gables, Fla.	*Lowe (U. of Miami)
x67. Miami, Fla.	(D) Viscaya
68. Sarasota, Fla.	Ringling
69. New Orleans, La.	Delgado
70. Birmingham, Ala.	Wells
71. Memphis, Tenn.	Brooks

Note: There are two divergent routes from Washington to Memphis, one Piedmont route via Atlanta and Birmingham, one seacoast route via Savannah, Florida, and New Orleans. It is hard to combine them smoothly.

VI. *Plains and Southwest*

72. Wichita, Kan.	(A) ———
73. Tulsa, Okla.	(A) Gilcrease
74. Tulsa, Okla.	Philbrook
75. Ft. Worth, Tex.	Kimbell
76. Ft. Worth, Tex.	(A) Carter
77. Ft. Worth, Tex.	(C) Ft. W. Art Assoc.
78. Dallas, Tex.	———
79. Dallas, Tex.	(S)*Meadows (Southern Methodist U.)
80. Houston, Tex.	———
81. Houston, Tex.	(D) Bayou Bend
82. San Antonio, Tex.	McNay
83. San Antonio, Tex.	(A,O) Witte
84. Roswell, N.M.	(A,O) ———
85. Santa Fe, N.M.	(A) N.M. Mus.; Fine Arts
86. Santa Fe, N.M.	N.M. Mus.; Folk Art
x87. Taos, N.M.	(AI) Rogers
88. Tucson, Ariz.	*(U. of Ariz.)
89. Phoenix, Ariz.	———
x90. Phoenix, Ariz.	(AI) Heard

VII. *Coast and Northwest*

91. San Diego, Cal.	———
92. San Diego, Cal.	Timken
93. Honolulu, Haw.	———
94. Los Angeles, Cal.	LACMA
95. (Pasadena, Cal.	Simon

96. (San Marino, Cal.	(E) Huntington
97. (Malibu Beach, Cal.	Getty
98. Santa Barbara, Cal.	———
99. San Francisco, Cal.	(F) Legion
100. San Francisco, Cal.	De Young
101. San Francisco, Cal.	(C) S. Fran.
102. (Oakland, Cal.	(A) (Cal. Art)
103. (Berkeley, Cal.	*(U. of Cal.)
104. Sacramento, Cal.	Crocker
105. Eugene, Ore.	*(U. of Ore.)
106. Portland, Ore.	———
107. Seattle, Wash.	———
108. Seattle, Wash.	Frye
109. Cody, Wyo.	(A) Whitney
110. Denver, Colo.	———

VIII. *Midwest*
 Southern Tier (west to east)

111. Kansas City, Mo.	Nelson
112. St. Louis, Mo.	City Mus.
113. St. Louis, Mo.	*(Washington U.)
114. Louisville, Ky.	Speed
115. Cincinnati, Ohio	Art Mus. & Taft
116. Pittsburgh, Pa.	Carnegie
x117. Pittsburgh, Pa.	Frick

 Central Tier (east to west)

118. Youngstown, Ohio	(A) Butler
119. Columbus, Ohio	———
120. Dayton, Ohio	———
121. Indianapolis, Ind.	———
122. Bloomington, Ind.	*(U. of Ind.)
123. Champaign, Ill.	*(U. of Ill.)
124. Davenport, Iowa	———
125. Iowa City, Iowa	*(U. of Iowa)
126. Des Moines, Iowa	———
127. Omaha, Neb.	Joslyn
128. Lincoln. Neb.	(A)*(U. of Neb.)

 Northern Tier (west to east)

129. Minneapolis, Minn.	———
130. Minneapolis, Minn.	(C) Walker
131. Madison, Wis.	*(U. of Wis.)
132. Milwaukee, Wis.	———

VIII. *Midwest* (cont'd)
133. Chicago, Ill. ———
134. Chicago, Ill. (Aq)*Oriental Inst.
 (U. of Chicago)

135. Ann Arbor, Mich. *(U. of Mich.)
136. Detroit, Mich. ———
137. Toledo, Ohio ———
138. Oberlin, Ohio *(Oberlin)
139. Cleveland, Ohio ———

IX. *New York State*
140. Buffalo Albright-Knox
141. Rochester *(U. of Roch.)
x142. Elmira Arnot
143. Ithaca *White (Cornell)
144. Syracuse Everson
145. Syracuse *Lowe (U. of Syracuse)
146. Utica Munson-Procter-Williams
147. Cooperstown (A) N.Y. Hist. Assoc. Museums
x148. Glens Falls Hyde Coll.
149. Albany ———
150. Poughkeepsie *(Vassar) and back to N.Y.C.

Books and Acknowledgments

i

As this is a book for the general reader, I have not used footnotes for reference nor do I append a bibliography. I do, however, include a short book list for the benefit of those who may want to pursue a given subject further. It is far from being all-inclusive, but does list books, most of them in general circulation, most of which I have found useful.

It is usual in a work of this kind to acknowledge kindnesses. If I were to do so, many pages of gratitude would have to be printed, since in nearly every one of the nearly one hundred and fifty museums I have visited, one or more persons — directors, curators, docents, librarians, guards — have been kind and helpful. Many others not actively connected with museums have been extremely generous. They all have my heartiest thanks, but after a good deal of cogitation I have decided it would be better not to name names. Many of my informants are above criticism, but many are still actively involved in museum work. The world of the museum is a very tight one indeed, and it would be inexcusable if even one item in this book could be traced, even by inference, to even one person and that person possibly credited with

opinions that are really mine. To mention some and exclude others would be invidious. Discretion, or cowardice, has therefore been the better part of my valor. All of my helpers have all my thanks — anonymously. I hope they will understand and perhaps forgive. It is safe, however, to thank the Marquand Library of Princeton University and its staff. I could not have written the book without it.

As for the books: a few have been used throughout and in general. I list them first, with comment. The others I merely cite, indicating the chapter and section of this book for which they served as sources. I have not usually included books from which only one citation has been made, but only those of broader scope. Most of my information has been dug out of museum bulletins, handbooks and catalogs; art magazines; newspapers; mimeographed publicity; historical material and scrapbooks, or supplied during personal interviews. None of this is cited. I also have not included numerous biographies of artists or historical studies that do not seem directly pertinent.

ii

A. No books of current interest or importance seem to have been published on the subject of the American art museum as a whole. Numberless articles in art magazines deal with trends and problems, but there are no complete summaries.

 I. On American museums in general, not just art museums:

 1. COLEMAN, LAWRENCE V., American Assoc. of Museums, *The Museum in America* (3 vols., Washington, D.C., 1939). This is considered the classic, but it is out of date, not much concerned with art, and involved with practical details of administration.

 2. KATZ, HERBERT and MARJORIE, *Museums U.S.A.* (New York: Doubleday, 1965). A concise total coverage, with some art museum history.

 II. On American art museums in general, there are two guidebooks:

 1. CHRISTENSEN, ERWIN O., *A Guide to Art Museums in the United States* (New York: Dodd, Mead, 1968).

 2. SPAETH, ELOISE, *American Art Museums* (New York: Harper & Row, 1975). The latter is a necessary companion for the museum tourist. However the required "Baedeker" of American art museums has not yet been created.

 3. *Treasures of America* (Reader's Digest, 1974). Covers art museums and all the other sights.

III. Art museums in particular:
 1. FAISON, S. LANE, *A Guide to the Art Museums of New England* (New York: Harcourt Brace, 1958) and *Art Tours and Detours in New York State* (New York: Random House, 1964). Would that there were more such regional guides, brought up to date!
 2. On the Metropolitan Museum of New York, two books are basic and are in the background of everything I have written on the subject:
 i. HOWE, WINIFRED E., *A History of the Metropolitan Museum of Art* (2 vols., New York: Met Museum, 1913–1946). The basic text, but not fun to read.
 ii. TOMKINS, CALVIN, *Merchants and Masterpieces* (New York: Dutton, 1970). Fun to read; the earlier history is based on Howe.
 3. Similarly for the Boston Museum of Fine Arts:
 i. GILMAN, BENJAMIN I., *Museum of Fine Arts, Boston 1870–1920* (Boston: Mus. Fine Arts, 1921).
 ii. WHITEHILL, WALTER M., *Museum of Fine Arts, Boston* (2 vols., Harvard, 1970).
 The first is for reference, the second for reading; but its monumentality makes it more than can be digested in one swallow, for all the charm of style. However, it is the best of all books in the area of the American museum.

Other books on other museums I cite where applicable.

IV. Here follows a list of books not dealing with art museums but valuable as background. Most of them have served as general influences and will only be listed where especially pertinent.
 1. DUNLAP, WILLIAM, *A History of the Rise and Progress of the Arts of Design in the United States* (originally published in New York, 1834; paperback reprint, 3 vols., New York: Dover, 1963). A basic and picturesque biographical account of early American artists. Not very accurate by modern standards.
 2. FLEXNER, JAMES THOMAS. Four books, all now in paperback editions, all obligatory reading for the general reader interested in earlier American painting. *America's Old Masters* (New York: Viking, 1939; Dover, 1967); *First Flowers of Our Wilderness* (Boston: Houghton Mifflin, 1947; Dover, 1969); *The Light of Distant Skies* (New York: Harcourt Brace, 1954; Dover, 1969); and *That Wilder Image* (Boston: Little, Brown, 1962; Dover, 1970).
 3. RICHARDSON, EDGAR P., *A Short History of Painting in Amer-*

ica (New York: Crowell, 1963). This abridgment of a larger history, *Painting in America* (New York: Crowell, 1956), is a concise and judicious introduction to the whole history of American painting.

4. SAARINEN, ALINE B., *The Proud Possessors* (New York: Random House, 1958). The classic book on art collectors, including Freer, Johnson, Isabella Gardner and many others.

5. LYNES, RUSSELL, *The Tastemakers* (New York: Harper, 1949). Of this author's many explorations into the area of art and taste, this is perhaps the best known.

6. WECTER, DIXON, *The Saga of American Society* (New York: Scribners, 1937). Not about art, but lots about the collectors and donors of it.

7. BROOKS, VAN WYCK. His books on the history of American literature are invaluable for background on such figures as Charles Eliot Norton and John Jay Chapman. Especially *The Flowering of New England* (New York: Dutton, 1936); *New England: Indian Summer* (New York: Dutton, 1940); and *The Confident Years* (New York: Dutton, 1952).

8. SHINN, EARL (Strahan, Edward, pseud.), *The Art Treasures of America* (Philadelphia: Barrie, 1879–1880). Gives a vivid picture of art collecting in America after the Civil War.

V. A few specialized reference works are moderately useful:

1. *The Britannica Encyclopedia of American Art*. Very mod and faddish but of some use for the better-known older artists.

2. Three not very comprehensive biographical dictionaries of earlier artists are:

 i. NYHS, *Dictionary of Artists in America 1564–1860* (Yale, 1957).

 ii. FIELDING, MANTLE, *Dictionary of American Painters, etc.* (New York: Carr, 1965).

 iii. YOUNG, WILLIAM, *Dictionary of American Artists, etc.* (Young, Mass., 1968).

3. *Official Museum Directory, United States, Canada* (Crowell-Collier, 1971). Covers all museums, not just art museums.

B. A listing of books in the order of the chapter and section for which they have been useful as sources:

Book I In the Beginning
Chapter II

 ii: *Basel:* BOERLIN, PAUL H., *Die öffentliche Kunstsammlung Basel* (Braunschweig, Germany, 1960).

iii: *Ashmolean:* WATERHOUSE, ELLIS, *Painting in Britain, 1530–1790* (Baltimore: Penguin, 1953; Pelican History of Art).

iv: *British Museum:* SHELLEY, HENRY C., *The British Museum* (Boston: Page, 1911).

Chapter III

i: *Louvre:* BABEAU, ALBERT, *Le Louvre et son histoire* (Paris, 1895).

GOULD, CECIL H. M., *Trophy of Conquest: The Musée Napoleon* (London: Faber, 1965).

ii: *Peale:* SELLERS, CHARLES C., *The Artist of the Revolution* (Yale, 1939) and *Charles Willson Peale* (2 vols., Philadelphia, 1947; Scribncrs, 1969).

Chapter IV

i: *Trumbull:* SIZER, THEODORE, *The Works of Col. John Trumbull* (Yale, 1950, 1967).

JAFFE, R. P., *John Trumbull* (Boston: N. Y. Graphic Society, 1975).

Chapter V

ii: *Bonaparte:* CONNELLY, OWEN, *The Gentle Bonaparte* (New York: Macmillan, 1968).

iii: *Bryan:* WHARTON, EDITH N., *False Dawn* (New York: Appleton, 1924).

CONSTABLE, WILLIAM G., *Art Collecting in the United States* (London: Nelson, 1969).

iv: *Jarves:* STEEGMULLER, FRANCIS, *The Two Lives of James Jackson Jarves* (Yale, 1951).

Chapter VI

i: *NYHS:* WHITEHILL, WALTER M., *Independent Historical Societies* (Boston, 1962).

VAIL, ROBERT W. G., *Knickerbocker Birthday* (New York, 1954).

ii: *Smithson:* CARMICHAEL, LEONARD, *James Smithson and the Smithsonian* (New York: Putnam, 1965).

HELLMAN, GEOFFREY, *The Smithsonian, Octopus on the Mall* (Philadelphia: Lippincott, 1967).

iii: *Albany:* FAISON, S. LANE, *Art Tours and Detours in N. Y. State* (New York: Random House, 1964).

Salem: WHITEHILL, WALTER, *The East India*

Marine Society and the Peabody Museum of Salem (Salem, 1949).

Note: For the Tradescants, Ashmole, Smithson and his ancestors, the English *Dictionary of National Biography* is a source.

Book II Pioneers, O Pioneers!

Chapter II

i: HOWE, W.; TOMKINS, C.; SHINN, E. (op. cit.).

iv: *Cesnola:* McFADDEN, ELIZABETH, *The Glitter and the Gold* (New York: Dial, 1971).

DUSSAUD, RENÉ, *Les Civilisations préhelleniques dans le bassin de la mer Egée* (Paris, 1910).

MYRES, JOHN L., *Cesnola Collection, Handbook* (New York: Metropolitan, 1914).

Chapter III

i: *BMFA:* GILMAN, B.; WHITEHILL, W.; STEEGMULLER, F. (op. cit.).

ii: *Boston:* AMORY, CLEVELAND, *The Proper Bostonians* (New York: Dutton, 1947).

iii: *Brimmer:* CHAPMAN, JOHN J., *Memories and Milestones* (New York: Moffat & Yard, 1915).

HOWE, MARK A. DeW., *John Jay Chapman* (Boston: Houghton, 1937).

iv: *BMFA, Orient:* WAYMAN, DOROTHY G., *Edward Sylvester Morse* (Harvard, 1942).

MORSE, EDWARD S., *Japan Day by Day* (2 vols.; Boston: Houghton, 1917).

v: BROOKS, VAN WYCK, *Fenollosa and His Circle* (New York: Dutton, 1962).

CHISHOLM, LAWRENCE, *Fenollosa* (Yale, 1963).

viii: *Egypt:* GREENSLET, FERRIS, *The Lowells and Their Seven Worlds* (Boston: Houghton, 1946).

Chapter IV

i: *PAFA:* HENDERSON, HELEN W., *The Pennsylvania Academy of the Fine Arts and Other Collections of Philadelphia* (Boston: Page, 1911).

GOODYEAR, FRANK, JR., et al., *In This Academy* (Philadelphia: P.A.F.A., 1976).

ii: RUTLEDGE, ANNA W., *P.A.F.A. Cumula-*

tive Record of Exhibition Catalogues 1807–70 (Philadelphia: P.A.F.A., 1955).

SARTAIN, JOHN, *Reminiscences of a Very Old Man* (New York: Appleton, 1899).

vi: *U. of Pa. Mus.:* MADEIRA, PERCY C., *Men in Search of Man* (Philadelphia: U. of Pa., 1964).

Chapter V

iii: *Balt. Peale Mus.:* HUNTER, WILBUR H., *The Peale Museum* (Baltimore, 1964).

Book III Westward the Course

Chapter I

ii: *Chicago:* DE MARE, MARIE, *G.P.A. Healy* (New York: McKay, 1954).

iii: *Detroit:* CLAYTON, WALLACE C., *The Growth of a Great Museum* (Detroit, 1966).

STREET, JULIAN L., *Abroad at Home* (New York: Century, 1915).

vii: *Indpls:* PEAT, WILBUR D., *Pioneer Painters of Indiana* (Indianapolis, 1954).

Chapter II

i: *Cincinnati:* HARLOW, ALVIN F., *The Serene Cincinnatians* (New York: Dutton, 1950).

CLARK, EDNA H., *Ohio Art and Artists* (Richmond, 1932).

TROLLOPE, FRANCES M., *Domestic Manners of the Americans* (London, 1832; New York: Knopf, 1949).

ii: DUVENECK, JOSEPHINE W., *Frank Duveneck* (San Francisco, 1970).

vi: *Toledo:* STEVENS, NINA S., *A Man and a Dream* (Hollywood, 1941[?]).

vii: *Cleveland:* WITTKE, CARL F., *The First Fifty Years* (Cleveland, 1966).

CLARK, E.; STEEGMULLER, F. (op. cit.).

Book IV The Age of the Titans

Chapter I

i: MYERS, GUSTAVUS, *History of the Great American Fortunes* (Chicago: Kerr, 1911–1917; Modern Library, 1936).

JOSEPHSON, MATTHEW, *The Robber Barons* (New York: Harcourt Brace, 1934, 1962).

HOLBROOK, STEWART H., *The Age of the Moguls* (New York: Doubleday, 1953).

ii: *JPM:* WINKLER, JOHN K., *Morgan the Magnificent* (New York: Vanguard Press, 1930).

SATTERLEE, HERBERT L., *John Pierpont Morgan* (New York: Macmillan, 1939).

ALLEN, FREDERICK L., *The Great Pierpont Morgan* (New York: Harper, 1949).

iii: *AC:* HENDRICKS, BURTON J., *The Life of Andrew Carnegie* (New York: Doubleday, 1932).

iv: *HCF:* HARVEY, GEORGE B. M., *Henry Clay Frick* (New York: Scribner, 1928).

v: *AWM:* LOVE, PHILIP H., *Andrew Mellon* (Baltimore: F. H. Coggins, 1929).

O'CONNOR, HARVEY, *Mellon's Millions* (New York: Day, 1933).

vi: *JDR:* NEVINS, ALLAN, *John D. Rockefeller* (1 vol., New York: Scribner, 1959).

COLLIER, PETER, and HOROWITZ, DAVID, *The Rockefellers* (New York: Holt, Rinehart & Winston, 1976).

Chapter II

i: *Met:* TAYLOR, FRANCIS H., *Pierpont Morgan as Collector* (New York, 1957).

CANFIELD, CASS, *The Incredible Pierpont Morgan* (New York: Harper, 1974).

Chapter III

i: *Nat. Gall.:* BEHRMAN, S. N., *Duveen* (New York: Random House, 1952).

FINLEY, DAVID E., *A Standard of Excellence* (Washington, D.C., 1973).

WALKER, JOHN, *Self Portrait with Donors* (Boston: Little, Brown, 1974).

v: *Freer:* SAARINEN, A. B. (op. cit.).

vi: *Phillips:* PHILLIPS, MARJORIE, *Duncan Phillips and His Collection* (Boston: Little, Brown, 1970).

Chapter IV

i: *Phila.:* ROBERTS, GEORGE and MARY, *Triumph on Fairmount* (Philadelphia: Lippincott, 1959).

iii: *JGJ:* WINKELMAN, BARNIE T., *John G. Johnson* (Univ. of Pa., 1942).

JOHNSON, JOHN G., *Sightseeing in Berlin and Holland* (Philadelphia, 1892).

iv: *Wideners:* WIDENER, PETER A. B., II, *Without Drums* (New York: Putnam, 1940).

v: *Barnes:* SCHACK, WILLIAM, *Art and Argyrol* (New York: Yoseloff, 1960).

HART, HENRY, *Dr. Barnes of Merion* (New York: Farrar Straus, 1963).

Chapter V

i: *Cones:* POLLOCK, BARBARA, *The Collectors* (Indianapolis: Bobbs-Merrill, 1962).

CONE, EDWARD T., "The Miss Etta Cones, the Steins and M'sieu Matisse" (*American Scholar*, Vol. 42, #3, 1973; reprint).

iv: *Gardner:* CARTER, MORRIS, *Isabella Stewart Gardner* (Boston: Houghton, 1925).

THARP, LOUISE H., *Mrs. Jack* (Boston: Little, Brown, 1965).

SAARINEN, A. B. (op. cit.).

v: *BB:* SPRIGGE, SYLVIA S., *Berenson, A Biography* (London: Allen & Unwin, 1960).

MARIANO, NICKY, *Forty Years with Berenson* (New York: Knopf, 1966).

CLARK, KENNETH M., *Another Part of the Wood* (London: Murray, 1974).

WALKER, JOHN (op. cit.).

BERENSON, BERNARD, *Sketch for a Self Portrait* (New York: Pantheon, 1949).

BERENSON, BERNARD, *The Bernard Berenson Treasury* (London: Methuen, 1962).

BEHRMAN, S. N. (op. cit.).

Chapter VII

ii: *Whitney:* ZIGROSSER, CARL, *My Own Shall Come to Me* (Private, 1971).

iii: *MOMA:* LYNES, RUSSELL, *Good Old Modern* (New York: Atheneum, 1973).

v: *Guggenheims:* LOMASK, MILTON, *Seed Money, The Guggenheim Story* (New York: Farrar Straus, 1964).

Book V Filling in the Form

Chapter I

vii: WALKER, J.; BEHRMAN, S. N. (op. cit.).

Chapter II

iv: *Miami:* GOODRICH, DAVID L., *Art Fakes in America* (New York: Viking, 1973).

viii: *California:* AMORY, CLEVELAND, *Who Killed Society?* (New York: Harper, 1960).

ATHERTON, GERTRUDE, *My San Francisco* (Indianapolis: Bobbs-Merrill, 1946).

ALTROCCHI, JULIA C., *The Spectacular San Franciscans* (New York: Dutton, 1949).

x: MAHER, JAMES T., *The Twilight of Splendor* (Boston: Little, Brown, 1975).

Chapter III

iii: McPHEE, JOHN, *A Roomful of Hovings* (New York: Farrar Straus, 1968).

HESS, JOHN L., *The Grand Acquisitors* (Boston: Houghton Mifflin, 1974).

Index